W9-ADK-288

GREEK ART AND ARCHITECTURE

JOHN BOARDMAN · JOSÉ DÖRIG

WERNER FUCHS · MAX HIRMER

Photographs by Max Hirmer

HARRY N. ABRAMS, INC. *Publishers* NEW YORK

Texts by J. Dörig, W. Fuchs and M. Hirmer
translated from the German

Library of Congress Catalog Card Number: 67–22850

No part of the contents of this book
may be reproduced without the written permission of the publishers,
HARRY N. ABRAMS, INCORPORATED, NEW YORK

Colour and Monochrome Plates printed by Kastner and Callwey, Munich, Germany.
Text phototypeset in Great Britain by Keyspools Ltd, Golborne, Lancashire,
and printed in Germany by Passavia.
Bound in Germany by Karl Hanke, Düsseldorf.

CONTENTS

ARCHITECTURE

INTRODUCTION

Of all the arts of ancient Greece its architecture is probably the best known and least understood. Perhaps it is the least understandable, since a building can only be fully appreciated in terms of its setting, of the buildings around it and of the society which planned and used it; and what imagination or historical knowledge can offer to the connoisseur of a vase or statue is not so readily supplied when the object of study may be a temple, isolated now in a wilderness (or, worse, a modern town) where there was once a live city, or a theatre, shorn of its stage, players and audience.

Yet we think we understand Greek architecture because we recognize it. Every schoolboy knows what a Greek temple looks like, and the difference between a Doric and an Ionic capital. The designers of the Industrial Revolution saw nothing incongruous in using Classical columns, though of cast iron, in their new *Fig. 1* machines. The façades of banks and offices, or at least of those built up to a few years ago, offered canonic examples of the Classical orders worked in stone or cement. Sometimes the copies are exact, sometimes grossly distorted, but their elements are all familiar. The mouldings and beading which the amateur wood-worker can buy by the metre are copies of Classical mouldings. It still seems as inevitable that the façade of a major building should include a colonnade, although modern construction methods have no need for it, as that a private house should have a chimney even when no solid fuel is burnt; so tenacious and conservative are fashions in building. If we think of what inspired the near-modern Classical façades we come eventually to Renaissance Italy, where the orders, mouldings and proportions of ancient buildings were yet more sedulously copied and adapted. The immediate source for this was the architecture of the Roman Empire.

Romans learnt from the Greeks. So it might seem quite natural that we should feel at home with Classical architecture and believe that we understand it. But this is not true, and not the least barrier to our appreciation of Greek architecture is its very familiarity; a deterrent even to our proper understanding of other Greek arts.

What we know of Greek architecture is essentially fragmentary. A very few temples stand in reasonable condition to near their roofs or can be so physically restored—the Parthenon, the Erechtheion and the *7–11, 21–25* Temples of Hephaistos and Athena Nike in Athens, the Paestum and Akragas temples—and these all lack *14–18, II* their cores to various degrees. There are a few minor buildings or monuments, surviving complete, or restored, like the Treasury of the Athenians at Delphi *30* and the Lysikrates monument in Athens. Theatres *Fig. 84* leave us only their seats, not their stage buildings. And all these must be viewed in isolation, robbed of their neighbouring buildings, or in a tourist setting designed to make them look like a country gentleman's folly. Moreover, where the physical setting is dominant, as at Sounion or Segesta, the atmosphere of remote- *12,20* ness and the natural beauty are false to sanctuaries where men once lived, worked and worshipped. For

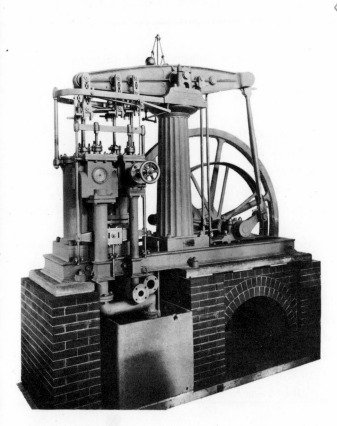

1 Compound beam-engine (ca. 1860) incorporating a Doric column. Science Museum, London

9

the other buildings, public and private, we rely on the scholar's painstaking assessment of foundations and architectural fragments; and the standard forms which many ancient buildings present in the archaeologist-architect's paper reconstructions may be in no small measure due to the fact that he can take into account only what he can understand. It is the fragments—capitals, mouldings, decorative details— which we know most about, and it is perhaps safer to approach Greek architecture from what we can know, however isolated and fragmentary it may be. It was, after all, the architectural decoration of the Greeks rather than their plans or construction methods (which were generally unenterprising and mechanically unambitious) that survived and was elaborated in the Roman period, when new and superior techniques of construction were practised; and this became the idiom of Renaissance architecture in Europe. We will accordingly in this chapter consider the various classes of Greek architectural orders and decoration, their origins and development, before discussing the different types of building on which they appear, while the niceties and problems of construction methods must of necessity be largely ignored. This is, in effect, treating Greek architecture as a branch of the decorative arts in Greece, rather than as an art in its own right—an approach largely justified by its inherent character and by the history of its influence on the architecture of the West.

MATERIALS

The architecture of any community must to some degree be determined by the materials available to it and the techniques it commands to handle these materials. The appearance of a modern building is controlled by what can be done with steel, concrete, brick and glass; or of many Roman buildings by what a dome could span, an arch and buttress bear. In ancient Greece the advantages offered by the arch were not exploited, and the strength of reinforced concrete not known. The architecture was inert, a piling of block on block with only a rudimentary understanding of stresses and with most attention paid to proportion and decoration, to the visual qualities of a building rather than its structure or even sometimes its function. This is not to say that in command of their material, of what it could and could not do, the Greeks learnt and practised skills unmatched in any subsequent period.

The methods of construction for simpler domestic buildings did not vary much in the Greek world, and in the early period down to the seventh century B.C. they sufficed for buildings of all types. The techniques of the palace architecture of Minoan and Mycenaean Greece were lost when the palaces fell, and it was probably harder for Homer's contemporaries, in the eighth century B.C., to envisage the 'Homeric house' of their Age of Heroes, than it is for the present-day scholar who can study the ground-plans and remains. Apart from the descriptions preserved by oral tradition and embedded in the poems of Homer, the Greeks of the Archaic period could look at the Lion Gate at Mycenae, and at the citadel's massive walls and at similar monuments elsewhere in Greece, but they had to attribute them to the hands of giants; or at the great beehive (tholos) tombs which they could understand only as 'Treasuries' that they had robbed of their gold and grave goods.

The house walls of early Greece were made of stone—little better than rubble but well laid, sometimes roughly coursed, and on occasion with the stone face well smoothed and jointed. Often the walls could rise in brick above a low stone base or socle. But the brick was not the fired brick of Roman or modern buildings. It was sun-dried—hence the need for it to be kept off the ground—and the bricks were large, averaging about 60 × 30 × 10 cm., and in the Classical period were often square in plan with sides of about 45 cm. In the simpler houses roofs were often flat, of packed clay over beams and branches with seaweed or leaves filling the cracks—a type of construction still to be seen in parts of Greece. Thatched roofs would have a steep pitch, but in other materials roofs of this shape would not have become common until clay tiles were in general use, and these do not appear at all in Iron Age Greece until after the middle of the seventh century.

The stone used would be quarried from the nearest hillside, and Greek limestone is a reasonably tractable material. When the Greeks began to aspire to monumental architecture they rapidly perfected more

sophisticated techniques for dealing with the softer rocks, and also went to considerable trouble to obtain and work harder but more attractive stone. It was at a time when their sculptors were accepting the challenge to produce figures of more than life-size in hard stone—the fine white marble which could be readily quarried in the Greek Islands and, as they eventually learned, in other parts of Greece, notably Attica (Pentelic marble). Marble was not much used at first by the architects, but saved for decorative mouldings which were treated in a sculptural manner. Where the Greeks had no ready supply of marble, in southern Italy and Sicily, and for some of the buildings at Olympia, they coated the poorer stone with stucco to render the sharp mouldings and clear planes.

The softer stones were treated with care and precision. They were exactly sawn and fitted for wall blocks, and by the sixth century the style of polygonal walling was perfected—with irregular, generally straight-sided blocks (the masonry with curved joints is called 'Lesbian') as precisely fitted as a jigsaw puzzle. The style long remained popular in Greece in limestone or marble, for walls of buildings, terraces and especially fortifications since its interlocking structure was more stable, but as soon as marble was in general use for major works (in the second half of the sixth century) coursed masonry of rectangular blocks (ashlars) was more commonly employed. This might have alternating tall and shallow courses (pseudo-isodomic), courses of equal height (isodomic), or with graded heights, the tallest at the base like a dado, while a variety of other patterns in the blocks was introduced by the arrangement of headers and stretchers and the like. The faces of the blocks could be chiselled smooth, or left rough and only trimmed at the joints in a form of rustication. Projecting lifting bosses would normally be trimmed away, but traces of them are sometimes left for decorative effect. Commonly only the edges of blocks or the ends of flutes on columns would be finished before being set on the building, for the final carvings to be done more safely *in situ*. Close joints were ensured by smoothing only the strip behind the face and hollowing slightly the rest of the sides of the blocks (anathyrosis). No mortar was used, but vertical and horizontal dowels of wood, bronze or iron set in lead bond the blocks together in larger buildings and occasionally in foundations. Simpler constructions might have coursed blocks only on the outer face with a rougher inner face and rubble filling. In the Greek period the arch and vault were employed but rarely in some tombs and fortifications, and architects only began to win confidence in their use in the Hellenistic period. But we may suspect that these devices were found unpleasing aesthetically however useful they might be structurally.

The carriage of stone in a country like Greece was no easy matter, the tracks over which the blocks of marble were dragged on sleds from Mount Pentelikon to Athens can still be seen. Around the more massive blocks wooden wheels could be made so that they could be rolled to the site. Vulnerable corners or mouldings could be left blocked out until safely in position and then finished. Just as favourite marbles could be brought from a considerable distance for a sculptor's workshop, so could they for buildings. At Delphi, for instance, when the Athenians and Siphnians built their treasuries, they sent marble from the island quarries, while the Sicyonians, just over the waters of the Gulf of Corinth, sent their local stone for the Monopteron with the metopes.

Occasionally the architect used iron beams to reinforce the upper works where ceiling loads were feared to be excessive—as in the Parthenon beneath the pedimental statues, in the Propylaea at Athens, and in two of the temples at Akragas, but for virtuosity in the handling of colossal blocks of stone we look to pre-historic Greece (the lintel of the Treasury of Atreus) or to the Roman period (the trilithon at Baalbek). In Greek architecture it is not so much the size of the blocks (which can be considerable) as the manner in which they are worked and fitted which is so impressive: a perfection and exactitude which goes beyond the call of ordinary efficiency or utility, and which gives the masonry of Classical buildings, and certainly their carved mouldings, something of the quality which we discern and enjoy in Greek sculpture.

In the stone temples of the Classical period the ceiling and roof beams were generally still of wood although stone ceilings were soon fashionable for major works. In the simpler and primitive buildings the pillars were wooden, usually no more than roughly shaped tree trunks, no doubt, but we have a hint of the elaborate carpentry of the upper works in early buildings in the details of the stone Doric order, in which many features of woodwork are translated into stone. The wooden parts of these early buildings were often encased and protected with clay revetments. Greek skills in firing massive slabs of clay are nowhere better

displayed than in the colourful revetments of Archaic buildings. Even the clay roof tiles represent no mean achievement in ceramics. Their size, averaging 65 to 90 cm. long by 55 to 70 cm. wide, and some 3 to 4 cm. thick, is not matched today, and when the American excavators of the Athenian Agora sought to make tiles of the ancient type for their reconstruction of the Stoa of Attalus they were hard put to it to find in Greece a pottery which could face the technical difficulties involved. The flat tiles interlock top and *Fig. 2* bottom, and the side joints were linked by cover tiles (the ridged 'Corinthian', semicircular 'Sicilian'— also current in East Greece). Another variety, 'Laconian', offered overlapping concave and convex tiles, a

2 Types of roof tiles: Laconian, Sicilian, Corinthian

more familiar scheme to be seen still on older houses today, but again the ancient tiles were far larger. The painted decoration of these clay revetments and tiles will be further discussed below. Marble tiles of similar pattern were first used in the sixth century. They are of course extremely heavy, and so are often confined to the outer rows, behind the gutters over the side walls and columns, but occasionally cover the entire roof.

In the luminous atmosphere of Greece house and temple lighting could be effected by small apertures high in the walls, or sometimes simply from the doorway. There was rare use of pierced tiles to admit light from above, and clear window glass was not known. Smoke escaped by gable ends but simple clay chimneys are found, and the upper parts of large storage jars no doubt also served (as they do today) for chimneys, as they did certainly for well tops.

We read so much about the Greek artist's sensitive appreciation of proportions that we might expect that he not only commanded elaborate and generally agreed standards of measurement, but also rigorously applied them. This is far from the truth, but the mathematical delights of trying to elicit standards of measurement from extant buildings continue to excite scholars. The most that they generally demonstrate is that one basic standard was employed in a single building, without necessarily exact correspondence with that used in any other. Much, if not all, must have been determined by the mason's measuring rod, marked and subdivided, but not checked against any national or even local standards. It is even an over-simplification to say that only two standards were employed—the long foot of about 32·65 cm., and a short foot of about 29·4 cm.—since so many intermediate standards are thought to be identified, quite apart from local varieties like the Samian 'ell' of 52·4 cm. The last corresponds roughly with the Egyptian cubit (as Herodotus had observed) and the two foot standards are also met in Egypt, the short having replaced the long during the seventh century B.C. In an age in which winning a race was more important than record times it mattered nothing at all that no two race-track stadia in Greece had exactly the same length, local standards or caprice determining the actual length of the expected stadion of 600 feet. Hardly more encouraging is the search for detailed principles of proportion employed in designing all the parts of a building, beyond some very simple aids in laying out foundations and plans, or in directing the mason's work. The Roman writer Vitruvius, who deduced and propounded such principles, has probably been the source of this false optimism. Some very broad if not conscious principles can be distinguished, however, and they can be seen to alter as time passed and taste changed. Greek architects began themselves to theorize about proportions when Greek sculptors did, and of course architects were very often also practising sculptors.

Some uniformity is, however, imposed by the use of mud bricks, and we can see that some wall widths are so determined, or by roof tiles. Publicly approved tile standards were accordingly displayed in some Greek cities (found in Athens, Assos, Messene). A comment on the diversity of standards may be read in *42 above* the strange Metrological Relief in Oxford on which the man's outstretched arms (2·07 m.) give a fathom of 6 rather long feet, or 7 short feet of usual length, such as is also shown on the relief, or 4 rather short ells. Whether this monument can have anything to do with the imposition of Athenian standards within her empire is not clear. When we come to measure actual buildings it is not uncommon to find discrepancies of a centimetre or so in measurements which, in the interest of symmetry or strict mensuration, should correspond exactly. Rule of thumb must have been as important during actual construction as rule of eye was in determining some of the simpler optical corrections which will be considered later.

THE ORIGINS OF GREEK MONUMENTAL ARCHITECTURE

In the Bronze Age Greek world the only truly monumental architecture was that of the less sophisticated culture—of the Mycenaean Greeks, and not of the non-Greek Minoans of Crete. Apart from their colossal walls and tombs the Mycenaeans offered also in their palace architecture a monumental feature by making the central element a single large structure, the baronial hall (megaron), in contrast with the Minoan palaces where the state rooms, stores and apartments were grouped on two stories or more around a large central court. The megaron was rectangular in plan with an open columned porch, leading through an anteroom to the main hall with its central hearth. With the end of the Bronze Age this exact building form, and its construction—stone tied with timber—disappeared from Greece. But it is the generic megaron form which we recognize first again in the buildings of the resurgent Greece of the Geometric period.

The Orientalizing influences which remodelled Greek art in the later eighth and seventh centuries had their effect also upon her architecture, although far more slowly and, as a result, the effect can be explained even less readily in terms of mere imitation.

The great buildings of the Near East which Greeks may have seen were constructed largely of brick with stone elaboration only in the lower parts and at gateways. In North Syria, a crucial area for the understanding of the new influences at work in Greek art, we find free use of stone sculptural detail on façades, and a very common element is the dado of relief sculpture, best known to us, perhaps, on the Assyrian palaces. In Egypt, on the other hand, all-stone construction was the rule, and the Greeks there observed the aesthetic values of the stone column, and the decorative effect of repetition of mouldings and architectural elements, from which they were to derive their conception of the orders. Both these features, the columns and the regular mouldings, were familiar to their Mycenaean predecessors.

Greeks were slow to adapt these decorative elements to their simple architectural needs. A minor relief frieze of eastern type is seen in Crete in the eighth century, and later in the seventh century a small temple in the island, at Prinias, incorporates another frieze of horsemen. This is generally restored as a crowning *Fig. 3* frieze, perhaps falsely *a posteriori,* on the analogy of later Ionic friezes. It might as well have been a dado in the porch. On the same building seated figures in the round flank a window or relieving aperture over the main doorway, which may again be an Egyptian feature. From Arkades in Crete comes a stone version of the palm capital, known alike to Egyptians and Mycenaean Greeks. These features in Crete are intimations only of the all-stone architectural orders which do not begin to appear until the very end of the century,

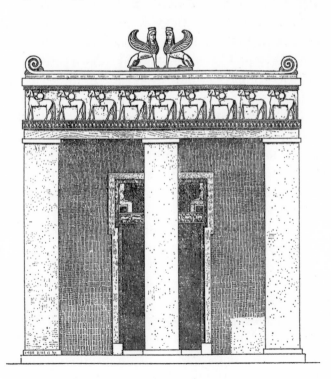

3 Temple A at Prinias, Crete. Restored façade. Late 7th century
B.C. (after Stephani)

and which must be attributed to the same direct inspiration of Egyptian practice, by which we explain the contemporary beginnings of true monumental sculpture in the Greek world.

THE ORDERS

The canonic orders in Greek architecture are defined in terms of a colonnade with entablature above, the different treatment of each element, from column base to gutter, determining the order. These orders are rarely mixed, and the changes in detail and proportion from one period to another are slow and subtle, so that from a few pieces it is generally thought possible to restore with some degree of accuracy the whole external order of a building. In the account below the orders are taken separately, described in their classic form, and their origins and development briefly sketched.

DORIC

Fig. 4 Doric columns have no bases, but rise straight from the pavement (stylobate), at the top of three steps. The shaft usually has twenty shallow flutes, with sharp ridges between. At the top there are three shallow necking rings before the capital spreads into its two parts—the round echinus, and the flat square abacus above. Plain architrave blocks lie across the capitals, but above them is an elaborate frieze which gives the appearance of nearly square panels (metopes) which often carry sculpture reliefs, framed at either side by the triple-ridged triglyphs (early triglyphs taper upwards slightly). Below each triglyph, on the face of the architrave, appear six peg-like guttae, while similar blocks with protruding pegs (the mutules) are seen on the underside of the cornice which projects above. Crowning all comes the gutter (sima) pierced with spouts which often take the form of lions' heads. This is basically the external order but in temples the Doric upper works (entablature) are repeated along the top of the walls within the colonnade and over the porch.

The origin of these rather strange stone forms is clearly woodwork, but they do not exactly copy the timbering which would appear in the same position. Thus, the pegs of the guttae appear to fasten the planks of the triglyphs, which mask the beam ends of the ceiling. But there is no strict logic in the disposition of these elements. The basic triglyph-metope pattern was determined by beam ends and intermediate spaces, but the rest is an intelligent composition of carpentry forms translated into stone. Even the shallow flutes of the column resemble nothing more than a carpenter's rough finish to a tree trunk with an adze. Both convex and concave flutes for wooden columns were known in Bronze Age Greece, the former recalling an Egyptian type, itself probably derived from pillars of reeds bound together. In the stone buildings the stub ends of the side walls by the porch (the antae) are thickened in imitation of the wooden revetments which must have protected the exposed ends of brick walls.

The swelling cushion-like capitals of the earliest Doric buildings have been likened to Mycenaean capitals, whose profile edges are generally semicircular, and which have a bold floral necking. We know them best from ivory miniatures or on the Lion Gate at Mycenae, which is probably how the Greeks in the seventh
48 above century knew them. A few Doric capitals bear the floral necking too, and a bronze fragment from Olympia might have been from one of the wooden Doric columns in the early Temple of Hera there. But it is well to be wary of such facile parallels. We cannot be sure, for instance, what early wooden capitals may have been like. The capital of a column shown on a Corinthian vase of before the middle of the seventh century has a swelling rounded outline, while an Attic vase of the end of the seventh century shows the fully Doric type, with necking rings, but also a base, and this, with perhaps some models from Sparta, is our earliest
2, 3 above certain representation of a Doric column, whether of stone or wood. At Olympia the old Temple of Hera had at first only wooden columns, which were replaced by stone ones as time passed. The old wooden capitals must have closely resembled the earliest stone replacements.

The early Doric capitals have full, curving outlines. There is no positive evidence to demonstrate that any which survive are earlier than 600 B.C. Thereafter the curve is gradually diminished and by the time
Fig. 43 of the Temple of Zeus at Olympia in the middle of the fifth century the sides of the capital are straight, flaring. This development of the profile can be traced in the various replacement stone columns on the

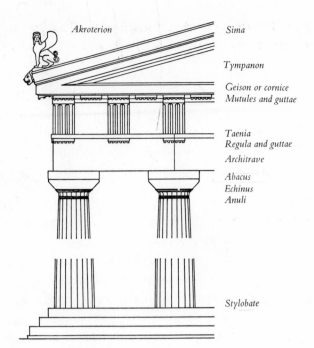

Akroterion

Sima

Tympanon

Geison or cornice
Mutules and guttae

Taenia
Regula and guttae

Architrave

Abacus
Echinus
Anuli

Stylobate

4 The Doric order of the Temple of
 Aphaea, Aegina.

Temple of Hera at Olympia, which has just been mentioned. As time passed the columns become slimmer, the capitals shallower. The sequence of examples from Delphi is instructive. *Fig. 5*

Some eccentric additions were permitted on Doric temples in areas permeated by Ionic taste. At Paestum, on the 'Basilica' (Temple of Hera I: late sixth century), elaborate floral collars are seen on capitals, and, *48 above* again in the west, the Doric columns of the fifth-century Temple of Zeus at Akragas have bases. This variant *Fig. 54* is otherwise only admitted on very late Doric buildings. On the only early Doric temple actually built in East Greece, at Assos, there is an Ionic sculptured frieze above the architrave, below the usual triglyphs and metopes. A Late Archaic temple on Corfu, at Kardaki, had Ionic mouldings in its entablature instead of the *49 below* usual Doric, but this sort of hybrid is commoner in Sicily. On the strange Archaic throne of Apollo near

5 Doric columns at Delphi: (a) Temple of Athena Pronaia I, about 600 B.C.; (b) Temple of Athena Pronaia II, about 510 B.C.; (c) Temple of Apollo, about 525 B.C.; (d) Athenian Treasury, late 6th century B.C.; (e) Tholos, 4th century B.C.; (f) Temple of Apollo, later 4th century B.C. (after Gruben)

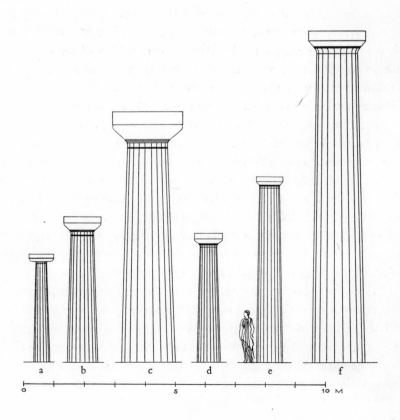

a b c d e f

0 5 10 M

Dorian Sparta (at Amyklai), but built by an Ionian artist (Bathykles), capitals are composed half-Doric and half-Ionic volute, set like a console.

The Doric entablature changed very little although its height decreased steadily in proportion to the height of the column. The highly artificial triglyph and metope frieze presented architects with peculiar problems. Normally alternate triglyphs were centred over the columns. The problem came at the corners where, if the principle was strictly observed, an ugly half metope or less would be left over; or, if the triglyph were moved to the corner, it was no longer squarely over the column and the adjacent metopes had to be correspondingly wider. Another attempted solution was to contract the spacing between the columns at the corners, and in some of the Greek temples in Sicily and South Italy gradual contraction begins with the third column from the corner at the front and sometimes at the sides. This tiresome problem was solved in various ways, and generally, one supposes, to the satisfaction of all but the mathematical purists.

The Doric order must certainly have been the invention of one man. It typifies the most conservative elements in Greek art in the way in which it remained basically unchanged for so long, while it continued to serve as a far more searching test of the architect's and the mason's skill than its more decorative competitor, Ionic. As its name suggests it was most popular in the southern Greek mainland, but it was also regularly employed in the western colonies in Italy and Sicily. Apart from the strange early temple at Assos near Troy it was not commonly used for temples in East Greece until the Hellenistic period, and then in the face of disparaging propaganda by local architects who had reason to prefer their native Ionic.

IONIC

The Ionic order was far more diversified than the Doric. The canonic form was established only after two generations of experiment, unlike Doric, and there were always vigorous and individual schools in different parts of the Greek world. It is essentially a decorative order and a great part of the architectural decoration which will be described later was developed for it, and then repeated on a multitude of smaller objects. Difference in scale meant nothing to the efficacy of the decoration. Since the origins of the order are so complex and diverse, they must be considered first.

The earliest intimations of monumental stone architecture in East Greece are some stone capitals covered with floral ornaments in low relief. Some at Smyrna had been already carved for a new temple when the *42 centre* Lydian Alyattes sacked the town soon after 600 B.C. These are bell-shaped, of limestone. The column drums for them were unfluted, nearly a metre thick. Other capitals of simpler form are known, as from Phokaia, and the important element appears to be a ring of leaves carved on a shallow convex moulding, and overlapping in such a way that the tips of the second row of leaves are seen between the leaves of the front row. A number of capitals are found on which this ring of leaves is topped by a pair of volutes, rising straight from the shaft, with the wedge between them filled by a carved palmette. These appear on sites in *42 below* the northern parts of East Greece and are often therefore called Aeolic, or simply proto-Ionic.

All these elements—the floral band, the volutes—derive from Near Eastern art, and as decorative detail were in no way foreign to the already established Orientalizing arts of Greece. But in the Near East they had not been applied to monumental architecture. There are, certainly, mouldings carved with florals from North Syria, but these are bases for wooden columns, and offer no exact parallels. We get nearer with the Aeolic capital, for a roughly similar capital is seen in Cyprus and the Near East. It is, however, usually constructed very differently, with crossing volutes, and is generally used only with a square pillar or engaged pilasters. Only in Palestine (at Hazor and Ramat-rahel) is it used for a column in the Greek manner, and at an earlier date than the Greek. But even there it tops rectangular pillars and the volutes are not carved so as to appear to spring organically from the shaft. These very elements of the early Greek capitals appear, however, in exactly the same form in the Near East in the supporting members of furniture and minor objects. It seems more probable then that the East Greek architect enlarged these Orientalizing decorative details and applied them to his new monumental architecture. If the result in some respects resembles Egyptian architecture of a much earlier date this in part reflects the origin, even in the East, of some of the floral patterns involved, and perhaps the immediate inspiration of standing Egyptian monuments which influenced the architecture of the Greeks in much the way that Egyptian sculpture had done, and equally

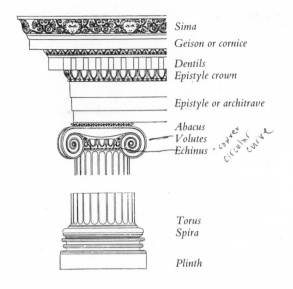

Sima
Geison or cornice
Dentils
Epistyle crown

Epistyle or architrave

Abacus
Volutes — *convex circular curve*
Echinus

Torus
Spira

Plinth

6 The Ionic order of the Temple of Athena Polias, Priene. 4th century B.C. (after Wiegand and Schrader)

without also encouraging the exact copying of Egyptian types or motifs.

The upperworks of these early buildings were wooden. When stone was used and tiled roofs added the columns had to be set closer together or a capital with a broader bearing surface was required. One way to do this would be to spread the volutes of the Aeolic capital until they lay flat leaving the floral between them. This, in effect, is what the earliest Ionic capitals are, with the girdle of leaves drawn up between the volutes to form the echinus moulding of leaves, turned to 'egg and dart'. Naxian capitals offer this primitive form, and it may be that it was invented on Naxos, which, as an important marble-producing and marble-working centre, may have exported finished or part-finished architectural members, as she did the material for sculpture as well as part-finished (and probably finished) figures. An early example is the capital supporting the Naxian Sphinx dedication at Delphi, of about 560 B.C. This is generally restored with the 119 volutes linked, in the ordinary, later Ionic manner; but the crucial part on each side is broken away—presumably because there was something there to break away, and this could only have been a relief floral. This origin of the Ionic capital as two separated volutes was never quite forgotten, but on the great mid-sixth-century temples of East Greece the volutes were joined in a single channel and the canonical Ionic form was born. We may now consider the other members of the order as it appears fully developed in later years.

For the Ionic order in its classic form we may take the Temple of Athena Polias at Priene, built in the *Fig. 6* later fourth century. Ionic columns have bases. These are generally composed of a rounded member (torus) over a concave one (scotia or spira), and here there is a third square member beneath, which is a peculiarity of East Greek Ionic in certain periods. Another variety, known as Attic Ionic, has a small rounded member, broader than the top one, in this position (as on the Temple of Athena Nike in Athens). The main two *Fig. 64* members can be fluted horizontally and treated in different ways in different places and periods, as we shall see, and there are other possible embellishments. An Ionic column normally has twenty-four flutes, four more than the usual Doric, and they are proportionately more deeply cut both for this reason and because a flat band was left dividing the flutes. The shaft is often topped with a shallow moulding of bead and reel. The whole column was slimmer than the Doric, and the fact that an Ionic column of the same thickness as a Doric one would be considerably taller was cleverly exploited in the Propylaea to the Acropolis at Athens *40* to offset an awkward change in ground level. In Classical Greece the proportions of lower diameter to height for a Doric column are 1:5 to 6, for an Ionic column 1:8 to 10.

The capital is composed of two main members (though carved in one block). The echinus is a round disk with egg and dart moulding carved on it which sits upon the shaft. It is covered by the volute member which lies flat across the top, sagging slightly at the centre, and rolled in two great scrolls at each side, with tiny palmettes to fill the inner corners. The sides of the volute were hollowed and ribbed. It will be noticed that the Ionic capital, unlike the Doric, could only be satisfactorily viewed from the front or back. The problem thus posed by capitals set on corner columns was solved by carving the volute faces on the front and outer side, and thrusting the corner volute out at an angle to serve both views. Above comes a shallow moulded abacus.

The architrave blocks which lie across the capitals are divided horizontally into three flat bands, slightly overlapping and increasing in height from bottom to top, crowned by a small moulding. Above this comes the frieze, in this case a continuous heavy moulding of egg and dart (epistyle crown) with a dentil frieze above (like teeth, representing ceiling beam ends). But a sculptured relief frieze can occupy this position

17

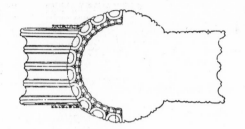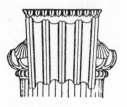

7 Ionic capital from the Temple of Artemis, Ephesos. Mid 6th century B.C. (after Dinsmoor)

21 over the architrave, and often does on mainland Greek Ionic buildings (like the Athena Nike Temple façade,
22 or the Erechtheion North Porch). The cornice above projects in the usual manner. There are thus no vertical
elements in the Ionic entablature to correspond with the triglyph-metope rhythm of Doric.

This is the developed Ionic order of East Greece. We have now to consider the order in all the diversity
which time and place offer.

On the earliest Ionic capitals, where the volutes were not linked, or were separated still by a floral device,
the channels of the volutes were concave. This is however true only of the few early Naxian capitals, and

Fig. 7; 42 below all other Ionic, and Aeolic, capitals of the Archaic period, in fact until well into the fifth century in East
Greece, have bulging convex channels winding either to a point or to a circular eye, which might be inlaid
in other material or carved as a rosette. At Ephesos it seems that on some of the capitals the whole circle

43 centre of the volute was replaced by a large carved rosette, and at Samos the abacus was ignored by making the

Fig. 12 top line of the volute meet the upper bearing surface at an angle. Some odd capitals of the early fifth century
from Kavalla and Eretria have volutes with concave channels on one side, convex on the other, and at
Kavalla the old central floral is recalled by a large rosette. The early capitals are rectangular in plan, but later
they become more square and the volutes are drawn closer together until their eyes are close to the line of
the column sides.

The order was introduced to Athens before the end of the sixth century, at least for decorative and votive
columns. There, concave channels for the capitals were preferred, perhaps under the immediate influence of

43 below Naxos, and this remains the rule throughout the Classical period. A variant appears for the engaged Ionic

Fig. 8 columns within the Doric Temple of Apollo at Bassai. Here the capitals have high-swung upper lines with
no carved echinus, and the bases splay like the feet of black-figure cups. Attractive innovations are introduced

24 above by the architect of the Erechtheion in Athens, as a result of which its columns were often taken as models
both in antiquity (at Delphi, Halikarnassos, Xanthos in Lycia, for the Temple of Roma and Augustus on the
Acropolis, in Phoenicia near Tyre) and in more modern classicizing architecture. The volutes were given

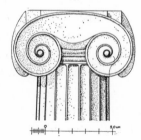

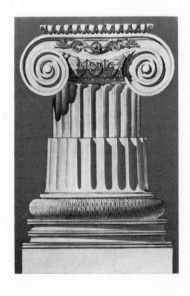

8 Ionic capital from the Temple of Apollo, Bassai. Late 5th
century B.C. (after Gruben)

9 Ionic capital and base from the Temple of Artemis,
Sardis. 4th century B.C. (after Butler)

18

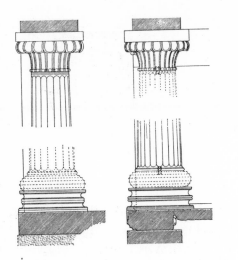

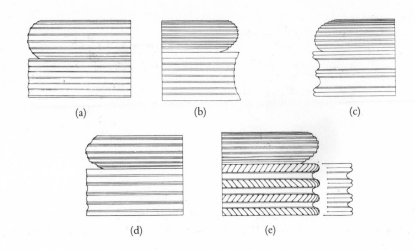

10 Delphi. Capitals and bases from the Treasuries of Klazomenai and Massilia. 6th century B.C. (after Dinsmoor)

11 Ionic column bases: (a) and (b) from the Temple of Hera, Samos, middle and late 6th century; (c) from the Temple of Artemis, Ephesos, second half of the 6th century; (d) and (e) from the Temple of Apollo, Phanai, Chios, limestone, mid 6th century; marble, late 6th century B.C.

double concave channels. Above the echinus a small rounded moulding carved with guilloche was introduced, and there were several inlaid details in glass and gilt bronze. But Ionic capitals were rarely so ornate until later. In fourth-century Sardis elaborate florals are carved between the volutes, but there are precedents for this as we have seen, as there are also for the palmettes carved on the echinus edge. In the Hellenistic period the popularity of the Corinthian order (see below) suggested other floral or acanthus-leaf embellishment, and even, at Mylasa in East Greece, capitals with volutes on all four sides, precursors of the Roman Composite order. In the second century B.C., at Didyma near Miletos, we find sculptured heads emerging from the volute centres, an extravagant feature very popular in later years. *Fig. 9*

Occasionally Ionic buildings were provided with capitals of a quite different sort recalling the Egyptianizing palm capital from Crete. They appear on the Archaic treasuries built at Delphi by Massilia (Marseilles) and Klazomenai. The form was revived for the interior columns of some of the stoas at Pergamon and elsewhere under the Hellenistic kings, and could be combined with the Corinthian ring of acanthus leaves. *Fig. 10*

Column bases offer just as much variety. Early Naxian columns, as that supporting the Sphinx at Delphi, and the row in the Naxian Oikos (apparently a sanctuary guest-house) on Delos, have simple cylindrical bases. The big sixth-century buildings offer two main varieties. There is the Samian with torus and spira bearing shallow, intricate patterns of fluting. These massive bases, in soft stone, for the earlier Temple of Hera, had been finished on a wheel in a technique exactly analogous with carpenter's turning. In Samos too the fluted torus could be used as a capital for small column dedications. The Ephesian bases, for the first great Temple of Artemis, have deeper flutes, and the scotia is divided into two deep concave hoops, separated by heavy double rolls. On some the torus is carved with a leaf pattern. The bases stand on shallow square plinths. Hybrid versions in Chios have three such concave bands and carved rope mouldings. The moulding of the sides of the volutes on the Ionic capitals echoes that of the scotia base. These early columns have more flutes than the later canonic twenty-four and lack the fillets between, like Doric. In Chios we find a variant with double ridges between the flutes, and some of the fluting at Ephesos is alternately broad and narrow. The Samian architects also introduced a floral necking below the capital, which is seen in an early Ionic temple at Naukratis, the Greek trading town in Egypt, and later at Locri, in South Italy, with other Samian features of capital and base. It is reported at Ephesos too, so the motif may have been shared by the two major East Greek schools and we cannot say who invented it. It reappears on the columns of the Erechtheion. *Fig. 11* *41* *Fig. 12* *24 above*

The Attic Ionic base, with its shrunken scotia and spreading added torus we have already met on the Athena Nike Temple. This was the rule in Athens, but it was introduced to East Greece in the second century B.C. and could appear in the same building with the eastern form, as at Didyma. Another addition to the eastern Ionic bases was the simple rectangular plinth below the scotia, which appeared at Archaic Ephesos, *21, Fig. 64*

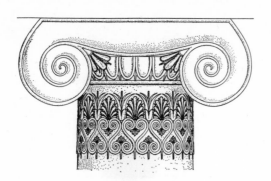

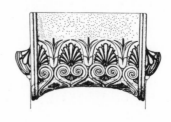

12 Ionic capital from the Temple of Hera, Samos. Early 5th century B.C. (after Gruben)

Fig. 6 then on the Temple of Athena at Priene in the fourth century and is common thereafter. In the Hellenistic period the lower part of the column shaft is sometimes left unfluted, or only lightly facetted, possibly because the deep-cut flutes would be too vulnerable. 'Cannelated' columns, with convex reeding in the lower part of the flutes, were introduced in Greece in the second century B.C.

In the entablature the arrangement with a sculptured frieze is well attested in Athenian buildings like the Temple of Athena Nike or the Erechtheion. In East Greece the evidence is often much more fragmentary, but it seems that the arrangement with dentils and epistyle crown was the usual one. Translations from wood in Ionic are not as common as in Doric, but besides the dentils there is the triple architrave like three overlapping planks.

43 above One other East Greek peculiarity in Archaic Ionic is the type of capital for an anta, the stub end of a side wall. The commonest type presented a splaying profile from the front, on which is carved a triple cushion of egg and dart or florals.

As we have seen, much of eastern and Orientalizing art went into the early development of the Ionic order, although the concept of a stone order for a colonnade was not eastern. This concept, however, together with various Ionic decorative motifs, passed east again already in the sixth century B.C. and contributed to the early development of monumental stone architecture in the Persian Empire, just when other Greek arts and artists were being welcomed in the courts of the Achaemenid kings. In the capitals of the great palaces we see Ionic mouldings and patterns applied to volute capitals which are closer in their composition to *Fig. 13; 49 above* eastern volute patterns than anything in Greece. The use of animal foreparts we shall meet also in Greece. Bases and fluting like the Ionic appear, and the larger bases carry Orientalizing patterns more Greek than *Fig. 14* oriental in their immediate inspiration. A similar blend of Greek patterns and techniques with eastern subjects can be observed in Achaemenid sculpture.

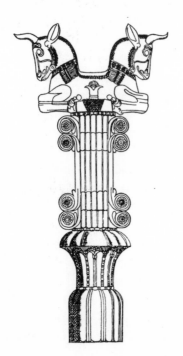

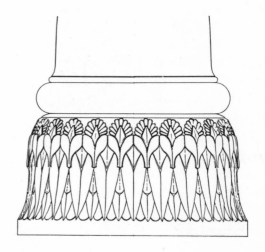

13 Capital from the Palace of Artaxerxes at Susa. 5th century B.C.

14 Base from the Palace at Persepolis. Early 5th century B.C.

CORINTHIAN

The Corinthian capital was said to have been invented by Kallimachos. The earliest example that we know stood within the Temple of Apollo at Bassai (after the mid fifth century). It was drawn early in the last *Fig. 15* century before being destroyed. The advantage of the Corinthian capital over the Ionic, and presumably therefore the reason for its invention, was that it could be viewed from all sides. The basic shape was that of an inverted bell, no doubt in part inspired by the palm capitals. At the base were two rows of ornate acanthus leaves above which taller leaves sprang out to the four corners, where small volutes projected diagonally. The faces of the capital between the volutes had relief decoration of spirals and a palmette.

The capital was regarded as a substitute for the Ionic, and the rest of the order was as the Ionic. But it was a fussy, ornate affair, best suited to interior columns, and it took some time to become popular or to win a place on the exterior of buildings. A rather squatter variety of capital appears on engaged columns within the Doric Temple of Athena Alea at Tegea in the fourth century. Here the volutes seem to grow organically *Fig. 16* from the acanthus plant. Corinthian capitals are more commonly employed towards the end of the fourth *Fig. 17* century and in the Hellenistic period, especially for smaller monuments on which their fussy detail seemed particularly fitting. In the later period they naturally invited many different compositions. The once formal spiral and volute were carved as growths from the acanthus ring, like the corner volutes. An infinite variety *Fig. 18* of botanical extravaganzas was composed on this theme, the most ornate being reserved for the Roman

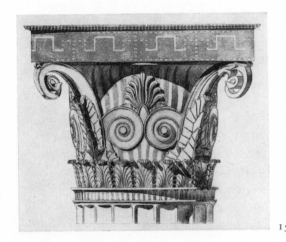

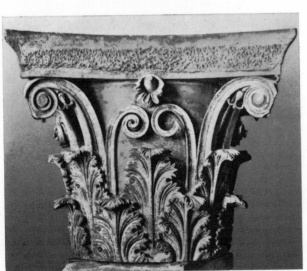

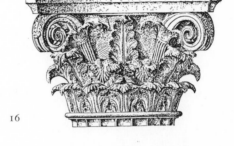

16

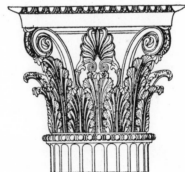

18

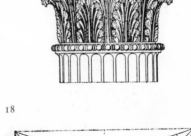

15

17

15–18 Corinthian capitals. 15 From the Temple of Apollo, Bassai. Late 5th century B.C. (after Cockerell); 16 from the Temple of Athena Alea, Tegea. Mid 4th century B.C. (after Dugas and Clemmensen); 17 model capital for the Tholos, Epidauros. Late 4th century B.C.; 18 from the Temple of Apollo, Didyma. 3rd century B.C. (after Dinsmoor)

period when, to confine attention only to the Greek world, we find the near classic type in the Temple of
28 Zeus Olympios at Athens, while at Eleusis an exotic six-sided type is seen, with winged horses carved instead of three of the corner volutes, in a building (the Lesser Propylaea) which also offers a hybrid Doric-Ionic entablature. In another variety, perhaps barely Corinthian, a version of the palm capital rises above the acanthus leaves (first on the Tower of the Winds in Athens: a first-century B.C. clock tower). But by this time the discipline of the orders had already been severely undermined by other architectural fantasies.

Although it was possible on occasion for one order to become contaminated by some details of another, as we have seen, they were in general kept quite distinct. It is, however, possible for them to be combined
49 below in a single building. The advantageous height or comparative slimness of Ionic or Corinthian columns
Fig. 45 recommended them for the interiors of some Doric temples, as at Bassai. In the Doric Temple of Athena at
Fig. 58 Paestum Ionic columns are used for the inner porch. In the Doric Propylaea on the Athenian Acropolis they
40 flank the passage-way between the two façades, which stood at different levels, and they probably served in the rear room (opisthodomos) of the Parthenon. In colonnaded stoas Ionic columns are regularly found behind the Doric façade, and where there are two stories the upper order on the façade is often Ionic.

ARCHITECTURAL DECORATION

The elements of Greek architectural decoration long outlived Greek methods of construction and the types of building for which they were first designed. Throughout the history of Roman and Renaissance art we are reminded of them. Taken on their own they can readily be correlated with the development of the other arts in Greece, and in any one place and period a motif is little altered whether it is executed for a temple or a tomb, in clay or in marble, measured by the metre or the centimetre.

Fig. 19 The earliest and gaudiest types of architectural decoration are represented by the fired clay revetments which were made to protect the wooden upper works of early buildings, and which persisted for a while as a ready method of applying intricate decoration to a stone cornice. The first in Greece are Corinthian, or made by travelling Corinthian artists, as for Thermon in the seventh century, and in the sixth century at
93, VII Kalydon. At Thermon there were metopes of fired clay with painted decoration, where later stone reliefs would be expected, and one of the buildings at Thermon had clay triglyphs too.

The revetments are brightly painted in basic colours. On early Doric temples of mainland Greece they run along the cornice and gutters as a simple curved moulding (cavetto) decorated with a tongue pattern, and bands of meander or florals, pierced by simple spouts to carry off the water from the roof, or by the lion-head spouts with which we are more familiar in stone. The most showy clay revetments of this form

19 Clay revetments from the Treasury of Gela, Olympia. Mid 6th century B.C. (after Borrmann)

22

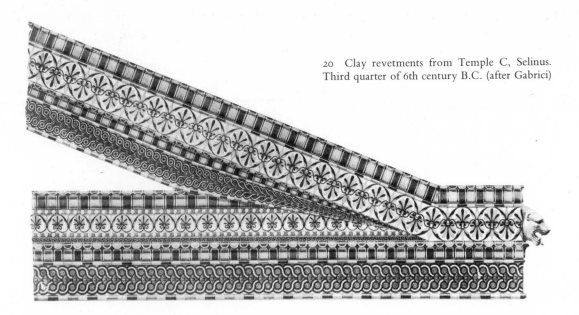

20 Clay revetments from Temple C, Selinus.
Third quarter of 6th century B.C. (after Gabrici)

are seen on the temples of Sicily and South Italy, where the elaboration of the façade gable cornice is often *Fig. 20*
also carried along the horizontal cornice below the pediment and along the sides of the building, and they
offer a greater variety of painted patterns. The ends of the cover tiles are masked by antefixes which need
be no bigger than the cover tiles themselves, and may be decorated with a simple painted floral, sometimes
in low relief. But larger antefixes soon became popular, with high-standing palmettes. From even as early
as the seventh century some antefixes are moulded with human or monster heads facing out from the side
gutters. The western Greeks admitted even more elaborate relief compositions on these antefixes, and they
include some very striking examples of minor sculpture in terracotta. Along the crown of the roof there *16 above*
was usually a corresponding set of ridge palmettes facing both ways.

On the roof itself clay figures could be used for the acroteria at the corners, and there was a vogue in
Laconia in the Archaic period for big disk acroteria spreading like gorgeous fans over the gable centre. In *Fig. 21*
eastern Greece there was a rather different system of cornice frieze revetments in painted clay, usually in low
relief, composed of separate slabs repeating the same or related themes—chariots, banqueters, animals. This
fashion spread into non-Greek Anatolia (Phrygia and Lydia) in the sixth century. *Fig. 22*

The painted decoration on the revetments offers the sort of floral, cable or meander patterns which are
familiar from so many other objects in Greek art from the Orientalizing period on. The Archaic period

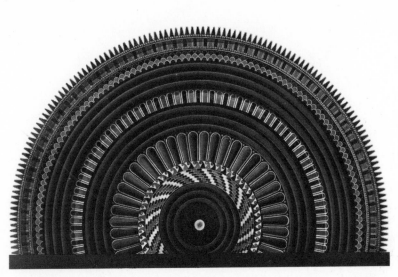

21 Clay disk acroterion from the Temple of Hera, Olympia. Early 6th century
B.C. (after Borrmann)

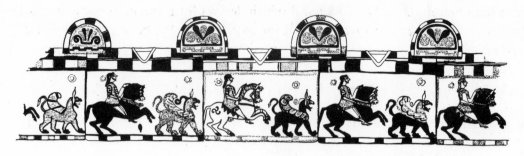

22 Clay revetments from a temple at Düver in Phrygia. Mid 6th century B.C. (after Thomas)

offers the greatest variety, and then the patterns of lotus and palmette obey the fashions of time and place observed for the same ornament on smaller objects. The patterns are at first applied as pure decoration. Later, when they were more familiar on buildings carved in relief on stone, it became the rule for the clay
44 revetment to be coloured accordingly, and the patterns, whether in relief or not, were picked out in pale paint against a dark background, like relief sculpture or red-figure vase painting.

Not all these clay revetments had their stone counterparts, for, in stone, decoration and shape were more closely allied, whether the decoration was painted or carved. For the straight mouldings, that might run along a gutter, wall-crown or base, or round the door, there was one basic principle generally observed by masons, that the profile of the moulding should determine its decoration. The application of this we can observe as the mouldings are described, but for the earliest both the profile and its decoration were taken over together from Egypt. This is the cavetto, which is the only important moulding of this type associated with wholly Doric buildings. In its simplest and earliest form it is a flat strip curving out above, and its profile—straight with a rounded top—determined the pattern of upright tongues or leaves with semicircular ends with which it is regularly decorated. An exaggerated version is the Doric hawksbeak, a moulding profiled like a parrot's beak, and decorated with broad rounded leaves. After the Archaic period the cavetto which had been used for gutters and some pillar capitals (as for gravestones), more often has a return, convex curve at the base, resembling the Ionic cyma recta (below). Perfectly flat bands or *fasciae* naturally invited the strict regularity of the meander or its variants, although there were always exceptions, as at Sounion where the flat back to the architrave is painted with an elaborate guilloche pattern.

The Ionic order employed several different mouldings of persistent popularity in Classical and classicizing
44 architecture. The simple small half-round moulding (astragal) demanded the full-round as decoration: not the succession of round globules we see in modern wood beading, but the bead and reel which is a version

23 Developed decoration of mouldings from Chios (Phanai and Emporio). Late 6th and early 5th centuries B.C. (Boardman)

of a pattern seen long before in the Near East and which derives from turned woodwork, as for chair legs. In Greek architecture the bead and reel was reserved for relatively small mouldings articulating, for example, the top of a column shaft or edging some heavier moulding. A less common way of decorating the half-round was by carving it as a rope or cable.

The ovolo had a bulging profile, curving in sharply below, and was inevitably decorated with a row of egg-shaped leaves. The Archaic, more bulging ovolo, has proportionately broader, rounder eggs while the Classical, with a flatter profile, carries them slimmer and more pointed. The decoration recalls the old Ionic overlapping leaves, with the tips of the second row seen between the front leaves, in the introduction of a long dart with a broad tip between the eggs. This is the moulding we see on the echinus of any Ionic capital or often as an epistyle crown and around doors or windows.

The cyma or wave mouldings with S-shaped profiles are the cyma recta and cyma reversa, distinguished according to whether the protruding part is concave or convex (they can, of course, be inverted). For the cyma reversa the inevitable decoration was the heart-shaped ivy leaf with the same development from the plump Archaic to the pinched Classical, and the same darts between. These are popular base and crowning mouldings.

Merely from a comparison of the mouldings so far described it will be realized that the Ionic order lent itself to detailed ornament, and it is not surprising that there were local schools which invented their own variants on the basic pattern. Thus, the swelling and sinuous outlines of egg and dart or leaf and dart were assimilated to other floral patterns by the architects of Chios in the Late Archaic period, who superimposed *45 centre* them on the architectural mouldings. Some of these patterns are here reproduced as drawings. *Fig. 23*

In the Classical period other floral patterns are admitted as architectural decoration. We have seen already how the acanthus leaf was used on the Corinthian capitals. The same plant, with its thick, celery-like stem, is also introduced on other mouldings. It can creep around the cushion sides of an Ionic capital, or even replace the palmettes in the volute corners. Palmettes are grafted on to it on Corinthian capitals, and the same hybrid growth invades palmette finials. Soon the spare, taut scrolls of Archaic art are translated into exotic foliage carved in vivid high relief on flat or curved mouldings in patterns destined to play a major *45 above* part in the decorative arts of Rome and the Renaissance.

Probably the most elaborate combinations of these mouldings on Ionic buildings are to be seen in the design of doors. That in the North Porch of the Erechtheion in Athens is a prime example with the elaborate *Fig. 24* floral on its crowning cornice, the usual 'egg and dart' and 'bead and reel' mouldings, and a deep-cut floral

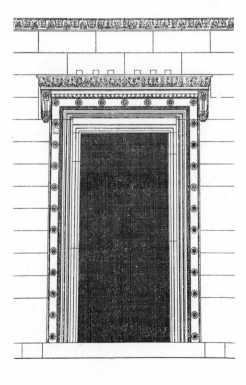

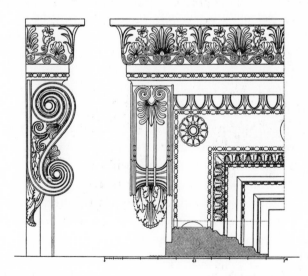

24 The doorway in the North Porch of the Erechtheion, Athens. About 410 B.C. (after Middleton)

25 Painted ceiling coffer from the Propylaea, Athens. About 435 B.C. (after Penrose)

26 Painted decoration on the architrave of the Parthenon, Athens. Third quarter of 5th century B.C. (after Penrose)

frieze on a cyma. The rosettes on the frame are a decorative device often used to diversify flat fields or friezes. We are introduced here also to the elaborate S-shaped consoles at either side of the frame, seeming to support the upper lintels. In the sixth century these console-brackets may have only a single volute, but in this developed form they had a long career and survive in stone or wrought iron to support balconies or eaves to the present day.

Fig. 25
45 below
 The ceilings of the finer stone buildings in the Classical period were generally also of stone, and coffered in imitation of timbering. The square sunken coffers were framed with elaborate mouldings, and the flat centre-piece usually carried a star or rosette, painted or carved in relief. Some later ceilings offer extreme elaboration of these features, and we have to remember the bright Greek sun and the reflective qualities of marble floors and walls, to realize how details of this sort could be seen and appreciated high in colonnades.

46 below (r.)
46 below (l.)
24 below
185 (r.)
238
 The palmette has often been mentioned as a subsidiary element in architectural decoration. There is one series of objects, semi-architectural in character, on which it is of prime importance—gravestones (stelai). The type with a palmette finial was invented in East Greece and about 530 B.C. it was adopted in Athens, where hitherto the crowning member had been a simple cavetto, or a spiral scroll topped by a sphinx. The graceful Archaic Ionian palmettes are best known in the Samian series, and some of them offer a delicately carved alternation of convex and concave in the palmette leaves, recalling the moulding of Samian column bases. On others the spiral element is dominant. In the fifth century palmette leaves elongate, slim and eventually curl to produce the flame-like leaves of the Erechtheion friezes. Now too they combine with acanthus. The gravestone finial in this form can be followed in the Greek islands through the first half of the fifth century, but the new type of gravestone in Athens after the mid-century offers a different sort of architectural motif in miniature—a whole door or façade flanked by pilasters and crowned by pediments.

Fig. 25, 26
 So far little mention has been made of colour, except on the clay revetments whose colours were fired on and so have survived well. The colours on architectural marble have survived no better than they have on statues, and it is as difficult for us today to envisage and enjoy the effect of painted stone architecture, as it is to appreciate painted marble statuary. So far as we can judge, the colour on marble was confined to the carved mouldings and parts of individual members like the capitals and bases, and not generally lavished on shafts or broad flat surfaces of walls. In brilliant sunshine the colours would be muted and they would help articulate the building and emphasize its decorative scheme, if not always its structural scheme. No reconstruction on paper can hope to recapture the effect successfully, and no reconstruction in stone has dared attempt it. Red and blue were the dominant colours, but gold and green could be used. In the Doric entablature, for instance, the triglyphs would normally be blue while the background to the relief metopes would be red. Occasionally inlays of a different coloured stone are used, even in the Classical period, and on some of the Erechtheion capitals there were inlays of gilt bronze and coloured glass. Gilt-bronze rosettes and
Fig. 24
similar ornaments could be attached to walls or coffers, like those carved in stone around the Erechtheion north door.

 Deliberate colour contrast by the use of different stones was rarely sought, but there are a few examples of the Classical period like the dark stone step in the Propylaea in Athens and the bottom steps of the Temple of Hephaistos in Athens and of the Temple of Nemesis at Rhamnus. In an island like Chios, where the local

marble was blue, and white marble was in short supply or imported, there was often a contrast between, on the one hand, walls and shafts and, on the other, the carved white mouldings. The same contrast was effected in the Great Altar constructed by the Chians for the Temple of Apollo at Delphi, and becomes far commoner later, but never a dominant feature in architectural design, as it could be in the Roman period.

Architectural sculpture deserves a special mention here because, although in content and style it belongs to the history of Greek sculpture, its application to a building was an integral part of that building's design. This union between sculpture and architecture was one peculiar to Greece. In Egypt whole buildings may be covered with reliefs, but they are never more than superficial ornaments and not a basic element in the design. In the Near East the sculptural parts of buildings, usually friezes, were severely subordinated and purely decorative. On a Greek temple the sculptural decoration is as essential to its design and effect as the details of its columns and mouldings.

On the primitive stone buildings of seventh-century Greece we have seen the occasional use of frieze sculpture in the eastern manner, and remarked the seated goddesses facing each other over the doorway on *Fig. 3* the temple at Prinias. When we come to the sculptural decoration of all-stone temples in the Doric or Ionic order we find that the places and ways in which it can be applied are strictly circumscribed.

On the roof of a temple or other building the gable corners and centre are frequently decorated only with palmettes, but there can be sculpture here too, often just animals, occasionally human or divine figures and *Fig. 39, 41* groups (acroteria). For extreme treatment of this, as of many other Greek architectural motifs, we have to turn to Etruria where massive clay figures could stride along the actual roof ridge.

The low triangular gables or pediments on Doric buildings offered a rather awkward field for sculptured groups. They are not usually found on Ionic buildings, probably because there were too many other opportunities for sculptural decoration in the upper part and the building might look top-heavy. For example, the gutter may have a parapet on an Ionic temple, and this could have sculptural decoration— either a terracotta frieze such as we have described or, as at Ephesos, a stone relief frieze. The use of lions' *Fig. 63* heads as rainwater spouts goes back to the period of the earliest terracotta revetments, but both the spouts and *45 above, 47* the antefixes assume such an important role in the decoration that their scheme is not always wholly dictated by their function. On two fourth-century temples of Artemis (at Kalydon and Epidauros) heads of the goddess's hunting dogs replace the usual lions' heads and we see rams' heads at Eleusis.

In its entablature a Doric building offered the rectangular fields of the metopes for relief sculpture which appeared thus in separate panels, although in the Archaic period a scene could occasionally overlap two metopes. A single theme could be developed in the metopes around the building or on each side, so that a unity was preserved. It is not always on the metopes of the outside of the building that the decoration appears. In the Temple of Zeus at Olympia they are plain, and the famous relief metopes with Herakles appear over the end porches within the outer colonnade. It will be realized that a Greek temple building *Fig. 43* was intended to offer interest and instruction, even to give pleasure, both from a distance and from a close view. On Ionic buildings sculpture in the entablature could be deployed in a frieze, confined to the front or running round the whole building. This difference between Doric and Ionic was not, of course, rigidly observed. The Doric temple at Assos in East Greece (near Troy) had both an Ionic frieze and sculptured metopes. In Athens the Parthenon had a frieze running at the wall-top within the outer colonnade, and in the Temple of Hephaistos and at Sounion there are friezes within each porch, also behind the façade columns. At Bassai the frieze ran inside the cella wall. A dado frieze as the base of a wall was not commonly found. *Fig. 45* The nearest approach is the frieze from the Great Altar at Pergamon, and the Ephesos temples may have *290–296, 272* had relief decoration at the anta bases—the stub ends of the side walls to the porch.

On Doric buildings it is rare to find sculpture in any other positions—the bulls' heads on triglyphs on Delos are a notable exception. Only Ionic buildings offered further opportunities for figurative carved decoration. We have noticed already the heads appearing in the volutes of some Ionic capitals, but only at the end of the Hellenistic period. Already in the earliest monumental temples, as at Ephesos and Didyma, relief decoration was applied to the lower drums of the column, and bordered by mouldings. The scheme *Fig. 63* was copied in the rebuilt Temple of Artemis at Ephesos at the end of the fourth century where there were *Fig. 71* also decorated square pedestals (the correct position for these is still not known with certainty). Minor relief

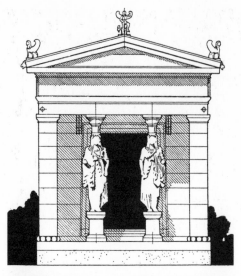

27 Restored front of the Siphnian Treasury at Delphi. About 525 B.C. (after Dinsmoor)

28 Giant, from the Temple of Zeus, Akragas. 5th century B.C.

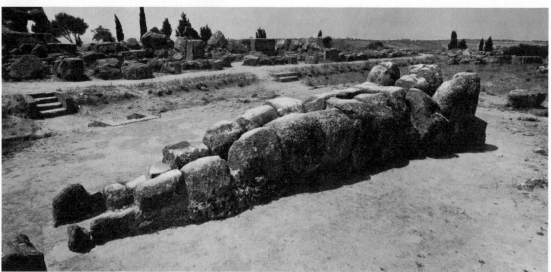

50 decoration could appear on the angular plinths which were often added to Ionic bases in East Greece after the fourth century, and was occasionally applied to other architectural members, like the wing capitals of

Fig. 32 the Great Altar of Hera on Samos.

 Sometimes a sculptured figure or part of a figure in the round is used in the place of an architectural member. The obvious examples of this are the statues which serve as columns. The practice was to be found in North Syrian buildings. In Greece the figures in the round are invariably women. They were called Caryatids in antiquity, at least when they were applied to smaller monuments, and the device of a human figure support had long been familiar in Greece for mirrors or basins. Pairs of them appeared in the porches

Fig. 27 of two of the Archaic treasuries at Delphi (the Siphnian and another) in the place of the usual columns, and there were others, described by ancient authors, in the monumental Throne of Apollo at Amyklai. The

25 most famous examples are in the Maiden Porch of the Erechtheion in Athens, and they are recalled in a monumental entrance way at Eleusis of the last century B.C. (the Lesser Propylaea). We may mention here too the colossal male figures which stood against the upper screen wall between engaged Doric columns on the outside of the massive Temple of Zeus Olympios at Akragas in Sicily. Their arms are raised and bent,

Fig. 28, 54 their heads lowered, helping support the mass of the entablature. The maiden Caryatids never look distressed at their loads.

49 above Bracket capitals could take the form of animal foreparts, like the winged horse capitals on Thasos and Chios. In third-century Delos the foreparts of kneeling bulls are found in this position in a strange building of the Doric order in which a warship was dedicated (the Sanctuary of the Bulls), and in the House of the

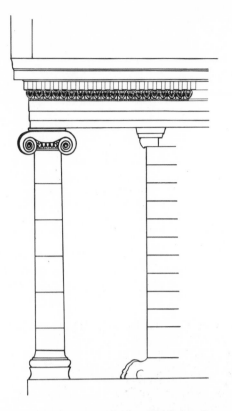

29　Restored elevation of the side front of an apsidal temple at Emporio in Chios. Mid 5th century B.C. (Boardman)

30　Classical lion's paw re-used in a Genoese house in Chios

Trident there are capitals with the foreparts of bulls and lions. Foreparts back to back as column capitals were a common feature of Persian architecture in the Achaemenid Empire, and may have suggested these *Fig. 13* forms in Greece. In Chios in the Late Archaic and Classical period anta bases may take the form of massive lions' paws, but this odd conception did not win popularity elsewhere. It seems another example of the *Fig. 29, 30* enlargement of a detail better suited to furniture to serve the needs of monumental architecture.

It is impossible to list or even summarize here all the varieties of architectural decoration with which the architects of the fourth century and Hellenistic period experimented, but the more important have been mentioned. In general they are confined to Ionic buildings, or are Ionic-inspired and grafted onto Doric. The over-all effect is more showy, especially as the floral carvings deliberately ignore the basic masonry forms, where before the very shape of an egg and dart or leaf and dart was determined by them. It is not surprising that some of these innovations are attributed to the influence of the work of stage painters making backdrops and experimenting with problems of perspective; or that the word 'baroque' should be used of some of the more painterly conceits.

THE BUILDINGS: THEIR PLANS AND FUNCTIONS

So far we have considered how the Greeks built, and what sort of decoration they thought appropriate to their buildings, especially the way in which the canonic orders evolved and were developed. We now have to turn to the various classes of building which we know to have been constructed in Greece. With a very few exceptions, generally temples, we are here at the mercy of what can be understood from excavated ground-plans and the fragments of carved stone mouldings that have survived the lime-kilns which are such a feature of the Greek sites. Fortunately the decorative value of such mouldings was such that they were prized and used for special effect in later buildings, like Christian churches, but they were often carried far *45 centre* from their original position. Even when the pieces are fairly well preserved and numerous all reconstructions on paper of the upper works of these buildings are bound to be rather speculative, and have to rely on the expected uniformity of practice in the use of the orders in different parts of the Greek world. It is naturally most difficult for the early buildings, especially the Ionic before many features had been standardized, and

for buildings of types less familiar to us than the temple. The Greeks built to impress mortals, even when the avowed object was to honour the gods, but their buildings were designed to serve particular functions, and it is not possible to judge them properly without due account of the purpose for which they were constructed and how well that purpose seems to have been served.

ALTARS

In Greek religion the focus for active worship was the altar not the temple. Thus, at Olympia, the most sacred place was not the great Temple of Zeus and the altar built with it, but the site of the old altar, a great mound of ashes which had stood there since long before the temple was built. At its simplest the altar is a hearth, but more commonly a raised block or platform on which the offerings were burnt, the smoke ascending to the gods above. For the earth-bound deities it might rather take the form of a pit into which offerings are poured (a bothros), but these offer little scope for architectural embellishment.

Usually the altar was set before the door of the temple, to the east. When they were simply massive solid blocks, the only added features needed might be a parapet to serve as a wind-break for the fire, the ends of which could be covered by volute acroteria. Doric altars could have a triglyph frieze to crown their walls.

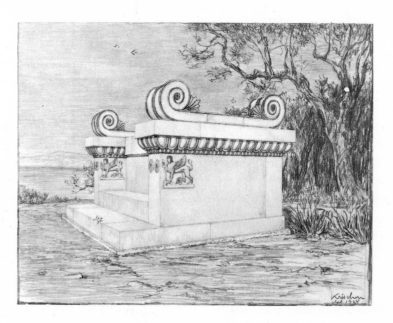

31 An altar at Miletos. Late 6th century B.C. (after Krischen)

Fig. 31 Ionic altars, at least those in East Greece, took a more elaborate form with a broad flight of steps rising to a long platform and flanked at either side by projecting wings with elaborate capitals and sometimes relief decoration. The type with steps may have been inspired by Egyptian stepped altars. Of this type was the *Fig. 32* Altar of Hera on Samos in both its sixth-century forms, and there was a massive altar for Poseidon in a *Fig. 33* sanctuary (without, it seems, a built temple) on Cape Monodendri near Miletos. It carries fine bulging Archaic mouldings and, at the corners, big volute acroteria. The most elaborate later form of this altar type *Fig. 34; 290* is seen in the second-century Great Altar of Zeus at Pergamon, which again is not closely associated with

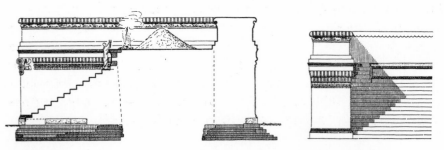

32 The Great Altar of the Temple of Hera, Samos. Mid 6th century B.C. (after Schleif)

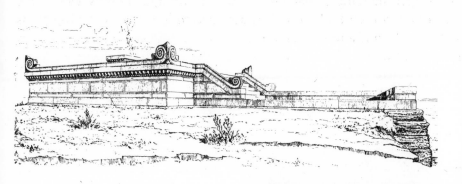

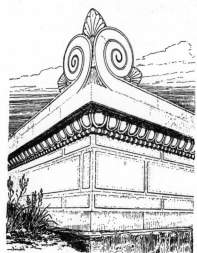

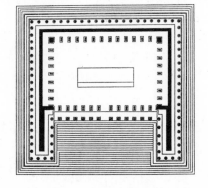

33 The Altar of Poseidon at Cape Mono-
dendri near Miletos. Second half of 6th
century B.C. (after von Gerkan)

34 Plan of the Great Altar of Zeus,
Pergamon. Mid 2nd century B.C.

any temple structure, but stands isolated in a court of its own. It stood over 36 m. wide, with its platform
and wings colonnaded and its base decorated with a massive relief frieze. Its Doric rival was the third-century
Altar of Zeus Eleutherios built by the tyrant Hieron II at Syracuse. It was nearly 200 m. long and may have
had to serve the annual sacrifice of 450 oxen inaugurated two centuries earlier to celebrate the liberation of
the city from tyrants. It was not, however, as ornate as the Ionic altars, but carried the usual Doric triglyph
friezes and cornice, topped by volute acroteria. This too was an independent structure.

The smaller solid altars which stood in houses or streets were circular or rectangular in plan, crowned
with an egg and dart or triglyph frieze, and in later times often carved with reliefs, swags and bucrania.

TEMPLES

A temple was a house for the god, and the Greeks could use the same word for it as they used for their
homes—oikos. It only became important, however, as more importance was attached to the cult image
which it housed. The positive service to the gods—the sacrifice—was performed at the altar and not within
the temple, and it was possible to have a sanctuary without a temple, but not one without an altar. Only
some of the more primitive temples have an interior hearth or altar and so make the god completely at
home.

The temple therefore came to be treated simply as a monumental home for the image of the deity, looking
out through the open door to the altar of sacrifices. Thus, in the most basic representations of sacrifice on
Greek vases, the temple is ignored or at the best indicated by a single column, while the essential elements
are only the offerings, the altar, the cult image. This image could be aniconic—a stone or rough tree trunk
dressed in finery, but in time it called for the most ambitious works in gold and ivory from the finest artists *Fig. 43, 46*
of the day, and its housing naturally demanded comparable expense and care. The only rites or ceremonies
conducted within the temple were to do with the image, its ritual dressing or removal for washing. And
although it might serve as a place of sanctuary for fugitives and a place for dedications, still the altar was
thought to offer more immediate communication with the godhead. The temple was also a natural place for
the safekeeping of valuable dedications and part could be set aside for a state treasury, as the opisthodomos
of the Parthenon. Greek temples generally face the east, but the lie of the land may dictate other orientations,
and in East Greece some face west.

31

The basic plan of the temple was determined by its nominal function, as a house. A common house type of the Early Iron Age had the so-called 'megaron' form of a rectangular hall with the entrance through an open porch at one end. Some of the early houses are apsidal, a few even oval, and it is likely that the clay models, rectangular or apsidal in plan, which were made in the years around 700 B.C., notably at Argos, are meant to represent temple buildings. These have steeply pitched roofs, representing thatch, and one Fig. 35 from the Argive Heraion, rectangular in plan, seems to have had a flat roof to the porch only and a

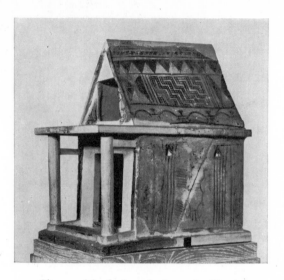

35 Clay model of a temple from the Heraion at
Argos. About 700 B.C.

rectangular opening into the roof space behind it. An earlier model in Crete offers a circular hut (or just 1 possibly a tomb), presumably imitating a wooden structure, with the goddess seated at the back and being spied upon by two mortals and a dog on the roof. Some of the unusual temple plans in Crete comprise broad rectangles which perhaps reflect the old Minoan shrines. Some have benches for offerings and images at the back (as at Dreros) and interior hearths or pits (Dreros and Prinias). Prinias too offers the sculptured Fig. 3 frieze and other decoration which we have already noticed.

DORIC TO THE FIFTH CENTURY: GREECE

At Thermon in Aetolia, which may not always have been as backward a corner of the Greek world as it later became, there is an interesting sequence of buildings which illustrates many of the more important Fig. 36 features of early temple plans. A Late Bronze Age apsidal megaron (A) stood near a more rectangular version of the Greek Geometric period (Megaron B: 7·30 × 21·40 m.). This had been provided with an exterior colonnade of wooden posts which curved round the back of the building and presumably supported overhanging eaves, or an extension of them designed to provide a covered ambulatory and incidentally to protect the sun-dried brick walls. In the rebuilding of this temple of Apollo (12·13 × 38·23 m.: 5 × 15 columns)—for such Megaron B must also have been—we see the first clear example of the canonic temple

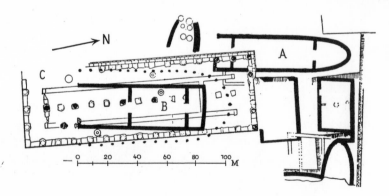

36 Plan of the megara and
Temple of Apollo, Thermon
(after Kawerau)

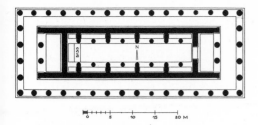

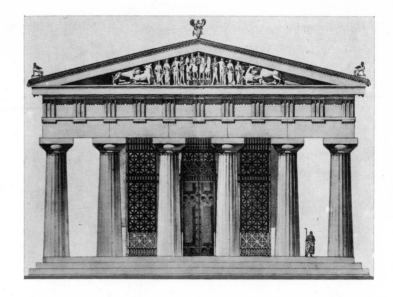

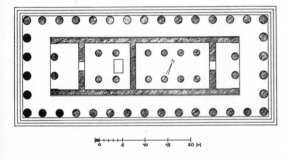

37 Plan of the Temple of Hera, Olympiá. Early 6th century B.C.

38 Plan of the Temple of Apollo, Corinth. Mid 6th century B.C.

39 Restored front of the Temple of Apollo, Delphi. About 525
 B.C. (after Courby)

plan (about 630 B.C.). The core is a long megaron without a true porch at the front, but with a false porch
with two columns at the rear. There is a colonnade around all four sides. The number and spacing of the
columns at the front were determined by the spacing of the temple walls and porch columns, a principle
only observed in early temple plans. But here, and in other Doric temples down to the fifth century, the
side columns are closer spaced than the façade columns. The very long plan is characteristic of this early
period, and so is the central line of interior columns, which we find in contemporary Greek houses but
which do little to help an effective axial alignment of any cult statue within. This is the Doric building which
carried the early clay revetments and painted metopes already described, and it offers the earliest evidence
for clay tiles. The columns and upper works were of wood but the sheer weight of a tiled roof soon demanded
something stronger than timbers for supporting columns. The temple stood a long time, and the painted
metopes were renovated in the fourth century. At near-by Kalydon stood a similar temple of rather later
date.

In the Doric Temple of Hera at Olympia (18·75 × 50·01 m.: 6 × 16 columns) we are introduced to fresh *Fig. 37; 2, 3 above*
developments in temple planning. Instead of the single row of centre columns in the main hall (cella) there
are two rows, pushed close to the side walls (in fact with alternate columns engaged in the walls) so that a
clear aisle was left between the cult images and the door. The second porch at the back, not communicating
with the main hall, introduced a further measure of symmetry to the plan. The clay revetments included a
disk acroterion of Laconian type. With columns before the side walls and two porch columns, plus the two *Fig. 21*
corner columns, there are now six columns to each façade, which will remain the usual number. The sixteen
side columns make for another elongated Archaic plan. The columns were at first of wood, being replaced
in stone as they threatened to collapse. Some shafts are monoliths, others cut in separate drums, and the
capitals reflect the profiles current at the time of each rebuilding.

The Temple of Artemis on Corfu (21·94 × 47·50 m.: 8 × ? columns), from which came the famous
pedimental sculptures, was of about the same date, early sixth century, but seems to have had eight façade *100, 101, Fig. 144*
columns which is unusual so early. Some of the monolith columns of the Temple of Apollo at Corinth *1*
(21·36 × 53·30 m.: 6 × 15 columns) still stand. Its plan incorporates all the features met at Olympia, but the *Fig. 38*

33

40 Plan of the Temple of Aphaia, Aegina. Early 5th century B.C.

41 Restored drawing of the Temple of Aphaia, Aegina. Early 5th century B.C. (after Furtwängler and Fiechter)

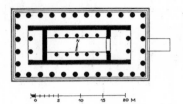

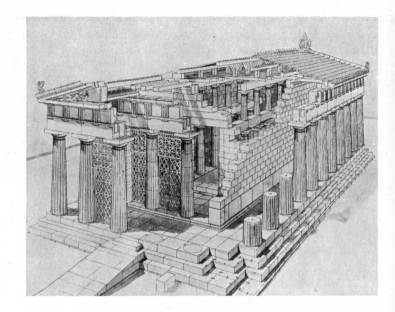

rear porch unusually gives entrance to a second, subsidiary cella and the temple was all-stone but for the gutter. It was built by about 540 B.C.

There are no important variations on this basic plan for mainland Greek Doric temples through the rest of the Archaic period. The old Temple of Athena on the Acropolis at Athens was of this type, a highly decorative building with the attractive feature of flying cranes painted under the pediment eaves. This building, like the later Peisistratid Temple and the Temples of Apollo at Delphi (21·65 × 58·00 m.: 6 × 15 Fig. 39 columns) and Eretria, we probably know better from its pedimental sculpture. The temple at Delphi had one façade built wholly of marble at the expense of an Athenian family, and at a time when marble was employed only for sculptured decoration or elaborate mouldings on temples (although for whole treasuries). Its counterpart in Athens, a new Temple of Athena on the Acropolis (21·3 × 43·15 m.: 6 × 12 columns), Fig. 37 may have admitted both Ionic columns to its porch and a frieze. Its tripartite cella anticipates the Erechtheion, which eventually replaced it and overlaps its foundations. From the early fifth century the Temple of Aphaia Fig. 40, 41 on Aegina (13·80 × 28·50 m.: 6 × 12 columns) is comparatively well preserved and intelligibly restored. 6 Here we can see how the inner row of columns was built in two tiers to avoid disproportionately heavy shafts and to make good the full height to the roof timbers. In temples with such an arrangement the outer aisles were occasionally provided with upper galleries for viewing the cult image.

The only deliberate attempt to ape the colossal Ionic buildings of East Greece was made by the Athenian tyrants of the later sixth century in their plans for a Temple of Zeus Olympios (42 × 107·75 m.) but it is still by no means certain that it was intended to be a Doric structure, and it was never finished.

Fig. 42, 43 The Temple of Zeus at Olympia (27·68 × 64·12 m.: 6 × 13 columns) was finished a little before the mid 3 below fifth century and affords a classic example of Doric plan and details, which can be readily understood from the reconstruction drawing of the façade, and the sections through the porch and through the cella, with its Fig. 43 double tier of columns and Pheidias's great statue which was installed a generation later. The poor local limestone was covered with stucco to give a fine surface, but island marble was imported for the sculpture, tiles and gutters.

Fig. 44, 45 Not so far away in the Peloponnese, in a remote and dramatic Arcadian setting, stood the Temple of 4, 5 Apollo Epikourios near Bassai (14·63 × 38·29 m.: 6 × 15 columns), said to have been designed by the architect of the Parthenon, Iktinos. Despite its incredibly fine state of preservation it eluded rediscovery until Fig. 8 1765. The unusual features here are the internal frieze, the engaged inner Ionic columns with their unorthodox Fig. 15 bases and capitals, the earliest Corinthian capital known to us, and a side door at the back of the cella. The last was probably necessary because the lie of the land dictated a north–south orientation for the temple while an eastern doorway was *de rigueur*. It has been thought that the cult statue faced out through it, rather than being enclosed in the area limited by the engaged Ionic and the Corinthian columns, and the suggestion

I Corinth, Temple of Apollo, seen from the south-west. Mid 6th century B.C.

is that it would thus face the venerable Mount Lykaion. If so, we are here dealing with a rather unexpected function of both cult statue and temple.

Fig. 46, 47 With the Parthenon (Temple of Athena Parthenos) on the Acropolis in Athens (30·86 × 69·51 m.:
7–10 8 × 17 columns), we come to the most refined version of the Doric temple, although not the most classic, for it admits more individual and uncanonical features than any other. For the sheer beauty and crisp precision of its carved mouldings, even the very jointing of its plain walls, it cannot be equalled, while its state of

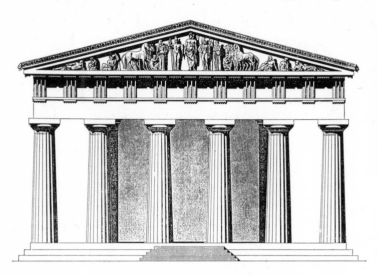

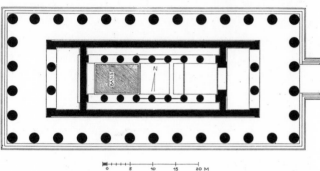

42, 43 The Temple of Zeus, Olympia. Second quarter of 5th century B.C. 42 Plan. 43 The east façade; section of porch behind east façade; section through cella. Second quarter of 5th century B.C. (after Doerpfeld)

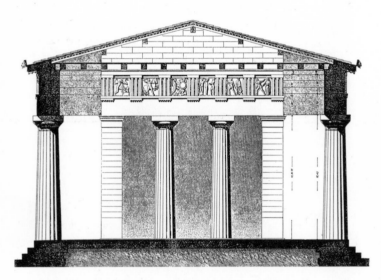

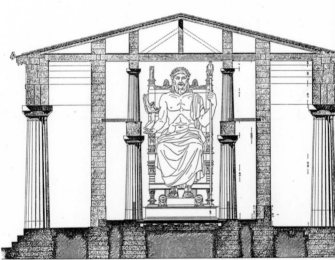

44, 45 The Temple of Apollo, Bassai. 44 Plan. 45 Interior, looking south. Late 5th century B.C. (after Krischen)

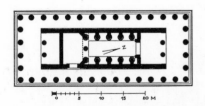

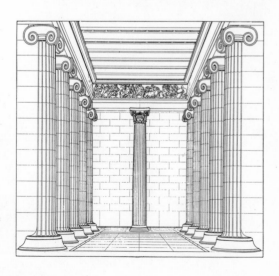

preservation and restoration make it possible for us to get at least an inkling of the over-all effect of such a massive, though infinitely subtle structure. More than most other temples this was an expression as much of civic pride, even arrogance, as of piety, built with funds paid by allies for their common protection and turned to other purposes. This is reflected in its sculpture, and the most deeply sacred rites were not practised here on the Acropolis, nor was Pheidias's Parthenos the most revered image of the city goddess.

One great advantage the Parthenon had over the temple at Olympia was the ready accessibility of fine white marble from near-by Mount Pentelikon, instead of the stuccoed limestone of so many Peloponnesian buildings. In plan the temple has eight columns at either end, which made for an impressively broader façade. The outer of the six porch columns stand in front of the side walls, not enclosed by them, and there is a large opisthodomos treasury, its ceiling supported by four columns, probably Ionic. The double tiers of columns in the cella are carried round behind the cult statue. As well as the sculptured pediment and metopes there was the famous frieze encircling the outer wall of the cella, running over the porches within the colonnade. *203–215* The roof was covered with marble tiles, such as were generally used by this date on the more important buildings in place of the usual terracotta.

There was a danger that these rather box-like Doric temples which relied on severely angular mouldings and presented to the eye something like a regiment of columns could appear unduly static, welded to the earth. The effect was to some degree mitigated in the Archaic columns with their plump swelling shafts, which are aggressively sturdy. These effects were too crude for fifth-century taste and more subtle refinements were required to correct the general impression by adjustments to the strictly vertical and horizontal which were perceptible only to the practised eye. Thus the swelling (entasis) of the column shafts does no more than correct the hour-glass effect which a straight-sided column would give viewed against the sky (as at a corner). Such refinements appear in many temples of the Classical period, but in none with the variety and degree of precision practised in the Parthenon. Apart from entasis many of these refinements appear in varying forms in earlier buildings, when they may have been applied not with a view to correcting appearance but with a practical purpose, like drainage (the floor sloping away to the corners) or stability (inward leaning columns). In the Parthenon the stylobate, the level from which the columns rise, drops slightly to each corner, only about 11 cm. on each long side (69.51 m.). The central axis of the columns (5.48 m. high) leans slightly inwards by about 6 cm. and their sides bulge very slightly, barely 2 cm. beyond the straight. The distance between the columns was narrowed at the corners, in part to answer the triglyph

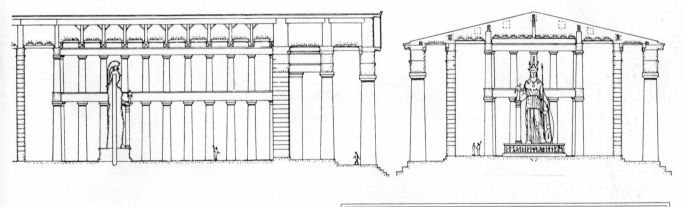

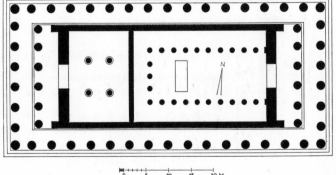

46 Sections through the cella of the Parthenon, Athens, showing the cult statue. Third quarter of 5th century B.C. (after Stevens)

47 Plan of the Parthenon, Athens. Third quarter of 5th century B.C.

problem, in part to lend an impression of greater stability here. Moreover the corner columns were fractionally thicker, to compensate their apparent loss of girth when seen silhouetted against the sky, as only they could be. In the entablature no planes are strictly vertical. All these refinements, together with the proportions as a whole, conspire to give the impression of a great building rising, almost growing from the rock citadel. The eye is led up and down the columns, along the friezes, with no suspicion of the weary rectangularity which a simple composition of such basic forms could so easily present.

Fig. 48; 11 In the lower city of Athens stood the Temple of Hephaistos (13·72 × 31·77 m.: 6 × 13 columns), which was a more conventional Doric building, although it too introduced an Ionic frieze in its sculptural decoration. The interior arrangement resembled that of the Parthenon, on a reduced scale. Its state of preservation is almost as remarkable as its unpopularity. The latter is probably the result of the former, its

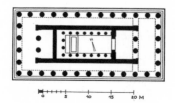

state of completeness recalling nothing more than many Roman monuments, like the Maison Carrée at Nîmes, and so resented. Its refinements are not as subtle as the Parthenon's but still remarkable, its sculpture is exquisite, and it can now be viewed as it should be, not through binoculars from the Acropolis, but from the ancient market-place (Agora) below it to the east. The formal garden later laid out around it, with its neat and orderly rows of shrubs (the flowerpots only are preserved) does nothing to inspire admiration for any ancient Greek feeling for landscape gardening. To the same architect can be attributed also the design of the Temples of Ares

48 Plan of the Temple of Hephaistos, Athens. Mid 5th century B.C.

(14·34 × 33·17 m.: 6 × 13 columns) and of Demeter and Persephone which stood in the Attic country-
12 side at Acharnai and Thorikos until they were removed in the Roman period to the Agora in Athens; the Temple of Poseidon at Sounion (13·48 × 31·15 m.: 6 × 13 columns), and the Temple of Nemesis at Rhamnus (10·10 × 21·30 m.: 6 × 12 columns).

THE WESTERN GREEKS

The dominant order in the Greek colonies of Sicily and South Italy was Doric, but never Doric in its classic purity. Often it is combined with elements of Ionic decoration, and then generally for the sake of effect rather than from any deliberate desire to balance or contrast the complementary styles. Wholly Ionic buildings are hard to seek—at Locri, at Syracuse (colossal, but unfinished Archaic) and, in the South of France, in the East Greek colony of Massilia (Marseilles). The popularity of Doric must be largely due to the Peloponnesian origins of most of the settlers, and the fact that the Ionian cities were generally from homeland states in which the Ionic order was not dominant, while the colonies themselves were relatively poor, or have been less fully explored than their Dorian or Achaean neighbours. The main influence of eastern Greece was in the example and challenge that its great Archaic temples set to the rich tyrants of the west who seemed to be at pains to outdo the home country in matters of size, show and expense—a weakness which can be detected in other colonies which have won independence.

Two great Doric temples were built in the Corinthian colony of Syracuse in the mid sixth century, for
Fig. 49 Apollo (21·57 × 55·33 m.: 6 × 17 columns) and for Zeus Olympios (22·10 × 62·40 m.: 6 × 17 columns). One unorthodox feature in their plans is the additional front porch, two columns deep, which was probably inspired by the near-contemporary though very much larger temples being built in the cities of Ionia, on Samos and at Ephesos. On the flanks of the Apollo temple the columns were set excessively close together,

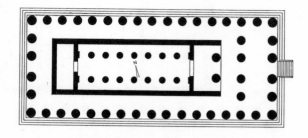

49 Plan of the Temple of Apollo, Syracuse. About 480 B.C.

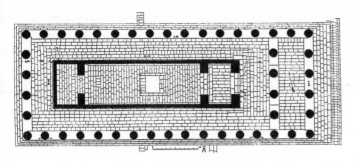

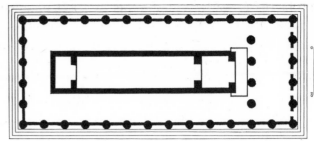

50 Plan of Temple C, Selinus. Third quarter of 6th century B.C.

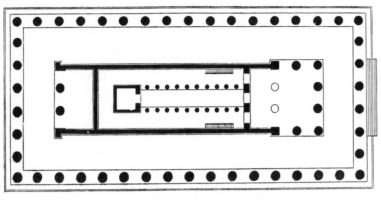

51 Plan of Temple F, Selinus. Late 6th century B.C.

52 Plan of Temple G, Selinus. End of 6th century B.C.

and there was probably only one triglyph to each intercolumniation, not the usual two, producing very elongated metopes. The centre pair of columns at the front were set wider apart, opposite the door, as in the Ionic temples.

Selinus, in western Sicily, presents an imposing number of early Doric temples. They introduce a feature in plan which recurs in several Sicilian temples and may have been present at Syracuse—a separate inner room or adyton at the back of the cella and reached through it, and not through a rear porch. Temple C *Fig. 50* (23·93 × 63·76 m.: 6 × 17 columns) is hardly later than those at Syracuse, and like them has the double *13* porch. The columns, some of them monoliths, offer a peculiarity met in other examples of western Greek Doric—a distinct sinking or collar immediately below the capitals. Here too we find a distinctive and elaborate form of clay revetment used for the gutter, which will also be characteristic of much western *Fig. 20* Greek work. Temples D (23·53 × 55·96 m.: 6 × 17 columns) and FS (24·23 × 61·83 m.: 6 × 14 columns) *Fig. 51* are more orthodox in plan though with deep porches, and later in date, but the latter seems to have had low screen walls running between the outer columns offering some degree of privacy to the ambulatory.

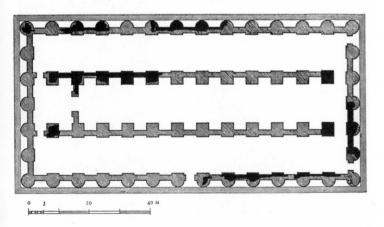

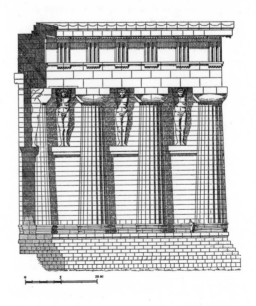

53 Plan of the Temple of Zeus, Akragas. Early 5th century B.C.

54 Elevation and section of the flank of the Temple of Zeus, Akragas. Early 5th century B.C. (after Koldewey and Puchstein)

The wide colonnades or pteron on these Sicilian temples meant that the cella was narrower and could dispense with interior columns. It has been suggested that such spans were possible because some Sicilian architects understood the principle of the truss-roof. We get the impression that these interiors were seldom displayed, and that an air of mystery was sought by the long narrow cellas without colonnades, but with
Fig. 52 the adyton recess beyond. Temple GT (50·10 × 110·36 m.: 8 × 18 columns) was begun at the end of the century and is the largest on the site, approaching the size of the big Ionian temples of rather earlier date, and like them, with an eight-column façade. The outer colonnade is at two columns' distance from the walls leaving a broader free walk (pseudo-dipteral: i.e., with room for a double colonnade all round). The two rows of columns within the cella rose in double tiers. This ambitious work was never finished.

The other colossal temple in Sicily, begun not long after GT at Selinus, was the Temple of Zeus Olympios
Fig. 53, 54 at Akragas (52·74 × 110·10 m.: 7 × 14 columns). This had many, far stranger features. There were screen
Fig. 28 walls the full height of the columns embellished with the giant sculptures (each nearly 8 m. high) seeming to support the entablature, which was reinforced with iron beams. The columns and capitals themselves were so massive that they had to be built up in rectangular blocks and not in one piece or of whole drums, and they were given bases. This temple also was never finished, and the intended final arrangement with the massive inner piers of the cella walls, and the plans—if any—for roofing, are beyond conjecture. The smaller Temple of Herakles at Akragas (25·28 × 67·04: 6 × 15 columns) was more orthodox, and here the Sicilian fashion of setting the side columns close together was abandoned.

At Paestum, on the Italian mainland, there stand still in a fair state of preservation three of the most
Fig. 55; 14, 15 interesting Doric temples in any part of the Greek world. The Hera Temple (Hera I), long known as the Basilica (24·52 × 54·27 m.: 9 × 18 columns), was built in the later sixth century. It has a broad, nearly pseudo-dipteral colonnade, and is unorthodox, at this date, in having a row of columns down the centre of the cella, and nine-column façades. The nine capitals of the western columns are unusually ornate for Doric,
48 above with rings of leaves and florals carved in the necking. These features borrowed from the repertory of Ionic
Fig. 57, 58 architectural decoration are seen again in the smaller and slightly later Temple of Athena (long known as a
18 Temple of Demeter: 14·53 × 32·88 m.: 6 × 13 columns) where the Ionic bead and reel is introduced. Moreover the inner porch here has six and two half Ionic columns standing before and across the side walls. Both temples had an Ionic moulding running along the top of the architrave and the Athena temple had carved coffers beneath its eaves instead of the usual mutules. A different sort of intrusion is seen in a smaller

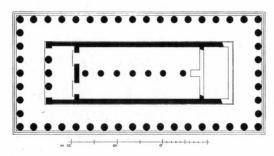

55 Plan of the Temple of Hera I, Paestum. Mid 6th century B.C.

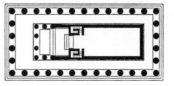

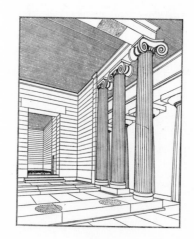

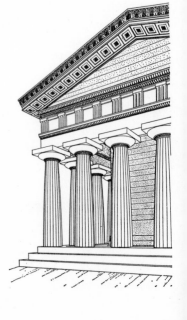

56 Plan of the Temple of Athena, Paestum. Late 6th century B.C.

57, 58 The Temple of Athena, Paestum. Porch and façade (after Krauss)

40

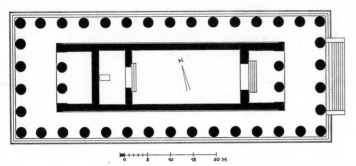
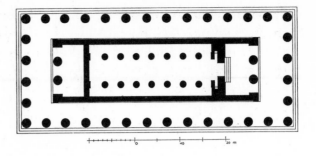

59 Plan of Temple E, Selinus. Third quarter of 5th century B.C.
60 Plan of the Temple of Hera II, Paestum. Mid 5th century B.C.

and earlier Temple of Hera (about 9 × 16·5 m.: 4 prostyle columns) at a near-by site at the mouth of the River Silaris, where the anta capitals (at the ends of the side walls) have a splaying cavetto outline with richly carved rosettes and florals, but the new elements here are not obviously Ionic. At Locri, in the south, a small Doric temple introduced odd features like carved leaves on the cornice, pomegranates cut in the round between the guttae, and most elaborate clay revetments and acroteria.

The fifth-century temples are more orthodox, though no less ambitious in the matter of size. First come the temple at Himera (22·45 × 55·91 m.: 6 × 14 columns), built to commemorate the victory over the Carthaginians in 480 B.C., and the Temple of Athena at Syracuse (22·00 × 55·00 m.: 6 × 14 columns), *52* partly preserved in the structure of the city cathedral. At Selinus Temple ER (25·32 × 67·74 m.: 6 × 15 *Fig. 59* columns) and the smaller (by Sicilian standards) Temple A (16·23 × 40·24 m.: 6 × 14 columns) combine the traditional Sicilian inner chamber with the Greek rear porch. At Paestum the 'Temple of Poseidon' (really a second Temple of Hera: 24·28 × 60 m.: 6 × 14 columns) must be a near contemporary of the *16, 17* Temple of Zeus at Olympia. Its plan resembles that of the Greek temples of this period, with two tiers of interior columns. It is moreover one of the best preserved of all ancient temples.

At Akragas the impressive range of temples set just inside the long southern course of its great city wall was added to by the construction of two more: the Temple of Hera Lakinia (16·89 × 38·13 m.: 6 × 13 columns) and the so-called Temple of Concord (Temple F: 16·92 × 39·42 m.: 6 × 13 columns) which is *11* another of the best preserved of all Greek temples. Stairs at the back of the porch led to the roof space and not to any hypothetical gallery behind the inner columns. Such stairs are features of other Sicilian temples, like that of Herakles at Akragas, already mentioned.

The last of the important Classical temples in Sicily is the strange and impressive temple at Segesta *20* (23·25 × 57·50 m.: 6 × 14 columns) set in a western part of the island where the interests of the Greeks were never quite dominant over those of the natives or neighbouring Carthaginians in the coastal cities. The columns were never fluted, the lifting bosses on the stones never cut away, and the cella walls never built (unless, as some believe, they were never intended).

Throughout this long and impressive record of temple building by the western Greeks the emphasis has been more on size and elaboration of ornament, be it painted or carved, than on the subtleties and more carefully judged blend of Doric and Ionic seen in much homeland Greek work. So many of the peculiarities of plan and detail are repeated in the western temples that it is right to speak of individual schools, or indeed to look for the influence of individual though unnamed architects, who had both to meet the restrictions of the materials at their disposal and satisfy the aspirations of the rich tyrants for whom they worked.

IONIC: TO THE FIFTH CENTURY

The story of the development of the Ionic temple is a far more checkered one, although the basic requirements of plan were the same as for Doric and as regularly observed.

In the Sanctuary of Hera on Samos a succession of temple buildings takes us back well into the Geometric period. The long slim Temple of Hera (6·50 × 32·86 m.) may have had a colonnade (7 × 17 columns?) added to it already in the eighth century, but certainly by the middle of the seventh century a rebuilding of the traditional thin hall introduced an exterior colonnade, an innovation which in Doric we saw first in a

rather later Temple of Apollo at Thermon. The new Samos temple (Hekatompedon II: 11·70 × 37·70 m.: 6 × 18 columns) had a six-column façade and the four columns which stood before the inner porch give the effect of the double front row which becomes a feature of later building. But the columns of this temple were wooden and we are still far from anything approaching a stone order. The cella, or main hall of the earlier buildings was divided into two aisles by a central row of wooden pillars; the later one had pillars engaged in the side walls.

42 centre At Smyrna a temple using carved stone capitals and drums was being built around 600 B.C. when the Lydians arrived and interrupted the work by sacking the city. Of the buildings for which Aeolic capitals were made in the first half of the sixth century we know the plan of the long slim temple at Neandria with a central row of columns, no external colonnade, and the primitive feature of an internal hearth at the end of one aisle. It seems also to have been built on a raised platform, or podium, with a walk around: a feature only seen or suspected in Greece in a few early East Greek temples.

Fig. 61 In the monumental Temple of Hera built on Samos just before the mid sixth century (52·5 × 105 m.: 8/9 × 21 columns) we have the first of the great Ionic buildings, corresponding to the earlier colossal kouroi and, like them, long unrivalled for their sheer size and ambitious techniques. The ground-plan shows a feature peculiar to these Archaic Ionic temples, which may have inspired the pseudo-dipteral temples of the western Greeks which we have already discussed. This is the true dipteral form, with two rows of columns round the cella. The deep porch has two rows of columns in it, like the cella, and this arrangement leaves eight columns, broadly spaced at the centre, on the front (recalling the Doric system which was applied to answer the triglyph problem), but nine evenly spaced at the back. Of the columns we have only the shafts *Fig. 11; 41* and the bases. Capitals and upper works must have been wooden. The massive turned bases of limestone with their delicate and varied fluting are preserved in the foundations of the later temple.

This second temple (52·45 × 108·63 m.: 8/9 × 24 columns) was started after the first had been destroyed by fire in or soon after about 540 B.C., possibly the result of a Persian attack. With it we associate the names of the architects Rhoikos and Theodoros, who may also have designed the earlier structure. The new plan resembled the first, but there are now three rows of columns front and back as well as two at the *41* sides. Of the earliest capitals there are only egg and dart echini, and there was probably never any volute member above, while the rest of the upper works was of wood. But the temple was never properly finished and there were several periods of active building. From the earlier fifth century come scraps of fine capitals *Fig. 12* with a floral necking, which we have come to recognize as a Samian type, probably for the exterior order. For the new temple these members were carved from marble, and we here also meet first the usual later type of Ionic fluting for column shafts, with flat bands between the deep flutes.

Between the building periods of the two great temples on Samos comes the start of the construction of the *Fig. 62, 63* Temple of Artemis at Ephesos (55·10 × 115·14 m.: 8/9 × 21 columns), which rivalled them in size, but, as

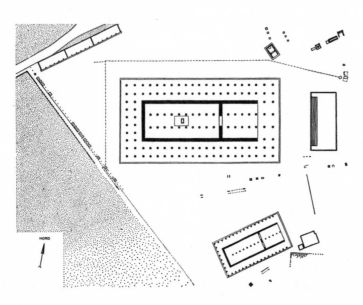

61 The sanctuary of Hera, Samos. About 540 B.C., showing the Temple, Altar, and South Building (after Buschor and Schleif)

II Akragas (Agrigento), Temple F, so-called Temple of Concord, seen from the south-east. Late 5th century B.C.

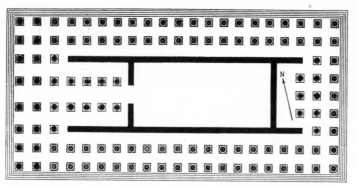

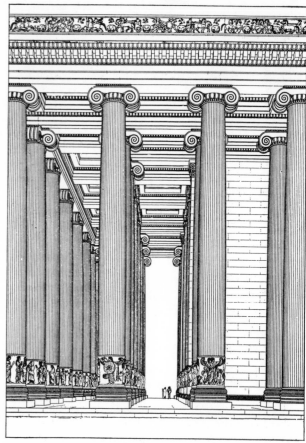

62 Plan of the Temple of Artemis, Ephesos. Mid 6th century B.C.

63 Temple of Artemis, Ephesos. 6th–5th century B.C. View of the south side at the west end (after Krischen)

Fig. 11 we have seen, had distinctively different forms of capital and base, and admitted more sculptural decoration on columns and gutters. The plan was as that of the Samos temples, but with three rows of eight columns at the front, and two rows of nine at the back where there was, however, an inner porch whose columns would have given the effect of a triple row. This temple too took some hundred years to complete. A massive egg and dart crowned the architrave. The cella was possibly not roofed and the evidence that the building had a gabled façade is purely circumstantial: but, unless its sculptured parapet was intended as an ornate horizontal border to the structure, the peristyle at least probably had a low-pitched roof, and clay roof tiles were attributed to the building by the excavators. The Lydian king Kroisos contributed to the cost of the columns, and may have built himself a comparably massive temple at Sardis.

Of the plans of other Ionic temples of the later sixth and early fifth centuries little is known. That of Apollo at Didyma near Miletos may have been dipteral and of a size approaching those at Ephesos and Samos. Its most striking feature was the tall sculptured frieze filling the height between the capitals and the moulding below the (presumed) dentils, and the lower column drums with relief sculpture, as at Ephesos. Its cella was not roofed and enclosed a smaller shrine (naiskos) but the plan is best studied in the later *Fig. 72* rebuilding which retained these basic features. On Chios the temples at Phanai offered a plethora of *Fig. 11, 23* elaborate carved mouldings, and there were important temples, known only from few of their mouldings, at Miletos, Myus, Magnesia and Smyrna in East Greece, on Delos, at Naukratis in Egypt, and at Neapolis (Kavalla) on the north coast of the Aegean opposite Thasos. After the Persian Wars there was occasion for rebuilding on some of these sites.

For the full Classical period and the most refined use of Ionic for temple building we turn to Athens where the order had been adopted already in the Late Archaic period, although only for minor buildings or monuments. It was again the Persian Wars and the sack of Athens by the Persians in 480 B.C. that gave the opportunity for the complete replanning of the Acropolis, although this was not seriously undertaken until military commitments to Athens' allies against the Persians had been fulfilled.

Fig. 64, 65 The little Temple of Athena Nike (5·38 × 8·27 m.: 4 prostyle columns) on the Acropolis has a simple *21* square cella with columns only at the front and back. Here we see the new type of capital, with concave

44

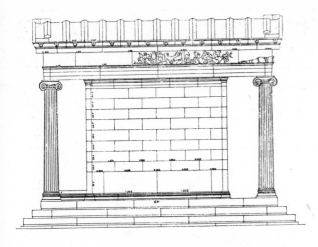

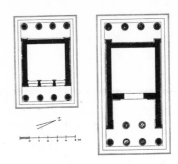

64 The Temple of Athena Nike, Acropolis, Athens. Late 5th century B.C.

65 Plan of the Temple of Athena Nike, Athens.

66 Plan of the Temple on the Ilissos, Athens. Mid 5th century B.C.

channels, the Attic Ionic bases, and a fine sculptured frieze, all executed with the same finesse that was lavished on the Doric buildings which formed part of the same great Periclean building plan in Athens. The temple was not finished until later in the century but the plan and style appeared earlier in a temple by the River Ilissos (5·70 × 12·40 m.: 4 prostyle columns), just outside the city walls. This was drawn in the *Fig. 66* late eighteenth century but all that survives of it are two bases, only recently recognized and far from their original position, and some scraps of relief sculpture.

The finest and most unorthodox of the Ionic temples was the Erechtheion (13·00 × 24·07 m.: 6 prostyle *Fig. 67, 68* columns). Reasons of cult and the irregular surface of the Acropolis rock presented its architect with peculiar *22–25* problems which he successfully solved by planning this strange building on three different levels. It is unthinkable that it was ever intended to be strictly symmetrical, with a great wing added to the west and central porches like some modern museum gallery. The arrangement of the main block was determined by cult requirements, and its main entrance to the east has a six-column façade. From the deep basement at the rear (west) a door gave onto an enclosure, below the level of the screen wall with windows and half columns which marks the main level of the temple, but which in its present form is a Roman rebuilding. There was access too through the magnificent North Porch which rose from basement level to near the full height of the building, and incorporated the most elaborate carved features of capitals, bases, and doorway. To the *Fig. 24* south stairs gave access to the closed porch with the six Caryatids, like a royal box looking across the *25* Panathenaic Way to the Parthenon. The most sacred rites for the city goddess were enacted in the Erechtheion and the porch may represent some sort of link between it and the Parthenon. Architecturally it presents a challenge of Ionic delicacy and elaboration to the subtle Doric severity of the Parthenon's exterior.

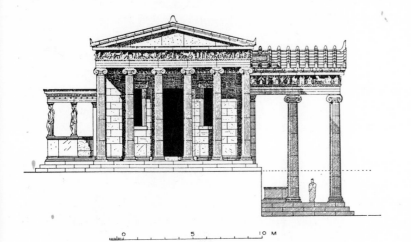

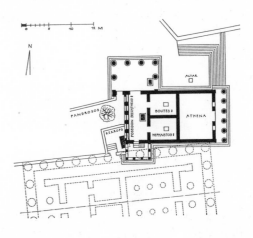

67 Restored east elevation of the Erechtheion, Athens. About 410 B.C. (after Stevens)

68 Plan of the Erechtheion. Athens. About 410 B.C.

The later history of the Greek temple in Greek lands is mainly the story of new theories of proportion and innovations in architectural decoration. Temple plans remain little changed, but some rebuilding of the great Archaic temples in East Greece in the fourth century, and the stimulus provided by the ambitious building plans of the Hellenistic princes, produced some impressive structures. In general the architect's skills were turned more and more to the designing of other public and private buildings, and in most cities the great temples of the Classical period required neither replacement nor supplement by new ones. With the problems of technique now largely solved for buildings of such limited structural ambitions, and with interest now more concentrated on decoration, there is a perceptible, perhaps inevitable, falling off in standards of finish and precision, and the subtler Classical refinements are ignored. The new Doric temples in particular lost the characteristic proportions which gave them their strength as the order approximated more closely to the Ionic and the plan and details admitted more variations on the ideal, canonic design.

Fig. 16 The fourth-century Doric temples of mainland Greece offer little new. A Temple of Athena Alea at Tegea (19·16 × 47·52 m.: 6 × 14 columns) has the usual plan, but in the cella the columns are Corinthian with unusually shallow capitals engaged along the side walls. The Temple of Zeus at Nemea (20·00 × 42·5 m.: 6 × 12 columns) dispensed with the rear porch entirely, but its interior Corinthian columns were free-standing. The introduction of Ionic or Corinthian columns was more common now in these Doric buildings. At Delphi new temples were built for Apollo (21·65 × 58·0 m.: 6 × 15 columns) after the old one had been destroyed by a fall of rock, and for Athena Pronaia in the smaller sanctuary at the same site.

Fig. 93 In East Greece the Ionic rebuildings were more lavish. For the new city of Priene a plan could be devised
Fig. 69, 70 without reference to earlier buildings, and its late-fourth-century Temple of Athena Polias (19·55 × 37·20 m.: 6 × 11 columns) was a classic example of Ionic. A consciously classic one too, to judge from its most carefully judged proportions and the fact that its architect wrote a book about it. Its plan is orthodox, though with a very deep porch. The whole order can here be restored from what survives, from the square plinths
Fig. 6 introduced beneath the Asiatic Ionic bases, to the canonical eastern treatment of the entablature.

At Ephesos the old Temple of Artemis had been destroyed by fire, and a new one was constructed at a
Fig. 71 higher level. The plan was the same and details like the sculptured drums and the bases were remembered.
26 At Sardis a new Temple for Artemis (45·73 × 99·16 m.: 8 × 20 columns) rivalled the Archaic Ionic temples in size. Its cella plan is more complex, and it is pseudo-dipteral along the flanks. It was never completely finished and different building periods introduced different plans for the interior. Several of its elaborately
Fig. 9 carved capitals and bases are preserved.

Fig. 72, 73 Apollo's new temple at Didyma (51·13 × 109·34 m.: 10 × 21 columns) recalls its Archaic predecessor. Its
27, 50 plan seems orthodox dipteral, but the immense cella stood open to the air as a courtyard with engaged pilasters along its inner walls. A smaller Ionic building (8·24 × 14·23 m.) with a four-column façade stood within the court, which was entered through stairs and tunnels running from either side of the porch. The room behind the porch was to be reached only from a broad flight of steps up from the court itself, and

69 Plan of the Temple of Athena Polias, Priene. 4th century B.C.

70 Restoration of the Temple and Altar of Athena Polias, Priene. 4th century B.C. (after Schede)

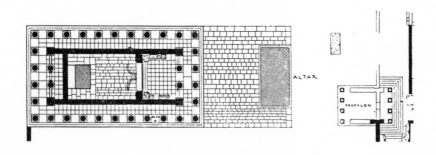

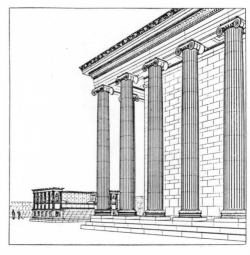

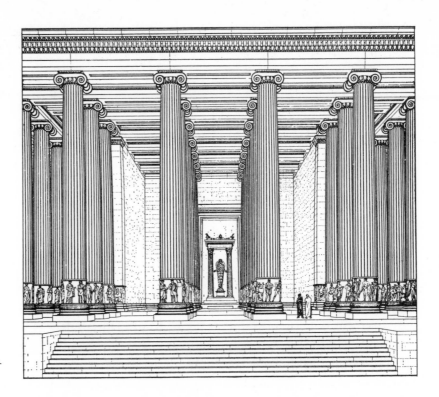

71 Temple of Artemis, Ephesos. The west façade.
 4th century B.C. (after Krischen)

not through the magnificent porch door with its 1·5 m. high threshold. No doubt this arrangement was dictated by the ritual of the oracles which were delivered at the temple.

In the third and second centuries, under the Hellenistic kings, the new cities offered opportunities lacking in mainland Greece, while work continued on many of the still incomplete projects of the fourth century. The architecture of the East Greek world was dominated by the activity and theories of architects like Hermogenes and Pytheos, who hoped through their books and buildings to canonize new standards and proportions for Ionic. A pseudo-dipteral plan, which we have met hitherto only in the west and on the long sides of the Temple of Artemis at Sardis, now finds favour, as in a temple for Apollo Smintheus in the Troad (23 × 40 m.: 8 × 14 columns), and in Hermogenes's plan for a Temple of Artemis Leukophryene at Magnesia on the Meander (31·3 × 57·7 m.: 8 × 15 columns). The introduction of Attic Ionic bases in this and other buildings seems to have been a conscious imitation in Ionia of the achievements in Classical Athens. The pediment walls in the Magnesia temple were pierced by three door-like apertures, to relieve the weight on the façade colonnades if not also for ritual displays, and there seems to have been a similar arrangement at Ephesos.

Corinthian columns begin to be used for the exterior order of temples, instead of being confined to the interior or subsidiary positions. An early example is the third-century Temple of Zeus at Olba in Cilicia

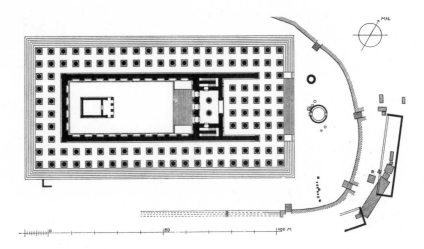

72 Plan of the Temple of Apollo, Didyma. 4th
 century B.C.

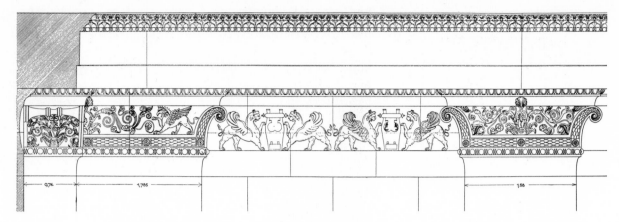

73 Pilaster capitals and frieze in the Temple of Apollo, Didyma. 4th century B.C. (after Knackfuss)

28 (22 × 40 m.: 6 × 12 columns) and the same scheme was adopted for the new Temple of Zeus Olympios at Athens (41·11 × 107·89 m.: 8 × 20 columns), outside the city walls, although most of the work on the building was not completed until the reign of Hadrian. It was to be dipteral, with three rows of columns at each end, like the Archaic Ionic temples in East Greece. Its foundations had in fact been laid in the Archaic period, as has been remarked already.

The Doric order gained more of a foothold too in East Greece, even for temple building, in the Temple of Athena which was built at Troy (16·40 × 35·70 m.: 6 × 12 columns) over the ruins of the Bronze Age town, and another Temple of Athena built on the Acropolis at Pergamon (12·27 × 21·77 m.: 6 × 10 columns). On the island of Samothrace a Temple of the Kabeiroi carried an added prostyle porch, like the earlier Sicilian temples, and had an apsidal end within, but no pteron.

The temple buildings of the Hellenistic Greek world deserve more attention and credit than they are generally accorded in hand books, while their successors, of the Roman period in Greece, have a special interest for the way in which they show the survival and development of old traditions beside the new building styles and techniques of the Roman Empire.

OTHER SACRED BUILDINGS

The odd design of the Erechtheion was dictated by cult practice and the ground surface, but it conforms basically, as have all the other temples mentioned, to the megaron form of cella and porch. Apsidal temples, without a pteron of columns, recall the more primitive house plan, and there are sixth-century examples (Athens, Corinth, Delphi) and a fifth-century Ionic one with a four-column façade on Chios (Emporio).

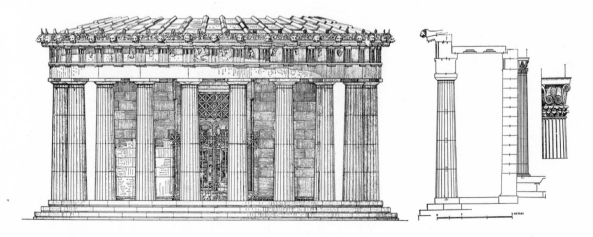

74 Elevation and section of the Tholos, Delphi. 4th century B.C. (after Pomtow)

48

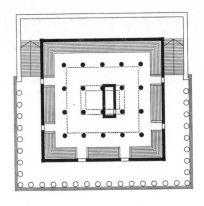
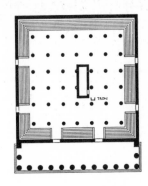

75 Plans of the Telesterion, Eleusis; Periclean and 4th century B.C. (after Travlos)

Monumental circular buildings have a long history in Greece, although for several we cannot be sure that 'temple' is quite the right description. They were known as 'tholoi'. There was a circular sacred building of some sort at Delphi in the first half of the sixth century, and in the fourth century a fine example was erected in the lower sanctuary there (diameter 13·50 m.). Its outer columns were Doric, and within the circular cella *Fig. 74; 29 below* Corinthian columns of an early type were ranged against the wall, their bases set on a shallow stone bench. A little later in the fourth century a larger tholos was built in the Sanctuary of Asklepios at Epidauros *Fig. 17* (diameter 21·68 m.), again with outer Doric and inner Corinthian columns. The carved decoration on this building is extremely elaborate, including metope reliefs of rosettes instead of the usual figures. The tholos *45 below* built by Philip of Macedon at Olympia (diameter 13·92 m.), completed by his son Alexander the Great, had an exterior Ionic order, with Corinthian columns engaged within. This held statues of the Macedonian royal family and so is no temple in the ordinary sense of the word, although it was clearly intended to convey a suggestion that the royal house deserved a pied à terre at Olympia beside the Father of the Gods.

After this period of popularity for tholoi in the fourth century there are but few more examples built in Greece (one on Samothrace) and the circular Roman temples (including that to Roma and Augustus on the Athenian Acropolis) owe a different source of inspiration.

A special type of temple building, which was not a house for a cult image, but a place in which particular rites were performed, was required for the worship of Demeter and Kore at Eleusis. The rites of initiation *29 above* required accommodation for spectators and some form of display; also a considerable degree of privacy. The ultimate form of the 'Telesterion' was already determined in the sixth century—square, with seats in tiers on three sides, a forest of columns spaced equally across the flat central area, and access through narrow doors from the open colonnaded porch. A Periclean plan for the building (51·56 × 49·44 m.) was never *Fig. 75* completed. It involved seats on all four sides and two concentric rows of columns (5 × 4 and 3 × 2). The final, fourth-century plan, had the same seating arrangement, but 7 × 7 columns enclosing still a primitive small adyton in the centre.

TREASURIES

In the Archaic period state dedications to the national sanctuaries of Olympia and Delphi could take the form of pavilion buildings known as treasuries. They were not temples, but repositories for dedications both by the donor state and others. They generally take the form of small one-roomed buildings with two columns in antis in the porch (i.e., within the ends of the side walls) and they attracted lavish decoration.

At Delphi the Doric Treasury of the Sicyonians is best known for its sculptured metopes, but more can be reconstructed of the Ionic buildings. The Siphnian, the most ornate and best preserved, was built about *Fig. 27* 525 B.C., and introduced the Caryatid kore figures in place of porch columns, as well as the famous frieze and some highly ornate mouldings. An earlier, unidentified treasury also had a Caryatid porch. The *44 below* Treasuries of Klazomenai and Massilia (Marseilles) had Asiatic Ionic column bases, and palm capitals. At the *Fig. 10* end of the sixth century comes the Doric Athenian Treasury which has been reconstructed *in situ*. Later *30* Doric treasuries were built by Kyrene and Thebes, but treasury building was not very common after the Archaic period.

At Delphi the treasuries flanked the Sacred Way up to the temple. At Olympia they stand on a terrace
54 below overlooking what was the end of the Archaic and Classical stadion, and, after the Echo Stoa was built, overlooking the entrance way to the new stadion. Of the ten named treasuries (there were more) five were built by the western colonies of Sicily and South Italy and three are from cities at least as remote—Kyrene,
Fig. 19 Epidamnus, Byzantium. All were Doric, and the Treasury of Gela in particular offers fine examples of the elaborate clay revetments fashionable in Sicily and imported especially for this building. In this instance they mask stone, not woodwork. The only deviant plans are in that built by Metaponton, with three columns in antis, and the Megarian Treasury which is prostyle (the porch columns in front of the side walls, not between them).

There are treasury-like buildings at other national sanctuaries, like Delos and Dodona, but we cannot be sure that they were independent state dedications.

THEATRES

The essential feature of any early Greek theatrical production was the dance. As a result all buildings designed for such performances take the form of banks of seats arranged on almost all sides of a flat dancing floor—the orchestra—rather than the modern arrangement of seats facing one way, towards a stage or screen. As time passed more importance was attached to the dialogue episodes in plays and less to the dancing, with the result that to the circular orchestra a straight edge was added for a stage building, and the stage itself was in time (first in the fourth century) raised above the level of the orchestra. The seating arrangements were not much changed and the poor view of the stage proceedings enjoyed by the audience on the wings can be readily imagined—and experienced in the modern productions staged in ancient theatres.

Greek theatres take advantage of the natural slope of a hillside—for instance, of an acropolis hill, as at
34 Athens or Pergamon—to accommodate the seats which would be cut back in the rock and in the finer theatres faced with stone. This way any building-up for the circle of seats (the cavea) was required only on the flanks. There was no covering for the spectators. For a big cavea there were radial flights of steps and

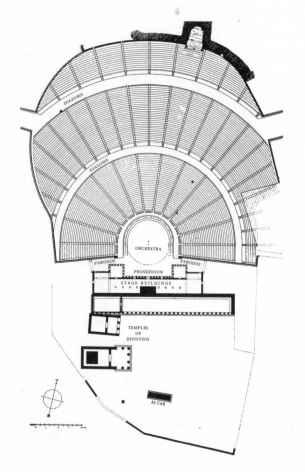

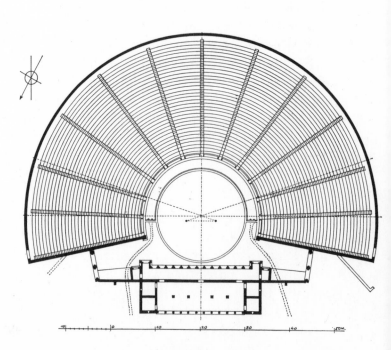

76 Plan of the Theatre of Dionysos, Athens. 4th century B.C.

77 Plan of the Theatre, Epidauros. 4th century B.C.

50

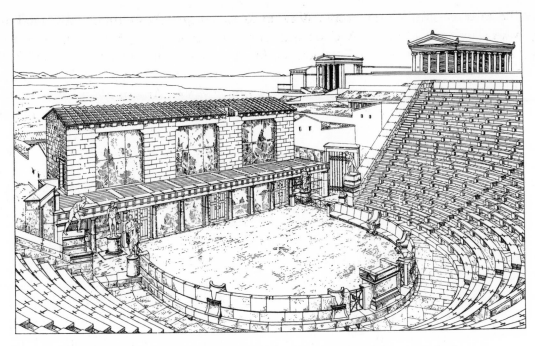

78 The Theatre at Priene. Restoration of its Hellenistic form (after von Gerkan)

broader horizontal passages (diazomata). Marble seats for dignitaries were set at the centre at orchestra level, or a little raised. The architectural elaboration was confined to entrance ways to the cavea and orchestra from either side (parodoi), and to the stage buildings, as soon as they were large enough to warrant it.

Theatrical performances were an act of worship, and there was normally a small shrine at hand. They also played an important part in the festivals of national sanctuaries where there were contests for plays or music, and theatres are a normal feature of sanctuary plans. Only at Olympia we lack, or have failed to find, a formal theatre building.

The sequence of plans for the Theatre of Dionysos in Athens illuminates much of the whole history of the Greek theatre. In the sixth century there seems to have been no more than a circular orchestra with no formal arrangement for seating on the Acropolis slopes. In the fifth century the more complex dramatic action of the plays performed required a straight stage wall behind the circle of the orchestra. At the end of the century the arrangement was executed in stone, the orchestra shifted slightly and the slope of the cavea made steeper artificially. Many seats were marble, some still wooden, and there was always the bare earth of the hillside above. Behind the stage wall (skene) a colonnade opened onto a sanctuary with a small shrine to the god of the theatre, Dionysos. A hundred years later a complete rebuilding offered a broader *Fig. 76* sweep of built seats making it possible to accommodate an audience of perhaps 17,000. The new skene had slightly projecting wings and the proskenion for it served to support painted panels, like backdrops. By the Hellenistic period a movable wooden proskenion was used, and not simply as a background but as a raised stage for the new plays in which the action of the chorus was restricted or dispensed with, and the action of the protagonists was the prime attraction. The focus of interest had shifted from the dancing to the acting, from the orchestra to the stage.

New theatres were able to provide a permanent colonnaded proskenion for the stage. In the little theatre at Priene (seating about 6,000) the excavators thought they could detect the transition between the two uses *Fig. 78; 31* of the proskenion. But the most beautiful of Greek theatres, and with its seating best preserved, is that built for the Sanctuary of Asklepios at Epidauros in the fourth century. The broad semicircle of seats could *Fig. 77; 32, 33* accommodate 13,000, but the details of the original stage building are not certain. For other well preserved theatres of the Greek period we turn to Syracuse, Delos, Eretria, Ephesos or the massive theatre at Pergamon. *34*

Small buildings for recitals, true 'odeia' or music halls, did not require a hill slope but were built square in plan, and roofed. There was such a building in Periclean Athens, next to the Theatre of Dionysos, and the plan is repeated for other assembly halls, as we shall see. More like a theatre was the open assembly place

for the citizens of Athens on the Pnyx hill. Here the natural slope was used until the end of the fifth century when the cavea of seats was built up against the slope of the hill, facing the speaker's platform (bema) and, beyond it, the port of Athens and the sea. At Megalopolis a roofed building called the Thersilion (65·4 × 57·9 m.) was provided for a citizen assembly of 10,000 in the fourth century, although probably never more than 6,000 could be seated in it. It resembled the Telesterion at Eleusis in plan, the rows of inner columns being arranged radially so as not to obstruct vision, but in rows parallel to the side walls, not in semicircles. There was a prostyle porch.

BUILDINGS FOR ATHLETICS

In Greek athletics races were run up and down a straight course and not on a circular or oval course as today. So the Greek stadium is a long hairpin-shaped structure giving a course 600 feet long. Only late stadia have stands with stone seats for spectators. They run along each side and usually at one end only where the plan might be semicircular or rectangular. At the other end an elaborate screen wall was sometimes constructed in the later period. The stadium in Athens, as it was reconstructed for the first modern Olympic Games in 1896, gives a fair idea of the Greek stadium in its most developed form.

35 Exercising grounds for athletes were provided in the gymnasion or palaistra. Both usually take the form of a large colonnaded court with rooms grouped around it for bathing, lectures or exercises, and sometimes the sides were long enough to afford covered running-tracks.

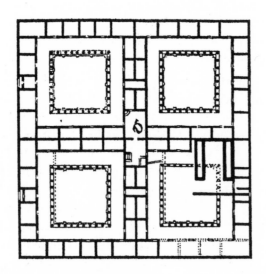

79 Plan of the Hotel at Epidauros. 4th century B.C.

These buildings would be found in any well appointed town after the fifth century, and certainly at all the sanctuaries where games were an important part of the festivals. Here there were also problems of accommodation for both athletes and visitors who flocked in for the games. For the more important hotels were provided, not unlike the gymnasia in general plan—with guest rooms lining a big square court and sometimes one larger dining-room. There are good fourth-century examples at Olympia, like the Leonidaion, which had an external Ionic colonnade, and Doric columns in the court. At Epidauros less Fig. 79 lavish accommodation was provided in a building of comparable size, but divided into four square courts with smaller rooms.

STOAS

The stoa was the most versatile of all Greek buildings. In origin it was no more than a long covered structure, with one row of wooden posts down the centre and another on one open side. There would be a plain wall at the back. In the Sanctuary of Hera on Samos such a building (the South Hall) stood already soon after the mid seventh century. It could serve as a store and exhibition place for votive offerings, as a shelter for visitors or patients (at sanctuaries of Asklepios, the healer god), even as a sort of grandstand for ceremonies enacted in the open area before a temple. Similar stoas are seen in other Archaic sanctuaries, as in that for Fig. 80 Hera near Argos. At Delphi the Athenians built a small but elegant stoa to celebrate a naval victory in the

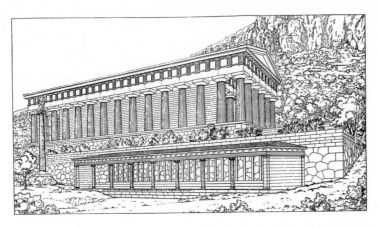

80 Delphi. View of the Stoa of the Athenians, with the Naxian Sphinx and
column to the left and the Temple of Apollo behind (after Fomine)

early fifth century. Its Ionic columns were wide spaced (the upper works must have been wooden) and its
back wall was provided by the magnificent polygonal terrace that supported the Temple of Apollo. In later
stoas a row of rooms is added at the back to serve as dining rooms or bedrooms, as in the little Classical
Sanctuary of Artemis at Brauron in Attica. Near any theatre the advantages of a stoa as an ambulatory are
obvious.

In its secular function too it required a row of rooms behind the colonnade, which could then serve as
shops or offices, and at Pergamon the Library was installed in a building of stoa form. The famous Painted
Stoa in Athens sheltered paintings of the great Classical artists, and gave its name to the Stoic philosophers
who walked and talked in its colonnades. The broad open area of the colonnade could serve for an assembly,
perhaps even a law court, while its function as a grandstand was even better served when the building was
two stories high, with a similar plan of colonnade and rooms on each floor. Such stoas became a regular
feature in the plans of market-places, flanking the central area (at Athens also overlooking the Panathenaic
Way) or limiting separate market areas for which the stoa's rooms could provide permanent booths and
administrative offices. A common arrangement of columns was to have Doric externally and Ionic within,
where the latter's relative slimness and height could be used advantageously.

Best known, perhaps, are the stoas of Pergamene type, especially now that a stoa built in Athens by a king 36
of Pergamon (Attalus II) has been restored by the American excavators to house a museum, store and work-
room. This had Doric columns below, Ionic above, and the inner colonnades were Ionic below and columns
with palm capitals above. The last are a common feature of Pergamene architecture, but it is the first time
we have met them since the Archaic treasuries at Delphi.

At Pergamon itself and in other Hellenistic cities linked stoa complexes were planned on three or four
sides of a market area or court containing a shrine or altar, and they proved an important and useful element 37
in the deliberate planning of civic centres. The great South Market at Miletos comprised a court measuring
about 160 × 120 m. enclosed by stoas giving a colonnade which was continuous except at the western
gateway.

OTHER PUBLIC BUILDINGS

There is no better way to appreciate the range and type of Greek civic architecture than to consider the
buildings in the market-place (Agora) at Athens in the Hellenistic period, for here there are traces of the very Fig. 81
first Greek buildings which were devoted to public administration, as well as fine examples of Hellenistic
civic architecture on the grand scale.

The open area lay beyond the lower slopes of the hills of the Acropolis and Areopagus, limited on the
west by the hill on which the Temple of Hephaistos stood. Diagonally across it ran the Panathenaic Way,
overlooked to the east by the stoa built for the Athenians by the Pergamene king, Attalus II, which has just 36
been described. The south side was also enclosed by a complex of stoas, including the Middle Stoa, which
faced both ways, and a separate colonnaded market area. Behind these were the state Mint and two of the

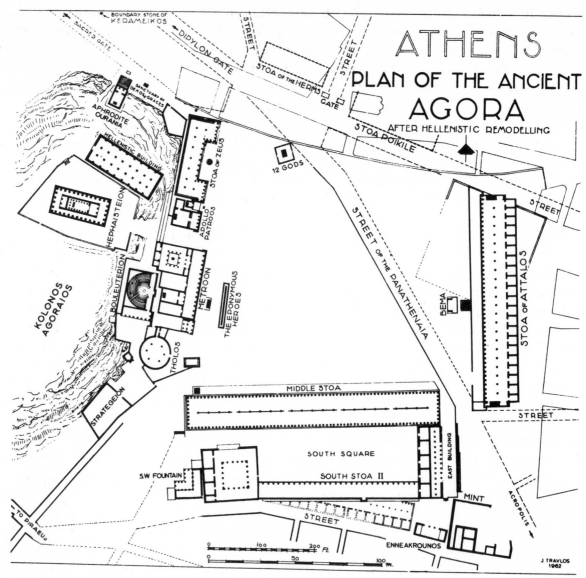

81 Plan of the Agora, Athens. Hellenistic period (after Travlos)

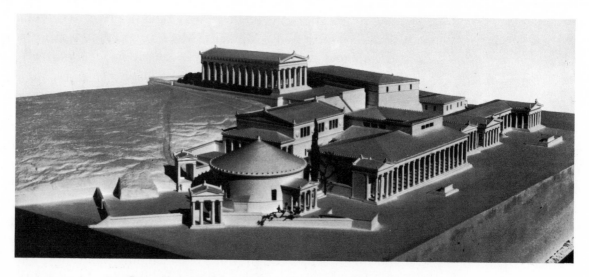

82 Restored model of the west side of the Agora, Athens, seen from the south

54

city fountain houses. One of these formed part of a sixth-century water system installed by the tyrant Peisistratos, the other is Classical. The former is rectangular in plan, the latter L-shaped, but both observe the usual principle in such buildings—a back wall pierced by lion-head spouts which pour into a raised basin to which access is gained through a front colonnade. We can get some idea of the complete buildings from sixth-century vase paintings which seem to commemorate the early installations, or on the earlier François *109* Vase. Later the fountain houses keep this general scheme but the architectural setting is more elaborate and there is sometimes a forecourt.

On the west side of the Agora the first building was the strange circular Tholos. This was built at the end *Fig. 82* of the fifth century, with a plain outer wall and six columns within. It served as a sort of club-house for city councillors, where there were always officials on duty and where, for instance, a set of the standard weights and measures was stored. A kitchen was attached. No comparable buildings have been found on other Greek sites.

Next door was the Council House (Bouleuterion). The older building here had a simple square plan for the Council of 500, with a chapel for the Mother of the Gods attached and a document store. Towards the end of the fifth century a new Council House was built behind it, cut into the hillside, while the old structure was converted, then rebuilt, as a state archive (the Metroön). The new Bouleuterion had semicircular tiers of seats, like a theatre. Rather similar buildings in other Greek cities serve the same purpose, and we find the same change from the simple rectangular building to the miniature theatre arrangement. The best known are in East Greece, at Priene, where the seats were laid out in straight rows on three sides (compare the *Fig. 83* Megalopolis Thersilion), or the larger building at Miletos with its half-circle of seats (for up to 1,500) and only four inner columns, looking out onto a colonnaded court (Doric) with an altar, and, beyond it, an ornamental gateway with Corinthian columns. At Olympia there was an odd complex consisting of two apsidal buildings (one of them Archaic) set parallel and each with central rows of columns, eventually linked with a long common porch of Ionic columns.

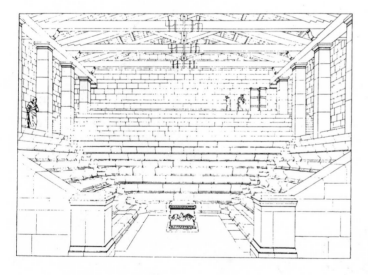

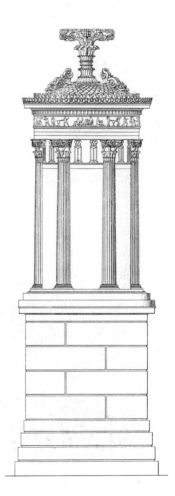

83 The Bouleuterion at Priene. 4th century B.C. (after Krischen)

84 The Lysikrates monument, Athens. Late 4th century B.C. (after Bühlmann)

55

Returning to the west side of the Athenian Agora we pass a small fourth-century Temple of Apollo Patroös, and come to the Stoa of Zeus. This had the usual stoa form, without rear rooms, but with the two wings projecting slightly forward. This was a fifth-century building; its outer order was Doric, the inner Ionic. The wings gave it a façade with two pediments and so it could carry the sort of sculptural elaboration —here acroteria—missing on the usual straight-roofed stoas. It was, after all, an uncommon building, being both sacred to a god and also fulfilling the function of an important civic office where one of the Athenian law courts met.

The plan of this sequence of civic buildings and stoas in Athens was determined by the earlier history of the area and the placing of the fewer and simpler structures which served the early state and market. In the new cities of East Greece of the fourth century and Hellenistic period the planning of the big rectangular markets was more methodical, but lacked the variety and careful balance of styles which must have characterized the market-place of Greece's first city.

A very few other, rather unusual structures may be mentioned here. The most famous is the third-century Lighthouse of Alexandria, known to us only from descriptions in ancient authors and a few very small and equivocal representations. It seems to have risen from a square base, to an octagonal tower, capped by a cylindrical top where the light was kept. It was said to stand over 100 m. high. Some monuments, commemorating private or public successes, are also given a monumental architectural form. In the Archaic *119* period statues may be set on columns (like the Naxian Sphinx at Delphi and many of the Acropolis statues), and later single- or two-column monuments are found. The tripods won in dramatic or choral contests were *Fig. 84* displayed in Athens along a street near the theatre. Lysikrates won a victory in 334 B.C. and the monument he erected to support his prize tripod is one of the best preserved and most admired in the city. It takes the form of a slim circular building with engaged Corinthian columns of an early type, appearing for the first time here on the exterior of a building. The canonic entablature has a carved relief frieze. The conical marble roof is cut in one piece, and is crowned by a rich floral which carried the tripod.

TOMBS

46 below In the Archaic and Classical periods gravestones bore architectural mouldings and finials, as we have seen, and there were in Athens some low built tombs of brick. Only on the fringes of the Greek world do we find elaborate built tombs—in Lycia in south-west Asia Minor. There the eastern practice of building house-like tombs was current, but although several of the tombs are decorated with reliefs carved by Greek artists, they offer little in the way of architectural elaboration. Others, however, seem to copy faithfully local types of structure in wood, and this sort of tomb continued to be made for a long time locally. At the end of the fifth century the tomb known as the Nereid Monument (at Xanthos in Lycia) took the form of a small Ionic peristyle temple, with elaborate sculptured decoration and capitals copying the Erechtheion. Many sarcophagi *51 above* (coffins) of the Classical and Hellenistic period (with an occasional Archaic example, as on Samos) are in form no less than miniature temples, with or without *51 below* the peristyle columns engaged in the walls. The best examples are again from the Greek east, notably the royal cemetery at Sidon.

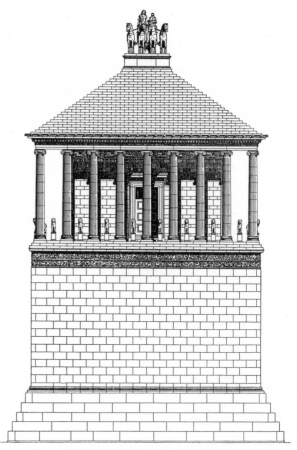

85 Conjectural restoration of the Tomb of Maussollos at Halikarnassos. Mid 4th century B.C. (after Krischen)

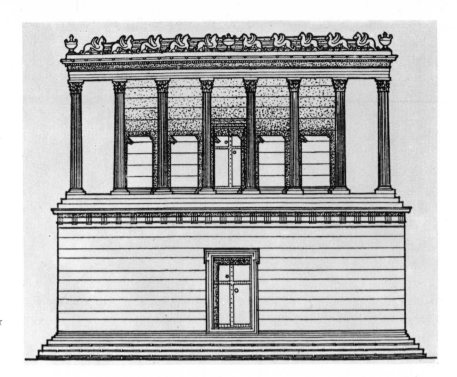

86 Restoration of the tomb at Belevi, near Smyrna. 3rd century B.C. (after Keil)

A different eastern tomb type, rock-cut with an architectural façade, was to be found in Asia Minor in Phrygia in the Archaic period, and was introduced to the Greek colony in Kyrene (North Africa), possibly through contact with the Persian invaders.

Truly monumental tomb buildings suited the eastern despot, and when he was regularly served by Greek artists we find the only examples of this type of building executed in the usual Greek idiom. King Maussollos of Halikarnassos was building himself the first of all 'mausolea' when he died in 353 B.C. and his widow completed the building. It stood on a high base, and apparently took the form of an Ionic colonnaded *Fig. 85* building having a massive pyramidal roof with a chariot group on top. We know more about its sculptural decoration than its architecture. The Lion Tomb was a similar, but earlier and simpler structure near by, with engaged Doric columns around the tomb chambers, and a lion on the pyramidal roof. The type recurs in the Greek east near Smyrna in the elaborate third-century tomb at Belevi, at Mylasa (with Corinthian *Fig. 86* columns) and in Syria.

The idea of covering a built tomb chamber with a mound of earth (tumulus) was common in Asia Minor and is met in varying forms in Greece itself. The type assumes a monumental form in North Greece in the later Hellenistic period, when the chamber is often vaulted and provided with a four-column façade, generally Doric. The elaborate painting of these buried façades has sometimes been found well preserved.

HOUSES AND PALACES

The primitive megaron type of Greek house has already been described in tracing the origins of the Greek temple plan. It was not the only type of house in Archaic Greece, and there were many simpler structures. Two basic house types are found in a seventh-century village at Emporio in Chios. One is a megaron, with *Fig. 87* interior hearth and a central row of two columns; the other is a simple square structure with four inner columns and a sleeping platform at the back. These would have had flat mud roofs. They are built in a village on a steep hillside, and overlook one of the lateral roads. This sort of village architecture in early

87 House plans at Emporio in Chios. 7th century B.C. (Boardman)

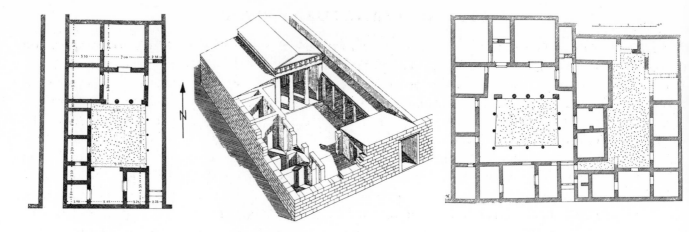

88, 89 House plan and restoration, Priene. 4th century B.C. (after Wiegand and Schrader)

Greece must have given much the impression that we get today from the smaller villages in the Greek islands—irregular plans, flat roofs, stepped streets. Before the megaron was an open area, reached by steps from the road. This court before the house is a basic feature of such a complex, and it remains a feature of Greek house design whether the building is isolated (like the fifth-century Dema farmhouse in Attica) or one of several in a city block. The one-room megaron is replaced by series of rooms around a courtyard, but the general principle is still observed of having the main rooms face south, through a colonnade (the pastas, corresponding to the megaron porch) across the court. Fourth-century houses of this sort are seen at Olynthus. Later, the main room may be given more prominence and we find something which seems *Fig. 88, 89* almost to return to the megaron form, as at Priene. On Delos the court is often given a colonnade on all *Fig. 90, 91; 56* four sides, foreshadowing the Roman house. The court floor may be covered with mosaics, and conceal a cistern. The north side of the house, where the main room stood, was often built on two floors, giving a balcony overlooking the court. These are luxury houses and the peristyle courts in particular gave opportunities for architectural elaboration, although the exteriors remained plain and there was generally no attempt to design imposing house façades.

There was no place for palaces in Archaic or Classical Greek society, so there were no structures in which provision is made for both the high life of a ruler, and the stores and administration which he had to keep within his purview. The Hellenistic princes had grander notions, fostered by the example of the Persian courts which Alexander had overthrown. Even so their palaces are no more than large versions of the usual house plan, and only with the Romans do we find palace complexes properly planned to accommodate court, offices, guard and administration, in a setting suitable to the dignity of a king or emperor.

90 Plan of the Maison des Dauphins, Delos

91 Reconstruction of the Maison des Comédiens, Delos (after Fister)

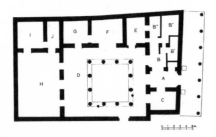

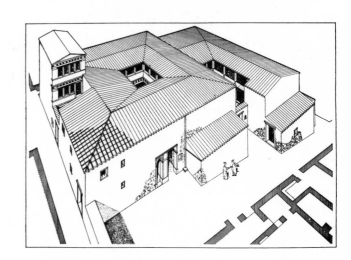

Most city plans in old Greece just grew, encompassing the basic elements of a fortified core or acropolis and an open agora or market and meeting-place, a primary consideration being defence. It required an overwhelming disaster, a completely new site, or the sort of centralized authority better realized under a despot than a democracy, to effect any radical planning. If seventh-century Smyrna does seem to have had its streets *Fig. 92* laid out in a sort of grid, this argues that opportunities could be taken well even at this early date. The prerequisite fulfilled here was a devastating earthquake.

Hippodamos of Miletos, a fifth-century architect, saw the advantages of a grid plan for a city with blocks of regular size for houses, and numbers of blocks combined to give areas for larger complexes like markets. Ease of communication within the city was probably not a serious problem, but the most effective use of space within a city's walls certainly was, and this was a time in which many cities were overflowing into large extra-mural suburbs. Hippodamos helped lay out a new plan for the port of Athens, Piraeus, and his plan for Miletos survives on the ground; but the real opportunities to enforce his system were only given in the new cities of the fourth century and Hellenistic period in East Greece. At Priene the grid is laid out *Fig. 93* with a sublime disregard for the contours and steep slope of the site, reminding one of nothing more than the siting of Roman roads.

Even less tractable sites, like the mountain-top acropolis of Pergamon, gave magnificent opportunities for *54 above* what might almost be termed scenic architecture. Here successive terraces rose to the crown of the hill; markets below, then the Great Altar, and the Temple of Athena, crowned by palaces, and all embracing the steep theatre cut in the hillside, where 10,000 could sit together. *34*

Sanctuary plans were determined by the position of the original shrine and altar and, usually, the approach to them which was treated as a sacred way. Alongside this—a steep zigzag path at Delphi—the treasuries *38* and monuments would be set, or on a flatter site like Olympia they would be disposed to overlook the *54 below* stadion or the approach to the temple, while subsidiary buildings could be laid out on the perimeter of the sacred area (temenos).

The Acropolis at Athens is a sanctuary site with a difference. At first it was simply the fortified heart of *Fig. 94; 39,* the city, but already in the sixth century it seems to have been given over wholly to the service of the city's *40, 53, 55* gods. The siting of buildings was largely determined by existing structures or traditionally sacred areas, even in the Periclean period, after the ravages of the Persian occupation. But when the temples were rebuilt, or new ones planned, they were placed with an eye to architectural harmony and contrast which makes of the

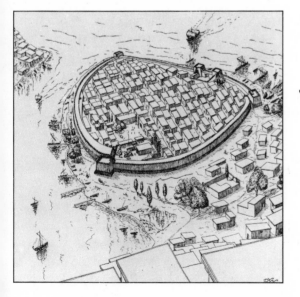

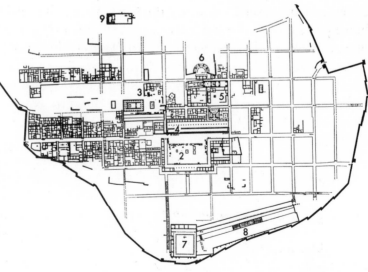

92 The city of Old Smyrna. Late 7th century B.C. (after Nicholls)

93 Plan of the city of Priene (after Wiegand and Schrader)

Acropolis a unique architectural experience. It is fitting that a chapter on Greek architecture should end with a description of a complex whose individual buildings have already been studied one by one for their peculiar merits.

The main approach to the Acropolis rock was up a steep zigzag path from the west. In keeping with the *40, 55* deliberately spectacular character of the Periclean architecture of Athens, the entrance way (Propylaea) was elaborated into a monumental structure far more imposing then the simple two-way porch with two pairs of columns in antis which served as propylon elsewhere, and which had served the Acropolis itself in the sixth century. The visitor was faced by a towering Doric façade and pediment, with a projecting wing to

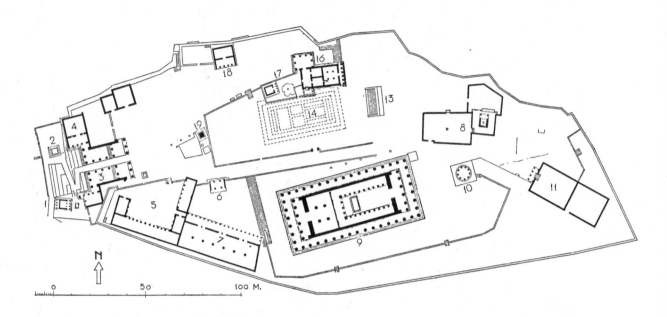

94 Plan of the Acropolis, Athens. 1 Temple of Athena Nike; 2 Monument of Agrippa; 3, 4 Propylaea and Picture Gallery; 5 Sanctuary of Artemis Brauronia; 6 Propylon; 7 Chalkotheke; 8 Sanctuary of Zeus Polieus; 9 Parthenon; 10 Temple of Roma; 11 Heroön of Pandion; 13 Altar of Athena; 14 Old Athena Temple; 16 Erechtheion; 17 Pandroseion; 18 House of the Arrephoroi

the left, which housed a picture gallery. The wing on the right was truncated since here there projected the bastion which carried—and had to carry, for this was her home—the Temple of Athena Nike. Behind this *53* wing a stretch of the massive Mycenaean fortification wall, the handiwork of giants, remained visible.

The passage through the Propylaea rose to another Doric façade and pediment facing the interior, but on *40 above* a higher level than the front. The change in level was effected by steps through the doors at colonnade level, and by flanking the central ramp with Ionic columns which, while matching the girth of the Doric columns, could with their greater relative slimness compass the height between the bases of the outer columns, and the capitals of the inner.

Within the Propylaea the first full view of the Parthenon was denied until the visitor either passed through a gateway into a court before its west end, an area where there were other, minor sanctuaries, or walked on beside the north flank of the building, along the path taken by the Panathenaic processions. From here *206–209* he could look up through the columns to the frieze commemorating the procession itself. On the left stood the Erechtheion, an Ionic counterpoint to the massive Doric of the Parthenon, the maidens of its Caryatid porch linking, by their gaze, the dual aspect of the city goddess—worshipped as warrior protectress in the Erechtheion, admired in Pheidias's gold and ivory in the Parthenon, a manifestation of the city's greatness and pride.

60

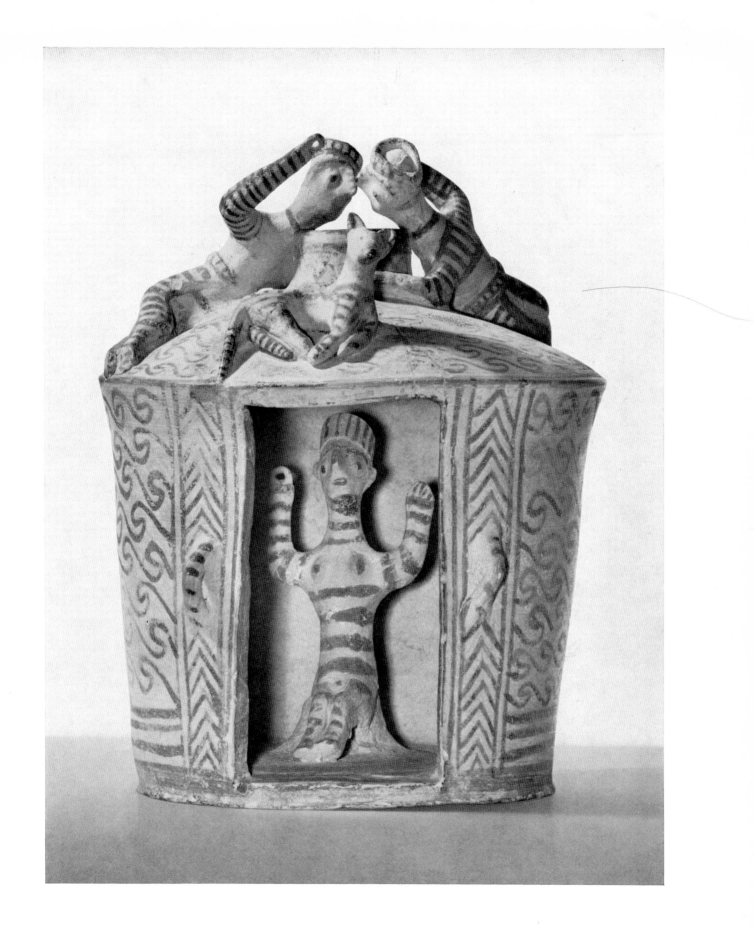

1 Clay model of a shrine from Archanes. Ca. 800 B. C. Heraklion/Crete

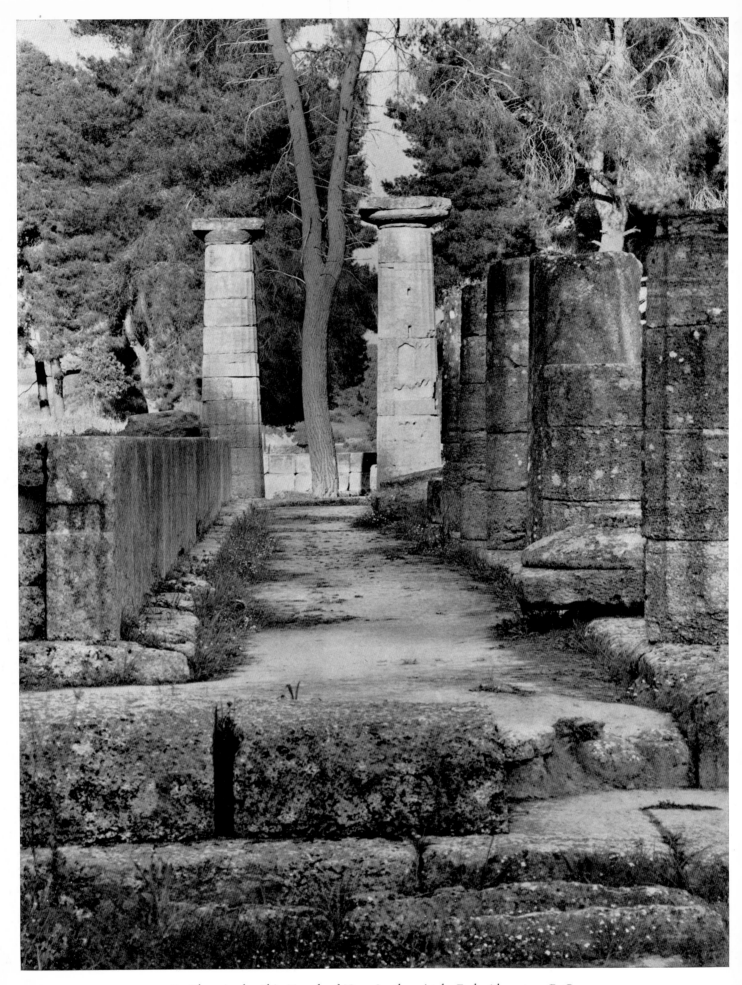

2 Olympia, the Altis. Temple of Hera. South peristyle. Early 6th century B. C.

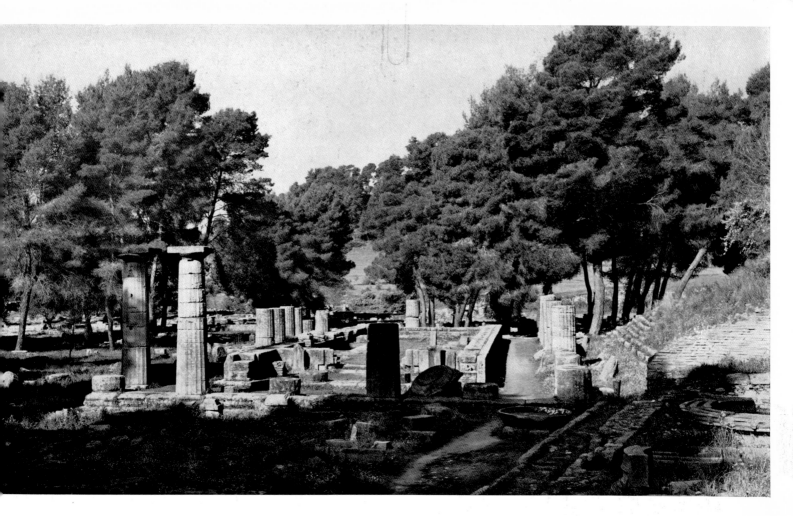

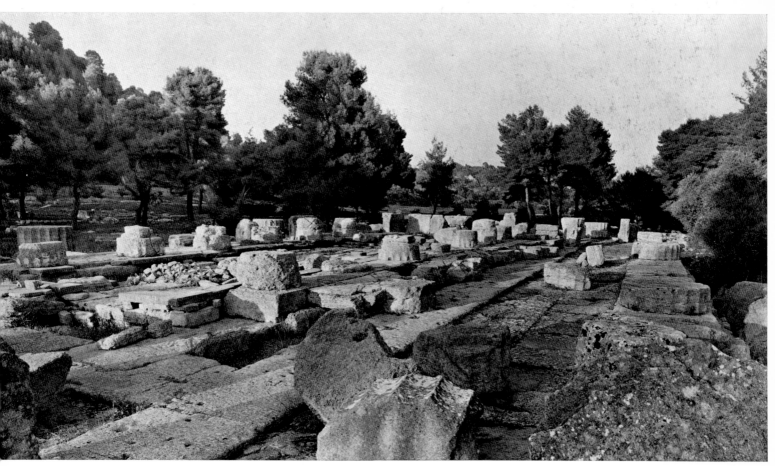

3 Above: Olympia, the Altis. Temple of Hera. View from the east.
Below: Olympia, the Altis. Temple of Zeus. View from the south-east.
Second quarter of 5th century B. C.

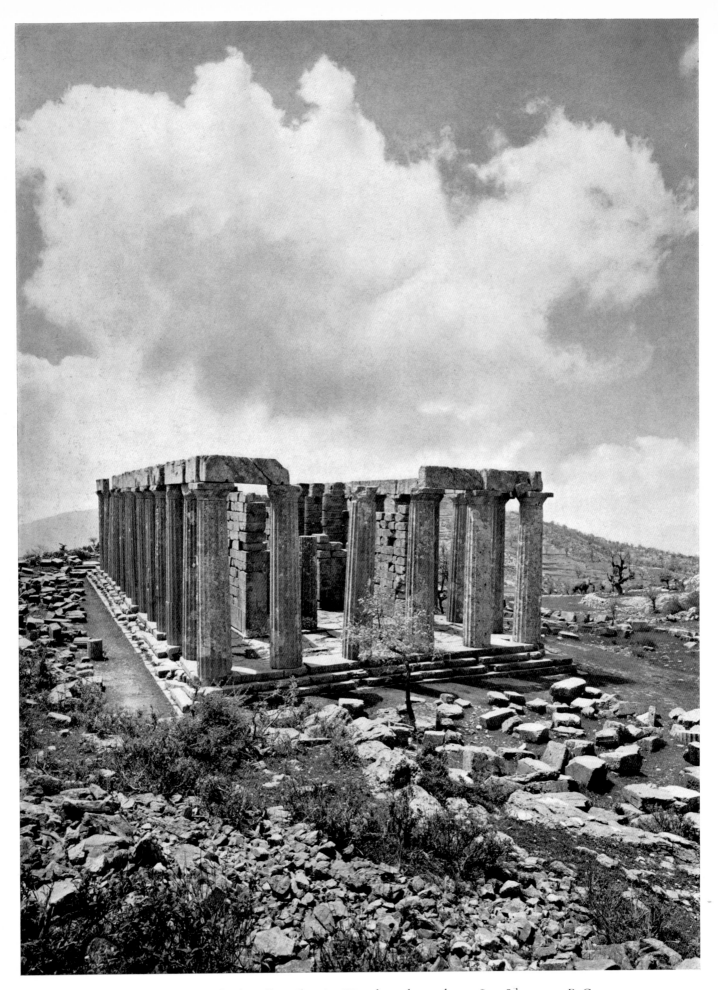

4 Bassai, the Temple of Apollo Epikourios. View from the north-east. Late 5th century B. C.

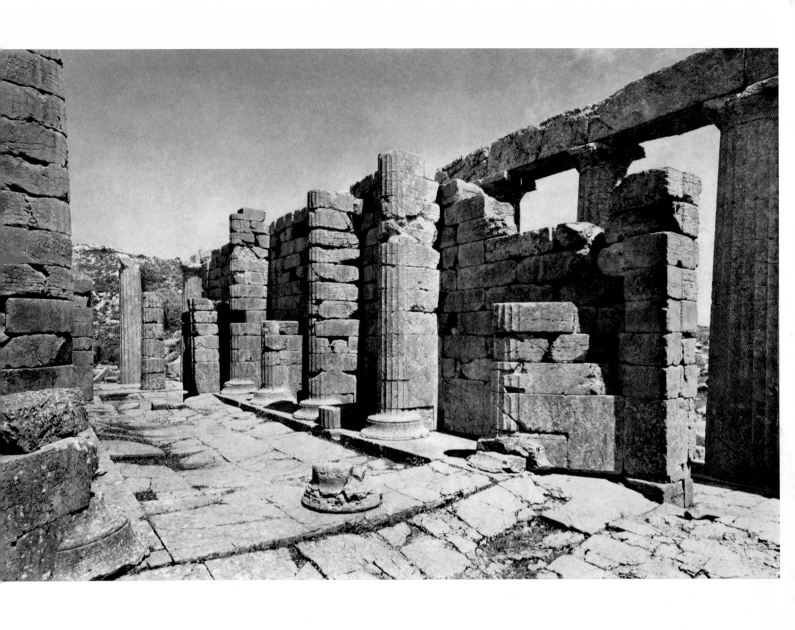

5 Bassai, the Temple of Apollo Epikourios. The cella from the south

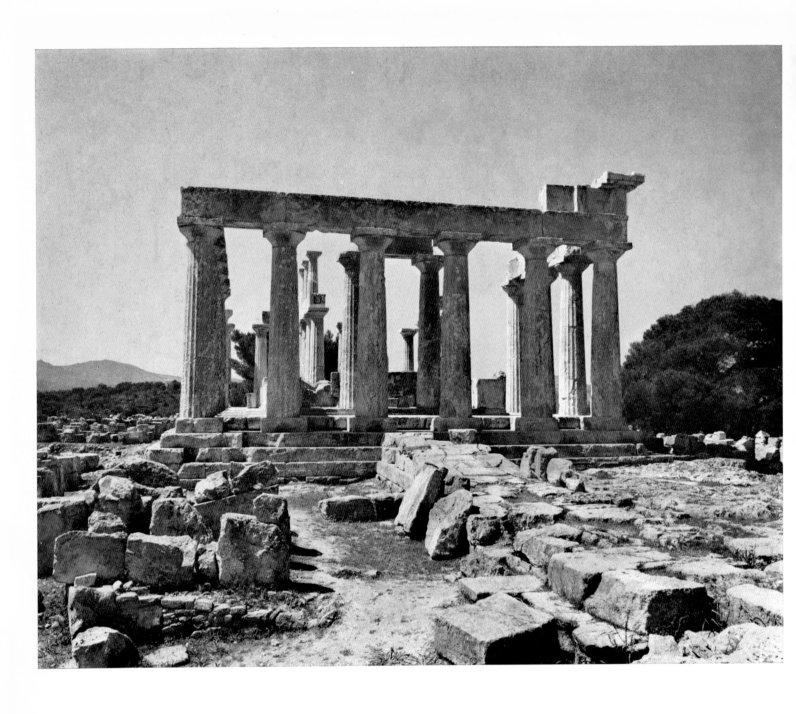

6 Aegina, the Temple of Aphaia. View from the east. Early 5th century B. C.

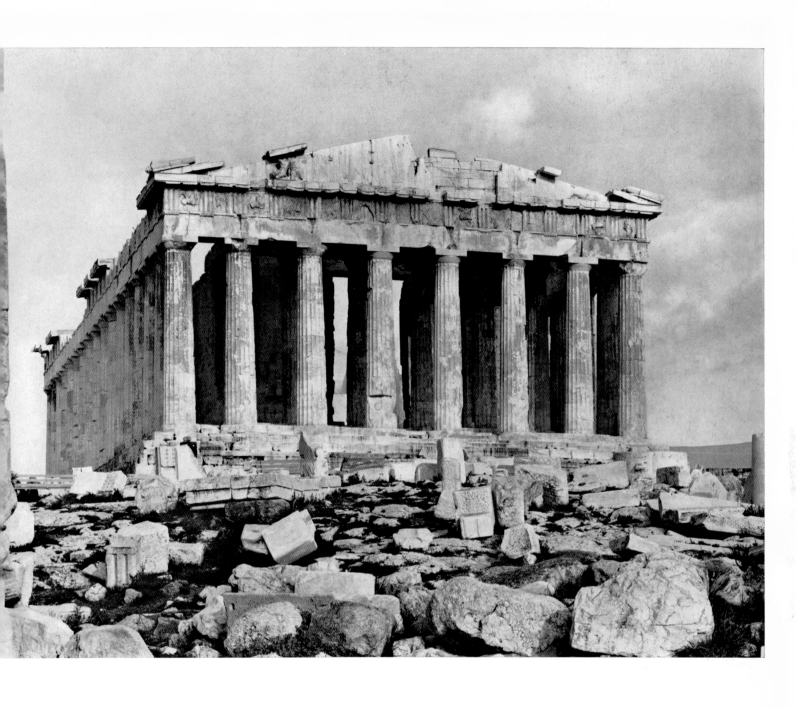

7 Athens, Acropolis. The Parthenon. View from the north-west. Third quarter of 5th century B. C.

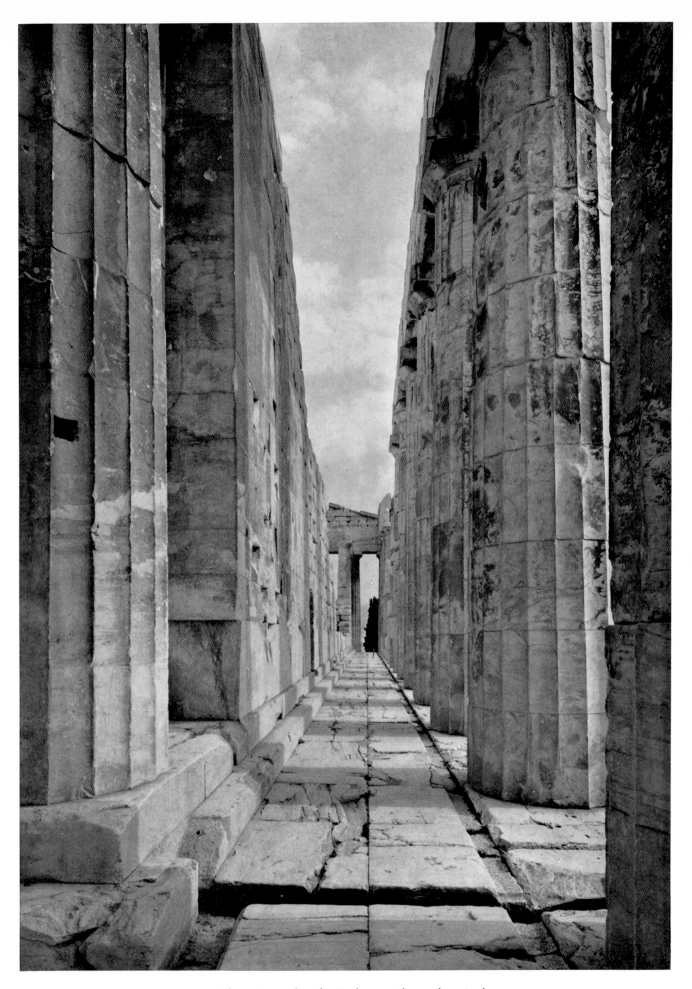

8 Athens, Acropolis. The Parthenon. The south peristyle

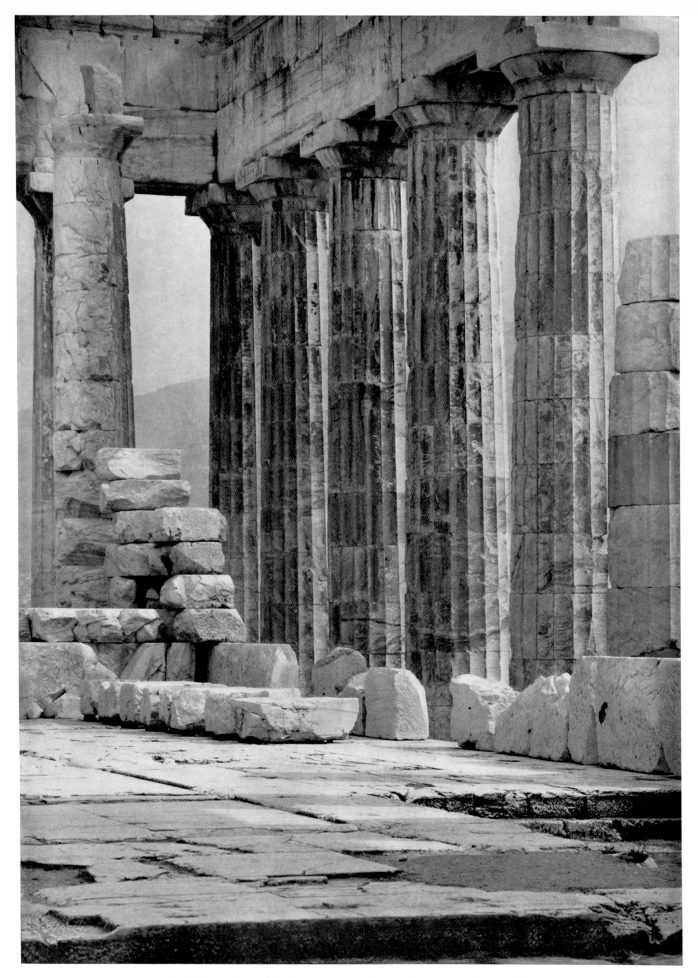

9 Athens, Acropolis. The Parthenon. The south-east corner from within

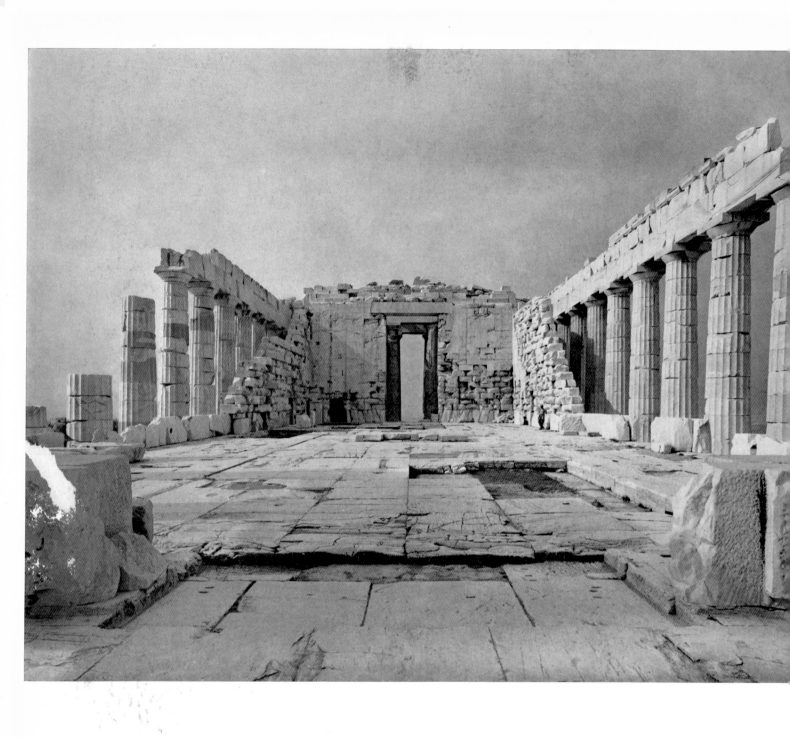

10 Athens, Acropolis. The Parthenon. The interior from the east door

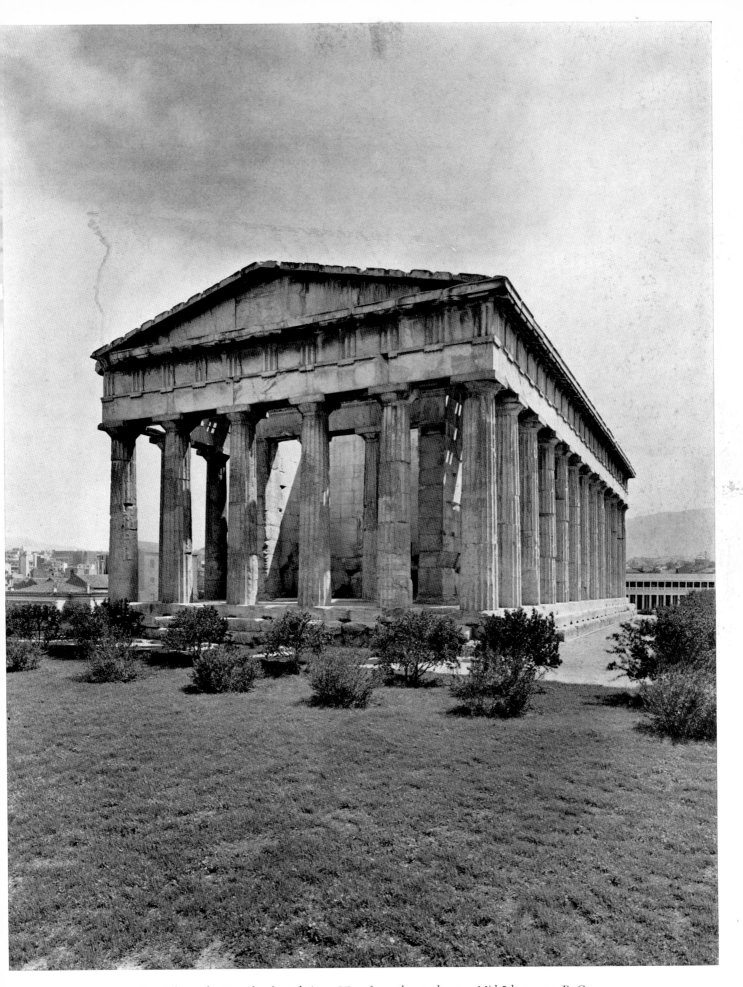

11　Athens, the Temple of Hephaistos. View from the south-west. Mid 5th century B. C.

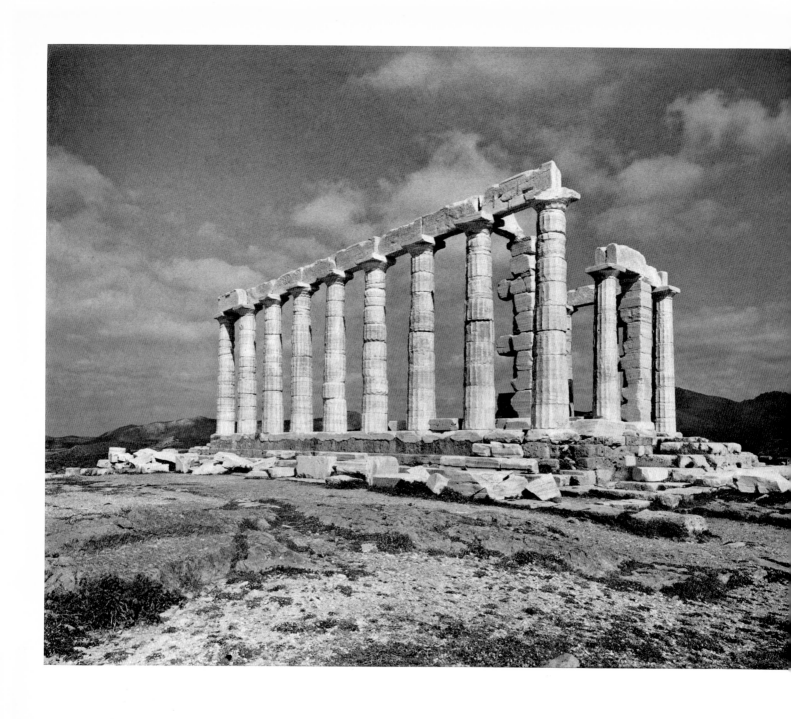

12 Sounion, the Temple of Poseidon. View from the south-east. Mid 5th century B. C.

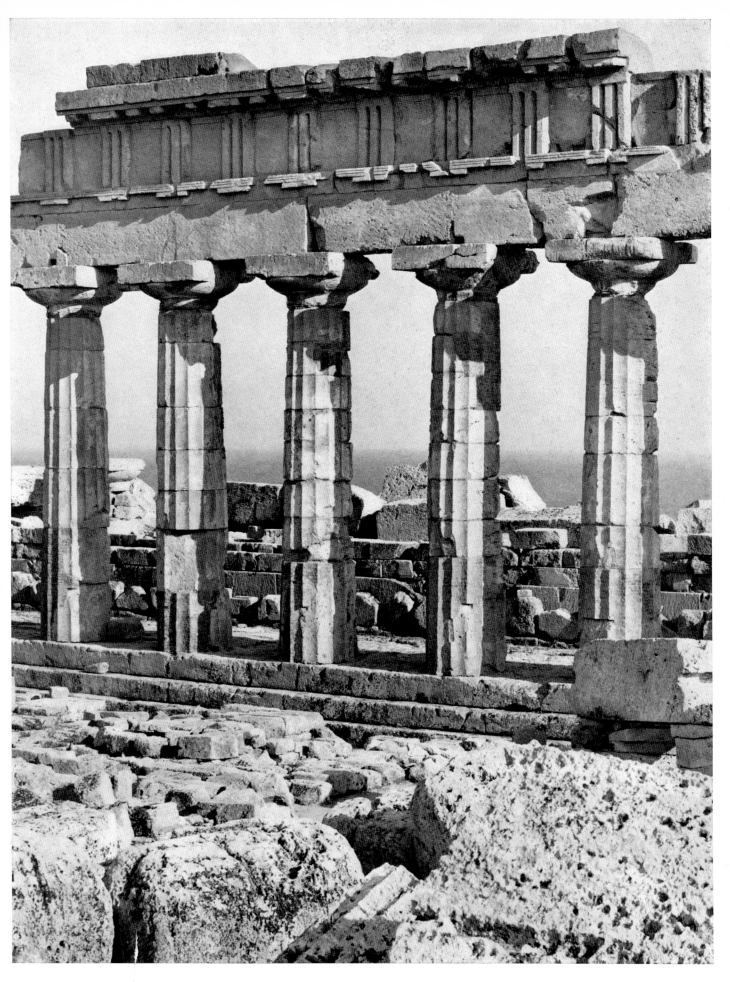

13　Selinus, Acropolis. Temple C. Part of the north colonnade. Seen from the north

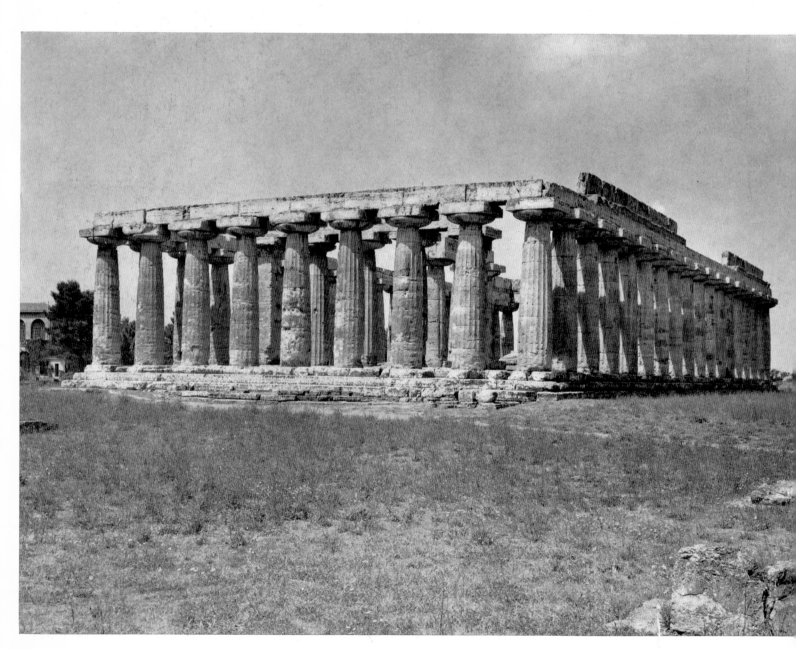

14 Paestum, the Temple of Hera I, so-called Basilica. View from the north-east. Mid 6th century B. C.

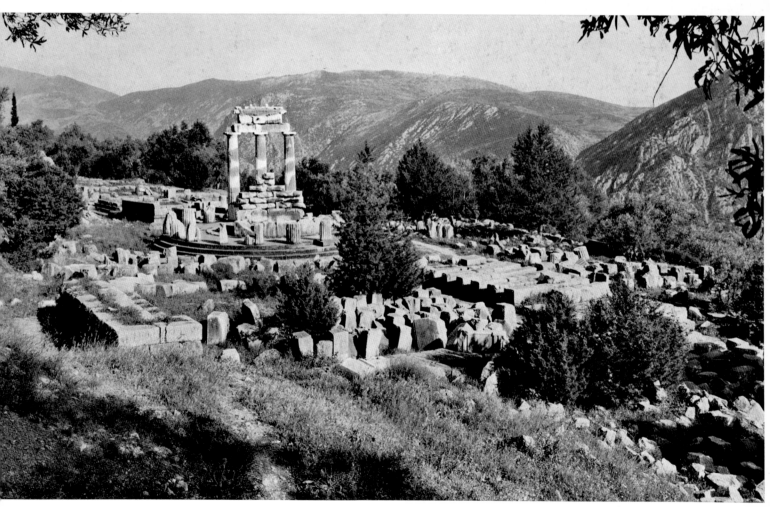

29 Above: Eleusis, Telesterion. View from south-west.
Below: Delphi, Marmaria. General view with the Tholos. 4th century B. C.

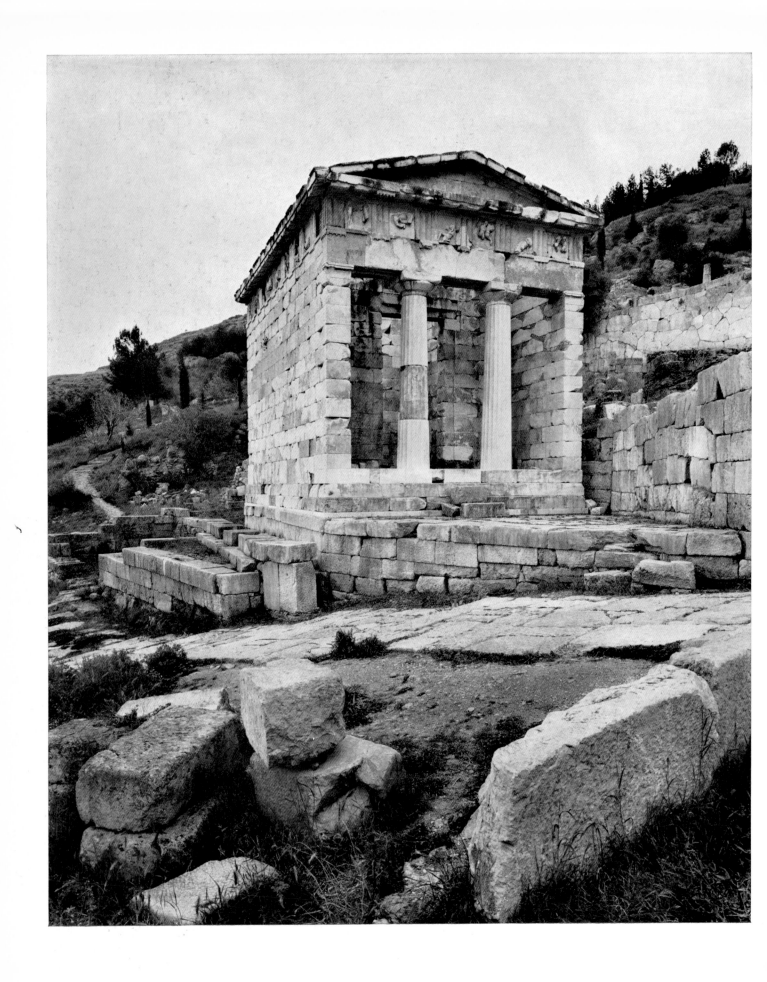

30 Delphi, the Athenian Treasury. Late 6th century B. C.

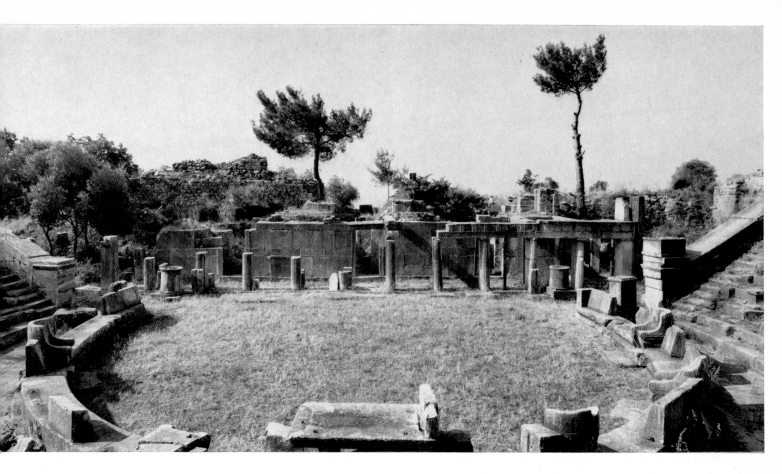

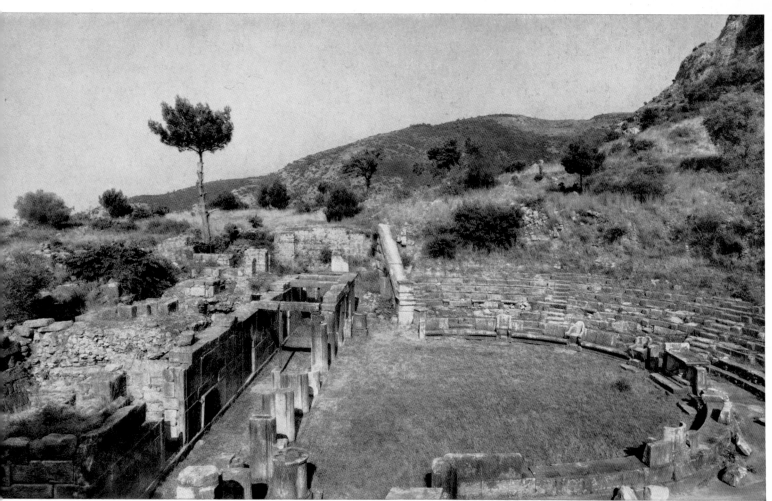

31 Priene, the Theatre

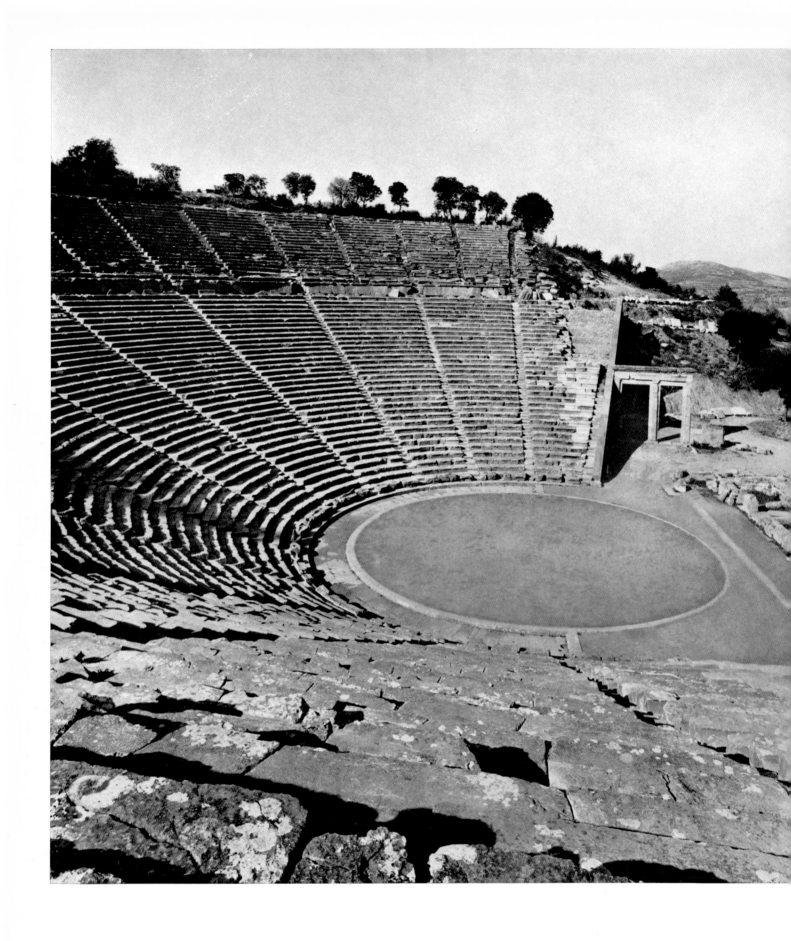

32 Epidauros, the Theatre. Mid 4th century B. C.

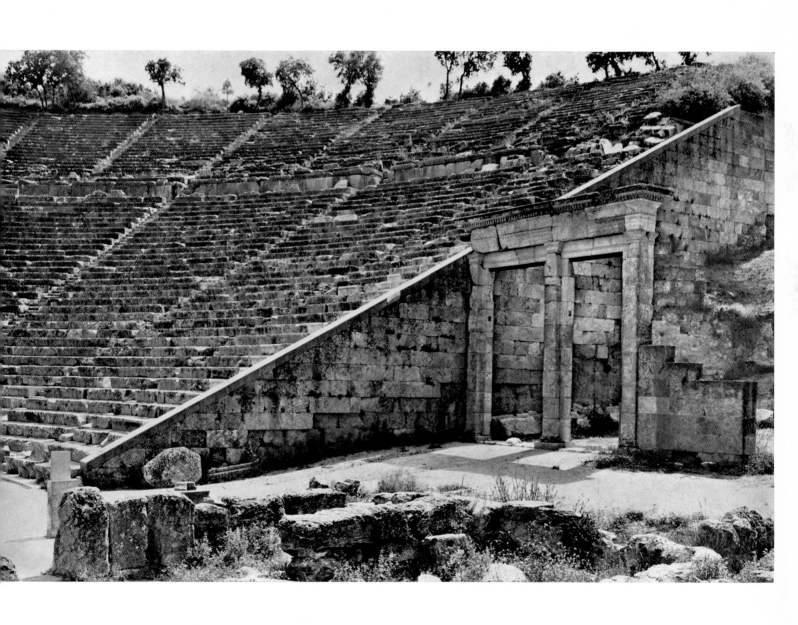

33 Epidauros, the Theatre

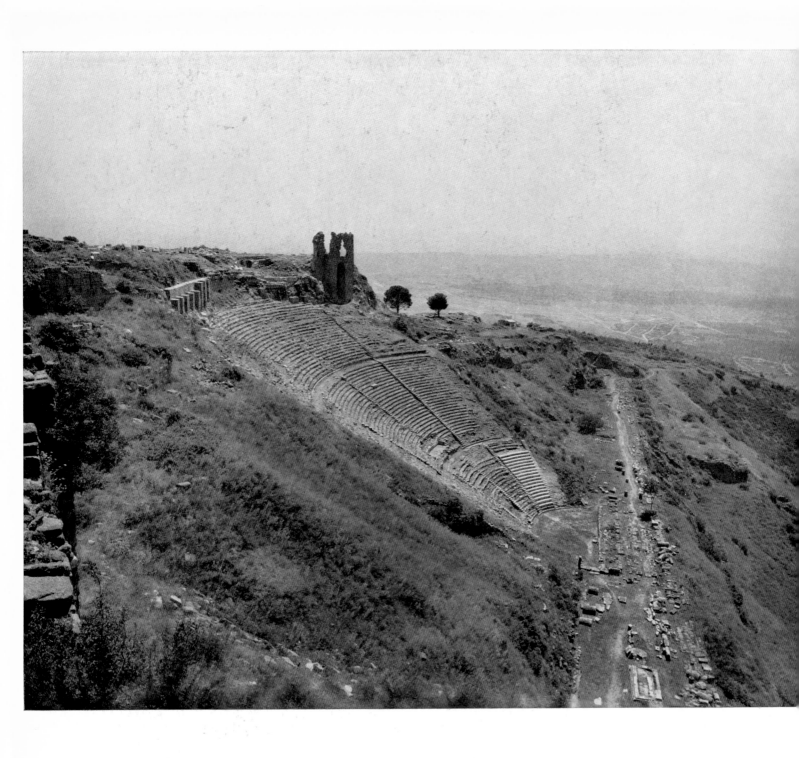

34 Pergamon, the Theatre

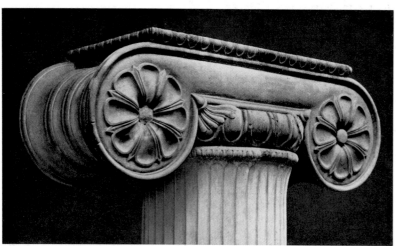
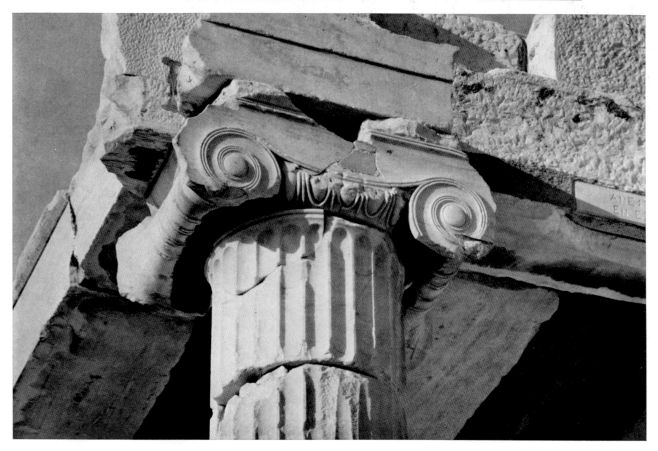

43 Above: Anta capital from Didyma. Berlin Museum. Mid 5th century B.C.
Centre: Ionic capital from Ephesos, restored. British Museum. Mid 6th century B.C.
Below: Ionic capital from the Propylaea, Athens. Ca. 435 B.C.

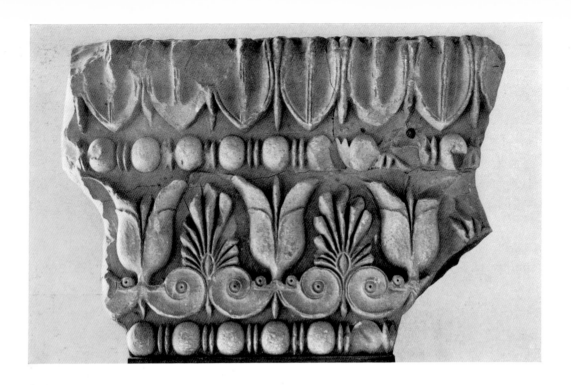

44 Delphi. Above: Moulding from a Treasury. Late 6th century B.C.
Below: The underside of the cornice of the Siphnian Treasury. Ca. 525 B.C.

45 Above: Sima and lion-head spout from the Heraion near Argos. 4th century B.C.
Centre: Ovolo moulding with a floral, built into a church near Emporio in Chios. Mid 5th century B.C.
Below: Ceiling coffers from the Tholos, Epidauros. 4th century B.C.

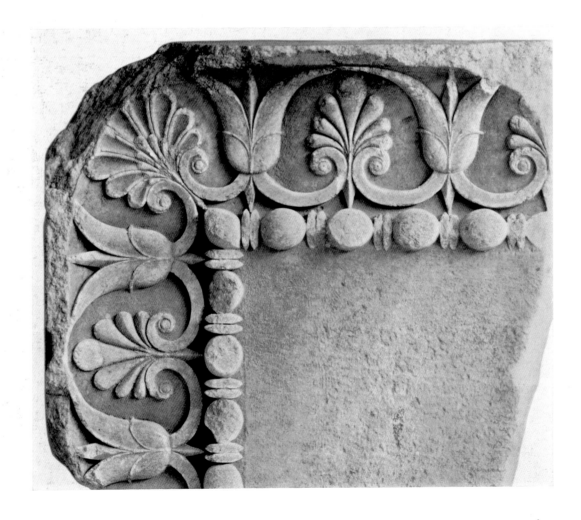

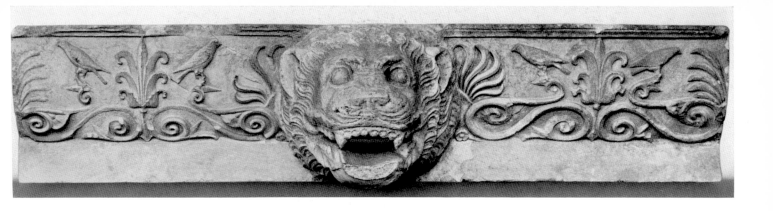

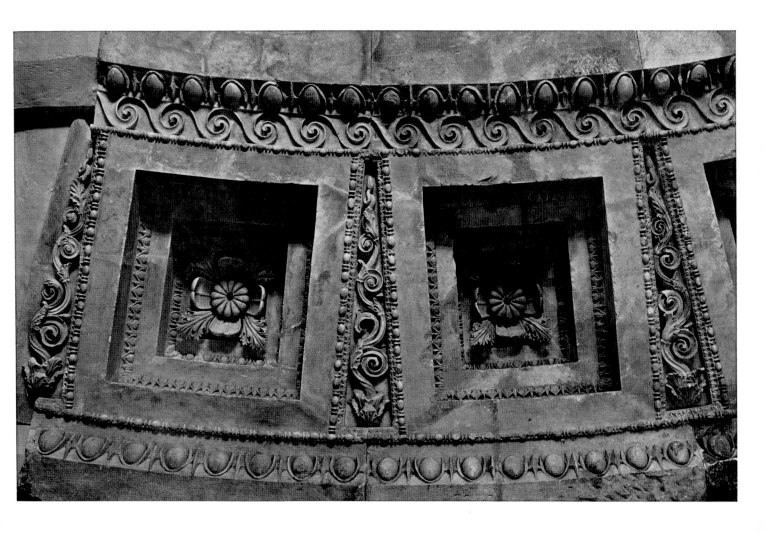

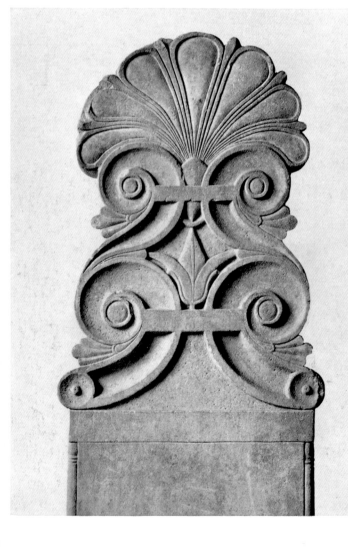

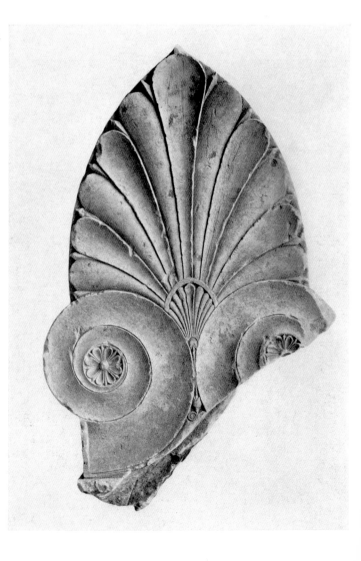

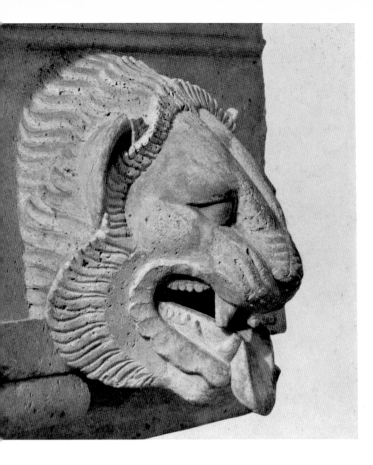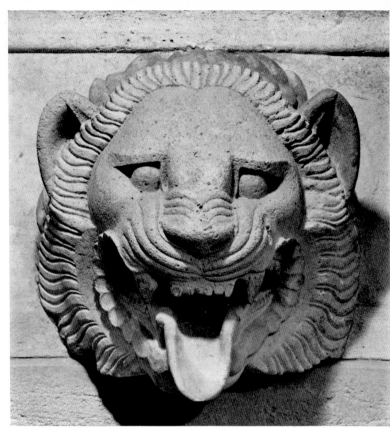

46 Above: Clay antefix; a satyr's head, from Gela in Sicily. Early 5th century B.C.
Below, left: Finial from a gravestone, from the Troad. Boston Museum of Fine Art. Late 6th century B.C.
Below, right: Finial from a gravestone, from Samos. Mid 6th century B.C.

47 Lion-head spouts. Above: From Himera, in Sicily. Ca. 475 B.C.
Below: From Akragas, in Sicily. Mid 5th century B.C.

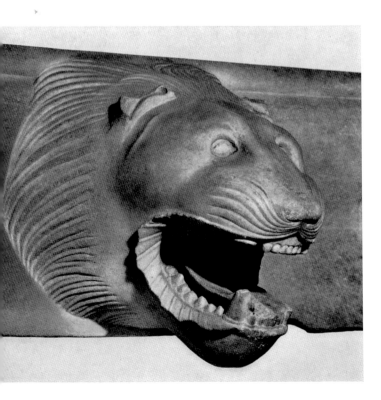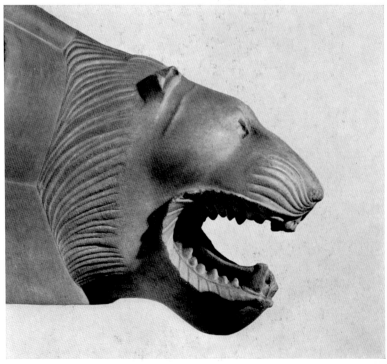

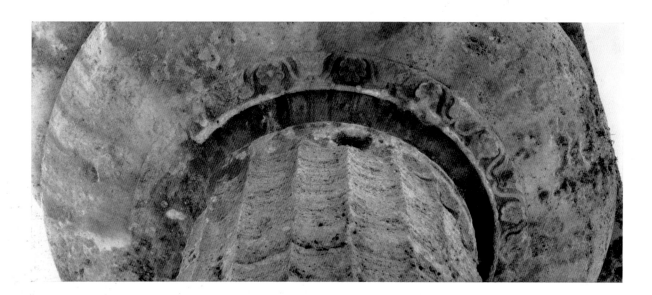

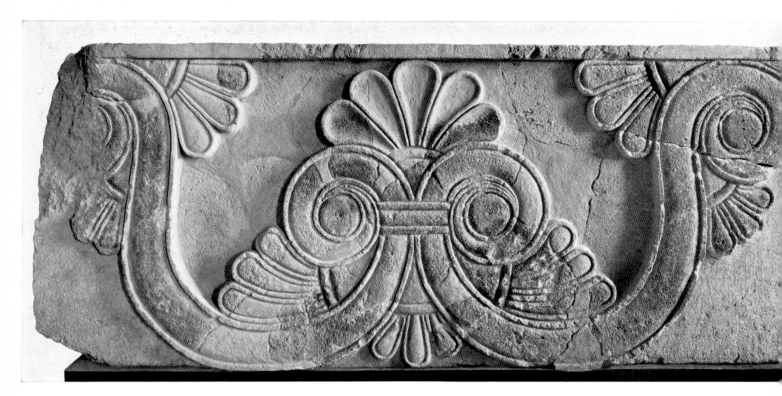

48 Above: Paestum, Temple of Hera I. Neckings of Doric columns. Mid 6th century B.C.
Below: Syracuse, Temple of Athena. Side parapet from the altar. Third quarter of 6th century B.C.

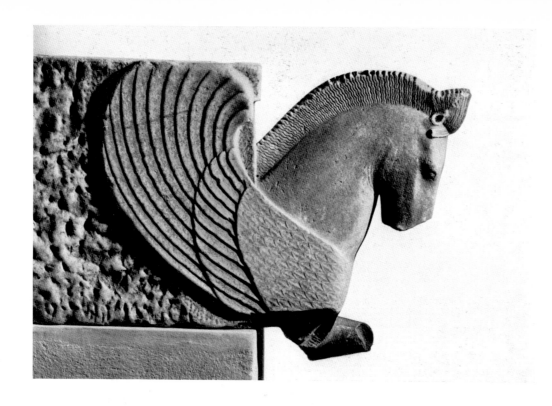

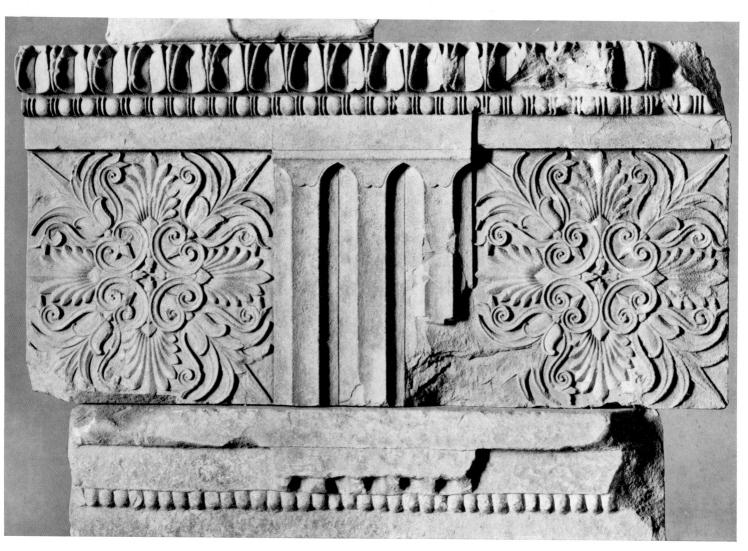

49 Above: Thasos. Capital in the form of a winged horse. Ca. 500 B.C.
Below: Megara Hyblaea, Sicily. Entablature from a small temple. Ca. 400 B.C.

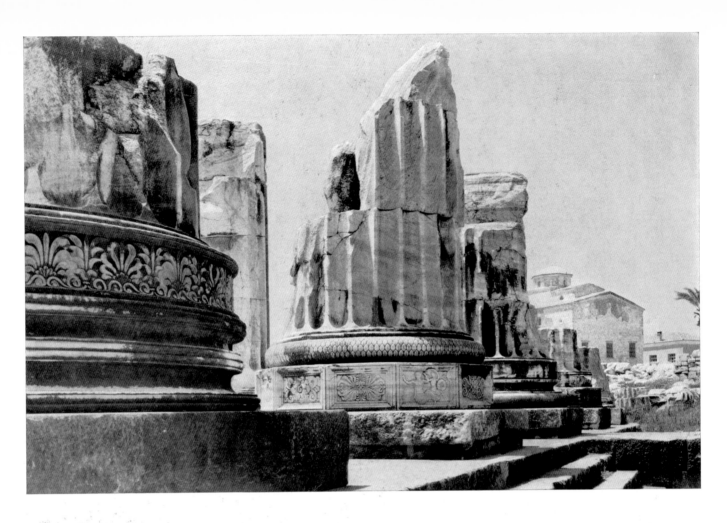

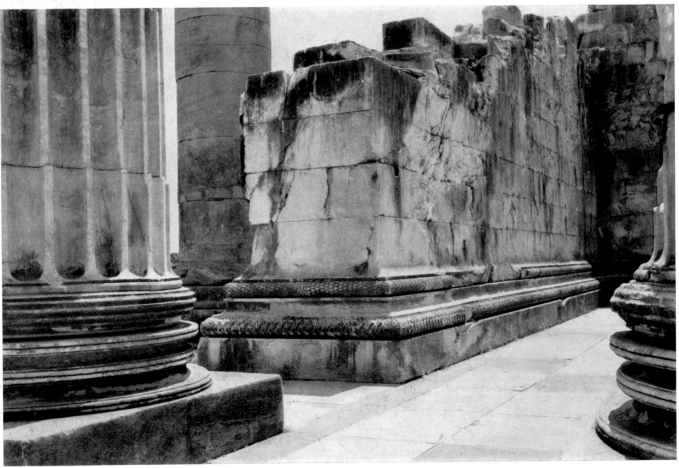

50 Didyma, Temple of Apollo. Column and wall bases. Late 4th century B.C. and later.

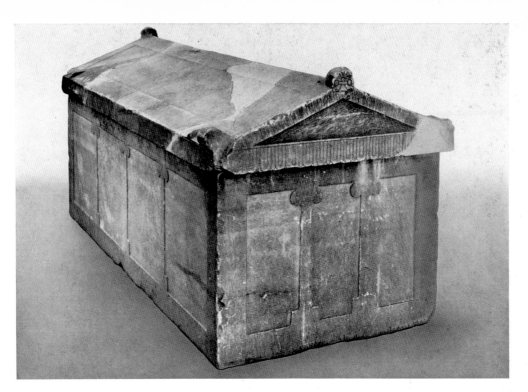

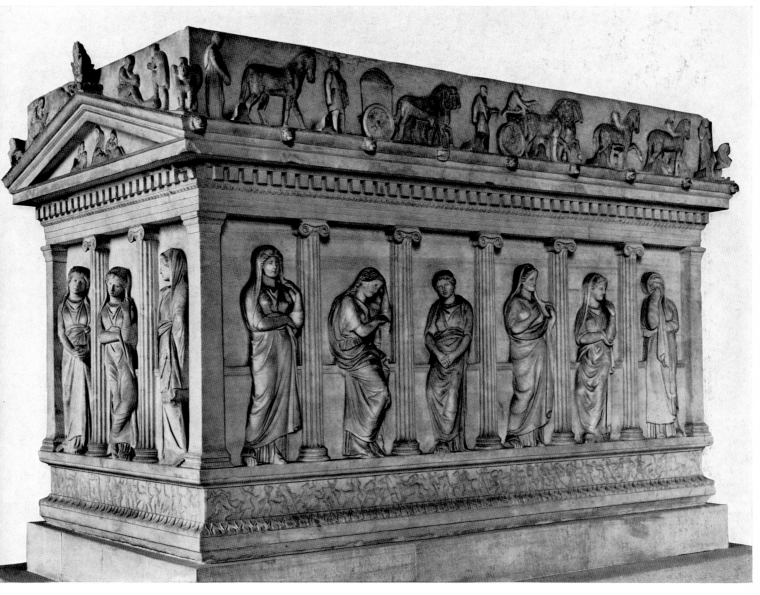

51 Above: Sarcophagus in the form of a primitive Ionic building, from Samos. Mid 6th century B.C.
Below: Sarcophagus of the Mourning Women, in the form of an Ionic building. From Sidon.
Istanbul Museum. Mid 4th century B.C.

52 Syracuse, Temple of Athena, now the Cathedral. The south peristyle. Ca. 480 B.C.

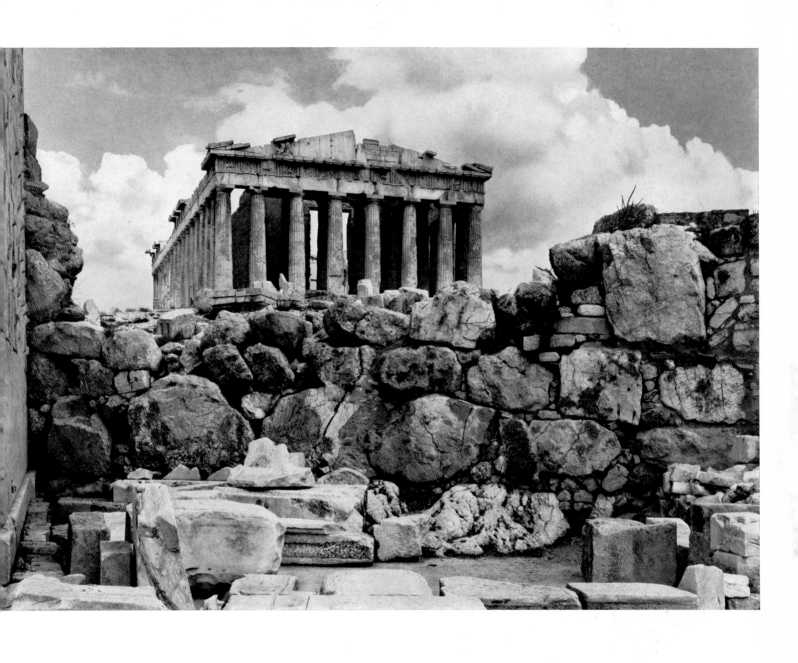

53 Athens, Acropolis. The Parthenon from the west, with the Mycenaean fortification wall in the foreground.

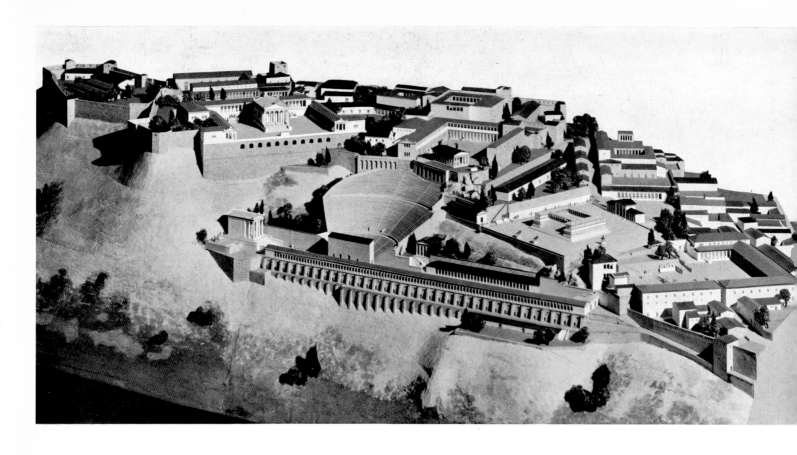

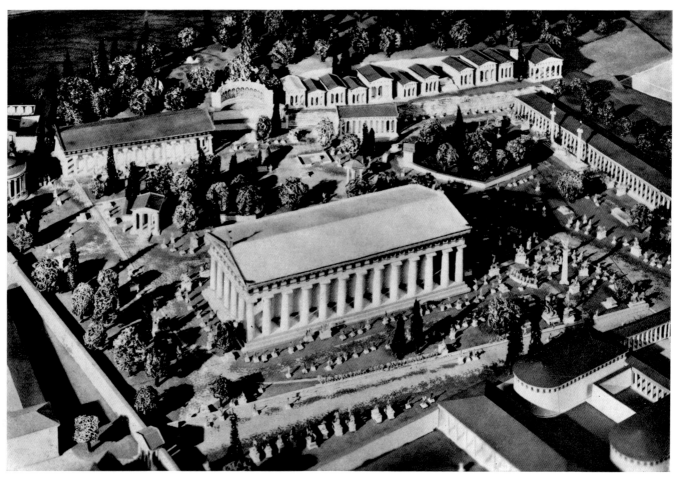

54 Above: Pergamon. Restored model of the acropolis. Berlin Museum.
Below: Olympia. Restored model of the sanctuary.

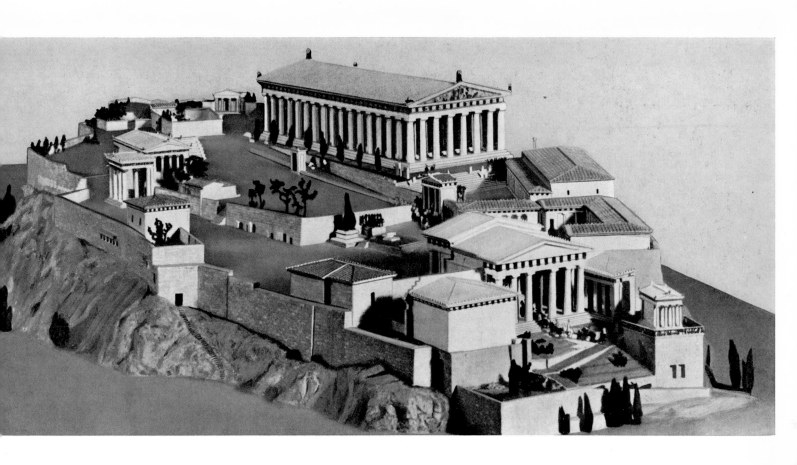

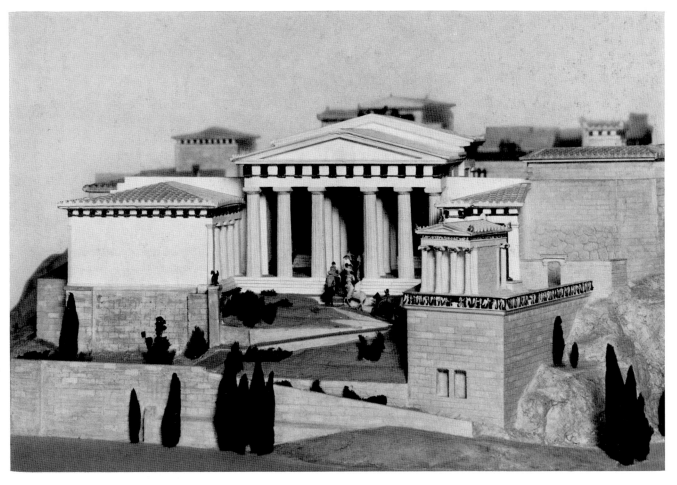

55 Athens, Acropolis. Restored model. Toronto Museum.

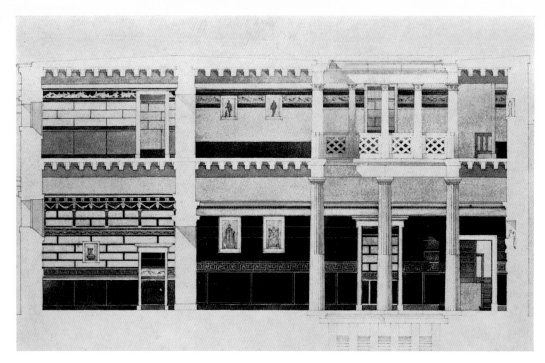

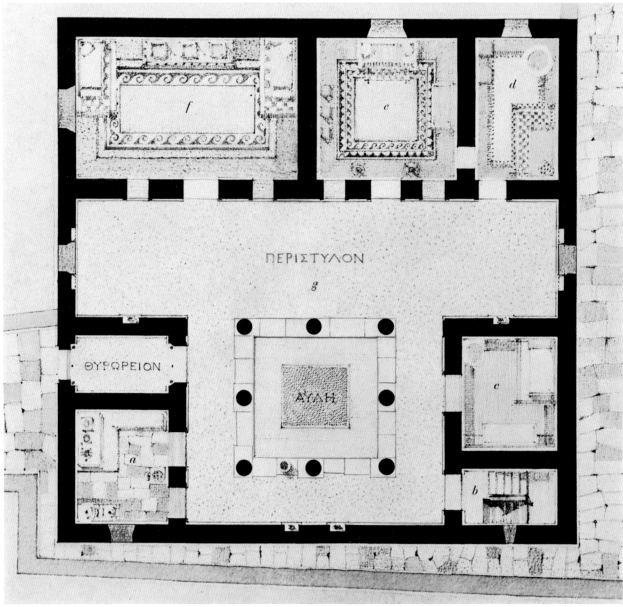

56 Delos, Maison de la Colline. Restored section and plan.

SCULPTURE, PAINTING
AND OTHER ARTS

GEOMETRIC ART · 1100–700 B.C.

There is evidence on the Greek mainland of settlements dating back to the New Stone Age, and finds in Boiotia, Phokis and Thessaly bear witness to advanced craftsmanship in the prehistoric era. The art of Crete, called Minoan after the mythical king Minos, is also pre-Greek. The style is characterized by its derivation from plant forms, and is well exemplified by the 'Kamares' vases of the second Middle Minoan period. Plants and swelling sinuous linear decoration cover the surface; the flow is unbroken and the structure of the composition is not emphasized. In the Late Minoan period this suppleness and the suggestion of movement in the composition become increasingly evident. The frescoes in the palaces depict lively scenes; cult dances surrounded by crowds of spectators, the bull game, processions, birds and apes in willowy thickets. On occasion ecstatic movement is matched by an uninhibited exaggeration of colour. The most frequent decorative motifs on the vases are sea molluscs, octopus, seaweed, nautilus, starfish and sea-snails. Minoan plastic art shows the same love of unrestricted movement and sinuous lithe forms.

This was the art encountered by the Greek tribes who, at the beginning of the second millennium B.C., conquered the mainland territories and laid the foundations of Mycenaean civilization. Little by little the inhabitants of the Peloponnese developed a native style based on their Cretan models. In their fortifications of heavy masonry (the so-called Cyclopean construction), the citadels at Mycenae and Tiryns and the Acropolis at Athens contrasted markedly with the palace complexes of Crete. The vaulted graves aim at monumentality, and in sculpture, too, one can see the rudiments of a monumental style. Frescoes and vase paintings express the main concerns of the conquerors—war and the chase. The Achaean kings put their prowess as warriors above all else and, in their arms and weapons, consciously distinguished themselves from the lithe and slender Cretan princes. The Cretans surrendered themselves wholeheartedly to the powers of nature; the people of the Helladic mainland actively sought to come to terms with their environment.

It has been suggested that the beginnings of Greek sculpture can be traced in the highly finished marble idols found in the Cycladic islands, where they were made, and other parts of the Eastern Mediterranean. However, these figures and groups are rarely life-size and still less often more than life-size, and no continuity can be established between them and the sculpture of the first millennium B.C. There is not even any formal relationship between them and Late Helladic sculpture. The giant relief on the famous Lion Gate at Mycenae is in a totally different style.

In fact it cannot be truly said that the creators of Mycenaean civilization practised any of the major later Greek arts although it is now known from archaeological research that they were a Greek people. The decipherment of Linear B by Ventris has proved that they spoke Greek, and in the Homeric poems the Achaean princes of these Helladic cities, Agamemnon, Menelaos and Nestor, are shown as the heroes of Greece. Thebes stands at the centre of the Theban cycle of sagas and Athens at the centre of the Theseus sagas.

A true, independent Greek spirit emerges in clear and unmistakable fashion only at the end of the second millennium B.C., after the end of the Minoan period and the decline of Mycenaean art. From about 1200 B.C. a new wave of invading tribes flooded into Greece from the North Balkans, established themselves in the Peloponnese and subjected or drove out the Achaean inhabitants. These invaders whom we know as Dorians, altered the structure of the whole Greek world as far as Asia Minor. The epics of the conquest and destruction of Troy mirror these historical events. With this regrouping of peoples came also the key moment in the birth of Greek art. Yet the Dorian conquerors did not bring with them the new Greek spirit fully formed, nor even was it they who had developed it in their homelands. We find the new beginning, not in the Dorian territories, but in Attica which becomes of leading importance in the history of Western art from this point onwards.

Attica was not to any significant extent affected by the Dorian invasions. Some Achaean refugees may have sought sanctuary there and a few Dorian elements may have peacefully infiltrated, yet it was the autocthonous Ionians who were responsible for these decisive developments—developments of such significance in terms of the history of world art. The transition was completed almost unnoticed, during the last two centuries of the second millennium. The age-old art of pottery continued undisturbed; the vases were still thrown in fine potter's clay; the bright glazes of the Late Mycenaean period were still used in decoration; the traditional shapes persisted even when decorated in a new style; sometimes the process was reversed and Late Mycenaean motifs were applied to new vase shapes; shapes in the Mycenaean style continued to be produced alongside vessels obviously conceived in the new spirit.

PROTOGEOMETRIC ART · 1100–900 B.C.

One of the earliest vases of the new Protogeometric style is the shoulder-handled amphora in the Kerameikos (No. 556); the opulent curves of the Mycenaean style are here adapted to the well-proportioned lines of the vase. The vessel stands firmly and confidently upon a strongly defined base ring. The line moves in a clean contour up to the shoulder, follows the curve of the handle and the sturdy neck to reach its climax in the full thrusting lip of the vessel. The clearly worked-out structure of this amphora, the just subordination of the parts to the whole and the mutual harmony of the parts witness to a mastery of the potter's art that rises far above purely utilitarian considerations. This vase breathes a pure and full quality which is an unmistakable precursor of the rhythm and symmetry of later Greek art. The taut precision of the painted decoration is quite unlike the luxurious abandon of Late Mycenaean work; tightly drawn rings divide off the foot from the body of the vase, the shoulder is marked by a broad band between two narrow ones, the plane of the shoulder being further emphasized by concentric circles.

The indissoluble unity between the form and its decorative articulation distinguishes this vase from the earlier types of Helladic vessel. The latter are much more immediately sympathetic, and in their way bear witness to an all-embracing accord with nature and to the cult of the mother-goddess. In view of the penetrating clarity which broke through with the new Protogeometric style, one can speak of a new spirit, a presage of the Apollonian which was to come later. That such a revolutionary development is apparent both in the vases of funeral cult and in those in daily domestic use shows how completely the new spirit prevailed. We may regard this as the birth of that new Greek art which the succeeding millennium was to fulfil.

Thanks to the evidence of the artefacts excavated from the early cemeteries, and now exhibited in the Kerameikos at Athens, we are able to assess this important development with reasonable accuracy. Unfortunately the loss of the contemporary sculpture obliges us to rely on the vases for our knowledge of that art form too; however, pottery of the Geometric period serves this purpose surprisingly well. It is no mere affectation that prompts us to speak of the foot, the body, the shoulder and neck of these vases, of their growth or 'build'. Such terminology reveals the true character of the Greek potter's art. These vases are living organisms which, from the Protogeometric period on, evince the astonishing plastic sense of the Greeks.

58 The new direction apparent in the Kerameikos amphora 556, is confirmed in the Protogeometric amphora 544. The tightening and lengthening of the contours is now unmistakable, although there seems to be no great time-lag between the two works. The two free-hand, undulating lines, stretching between the handles of 544, indicate its close temporal proximity to the free decorative style of the Late Mycenaean period; the stressed articulation of this body-handled amphora and the black and white treatment of the decoration indicate an early date. The vessel is probably from the tenth century B.C.

59 above A goblet with steep conical foot is pure Protogeometric. Instead of concentric circles linked by tangential lines, as on earlier goblets, the handle area is here divided into diamond and checker patterns. The strong use of dark colours increases the unity between the consciously supple form of the vessel and the heavy overlay of full black or hatched paint-work.

59 below From the same century comes the clay deer in the Kerameikos, in which the legs carry the heavy body in the manner of a vase on four supports. What has interested the artist is less the light-footed agility of the

listening animal, than its wary alertness, the long craning neck with its crown of antlers. Traces of a rim at the top indicate that the vessel was an open vase, probably a Protogeometric libation vessel; the decoration is a dense field of cross-hatched lozenges, checker patterns and zigzags. It is no mere chance that such three-dimensional figures are scarce. On the Protogeometric amphora, Kerameikos 560, the figure of a little horse *60, 63 above* is introduced beneath the wavy line linking the handles, and a few clay animal figures of the earliest Greek period have also been found on Samos. But the artists of the Protogeometric and Early Geometric periods preferred to use the simplest means to express their sense of the ordered penetration of the world and the structure of the cosmos. They used the straight line, the circle, their fragmented forms of the zigzag and the arc, and the diamond and rectangle. This was not a representation of the natural world in abstract forms; it was in this early art a way to the very roots of all design, the line, the plane and the circle. Thus this period of Greek art is termed 'Geometric' (the term was coined by Conze in 1870) in the fullest and strictest sense of that word.

EARLY GEOMETRIC ART · 900–850 B.C.

During the Early Geometric period, the vase shape became ever more slender, the tautness of the steep contours and the direct contrast between the black painting and the bright clay ground were more and more emphasized. The black areas increasingly dominated the vase surface, leaving the narrow bands of bright colour like the Milky Way in a night sky. The vases achieve their effect by their conscious simplicity and the precise articulation of the surface by encroaching black. The artist of the Early Geometric period increasingly adopted the meander, which, for the next two centuries, divided and embellished the vase in ever more elaborate patterns. The meander became the *leitmotif*, the very symbol of the true Geometric style. Despite the sharp angularity of its line it symbolized a coherent flow of movement. It resembles the cadences of the epic verse metre; sometimes placed vertically the meander provides the vital caesura between neighbouring areas.

The ninth century discovered afresh the plastic potentialities of the vase. From the night of black glaze the bright friezes and bands of the strict Geometric style shine out like a dawn light. The dark foot of the Kerameikos amphora 2146 is divided by a broad band of light colour; a battlement meander runs round the *61* narrow neck, and the shoulder of the vessel is embellished with cross-hatched lozenges and a triangular motif with dots in the intervening areas. The zone on the belly between the two handles is emphasized; it is divided into two metopes each decorated by six concentric circles surrounding a dark solid disk which is divided by a reserved cross. The vertical zones which divide the metopes are decorated with cross-hatched triangles, lozenges and herring-bone pattern and a vertical hatched key meander.

THE SEVERE STYLE OF GEOMETRIC ART · 850–800 B.C.

During the following decades the horizontal bands round the vase are gradually broken up. In the beautiful Angelopoulou pyxis, which has survived virtually intact, the foot area is articulated by five black *Fig. 95* bands divided by thin stripes, subdivided in their turn by lines where the ground colour has been left to show through. The picture area has been moved up to the shoulder of the vase and consists of a hatched meander framed by a zigzag pattern above, three zigzags below and, on either side, by decorated vertical bars.

The pyxis in the Louvre, A 514, has the fine ornament in the top zone of the vase enriched by two stylized *62* horses which stand on either side of the central key pattern and complete the picture up to the handles. This Louvre vase represents a more mature style than the Angelopoulou, although they are close in time. The lid handle is in the form of a jug which grows out of the turned bands of its pillar-like foot.

In a similar way the tripod cauldron of beaten bronze from Olympia, B 1240, is full-bodied. The massive *Fig. 96* cast legs are decorated with hatched bands; at the top they flare out and are welded to the upper rim of the vessel; two large embellished ring handles dominate the whole piece. This kind of utensil was highly prized in Homeric times; for example, the tripod given by Achilles as a prize for the funeral games of Patroklos was valued at 12 head of cattle, whereas a skilled and experienced housekeeper was reckoned at only four.

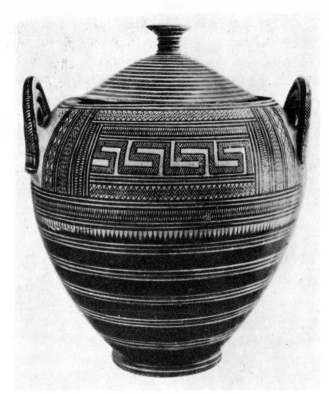

95 Lidded pyxis in the Severe Geometric Style. Second half of 9th century B.C. Athens, Acropolis Museum

96 Bronze tripod cauldron in the Severe Geometric style, from Olympia. Height (without handles) about 51 cm., diameter 57·5–61 cm. Second half of 9th century B.C. Olympia, Museum B1240

97 Apollo and Herakles fighting over the tripod cauldron, from the leg of a Late Geometric tripod, from Olympia. Cf. plate 69 right. Olympia, Museum B1730

The tripod cauldron from Olympia, the only one to have survived from early times, was not designed for domestic use; it would have been dedicated to Zeus, since it was believed that the gods too delighted in fine craftsmanship.

RIPE GEOMETRIC ART · 800–750 B.C.

63 below The transition to the eighth century is marked by a low pyxis, in the Kerameikos (No. 257); the body is decorated with a meander in monumental style, only slightly above the foot. The lid handle is in the form of a horse with ornamental mane, neck and head. This vase in its compactness and simplicity, is an important harbinger of the eighth century, often called 'the century of Homer'. In the pictorial arts the new age is distinguished by the introduction of men and animals, not simply as figures but in ordered rows.

III The versatile eighth century, with all its new achievements, the striving after inner as well as outward monumentality, the incorporation of a picture world from the animal and human realm, forfeited some of the achievements of the previous century. The Geometric amphora, Munich 1250, represents a new stage in the Ripe Geometric style of the eighth century. Save for a shallow dark-coloured base zone, the whole vase is covered with numerous broad and narrow friezes. Rows of triangles and diamonds alternate with bands of key meander, the zone beneath the swelling of the shoulder has a checker pattern. The neck is embellished with counter-key patterns. One of these is treated so that it can be read in two ways, giving prominence either to the dark hatched bands or to the light reserved areas. The decorative system has lost the richness and objective significance which formerly had given it unity. The linear decoration now has the effect of tracery. The new accent has placed the grazing deer under the swelling of the lip of the vase, the couchant goats with heads turned, on the shoulder, and the herons with stretched necks in the frieze immediately above the base rings.

The climax of the Geometric style is achieved in the Dipylon vases, so called after the site where they were discovered. In size alone they are remarkable, being one and a half metres in height, that is, almost as tall as a man. Such vessels are the grave monuments of this early period. They anticipate the monumental marble animal and human forms which mark Archaic graves from the late seventh century onwards; some of the burial vases have minute female breasts on the body of the vessel, an unmistakable indication that such works were conceived as living organisms.

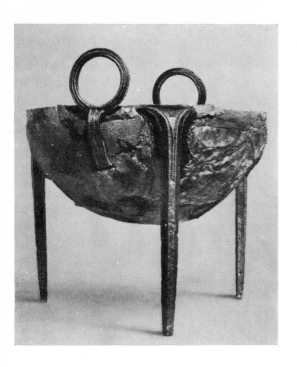

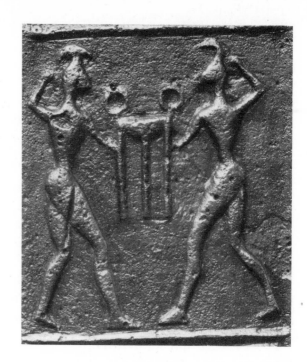

LATE GEOMETRIC ART · 750–700 B.C.

These huge vases are decorated with a dense network of Geometric patterns which in their delicate precision counteract the massive nature of the form itself and imbue it with the breath of life. The animal frieze is confined to the marginal zones of the magnificent neck of the vessel and the main area of decoration, formerly dominated by the abstract meander motif, now expounds the great theme of lamentation for the dead. The Dipylon vases embody a grand unity of occasion, ritual use and design.

The theme of mourning is impressively stated. The dead man is laid out on a funeral couch set on tall *Fig. 98* legs; the pall is of checker pattern; on either side stand the mourners with upraised arms; beneath the couch are four figures, two kneeling and two seated on diphroi. A small figure adopts a posture of desolate misery, surely a mourning child.

This theme of mourning, of the ekphora (the funeral procession), is treated in epic manner on the krater, *65* Athens 990. The large picture is less compact: stars, circles, swastikas, water-fowl, rows of points and zigzags

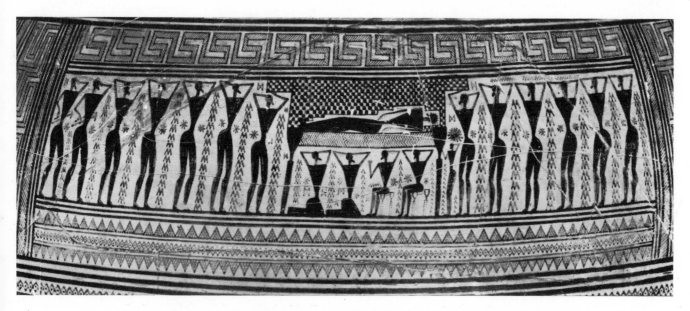

98 Scene of mourning, from Ripe Geometric amphora. Cf. plate 64. Athens, National Museum 804

fill out the spaces between the figures. The funeral couch is not presented in a simple profile view, the four turned legs and the cushions being fully detailed. In a frieze immediately adjoining the scene of lamentation for the dead is depicted the ekphora; two horses stand ready harnessed to a wagon on which has been placed the funeral couch with the dead man on it. The mourners are shown as stylized figures, the men bearing swords, the women with breasts. In a third frieze, separated from the handle by a zigzag bordered by black and white lines, ten charioteers lead their two-horse teams, obviously in honour of the dead; one is reminded of Achilles's orders to his Myrmidons in the *Iliad* (23.7ff., trans. E. V. Rieu):

> 'We will not unyoke our horses from their chariots yet, but mounted as we
> are, will drive them past Patroklos and mourn for him as a dead man should
> be mourned. Then when we have wept and found some solace for our tears,
> we will unharness them and all have supper here.'
>
> The Myrmidons with one accord broke into lamentation. Achilles led
> the way, and the mourning company drove their long-maned horses three
> times round the dead, while Thetis stirred them all to weep without
> restraint. The sands were moistened and their warlike panoply was bedewed
> with tears.

64, Fig. 98 The Homeric theme of a hero's death—the lying-in-state, the mourning and the funeral games— condensed into a short frieze in the Ripe Geometric amphora, Athens 804, is pictured on the krater, Athens 990, in a richly coloured, many-figured scene. The strict form and rigid syntax of the Ripe Geometric style which governed the first half of the eighth century has now been broken. The advent of the Late Geometric style is heralded by devoted attention to detail, extended narrative, attack and foreshortening, but above all by the glittering variety of figures and pattern which in a truly pictorial manner covers the surface of this krater.

66 The new pictorial style of Late Geometric finds yet freer expression in the New York krater 34.11.2. The strict regularity, the ordering of the individual units of circle and line and the symmetrical articulation of the parts are all moulded into a freer ensemble. The contour begins to waver, the fields lose their regularity and even the handles must conform to the demands of the artist and assume new shapes. The ceremonial themes of the lying-in-state and lamentation for the dead are reduced to small metopes. The fight by the ships is presented in a freely ordered frieze running below. This is of course an old Homeric theme (*Iliad* 15. 696; *Odyssey* 9.54). However, this picture seems to be concerned with something beside the battle of Greek heroes before Troy, and to reflect the experience of the contemporary colonists in southern Italy and Sicily.

67 A Late Geometric jug (Boston 2542) shows a similar breakthrough into new stylistic fields. In the broad picture zone on the body is depicted a herd of forest animals in flight—deer, fawns, dogs and foxes (recognizable by their bushy tails)—whilst swastikas fill out the background. Trappers and beaters with whips and *III* knobkerries follow. The free, untroubled composition witnesses to a sympathy with nature far greater than in the friezes of grazing deer and crouching bucks. The Late Geometric jug in Munich mirrors this spirit in its treatment of a shipwreck scene. The peaceful animal friezes of the Ripe Geometric vase and the orthodox strictness of their composition form an instructive contrast with the hunted animals of the Boston jug. Nature represented as a force surrounding, dominating and threatening man is again exemplified by pictures 68 below of man-eating lions found on Geometric gold bands or on the Late Geometric Attic kantharos in Copenhagen. Between them, two struggling lions tear an armed warrior to pieces; fighting men, a lyre-player and women carrying water pots frame this gruesome picture which allegorically symbolizes the conquering power of death. Embossed gold bands, depicting deer surrounded by animals of prey, fighting animals and man-eating Fig. 99/100 lions, were probably designed to decorate wooden boxes—larnakes—for the ashes of the dead. In such a

III Attic High Geometric amphora. Height 51 cm. Mid 8th century B.C. Munich, Staatliche Antikensammlungen 1250

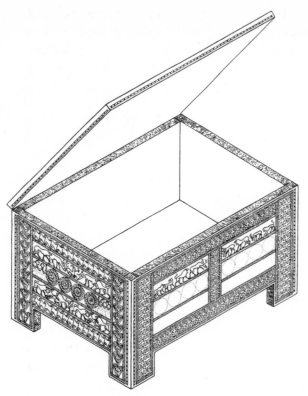

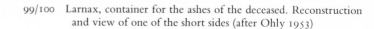

99/100 Larnax, container for the ashes of the deceased. Reconstruction and view of one of the short sides (after Ohly 1953)

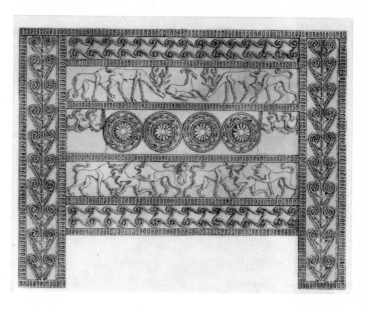

larnax the ashes of Hektor were deposited (*Iliad* 24. 795). The rich ornament is used to convey the same basic concepts as that on the vases of the Geometric funeral cult; life is seen as a costly treasure.

GEOMETRIC SCULPTURE

The eighth century produced sculpture that one may call Greek in the fullest sense of the word. Figures survive from earlier centuries but they are not realistic in their representation of the human form, or—like the early figures of Zeus with their boldly uplifted arms, found at Olympia—are technically and aesthetically gauche. They are too primitive to have any real artistic merit and lack style in the true meaning of that word; nor can it be said that they uniquely represent any specific historical period. This kind of claim can be made only on behalf of works of higher artistic achievement.

From the second quarter of the eighth century comes a series of ivory figurines, found in a Geometric grave near the Dipylon gate in Athens. The most important of them is a fairly well preserved nude female *70 left* figurine with her stiff arms pressed close to her sides and wearing a crown, decorated with a meander pattern, which identifies her as a goddess. Clearly the artist has not only used an eastern material but has also taken over the formal vocabulary of eastern models. He must have been familiar with Syrian representations of the mother-goddess Astarte. Yet despite its unmistakable associations with foreign works this figure from the Dipylon embodies a spirit quite new in the history of world art. We can legitimately regard these figurines as marking the birth of the Greek style in sculpture. Monumental sculpture appears only in the following century, yet these little figures from the Dipylon already contain the seeds of this development.

The firm stance of Greek sculpture, the conscious expression of the artist's will in the disposition of the limbs, the functional interplay of the elements of structure and mass, were recognized as formal problems and given artistic expression only in the seventh century. The figures and groups of the eighth century 'gain their unity, not from the organic ordering of their limbs, but from their harmony with life at large. It is obvious enough that the artist has not achieved a representation of the individual physical forms; indeed from this point of view all the figure representations of the period must be regarded as failures. Far more important is the way in which these figures embody that elemental, vital force which the Homeric Age experienced as a recognizable personal essence acting as the *Doppelgänger* of the mortal body.' (E. Buschor)

Apart from its links with the opulent nude female figures of the Near East, with their almost spongy flesh textures, the ivory goddess of the Dipylon presents a new Attic spirit of lucid clarity. The coiffure of the

eastern figures has been remodelled into a deity's crown, which proclaims its Greekness by the use of the meander in its decoration. Admittedly, the placing of the arms follows eastern models, but the Greek sculptor has used the long slender arms to clear and penetrating artistic effect. Together with the projecting shoulders they describe a tall narrow rectangle, which is echoed by the face and crown. The long slender legs are slightly turned in at the hollow of the knee; the silhouette pictures on the large funerary vessels of the period show this stance to have been a characteristic stylistic trait of the first half of the eighth century.

That we have here an Attic Geometric style in its very earliest stages is confirmed by the only slightly later bronze figurine from the Acropolis, No. 6503, which unfortunately is very badly corroded. Nevertheless, this piece does diminish somewhat the unique status of the ivory figures, accorded them on account of their remarkable state of preservation and their outstanding artistic quality.

In the early figure-groups the Geometric style had opened up a theme pregnant with future possibilities, and produced works which were to be fully developed in monumental sculpture only centuries later. From this early period have survived dedicatory offerings excavated at Olympia, charioteers standing helmeted in their chariots. A bronze group from Samos represents a helmeted hunter fighting a lion; a dog bites the *68 above (r.)* wild animal in the foreleg. It takes more than a brief inspection to follow the confusion of limbs and bodies, nor is the spaciousness of the composition, which in this exemplary work has been ordered into a pictorial unity, to be taken in at a glance.

The bronze group of a stag attacked by hounds is easier to comprehend. Here the whole dramatic agitation *68 above (l.)* of the theme is conveyed by the stringing together of apparently still figures. The bronze figure-groups of this period share this technique of presenting vigorous movement through statuesque still forms with the friezes of mourners and racing chariots in the funeral games seen on contemporary vases.

A mid-eighth-century bronze group formerly in the Morgan Collection (now in the Metropolitan *71 left* Museum, New York) portrays a vigorous battle scene. Seen in strict profile it shows in the sequence of the struggling bodies—a naked helmeted man and a helmeted Centaur—a rhythmic cadence and spatial inter-relationship akin to that in the stag group from Olympia. The interlocking arms of the two human bodies in the New York group describe a capital 'H' pattern, the lower body of the Centaur the shape of a small 'm'. It has long been recognized that this group cannot be a representation of a peaceful encounter or greeting; the remains of a weapon embedded in the left side of the horse's body indicates that a strenuous armed combat is intended. A Protocorinthian lekythos in Boston, about a century later, clearly identifies the *Fig. 101* Centaur's victorious opponent as Zeus, by his thunderbolt. A more modest artistic representation of the mythological theme behind this bronze group is seen in a clay group found in Boiotia. A fragment of a lost epic of the Geometric period, which told of the battle of the Gods and the Titans, tells that Kronos, Lord of the Titans, changed himself into a Centaur. The New York bronze group in all probability portrays the original conflict, symbolic of the struggle between the Olympians and Titans.

Among the many figures decorating the ring handles of Geometric tripods, a recently discovered figure of a javelin-thrower stands out brilliantly. If for nothing else, it would be remarkable for its state of

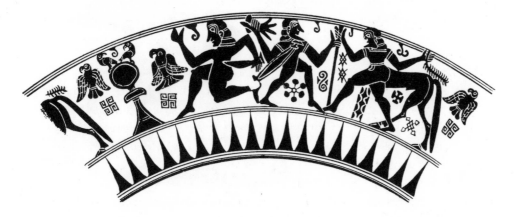

101 Zeus and Kronos, from a Protocorinthian aryballos. Over-all height 7·4 cm. Second quarter of 7th century B.C. Boston, Museum of Fine Arts

preservation. In his right hand the youth brandishes a javelin and leads a horse by the bridle with his left; the top half of his body is naked down to the waist. This separates the long pillar-like thighs from the thrust-forward torso, above which rides the head, characterized by a powerful countenance with pointed chin, narrow nose, somewhat protruding eyes and pouting lips. The hair forms a 'cap' of painstakingly arranged rings, which rises straight up from the forehead. The bronze figurine from Olympia, No. 4600, is not conspicuous in the superficial elements of its form, 'but in the clarity and discipline of its formal language is unequalled by any other piece. The figurine is, in the fullest sense, a masterpiece of Geometric sculpture.' (E. Kunze)[1] The javelin-thrower from Olympia represents a manifest advance on the fresh young ivory goddess of the Dipylon. Certainly, the difference between the Attic and Doric spirit seems to be expressed in the mature, pure Geometric carved figurine and the classic Geometric bronze youth from Olympia. Supple, lively charm in the one, collected, concentrated seriousness in the other. The lucidly composed body of the warrior recalls the Homeric phrase, μέλεα καὶ γυῖα, with its limbs well muscled, set together in strongly rounded joints.[2]

71 right An early attempt to represent the body as something more than just the sum of thighs, belly, torso, shoulders, arms and head was made in the bronze figurine from the Acropolis, No. 6613; in this work the undisturbed flow of line which informs the human body is brought out. The marked constriction between
70 right the upper and lower body and the wasp waist of the javelin-thrower has given place to a flowing line which rises from the slightly swelling thighs, over the barely noticeable hips, up to the chest, where it broadens and is taken up in the movement of the arms. The movement reaches its climax in the mighty face beneath the plumed helmet; in the furious glint of battle, blazing in the great eyes. Indeed, the life of the whole figure seems to flow from this passionate mien. Perhaps, in this magnificent figurine, we are looking upon the victorious young Zeus, vanquisher of the Titans; yet we see that even this masterpiece obeys the laws of the Geometric style, while embodying the might and power of the figures of mythology and the Olympian pantheon.

THEMES OF GEOMETRIC ART

72 On the shoulder of an eighth-century jug from Athens (No. 192) there appears an incised inscription. Numerous sherds in the Geometric style, discovered on Mount Hymettos[3] confirm that the Greek alphabet became current in Attica during the course of the eighth century. As a result of this development, the Greeks were in a position to record the long epic poems in writing; this in turn helped to make them more widely known. It can hardly be coincidence that figure subjects, introduced only sparingly and in isolated instances into the decoration of vases of the Geometric style, become ever more frequent and detailed in the later eighth century. It is as if the voice of Homer had called forth these crowded figure scenes from the artists of the vase paintings. Certainly the dead buried in the cemetery outside the gates of Athens were not Homeric heroes. The funeral cortèges, the ceremonial lamentations, the friezes of charioteers, may portray the contemporary death cult. None of these pictures has a name inscription which would enable us to identify it as a representation of the funeral games of Patroklos; for this reason we cannot be sure that the scenes of battles with ships show the events of the Trojan War rather than the experiences of Greek colonists in such

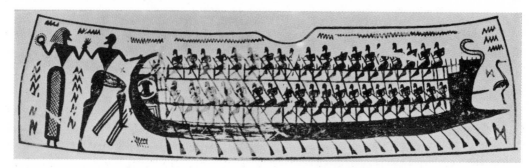

102 Abduction of Helen by Paris, from a Late Geometric bowl, from Thebes. Height of picture strip
9 cm. Second half of 8th century B.C. London, British Museum

103 Herakles and the Molione, from a Late Geometric bronze fibula, from Crete. Height 6 cm. Ca. 700 B.C. Athens, National Museum

104 Nestor in combat with the Aktorione, from a Late Geometric jug. Second half of 8th century B.C. Athens, Agora Museum P4885

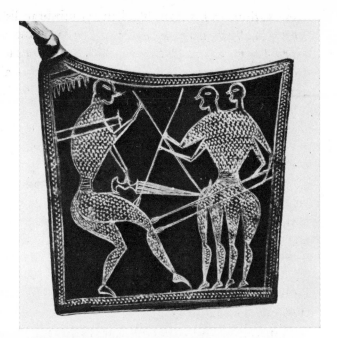

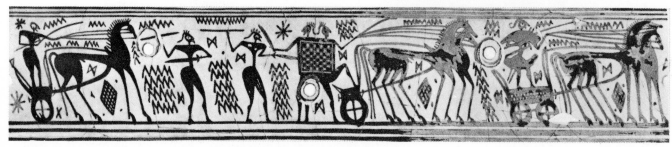

distant lands as southern Italy. For the modern observer such pictures are obviously reminiscent of the Homeric sagas, and one can reasonably ask oneself whether in fact a painter could depict the funeral ceremonies and games of Patroklos in any other way than has the artist of the scenes on the krater, Athens 990. Similarly, it has been assumed that the scene on the Late Geometric bowl from Thebes, now in London, *Fig. 102* represents the Rape of Helen. A man grasps a girl by her wrist and pulls her aboard a 38-oared ship; the rowers sit impatiently awaiting the orders of the master who has now arrived, with his bride or his abducted mistress, and will shortly take the vacant captain's seat. A Late Geometric sherd from the Agora shows the gruesome slaughter of a child in the presence of a man and woman in pitiful lamentation.

The picture on the neck of a jug, now in Munich, depicts a shipwreck, the mariners struggling in the *69 left* water as a shoal of fish swims amongst them. Anyone who has once seen this picture will surely recall it whenever he reads the account of Odysseus's shipwreck. All the same, we cannot say for sure that the artist was intending to depict this scene from Homer and not simply an ordinary wreck at sea or the survivors after an attack by sea robbers.

The number of surviving paintings unquestionably portraying mythological themes is not very great.

Among the earliest representations of legendary themes[4] are the wooden horse on a Late Geometric fibula, from Thebes, and the Labours of Herakles; for example, his fight with the many-headed Hydra, depicted on the Theban fibula. Herakles's battle with the Siamese-twin sons of the warrior-queen Molione is a *Fig. 103* frequent subject in Late Geometric art. In an Ibykos fragment Herakles is heard boasting of his victory. 'I have slain the youths with the white horses, the children of Molione: they were of the same age, of equal growth, of the same body, both born in a silver egg.' Another pair of famous twins in legend were the Aktorione, who were called after King Aktor of Elis. Their sire, however, was the god Poseidon, who *Fig. 104* snatched them from the heat of the battle and rescued them from the conquering Nestor. The twins, although young and inexperienced warriors, had joined a campaign of the Epeians against the Pylians.

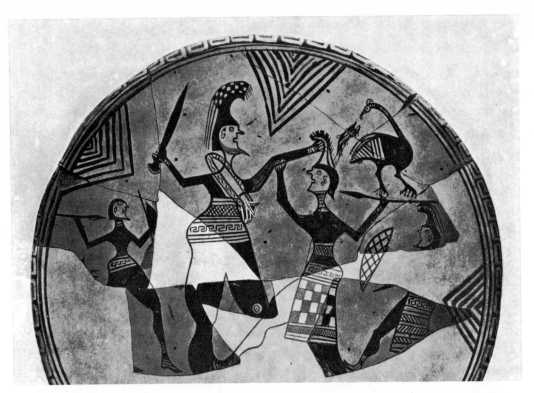

105 Herakles in combat with the Amazon queen Andromeda, from a Late Geometric clay shield, from Tiryns. Diameter about 40 cm. End of 8th century B.C. Nauplia, Museum

Fig. 105 These pictures are excelled by the great clay shield of Tiryns which has a diameter of some 40 centimetres. A helmeted warrior of heroic stature dominates the centre of the composition. On his head is a conical helmet with a lofty checker-pattern crest; a baldric is slung over his shoulders. With his left arm he has seized the helmet crest of his opponent, whose knee-length skirt and thrusting breasts show her to be an Amazon. With her right arm she parries the blow of her opponent, and in her left she brandishes a spear; another Amazon, bearing a shield, follows close behind her. A huge, dark bird hovers over the Amazons, craning its neck round towards the central combat. A feature of the composition is the way in which the bird answers the flashing sword in the hand of the mighty warrior hero, whose massive stature proclaims him Herakles, the son of Zeus. Close behind him stands Iolaos, his squire. His enemy is Andromache, queen of the Amazons, and her aide is probably Alkinoa, or Areximacha as she is called in an early Corinthian inscription.

The shield from Tiryns represents the earliest known plaque painting. The Herakles-Andromache group *71 left* is certainly reminiscent of earlier Geometric work such as the New York group of Zeus and Kronos. But a new, freer sympathy with the feel of the battle inspires the artist's handling of the figures, as shown by their angular limbs crossing the picture, their agitated mouths and small starting eyes. Although these forms burst through the delicate, fragile format of the miniature, one can not yet speak of a monumental painting. Despite the incomplete state of this piece one can see that the figures, instead of standing, seem to float in *71 right* the picture field. They show the style of the late-eighth-century bronze youth from the Acropolis, which breaks away from the Geometric form at all points and heralds the dawn of a new day in Greek art: the era of the seventh century.

69 right Another significant harbinger of the change in style is found in the beautiful upper section of a tripod leg *Fig. 97* from the Sanctuary of Zeus at Olympia. The unmistakably Geometric patterns have here been moulded into high rectangular picture fields. Apollo stands to the left in the upper picture; in his left hand he grasps the tripod which his opponent, Herakles, is trying to wrest from him. The sullen fury of their struggle gives added significance to the scene in the panel below. Here two rearing lions are opposed, symbolizing, like an Homeric metaphor, the strength, spirit and endurance of the two struggling warriors.

130

This tripod leg originates from the same Peloponnesian workshop, possibly Argive, as produced the Tiryns shield. Despite the provincial differences, we can recognize here the style of the late-eighth-century javelin-thrower of the Acropolis in the supple slenderness of the figures of Apollo and Herakles.

71 right

The depiction on the Tiryns clay shield of Herakles's combat with the Amazons brings to mind the bronze cuirass excavated not long ago in a Late Geometric grave in Argos and in a near-perfect state of preservation. It is in two sections, breast- and back-plate, of chased work and meticulously matched, locking together over *Fig. 106/107* the shoulders by means of a lug and socket join, so that the raised neck-band forms an unbroken circle. There are rings on the lower portion and openings on the side for the leather straps which would have been used to seat the armour firmly onto the wearer. Since, by remarkable good fortune, the piece was discovered *in situ* with Argive pottery, it can unhesitatingly be dated to the late eighth century; historical considerations would otherwise have prompted a distinctly later dating for this important find. As matters stand, however, we have an example of Greek monumental sculpture in its early state. The chest muscles are arched out from the body in two great curves, while the belly section is set back and separated from the rib-cage by a curving line. The hips are indicated by a broad girdle; a narrow band defined by two convex lines divides the rib-cage from the lower belly, the lower edge of the cuirass itself being marked by the hem of an undergarment.

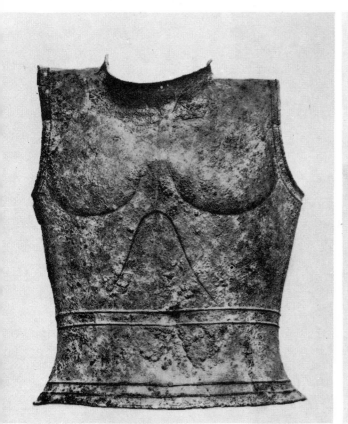 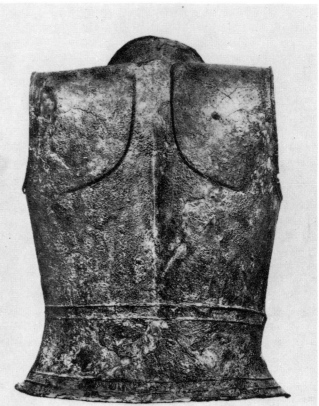

106/107 Bronze cuirass, from a Late Geometric grave in Argos. Height 47·4 cm. End of 8th century B.C.
Argos, Museum

In this piece, whose function is to protect an armed warrior, the Geometric characteristic of a triangular shape for the upper part of the body has been subtly modified. Here the human form has been rendered as a living entity, and a new unity is achieved between the shoulders, breast and belly. Indeed the boundaries between the various parts bring out the over-all inner unity of the form itself.

In sum, the cuirass presents the eighth-century image of the human form with a freshness and vitality that is impressive. Its attractive, dynamic treatment reveals a conscious disposition of masses. This world of form,

70 left this ordered unity, contains something of the weightless ideal movement of the ivory goddess from the Dipylon. We can already discern in this work signs of the true monumentality that was to become the hall-mark of Greek marble sculpture, an augury of the achievements of the great Polykleitos of Argos.

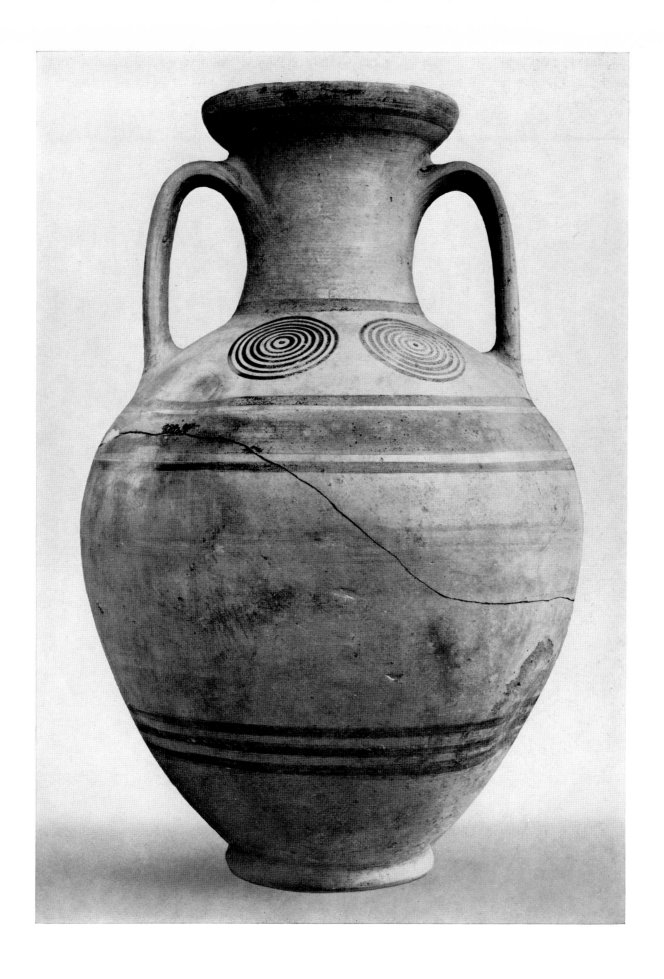

57 Attic Protogeometric shoulder-handled amphora. Height 39.5 cm. End of 11th century B.C.
Athens, Kerameikos Museum 556

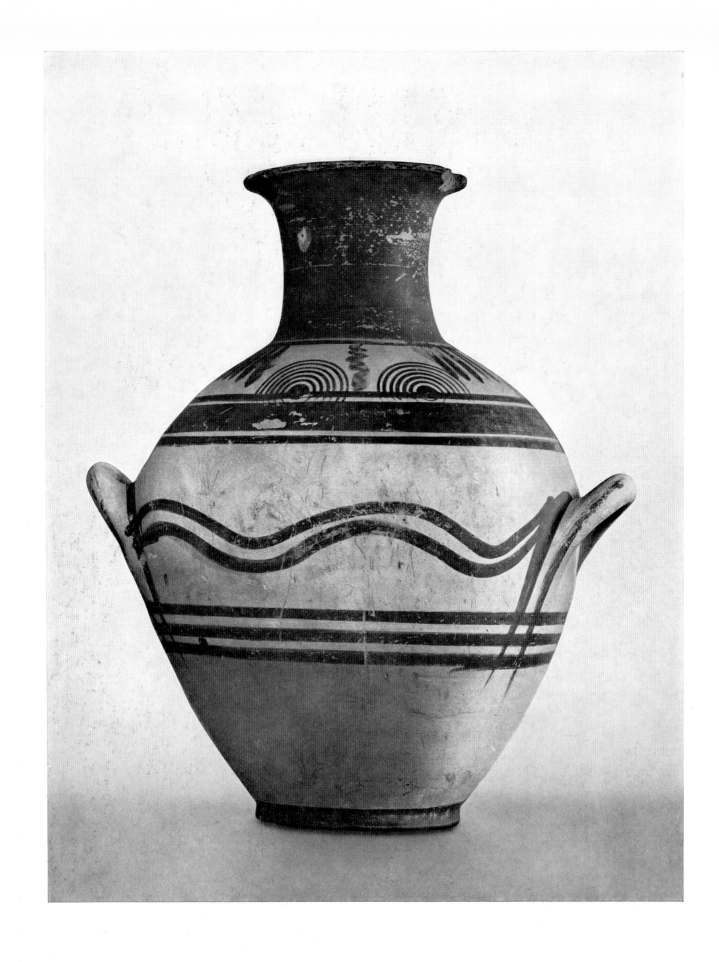

58 Attic Protogeometric amphora. Height 41.5 cm. 10th century B.C. Athens, Kerameikos Museum 544

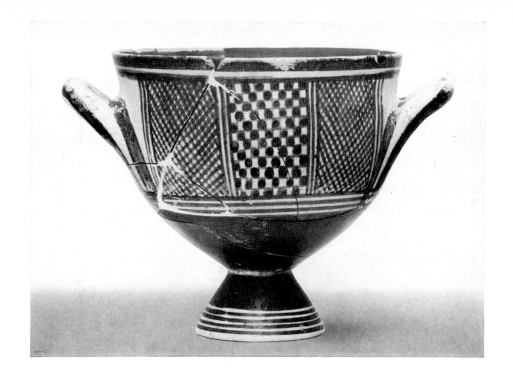

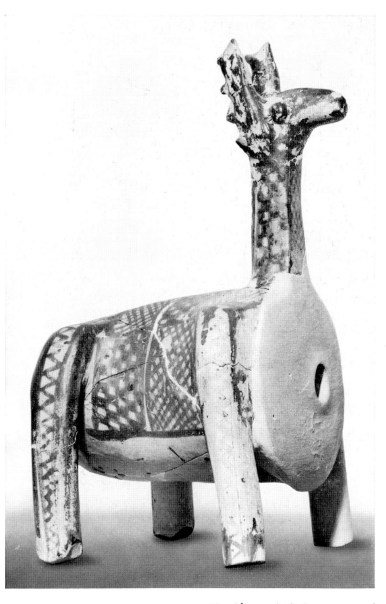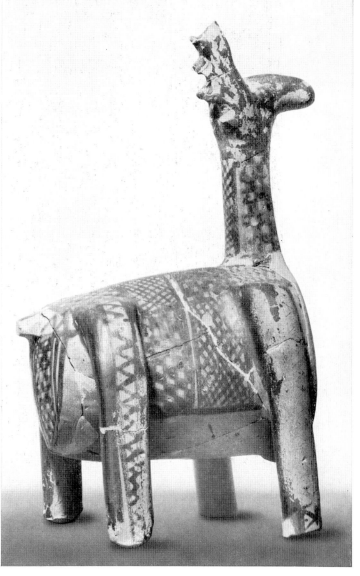

59 Above: Attic Protogeometric drinking cup. Height 11.7 cm.
Below: Attic Protogeometric rhyton in the form of a deer. Height 26.1 cm.
Both 10th century B.C. Athens, Kerameikos Museum 567, 641

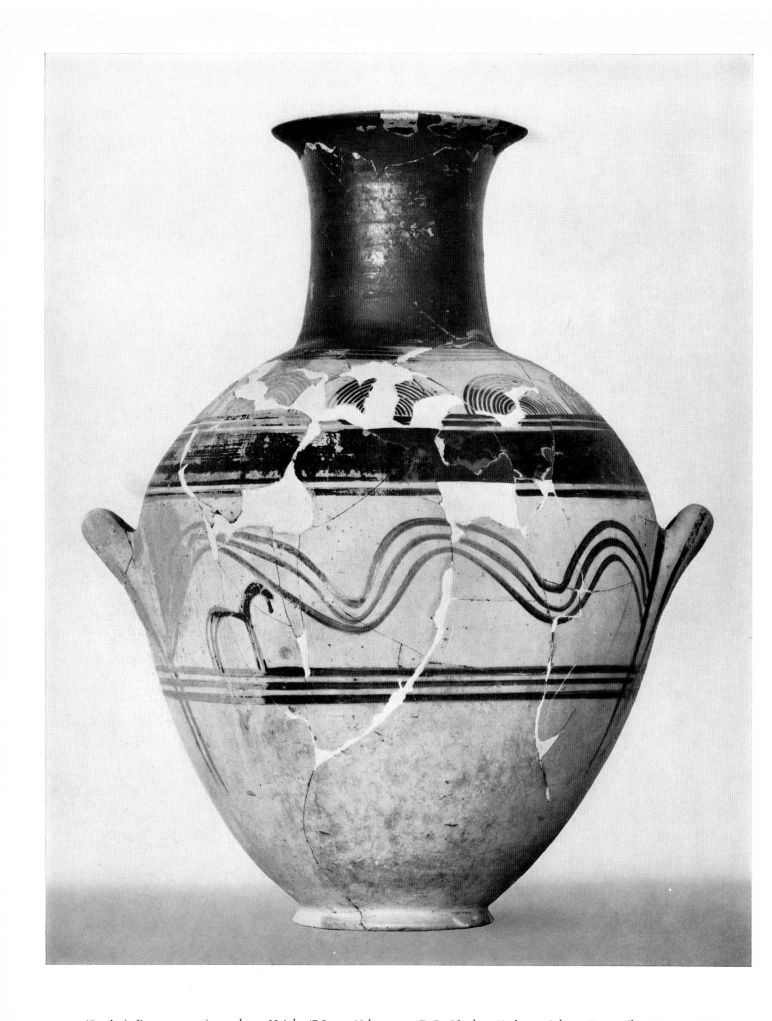

60 Attic Protogeometric amphora. Height 47.5 cm. 10th century B.C. Cf. plate 63 above. Athens, Kerameikos Museum 560

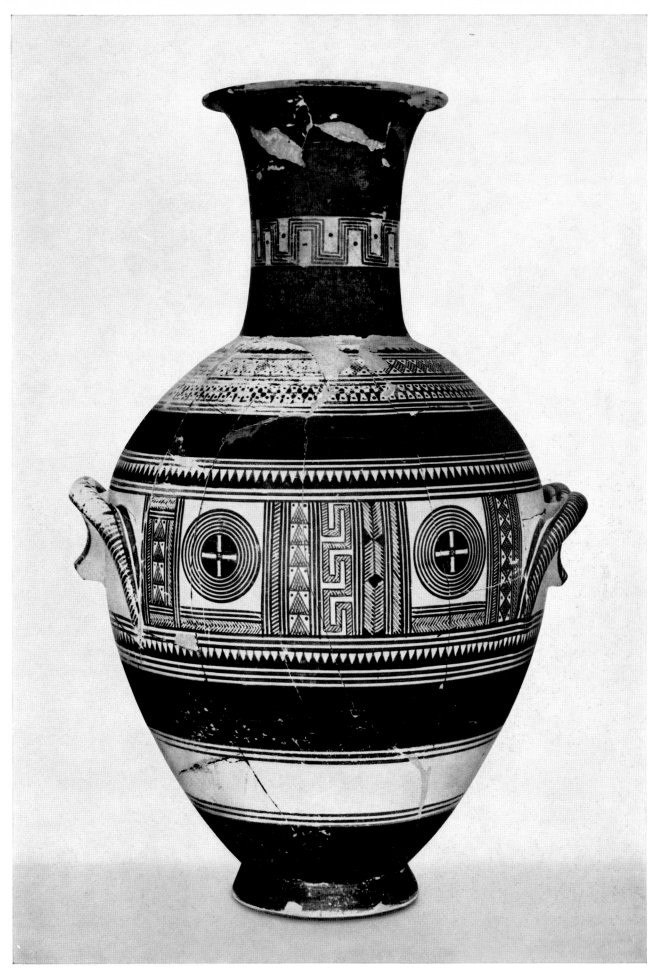

61 Attic Early Geometric amphora. Height 69.5 cm. 9th century B.C. Athens, Kerameikos Museum 2146

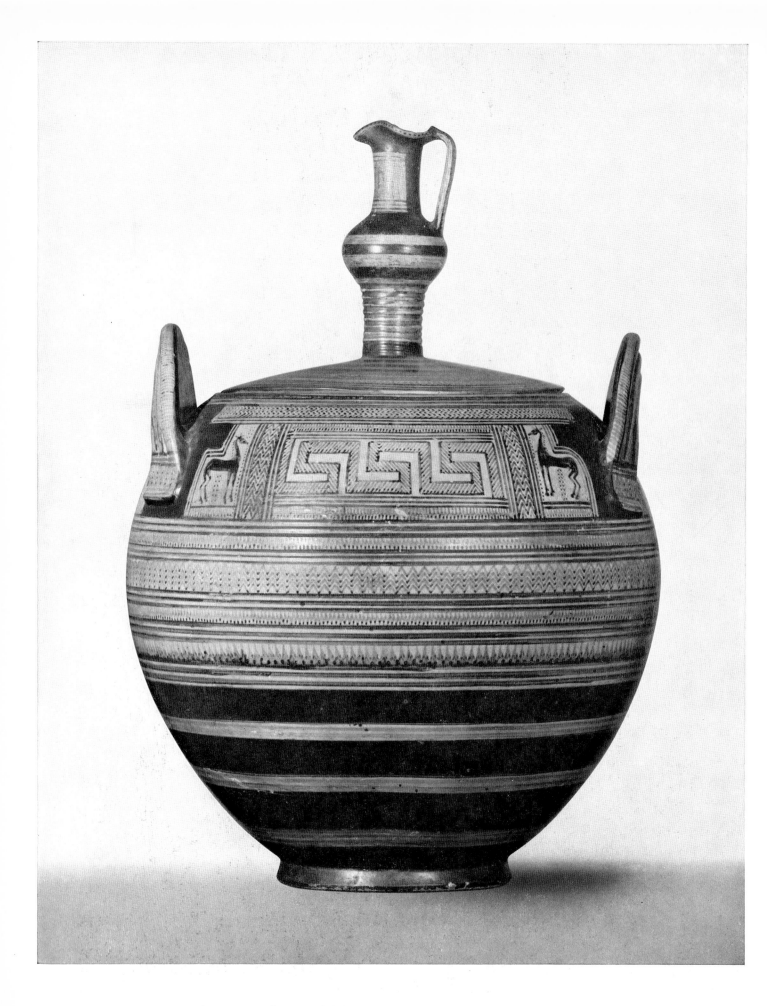

62 Attic Early Geometric krater with lid. Height 57 cm. Later 9th century B.C. Paris, Louvre A 514

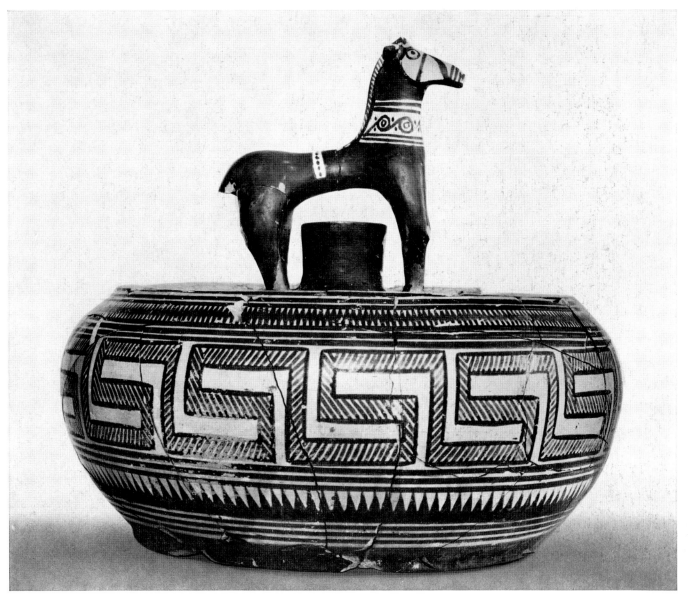

63 Above: Detail from an Attic Protogeometric amphora. Cf. plate 60.
Below: Attic High Geometric covered pyxis. Height without lid 10.5 cm. End of 9th century B.C.
Athens, Kerameikos Museum 560, 257

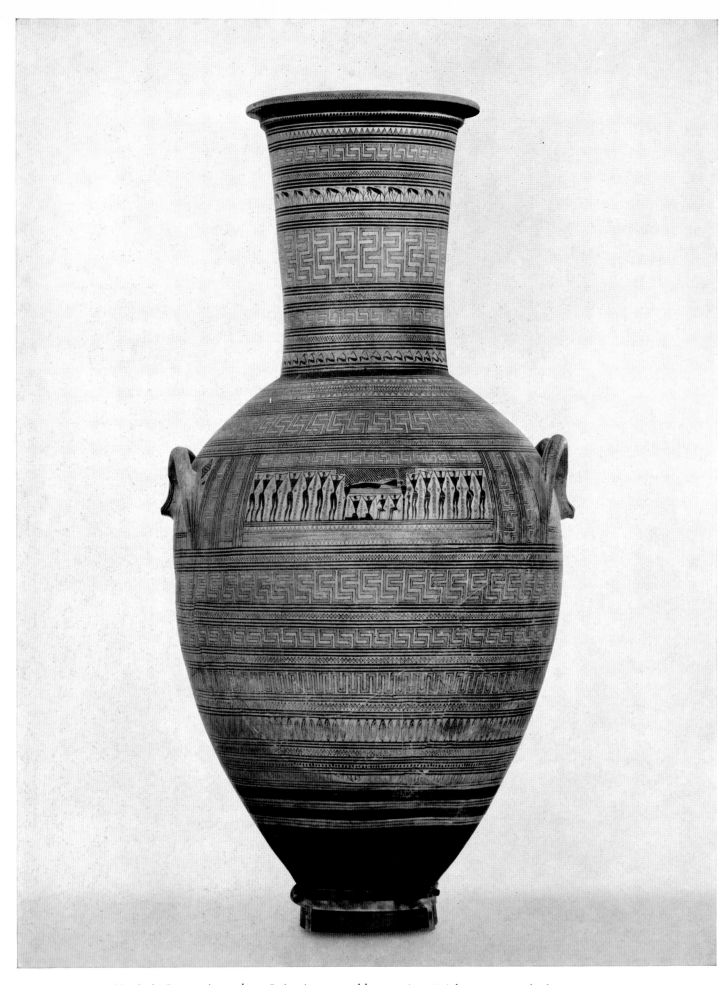

64 Attic Geometric amphora. Lying-in-state and lamentation. Height 1.55 m. Mid 8th century B.C.
Athens, National Museum 804

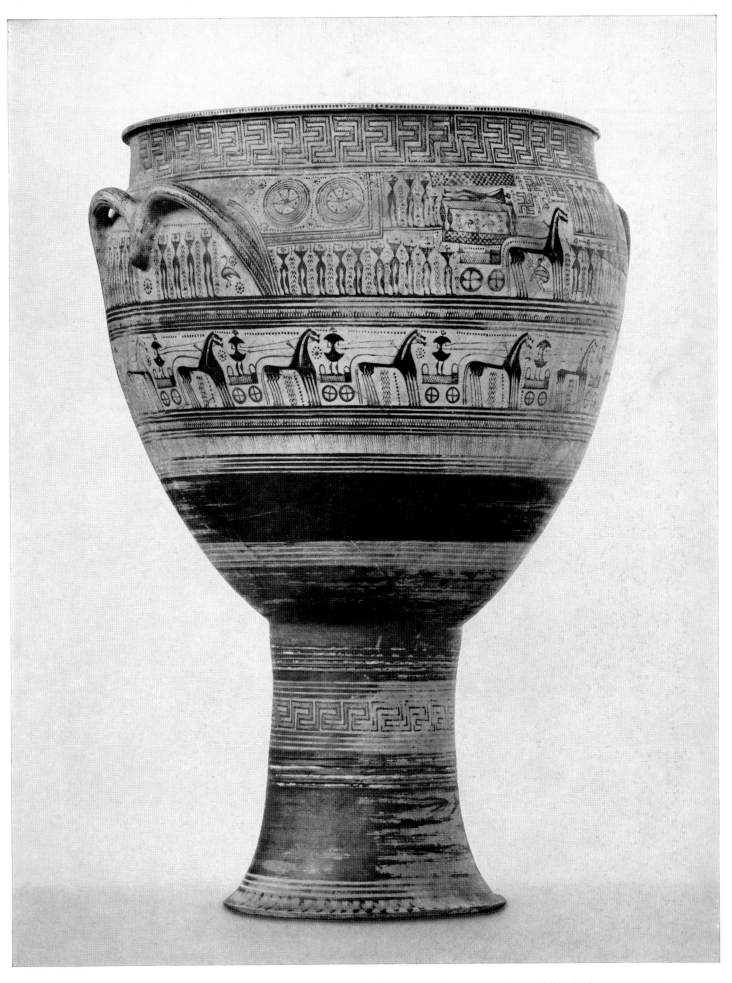

65 Attic Geometric krater. Lamentation and procession of chariots. Height 1.23 m. After middle of 8th century B.C.
Athens, National Museum 990

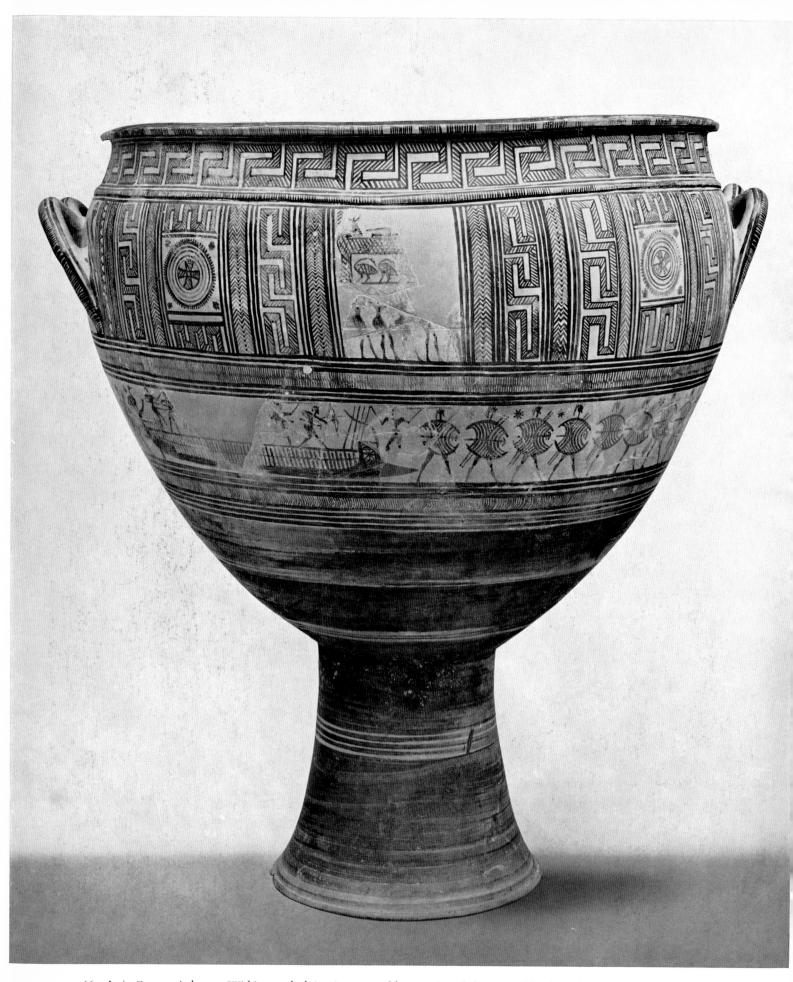

66 Attic Geometric krater. Within panels, lying-in-state and lamentation; below, naval battle and warriors. Height 97.5 cm.
Third quarter of 8th century B.C. New York, Metropolitan Museum of Art 34.11.2

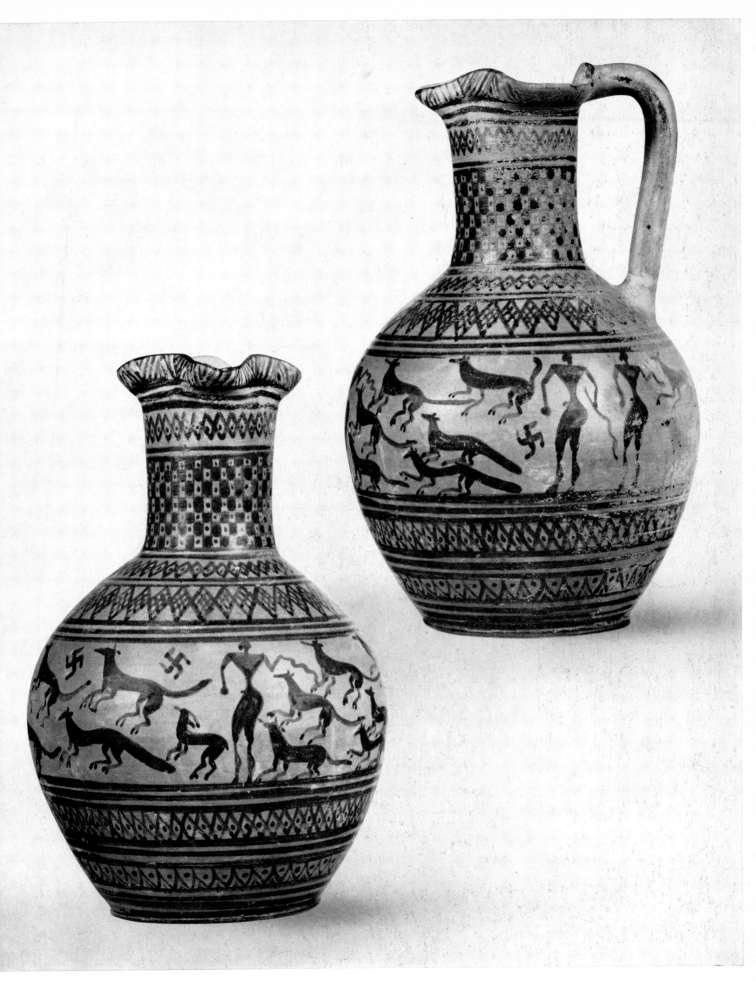

67 Attic Geometric oinochoe. Hunting scene with foxes. Height 23 cm. Third quarter of 8th century B.C.
Boston, Museum of Fine Arts 25.42

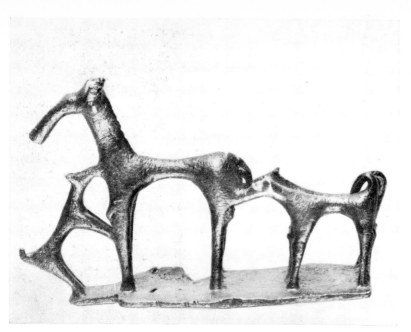
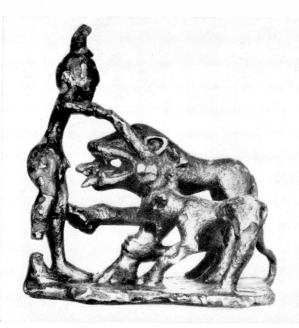

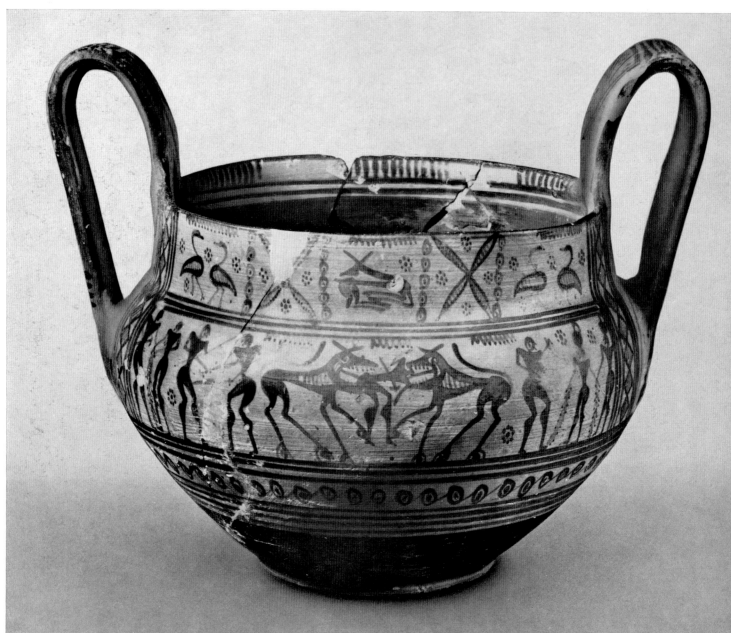

68 Above: Geometric groups in bronze, left: deer and hounds, from Olympia. Height 9.6 cm; right: man with dog fighting a lion, from Samos. Both 8th century B.C. Olympia Museum 4720, and Samos Museum.
Below: Attic Geometric kantharos with two handles. Height 17 cm. Last quarter of 8th century B.C. Copenhagen, National Museum 727

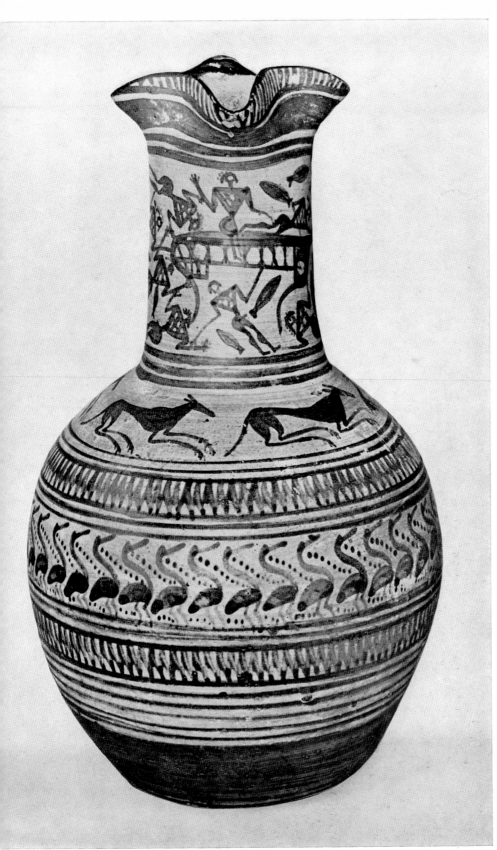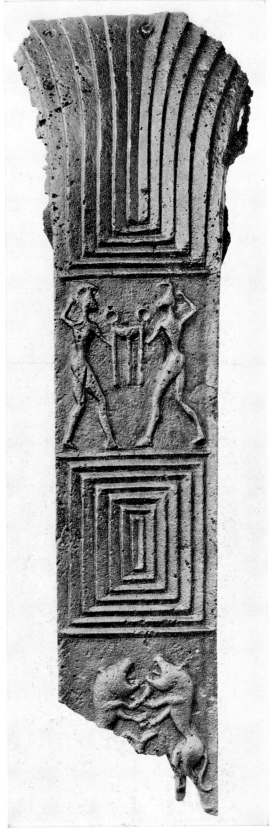

69 Left: Attic Late Geometric jug. Shipwreck of Odysseus. Height 21.5 cm. Second half of 8th century B.C. Munich, Staatliche
Antikensammlungen 8696. Right: Late Geometric bronze tripod, from the Zeus sanctuary of Olympia. Fragment. Height 46.7 cm.
Before 700 B.C. Olympia Museum B 1730

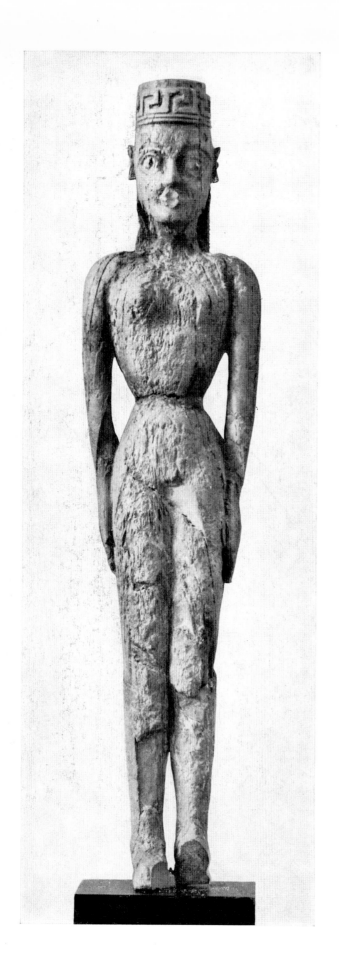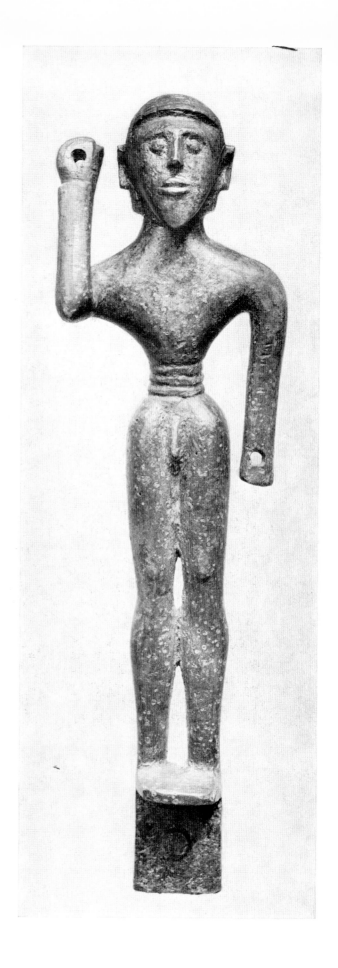

70 Left: Ivory statuette of a goddess from the Dipylon cemetery. Height 24 cm.
Geometric, second quarter of 8th century B.C. Athens, National Museum 776.
Right: Bronze statuette of a spear-thrower. Height 12.6 cm. Geometric. Mid 8th century B.C. Olympia Museum B 4600

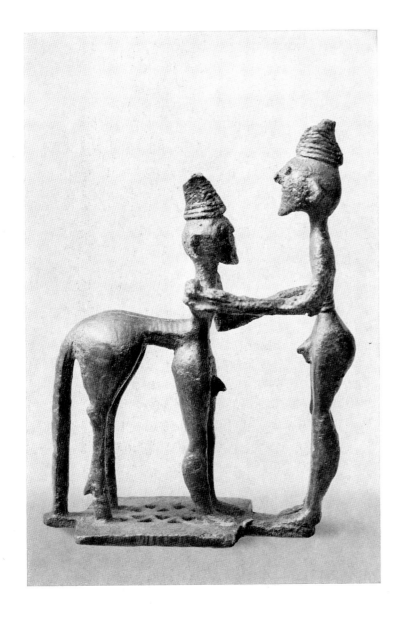

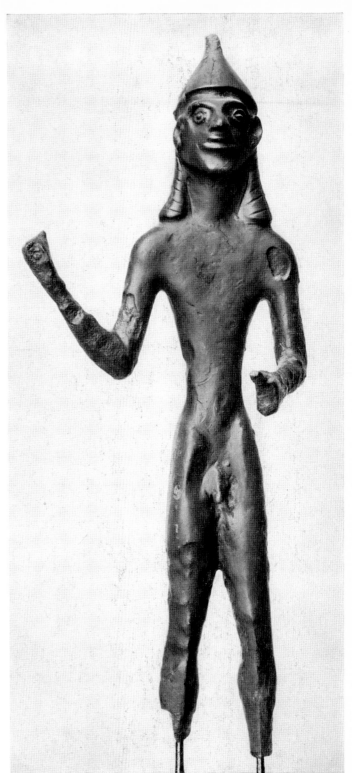

71 Left: Bronze group. Zeus and Kronos. Height 11.3 cm. Geometric. Ca. 750 B.C. New York, Metropolitan Museum of Art 17.190.2072.
Right: Warrior, from the Athenian Acropolis. Bronze. Height 20.5 cm. Geometric. End of 8th century B.C. Athens, National Museum 6613

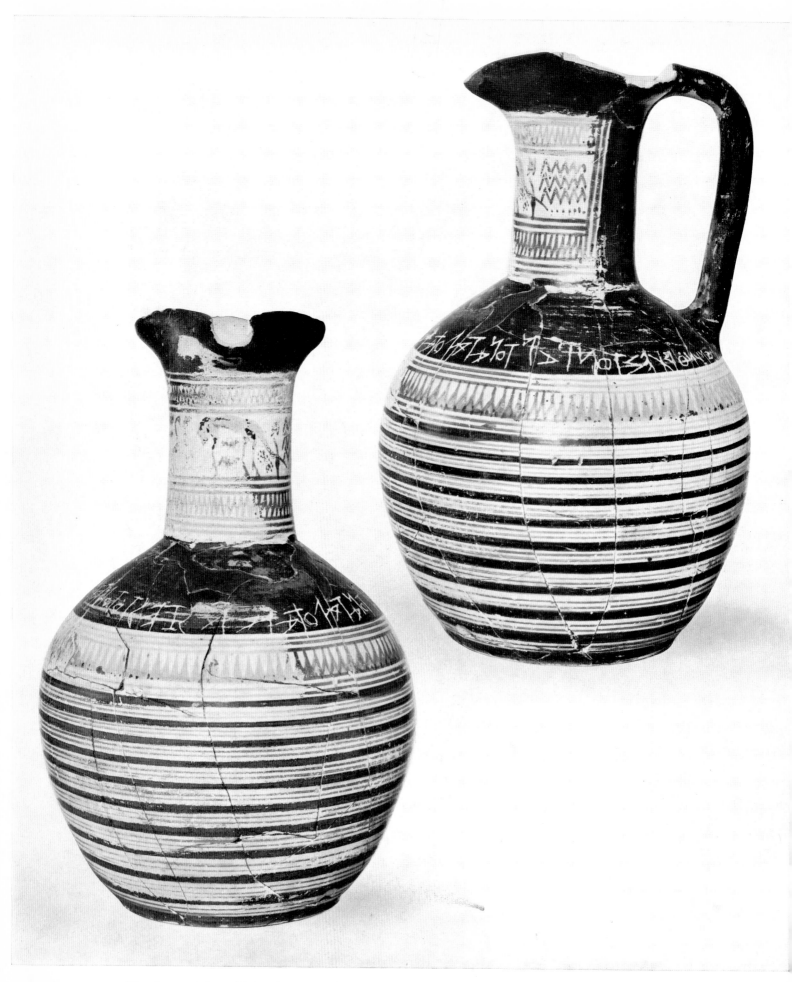

72 Geometric jug with inscription. Height 22.8 cm. Mid 8th century B.C. Athens, National Museum 192

Athens and Attica were the centre of the Geometric style until its decline at the end of the eighth century. *73 above*
Of course other Greek communities have left evidence of their artistic activity during the first centuries of
the Hellenic millennium, and one cannot ignore this work. However, its provincial dependence on
Athenian styles is sometimes obvious. Perhaps the one exception is Corinth. A bowl, now in Toronto, with
a scene depicting rowers in a large ship, proclaims the artistic independence of this city from very early on.
Nevertheless, the beginning of the seventh century marks not only a general liberation of style, in which
man, his legendary past and the animal world begin to move in a freer space, but also the development, in
the various regions of Greece, of individual artistic styles.

The term 'Orientalizing style' is freely used of the art of this century. The influx of oriental artefacts had
in fact begun in the Geometric period, through the activity of Phoenician traders, and certainly oriental
influences affected the work of Greek artists. However, even in the seventh century these influences, though
apparent, did not play a sufficiently important role to warrant the designation of a whole stylistic epoch as
'Orientalizing'. Nor will the term 'Idaian style' do to describe the diverse manifestations of early-seventh-
century art; it refers rather to a specific group of finds made in the cave on Mount Ida in Crete. The pattern
followed by Greek art in subsequent centuries was akin to that of the Geometric style: preparatory stages,
classical achievements, and the rich but decadent late phase. In this pattern, the art of these years corresponds
to the Protogeometric period, and one could legitimately speak of the 'Protoarchaic' decades.

EARLIEST ARCHAIC PAINTING · 700–660 B.C.

Corinth is first represented by small, spherical aryballoi, soon followed by attenuated pear-shaped and *73 centre*
egg-shaped lekythoi. These vases reveal a new, consciously experienced sense of volume. A silhouette style
dominates the surface; bright reserved lines and areas liven the work of the first quarter of the century. In
the second quarter of the century the black-figure style with incised lines becomes established; colour is
introduced and characterizes the new pictorial ensemble most fully. Along with animal motifs and winding
garland patterns, scenes drawn from legend are represented. For example, the Corinthian hero Bellerophon,
mounted on the winged horse Pegasos, does battle with the Chimaera, a monster part lion, part goat and

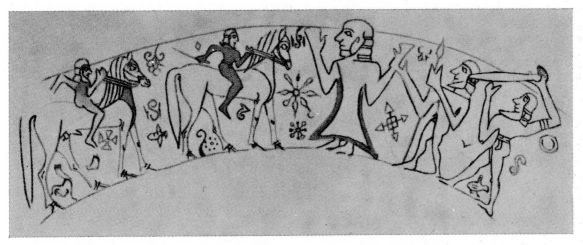

108 The Dioskouroi bringing back their sister Helen who had been abducted by Theseus and Perithoös, from a
Protocorinthian aryballos. Height of picture strip 7·1 cm. Ca. 680 B.C. Paris, Louvre

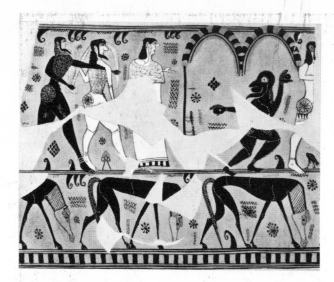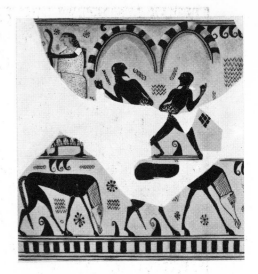

109/110 Murder of Aegisthos by Orestes. Fragment of a Protoattic krater. First half of 7th century B.C. Berlin, Staatliche Museen A32

part serpent;[1] or Zeus himself is depicted in battle, hurling a thunderbolt with his right hand and, with his left, wresting the sceptre from his Centaur opponent. Here is intended the primeval battle between Zeus and Kronos, according to ancient legend the progenitor of the Centaur, Chiron. Other scenes include *73 below* Herakles as archer fighting the Centaurs, and the Dioskouroi on horseback at Aphidnai in Attica, bringing *Fig. 108* back to Sparta their sister Helen after her abduction by Theseus and Peirithoös. Other Protocorinthian lekythoi are embellished with scenes from the Trojan War.

All these Protocorinthian pictures retain the spirit of miniature painting, despite the vigour of the battle scenes. Protoattic vase painting of the first half of the seventh century provides a most remarkable contrast. *IV* The loutrophoros, Louvre CA 2985, represents the new pictorial style in the light spreading of its picture friezes and pattern zones with many-petalled blooms and vertical bands of cable, lines of dog-tooth pattern, double volutes and rows of lozenges. The new vision is revealed in the freer disposition of ornament, the decoration of the sphinxes' wings with a scale pattern and of the girdled peploi of the dancers with a semée of dots. The elastic dance step of the flute-player communicates itself to the sphinxes in the topmost picture frieze and the horse in the main scene, as well as to the dancers; indeed this light-footed atmosphere of the dance pervades the Early Archaic style as a whole. Protoattic vase painting is characterized by powerful forms which dominate the vase in pictures that seem to break out of the surface of the vessel by their very impact. The trend towards dramatic themes about the middle of the century is exemplified by the murder *Fig. 109/110* of Aegisthos by Orestes depicted on a krater now in Berlin. Klytemnestra averts her face in horror only to be haunted by the ugly demon, the embodiment of revenge or of evil, which pursues her for the murder of her husband.

74 Herakles's killing of the Centaur Nessos, as portrayed on the New York amphora, is imbued with tremendous dynamic force. The scene on the vessel's neck, in which a lion with scaled neck and bared teeth tears at a hind, translates the violence of the main frieze into animal terms.

The killing of Medusa by Perseus and the blinding of Polyphemos by Odysseus and his companions are *75, V* superbly handled on the Protoattic amphora from the second quarter of the seventh century, now in Eleusis. The death-dealing monster has been cut down like a felled tree. Perseus flees with his fearful booty, Medusa's head, but is pursued by her Gorgon sisters; the painter has intensified the reality of their furious chase by painting in white the left legs which emerge from their dress. Their frontal heads recall contemporary griffin-cauldrons. Withal they are cheated of their victim by the goddess Athena who protects the hero from his terrible pursuers.

IV Analatos Painter. Protoattic loutrophoros. On the neck: Couples dancing to the double-flute; above these, winged sphinxes. On the body of the vessel: Parade of Chariots. Height 80 cm. Ca. 700/680 B.C.

150

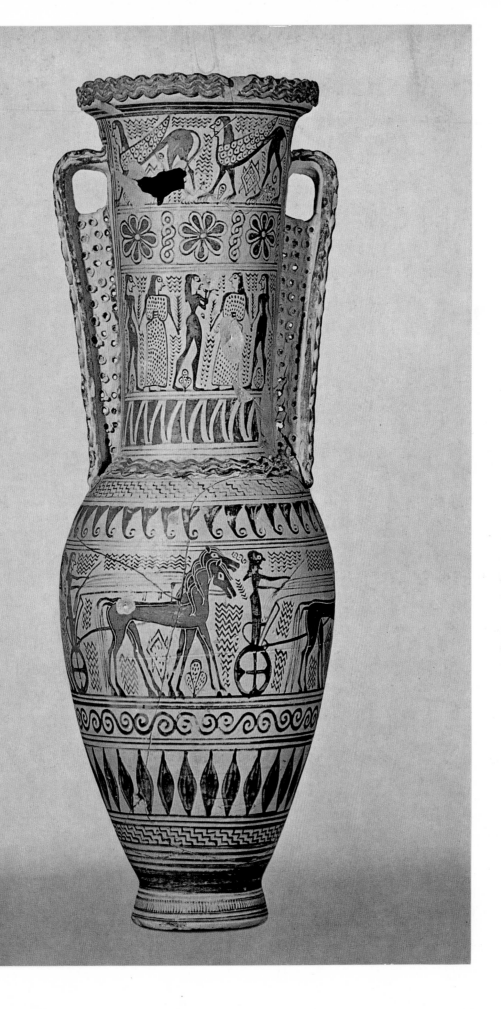

These Protoattic vase paintings point to the existence of true large-figure plaque and wall paintings. They consciously avoid the black-figure style because they aim at true painting. Odysseus, as befits the hero of Polyphemos's blinding, is painted white; such differentiation in clothing is seen in the figures on the bases of Protoattic vessels. One such scene depicts the assembly of the princes of Greece to hear Menelaos, designated as the main figure by an inscription, solicit their aid against Troy. Some Doric inscriptions of this kind, on vases originating in Attica and Aegina, seem to indicate a connection with the panel painting of the north-eastern Peloponnese; a suggestion reinforced by the evidence of the Tiryns shield.

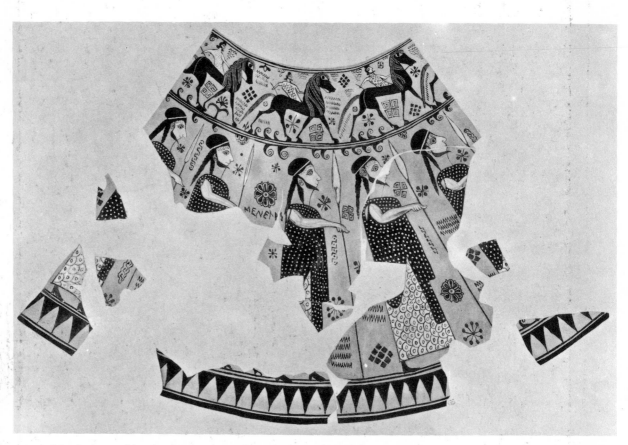

111 Menelaos assembles the Greek princes, from the base of an Early Archaic mixing bowl, from Aegina. Height, as preserved, 68 cm. First half of 7th century B.C. Berlin, Staatliche Museen

Some vases from the Cycladic islands also show the characteristics of large-figure plaque and wall painting, although these artists prefer more peaceful, ceremonial themes to the ones discussed above. For example, on a Parian amphora, now in Stockholm, the metope carries the picture of a single grazing deer, its long legs dividing the field in a bold zigzag pattern. On a Rhodian oinochoe (Munich) the main frieze shows a number of grazing goats. The idyllic effect of the scene is heightened by the rosettes, triangles and cross motifs scattered amongst the animals, by the lines of cable between the different friezes and above all by the large lotus flowers and buds at the foot. Another Cycladic amphora, from Melos, depicts the solemn encounter of Apollo and Artemis. Apollo, the lyre-player, stands in a chariot drawn by four winged horses. The decoration of the chariot-pole is lovingly depicted; the reins are loosely draped over one arm of Apollo's seven-stringed lyre to show how easily the god can handle the foursome while drawing heavenly music from the strings. The goddess Artemis appears before the horses, holding in her left hand a sacrificial stag and in her right an arrow; the garments of both deities are overlaid with complicated patterns. The two young women behind Apollo are perhaps the two Hyperborean maidens honoured at Delos, Arge and Opis. Patterns scattered between the figures fill the picture field like a carpet, while the rest of the vase is closely covered with spirals and palmettes.

152

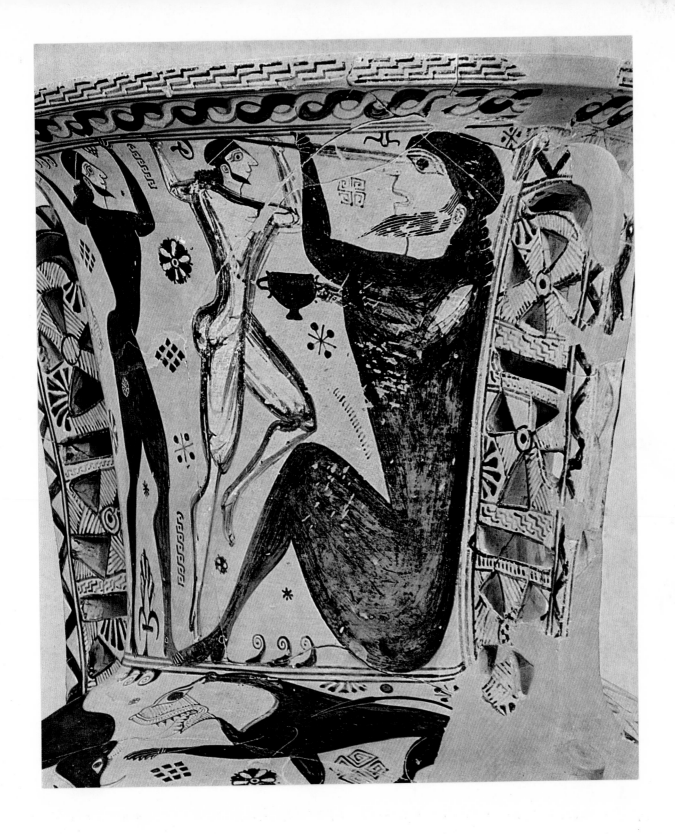

V Protoattic amphora, from Eleusis. From the neck: Blinding of Polyphemos by Odysseus and his companions. Total height of vessel 1·42 m. Ca. 670 B.C. Eleusis, Museum

71 right The fire burning in the eyes of the bronze youth from the Acropolis touched many figures of the early seventh century. We can sense this in cauldron attachments of true Greek origin, where the oriental models have been completely remoulded; we can understand the depth of experience behind the helmeted warrior in Delphi[2] and the Attic bronze figurine from the Acropolis, No. 6618, probably an ornament for a cauldron-handle.[3]

80 left In a female bronze figurine from the Menelaion near Sparta we can recognize a similar force. The head is almost as big as the upper part of the body. The widely-spaced staring eyes, the great eyebrows running together over the short powerful nose and the wide mouth all emphasize the strength of the features unified by the broad arch of the skull. The luxuriant hair, falling to the nape and then broadening out on either side of the powerful neck, also reflects the new purposive approach; the body conveys a full sense of volume which is somewhat restrained by a downward contraction into the hips and established only superficially in the flat thick-set abdomen. For, despite the large feet and the spreading hem of the garment just above the ankles, the figure does not truly 'stand'. A springing movement flows up from the slender waist, over the arms to the spread of the shoulders; the sculptor's obvious attempt to order his masses has not quite succeeded because of the dynamic outward movement.

 The new corporeality, exemplified by the swelling breasts, is an indication that a new great sculpture is being born. This bronze figurine from Sparta is of about the same date as the Protocorinthian lekythos
Fig. 108 showing Helen at Aphidnai. The absence of any attribution makes it unlikely that the figurine is of a goddess; the fact that it was discovered at the Menelaion in Sparta suggests perhaps that the subject was the 'much admired yet much blamed Helen' (Goethe).

 Dramatic adventures such as the blinding of Polyphemos, or the killing of Medusa, constitute the main themes of Early Archaic art; but the meetings of famous lovers of myth are also depicted. On a clay plaque[4] from Taranto, Theseus woos Ariadne as she spins the thread which is to guide him in the labyrinth. The long-legged, slender forms move towards each other with dance-like, springing steps.[5]

 That the dance was a subject of pictorial expression in the mythological themes of this period has a wider
81 significance. A magnificent ivory relief in New York has been regarded as a fine example of a group carving and attempts have been made to date the piece to the second half of the seventh century, i.e. in the Daidalic period. However, this pair of figures is not at rest, but caught, so to speak, in a wild dance, as the placing of the feet in profile shows. We are witnessing the delirious movement of maenads. The dancers are casting off their clothes; the head of the undamaged figure is turned back, the thick hair blowing in the wind. She has loosened her dress at the shoulder to reveal her naked body beneath, the high rounded thighs, the full breasts and the swelling pudenda.

 The second figure is less completely preserved, yet clearly of the same size as her companion, while the gesture of her left hand shows that she too has loosened her girdle—if she were tightening it, the thumb and first finger would be clasping the loose ends together. The figures, being of equal size, cannot represent a mother and daughter, or a goddess and her attendant. Nor does it seem possible that the artist intended these frenzied forms to represent two goddesses. Almost certainly they are the daughters of Proitos who were struck mad by the goddess Hera and ran wild in naked frenzy, until the seer Melampus healed them of their madness in the waters of the Lousos.

 This ivory relief of the Protides is surpassed by a half-life-sized hammered bronze figure of a youth,
80 right perhaps Apollo, found in Dreros together with two smaller female figurines. The technique used for the statue is an ancient one called sphyrelaton, in which separate bronze sheets are riveted to a wooden core; yet it is not simply the technique which leads one to date the work to the first half of the seventh century. The plant-like growth of the form, the loose interrelation of the torso and limbs, belong to an ancient tradition. Despite the constriction at the waist and the clear connection of the parts to the whole, there is scarcely a hint of any horizontal axis. The restful parallel placing of the legs reinforces the over-all impression of a failure to understand the statics of the problem. The buds which were to blossom into Greek sculpture have not yet opened.

The expressive achievements of Early Archaic art were applied to the decoration of pithoi, large storage vessels with magnificent relief scenes of gods and heroes. On one, a great goddess is depicted with upraised 82 arms, flanked on either side by two huge lions, while two smaller figures in long dresses clasp her body. The scene on the neck of a pithos recently discovered on Tenos[6] shows the birth of a winged and armed warrior from the head of an enthroned, winged deity. A relief pithos from Mykonos carries a pictorial account of 83 the Sack of Troy. The cruel atrocities of the victorious Greeks are depicted in the friezes. With great flashing swords the soldiers threaten defenceless women and mothers who, with arms upraised, implore mercy as their children are slaughtered before their eyes. The picture on the neck leaves no doubt of the events described; it shows the famous wooden horse on its high legs with wheels on the feet. The whole of the available picture space is filled with figures of armed warriors; the artist has not concerned himself with the epic events leading up to the fall of Troy, but has chosen the dramatic high point of the action. The Greeks in their strange horse are already within the walls and now the horse, the masterpiece of the wily Odysseus, begins to come to life. From its body and neck, as if in a metope and triglyph frieze, the heads of the Achaeans emerge, their great eyes stare down and the concealed weapons have been brought out—helmets and shields and baldrics heavy with menace for Troy.

Just as the artists of the first half of the seventh century chose the stirring or violent events of legend and depicted them with all available means of expression, so even the utensils of the period are decorated with wild animals and fabulous monsters. A small Tarentine clay plaque in Bari shows a round-bodied cauldron of the old style with great ring handles. Next to it stands a cauldron of the Early Archaic period, its rim decorated with griffin protomes. Lion and griffin protomes of this kind have been found in great numbers, 79 above all at Olympia. Originally they were beaten out of bronze sheets, later they were cast, as was the splendid example illustrated. With it, we stand on the threshold of a new stage of Greek art.

EARLY ARCHAIC SCULPTURE · 660–620 B.C.

Though earlier works had contained hints of what was to come, the true style of Greek monumental sculpture did not burst into bloom until the mid seventh century. The earliest known example of the new development is the slightly more than life-size statue of Artemis dedicated by a virtuous lady, Nikandre, at 84 left the Sanctuary of Apollo in Delos. The goddess stands on her long legs, her arms flat at her sides; a broad girdle separates the upper from the lower part of the body, and apart from the plinth and the lower hem of the garment it constitutes the only effective horizontal axis. Emphasis falls on the upper part of the body despite its short proportions and the smallness of the head, which attracts attention by the triangular frame formed by the hair falling to the shoulders. Despite severe surface damage, the statue nevertheless emanates a tender grace which is the stronger because of the flat, indeed angular, carving of the lower part of the body and the restrained plasticity of the whole. The statue is, by every criterion of form, a true example of the sculptor's art. The particular beauty of the work resides in the lucid articulation of the form which seems to grow naturally like a plant, in the lively interplay between the flat belly and the plastic treatment of the rise of the bosom, and the way in which the triangular elements of face and hair interlock. The sculptor has achieved a compact formal discipline; there is an inner dialogue between swelling and restrained volumes, a clearly organized effect of corporeality within a taut, vital contour. This statue is, above all, distinguished by a balanced unity of statics, dynamics and tectonics, and thus occupies a significant place amongst seventh-century sculpture at the beginning of its classic phase. Closely akin, despite its small size, is the wooden statuette of Hera discovered during the last excavation led by E. Buschor in the Heraion at Samos. This 85 left superb piece is informed by a true monumentality of conception which transcends its physical dimensions. It has been described, with good reason, as a miniature representation of the ancient Samian cult statue of Hera.

The important work of disciplining and directing the passion and force which filled Early Archaic sculpture was promoted both on the mainland and the islands, and we can trace this new subordination of passion, amounting almost to sobriety, in numerous works important in the history of Early Archaic art. This period has been named after Daidalos whom the ancients credited with the earliest statues of the gods. There is not, however, a single statue which, on the strength of an inscription, can be attributed to any

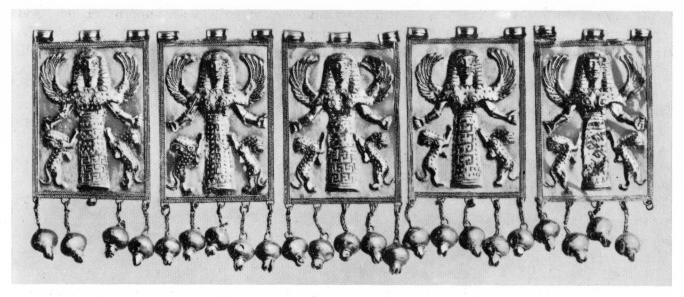

112 Part of a necklace of repoussé gold plaques, from Kameiros, Rhodes. Height of individual gold plaques 4·2 cm. Not before middle of 7th century B.C. London, British Museum (after Higgins 1961)

sculptor of this name, and the entire range of works from such widely separated parts of Greece can scarcely be ascribed to a single artist. Nevertheless, in using the term 'Daidalic' art we are following the Greek sense of history, which traced the birth of Greek monumental sculpture back to a Πρῶτος Εὑρέτης, that is the originator, Daidalos.

84 right A limestone figurine in the Louvre in Cretan style, the 'Auxerre statuette', represents an advance on the Artemis from Delos described above. It stands more firmly and suggests greater awareness; the drapery of the long skirt and the curve of the bosom are handled to more powerful effect; the arms are freed from the body and emerge from the shoulder-cape like flower stems from a sheath of leaves, the long-fingered right hand gesturing towards the left breast. The hair in all its fullness frames the face which appears as a triangle suspended between the supporting triangles formed by the heavy locks. The fierce glance which burned from the great eyes of the earlier statues has been tamed, the features are expressed in a restrained manner in the lines of the countenance. This new type of female statue won popularity throughout the Greek world

Fig. 112 with astonishing rapidity; in terracotta statues on the mainland, on a set of repoussé gold plaques from Rhodes, designed to be strung together as a necklace, or in distant Tarentum on a clay votive plaque[7] representing a goddess. Of this last piece only the lower part of the body survives. The dress is richly decorated with three figure-friezes; in the topmost of these we see Ajax with the body of Achilles, next a chorus, and finally a round-dance of youths and maidens. The figures of the girls can be compared with the

85 right goddess of Auxerre, the youths with a Cretan statuette from Delphi, which for the first time presents the Archaic form of the kouros.

80 right The stereometric forms of the sphyrelaton Apollo from Dreros are moulded in such a way as to convey their essential organic attributes. The breast seems to heave of itself, the girdle, which emphasizes the contraction of the hips between the lightly bent arms, is not simply decoration for the body, or merely there to articulate the figure, but is plastically treated so as to bring out its quality as leather. The contour loses its primacy to the precise, organized plastic forms which are the secret of the vitality, contained yet pulsating, of the whole figure. For the first time the position of the feet is different, and the same applies to the deliberate positioning of the arms, auguries of the rich future in the Greek portrayal of youth.

86 A kindred richness and heightened sensibility is achieved in a metope from Mycenae, which depicts a deity in the act of unveiling. The hair that frames the face is, unlike that of the Auxerre statuette, which is arranged in thick vertical rolls, given a triangular shape with step-like ridges; the face of the goddess emerges blooming and springlike from the veil. The theme of this metope is unknown to us. Perhaps Hera herself is intended, the noble wife of Zeus who especially loved the cities of Argos and Mycenae. The sculptor was undoubtedly a north-east Peloponnesian master following Cretan models.

156

An ivory relief of Perseus killing Medusa, from Samos, shows a related feeling of movement and precise *87* representation. But it is hard to accept the idea of an indigenous Samian school working in this style. The strict composition suggests that in fact this work derives from the Spartan tradition of ivory carving and a Spartan origin would certainly account for the artistic similarities to the Mycenae metope relief.

A true Samian tradition is represented by a somewhat earlier ivory carving of a kneeling youth, dating *72* from the turn of the third and fourth quarters of the century and obviously designed as an ornament for some luxury article. D. Ohly has suggested that it was one of a pair of finials for the arms of a kithara. The *Fig. 113* delightful glow that illuminates the face, the soft yet disciplined line of the cheek, the swelling fullness of the silken hair lovingly disposed in zigzag waves are all typically Samian. This interchange of influences between Laconian and Samian work may explain a clay head of a youth of about the same period found at Sparta.[8]

The art of ivory carving was not confined to Sparta, Samos and Corinth. Two magnificent ivory lions now in Copenhagen were undoubtedly produced at Tarentum, a sister-city of Sparta, at the beginning of *89 above* the last quarter of the seventh century. Together with a female figure of Artemis, surviving only in fragments, they decorated a small wooden box. Even the jewellery and trinkets of mortal women could be decorated with sacred subjects; possibly the object in question was 'a little box for sweet-smelling oil and *Fig. 114* other such things that ladies need'. Sappho called such little trinket boxes '*gryta*'; with gold chains, rich purple gowns, silver drinking vessels, even ivory carvings, they constituted typical wedding gifts for a young lady.

The significance of Corinth's contribution to Daidalic sculpture can be gauged from the terrifying lime-stone lion, found in her daughter-city of Corcyra. The mighty animal lies menacingly on its plinth, its tail *89 below* between its hind-legs, the fore-paws extended. The fore-legs and paws frame the fierce head of the animal so as to give full expression to the dark menace of the world of the wild. A strong roll of muscle marks off the face of the animal from its neck. A vertical channel separates the muscles on the brow; the muzzle is indicated by interlocking 'V' and 'U' lines which terminate in great bow curves.

The lion of Corcyra can be compared with a lion on a Protocorinthian aryballos in Berlin, produced soon after the mid seventh century;[9] the comparison, first drawn by Payne, deserves consideration. The early dating of the lion encourages a comparison with the limestone goddess of Auxerre, which reveals *Fig. 84* points of similarity in the treatment of the curves, the linking of the volumes, and the decisive boundaries between the limbs and other parts of the body. The world of gods, men and animals constituted a great

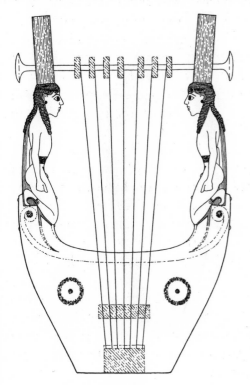

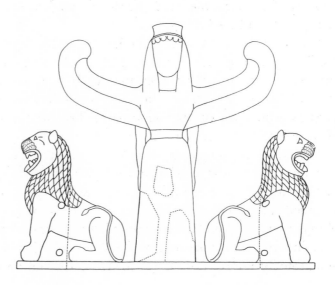

113 Reconstruction of a Samian kithara, Cf. plate 88 (after Ohly 1959)

114 Ivory decoration of a Tarentine wooden box. Reconstruction. The ivory lions are shown in plate 89 top.

single unity, and for all of these various aspects of the universe the artist of the seventh century used the same vocabulary of forms.

EARLY ARCHAIC PAINTING · 660–620 B.C.

Fig. 115 A back-plate of a corselet (now lost) from the Alpheios, offers an interesting example of the transition to the painting of the period; on the one hand its plastic form embodies the contemporary image of man, and on the other its rich engraved decoration illustrates the graphic art of the third quarter of the century. Rampant lions are depicted on the shoulder-blades, while beneath, in the next frieze, two bulls are shown facing one another; in the trough between the shoulder-blades, the artist has worked a design of panthers and sphinxes with their fore-paws touching. The main frieze is of a round-dance of gods. Apollo the lyre-player is the main figure; behind him come two dancing maidens. On the left of the scene three male figures dance to the music of the god; their bearded leader cannot be Zeus, since the only occasion on which he is described as having danced was at the celebration of his victory over the Titans. Of the other two figures, one is probably Hermes and the other either Hephaistos or Dionysos, the sons of Zeus and brothers of Apollo. The probable subject is Apollo's entry to Olympus, described in the Homeric Hymn to Apollo:

> While Apollo plays his lyre, stepping high and featly, and a radiance
> shines around him, the flashing of his feet and close-woven chiton. And
> they, even the gold-tressed Leto and wise Zeus, rejoice in their great hearts
> as they watch their dear son playing among the immortal gods.

The animal friezes on the shoulder-blades of this corselet may be compared with Ionian (Chian) work
90 such as the chalice in Würzburg, No. 311; and a similar organization of the friezes is found on the so-called

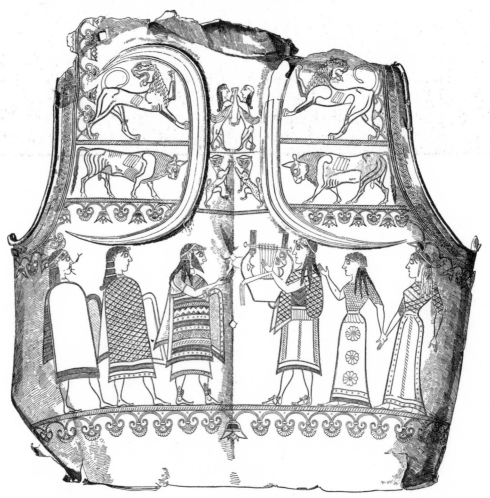

115 Entry of Apollo, playing the lyre, into Olympus and dance of the gods, from a now lost bronze corselet from Olympia. Height about 44 cm. Ca. 650 B.C. (after *Olympia IV*)

158

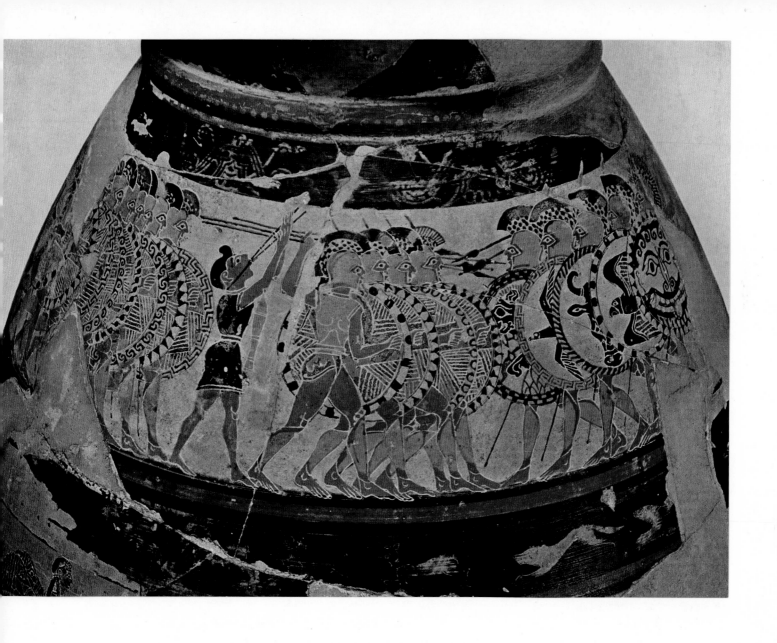

VI From the Late Protocorinthian oinochoe, so-called Chigi Vase. Hoplites going into battle. Total height of vessel 26 cm.
Ca. 640 B.C. Rome, Villa Giulia Museum. Cf. plate 76

92 Chigi Vase, of about the same period. This, a Late Protocorinthian work, has not only superseded the miniature format of the earlier aryballoi and lekythoi but also, in the three picture-friezes, achieved a notable firmness. The bright ground and the differentiation of the hoplites, horsemen and hunters by tones of brown and yellow all betray the influence of large-scale painting. Particularly excellent is the rich deployment of

VI pictorial techniques in the top frieze, which shows hoplites advancing to the attack to the sound of the strident aulos. A realistic, unschematized formation of the troops is achieved by the bold overlapping of figures. With a typically Corinthian enthusiasm for detail, the artist has recorded helmet crests, body armour, greaves and, with particular delight, a number of shield blazons; terrifying Gorgon-heads, birds of prey, bull and lion protomes, and even the inner sides of the shields of men advancing to the right are treated with great variety. In this example, the linear contour style has achieved a pictorial effect which one feels can hardly have been surpassed by the wall and plaque painting of the Daidalic period.

116 Lysippe and Iphianassa, the daughters of King Proitos of Tiryns. Reconstruction drawing of a painted clay metope from the Early Archaic Temple of Apollo at Thermon. Height about 60 cm. Ca. 625 B.C.

The importance of Corinthian painting becomes even more apparent, if we compare the Chigi Vase

91 with the small painting on the Rhodian plate, London A 749. The treatment of Menelaos and Hektor fighting over the body of Euphorbos echoes the style of the Corinthian hoplite scene. The only indication that the scene is the work of an artist with experience of an Ionian landscape is the number of tendril volutes, palmettes, cable patterns and rosettes. In this plate we can see that even at the end of the seventh century traditional modes of painting persisted.

No authenticated works survive of the highly esteemed Corinthian painters, Aridikos and Ekphantos; yet we can gain a reliable impression of their major painting from the clay metopes discovered in Aetolian

93 above Thermon. These depict enthroned Charites in richly ornamented gowns; Perseus fleeing with the head of Medusa, and on a metope originally adjoining this, the head of the Gorgon itself; another shows a lion, and yet another a Chimaera.

A hunter strides home with his kill slung from a pole over his shoulders; clearly the artist intended a figure

93 below from mythology, perhaps Orion, since mythological themes constituted the exclusive pictorial decoration of Early Archaic temples. Another set of metopes form a group because of their outrageous themes. One

VII shows Chelidon, designated by an inscription, and her sister Aëdon, who killed the boy Itys; another fragment shows a man and woman standing, making love. The faint traces on the fragment of another

Fig. 116 metope enable us to distinguish a representation of the daughters of Proitos, who audaciously challenged the goddess Hera and were driven out by her, possessed, to range wild through the land of Arcadia. It is said they boasted that their father's palace was more splendid than Hera's temple at Argos; or, according to another version, that their arrogant conceit made them refuse every suitor, so that Hera, the patron deity of marriage, punished them with madness. They were struck with a disease of the skin which caused their hair to fall out, and, because of the maddening pain of the sores, they tore off their clothes. Our comments on the ivory relief shown on plate 81 are pertinent (see page 154).

All these subjects are treated in a large format which dispenses with secondary motifs. Both the format and the coarseness of the clay excluded the use of incised detail; the flesh of female figures is white, that of male figures brown, while the garments are either cherry-red or white. Meander patterns or bands carrying triangular patterns or rosettes, frame the pictures. Even though the inscriptions on these large-figure paintings

VII From a painted clay metope, from the Early Archaic Apollo temple at Thermon. The sisters Chelidon and Aedon. Total height about 60 cm. Ca. 625 B.C. Athens, National Museum. Cf. plate 77

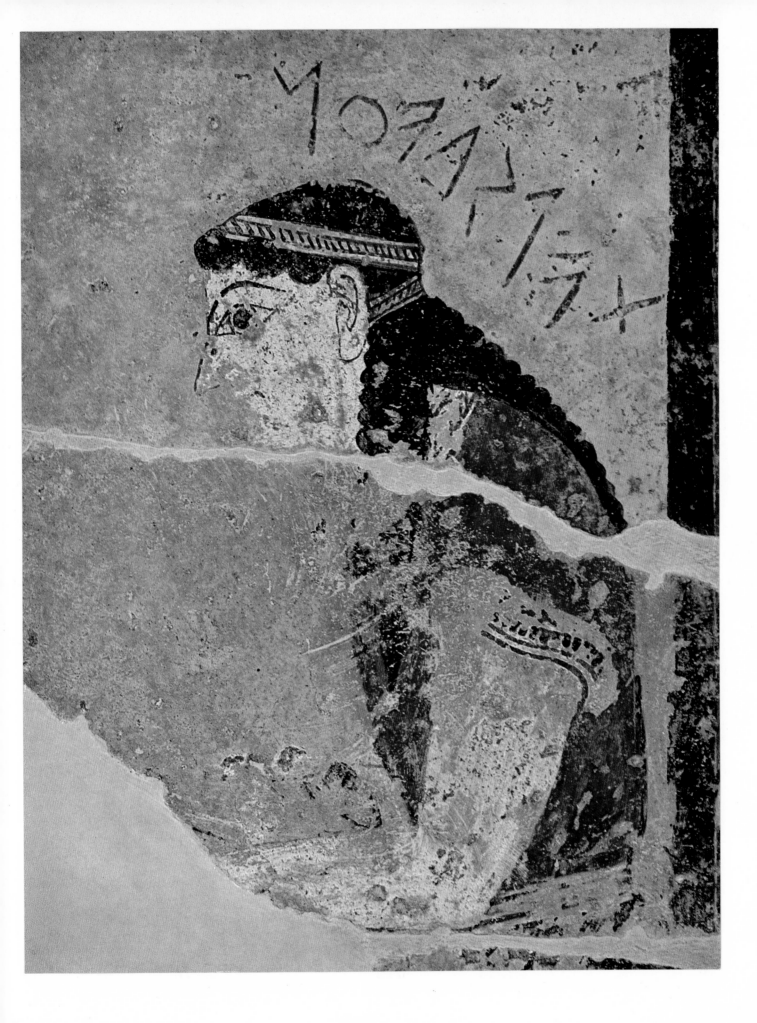

from Thermon are in the Achaean and not the Corinthian alphabet, one may nevertheless regard them as fair indications of the nature of Corinthian major painting. The fragments of painted metopes from Kalydon are less well preserved, but conform closely in style.

THE SEVERE STYLE OF ARCHAIC SCULPTURE · 620–570 B.C.

In the last quarter of the seventh century a style of painting came to maturity in Athens which seemed to challenge the supremacy of the Corinthian masters. Associated with this development was a series of more than life-size sculptures of youths, whose style and appearance become increasingly impressive towards the turn of the century. An almost undamaged figure of a youth (now in New York) presents us with the first example of the Attic sculptor's image of man. Even the girdle, which in earlier Doric and Ionian work had been the conventional indication of a garment, has gone, and the body, radiant in its nakedness, soars in an uninterrupted sweep from feet to head. This is adorned with luxuriant locks of curled hair fastened by an elegantly knotted fillet. The left leg is advanced and the hands, lightly balled into fists, rest against the upper thigh, though the arms are free of the body. The contours of the upper part of the body are contained by taut curves, which, with the slight drawing-in at the hips, heighten the effect of the figure's supple slenderness. At the same time the piercing of the rectangle formed by the arms and the upper body gives the whole composition a remarkable freedom and mobility. In the same manner the small space between the legs, together with the undulating contour of the thighs, produces a masterly effect of lucidity. With justice, this kouros is regarded as being imbued with the spirit of Apollonian clarity. Figures like this were not intended as representations of the god Apollo himself. Many were placed on the graves of the dead; stone embodiments of life at its richest and fullest, which should perpetuate life itself.

The use of Island marble is a physical indication that the artist was familiar with the brilliant and massive masterpieces of contemporary Cycladic sculpture. There survive a kouros from Thasos, three incomplete colossi in Naxian quarries and the plinth, upper torso and loins of a giant statue of Apollo, originally 9 metres high, on the island of Delos. A comparison of the work under review wifh the Naxian colossi, their predecessors and Doric works (like the Cretan youth from Delphi, see page 156) reveals the distinctive nature of the art of the Attic master, holding a middle course between these different styles. The restrained, coy, even tentative technique he employs to render the human figure effective in a large context, by making the most of plastic form, reducing detail to a minimum, and accenting certain aspects, constitutes the main charm of this figure.

Yet the early mastery of this kouros is excelled by a closely related work by the same artist. It survives in fragments: the head, 44 cm. high, discovered in 1914, the right hand, found in 1933, and parts of the back, the left upper thigh with the left hand attached, the left shoulder and the right knee, all excavated in the Athenian Agora between the years 1936 and 1955. The name of this pioneering sculptor is not known, and he is called the Dipylon Master, from the district where the head was discovered. This second piece is not simply larger than the earlier one, being about 2·5 metres high, but represents a more complete mastery and a stricter concentration of the means of formal expression. The component parts are more generously treated, the surfaces flowing freely into one another; the pearl-like ornamentation of the hair is worked out in a more unified manner, and the traditional elegant precision has been superseded.

More powerful still are the figures of three youths found on Cape Sounion. The best preserved of the three, Athens 2720, is 3 metres high. The span of the shoulders, the swelling of the breast, arms and thighs are all more telling. The plastic effect of the finely-shaped ears, of the powerful knee-caps and the surrounding musculature, is brought out more fully. Yet through all these innovations, which themselves bespeak a remarkable and individual talent, shines the inspiration of the New York kouros. The youth of Sounion shows the admiration felt by sculptors for the Attic vision of the youthful form in sculpture as established by the Dipylon Master; but more than this, it shows how another great sculptor gave expression to this vision, even when extending it in his own work. The tradition begun by the Dipylon Master continued far down the ensuing centuries. The standing goddess in Berlin represents this continuation in the first quarter of the next century and forms the transition to the work of Phaidimos, which we can trace in fragmentary remains up to the middle of the century. The acroterion of a running Gorgon, which adorned a Ripe

117 Running gorgon, from the ridge acroterion of a Ripe Archaic temple on the Athenian Acropolis. Probably by the Dipylon Master. Reconstruction drawing (after Schuchhardt 1935/36)

Archaic temple on the Acropolis, must derive from the Dipylon Master himself. The traditional clarity of line is combined with a new fullness in the cheeks and the undulations of the hair on the brow. The hand of the Dipylon Master is betrayed not only in the harsh definition of the lips and the flat lolling tongue, but also in the formation of the eyes and the great volutes formed by the shell of the ear, and the way the bared teeth and the sharp fangs are ordered. The demonic pictures of the Gorgon by the Nessos and Gorgon *104–106* Painters are stamped with the influence of one of the greatest of Attic sculptors.

About the turn of the century, Archaic sculpture reached a high level of maturity. The statues of the brothers Cleobis and Biton embody the new powers *99* of expression not simply in their formal, but also in their symbolic aspect. Herodotos (I, 31) records that the Argives dedicated the statues of the two brothers at Delphi and recounts their story as told by Solon to King Kroisos. One day the mother of the twins was preparing to journey to the Temple of Hera, but the oxen had not yet been harnessed to her car or even brought up. Seeing that their mother might arrive late for the temple ceremony, the two young men harnessed themselves to the heavy vehicle and dragged it to the temple, a distance of 45 stadia. The priestess entreated the gods to reward such filial piety with the greatest blessing in their gift; her prayer was heard and the exhausted youths fell into the sleep of the Blest from which there is no awakening.

The two statues were recovered during French excavations at Delphi. They are full of the unrestrained vigour of youth; thighs like sturdy pillars support the bodies whose central axes are clearly indicated by the line between the lightly clenched fists, the genitals and the boundary of the pubic hair. The lightly flexed arms contain the weighty mass of the upper part of the body and the gradual widening of the torso towards the shoulders is echoed in the powerful broadening of the face up to the temples. Both low foreheads are fringed by curling locks of hair, and the broad necks framed on either side by three column-like tresses. The weighty articulation of these bodies calls to mind the very much older Geometric cuirass from Argos *Fig. 106/107* (see page 131). The damaged inscription names the sculptor as the Argive master, Polymedes. His powerful figures stand in relation to the Dipylon Master's youth, as the works of Polykleitos to those of Pheidias. The restful, slightly inclined bodies of Cleobis and Biton embody all aspects of the art of sculpture.

A larger than life-size limestone head, probably from the seated cult statue of Hera at Olympia, is in a *98* related style. The forms of the face are set off by a crown of leaves, a fillet and the wave-like play of hair over the forehead. Even though faded, the painting of the pupils still conveys something of the original power of the look in the statue's eyes; a second accent is provided by the narrow tight lips. In this work

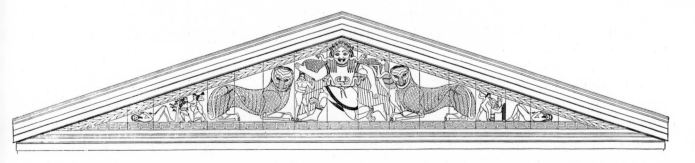

118 West pediment of the temple of Artemis on Corfu (Corcyra). Reconstruction drawing (after G. Rodenwaldt 1938)

163

Fig. 118
101

the sculptor, probably a Spartan, has imbued the facial expression with a new warmth and humanity. The statue dates from about the same period as the Gorgon by the Dipylon Master.

The powerful relief in the west pediment of the Temple of Artemis on Corfu (Corcyra), belongs to the first quarter of the sixth century. The centre of the pediment is dominated by the snake-girdled figure of Medusa, between her children Pegasos, the winged horse, and Chrysaor. Corcyra was a daughter-city of Corinth and this work bears the stamp of a Corinthian master's hand; comparison with the Gorgon head

Fig. 117

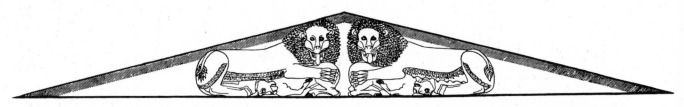

119 The oldest poros pediment on the Athenian Acropolis. Reconstruction drawing (after Schuchhardt 1940)

of the Dipylon Master only reinforces such an impression. Pindar, in his *Olympian Ode* (13. 20), honours the Corinthians, who, as the inventors of the pediment, 'were the first to set the double form of the king of birds upon the house of the gods'. We are able to build up the full original composition from numerous fragments which have been recovered. Two couchant panthers on either side of Medusa symbolize the menace of wild nature; the traditional figure is powerfully intensified. The primeval terror and its familiars, which claim the main section of pediment, are balanced by the scenes on either side and the prostrate figures of wounded naked warriors in the angles of the pediment. The group on the right represents the struggle between the young Zeus and his father Kronos for the lordship of heaven; on the left is a figure, presumably female from her posture and dress, threatened by the point of a lance. In the light of Corinthian clay plaques, one can guess that the attacker was a naked warrior, probably Poseidon who assailed his own mother. Behind Rhea, 'with the loftiest throne of all', can be seen the tower of Kronos and behind Kronos himself, a tree, which symbolizes the 'land of shimmering trees' which he and his consort ruled over in the Golden Age.

100
100 right
100 left

From the earliest years of the sixth century on, a series of buildings was erected on the Athenian Acropolis embellished with limestone pediment sculptures. The earliest of these poros pediments showed two antithetic lions tearing at their prey. Two later lion pediments come from the oldest of the Athenian peripteral temples. A simpler scheme with two couchant lions in the centre and serpents uncoiling in the angles, may have adorned the back of the great structure, whose sima was of marble decorated with a noble palmette and lotus pattern. The Gorgon acroterion was the work of the Dipylon Master in his old age (see page 162). The breakthrough into a new colourful world of legend, full of narrative art, is signified by the supposed east pediment of the temple. This shows the battle of Herakles against Triton in one half, and a three-bodied monster in the other. The serpent body of Triton balances the snake bodies of the three-bodied one (sometimes called Blue Beard from the colour of his hair), which are drawn together into a thick cable. In

Fig. 119

Fig. 120
Fig. 117

Fig. 121
102

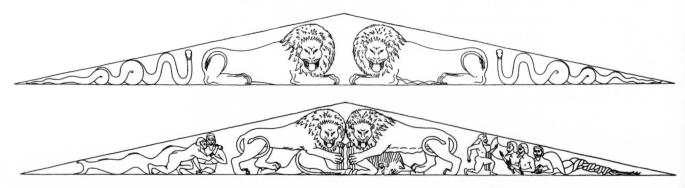

120/121 The two pediments of the oldest peripteral temple on the Athenian Acropolis. Reconstruction drawing (after Schuchhardt 1940). 120 The 'serpent' pediment from the west front. 121 The later 'lion' pediment from the east front. Cf. Plates 102 and VIII

164

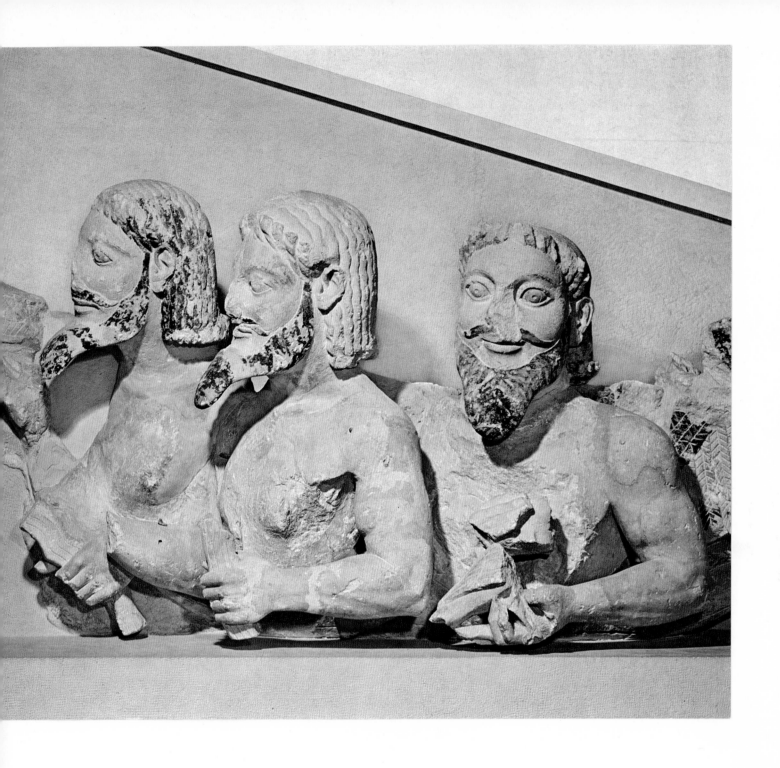

VIII Corner group from east pediment of the old Temple of Athena on the Athenian Acropolis. Nereus the Three-bodied.
Limestone. Length 3·40 m. Ca. 570 B.C. Athens, Acropolis Museum. Cf. plate 86

his left hand the triple monster holds a bird, a flame and a wave of water. The centre of the pediment was probably dominated by a group of two lions tearing at a powerful bull, which drew the two halves of the field together.

To grasp the measure of maturity which had been achieved by Attic sculpture one must compare the torso of the three-bodied one, inspired by sheer delight in existence, with the Dipylon Master's Gorgon on the same building, where ornament has been used to achieve a brilliant intensity of form.

120

Fig. 117

In this Triton pediment, 'a warm domestic spirit breaks through' (Buschor). It is inspired by a palpable earthy immediacy, somewhat elevated perhaps, but essentially the same spirit as finds its highest realization in the Calf-bearer. The inner sympathy between the great poros pediment and the worshipper bearing his sacrifice to the altar proclaims them to be by the same hand. This supposition, by no means new, gains weight when one takes into account the differences of the materials, in the one case limestone, in the other marble, and the time lapse between the two works. The marble group is obviously the later. The donor, named in an inscription as Rhombos, piously carries the calf on his shoulders; with arms crossed he holds the legs of the beast, shown in all its animal innocence. The man's forearms and the calf's legs form a cross over his torso which asserts in a truly arresting manner the interdependence of the human and animal worlds. The scrotum of the calf rests on the man's left shoulder, the tail hangs down his left arm; the head with pricked ears, great eyes and channelled nostrils forms with the face of the bearded donor a quite compelling union of unlikes. The man's body shows through his unconcealing garment as he approaches to bring the goddess her gift.

103

The pediments showing Herakles's fight with the Hydra,[10] his entry into Olympus[11] and the adventure of Troilos[12] achieve neither the inner greatness nor the truth of the unknown master of the Calf-bearer. Their detailed forms give them a marionette quality, like an early painting rendered as sculpture.

THE SEVERE STYLE OF ARCHAIC PAINTING · 620–570 B.C.

Developments in painting paralleled those in sculpture. In Corinth large vessels like the column-krater in the Louvre (E 635) took over the tradition of large-figure painting (see Thermon metopes, page 160). The delight in enumeration and frieze-like treatment of figures is exemplified in the scene of the banquet of Iphitos where the guests, all named with inscriptions, are disposed on four couches. The plates, foods, drinking and mixing vessels are all depicted, even the dogs leashed to the legs of the couches; yet the descriptive details of the Chigi Vase have given place to a conscious emphasis on the main action of the scene. Klytios and Toxos are drinking and talking together on the first couch, Didaion and Eurytos on the second; Iphitos and Herakles are to the right on separate couches. Iole stands between these two, the main figures, her head turned towards her brother but her body hesitantly, shyly bending towards Herakles, who is peeling a fruit and looks steadily at the girl destined to cause his downfall. The strength of personal passion, which had been expressed by Sappho of Lesbos at about the same period, is portrayed in a dramatic moment; here the most intimate emotions have been unveiled and their effects on human intercourse shown.

IX

92, VI

Amphiaraos took part in the campaign of the Seven against Thebes, persuaded by his wife Eriphyle who had been bribed with a necklace to do so. Ismene, sister of the warring brothers who had instigated the campaign against Thebes, dies a fearful death. For her unfaithfulness Tydeus kills her on the orders of Athena, while Periklymenos, her lover, flees. Such subjects from the epic cycle are treated on these Corinthian vases with telling dramatic force.

Fig. 122

X

The favourite themes of Athenian vase painters at the turn of the seventh century were monsters of legend such as the Chimaera, the Gorgon, or Nessos, and the spirit of the epoch is reflected in the names given by modern scholars to the painters, the Chimaera Painter, the Gorgon Painter and the Nessos Painter. The Chimaera on the krater in the Kerameikos[13] and the neck-amphora in Athens National Museum (1002), from which the Nessos Painter is named, both show a bias towards enlarged forms comparable to that in the giant youth from Sounion. The Gorgon Painter continues the work of the Nessos Painter yet evinces a trend away from the over-sized form. A differentiated, controlled and highly-charged style has been achieved which is to lead to the supremacy of the Attic black-figure style over the still important Corinthian masters. To measure the pioneer achievement of the Gorgon Painter one must set it against earlier work on

104

96 right

105/106

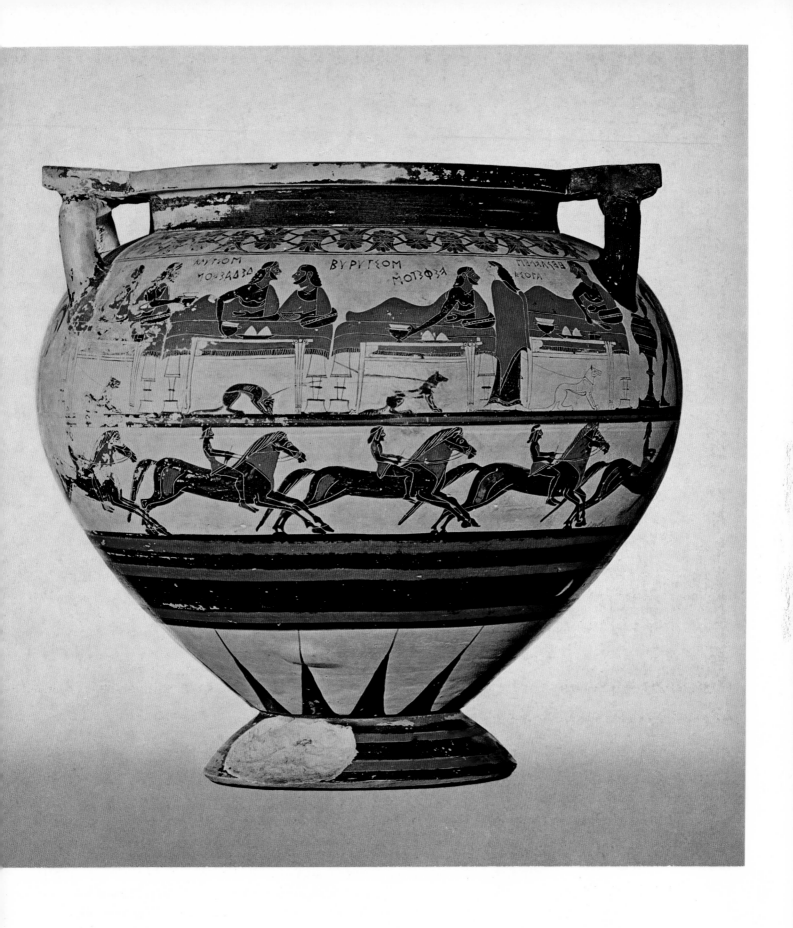

IX Early Corinthian column-krater. Banqueting scene in the house of Iphitos; below this, frieze with riders. Height 46 cm.
Early 6th century B.C. Paris, Louvre E635

the Eleusis amphora and the belly of the Nessos amphora. He has unified the surface of the vase by the dynamic interconnection of main picture frieze, palmettes and lotus flowers and animal friezes. The manner is new but recalls the achievements of Attic Geometric painting of long before. Awareness of Homer is the over-all mark of the period of Solon. In these decades the *Iliad* and *Odyssey* received their final form in Athens, as did many other epics now lost save for fragments and references.

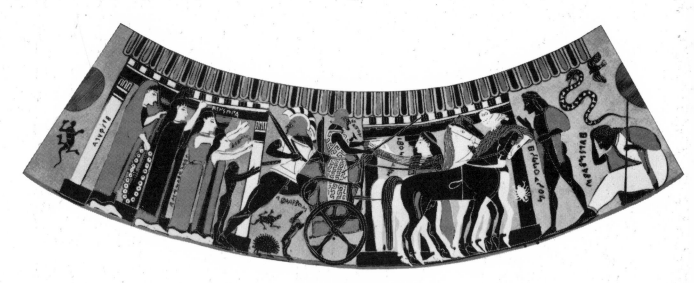

122 Amphiaraos setting out on the campaign of the Seven against Thebes, from a Corinthian krater in the Staatliche Museen, Berlin (F1658), now lost. Ca. 560 B.C.

XI A fragment from a dinos carries a scene which is inscribed not only with the artist's name—Sophilos, but also with the subject—the funeral games for Patroklos. The bearded spectators of the chariot race are to be seen on a grandstand excitedly gesticulating, standing up, or craning forward as they follow the event. The *97* work of Sophilos is as closely related to that of the Gorgon Painter as the standing goddess in Berlin is to *95/96* the statues by the Dipylon Master; a number of fragments from the Acropolis showing the procession of the *105/106* gods to the wedding of Peleus come from a vase like the one in Paris by the Gorgon Painter; far more has survived of an as yet unpublished vase in an English private collection, which bears an inscription showing it to be by Sophilos. Fragments of the foot and the turned column-like base witness to such a close connection with the Gorgon Painter that it must originate from the same workshop. The scene of the wedding procession not only expresses the contemporary delight in epic themes but also clearly mirrors a famous, possibly Attic painting of the sixth century. Possibly it originated with the Gorgon Painter, being repeated *107-111* at least twice by his pupil Sophilos and a third time by Kleitias, who apparently also worked in this same workshop. His great mixing vessel, excavated in an Etruscan grave and named the François Vase, is 60 cm. high and was made by the potter Ergotimos with whom Kleitias collaborated on a number of other works. This vase, now in Florence, is a rare jewel of the painter's art. Two hundred figures in six friezes densely cover the surface; 143 are identified by inscriptions; as a result, a treasure of epic themes has been brought together within a unified cycle. A veritable *Biblia pauperum* is laid open for the observer's delight and admiration. In the top frieze of the obverse Peleus takes part with Meleager and Atalanta in the hunt of the *108* Calydonian Boar; the neck frieze depicts the funeral games for Patroklos, with the tripod prize at the right-hand border. The main frieze—in the zone of the horizontal handle—depicts the great progress of *107, 110* the Gods, Graces and Muses to the wedding of Peleus and Thetis and circles the entire vase. Beneath it comes *109* a scene from the fall of Troy: Achilles in pursuit of Troilos. On the reverse, opposite the account of Achilles, the chief hero at Troy, and his ancestry—Peleus and Thetis were his parents—Kleitias places typically Attic *111* subjects: the joyful dance of the Athenian youths and maidens, saved from death by Theseus's killing of the *111 below* Minotaur; the battle of Theseus against the Centaurs and the return of Hephaistos to Olympos. Accompanied by Dionysos and his tipsy companions led by Silenos, Hephaistos merrily approaches Olympus, riding on his donkey. Only the skill of this patron of Athenian craftsmen can free Hera from the bonds by which he

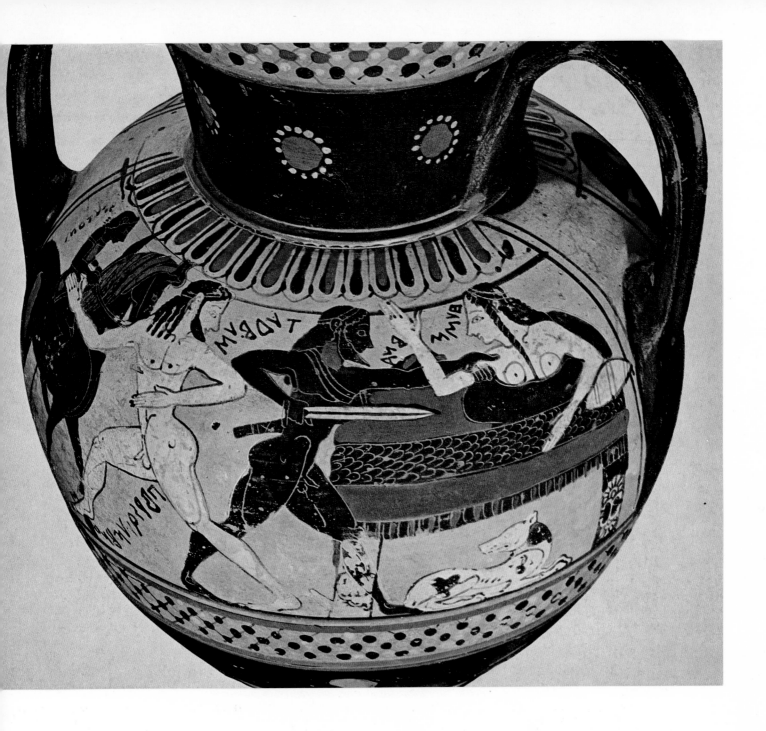

X Late Corinthian neck-amphora. Tydeus stabs Ismene. Height 32 cm. Ca. 560/550 B.C. Paris, Louvre E640

himself had bound her to her throne. The animal frieze, which occupied a comparatively important place in the work of the Gorgon Painter and of Sophilos, is here relegated to a humble position; the conical foot of the vase carries a frieze of figures showing pygmies fighting cranes.

RIPE ARCHAIC PAINTING · 570–530 B.C.

Only with the second quarter of the sixth century do a number of vases appear which can be identified as the work of named painters such as Nearchos, Lydos, and Exekias, and their work continues until around 525. The first of the Panathenaic amphorae awarded as prizes in the games dates from about 566.[14] A new compact power inspires the goddess Athena, who is portrayed in her long robe, with helmet, aegis, shield and spear; the young Lydos depicts the battle of the giants with new dramatic force on a great vase, many sherds of which have been discovered on the Acropolis.[15] This epic theme was the one woven onto the peplos of Athena made by the girls of Athens and carried in ceremonial procession to the protectress of the

Fig. 123/124 city at the Panathenaic festival. The thrusting vitality is manifest again in the krater in New York (31.11.11) which depicts Dionysos at a wild dance of maenads and satyrs.

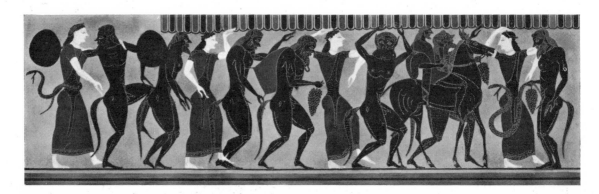

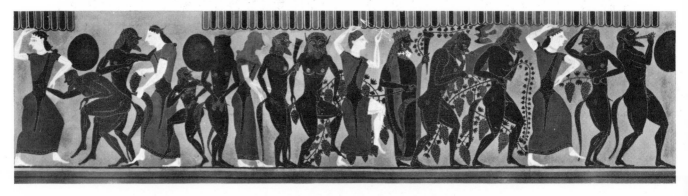

123/124 Lydos. Dionysos among dancing satyrs and maenads, from a column-krater. Height of picture strip about 26 cm. Mid 6th century B.C. New York, Metropolitan Museum of Art 31.11.11

113 This tradition was continued by the Amasis Painter in the second half of the century. The repertoire of Lydos and his circle, however, also comprised battle scenes from the Trojan War and the Labours of Herakles, and clay plaques depicting the lamentation for the dead; he also painted pictures of the leading citizens of the Athens of Peisistratos. An amphora in Naples takes over the convention, developed by masters earlier in the century, of having a picture field between the handles. A nobleman setting out with his

114 helmeted squire takes the place of female heads or horse protomes; behind them, a flying bird suffices to suggest the surrounding landscape.

An experience of a richer and more immediate nature seems to inform the picture on the inside of an

112 East Greek cup. Two trees fill the tondo with the balmy scent of their leaves and twigs; to the left a bird carrying food in its beak flies back to the young in its nest in the topmost fork, while a grasshopper and a large earthworm can be seen among the lower branches. A second bird perches in the right-hand tree.

170

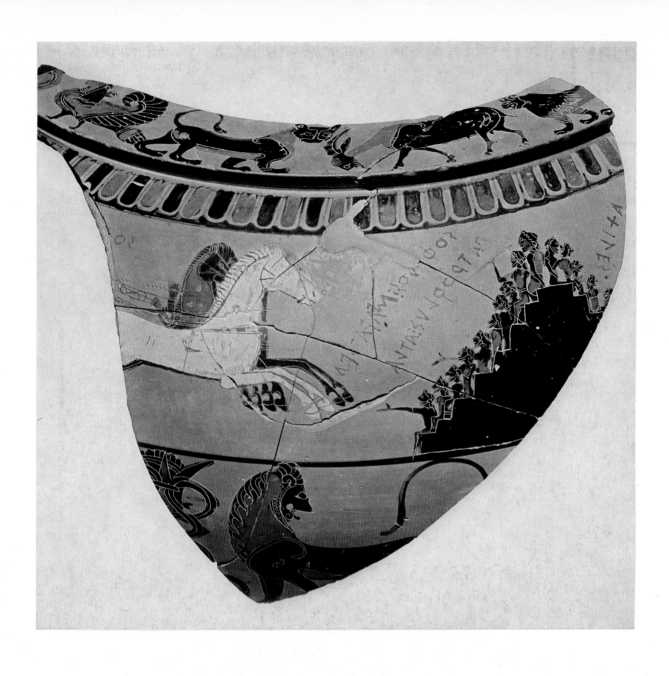

XI Sophilos. Fragment of a dinos. Funeral games in honour of Patroklos. Total height of vessel about 30 cm. Ca. 580/570 B.C.
Athens, National Museum 15499

Between the trees, a man, perhaps a hunter, in a short loin-cloth, is reaching up between the twigs with both hands. To experience the breath-taking magic of this spring scene one should ideally be able to turn the cup in one's hands.

XII From Vulci comes the most beautiful and the richest of all Laconian vases, the name-cup of the Arkesilas Painter, so called after the main figure depicted inside. The scene is a busy trading centre. A large pair of scales hangs from a wooden beam to which is attached an awning as a protection against the sun; atop the beam sit a little monkey and two birds. A crane wings its way over the men, who shout to one another as they weigh the white downy wool,[16] pack it into sacks and carry it off; in the lower picture area a foreman watches the sacks being stored. The main figure sits on a folding stool, to the left of the picture; he is distinguished not only by his great size but also by his strange pointed hat and the sceptre in his left hand. A small panther under his chair and a lizard behind him complete the picture. The seated figure is generally identified as Arkesilas II of Kyrene; more probably, however, he is a Laconian businessman perhaps known in local legend. Throughout the century Arkesilas was a common enough name in Sparta. It is possible that the legendary and successful business magnate of the cup is in part responsible for the name's popularity.

An Ionian workshop closely associated with Corinthian and Attic styles and techniques produced, from the middle of the century on, a large number of short-necked amphorae and lidded kraters with peculiar rounded handles like ears, and hydriai whose handle fitments imitate bronze vase handles. These vessels are known as Chalkidian vases because of the alphabet used in the inscriptions, which comes from Chalkis in Euboia; but it is disputed whether in fact Chalkis, or a West Greek centre, was their place of origin. The full body XIII and wide face of the winged Typhon stricken by Zeus's thunderbolt certainly suggest the Ionian style.

In some instances the subjects too would seem to betray the voluptuous Ionian approach. Here, a drunken satyr crouches behind a palm and stares lecherously at a dancing nymph; there, white-skinned maidens have cast off their clothes to bathe in a stream; they have been spotted by a group of satyrs who are creeping up on them; silently a bird shows the way. In the meantime Dionysos and Ariadne approach, unperturbed Fig. 125 by the droll satyrs dancing on the backs of the panthers and deer who draw their chariot. At the head of the procession a satyr has discovered the Naxian Spring; he cries out in delight when he sees that the lion's head wreathed with tendrils is spewing wine not water into his cup; opposite, the satyrs and nymphs are pairing off. On the outside of the vessel is depicted a demonic face with ornamental ears, nose and eyes—no mouth, but the whole cup is its mouth.

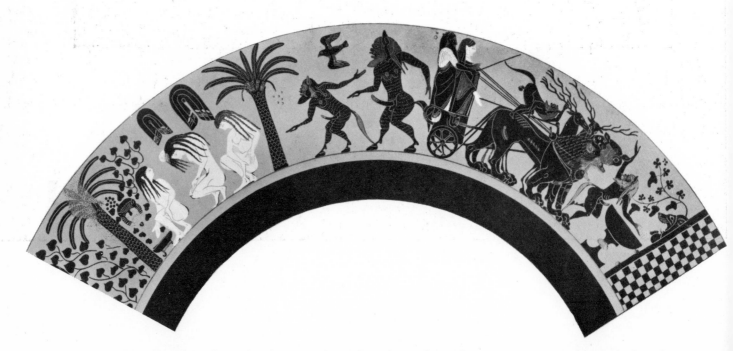

125 Dionysos and Ariadne in their four-horse chariot drawn by panthers and stags, among satyrs and maenads, from the rim of a Chalkidian 'eye-cup', the so-called Phineus cup. Last quarter of 6th century B.C. Würzburg, Martin-von-Wagner Museum 164 (extensively damaged in the war)

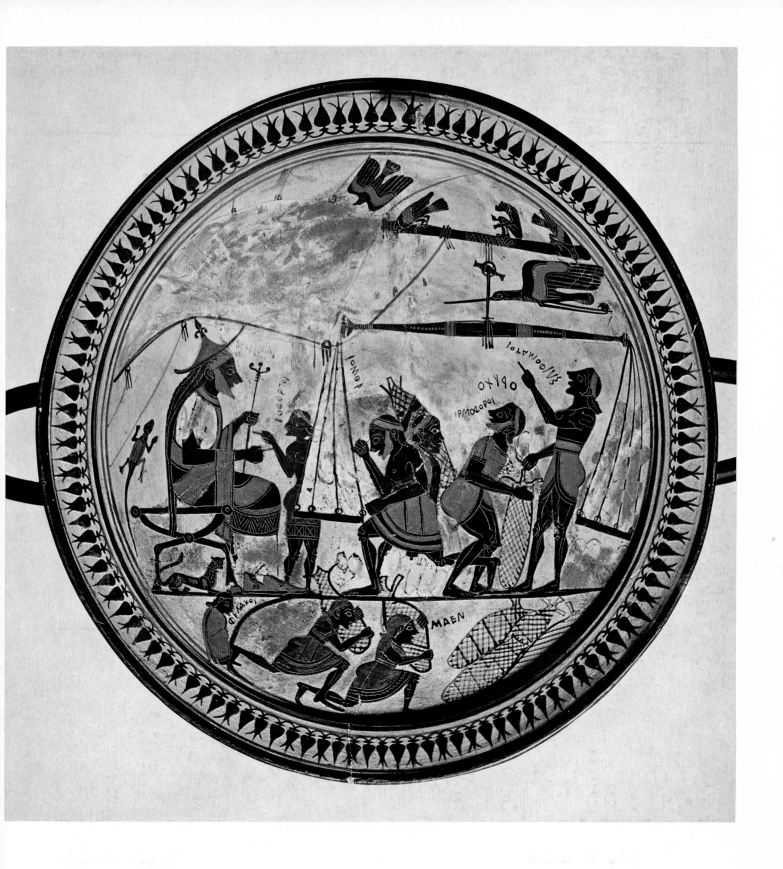

XII Arkesilas Painter. Laconian cup, interior. King Arkesilas of Kyrene supervises the weighing and despatch of silphion.
Diameter of cup 29 cm. Ca. 565/560 B.C. Paris, Cabinet des Médailles 189

In Attica, during the third quarter of the century, the Amasis Painter and Exekias carry on the achievements of Kleitias; their art is directed towards the beauty of garments and the embellishment of carefully combed hair and beards, which extends even to the manes and tails of the horses. Yet, unlike their lesser contemporaries, this does not lead them to mere mannerism. They have discovered the effect of superimposed layers of clothing, and fill the 'metope fields' of their neck-amphorae, now the preferred shape, with highly charged, vital pictures. The large vase shapes such as the dinos and krater which demanded multifrieze decoration on epic themes have given place to smaller, domestic forms whose decoration is of a more intimate character.

115 The noble discourse, the encounter or the meeting are the deepest concern of the Amasis Painter, and he develops them in ever new forms. Even the armed combats of legendary figures and the orgies of satyrs and maenads maintain this underlying tenor. The farewell of a warrior or the return home of the hero or hunter suit his talent, rooted as it is in old Attic traditions, better than the dramatic eruptions of Lydos. He

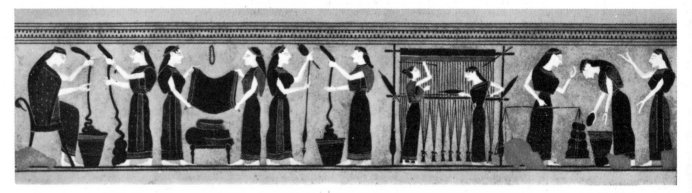

126 Amasis Painter. In a weaving room of Athenian girls, from a lekythos. Early work of the Amasis Painter. Height of lekythos 17·2 cm., of picture strip 6·2 cm. Mid 6th century B.C. New York, Metropolitan Museum of Art 31.11.10 (after Karusou, *The Amasis Painter*, 1956)

conveys Dionysiac frenzy by depicting finely clothed and tightly girdled maidens in measured dance step;
XIV the attributes, the ivy garlands and the animals—deer and hare—they have snatched up, these alone convey their profligacy. Their transport is concentrated in the meeting with the god himself who appears bodily before them with his great kantharos and welcoming mien. The Amasis Painter's preference for domestic scenes leads us to suspect that an early lekythos may be by him. Lovingly the artist observes the quiet
Fig. 126 movements of Attic girls as they weigh the wool and spin, work at the loom or fold completed lengths of cloth; we can catch a glimpse of the workroom of the noble Athenian ladies where every four years they
209 above make the peplos for the goddess Athena. (Cf. the scenes with the peplos on the east frieze of the Parthenon.)

EXEKIAS

The most notable successor of Kleitias was Exekias, one of the greatest painters in the history of art; it has been truly said that other artists have drawn as well as, but none better, than he. In many of his works he extols Onetorides, then in his prime and admired by all. Exekias was not only a vase painter; a number of
116, 117 above large plaques which may well have adorned a tomb show him to have been a panel painter and reveal the essence of his work. The Amasis Painter is imbued by a spirit of gaiety or, rather, joyfulness; for Exekias the path of the artist leads him among the lonely summits. One of his finest works, a neck-amphora in
XV London (B 210), sheds light on the artist himself. Achilles is in the act of killing the Amazon queen
117 below Penthesilea, who at the point of death turns towards her conqueror and sees through the slits of his visor that his eyes are full of love for her. Here at the very inception of Attic drama, the age of Thespis, we have a foretaste of Classical tragedy. In his treatment of the lonely sea voyage of Dionysos on the great picture
XVI inside the Munich cup (2044) Exekias endows his subject with a poetic lyricism. The god reclines in a boat with a fish-head prow, which continues its heavenly course without steersman or rudder; from the mast the branches of a vine, heavy with grapes, spread out like a canopy. About the ship gambol dolphins, the
XVII metamorphosed forms of pirates. Even the game of checkers during a lull in the fighting at Troy does not

174

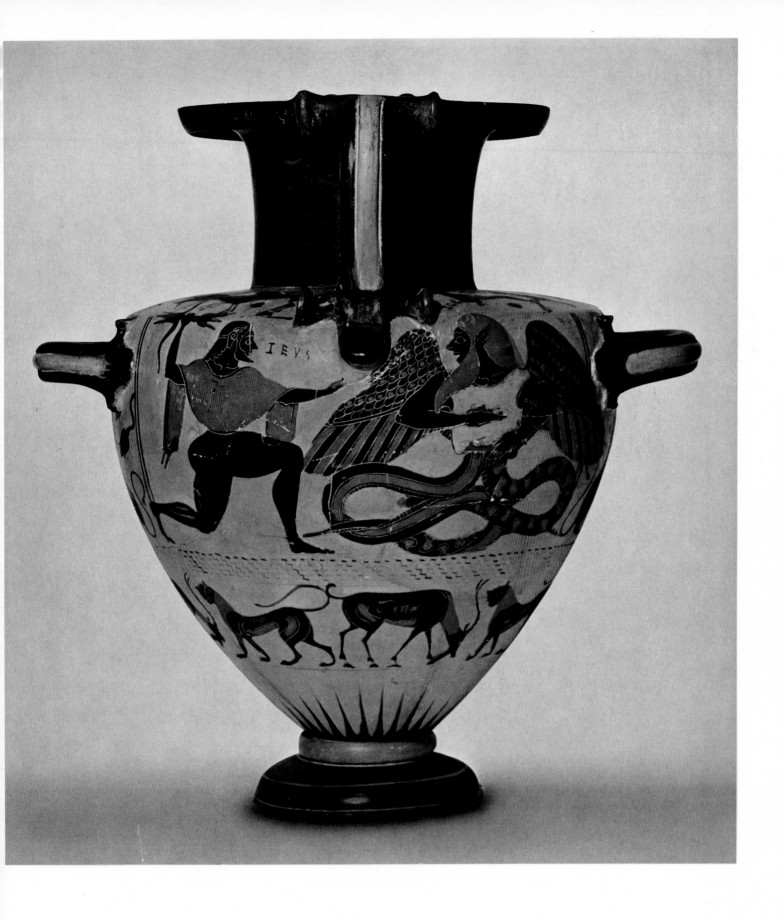

XIII Inscriptions Painter. Chalcidian hydria. Zeus fighting Typhon. Height 46 cm. Ca. 550/530 B.C. Munich, Staatliche
Antikensammlungen 596

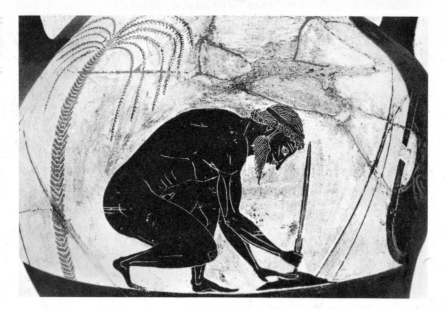

127 Exekias. Ajax prepares for death by his own sword, from an amphora. Third quarter of 6th century B.C. Boulogne, Museum 558

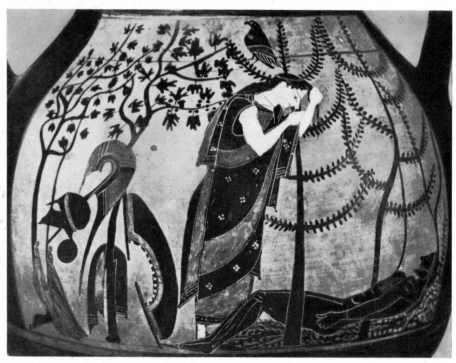

128 Circle of Exekias. Eos mourns the death of her son Memnon, from an amphora. Ca. 530 B.C. Vatican Museum 350

unite Achilles and Ajax in a true communion. Their passionate involvement in the game is depicted with astonishing vividness and their garments richly adorned with stars and fancy borders, their armour and greaves and shields are tellingly set forth; even their exclamations are inscribed. Yet each player seems to remain shut up within himself. The most personal statement of Exekias the man is surely to be found on the amphora picture of the suicide of Ajax. Clearly this was the artist's favourite subject since, as Beazley penetratingly observed, 'there was something in Exekias of Ajax: so that he could admire and understand the hero slow, and strong, and at heart delicate'.[27]

Fig. 127 Lost in the outer deserts of human solitude, Ajax prepares for his sad destiny beneath a lonely palm tree. He has laid down his weapons . . : 'Ah would to god that they were those of Achilles!' He cannot drive such thoughts from his mind and plants his own sword in the ground as if it were, despite its deadly point, a little rose tree. The strong sympathy of Exekias for his subject is obvious. The painter of the Vatican

XIV Amasis Painter. Neck-amphora. Dionysos and Maenads. Height 33 cm. Ca. 540 B.C. Paris, Cabinet des Médailles 222. Cf. plate 99

176

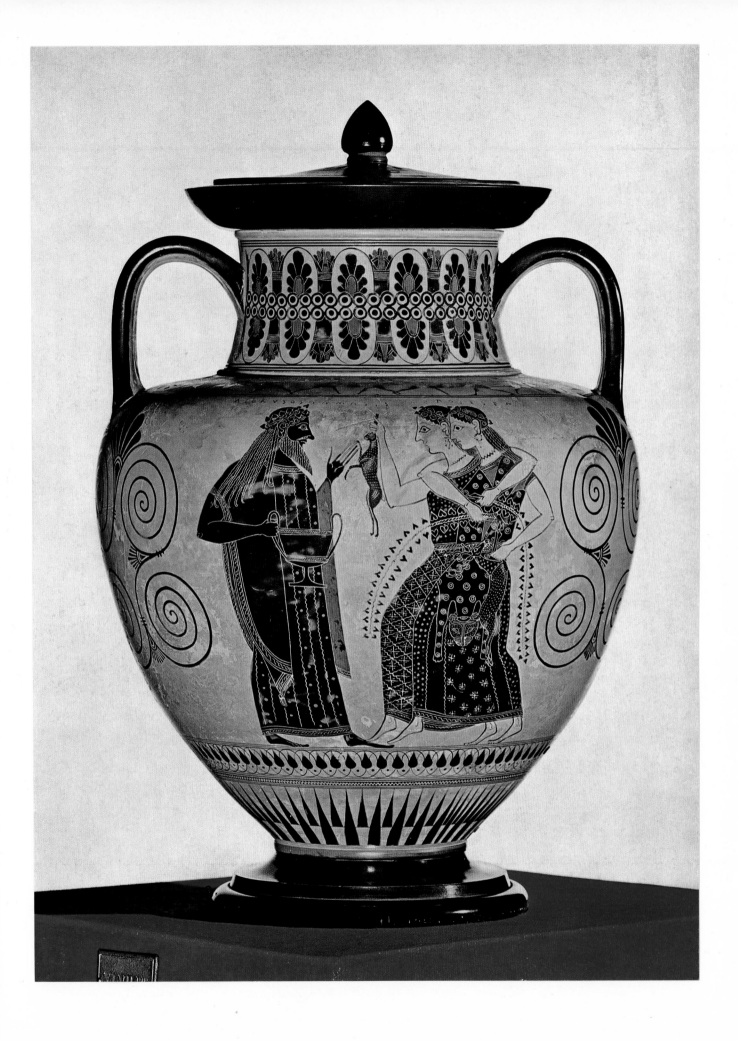

Fig. 128 amphora 350, whose style is similar to that of Exekias, has expressed this sense of desolate loneliness in his scene of Eos's lamentations over the death of Memnon. The weapons are stacked together behind the mother like a trophy; in the branches sits the bird of death. Perhaps not until the work of Rogier van der Weyden did any picture achieve so great an intensity of sorrow and piety; even in Attica such lofty achievements were rare.

118 Exekias shunned the harsh and the violent. The delight of reunion between the Dioskouroi and their parents is sketched in a few significant gestures and looks. The Laconian hound springs up to greet Polydeukes; Tyndareus, their old father, brings up a cushioned stool with the aid of a servant and strokes the noble Kylaros in greeting. Kastor turns to Leda, his mother, and she offers him a flower in token of welcome. The figure of Leda reminds one of the Peplos Kore by the Rampin Master, the Dioskouroi themselves of contemporary statues of youths, and indeed the whole picture gives the impression of a sculpture group. It is the quiet undemonstrative art used to portray the event which invests this picture with its special beauty; eternity has been caught in the moment.

RIPE ARCHAIC SCULPTURE · 570–530 B.C.

The artistic mastery of the dazzling but coarse-grained Naxian marble which had produced such more than 94 above life-sized forms as the colossal Apollo at Delphi, continued into the sixth century. The giant sphinx, 119 originally set on an Ionic pillar in the Sanctuary of Apollo, is an example of this art. The monster is confined within the sculptural space of a right-angled triangle. The line from lion-body to breast is tautly controlled; the forepaws, pillar-like, support the hybrid creature, which has been given the features of a ravishing young woman. Lightly waved hair curls over the flat temples and falls from the ears in long pointed tresses down onto the cat-like back. The scale-like armour of the breast, feathered like a bird's, effects the transition from lion to woman. A narrow band of small feathers springs from the roots of the wing and, beneath this, the great pinions stretch upwards. The head of the sphinx is stretched forwards as if braced against the wind which catches the taut wings shaped like narrow sails. The Naxian style of wide fugitive surfaces contained by fast lines is represented by two korai from the Acropolis and a still older head of a kouros in Copenhagen.[18] 122 The two young girls of the Acropolis also betray Samian influences; female figures of the rarest quality had been produced on the island well before the building of the Rhoikos temple.

120 left A larger than life-sized figure in the Louvre by the Cheramyes Master, so called after his patron, is a mature example of this sculptor's work and represents another pioneering achievement of Greek art. Like a noble tree the figure grows up from the firmly placed feet. A linen chiton with narrow parallel folds envelops the lower part of the body; a heavy Ionian cape lies diagonally across the upper torso in wider folds, while a large unpleated veil once covered the head (now lost) and the entire back. The right hand holds the hem of the veil, one end of which is tucked into the girdle in front under the hem of the cape. The lost left hand was held before the breast. This exalted and majestic figure can be no other than Hera 122 herself, the consort of Zeus. We can gain a faint idea of the missing head from the Acropolis kore 677. The whole figure of the Cheramyes Hera was copied in a contemporary statuette of wood recently discovered in the Heraion at Samos.

Fig. 129 The workshop of Geneleos produced a family statue group which it has been possible to reconstruct from scattered fragments although the heads and possibly also the figure of a small boy are still missing. The 120 right mother, Phileia, is seated at the left with her son standing next to her; her three daughters, Philippe, Ornithe 121 and a third, whose name is lost, follow; the reclining figure to the right must presumably be the father. The intimate personal atmosphere of the group is closely akin to the contemporary work of the Amasis Painter.

The youthful figures dating from towards the middle of the century possess a refined grace and movement and express in physical terms the inner spiritual life of those portrayed. The powerful plastic forms of the 124 Corinthian kouros from Tenea are infused with a vocabulary of line verging on the precious, which speaks

XV Exekias. Neck-amphora. Achilles killing Penthesilea. Height 41·3 cm. Ca. 525 B.C. London, British Museum B210. Cf. plate 101

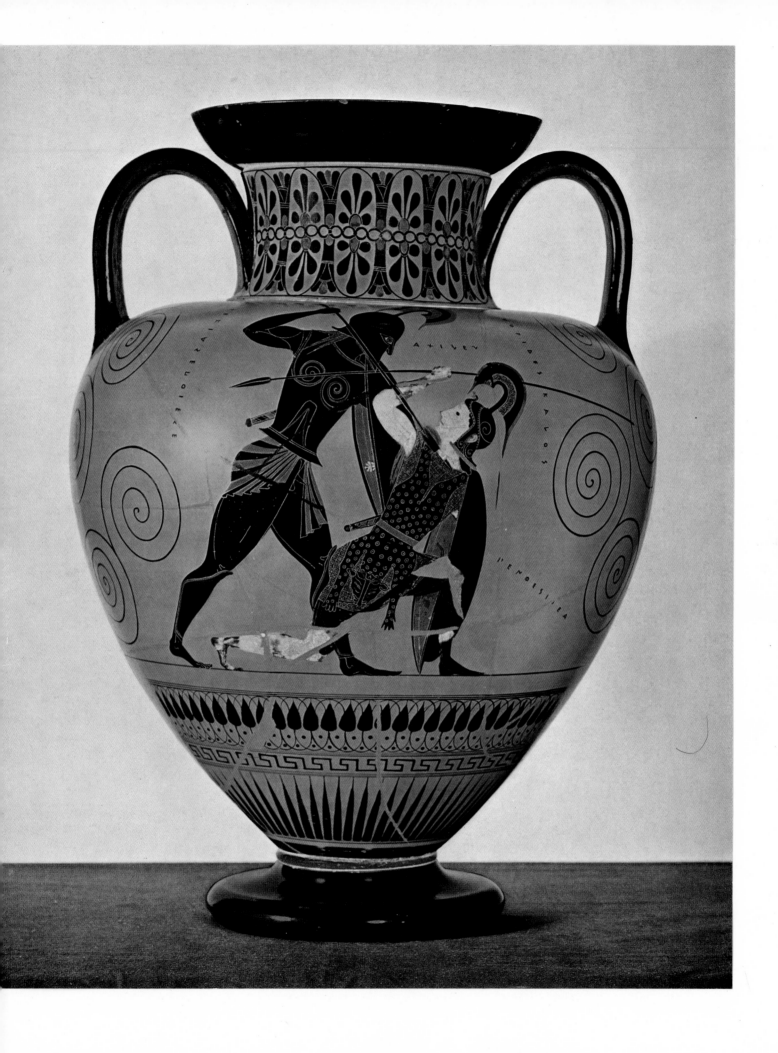

129 Family statue group by Geneleos, from the Heraion at Samos. Over-all view. The three figures, out of the original six, are: left, the mother; centre, the daughter Philippe (cf. plate 120 r.); right, the father (cf. plate 121). Towards the middle of 6th century B.C. Vathy, Museum

through the lithe contours of the body and the inner figuration. The accent is precise and accurate, as in all the best work from the Peloponnese.

The standing youth from Melos represents Naxian art at its finest. The delicate modelling of the all but flat body, and of the graceful limbs, the smooth flowing contour and the vibrant play of the hair all endow the form with a flower-like quality. For a true appreciation of the lasting change wrought in Naxian *84 left* sculpture over a century one should compare this figure with the Nikandre Artemis.

MIKKIADES AND ARCHERMOS

It would seem that during this period the famous sculptor Archermos and his sons were working on Paros. An inscription found on the island mentions Mikkiades, father of Archermos, but the alphabet is the Parian, not Chian; another inscription from the base of a statue found on Delos matches it to the smallest detail. There are strong grounds for believing that the Delian Archermos inscription belongs to the figure of a *123* winged goddess discovered in the same place, even though the loss of the section between the base and the figure itself prevents positive identification. Here we see a girl in rapid motion from left to right, cleaving the air with her bent right leg and upraised right arm; the right leg is balanced by the left arm whose fingers are resting lightly against the upper thigh while the right arm echoes the backward bend of the left lower leg. The way the limbs are disposed in the surrounding space recalls pictures of the windmills which are still to be seen in the Cycladic Islands. The outward-curving wings give the appearance of carrying the goddess; at the same time they constitute a foil for the thrust of the torso. The dream of the Daidalic artist has here been realized in Parian marble: the goddess seems to be flying. In its original lofty setting, probably the coping of a pediment, the statue would have been even more impressive. For in this situation the spectator would not at first glance see the supporting function of the flowing robe firmly set in the base between the ankles. The continuous interplay between sharp movement and effortless flow, the placing of the axes—one through the girdle, the other from forehead to left thigh, leading away from the figure's centre of gravity— makes the statue rich in pleasing tensions. The wide central fold of the peplos follows the contour of the left upper thigh and thus emphasizes the thrust of the broad right side of the torso. The lines which mark the folds of the garment between the legs are taut yet delicate like the sounding strings of a lyre; a gust of wind has lifted the dress over the right knee, and seems to have disturbed the hair rippling across the brow. As for the gold or gilded bronze rosettes and lotus blossoms, the earrings, the shoulder-brooches originally embellished with gold, ivory, faience or glass—only a goddess, surely, would have been accorded such rich adornment. As has been suggested, the statue was probably intended to crown a temple pediment and we

180

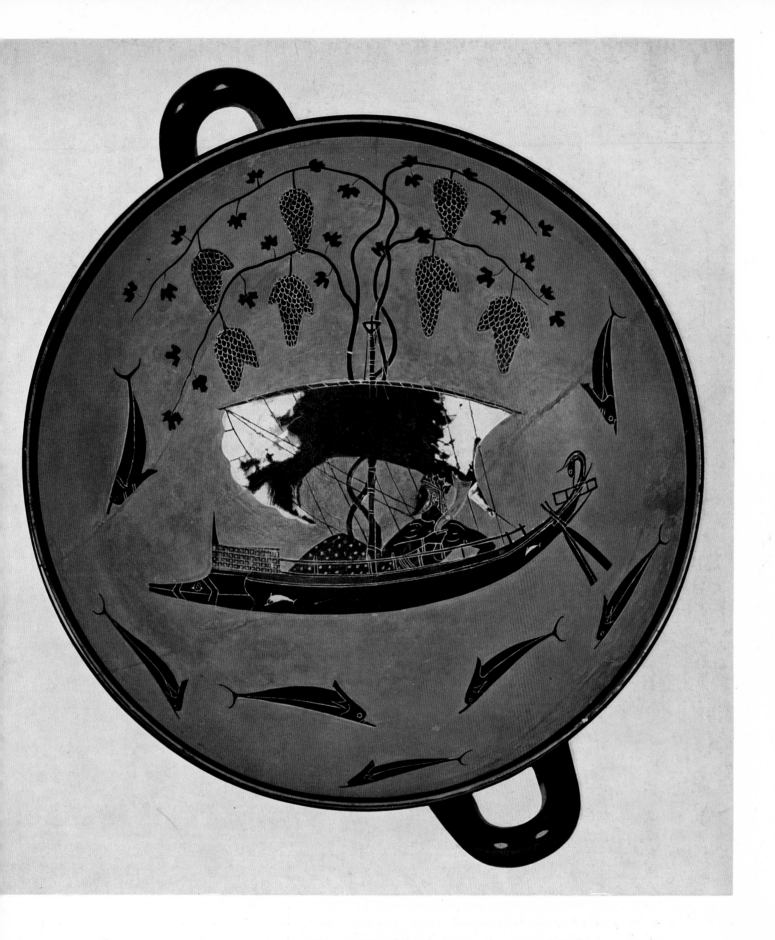

XVI Exekias. Interior of cup. Dionysos crossing the sea. Diameter of cup 30·5 cm. Ca. 535 B.C. Munich, Staatliche Antiken-
sammlungen 2044

may take it to represent Artemis, the mistress of nature. The splendour of this artistic achievement was felt throughout the Aegean from Siphnos to Athens. Two Late Archaic works from the Acropolis, kore 675 and Nike 693,[19] not only maintain the tradition of the so-called Nike of Delos, but can also probably be associated with inscriptions naming Chian artists. We do not know whether the artist was one or other of Archermos's sons, Boupalos or Athenis.

XVIII, 123

PHAIDIMOS

In Attica the immediate successor to the Dipylon Master and his close collaborators was Phaidimos; he is the earliest Attic sculptor known to us by name and fragments of whose work have been identified. A kore from the Acropolis (582)[20] of which so far only the lower section has been recovered, may belong to the beginning of the second quarter of the century. Although there are close affinities with the Berlin goddess (see page 168) the slenderness of the form and simpler treatment of the garments clearly point to some other hand. The pair of feet in Athens (No. 81)[21] shows the closest possible correspondence to kore 582 in the treatment of the sandals and their sharply defined leather-work and particularly in the rectangular or rhomboidal shape of the toe-nails; the base bears the names of both Phaidimos and Phile, sculptor and subject. The funerary stele of a spearman,[22] still beautiful even in its damaged condition, is somewhat earlier, dating from about 560 B.C.; from the treatment of the feet, toes and toe-nails it too would seem to be the work of Phaidimos. During the turmoil of the Persian wars it was commandeered for the building of the Themistoclean wall, after being stripped of its original surface ornament. The Kerameikos sphinx,[23] with the wing-tips recently restored to it, if not by Phaidimos himself is the work of a sculptor with an intimate knowledge of his style; indeed it may well have surmounted the spearman stele. A stele of a youth of which only the middle portion[24] survives appears to be by Phaidimos, as also does a Diskophoros stele from Phoinikia,[25] although the damaged condition of the latter allows of only a tentative judgment. The rear contour, sharply drawn in at the small of the back, and the slender shape of these figures relate them closely to the spearman stele. The contours of both youthful figures are similar in that the line rises steeply to the high chest muscles and then runs in an S-curve over the hollow of the neck to the chin. The long thumb of the left hand of the discus-thrower is like the spearman's. The sharply defined rim of the discus resembles the edge of the Gorgon's wing and the sandal-straps of female figures by Phaidimos. One must compare these stele fragments with the much better preserved Diskophoros attributed to the Rampin Master in order to distinguish—the many stylistic resemblances notwithstanding—the more rigid, more sharply outlined, more reserved, more archaic art of Phaidimos.

THE RAMPIN MASTER

Our first evidence of the Rampin Master is a 12-cm.-high female head (Acropolis 654) which proclaims itself at once as a descendant of the Berlin goddess. It is difficult to decide whether this sculptor, who has understandably been confused with the artist of the Gorgon and spearman, was a student or colleague of Phaidimos. The Rampin Master is named after a bearded head in the Rampin Bequest in the Louvre, which has been seen to connect with a headless horseman from the Acropolis. The delicacy of the head, the delight in rendering the curling hair of the brow and the pearl-like hair of the beard display the old inspiration of Attic sculpture, of the Dipylon Master, in a new light. Fragments have been discovered which suggest that there may have been a companion equestrian statue, and there is a fair case for the theory that the two horsemen represented the sons of Peisistratos. Earlier works of the Rampin Master can be identified in the torso of a youth (Acropolis 665)[26] and the famous Peplos Kore 679; to these we may add a hound (Acropolis 143),[27] a lion's-head water-spout from the Temple of the Peisistratids (Acropolis 69)[28] and a ram's-head water-spout from the sanctuary at Eleusis.[29]

The working life of the Rampin Master extended from 570/60 to 520 B.C. He refined and enriched the bold technique of Phaidimos, in so far as he welded together the sharply defined areas characteristic of his predecessor, thereby achieving a charming plastic modulation of surface and a sensitivity which reaches its highest expression in the Peplos Kore. Much as it recalls Phaidimos's kore in the lower part of the body, this figure possesses greater vitality, excelling in this respect even the naked horseman from the Acropolis. The gentle transitions cause the limbs and body parts to blend into a marvellous unity. There is a serenity in the countenance which communicates itself to the entire figure. She can be compared to the radiant Agido,

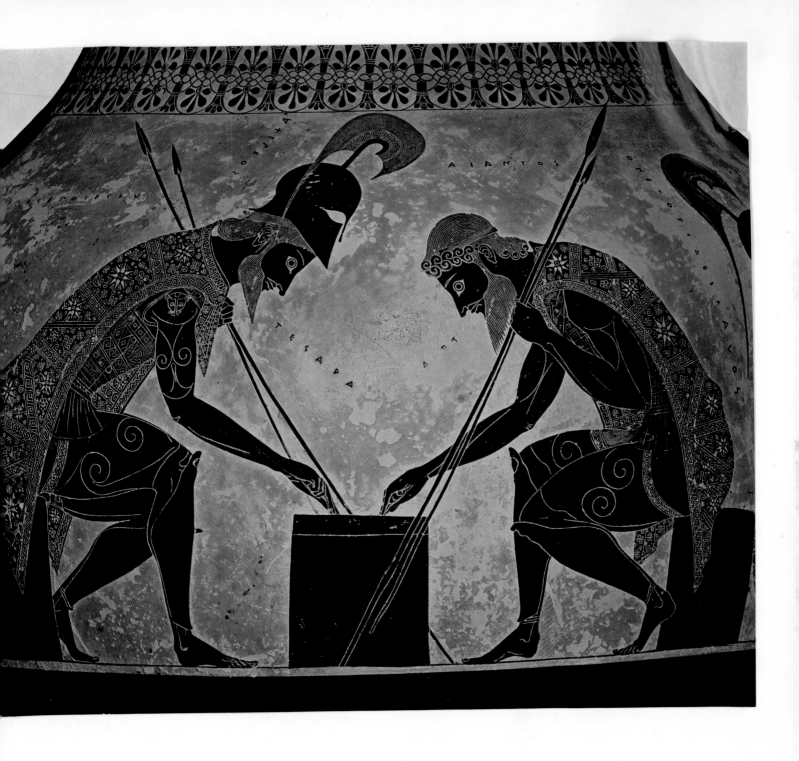

XVII Exekias. Amphora, obverse. Achilles and Ajax playing a board-game. Total height of vessel 61 cm. Ca. 540/530 B.C.
Vatican Museum 344. Cf. plate 102

described by the poet Alkman as the sun itself. In the animal pieces of his later years the Rampin Master brought an almost excessive degree of sensitivity to his handling of the luminous quality of the marble.

LATE ARCHAIC ART · 530–500 B.C.

From the mid sixth century onwards, both painting and sculpture begin to show an enrichment of surface modelling, and of internal detail, a refinement of contour and an intensification of thematic treatment; but it is not until about 530 B.C. that these features come to dominate. We may take the advent of the tragedian and actor Thespis of Ikaria at the Dionysia of 534 as symbolizing the initiation of Late Archaic Art.

LATE ARCHAIC PAINTING · 530–500 B.C.

The later works of the Amasis Painter and of Exekias played a decisive part in this development. The so-called
XIX Caeretan hydriae may have originated from an Ionian workshop in Phokaia in Asia Minor or from Caere in Etruria where most have been found; yet even they, in their burlesque narrative style, reveal a spirit which in Attica may well have been seen in presentations of the legendary themes on the popular stage.

 In these years too, the black-figure style of vase painting yielded to the red-figure style, as painters came to appreciate the more powerful plastic effects to be achieved by bright reserved figures shining out from a
128/129 black painted ground. With the amphora in Munich (2301)
by the Andokides Painter, we can study the two styles on
the same vase and in the same picture like parallel texts.

 The black-figure style was continued by a succession of
lekythos painters into the first decades of the fifth century
but the leading painters eagerly took up the new style and
adapted it to new themes. The palaistra scenes vividly present
the world of the Athenian citizens; the full-face view popular
in the Daidalic period is taken up again. The bearded wrestler
being thrown in the scene on the Berlin amphora stares
130 directly out of the picture at the spectator; on an amphora
by Phintias a satyr's face in full view, with furrowed brow,
Fig. 130 covetous eyes, coarse nose and sensual lips, makes a delightful
contrast with the profile of the maenad who is embracing

130 Phintias. Maenad and satyr, from a belly amphora.
Cf. plate 130. Ca. 525/515 B.C. Tarquinia, Museum
RC 6834

131 him. Carousing guests carried away by music or the power
of wine, the vivacious manners of the hetairai, twittering
girls at the baths, or scenes of the olive harvest are all pre-
sented with uninhibited zest. Even the myths of gods and
XX heroes are told with a new directness. Herakles, under the
protection of Athena, descends to the palace of Hades; at the
gate he circumspectly attempts to stroke Cerberus with one hand while holding in the other the chain with
132 which to bind him. We see Tityos preparing to abduct Leto, and Theseus abducting Korone.

LATE ARCHAIC SCULPTURE · 530–500 B.C.

133 The solid corporeality of the red-figure style is found also in the powerful body of the youth Kroisos, set
up over a grave in Anavyssos in southern Attica. This figure immediately brings to mind the Calf-bearer,
done almost a generation earlier; there is the same simple and natural piety. The effect of the richly arched
musculature is further heightened by the tight contours of the spaces between arms and thighs. The hair
retains the glory of earlier periods but now it gracefully follows the arch of the skull and shoulders and
flows down onto the back. The face has elements of a sphinx in the Kerameikos of the 'sixties,[30] a youth's

XVIII Kore. The work of a Chian master. Marble. Height 55·5 cm. Last quarter of 6th century B.C. Athens, Acropolis
Museum 675

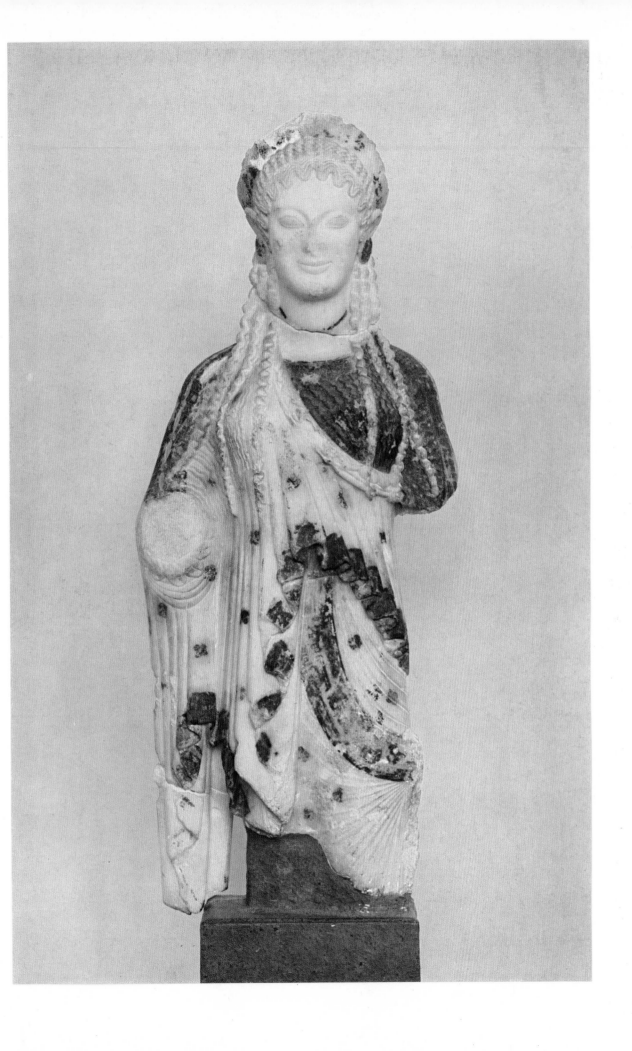

head in the Louvre (MNC 748),[31] and a stele of a boxer in the Kerameikos,[32] but they are fused and transmuted with a new radiance and richness. We do not know the name of the outstanding artist of this work and must perforce designate him the Kroisos Master.

Illustrious names which have come down to us from the Late Archaic period include Kanachos of Sikyon, Antenor and Endoios: indeed, to judge from a surviving gem and numismatic evidence for their Apollo of Delos, Tektaios and Angelion appear to have been working during the second half of the sixth century. Another work of the period was the Apollo Philesios by Kanachos of Sikyon.

ENDOIOS

Ancient writers mention works by Endoios, while the emperor Augustus had an ivory cult statue of his at Tegea brought to Rome. He can be associated with the seated Athena from the Acropolis (625)[33] and he lent his name to a work by his colleague Philermos,[34] thus enhancing the value of this humble kore which
135 bears an unmistakable resemblance to the Artemis on the east frieze of the Siphnian Treasury in Delphi. It is
134 possible that the famous artist produced the designs for the north and east friezes; the gigantomachy especially is similar to the treatment of that theme on fragments of contemporary Attic vases. It is, however, not clear whether Endoios was an Ionian who took Athenian citizenship, or an Athenian who gained important commissions in Ionia. The heavily damaged signed base[35] with the painting of a seated figure points to the Late Archaic period, as does a work commissioned in Athens by an Ionian woman called Lampito.

ANTENOR

Antenor certainly came from an Attic family of artists. His father was the painter Eumares. His group of the Tyrannicides, Harmodios and Aristogeiton, was renowned. Antenor's Tyrannicides shed a brilliant light on the Greek struggle for freedom during the early fifth century. It was plundered by the Persians in their sack of Athens and taken back to Persepolis as a pledge, and did not return to Athens finally until the time of Alexander the Great. Nothing survives which could give us an idea of this group—the treatments of the subject by Kritios and Nesiotes, ca. 480, being obviously new interpretations and not simple copies of the Late Archaic group by Antenor which had been completed some 30 years earlier. A good idea of what Antenor's Harmodios looked like is conveyed by the Webb head (2728)[36] in London. It appears to be one of the few examples of Roman copies based on Late Archaic originals.
136 However, it has been possible to reconstruct from fragments a statue of a kore (861) which Antenor did for the potter Nearchos, together with its base and inscription. The left leg of this elegant figure is slightly advanced and the chiton stretched tight between the thighs; a web-like series of folds fan out over the upper part of the body from the left hand which is grasping the material of the garment. The simple folds of the Ionian cape spread over the breast, while its hem falls in a series of triangles; the sculptor has fully exploited the contrast between the heavy woollen cloak and the rustling silk-like quality of the chiton. The right arm, stretched forward, balances the left leg, while the broad areas of the cloak over the right side of the body above the pillar-like right leg answer the backward bend of the left arm. The vertical axis runs between the inner side of the left foot and the base of the nose, being emphasized by the edge where the dress is drawn aside. The powerful shoulders and the irregular polygon of the upper part of the body, lend the figure a richness and splendour shared by none of her sisters.

Despite its damaged state, the head expresses a like inherent dignity and the eyes of inlaid coloured stone will have given the figure a compelling presence; in their glance, now lost beyond recall, the noble vitality of the whole figure found its climax. The fashionable cape, loosened from the body, and the tresses of hair which fall to the bosom show an unprecedented daring in the treatment of the marble such as only a master in bronze could have achieved; in this statue the farthest limits permitted to the sculptor in marble have been reached. A lesser artist would have produced merely a coquettish girl showing off her clothes; but the rustling garments of the Antenor Kore cannot infringe her dignity. Rather, they heighten the restful

XIX Caeretan hydria. Eurystheus takes refuge in a pithos from Herakles with Cerberus. Height 43 cm. Ca. 530/525 B.C.
Paris, Louvre, E701

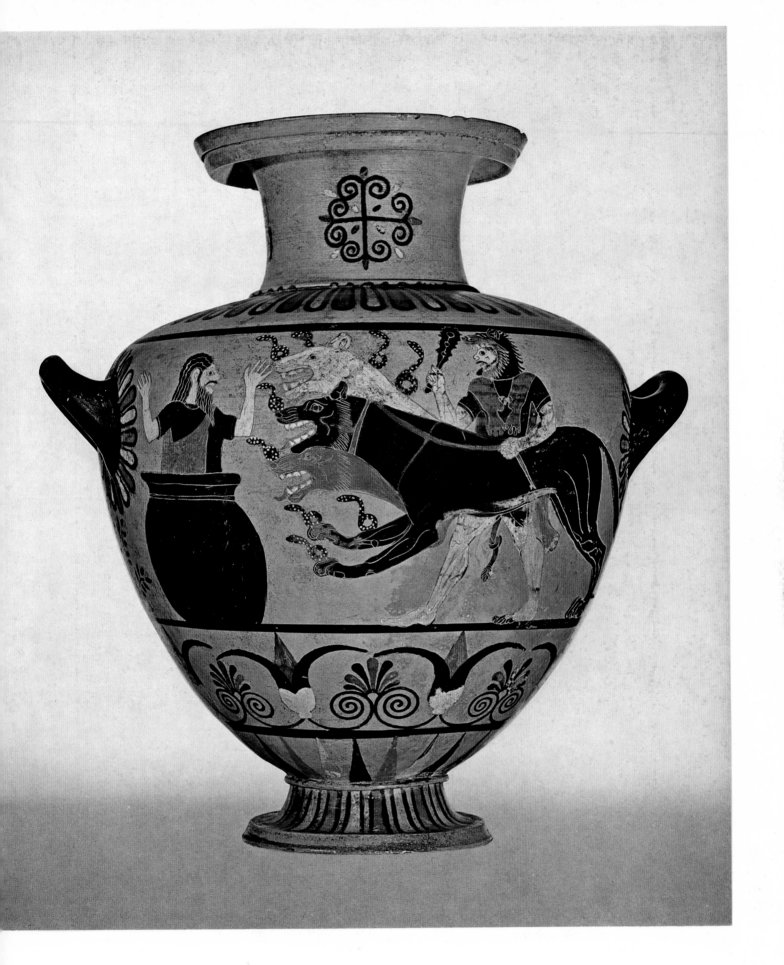

movement of her form which recalls the dignity, simplicity and grandeur of the Calf-bearer. This kore from the Acropolis (681) is the most mature surviving work by Antenor and dates from the late twenties of the sixth century.

Fig. 131/132 The figures from the Archaic pediment of the Temple of Apollo at Delphi are somewhat earlier; they too have been attributed to Antenor, and with good reason. The old temple was burnt down in 548 and contributions to the cost of the new building came from all over the Greek world and beyond. King Amasis of Egypt (died 526) donated 1,000 talents; the aristocratic family of the Alkmaionidai, banned from Athens in 540 by Peisistratos, generously endowed the reconstruction, under Kleisthenes. Herodotos expressly states

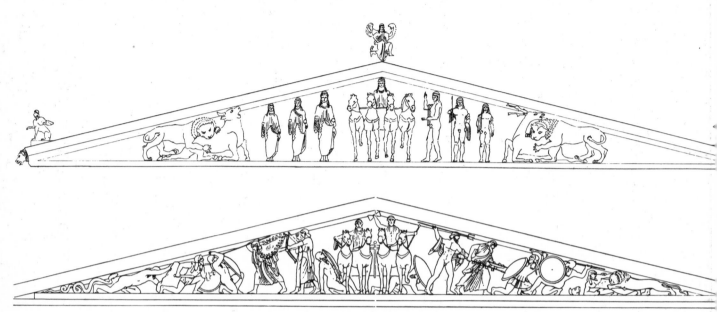

131/132 Reconstruction drawing of the two pediments by Antenor on the Temple of Apollo (V), the so-called Temple of the Alkmaionidai, at Delphi. Not before 540 B.C. 157 East pediment; 158 west pediment (after Courby)

Fig. 131 that they paid from their own resources for the marble of the east pediment sculptures, originally planned in limestone. Certainly none of the figures on these pediments have the refinement, the charm, the boldness, *136* bordering on bravura, of the kore 681. Even those forms closest to Antenor in style have stiffer, less fluid draperies—are, in a word, more old-fashioned. The magnificent youthful figure in the east pediment[37] suggests an earlier date. He stood in a frontal pose in the right half of the pediment, with a cape stretching behind him from left arm to right. From the delicate differentiation of the thigh muscles one can see that the right foot was slightly advanced, the head turned a little to the right. The contour flows in a fluent line from armpit to ankle. Where articulation of the limbs is concerned this figure is possibly superior to the Acropolis youth, 665, by the Rampin Master; but, what distinguishes one from the other derives from the difference between the artists rather than from the distance in time which separate them. The Rampin Master is the more adaptable, more sophisticated and more in tune with Ionian sensuousness. Antenor is quieter and more reserved. He has not any less to give, but is more basic and more restrained.

 This torso, compact and self-contained, does not suffer in the comparison with the Rampin youth and gives us a hint of the lost splendours of Antenor's Tyrannicides. The fame of the group survived into the period of Imperial Rome, being extolled by writers on art. The pediment sculptures at Delphi were destroyed by an earthquake in the early years of the fourth century; hence we have no description from Pausanias, though the Classical tragedians of the fifth century refer to them in glowing terms. The Chorus

XX Andokides Painter. From an amphora. Herakles and Cerberus. Total height of vessel 58·6 cm. Ca. 510 B.C. Paris, Louvre F204

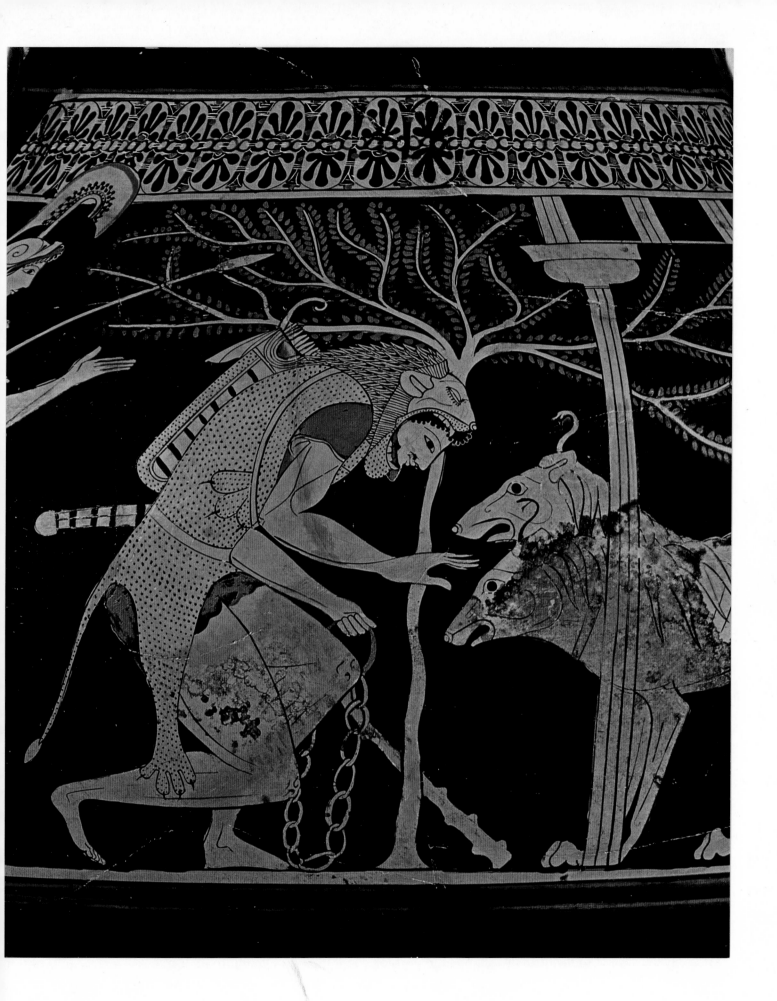

at the opening of the *Io* of Euripides sings of the beautiful temples of Attica and of the divine forms which decorate the pediments of Apollo's temple at Delphi, and passes them all in review. Some of the figures mentioned have not yet been excavated: Herakles and Iolaos in combat with the Lerna Hydra; Bellerophon mounted on Pegasos, slaying the Chimaera. These are clearly the metope subjects. Attention is then drawn

Fig. 132 to the pediment itself. There the gods do battle with the giants: Athena fiercely attacking Enkelados, Zeus hurling his thunderbolts at Mimas and Dionysos laying low other enemies with his peaceful thyrsos.

Fig. 131 The east pediment surpasses the west by virtue of not only its marble splendour but its noble theme also. We have the description of this from no less a hand than that of Aeschylus himself. At the beginning of the *Eumenides* the priestess appears before the Temple of Apollo at Delphi and directs her prayer to the inhabitants of the ancient oracle in the sequence in which Antenor represented them on the east pediment.

> First in my prayer of all the gods I reverence
> Earth, first author of prophecy; Earth's daughter then,
> Themis; who, legend tells, next ruled this oracle;
> The third enthroned, succeeding by good-will, not force,
> Phoebe—herself another Titan child of Earth—
> In turn gave her prerogative, a birthday gift,
> To her young namesake, Phoebus. From the Delian lake
> Ringed with high rocks he came to the craft-crowded shores
> of Pallas; thence to Parnassus to this holy seat.
> And in his progress bands of Attic worshippers,
> Hephaestus' sons, builders of roads, escorted him,
> Taming for pilgrim's passage ground untamed before.
> So Phoebus came to Delphi; people and king alike
> Paid him high honour; Zeus endowed his prescient mind
> With heavenly wisdom, and established him as fourth
> Successor to this throne, whence he, as Loxias,
> Interprets to mankind his father's word and will.

The battle groups are not merely *ad hoc* solutions to the problem of the pediment corners, but hark back

Fig. 119, 121 to the earliest Attic poros pediments (cf. page 164). They personify once wild nature which Apollo now controls since the sons of Hephaistos have cleared the road between Athens and his sanctuary of robbers, highwaymen and other terrors. The two youthful figures which stand, full-face, beside the group of deer

Fig. 131 battling with lions represent travellers setting out from Athens. The welcoming figure turned towards Apollo's quadriga is Delphos, prince of the territories around Parnassos. The three female forms to the left represent Apollo's predecessors in prophecy: Gaia; Themis, daughter of Ouranos and Gaia; and, next to Apollo, Phoibe, sister of Themis. It was she who gave to her godchild Apollo his other name, Phoibos. There can be no doubt that Aeschylus had seen this east pediment at Delphi. The subject is not a general assembly of the gods, but the specific theme of Apollo's induction at Delphi; every detail has significance and every form some relationship to the sanctuary. The artistic achievement of Antenor in this pediment

188–196 was not to be equalled until the Early Classical Temple of Zeus at Olympia.

COINS IN THE ARCHAIC PERIOD

The earliest minting of Greek Coins during the last decades of the seventh century B.C. marks a period when close economic contact was being established between the Lydian kingdom and the Greek cities on the west coast of Asia Minor. But it was not until nearly 600 B.C., it seems, that coins characterized by specific devices and which could be identified as the issues of the individual Greek cities made their appearance. Up to this point, the coins issued had taken the form of precious-metal pieces bearing no city-symbol but distinguished at most by a kind of punch-mark. The first coins issued around 600 B.C. normally display their characteristic device only on the obverse, and on the reverse merely the so-called 'incuse square' in the form of a stamped impression roughly like a windmill-sail. It is, however, a significant

190

turn of the Greek mind that even in this first moment when coin devices were conceived they were not thought of as merely symbolic signs but at once brought into play a full range of creative energies drawing on a very varied repertoire of images. It is possible that each one of these images was the civic device of the minting city and related to its religious background. In response to a simple requirement the Greek die-engraver emerged as an artist in his own right on a level with his contemporaries in full-scale sculpture.

The strongly stylized lion's scalp on an electrum stater of Samos ca. 600 B.C. remains, it is true, of a *137 (10)* somewhat heraldic aspect rather than a living image: but the grazing stag on the electrum third-of-a-stater of Ephesos, also of about 600 B.C., is far more naturalistic and true to life. No less close to nature is the cow *137 (11)* suckling her calf on an electrum stater of 575 B.C. that must belong to Miletos. The creative spirit of the *137 (12)* Greek artist found expression down to the smallest particulars, as is shown by the punch-marks on the reverse of an electrum stater of Miletos, again of about 575 B.C.: here we see in the lower section a star, *137 (14)* in the upper one the head of a stag and in the central panel a fox stealing through the undergrowth. The lion with backward-turned head, on the obverse, is conceived on the grand scale. The confronted heads of lion and bull on a Lydian gold stater of the time of King Croesus (561–546 B.C.), for all the vigour with *137 (13)* which they are depicted, produce an effect that is more symbolic than realistic. By contrast the fierce lion-protome on a Carian silver stater is lively in the extreme: these coins were perhaps minted by a dynast *137 (15)* of Mylasa about the year 500 B.C. Here as at Miletos the lion is the animal of the god Apollo, and as such it makes a further appearance at Knidos as soon as coins with types on both sides began to be minted there. Near to this Carian city there stood a very renowned shrine of Apollo, situated on the Triopian Cape, that was important as a religious and cultural centre for the six cities of Dorian Caria. The cult of Aphrodite Euploia, protectress of navigation, is reflected in the first coinage of Knidos as early as around 600 B.C.: and the coins originating in the last decades of the sixth century, for all their archaic severity of style, display heads of the goddess which are conceived in the most lively fashion—this is true of the silver staters of 520 *137 (16)* B.C. and even more of the drachms of 510 B.C. These small heads are animated by a breath of life that *137 (17)* comes very close to nature, and their quality sets them firmly beside the large-scale sculpture of their time, perhaps reflecting for us many a masterpiece that is now lost. Contemporary with these heads but still enmeshed in the severity of Archaic style is the small unidentified female head with hair-band and rosette earrings on an electrum hekte of Ionian Phocaea of 520 B.C. Finally, we can reckon some masterly *137 (18)* achievements in the art of Archaic coins among the electrum staters of Cyzicus. This city, on the southern shore of the Propontis, founded jointly by Miletos and Phocaea, was the centre of the tunny-fisheries and export, and these formed the basis of the city's wealth: the tunny fish was at all times the civic device on the coins. Moreover, the coinage of Cyzicus displays a richness and variety in the images accompanying the tunny symbol that is unequalled by any other city of the Greek world. The series of coins begins, as early as 520 B.C., with heads clearly conceived and incisively executed, for example of Athena in a winged *137 (19)* helmet. These were joined in a short time by other, minutely observed designs which are comparable with the relief sculpture of the period: Herakles with club and bow, or a naked warrior holding a helmet and *137 (20/21)* sheathed sword. A little later, ca. 500 B.C., there are representations of a winged male figure with the head of a lion—perhaps Phobos, the personification of Fear: or again a flying Nike looking back and shown in *137 (22)* a kneeling or running pose—in this case giving the impression of being earlier by contrast with the other *137 (23)* types mentioned, and surely the work of a die-engraver who was still fully under the influence of severe Archaic convention.

In the Greek homeland, one of the earliest coinages, that of Aegina, was probably executed around *137 (1)* 580–560 B.C. Emblematic of this sea-girt island, and of its ships and men versed in the ways of the sea, is the sea-turtle that remained Aegina's symbol up to the time when the island was overwhelmed by Athens in the year 456 B.C. and then depopulated for a period of over forty years. The didrachms known by the term *Wappenmünzen* have been recognized as the first coinage of Athens. The types of the obverse are, *137 (3)* among others, amphora, wheel, horse or horse-protome, bucranium, astragalos, owl; the reverse, as at Aegina, shows only an incuse square. The devices themselves are similar to those which we know from their appearance on the shields of the hoplites belonging to the Attic aristocratic families. This first series of Athenian coins seems to have begun around 570 and to have ended about 520 B.C.; thus it is approximately

137 (4) to the time of Peisistratos's tyranny (560–527 B.C.) that they belong. Towards 530 there were minted, briefly, tetradrachms with a Gorgon for the obverse, and on the reverse within a square depression either a facing lion-protome or a bucranium. These pieces are comparable in subject-matter with the *Wappenmünzen* and clearly connected with them in their typology, yet they radiate an amazing vigour and great expressiveness. Towards 520 B.C. come the first coins, once again tetradrachms, with the head of a helmeted Athena on 137 (5/6) the obverse and the owl on the reverse. Their beginning falls within the years of the rule of Hippias (527–510 B.C.), son of the great Peisistratos. There is a rich variety in the types of the city-goddess Athena's head that occur on the coins: it would be both fascinating in itself and also instructive to work out close comparisons between these varied profiles of the goddess's head and contemporary works of full-scale sculpture. We may remark merely in passing that the inexhaustible silver-mines of Laurion on the southern tip of Attica formed the basis of the wealth and power of the tyranny since the days of the Peisistratids. These mines were the key to the enormous issue of coins which reached its first climax about 483 B.C., and also explain why from about 500 B.C. onwards the Athenian tetradrachms constituted the money *par excellence* of the ancient world: on account of the purity of the silver content and the reliability with which their weight was maintained they became accepted as a standard of currency everywhere.

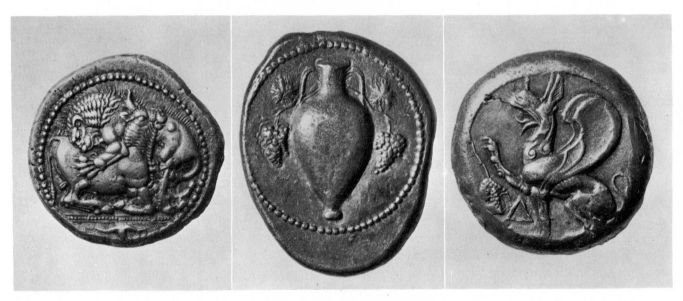

133 Archaic coins of northern Greece. 1 Akanthos. Tetradrachm, ca. 530/500 B.C. 2 Terone. Tetradrachm, ca. 500 B.C. 3 Abdera. Octodrachm, ca. 520 B.C. All 2:1

137 (2) From about 550 B.C. onwards Corinth was minting her silver staters with the Pegasus type for obverse: this type, representing the offspring of Medusa, was regular for the entire coinage of Corinth and also of her numerous colonies, and underwent many stylistic variations. From about 515 B.C. it was accompanied by a reverse type consisting of the head of Athena in a Corinthian helmet.

 Among the coins of the Peloponnese proper, only a few date to the period of Archaic art. Elis alone 137 (7) became prominent about 510/500 B.C. with the very powerfully conceived type of an eagle clutching a snake in its beak and claws on the obverse, and on the reverse the thunderbolt of Zeus: both these were symbols of the Olympian deity. In the area of the Cyclades some islands were minting coins from about 550 B.C. Thus we have Delos with the type of the Apolline lyre, Siphnos with that of an eagle with outspread wings, Seriphos with that of a frog seen from above; then around 530 B.C. there is Thera with the type of two dolphins one above the other, and Paros with that of a goat. All these types are placed on the obverse, while the reverse merely has the form of the incuse square.

 The early coinages of the northern Greek mainland and in particular those of the Thraco-Macedonian region, show a rich variety of types. In that region were important sources of silver: another factor was the presence of the Persians, who from 513/512 B.C. made this region their base in an attempt to dominate

Europe—which, perhaps, helped to stimulate the production of coins for the first time in many of the cities. Thrace was the homeland of Dionysos, god of the procreative powers of nature, and many of the wonderful images on the Thracian coins owe their inspiration to the worship of this deity and to his following of satyrs and maenads in their contests of love. Among the most prominent of such coinages must be mentioned that of Thasos, though similar representations extended also to the countryside of Macedonia, as for instance the Orreskioi and the Zaielioi, and the city of Lete. Among the most ravishing of these artistic products must be reckoned a tetradrachm of about 525 B.C. that must belong to the Pangaean area: it shows two maenads, adorned with diadem and earrings, gazing into a wine-amphora and awaiting the miracle of wine from *137 (8)* their god Dionysos. We can see how far the engravers have advanced beyond everything that savours of merely schematic or symbolic design and how close they are to monumental art. An even more purely heraldic type was given a significantly artistic treatment, to be seen in the tetradrachms of Akanthos, of about 530 B.C., depicting a lion attacking a bull: a theme which occurred as the device at the city-gates, *Fig. 133 (1)* and which also incidentally suggests that lions may have abounded in this region. Similarly, tetradrachms of Terone, 520–500 B.C., show an amphora hung about with grapes and vine leaves: whereas coins of *Fig. 133 (2)* Abdera, of about 520–515 B.C., give us the demonic griffin, the mythical beast connected with Hyperborean *Fig. 133 (3)* Apollo—perhaps the most grandly conceived of all this city's coinage, which continued into the fourth *198 (10)* century.

From the earliest times in Macedonia, before the establishment of the independent kingdom, we have a further group of attractive yet artistically primitive coins usually known as octodrachms. Here we see the peasant-like tribal chiefs with their war-horses or driving their ox-drawn plough, just as we find Hermes with his ox-team, or Herakles, or other such figures.

Of outstanding artistic merit is a tetradrachm of Peparethos, the Thessalian island, from about 500 B.C. *137 (9)* The tetradrachms of this island are known from very few extant specimens, and most of them display on their obverse a grape-cluster, the device of Dionysos, who fathered on Ariadne Staphylos, the mythical founder of the colony of Peparethos. On the reverse is a very animated figure, scintillating with life, a runner with winged boots holding a wreath in each hand. Should we call him Agon, the god of the contest, or Boreas, the north wind, as he storms ever nearer to seize as his bride Oreithyia, the daughter of Erechtheus, king of Athens?

Compared with the coins of Asia Minor and the Greek mainland which we have been considering, those of the Greeks of southern Italy present a quite different aspect. The earliest of these are of about 550 B.C. *138 (1–6)* and belong to the Achaean colonies, whose settlers came from the northern Peloponnese and from both the Locrian peoples of central Greece. These south Italian coins are characterized by their comparatively large format and especially by the use of the so-called 'incuse' method of minting, whereby both types give virtually the same image, the obverse in positive relief and the reverse in negative or incuse. Even Taras (Tarentum), which was not an Achaean but a Dorian colony, adopted for its earliest issues the incuse technique of the Achaean cities, for purely commercial reasons.

The large space available on the surface of these coins naturally made a more impressive treatment possible. Unsurpassed examples are to be found in the monumentally conceived tripod on staters of Croton, the powerful bull of Sybaris (the city destroyed by Croton in 510 B.C.) and the boar on the incuse stater of *138 (2/3)* Palinuros and Molpa. The Achaean staters reached their peak with the figures of Poseidon at Poseidonia and *138 (1)* of Apollo at Caulonia. As the distinctive device of the city of Caulonia there is a stag which stands in front *138 (4/6)* of the god, and we may see in the figure of the god himself none other than Apollo Archagetes, the deity presiding over the foundation of the colony. The crown of laurel which he holds in his right hand gives a similar indication; while the small running figure on his left arm may be the herald of Apollo's arrival at Delphi, the god's holy place whose oracle exercised a decisive influence on the foundation of many colonial cities. The incuse staters of Taras are outstanding not merely among the early coins of the Greeks in south *138 (5)* Italy but among those of any period. These coins show us Apollo Hyakinthios: originally venerated as a vegetation deity in his home, Lakedaimon, he was later supplemented by the figure of Apollo and in Taras became fused with Apollo. His divine figure, shown kneeling with flower and lyre in his hands, is executed so finely that one tends to forget the extremely small scale of the design.

138 (7) The types seen on the very rare staters of the city of the Serdaioi originated in south Italy, yet at the same time give a strong impression of artistic dependence on the early coins of Sicilian Naxos. Though it is a coin of an Achaean colony, this stater is not made by the incuse technique: the obverse is graced by a standing Dionysos, and the reverse by a picturesque vine.

 Sicily was settled by colonists of both Ionian and Dorian extraction at almost the same time. The foundation of Naxos in the year 735 B.C., by Ionians from the Cycladic island of the same name, was followed in 733 by that of Syracuse, founded by immigrants from Corinth. The god worshiped in the *138 (8a)* homeland of Naxos, the Cycladic island, was the gentle Dionysos Meilichios, and the same deity was accorded the highest veneration within the walls of the Sicilian colony. His head is represented in a variety of aspects in many coin types, and is found on the very earliest drachms dating to the year 530 B.C. The reverse of the coin is adorned with a vine-cluster. From the point of view of style, it is of the greatest interest to follow the way in which the representation of the god's head develops, starting from these early coins *197 (7), 239 (1)* right down to the year 403 B.C. when the city was ruthlessly destroyed by Syracuse.

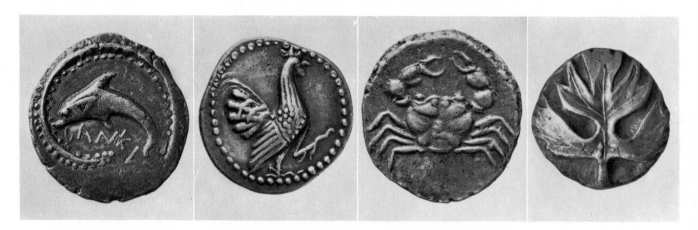

134 Archaic coins of Sicily. From left to right: Zankle. Drachm, ca. 515/510 B.C. Himera. Drachm, ca. 520 B.C. Acragas. Didrachm, ca. 520 B.C. Selinus. Didrachm, ca. 520 B.C.

 From the Archaic period down to the Hellenistic age, a dominating position is occupied by the coinage of Syracuse. The earliest issue is to be dated to about 515 B.C., and the first coins are tetradrachms and didrachms: this seems to show that a city like Syracuse, which attained to great wealth quite early in her history, found it comparatively easy to come by supplies of silver, whereas other Sicilian cities, in so far as they were minting coins at all at this period, had to content themselves with the issue of didrachms (Acragas, *Fig. 134* Selinus) or drachms (Naxos, Himera, Zankle). In connection with the obverse of the Syracusan coins, it is necessary to stress the great significance, not only for commerce but for the Syracusan way of life, which attached to the breeding of high-quality horses and the victories won by them in the chariot contests that *138 (9b)* formed part of the great Hellenic games. The tetradrachm displays as its type the four-horse chariot, and *138 (10)* the rather rare didrachm a rider mounted and leading a second horse. For the reverse of the coins, the incuse square seemed inadequate and abhorrent to Western Greek taste with its hankering for beauty: thus, apart from certain exceptional coins, even the reverse carries some device. On the earliest coins of Syracuse there *138 (9a)* appears, albeit only within the confines of a windmill-sail incuse, a tiny head of the water-nymph Arethusa. In the next issues, however, this head fills out the whole area of the coin and before the end of the century rises to new heights of sculptural beauty that are quite unsurpassed at this date when the Late Archaic style *138 (11)* was on the wane. The head is encircled by four dolphins, the expressive device of Syracuse, the sea-girt city.

 Syracuse had from the beginning introduced types of real significance for her coins, the four-horse chariot and the horseman for the obverse, and the Arethusa head for the reverse. But most of the other cities in Sicily who took up the minting of coins before 500 B.C. contented themselves with more purely symbolic *Fig. 134 (1)* devices. Thus we see Ionian Zankle, the later Messana, with its single dolphin swimming in a sickle-shaped

194

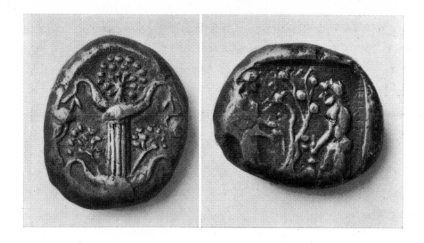

135 Cyrene. Tetradrachm, ca. 520/510 B.C.

harbour: and Himera on the north coast, another Ionian city, with its type of a cock, the symbol of dawn, *Fig. 134 (2)*
perhaps not unconnected with the similarity in sound between the Sikel word Himera and the Greek word
for morning. Among the Dorian colonies minting coins before 500 B.C., there are only Acragas, with an
eagle and crab on obverse and reverse respectively, and Selinus, with a feathery leaf of celery on the obverse. *Fig. 134 (3/4)*

Our survey of the Archaic coins minted by the Greeks would be incomplete if we did not spare a glance
for the early pieces of Cyrene in Libya, the most important Greek trading centre on the North African
coast apart from Naukratis. The earliest coins, which are tetradrachms, date from about 550 B.C., with their
device showing the double fruit of the silphium plant, that mainstay of the economy of Cyrene. A few
decades later appears a coin type which on the obverse boldly attempts the legend of Herakles in the *Fig. 135*
Garden of the Hesperides. Possibly, this theme could have been more felicitously handled at some other
mint of higher artistic standing: but the important thing is that the die-engraver embarked on this complex
theme in so adventurous a spirit. Faced with the problem of showing the confrontation of the nymph Cyrene
and Herakles, with the tree bearing the golden apples set in the middle, he arrived at a solution which may
be primitive but which betrays no lack of true artistic feeling. Indeed, the positively classical style in which
the silphium plant on the obverse is represented anticipates the coins of the succeeding centuries.

195

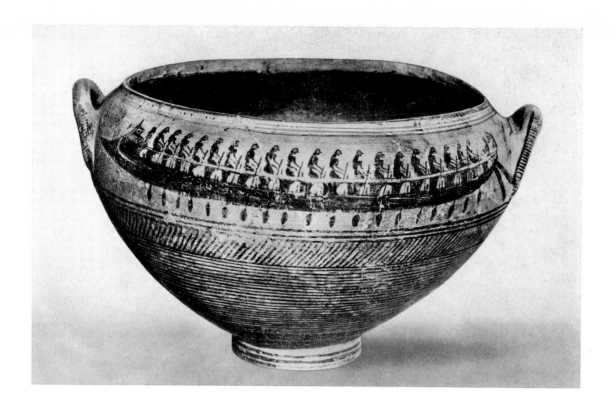

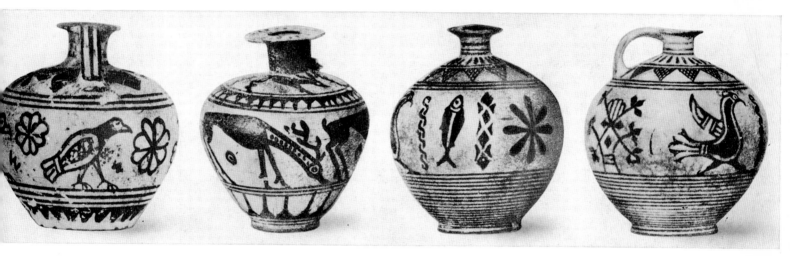

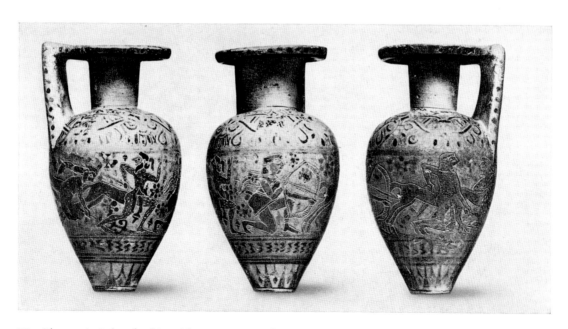

73 Above: Attic bowl. Ship with oarsmen. Height 22.6 cm. End of 8th century B.C. Toronto Museum.
Middle: Protocorinthian aryballoi. Height 5.5–6 cm. First quarter of 7th century B.C. In the museums of Boston, Syracuse and Naples.
Below: Protocorinthian lekythos. Herakles fighting the Centaurs. Height 6.5 cm. Ca. 660 B.C. Berlin, Staatliche Museen F 336

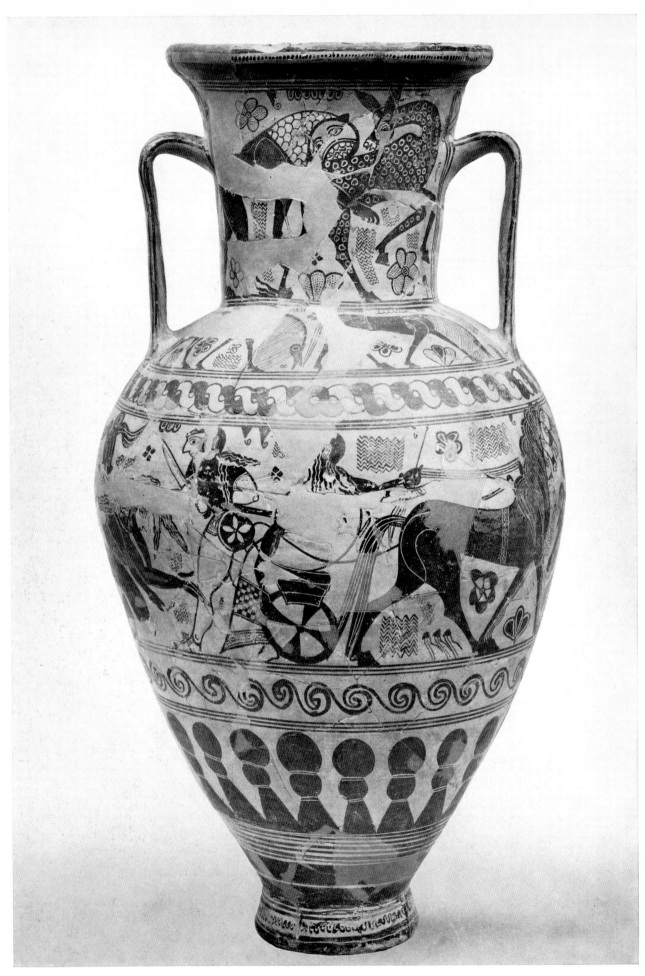

74 Protoattic amphora. Herakles killing the Centaur Nessos.
Height 1.09 m. Ca. 680 B.C. New York, Metropolitan Museum of Art 11.210.1

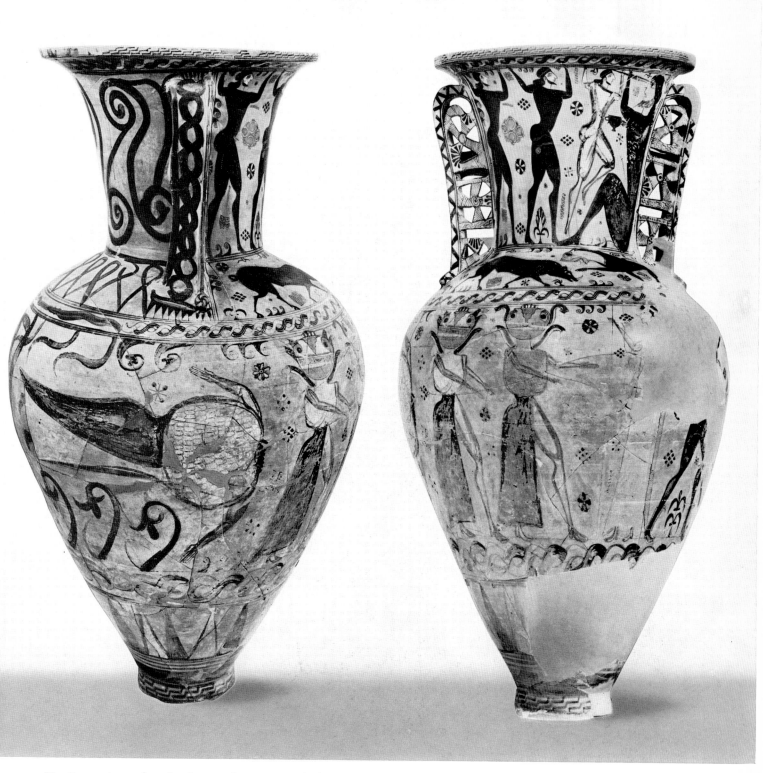

75 Protoattic amphora by the Menelas Painter. Cf. plate V. Perseus and the Gorgons, animals and the blinding of Polyphemos.
Height 1.42 m. Ca. 670 B.C. Eleusis Museum

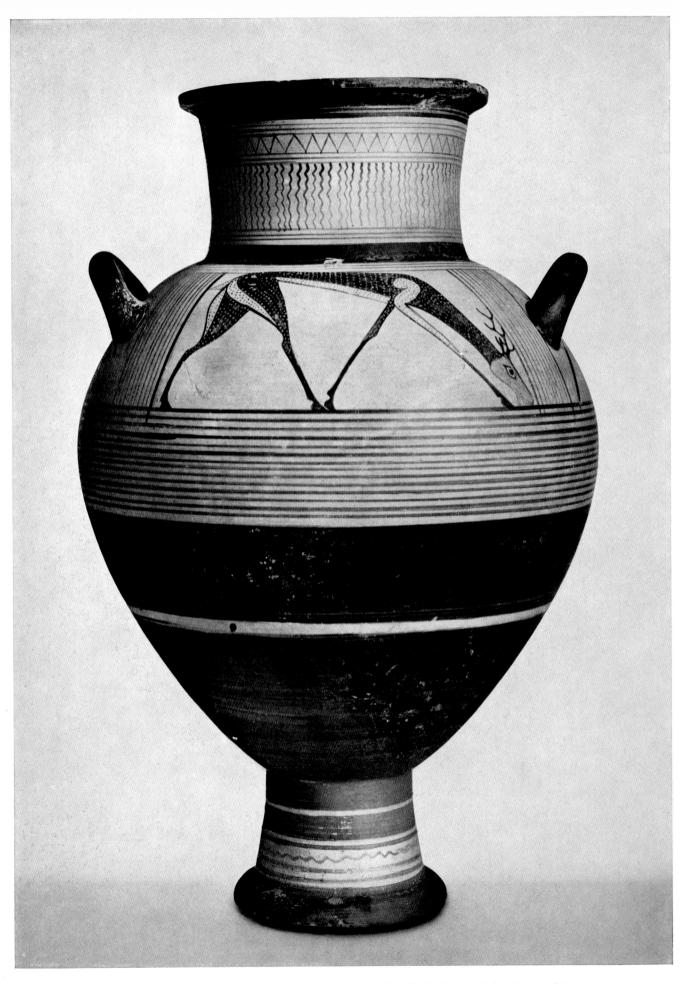

76 Cycladic Parian amphora. Grazing stag. Height 59 cm. Ca. 650 B.C. Stockholm, National Museum

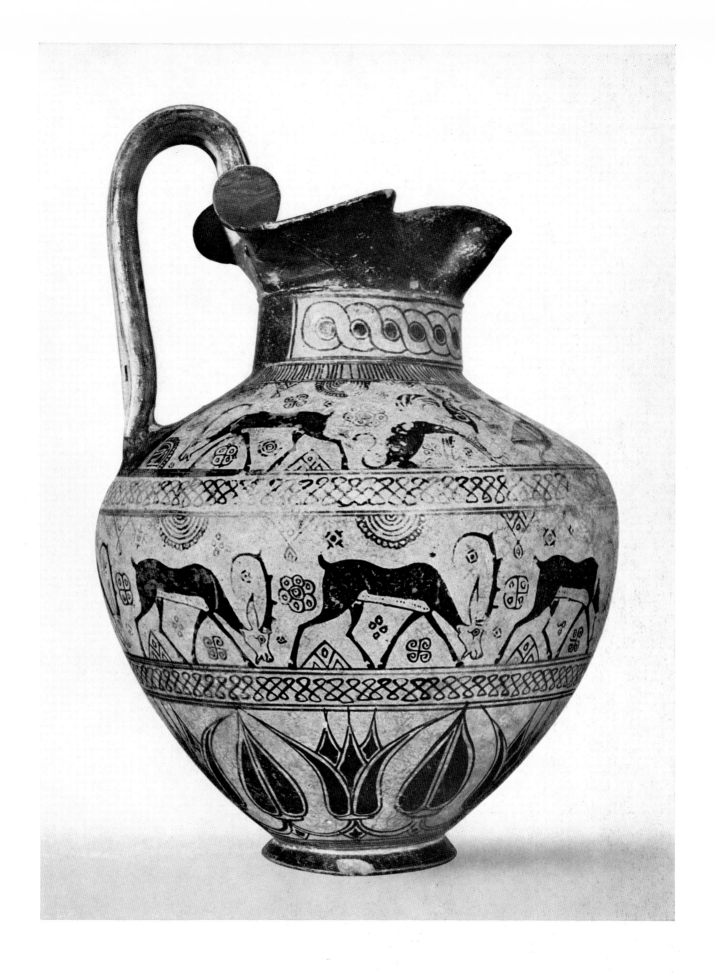

77 Cycladic Rhodian oinochoe. Grazing wild goats and animal friezes. Height 32.5 cm. Ca. 630/620 B.C.
Munich, Staatliche Antikensammlungen 449

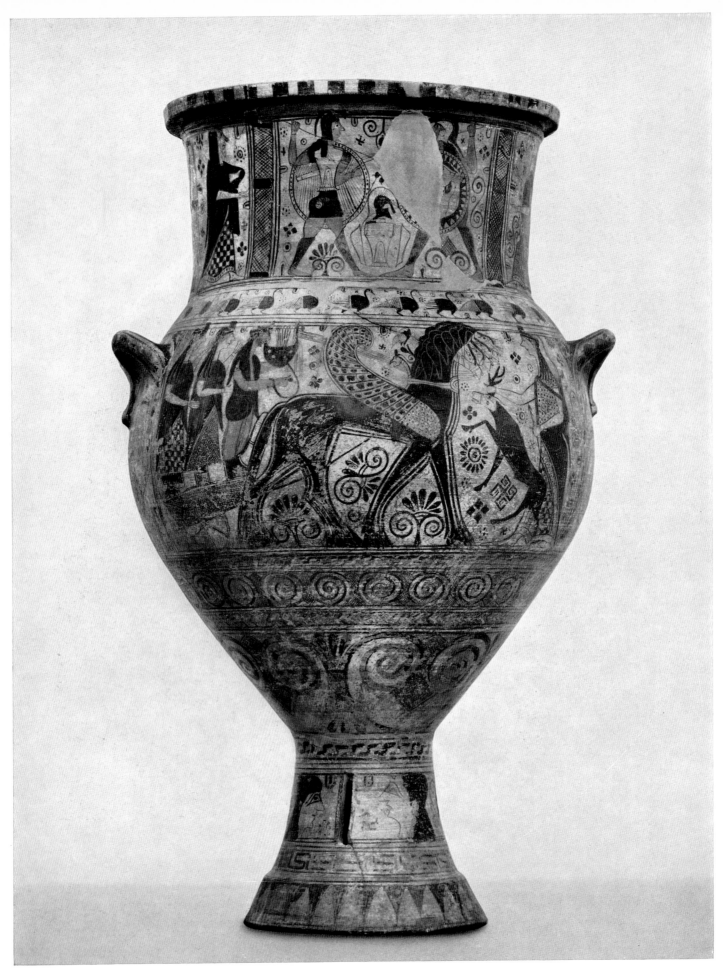

78 Cycladic Melian amphora. Apollo with the Hyperborean Maidens being met by Artemis.
Height 95 cm. Ca. 625 B.C. Athens, National Museum 311

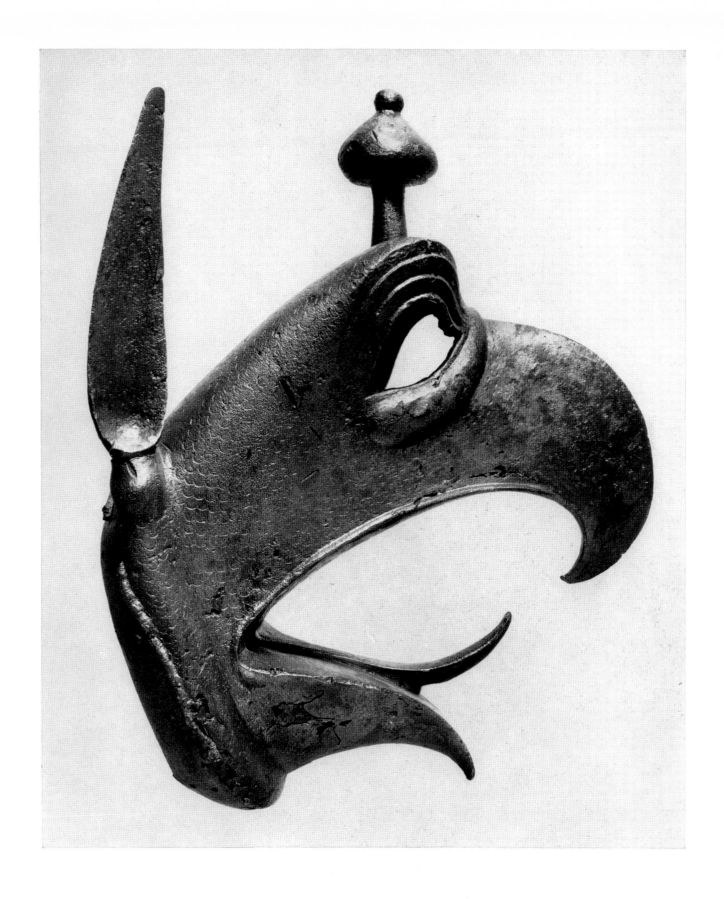

79 Head of a griffin protome found at Olympia. Bronze. Height 27.8 cm. Mid 7th century B.C. Olympia Museum

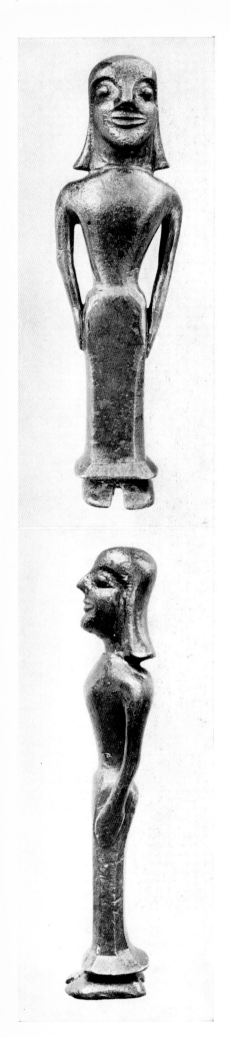

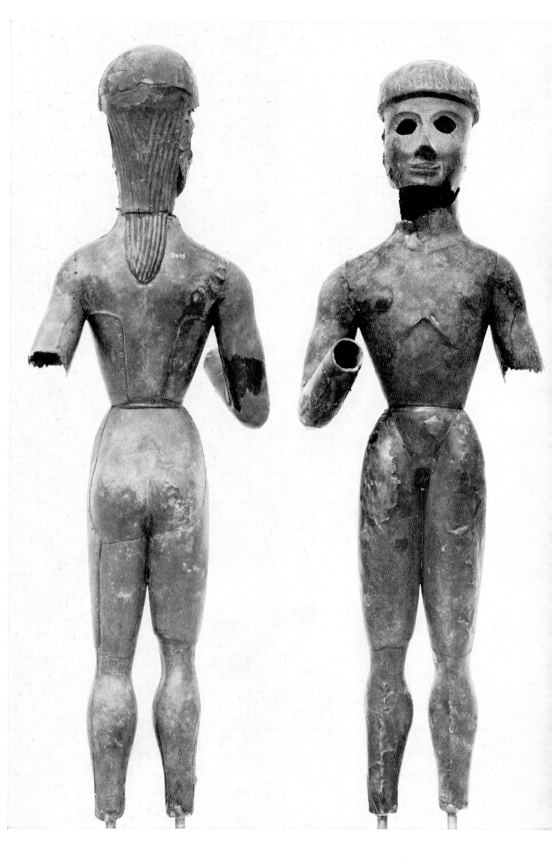

80 Left: Bronze statuette of a woman, from the Menelaion near Sparta. Early Archaic.
Second half of 7th century B.C. Sparta Museum.
Right: Early Archaic Apollo. Sphyrelaton bronze, from Dreros, Crete.
Height 80 cm. Second quarter of 7th century B.C. Crete, Herakleion Museum

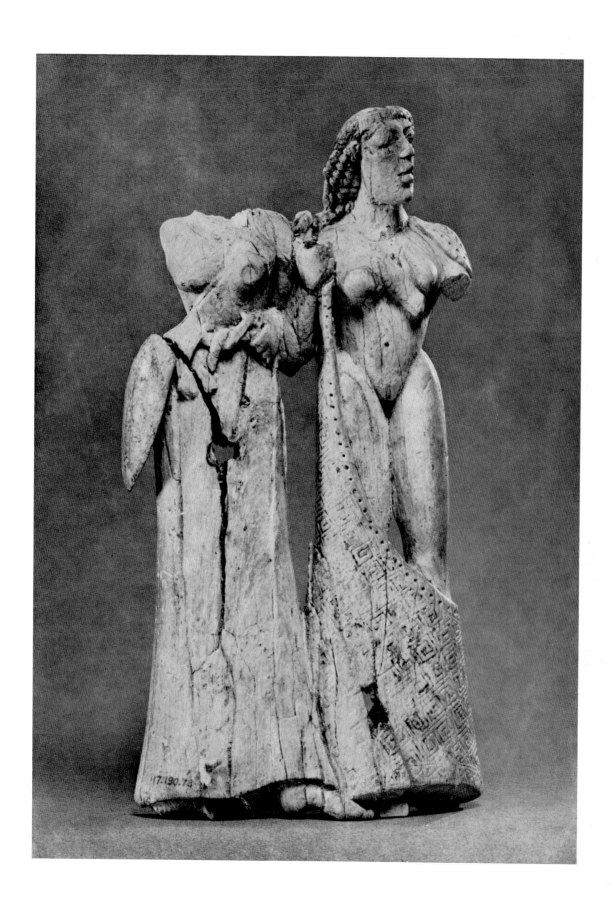

81 The daughters of Proitos, ivory. Height 13.7 cm.
Early Archaic. Second quarter of 7th century B.C. New York, Metropolitan Museum of Art 17.190.73

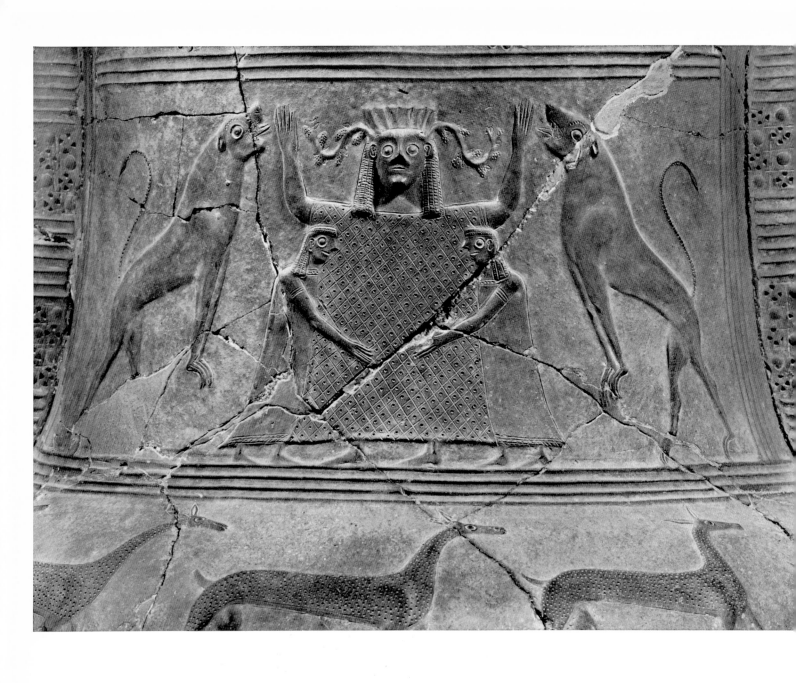

82 Leto gives birth to Apollo, from the neck of a relief pithos from Thebes.
Over-all height of the pithos 1.20 m. Early Archaic. After 700 B.C. Athens, National Museum 5898

83 Scenes from the sack of Troy, from a relief pithos from Mykonos. Height 1.34 m. Ca. 670 B.C. Mykonos Museum

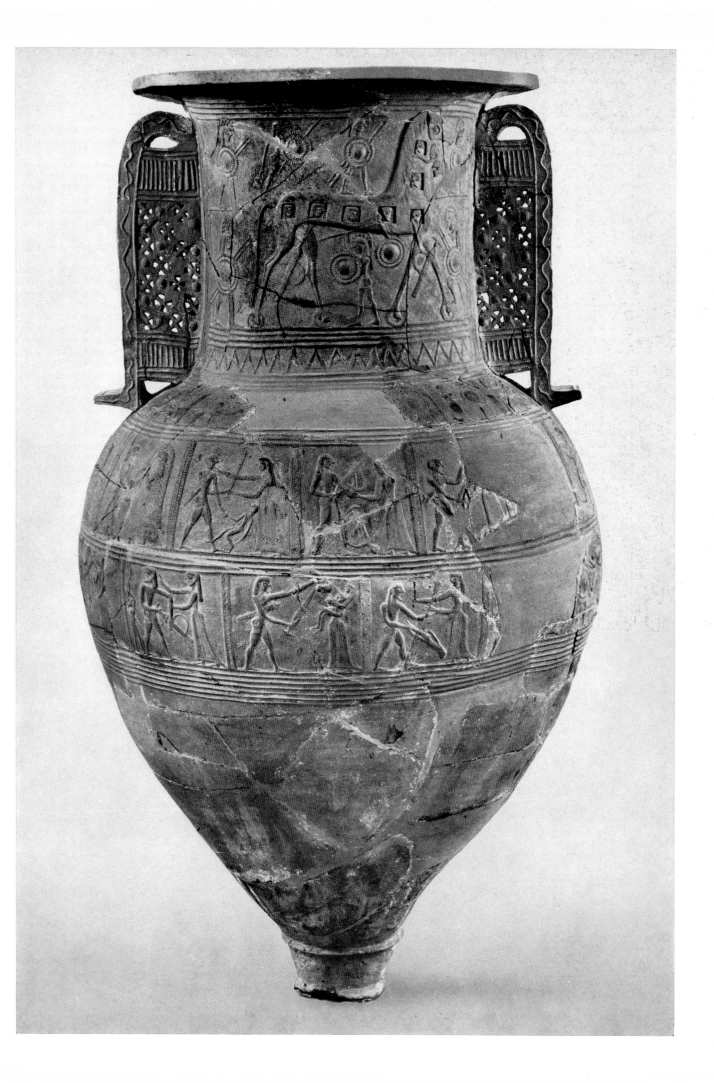

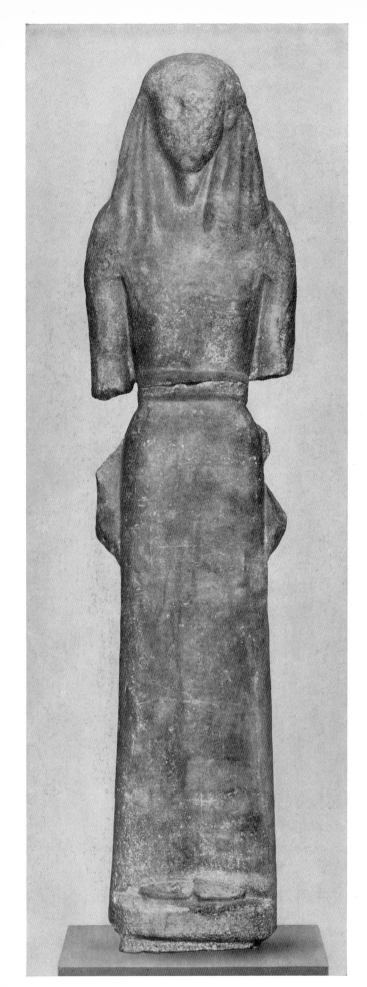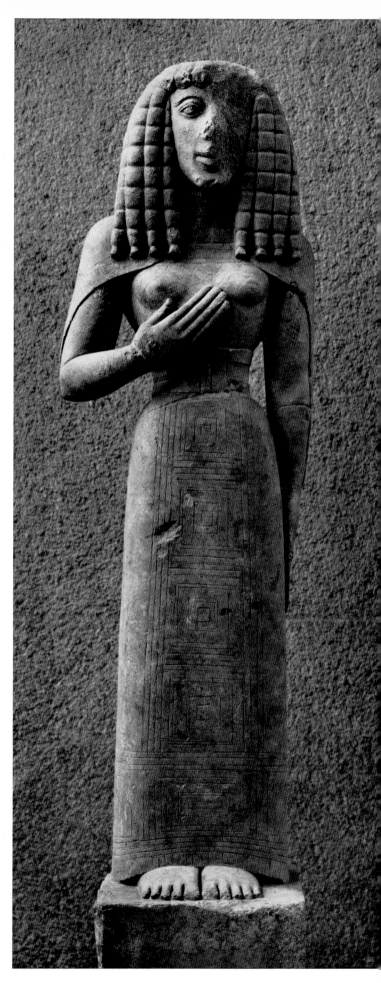

84 Left: Statue of Artemis dedicated on Delos by Nikandre of Naxos. Marble.
Height 1.75 m. Early Archaic. Ca. 660 B.C. Athens, National Museum 1.
Right: Standing female figure, known as the Auxerre statuette. Limestone. Height (figure only) 65 cm. After 650 B.C. Paris, Louvre 3098

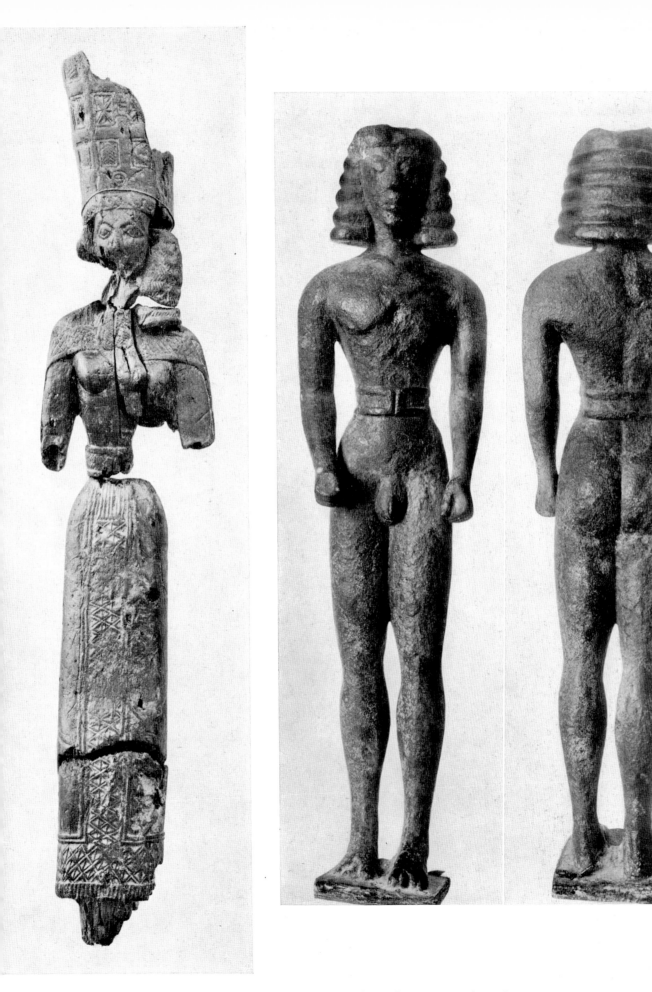

85 Left: Statuette of Hera, from Heraion on Samos. Wood. Height 28.7 cm. Early Archaic. Ca. 660 B.C. Samos Museum.
Right: Statuette of a youth in the Cretan style, from Delphi. Bronze. Height 20 cm. Early Archaic. Mid 7th century B.C. Delphi Museum

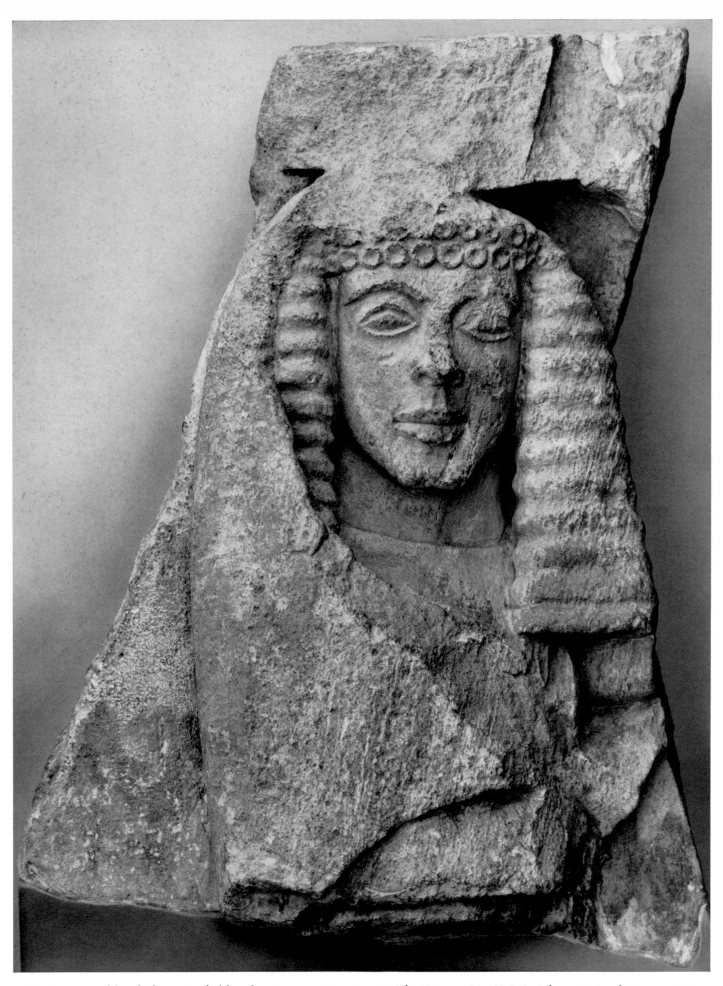

86 Fragment of female figure in relief found at Mycenae. Limestone. Height 40.2 cm. Ca. 630 B.C. Athens, National Museum 2869

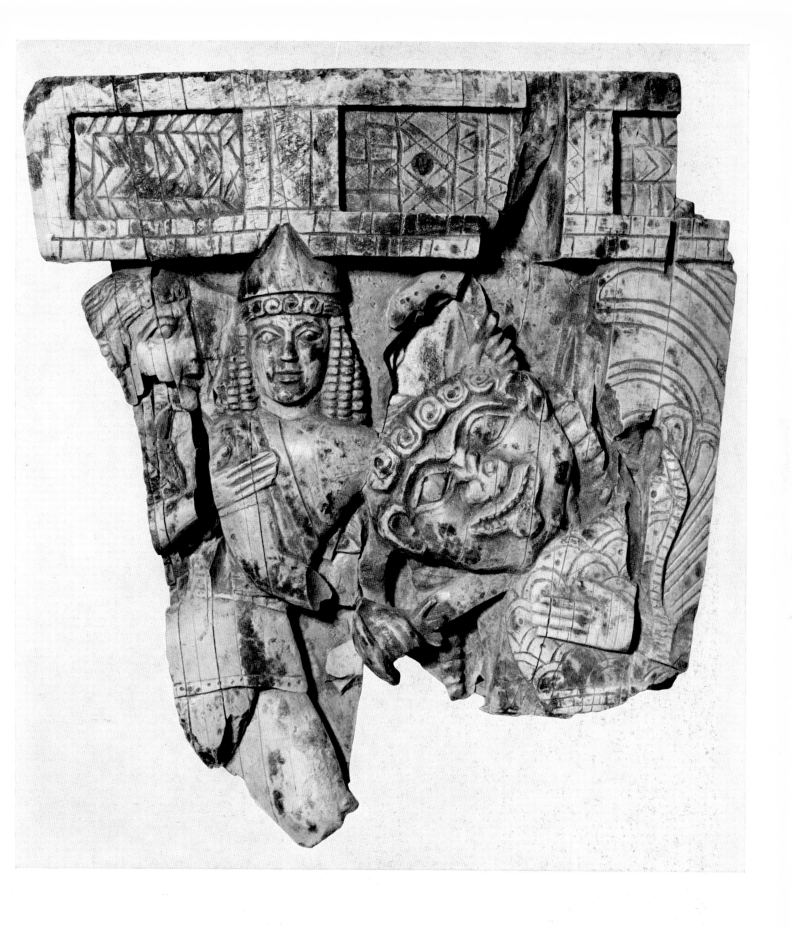

87 Perseus cuts off the head of Medusa, from Samos. Ivory relief. Height 10.8 cm. Ca. 630/620 B.C. Athens, National Museum

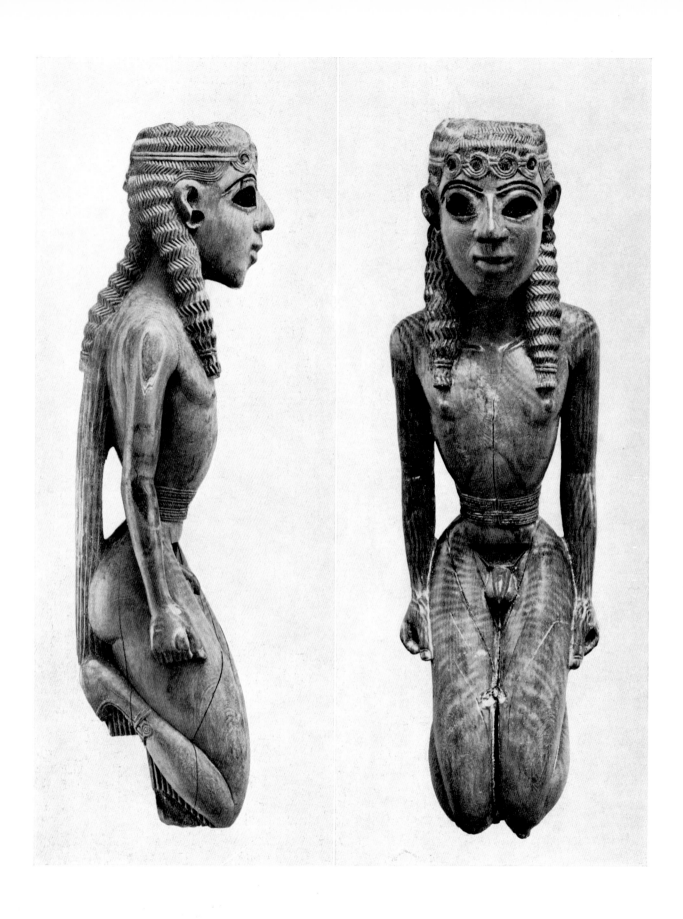

88 Kneeling youth, from Samos. Early Archaic decorative finial for a cithara, ivory.
Height 14.5 cm. Ca. 625 B.C. Samos Museum

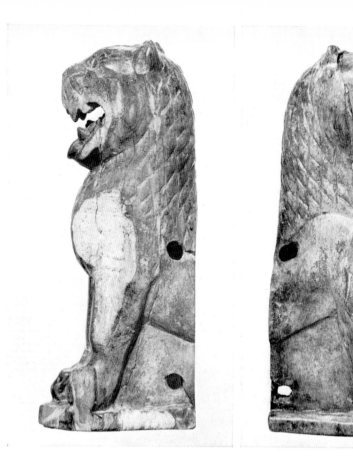

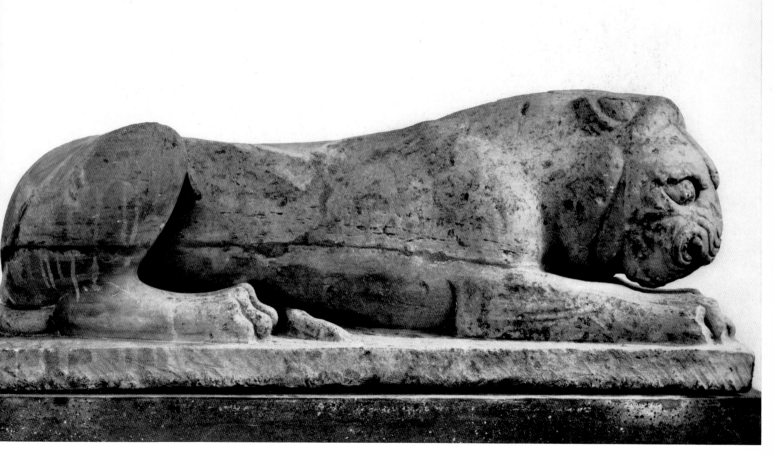

89 Above: Two lions in ivory, from Taranto. Formerly decorations for a small box.
Height 7.6 cm. Early Archaic. Last quarter of 7th century B.C. Copenhagen, National Museum.
Below: Reclining lion from Corfu. Limestone. Length of plinth 1.22 m. Third quarter of 7th century B.C. Corfu Museum

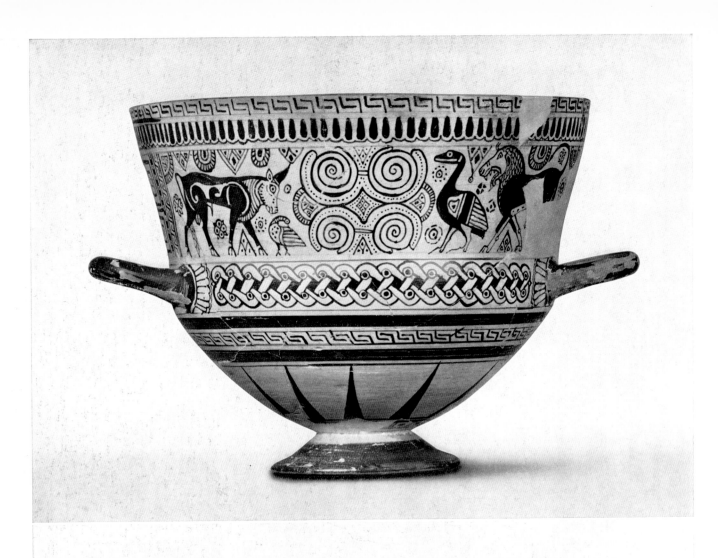

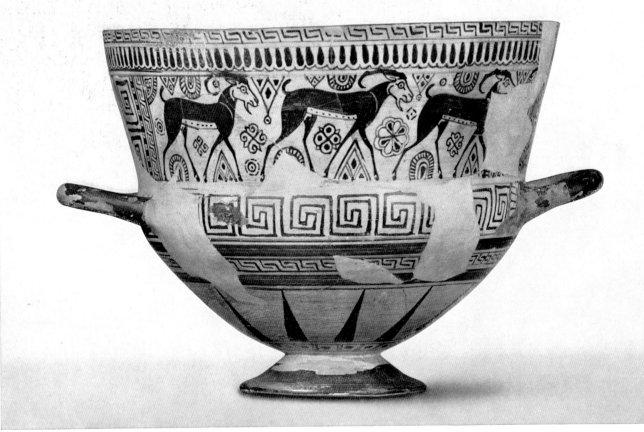

90 Chiot Chalice, from Vulci. Animal friezes.
Height 15.4 cm. Ca. 625 B.C. Würzburg, University (Martin-von-Wagner) Museum 311

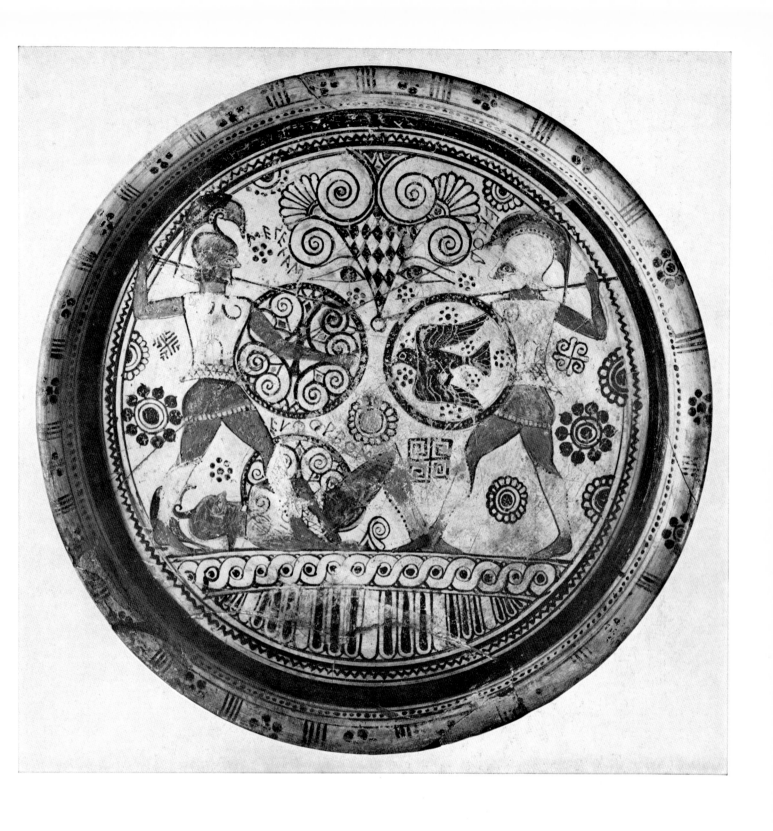

91 Rhodian plate, from Kameiros. Menelaus and Hector fighting over the fallen Euphorbos.
Diam. 38.5 cm. End of 7th century B.C. London, British Museum A 749

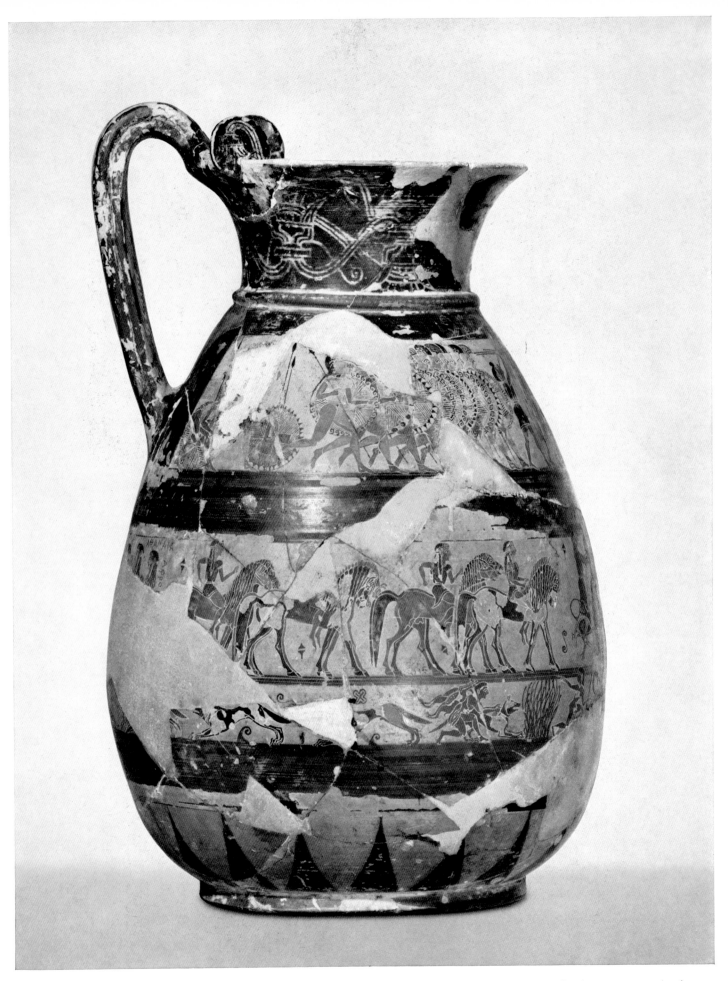

92 Proto-corinthian oinochoe (olpe) by the Macmillan Painter (Chigi Vase). Cf. plate VI. Main friezes: hoplites going into battle.
Below: Judgement of Paris, riders, chariots; in narrow frieze: hunting. Height 26.2 cm. Ca. 640 B.C. Rome, Museo Villa Giulia

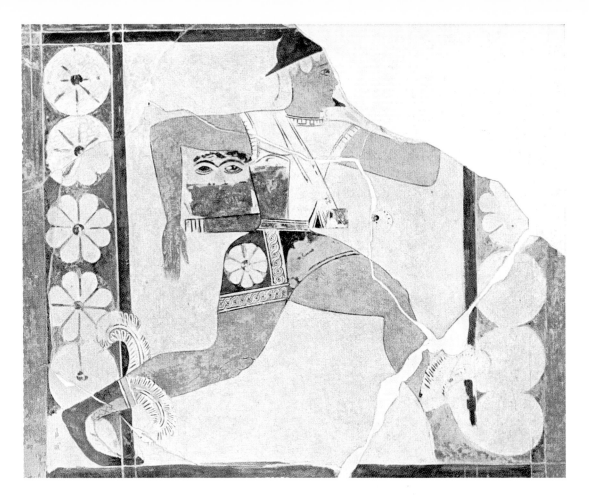

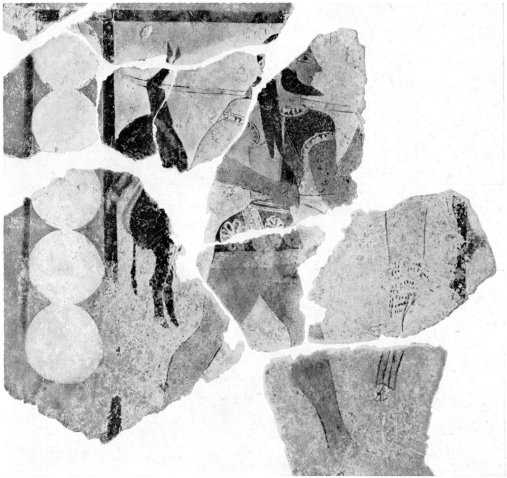

93 Two painted clay metopes, from the Early Archaic Apollo temple in Thermon. Cf. plate VII.
Above: Perseus flees with the head of Medusa. Below: Orion. Height about 60 cm. Ca. 625 B.C. Athens, National Museum

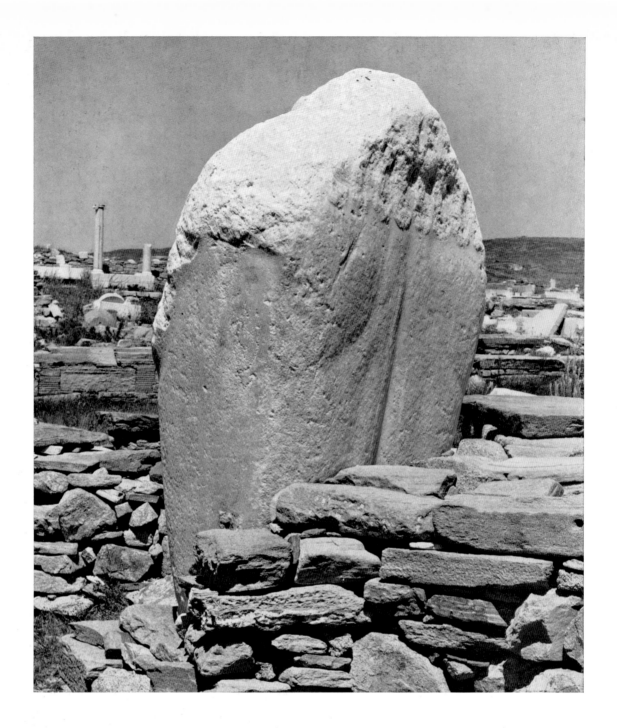

94 Delos, Apollo. Body of colossal statue, about thirty feet tall, which stood beside the Oikos of the Naxians.
Below: Its rectangular plinth, with on the side the inscription: 'I am from the same stone, statue and socle'. Ca. 600 B.C. Delos

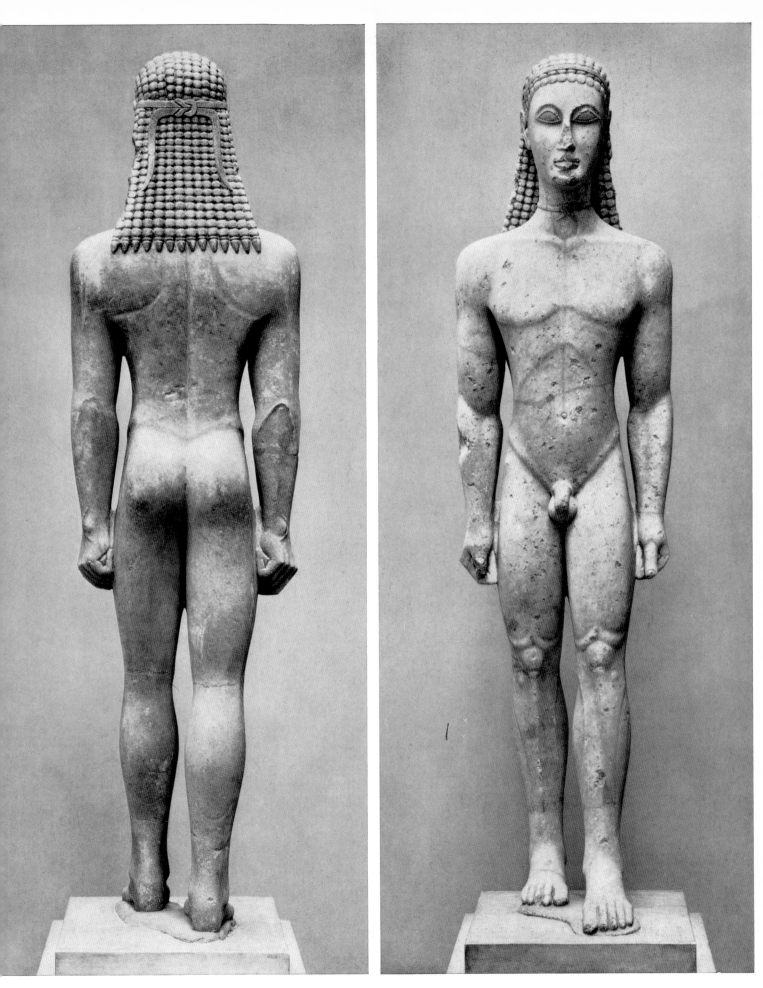

95 Standing youth, by the Dipylon Master. Found in Attica. Marble.
Height 1.84 m. Ca. 620 B.C. New York, Metropolitan Museum of Art 32.11.1

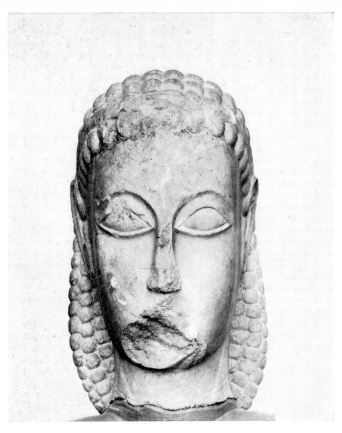

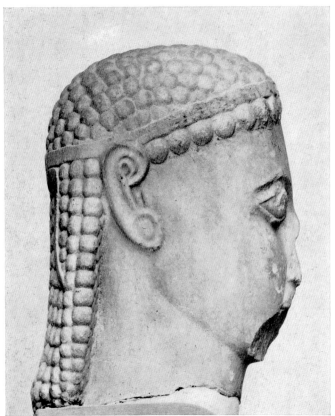

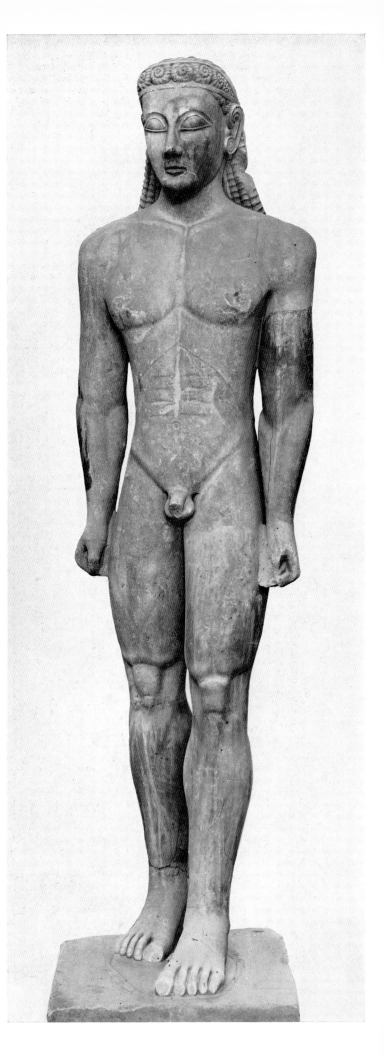

96 Left: Marble head of a kouros, by the Dipylon Master.
Height 44 cm. Early Archaic. Ca. 600 B.C.
Athens, National Museum 3372.
Right: Marble kouros from Sounion.
Height 3.05 m. Early Archaic. First quarter of 6th century B.C.
Athens, National Museum 2720

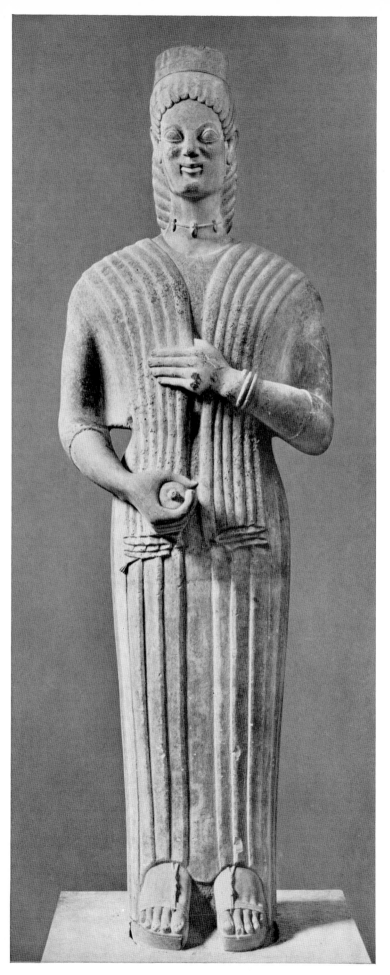
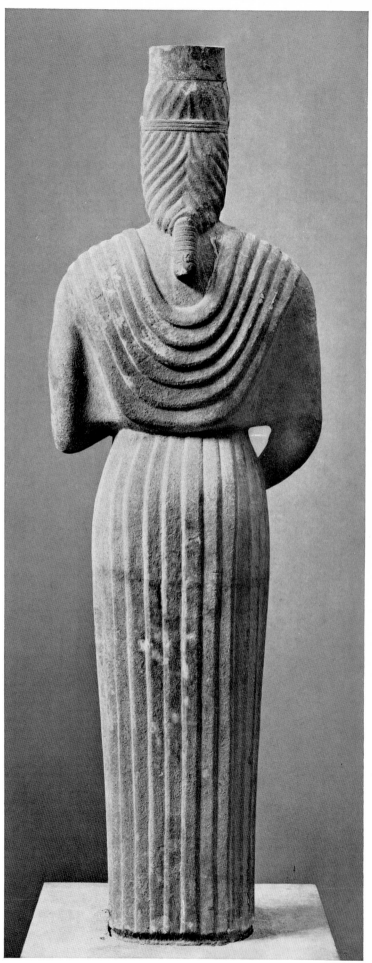

97 Standing woman with pomegranate, found near Keratea in Attica. Marble.
Height 1.93 m. Early 6th century B.C. Berlin, Staatliche Museen

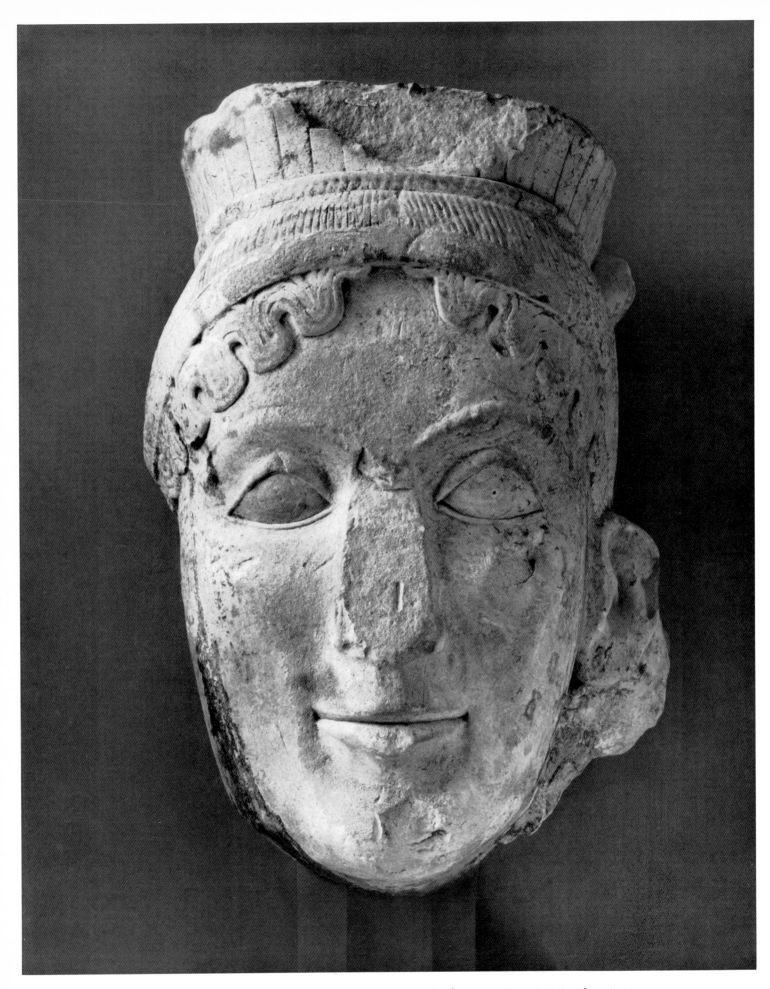

98 Head of Hera. From the Heraion at Olympia. Limestone. Height 52 cm. Ca. 590 B.C. Olympia Museum

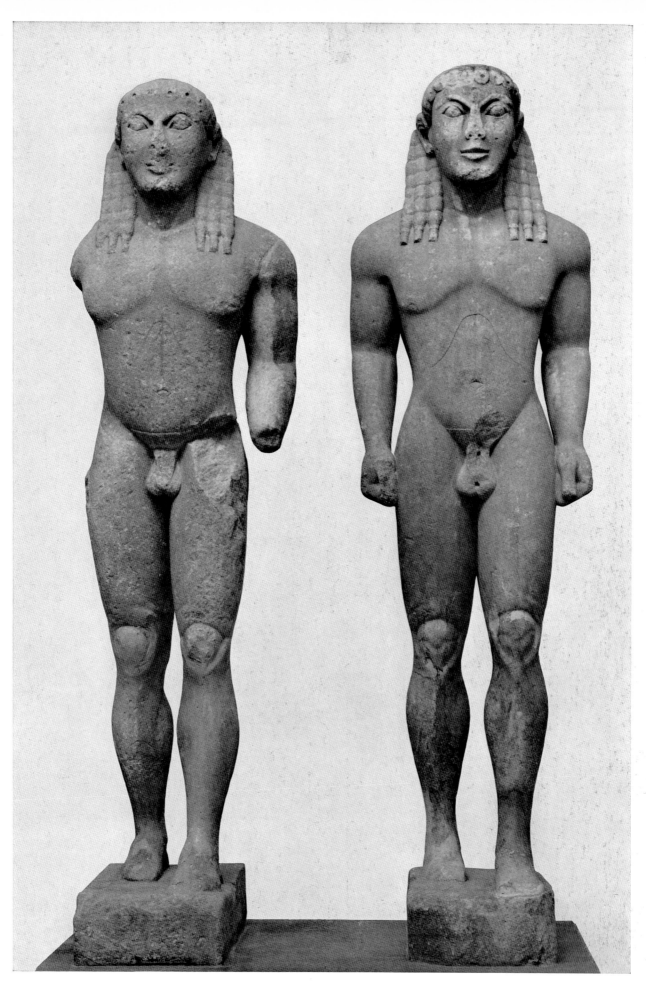

99 Cleobis and Biton. Marble. Height of the statues without bases 2.16–2.18 m.
Early 6th century B.C. Delphi Museum 467, 1524

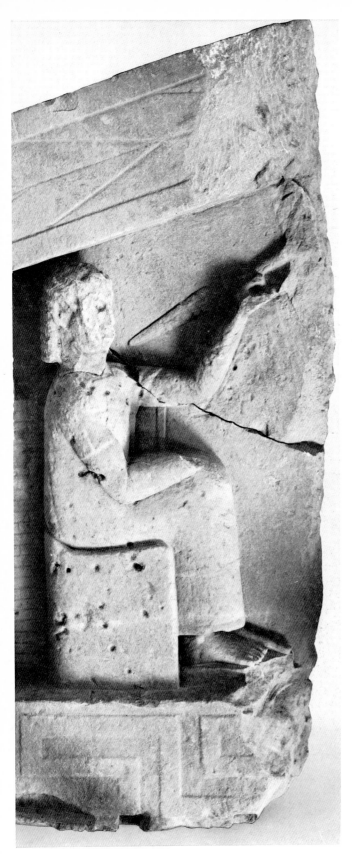 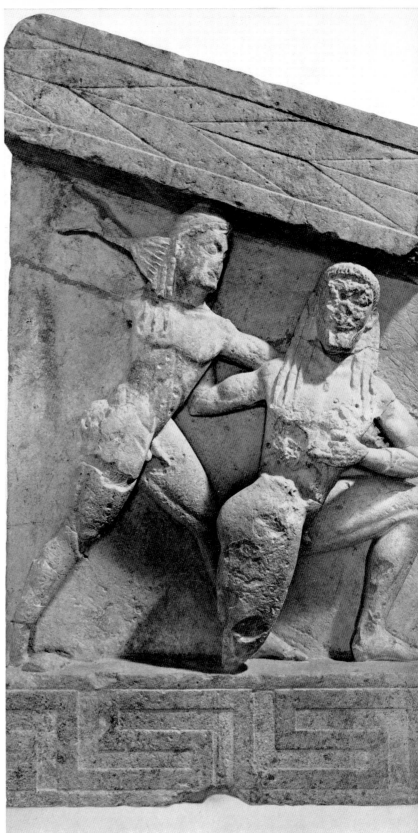

100 Angle groups from west pediment of the Temple of Artemis, Corfu.
Left: Rhea threatened by Poseidon; right: Zeus overcomes Kronos. Limestone. Height about 2.60 m. Ca. 590 B.C. Corfu Museum

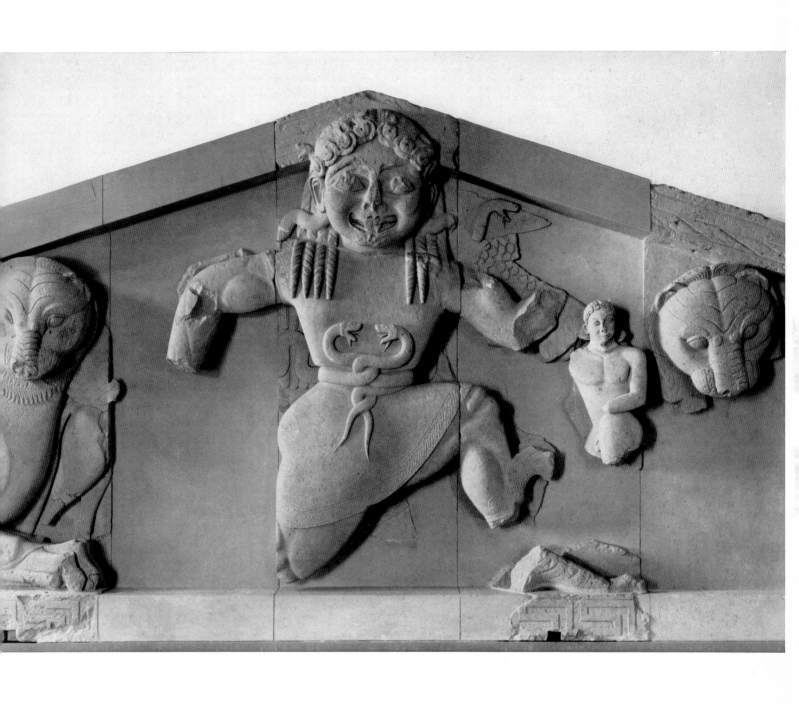

101 Centre section from the west pediment of the Temple of Artemis, Corfu.
Medusa and her two sons, Chrysaor (right) and Pegasus (left; only scanty remains). Limestone. Height 3.15 m. Ca. 590 B.C. Corfu Museum

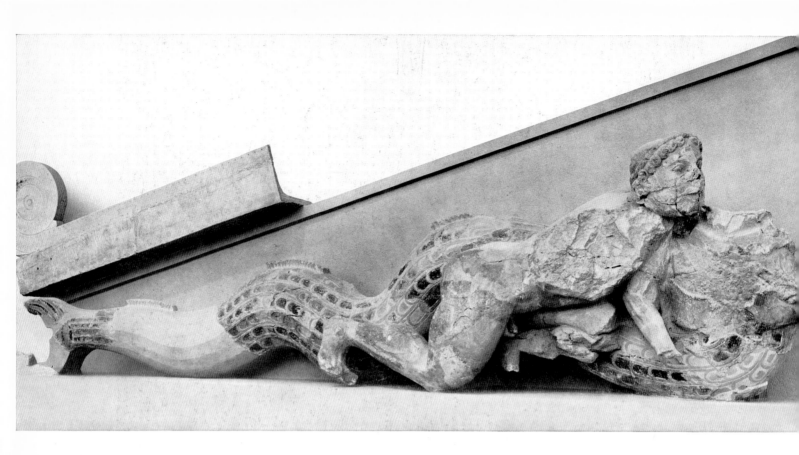

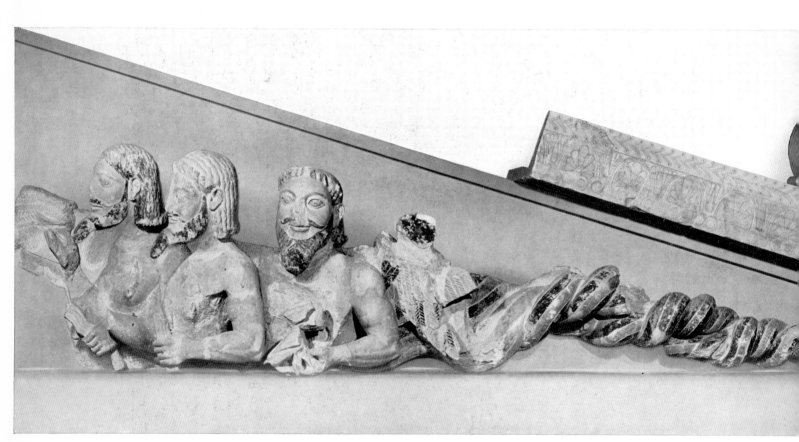

102 Angle groups from east pediment of the oldest Peristyle Temple on the Athenian Acropolis.
Above: Herakles wrestles with Triton; below: Nereus the Three-bodied. Cf. plate VIII. Limestone.
Length 3.53 m. and 3.40 m. respectively. Ca. 570 B.C. Athens, Acropolis Museum

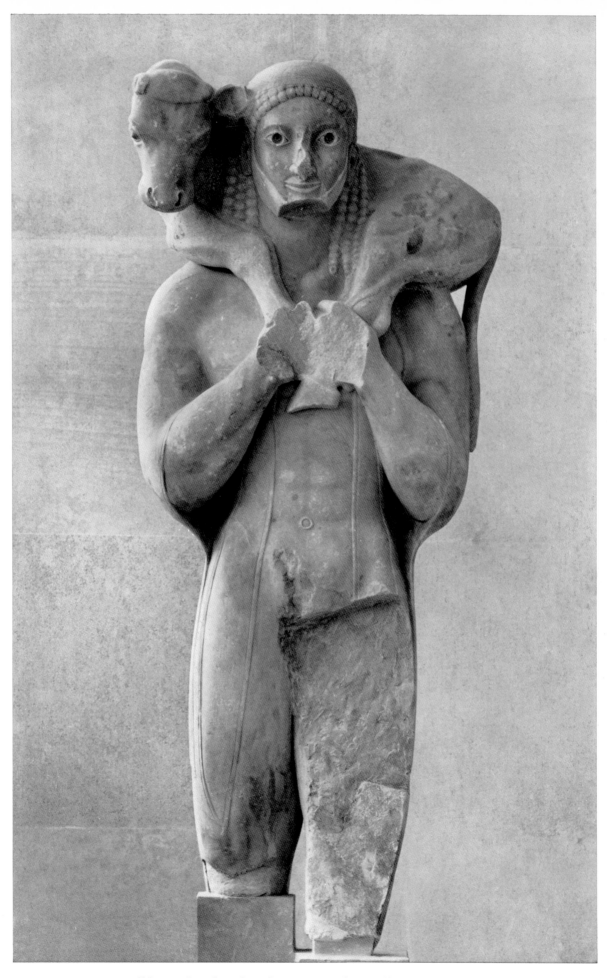

103 Calf-bearer, found on the Athenian Acropolis. Marble from Mt. Hymettos.
Height 1.65 m. Ca. 570/560 B.C. Athens, Acropolis Museum

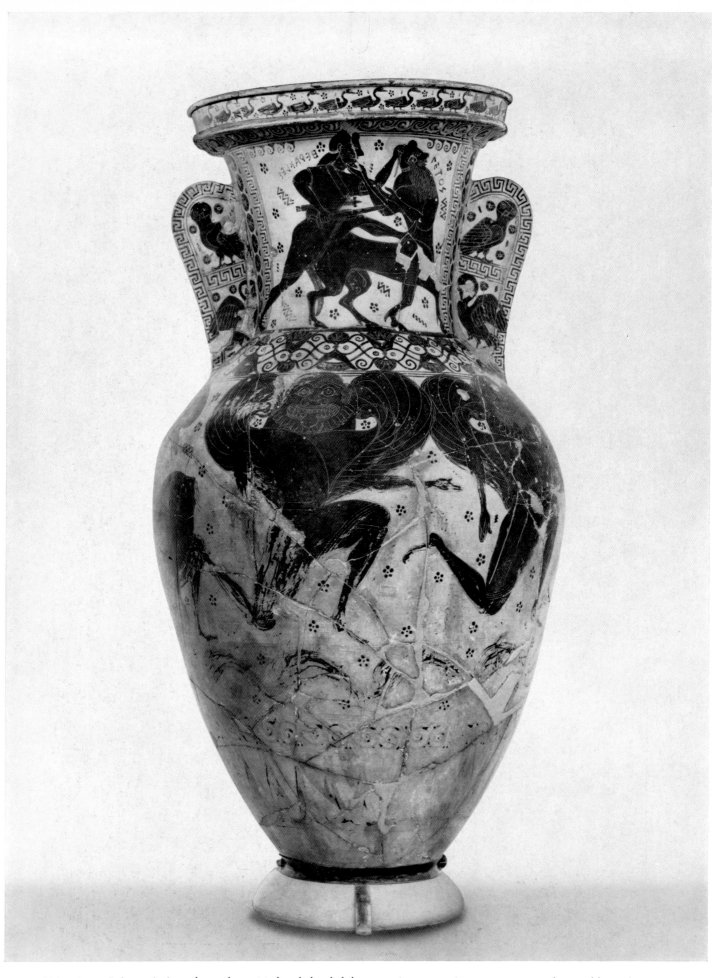

104 Nettos Painter. Attic neck-amphora. Medusa beheaded, her two sisters pursuing Perseus; on neck, Herakles and Nessos.
Height 1.22 m. Last quarter of 7th century B.C. Athens, National Museum 1002

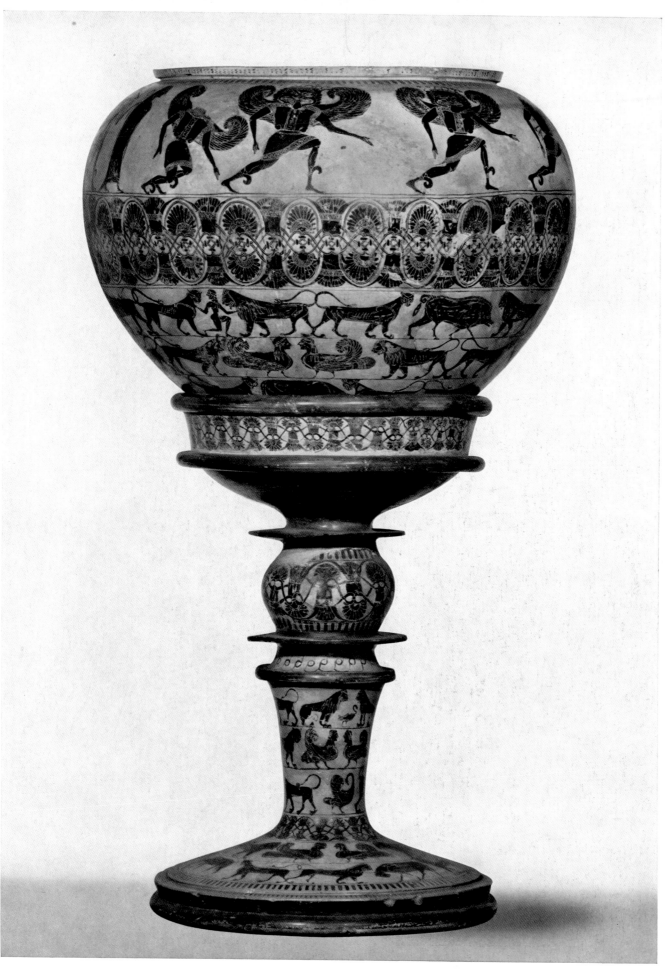

105 Gorgon Painter. Dinos with stand. Perseus and the Gorgons. Animal friezes. Height 93 cm. Ca. 600/590 B.C. Paris, Louvre E 874

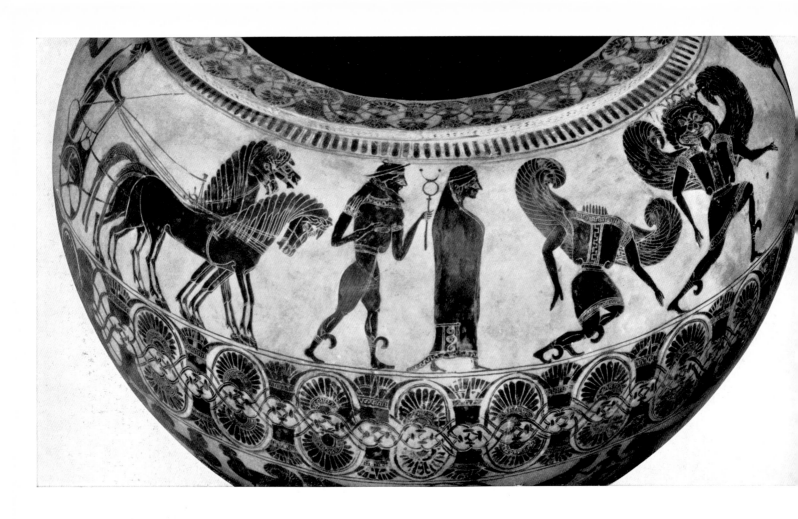

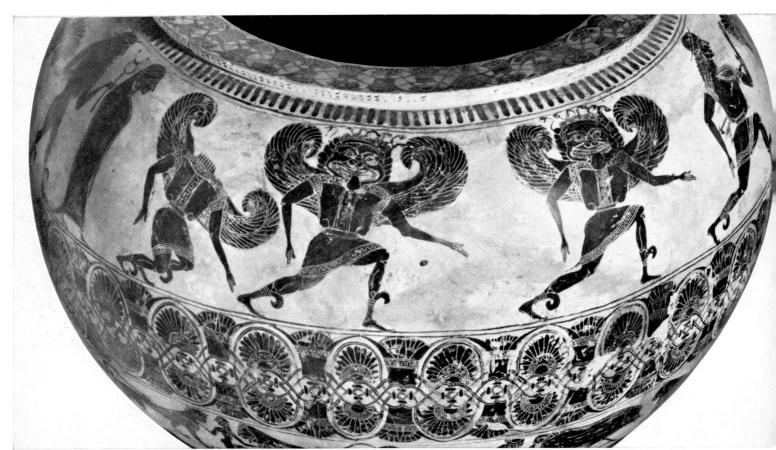

106 Gorgon Painter. Details from dinos (plate 105). Above: Hermes and Athena, Medusa and one of her Gorgon sisters.
Below: Gorgons pursuing

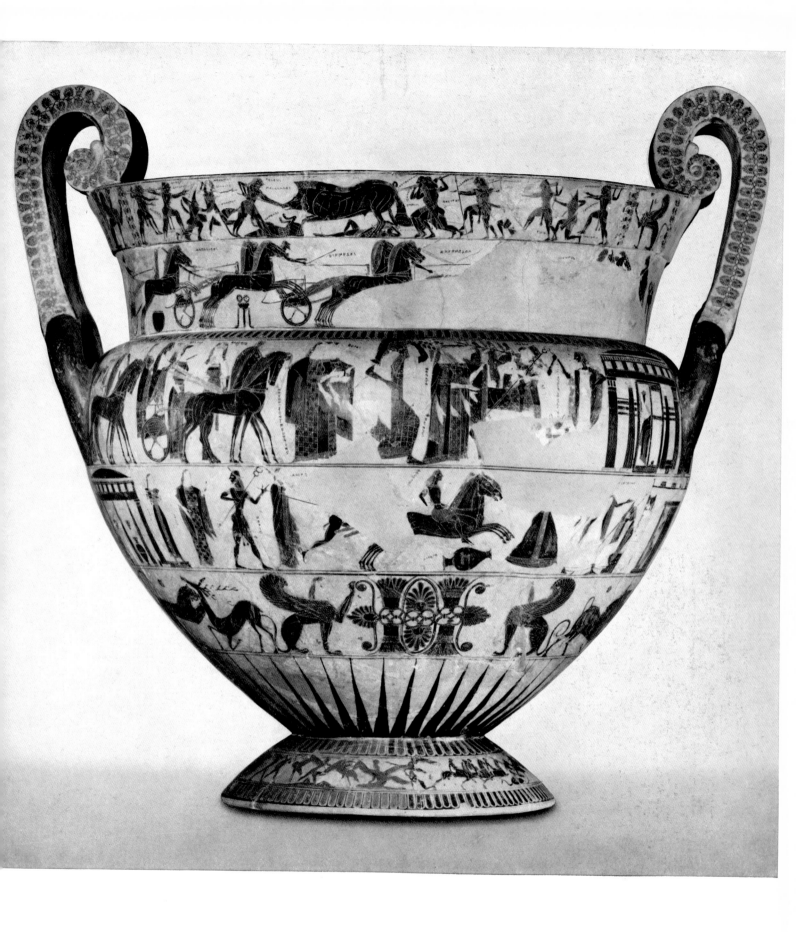

107 Kleitias and Ergotimos. Volute-krater (François Vase). Side A.
On neck: Hunt of Calydonian boar, funeral games of Patroklos; on body: Wedding of Peleus and Thetis, Achilles pursuing Troilos;
on foot: Battle of Pygmies and Cranes. Height 66 cm. Ca. 570/560 B.C. Florence, Archaeological Museum 4209

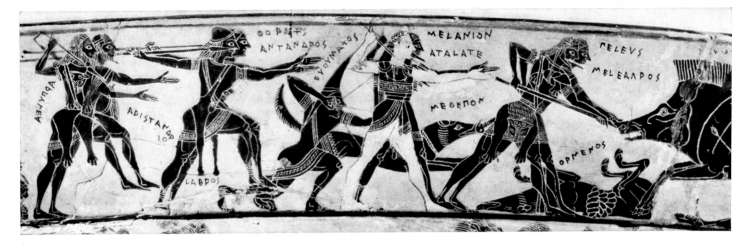

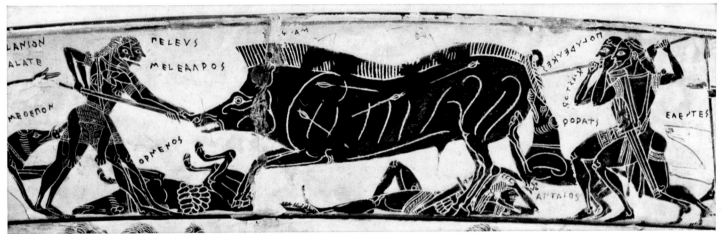

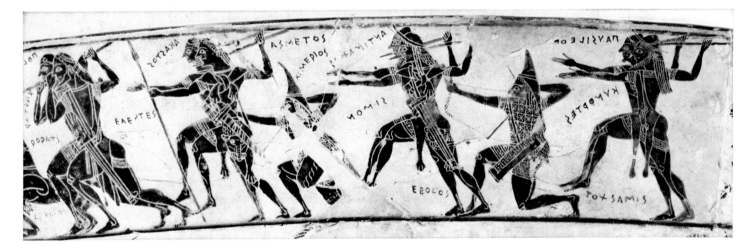

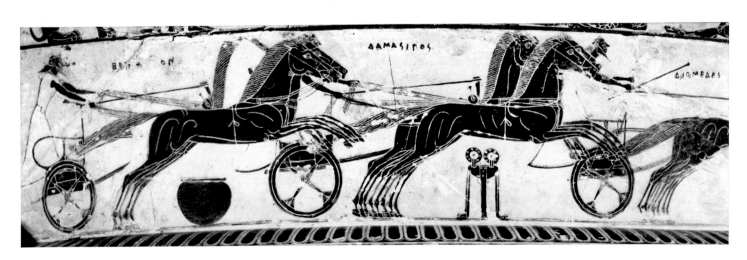

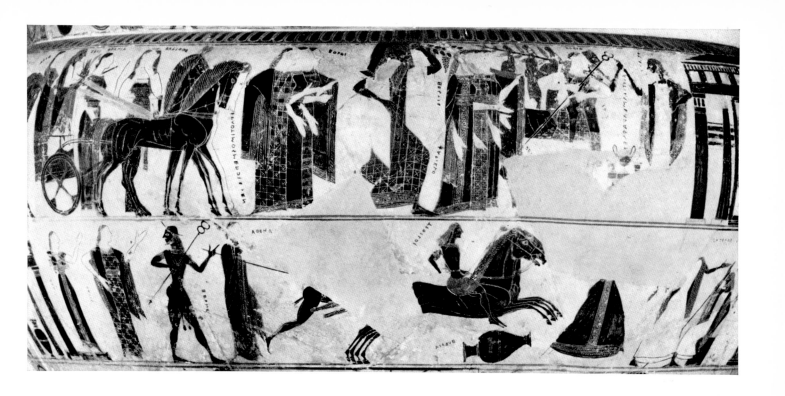

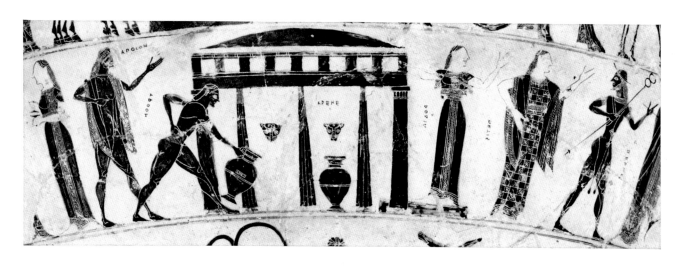

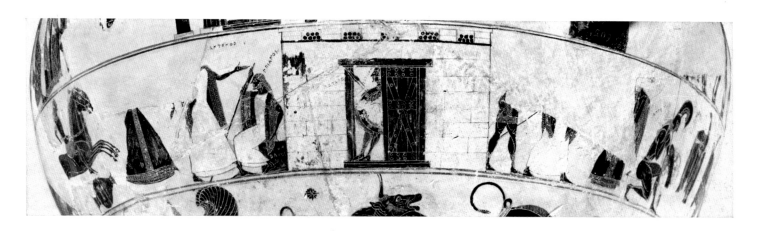

108, 109 Obverse of volute-krater by Kleitias and Ergotimos. Cf. plate 107.
108 Scene from the neck. The hunt of the Calydonian Boar; beneath: chariot races at the funeral games of Patroklos.
109 Scenes from the main zone. Above: The gods visit the newly married Peleus and Thetis; beneath: Achilles pursues Troilos; middle: The fountain-house; below: Priam before the city's gates

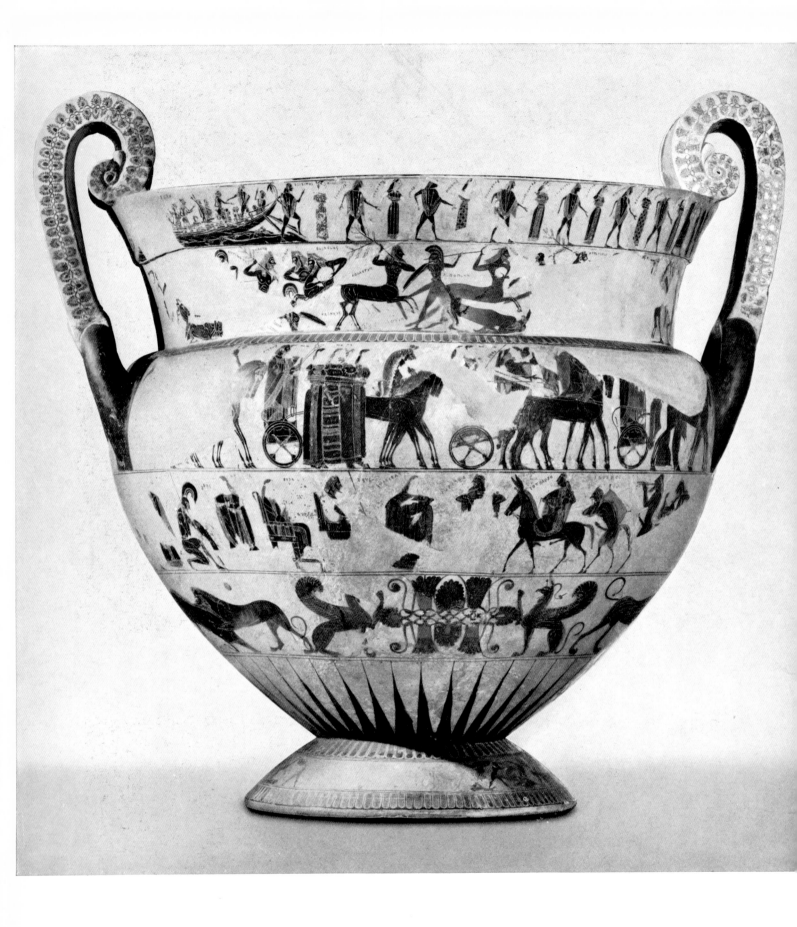

110 Kleitias and Ergotimos. Volute-krater (François Vase). Side B. Cf. plates 107–109
On neck: Dance of Athenian youths and maidens liberated from Crete, battle of Lapiths and Centaurs;
on body: Wedding of Peleus and Thetis, the return of Hephaistos to Olympus; on foot: Battle of Pygmies and Cranes.

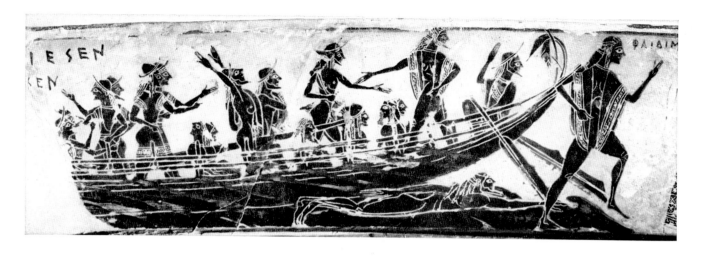

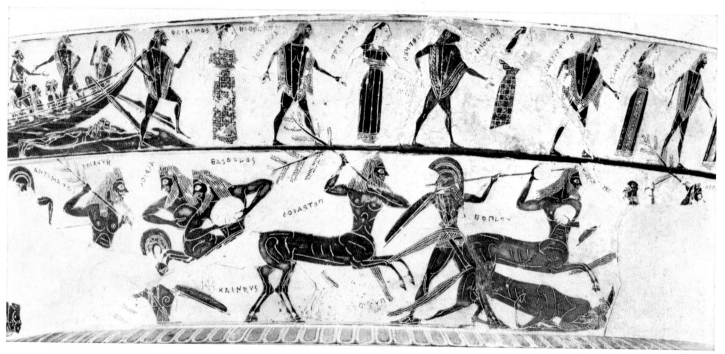

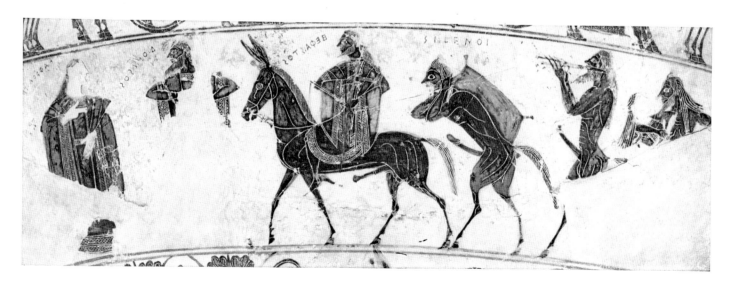

111 Scenes from the reverse of volute-krater by Kleitias and Ergotimos. Cf. plate 110.
Above and centre: Arrival of the Athenian children from Crete, battle of Lapiths and Centaurs;
below: The return of Hephaistos to Olympus

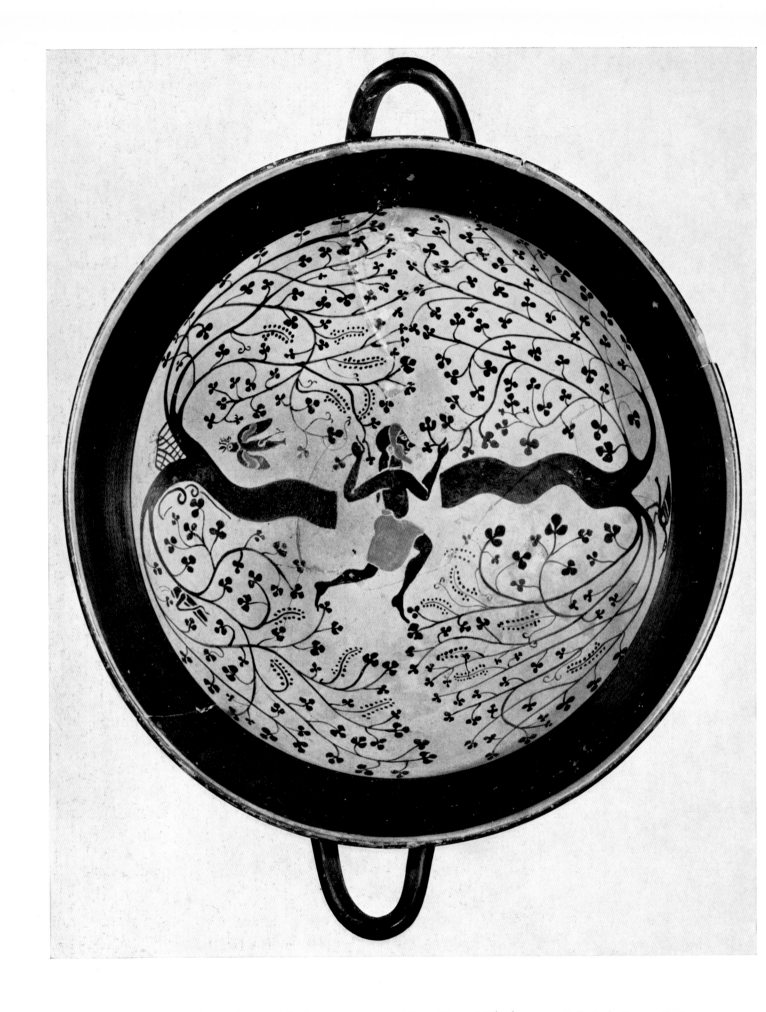

112 East Greek cup. Interior. Man between two trees. Diam. 23 cm. Mid 6th century B.C. Paris, Louvre F 68

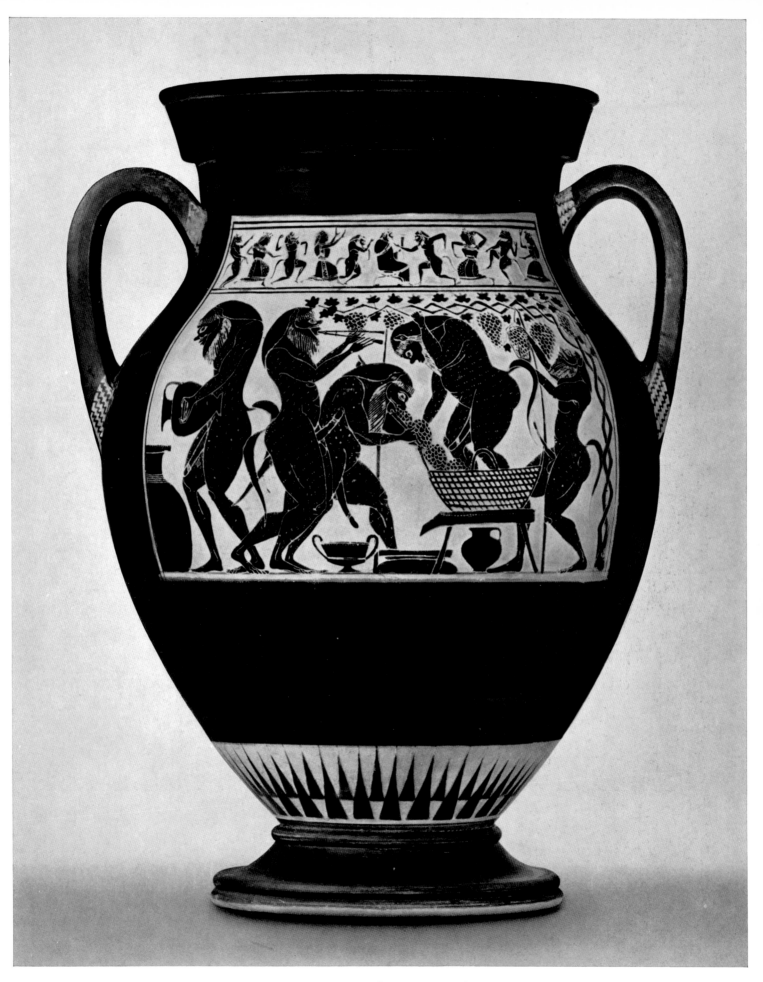

113 Amasis Painter. Amphora. Satyrs treading grapes.
Height 34.7 cm. Ca. 530 B.C. Würzburg, University (Martin-von-Wagner) Museum 265

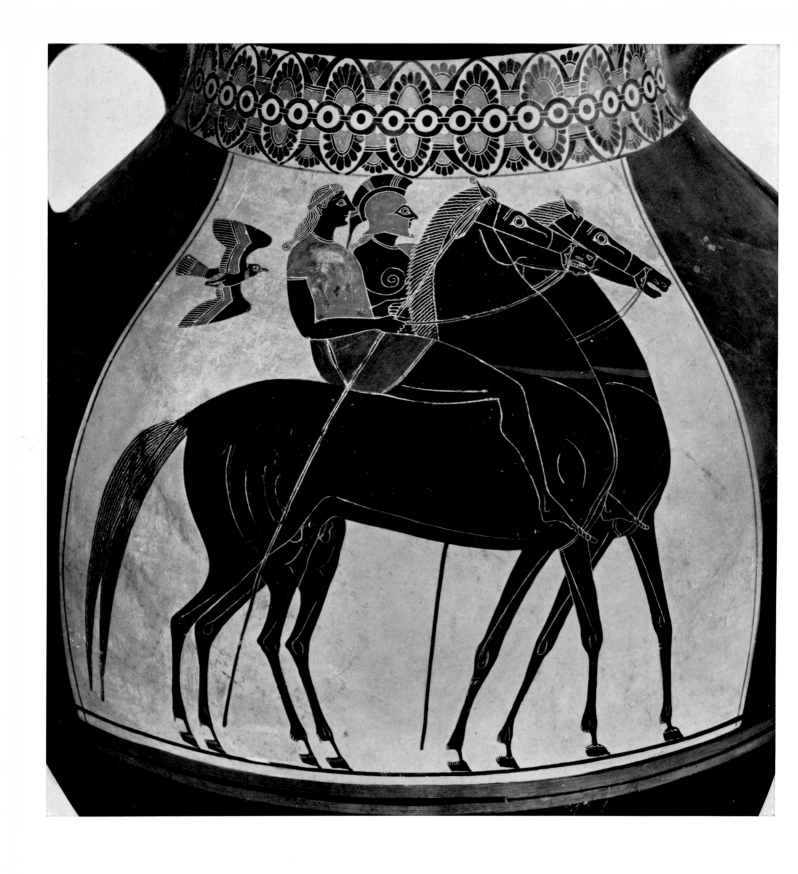

114 Lydos. Amphora. Mounted warrior with squire.
Height 58.3 cm. Ca. 540 B.C. Naples, Museo Nazionale Archeologico 2770

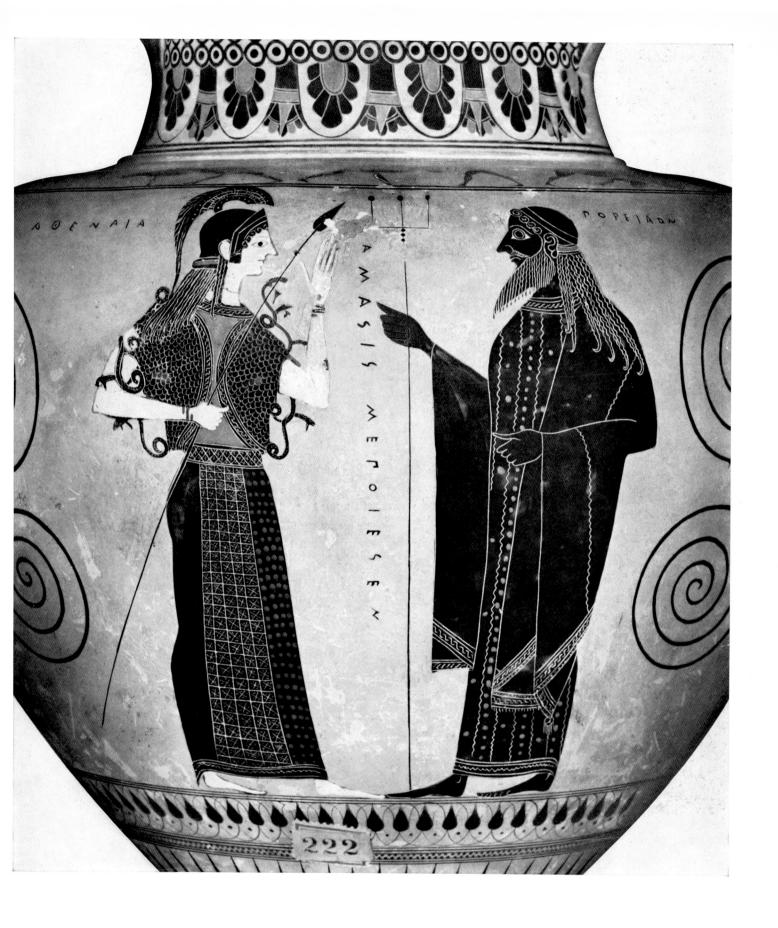

115 Amasis Painter. Obverse of neck-amphora. Cf. plate XIV. Athena and Poseidon.
Height 33 cm. Ca. 540 B.C. Paris, Bibliothèque Nationale 222

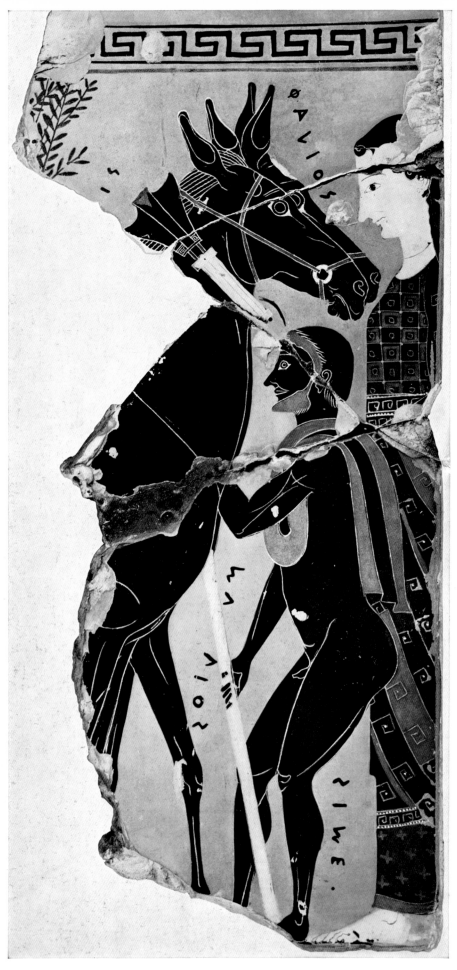

116 Exekias. Clay plaque (pinax) from a tomb, fragment. Harnessing of two mules to a cart for a funeral procession.
Ca. 540 B.C. Berlin, Ehemals Staatliche Museen

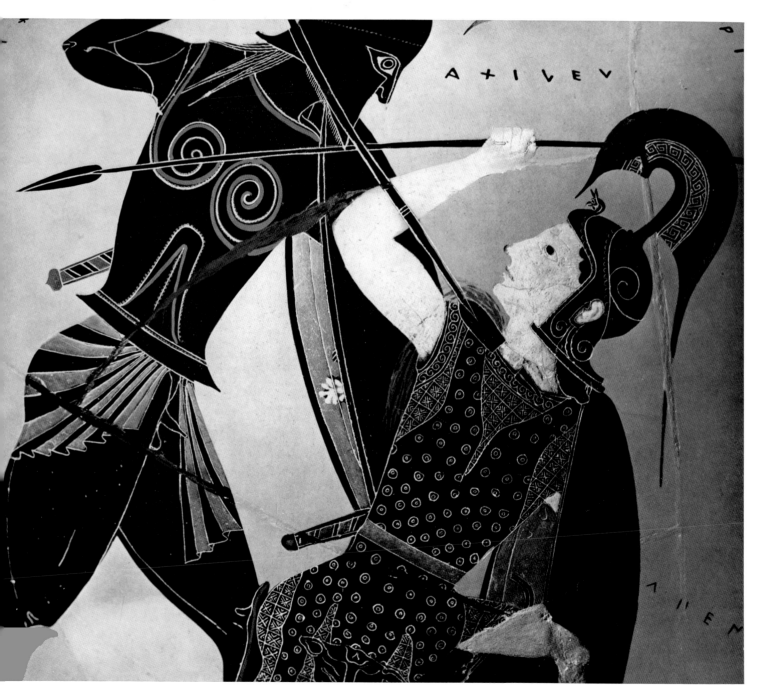

117 Above: Exekias. Clay plaque (pinax), fragment. Lamenting inside the house. Ca. 540 B.C. Berlin, Ehemals Staatliche Museen
Below: Exekias. Detail of neck-amphora. Cf. plate XV. Achilles killing Penthesilea. Ca. 525 B.C. London, British Museum B 210

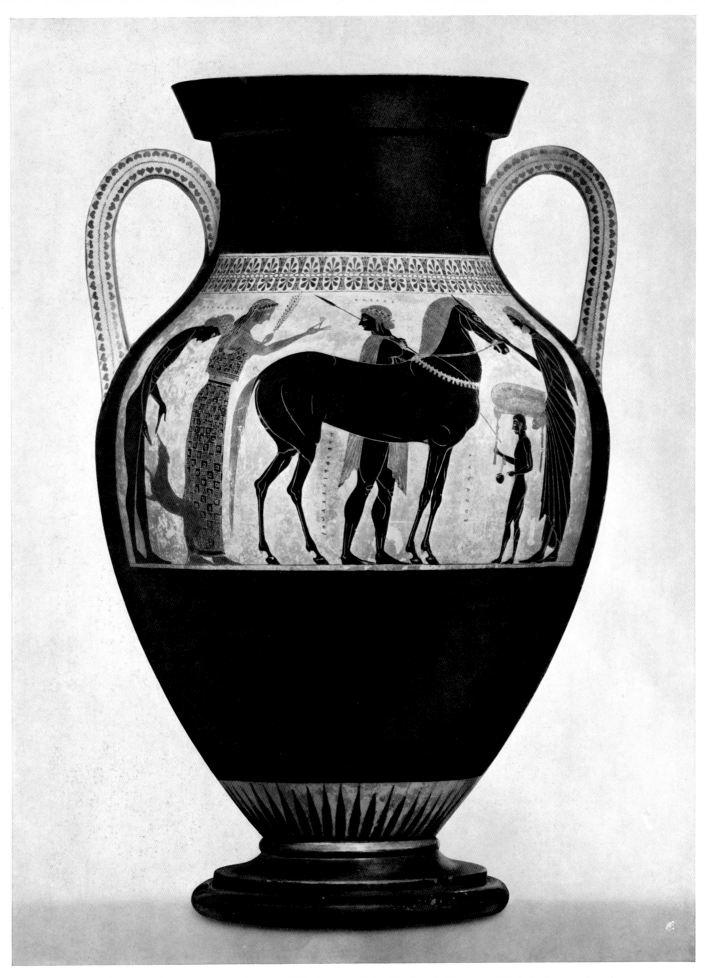

118 Exekias. Amphora, Reverse. Cf. plate XVII. Return of the Dioskouri, Kastor and Polydeukes, to their home. Height 61 cm. Ca. 540/530 B.C. Vatican Museum 344

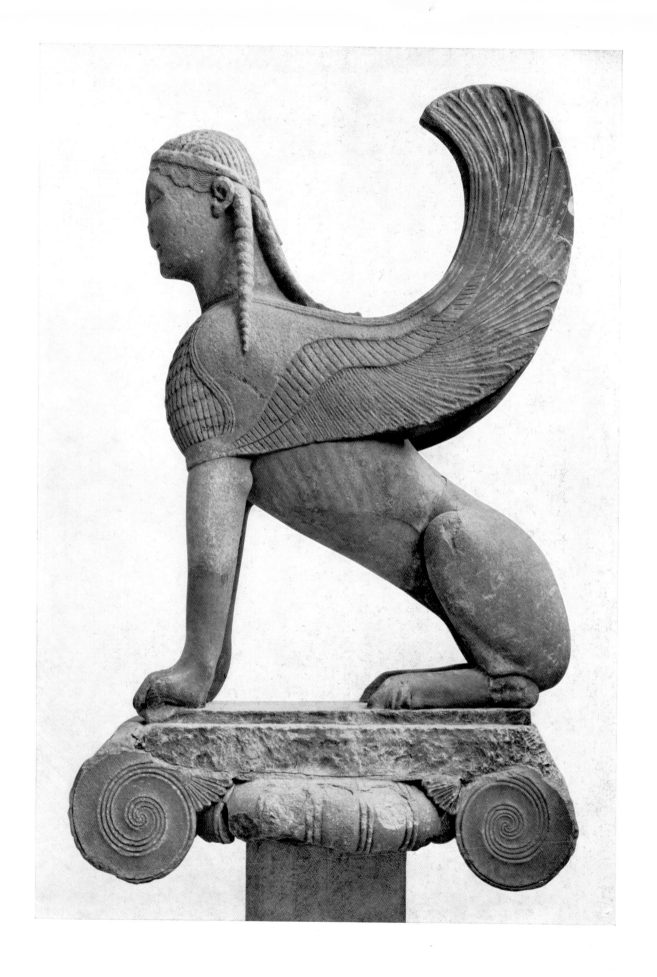

119 Delphi, Sacred Precinct. Naxian sphinx from beside the Sacred Way. Naxian marble.
Height 2.32 m. Before 560 B.C. Delphi Museum

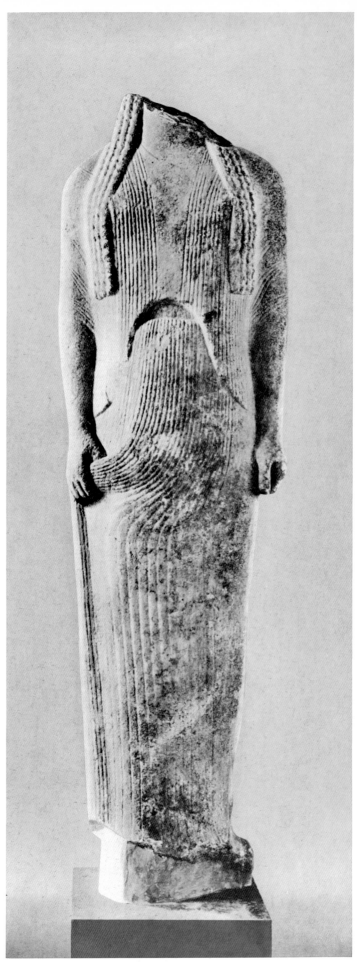

120 Left: Hera, votive offering of Cheramyes, found in the Heraion on Samos. Marble. Height 1.92 m. Ca.560 B.C. Paris, Louvre 686
Right: Philippe. From a family group of the High Archaic period, from the Heraion in Samos. Carved by Geneleos.
Marble. Height 1.60 m. Mid 6th century B.C. Samos Museum

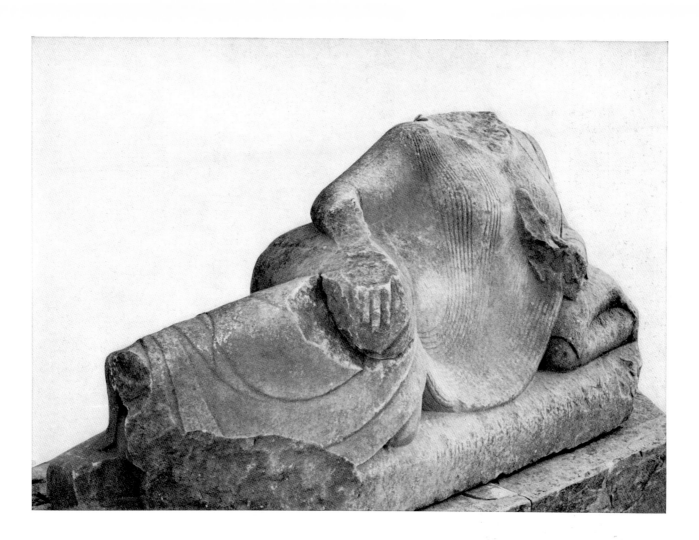

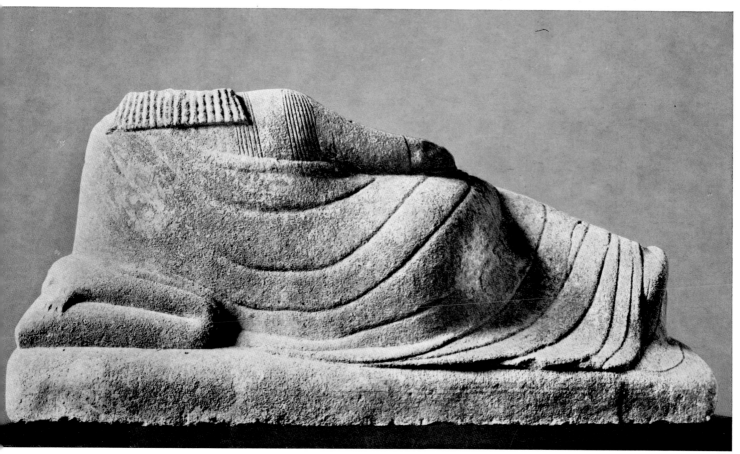

121　The figure of the father from the family group from the Heraion, Samos. Cf. plate 120, right

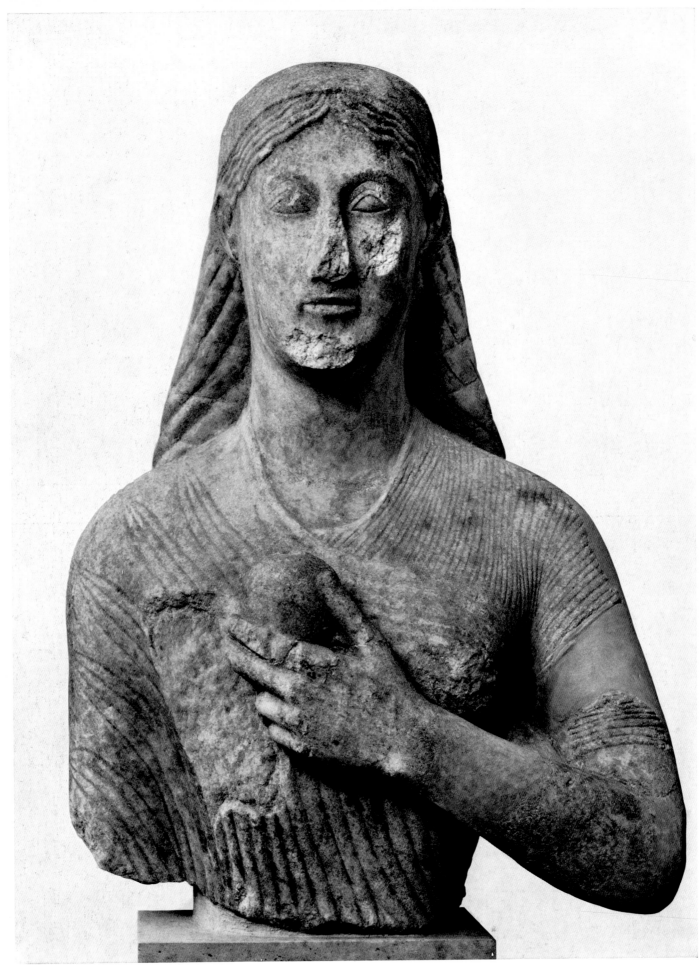

122 Upper part of a woman, found on the Athenian Acropolis. Marble.
Height 53.5 cm. Ca. 560 B.C. Athens, Acropolis Museum 677

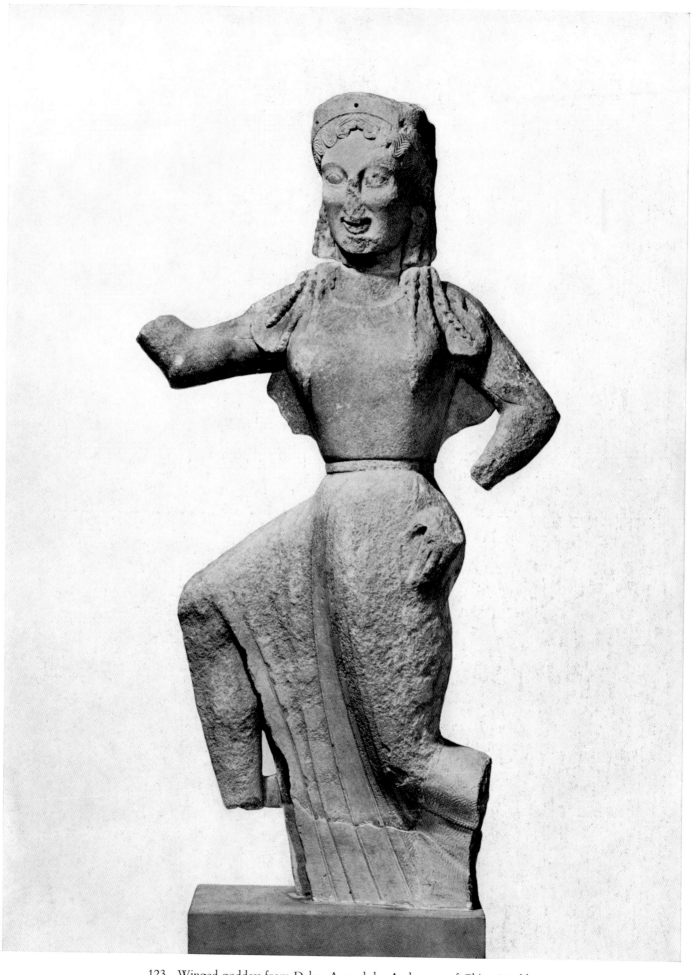

123 Winged goddess from Delos. A work by Archermos of Chios. Marble.
Height 90 cm. High Archaic. Mid 6th century B.C. Athens, National Museum 21

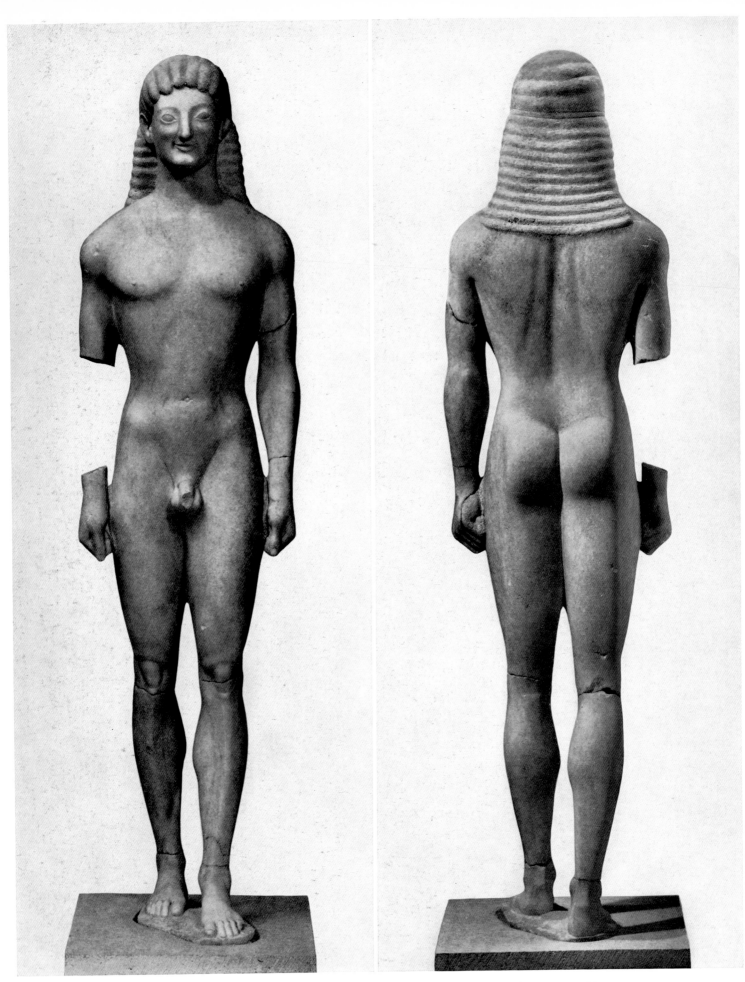

124 Standing youth (the Apollo of Tenea), found at Tenea, near Corinth. Parian marble.
Height 1.53 m. Mid 6th century B.C. Munich, Glyptothek 168

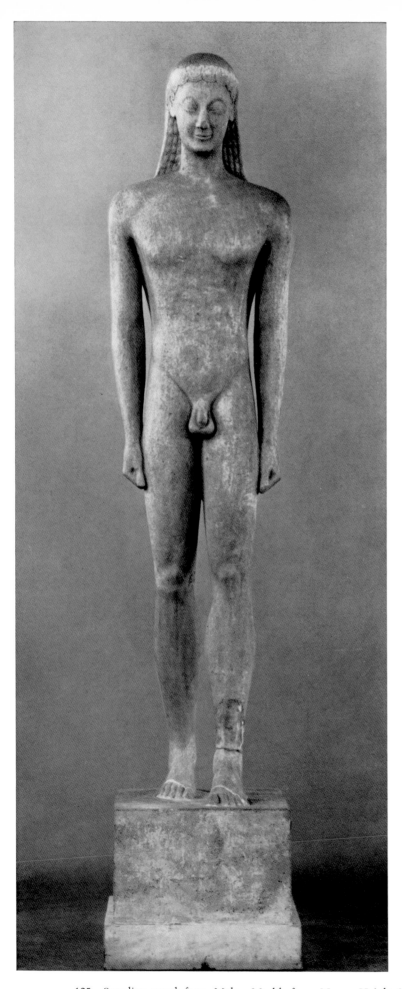
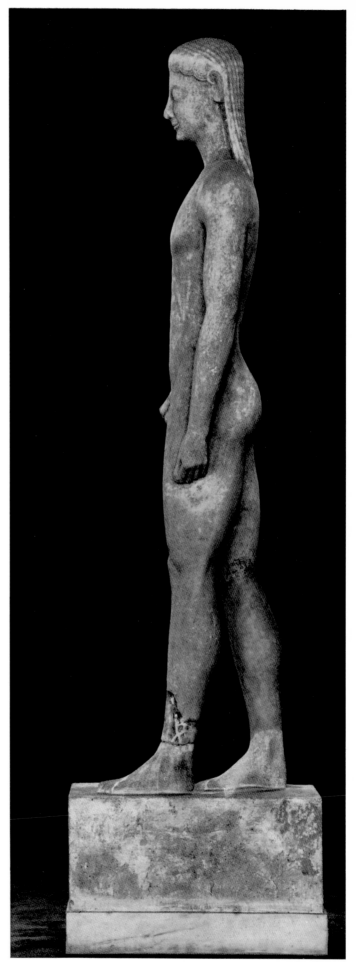

125 Standing youth from Melos. Marble from Naxos. Height 2.14 m. Ca. 560/550 B.C. Athens, National Museum 1558

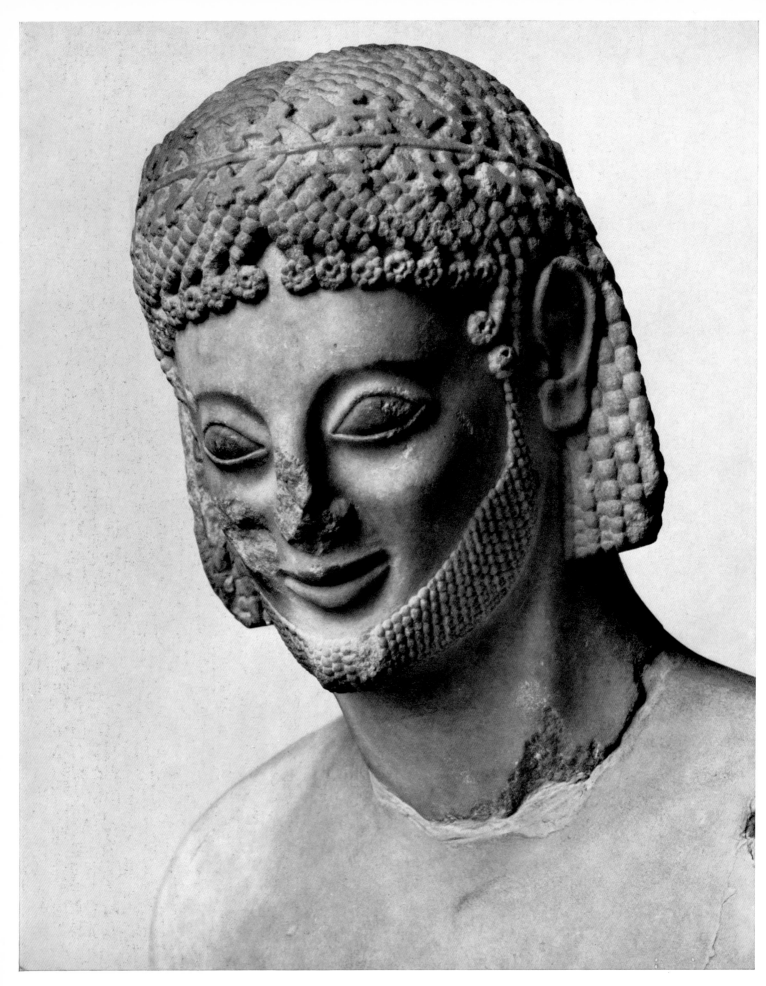

126 Rider's head (the Rampin head), from the Athenian Acropolis. Parian marble.
Height 29 cm. Shortly before mid 6th century B.C. Paris, Louvre 3104

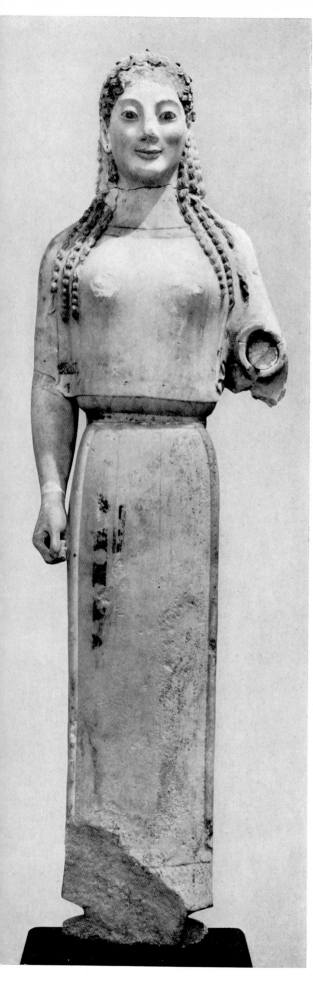
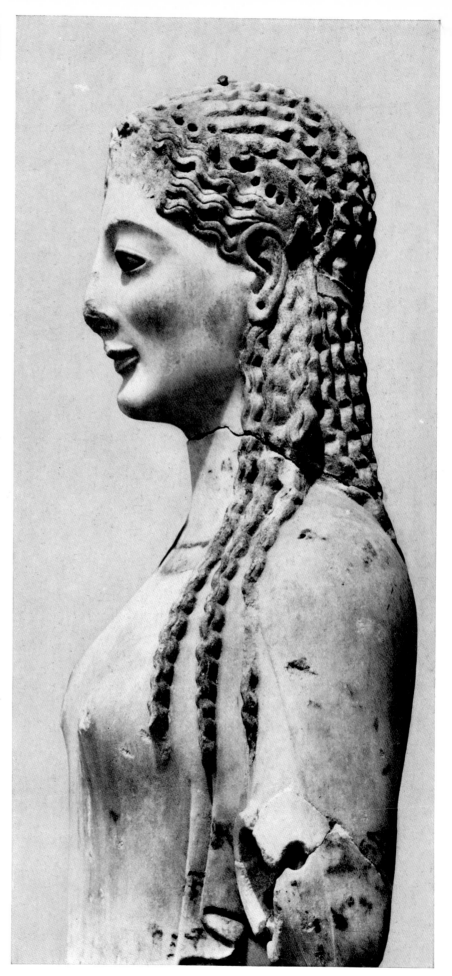

127　Standing girl (kore) in chiton and peplos. Parian marble. Height 1.21 m. Ca. 530 B.C. Athens, Acropolis Museum 679

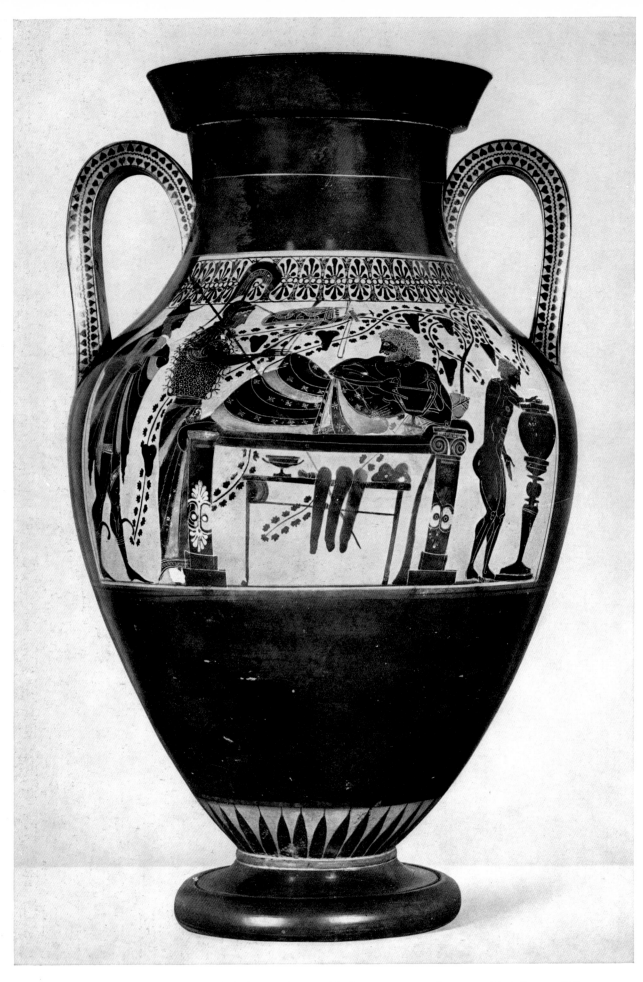

128 Andokides Painter. Amphora. Black-figure side: Herakles banqueting on Olympus, with Athena and Hermes.
Height 53.5 cm. Late Archaic. Ca. 510 B.C. Munich, Staatliche Antikensammlungen 2301

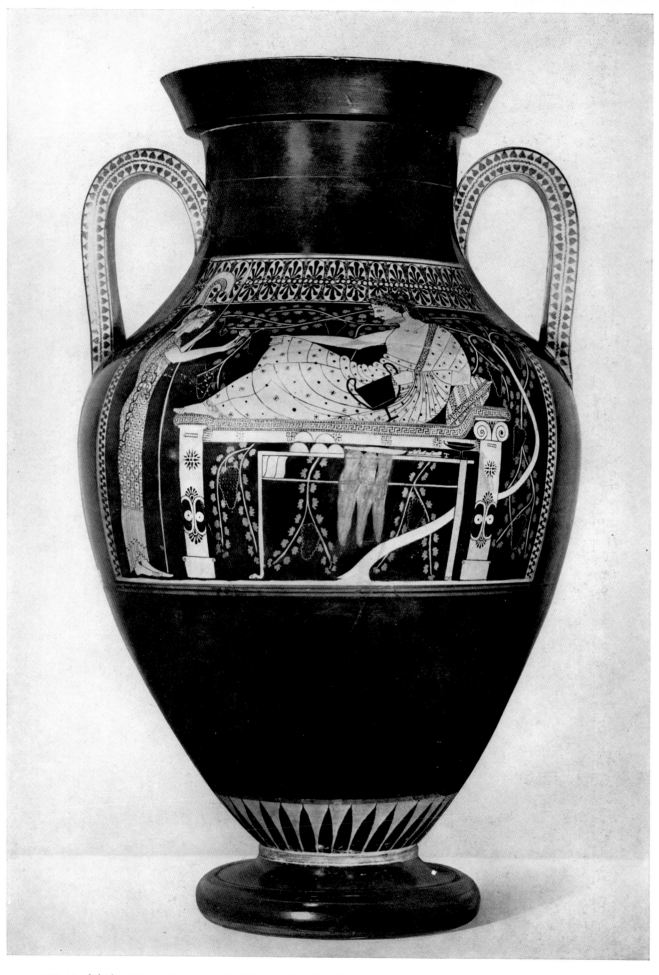

129 Andokides Painter. Amphora. Red-figure side: Herakles banqueting on Olympus, with Athena. Cf. plate 128

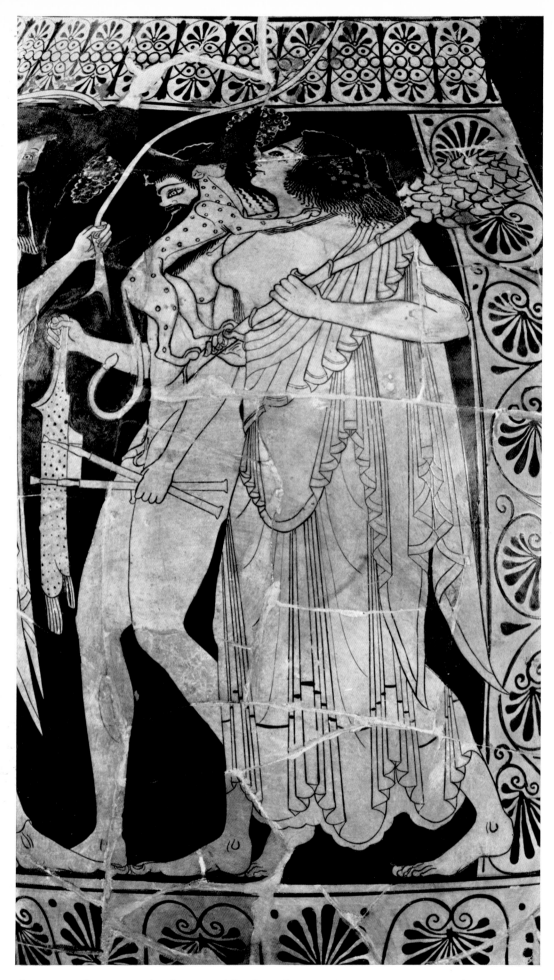

130 Phintias. Amphora. Maenad and satyr. Height of vessel 66 cm. Ca. 520/515 B.C. Tarquinia Museum RC 6843

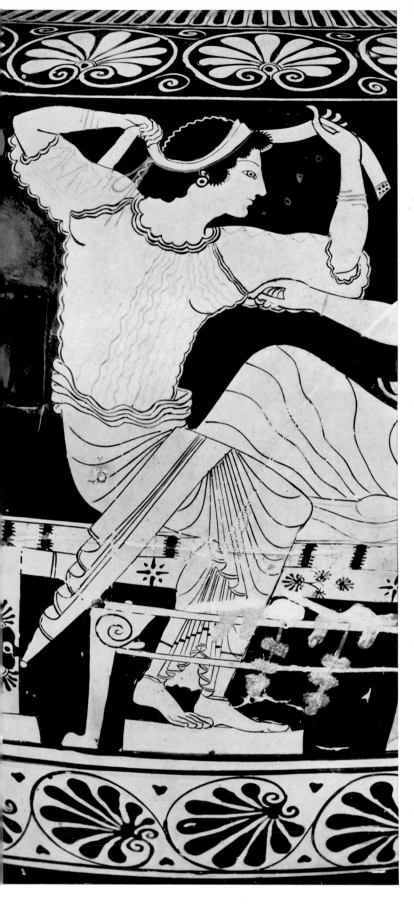
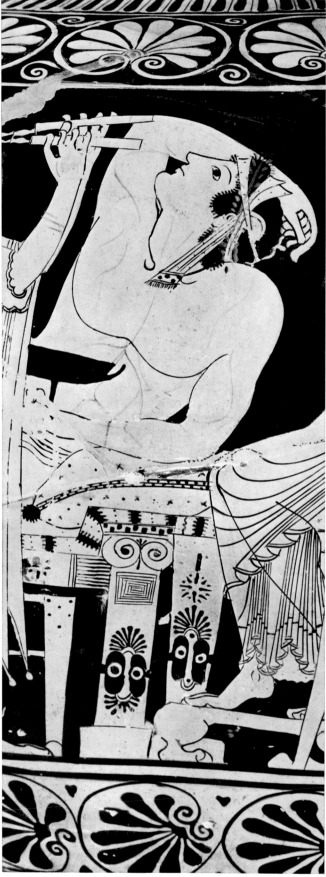

131 Smikros. Details from scene of carousal on stamnos. Total height of vessel 38.5 cm. Ca. 510 B.C.
Brussels, Musée Royaux d'Art et d'Histoire A 717

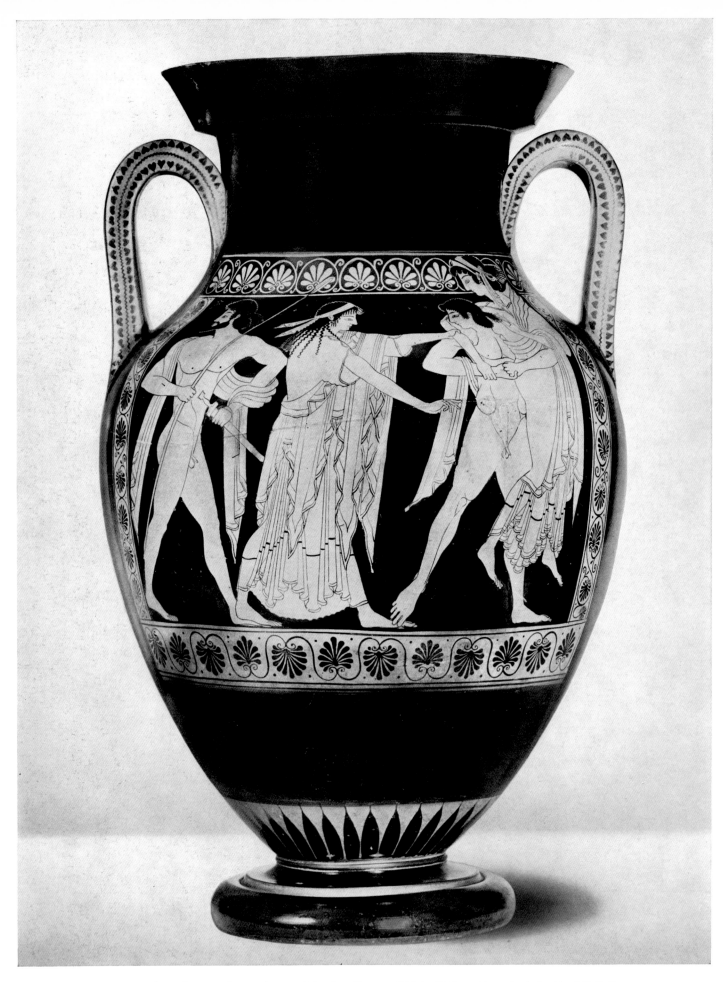

132　Euthymides. Amphora. Theseus abducting Korone. Height 57.5 cm. Late Archaic. Ca. 510 B.C.
Munich, Staatliche Antikensammlungen 2309

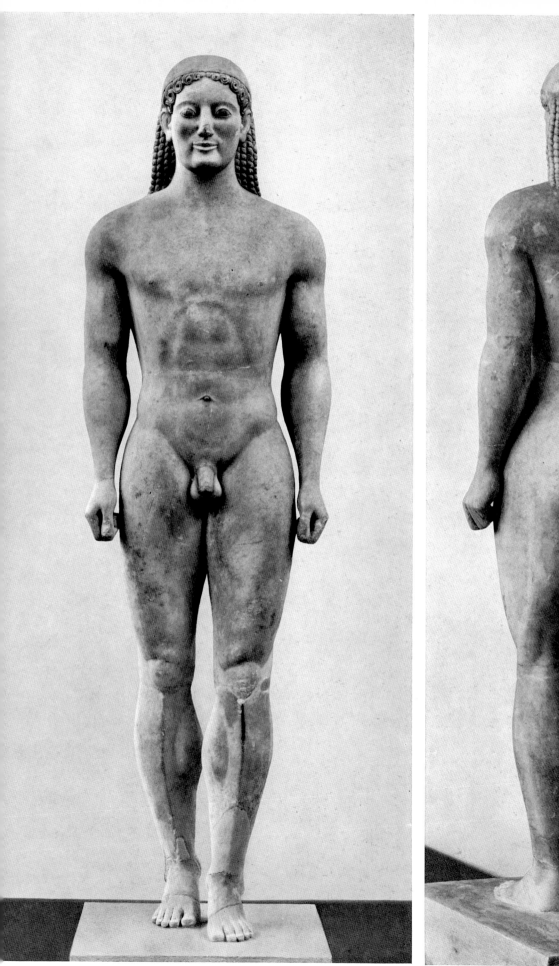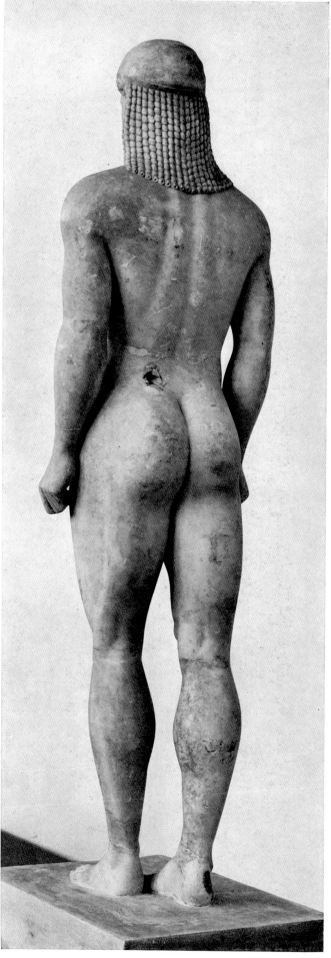

133 The youth Kroisos, found at Anavyssos, South Attica.
Parian marble. Height 1.94 m. Ca. 520 B.C. Athens, National Museum 3851

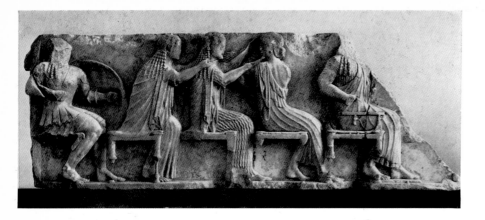

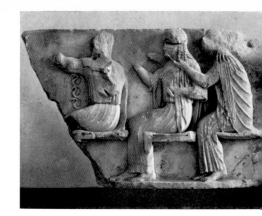

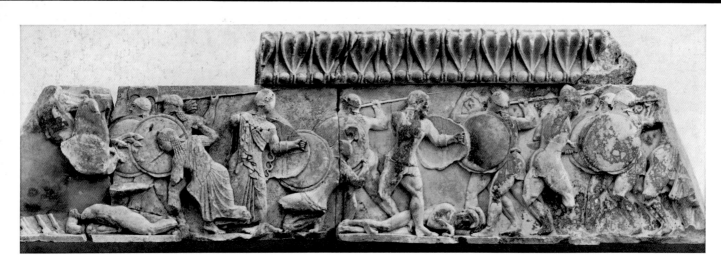

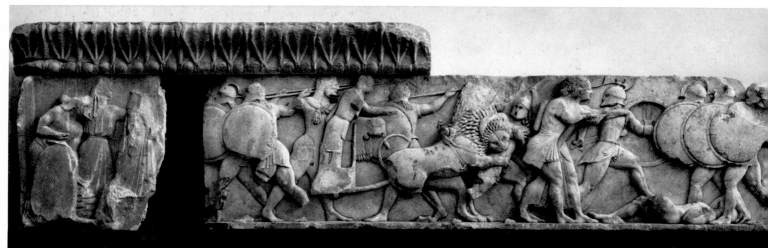

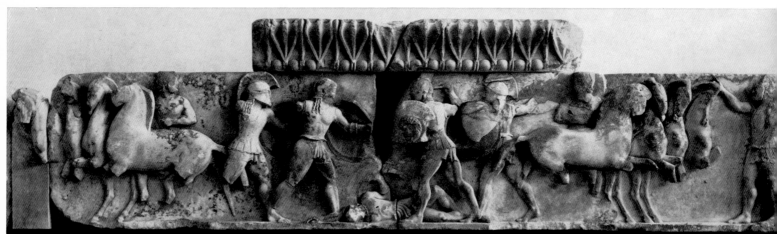

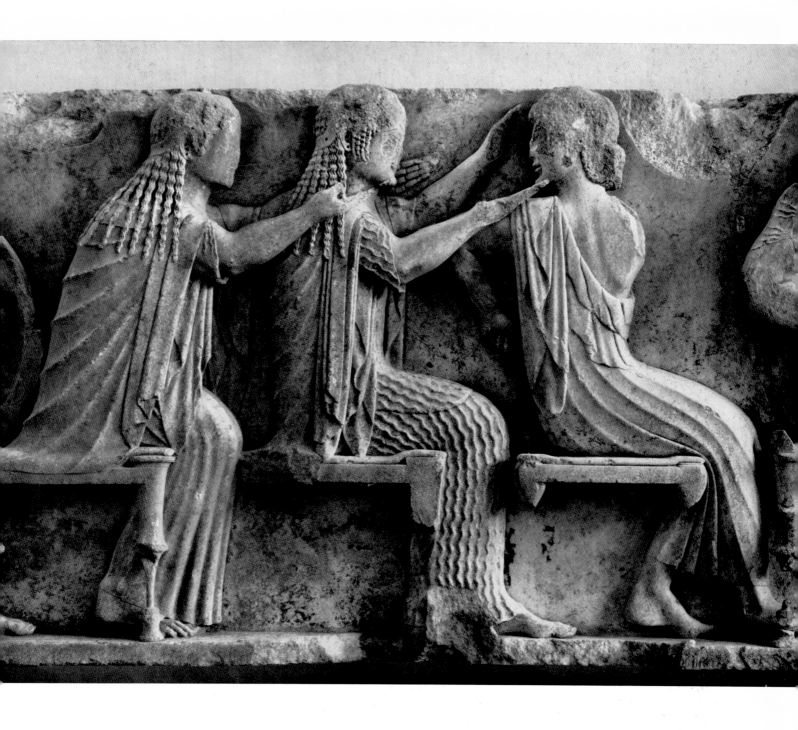

135 Aphrodite, Artemis and Apollo from the council of the gods.
Relief from the east frieze of the Siphnian treasury at Delphi, Sanctuary of Apollo. Cf. plate 134

134 Reliefs from the friezes on the Siphnian treasury at Delphi, Sanctuary of Apollo.
a: Council of the gods, east frieze (cf. plate 135); b: Battle between Greeks and Trojans, east frieze;
c, d: Battle of the gods and giants, north frieze. Parian marble.
Height of the frieze 63–68.3 cm. Shortly before 525 B.C. Delphi Museum

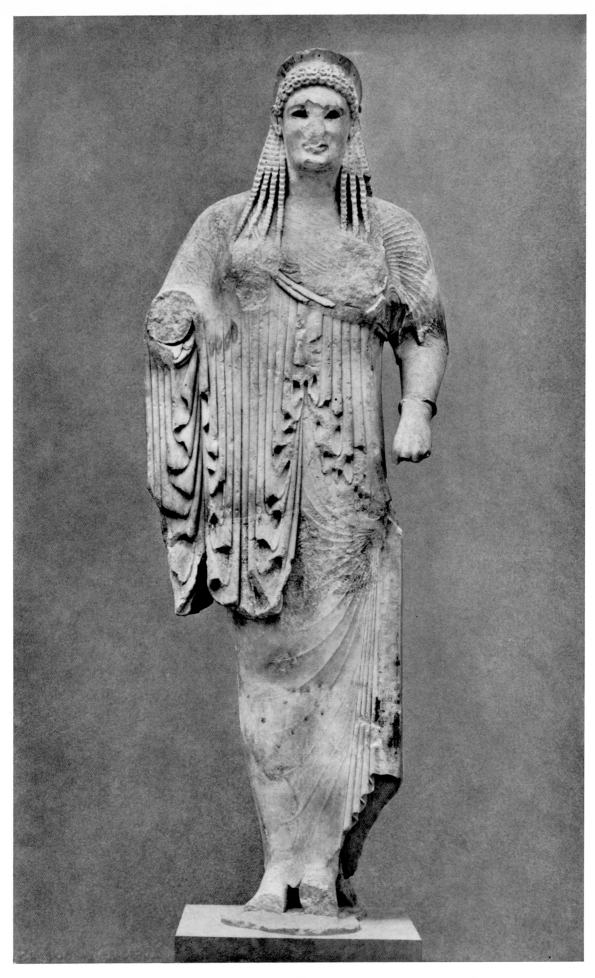

136 Antenor. Kore, made for the potter Nearchos. Marble. Height 2.55 m. Attic Late Archaic. Ca. 525–520 B.C.
Athens, Acropolis Museum 861

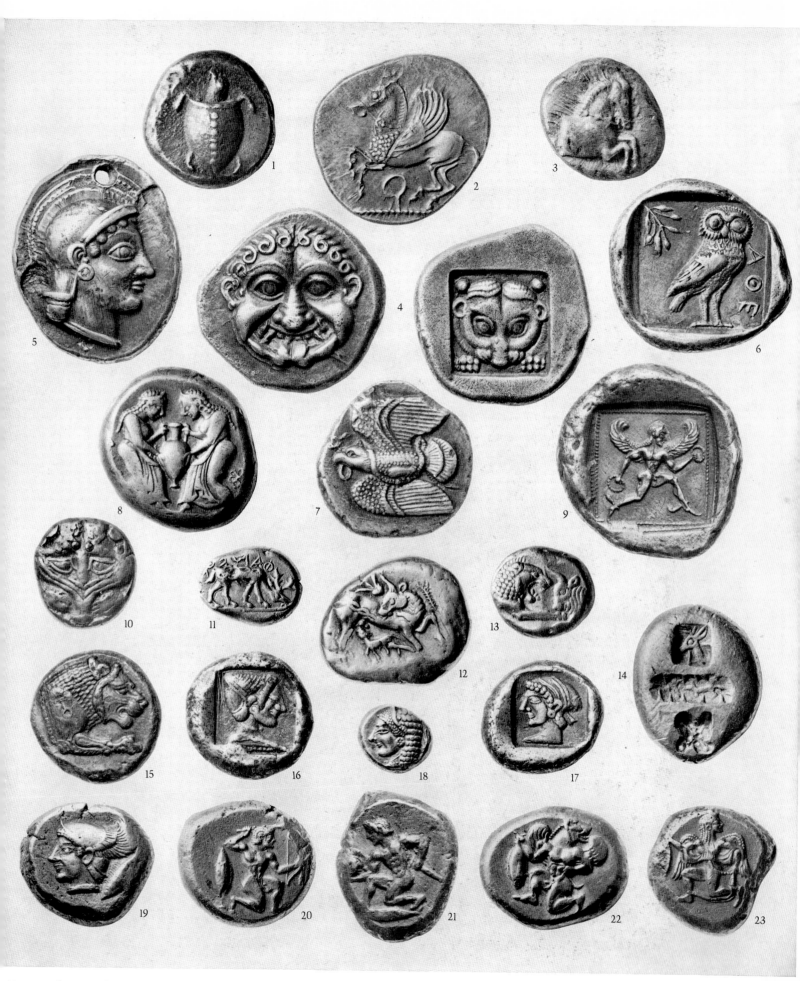

137 Greek coins of the Archaic Period. Greece: 1 Aegina, ca. 560 B.C. 2 Corinth, ca. 550. 3–6 Athens, 3 ca. 550–540, 4 ca. 530–520, 5, 6 ca. 520–510. 7 Elis, ca. 510. 8 Macedonia, Uncertain, ca. 525. 9 Peparethos, ca. 500. Asia: 10 Samos, ca. 600. 11 Ephesos, ca. 600. 12 Miletos (?), ca. 575. 13 Lydia, gold, 561–546. 14 Miletos, ca. 575. 15 Mylasa, ca. 500. 16–17 Knidos, 16 ca. 520, 17 ca. 510. 18 Phocaea, ca. 520. 19–23 Cyzicus, 19–21 ca. 520, 22, 23 ca. 500. All 2:1.

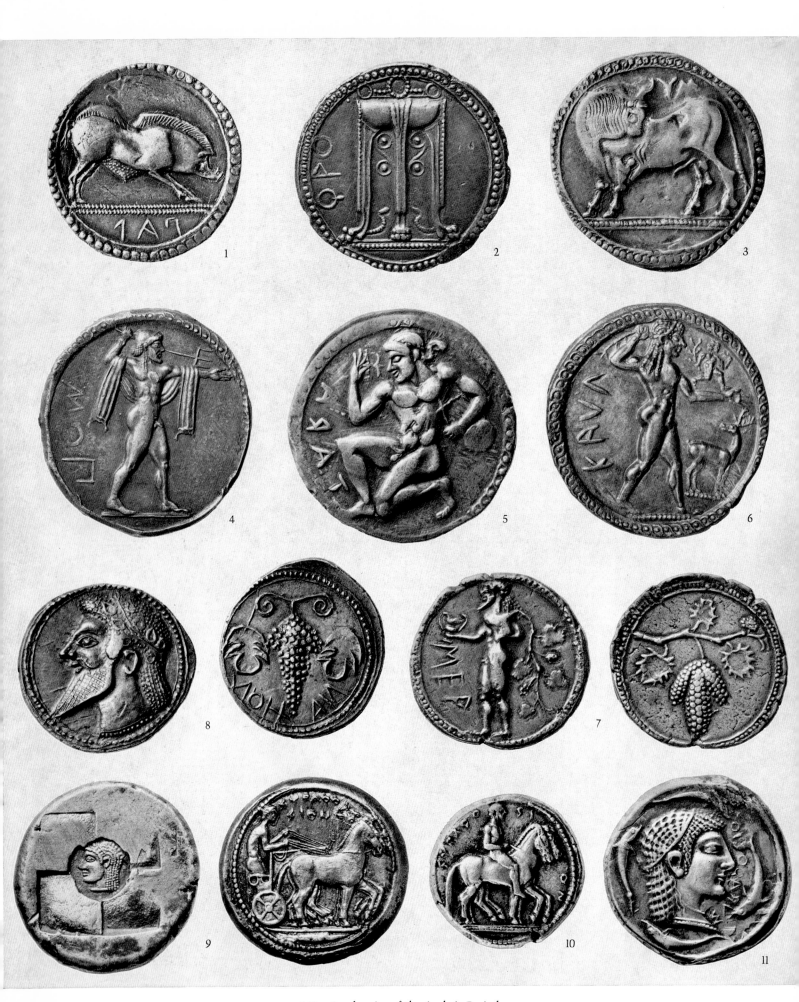

138 Greek coins of the Archaic Period.
South Italy: 1 Palinurus and Molpa, ca. 530 B.C. 2 Croton, ca. 550. 3 Sybaris, ca. 550. 4 Poseidonia, ca. 510. 5 Taras, ca. 500. 6 Caulonia, ca. 530. 7 Serdaioi, ca. 520. Sicily: 8 Naxos, ca. 530. 9–11 Syracuse, 9, 10 ca. 530, 11 ca. 510. All 2:1

THE EARLY CLASSICAL PERIOD · THE SEVERE STYLE · 500–450 B.C.

The year 500 B.C. has a symbolical significance in the history of Greece and her art; for it marks the end of a five-hundred-year epoch of artistic development and heralds the century of Classical achievement. A prelude of what was to come in the fifth century was the heroic resistance of Harmodios and Aristogeiton to the Attic tyrants, Hippias and Hipparchos, in 514 B.C. The rising of the Ionian Greeks against the Persians, which unleashed the storm of the Persian Wars, reinforced this new-found urge to freedom and emphasized to the Greeks themselves the essentially Hellenic nature of the impulse. The battles of Marathon, Thermopylai and Salamis constituted the climax of a drama which had opened with the murder of the two tyrants.

PAINTING

The interior of the Sosias cup in Berlin continues closely the scene of Achilles and Ajax playing checkers on *139* the Exekias amphora in the Vatican. The careful delineation of the details of the folds of the draperies, the *XVII* scale-armour and the shield on which Patroklos is sitting and Achilles kneeling—all this is in the noblest tradition of Archaic painting. And yet the artist has left such exemplars far behind. For now the encounter of the heroes is no longer in the nature of a diversion. The forms are more closely interwoven, the crouching and kneeling figures are drawn together and overlap one another. They are bound together in a communion of friendship which is not broken by the turned head and tensed out-stretched leg of Patroklos in his pain. Here for the first time, two heroes are shown drawn together not simply by a common activity but through a deep concern for each in the other's fate.

THE KLEOPHRADES PAINTER

The powerful bodies of the revellers on the Euthymides amphora in Munich fill the picture space more *140* violently while the black ground between them has dwindled to a minimum. The expressive art of Euthymides was continued by one of the greatest artists in the red-figure style of the first quarter of the fifth century. Much of his surviving work is on vases by the potter Kleophrades and consequently the painter is generally called the Kleophrades Painter, even though from the evidence of a somewhat later pelike in Berlin it is known that his name was Epiktetos. To distinguish him from his older contemporary of the same name it would be necessary to designate him Epiktetos II.

A comparison of the Munich amphorae 2307 and 2344 will show the close relation of his work to that *142/143* of his master Euthymides; notably the three-figure composition, the animation of the line and the bold convolutions of the bodies. While Euthymides places his figures in a frame, the Dionysiac revel depicted by the Kleophrades Painter rings the vase. Their wild frenzy and the titillating music of the flute have caused the maenads and satyrs to cast all restraint to the winds. The artist seems to have taken a special delight in large-scale vases, only one skyphos and one lekythos of his having survived whereas there are numerous amphorae, calyx-kraters, hydriae and stamnoi. He uses the most exquisite painterly technique to depict his *141* Dionysiac subject; for the panther's markings he employs a thinned glaze, thereby investing the work with the quintessence of wild-life; the snakes are iridescent and the figure of Dionysos is ringed with purple-blue *XXI* ivy leaves. The contrast between the purple-wreathed maenad musing behind the pipe-playing satyr and *XXII* her companion who, with head thrown back, is uttering a mighty yell, is positively miraculous; 'fair-haired and blue-eyed, moving more gently forward, dreaming silently, entranced' . . . 'As for the subsidiary pictures on the neck of the vase, they are surprisingly poor: the painter's mind that day was filled with giant women; and even the palaestra seemed to him tame.' (Beazley)[1]

Besides Dionysiac subjects, the Kleophrades Painter produced scenes of the wrestling gymnasion, warriors departing on campaign or putting on their armour, and lamentations for the dead.[2] But the subjects most

suited to his virile temperament are mythical ones, such as the battle of Herakles against the Amazons or against Kyknos, the deeds of Theseus, or the battles of the Centaurs. His Sack of Troy on a hydria in Naples 144 (2422) is contemporary with the Salamis campaign. It is filled with noise: the clatter and clashing of the armour and weapons, of the conquering Greeks and the stifled cries of the mortally wounded sprawling on the blood-stained floor; by the desecrated altar sits King Priam, his head cracked open and bleeding and on his knees the body of the boy Astyanax. The vengeance of the Greeks against Priam, and Ajax's attack on Cassandra (or Menelaos's threat to Helen, as it might be) appear even more pitiless in this violent picture 145 than in the scene by the Brygos Painter on the earlier cup in the Louvre (G 152). True, this also expresses vividly the Greeks' lust for vengeance and for blood; the carnage is in full spate and the conquerors fall upon their fleeing victims, but the Kleophrades Painter has chosen to depict a later stage in the tragedy.

MAKRON

Makron, working in the first decade of the fifth century, reveals a much gentler nature than the vehement Kleophrades Painter. His work, painted on cups by the potter Hieron, portrays maenad and satyr scenes, 146 but also deals with legend-versions not often found in vase paintings. His favourite cycle is the Kypria, about the events before the Trojan War and centring upon Paris and Helen.

Like the Brygos and the Kleophrades Painter, Makron did a version of the Destruction of Troy, but it differs in important respects from theirs. He depicts neither the blood-letting nor the lamentations of the women during the Sack. Beazley has reconstructed Makron's version from a cup in the Louvre, G 153,[3] with the help of numerous sherds. The subject is the sacrifice of Polyxena at the tomb of Achilles; the Brygos 145 Painter had merely alluded to the story by showing Polyxena being led away by Akamas from the altar on which her father, Priam, pleads in vain that she be spared, but Makron makes her journey thither his main theme. He shows Polyxena being led to the place of sacrifice by the Greek heroes Neoptolemos, Odysseus, Philoktetes, Agamemnon, Diomedes and possibly also Menelaos; the restrained drama of the procession seems to fill the entire surface of the cup, to the very rim. The interior picture is devoted to the same subject. Achilles is shown on a couch, brooding over his revenge, with the body of Hector lying under the table on which Achilles's meal has been set. On a skyphos, now in Vienna, the Brygos Painter treats this subject, but whereas Makron leaves Achilles alone with his thoughts, this rendering shows the old King Priam humbly approaching the Greek hero to beg for the body of his son.

It is apparent from his work that Makron was a deeply religious man. It is reasonable to accept Beazley's suggestion that the dancing maenads on a Berlin cup (F 2290) are taking part in the winter festival of the Lenaia.[4] Perhaps the painter had himself been initiated into the mysteries at Eleusis. A further instance of Fig. 136 this religious feeling is the depiction of the Departure of Triptolemos, on a skyphos in London. This piece is in any case an important introduction to the large number of red-figure representations of this theme, and attests not only the painter's genuine piety but also his high skill as an artist. The figures bidding the youth farewell include not only Demeter and Kore, standing next to the winged chariot of Triptolemos, not only his parents, portrayed as Eumolpos and Eleusis, but even Zeus himself and other Olympians. In his battle subjects, Makron elects to paint the feats of Herakles or Theseus, or depicts the Greek heroes fighting over the weapons of Achilles.

Fig. 137 On the interior of a cup in the Louvre (G 147), two maidens in transparent chitons are placed in a V-shaped composition which expresses the inner agitation of the figures. Obliged to use the language of the dumb, Philomela spells out with her fingers the story of her rape by Tireus, king of Thrace, and her sister's husband. Prokne, her hair dishevelled, recoils in horror from her sister's terrible account and from the vengeance which the speaking fingers are suggesting to her—that she should murder Itys, her own dear son, to be revenged upon a husband who has raped her sister and had her tongue cut out to silence her. In this simple composition, Makron has given us the tragic theme in all its intensity and in it also he 229 foreshadows the great age of fifth-century tragedy and looks forward to the Prokne and Itys of the sculptor Alkamenes.

Still more remote subjects are found in the work of other vase painters of the early fifth century. Onesimos, known as the Panaitios Painter from the inscriptions praising the beauty of Painaitios on many of his works, 147 depicts the visit of Theseus to Amphitrite on the floor of the sea. As a proof of his descent from the immortals,

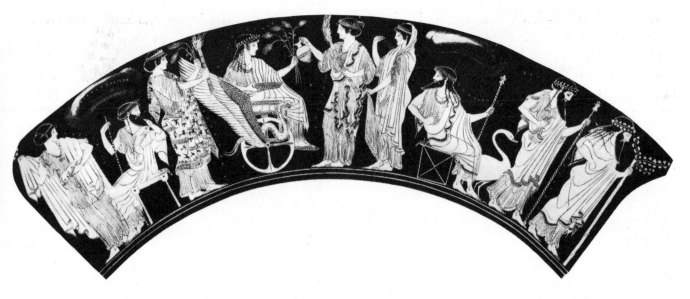

136 Makron. The departure of Triptolemos, from a skyphos. Ca. 490/480 B.C. London, British Museum E 140
(after Furtwängler/Reichhold)

the hero accepted the challenge of King Minos of Crete to recover a ring thrown into the sea. The artist has embellished his fairy-tale theme with charming figures clad in rustling chitons and carefully arranged cloaks. Three dolphins symbolize the sea, and the young Theseus is supported by Triton. Myson depicts King Kroisos seated enthroned on his pyre, as with oriental imperturbability he pours out a libation while *148* his servant kindles the flames. His pupil, the Pan Painter, also shows a delight in narrative, characteristic of the Late Archaic in literature and art, even though he depicts Herakles as an Early Classical hero, who is about to be sacrificed by King Busiris in Egypt; at first the hero allows himself to be led like a lamb to the altar, but suddenly he turns and lays about his captors.[5]

THE PAN PAINTER

The Pan Painter is called after the Boston bell-krater (10.185), which on its reverse carries a picture of the *Fig. 138/139* goat-god Pan chasing a young herdsman. The main scene of this masterpiece depicts Artemis carrying out the orders of Zeus and slaying the hunter Aktaion who had presumed to court Semele, beloved of the gods.

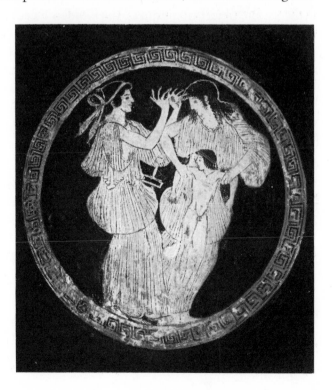

137 Makron. Philomele and Prokne with their young son Itys.
Interior of cup. Ca. 490/480 B.C. Paris, Louvre G 147

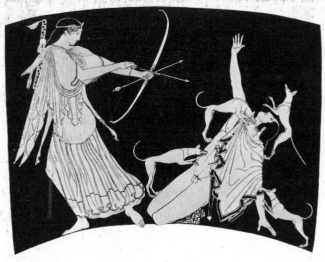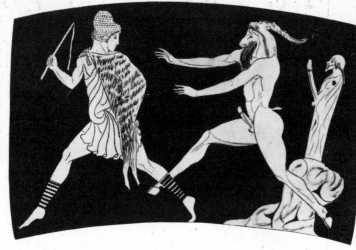

138/139　Pan Painter. Obverse and reverse of a bell-krater. Ca. 480/470 B.C. 138 Artemis and Actaion; 139 Pan chases a young herdsman. Boston, Museum of Fine Arts 10.185

149 Obviously Artemis a-hunting is one of the Pan Painter's favourite subjects, but he also enjoyed subjects which showed the gods in pursuit of mortal youths and maidens; he understood the herdsmen and fishermen, and knew the magic of the fields and pastures. In a way the Pan Painter's work carries through into the fifth century the simple delights and the freedom of the Archaic period; it displays his love of the slender sprightly form, and his naïve intuitive sense for the dramatic as well as an innate wit. His painting is purest nature poetry; his drawing is symmetrical and yet for the purposes of more intense statement or characterization may be quite consciously distorted; Beazley has called his 'a darting, fastidious touch'.[6]

DOURIS

Douris, like Makron, was a cup painter of great fecundity and like the Pan Painter he is in love with the clear, clean line. Like him too he continues the themes of the Archaic period which he is able, by his outstanding draughtsmanship, to imbue with a new significance for his own time. A painting by him on a cup in the Vatican seems to show an episode from the legend of the Golden Fleece which does not occur
150 in any other version. Jason is shown being disgorged by a sea-monster, by the authority of his protector, Athena; the object of his quest, the Golden Fleece, hangs in the branches behind.

151 　The inside picture of a cup in the Louvre (G 115) is based on the story of Memnon, king of Ethiopia, contained in an old epic, the Aithiopis. It recalls the Nikosthenes Painter's cup, London E12, which depicts the rescue of the body of Sarpedon by the winged spirits Hypnos and Thanatos. Douris has used two figures to epitomize the tragic events of the battlefield. Eos holds in her arms her dead son; his stiff legs divide the frame, his arms hang loosely down in the lower segment of the picture, the eyes are closed. His divine mother looks down at him in grief, while the black ground seems to frame the group like a shroud.

THE BERLIN PAINTER

Black also plays an important role in the works of the very prolific Berlin Painter. Like the Kleophrades Painter, his fellow student in the workshop of Euthymides, he prefers the larger forms of the amphora and the krater. Again like the Kleophrades Painter, he has a wide repertoire of subject-matter, from the doings of the Olympians and Heroes to everyday events like athletes in training. He produced his finest work as a young man, during the first two decades of the fifth century, and from this period comes his name-work, the Berlin amphora, F 2160. The incomparable drawing of the figures matches the vessel's exquisite form, further enhancing the beauty of this lidded amphora. The three forms of the main picture have been in fact
154 grouped as one profile: the satyr Oreimachos[7] looks longingly at the wine jar and jug held by Hermes as

XXI　Kleophrades Painter. Pointed amphora, obverse. Dionysos. Total height of vessel 56 cm. Ca. 500/490 B.C. Munich, Staatliche Antikensammlungen 2344. Cf. plate 126

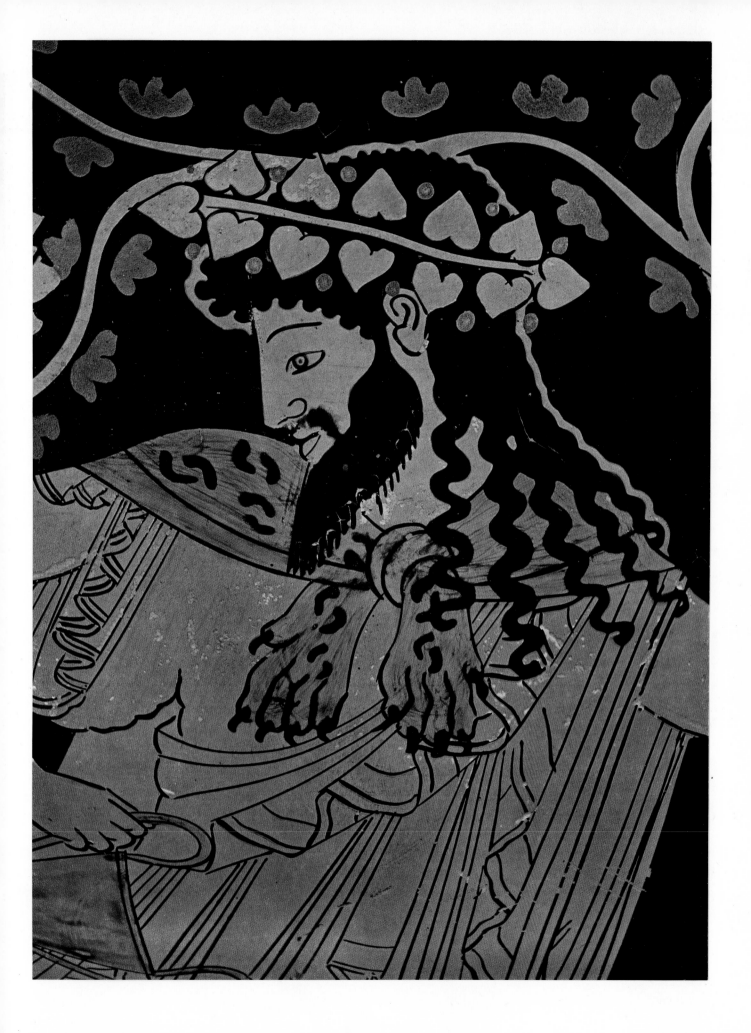

he attempts to play the seven-stringed lyre invented by the god. The picture on the back shows his dilemma even more acutely; he still holds the lyre but sniffs appreciatively at the kantharos. The Berlin Painter delights in solitary forms shining out from the black ground of the vase; Europa, charming and elegant, playfully catches the bull by its horn, little realizing what is to happen to her; the boy Ganymede happily plays with his hoop, holding in one hand a cock, a love-token from some admirer, quite unaware that Zeus himself, on the other side of the vase, is in hot pursuit. Stylistically, the body of Ganymede displays features characteristic of the three-dimensional sculpture of the Severe style. The Berlin Painter does not seek to present a statuesque sublimity, but rather the uplifting moment of experience, the presentiment of the divine. His lyre-player on the Hearst Amphora[8] expresses the bewitching power of music over the Greek mind of the early fifth century.

THE BRYGOS PAINTER

With the Brygos Painter, we come to a master who embodies all the finest qualities of his contemporaries: the temperament of the Kleophrades Painter, the exquisite pose of the Berlin Painter, the sure touch of Douris and of the Pan Painter, and the restrained tragic note of Makron. The mastery of the Brygos Painter is as apparent when he is handling the Sack of Troy as when he depicts a night's carouse; both pictures, though so very diverse in subject-matter, manifest the full power of his art. In his work, unlike that of the Berlin or the Pan Painter, the new method of the Early Classical period is unmistakable. The whirling train of revellers and hetairai on the Paris skyphos G 156 has lost the weightless quality of the Archaic style. The naturalistic and closely observed fall of the draperies emphasizes the volumetric solidity of the forms which they cover; or rather, one might say that the bodies stand out from the foil of their background. With this artist, the stance of the figures become more and more deliberate, weighty and forceful. The Phintias and the Sosias Painters had attempted to break down the isolation between the separate figures of their compositions. The seed which they had sown bears its full fruits in the work of the Brygos Painter; his figures express not only their separate individualities, but also a true awareness of their companions. Scenes of dancing and revelry are no longer simply artistic devices for a unity of composition. In their absorbed and frank scrutiny of their partners and in the very gesture of their bodies, the young men reveal their ardour and their desire is only increased by the coquettish resistance of the girls. Even the most commonplace occurrence, such as a self-indulgent party-goer being sick, makes a superb picture when treated with the unvarnished naturalism and artistic mastery of the Brygos Painter. Like the Kleophrades Painter and the Pan Painter, he uses a thinned glaze to depict hair, fillets and garlands. For example, for the inner picture, on the Munich cup 2645, the heightening effect of the diluted glaze is employed to increase the brilliancy— it shows a fair-haired maenad against a white ground. In the High Classical period this technique was to be used predominantly for the white-ground lekythoi which served as oil flasks in the funeral cult.

POLYGNOTOS OF THASOS AND HIS CIRCLE

Even before the turn of the century, painters such as the Pistoxenos and the Penthesilea Painter were tending to use this technique for choice votive offerings rather than for domestic utensils. The inner picture of the Taranto cup expresses still more completely the ethos of Early Classicism which we have already noticed in the work of the Brygos Painter. A satyr makes an eager grab at a beautiful maenad, while she, laying her arms on his bald head, returns his look understandingly, almost pityingly. The language of the eyes becomes still more expressive in the work of the Penthesilea Painter, notably in two cups in Munich. On the Tityos cup, the expressions of Leto and her son Apollo, and the imploring face of the impious Tityos raised in terror to the revengeful god, seal the intense involvement of the figures. In the cup named after him, the Penthesilea Painter achieves true tragic greatness. His theme is the death of the Amazon queen, Penthesilea, at the hands of Achilles, who with horror recognizes her love for him as he thrusts home his sword. Despite the size of the cup, the forms seem to burst the bounds of the picture space and it has been reasonably suggested that the artist took his inspiration from a major painting. There is no means of telling

XXII Kleophrades Painter. Pointed amphora, reverse. Maenad. Total height of vessel 56 cm. Ca. 500/490 B.C. Munich, Staatliche Antikensammlungen 2344. Cf. plate 127

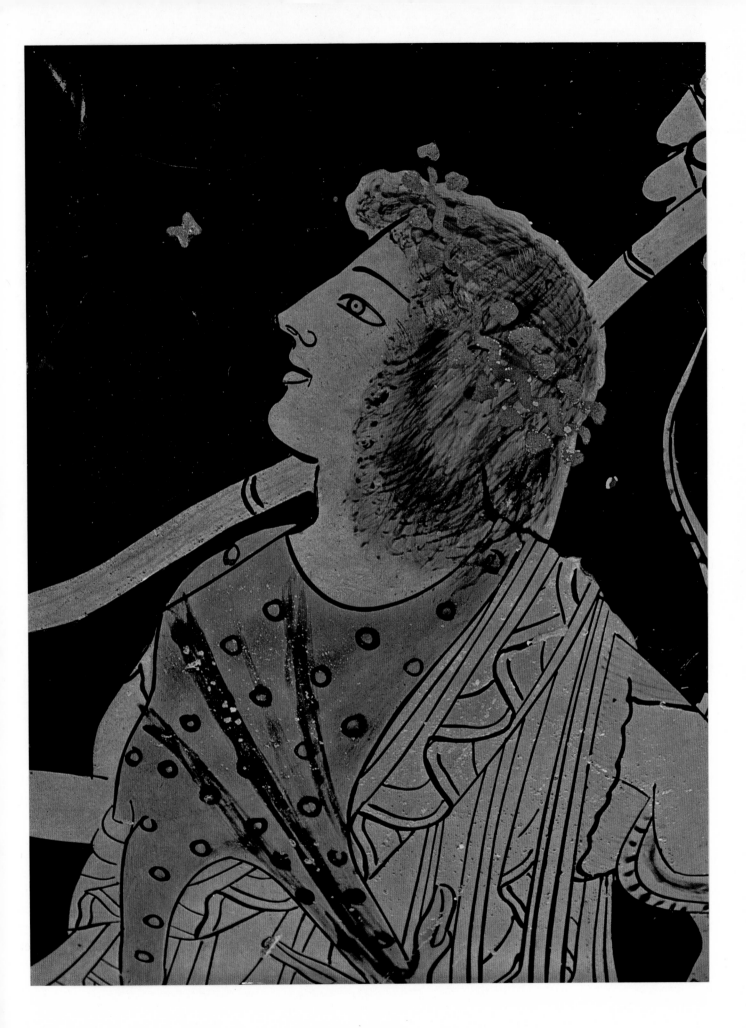

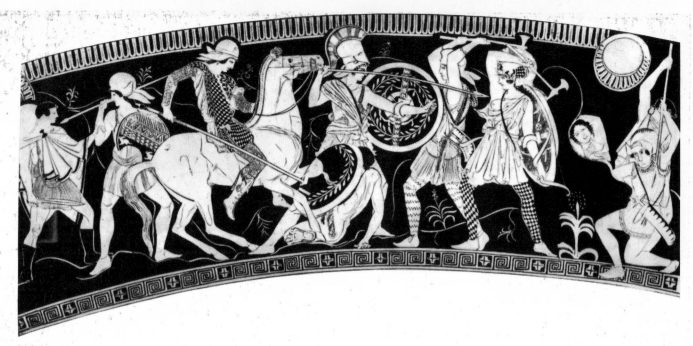

140 Painter of the Woolly Silens. Battle of Amazons, from a volute-krater. Ca. 440 B.C. New York, Metropolitan Museum of Art 07.286.84

if this original was the Amazon picture by Mikon, in the Theseion at Athens or the Stoa Poikile. Neverthe-less, we may take this vase painting as fair indication of the nature of Mikon's lost murals. This and other similar scenes on surviving vases are not, in any case, exact reproductions of works by the great Polygnotos of Thasos or Mikon of Athens but rather, contemporary reflections of the originals. There are in fact no authenticated reproductions of Classical paintings to parallel the numerous Roman marble copies of Greek sculptures. The descriptions by Pausanias of the Sack of Troy and the scenes of the Underworld, painted for the Knidian Lesche at Delphi, remain our safest guide to the compositional style of Greek major painting. He refers to figure groups placed next to or above one another, but makes it perfectly clear that these great wall paintings were not in any sense frieze paintings; the figures and groups were placed at

158/159 different heights and superimposed. The Orvieto calyx-krater in the Louvre (G 341) has long been recognized as the classic example in vase painting of the compositional principle of Polygnotos and his circle. 'Landscape' is very sketchily treated; a spruce at the back indicates Kithairon, simple lightly undulating lines supply the uneven terrain on which the figures are placed at various levels throughout

107–111 the picture field. The friezes of the François Vase, using an epic narrative style, achieve a unitary effect.

159 Apollo and Artemis pursue the children of Niobe who attempt in vain to flee their fate; one of the girls has fallen at the feet of Artemis, pierced by an arrow, while near by lies one of her brothers partly concealed by a fold in the ground. The subject of the picture on the front of the vase is not fully explained.

Whereas most Amazonomachies are composed in friezes, retaining only the lines of the landscape—as,

Fig. 140 for example, a volute-krater in New York (07.286.84) by the Painter of the Woolly Silens—a krater in Bologna (279)[9] bears one which shows the technique of Polygnotan superimposition. A calyx-krater in

Fig. 141 New York (07.286.86) with an Amazon being ridden down in the foreground, shows bold foreshortenings and overlapping; the influence of large-scale painting is obvious. A series of Centauromachies is related to these Amazonomachies not only by the boldness of the drawing but also by their inner monumentality; they would seem to be in a line of development originated by the works of Mikon in the Theseion. One can derive some idea of Mikon's picture of Theseus in the kingdom beneath the sea from a calyx-krater of the Syriskos Painter (Cabinet des Médailles, 418)[10] which depicts the hero before the enthroned Poseidon.

The circle of the Niobid Painter and the Altamura Painter, under the influence of the wall painting of Polygnotos and his followers, produced a very early style of narrative painting with subjects from mythology which, so far as we know, did not appear in the work of the great painter himself. On the lower picture area

160/161 of a volute-krater by a pupil of the Niobid Painter (Spina T579, Ferrara), the artist has depicted a four-horse

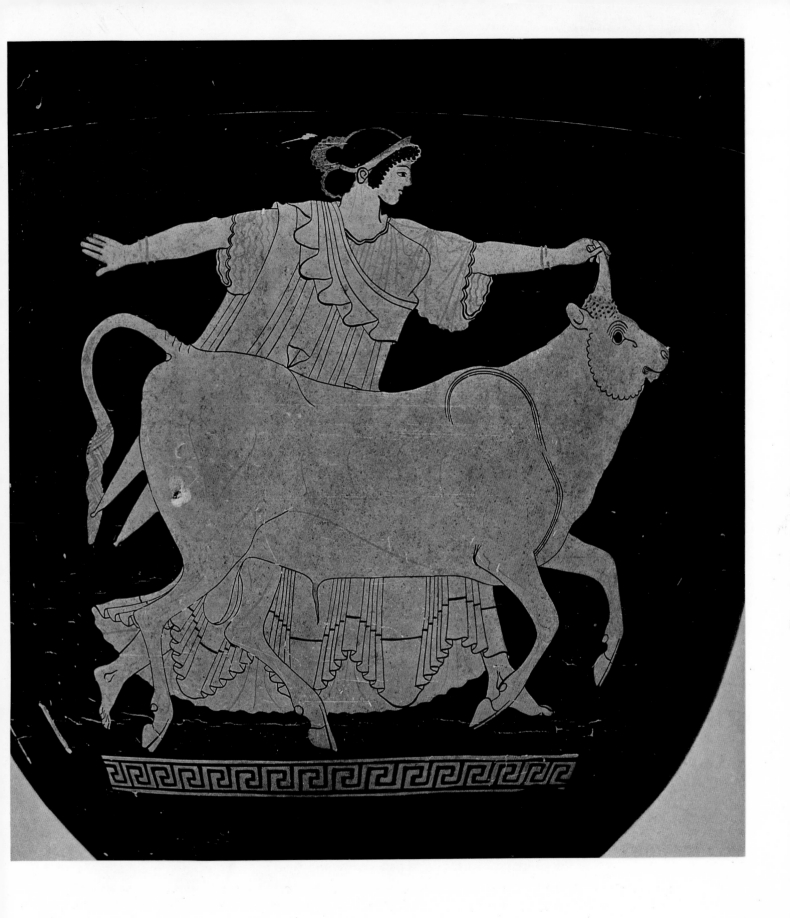

XXIII Berlin Painter. From bell-krater. Abduction of Europa. Total height of vessel 33 cm. Ca. 490 B.C. Tarquinia, Museo Archeologico RC 7456

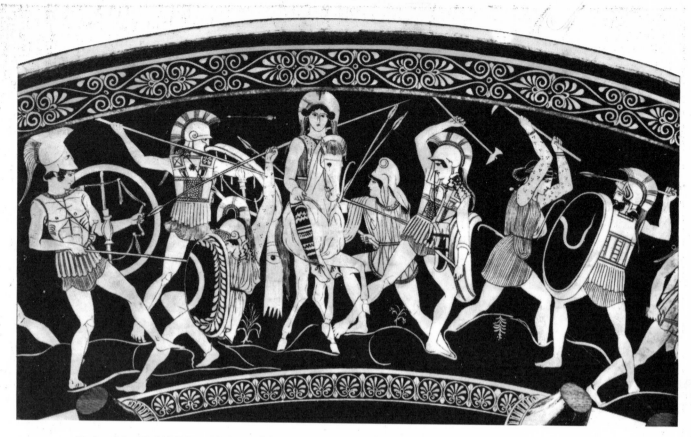

141 Circle of the Niobid Painter: Painter of the Berlin Hydria. Battle of Amazons, from a calyx-krater. Ca. 450 B.C. New York, Metropolitan Museum of Art 07.286.86

chariot. The animals are facing all ways and it is obvious that the subject of the picture is the team of Amphiaraos startled and maddened by a thunderbolt hurled by Zeus, which has opened up a cleft in the earth beneath the feet of the hero himself. Amphiaraos and his charioteer, Baton, are seen disappearing into 161 the abyss. He raises his arm for help from the warriors who fight above—the Seven against Thebes. According to Pausanias, there was a painting on this same subject by Onasias, apparently a follower of Polygnotos, in the pronaos of the Temple of Athena Areia in Plataia; possibly it provided the inspiration for the vase painting.

160 The picture on the reverse of this krater must also derive from a model by Polygnotos, although no satisfactory account of the theme has yet been suggested. Proposed possible subjects include: some incident during or before the journey of the Argonauts; an historical event, such as the capture of Samos; the gods and heroes at the battle of Marathon, as described by Pausanias in his account of the Marathon picture in the Stoa Poikile; or, it has been suggested, on account of the laurel branches carried by some of the figures, the suppliant sons of the fallen heroes of the Seven against Thebes. Perhaps an even more acceptable theory is that it represents the trial of the Lesser Ajax for his alleged rape of Cassandra before the altar of Athena.

THE SCULPTORS

In sculpture, the crucial transition from the style of the sixth century to that of the fifth is summed up in 162–167 the pediments of the so-called Temple of Aphaia on Aegina. The pediments of the original building were in the Late Archaic style of the sixth century. The figures of the west pediment have been largely recovered but only fragments survive of the eastern pediment, which must have been destroyed, either by earthquake or war, about 500 B.C. and was replaced in the second decade of the fifth century; comparatively numerous Fig. 142 remains of this new pediment have been discovered. The west pediment contained thirteen figures, placed in a frieze-like, two-dimensional composition; in each half six warriors, Greeks and Trojans, flank the

272

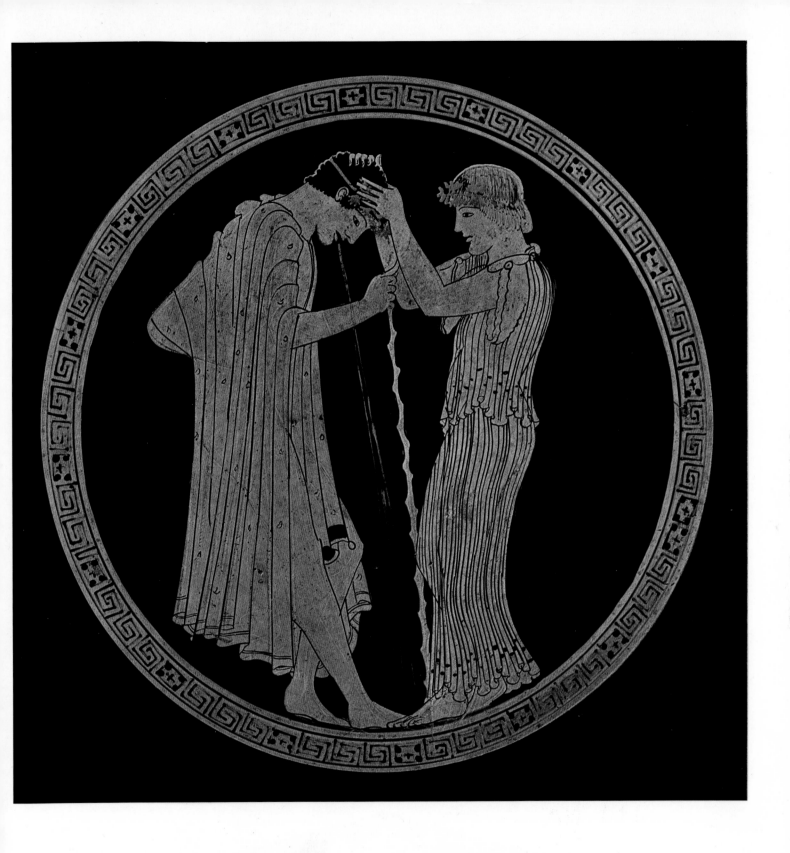

XXIV Brygos Painter. Interior of cup. Young reveller and *hetaira*. Diameter of cup 32·2 cm. Ca. 490 B.C. Würzburg, University (Martin-von-Wagner) Museum 479

162 central figure of the goddess Athena. Armed with shield, helmet and aegis, and clothed in a chiton and shoulder-cape falling in zigzag folds down the right side of the body, she forms not only the physical but also the spiritual centre of the composition. For, although she is invisible to the combatants and takes no part in the battle raging around her, she is the powerful protectress of the Greeks. The bold upward spreading of the figure from the close-set feet is reminiscent of the Antenor Kore. The compositional principles of the whole pediment are summed up in this figure; with her flat, spreading forms she represents the patron goddess expressed in the narrative manner typical of the Late Archaic; the carefully disposed folds of her garments are like the strings of a well-tuned instrument. Even the figures of the warriors themselves are 164, 166 embellished with elegant detailing such as the well-combed hair and the curled locks which frame the forehead and temples. The kneeling archer of this pediment expresses the taut contour still more forcibly and his clinging garment emphasizes the elegance and movement of the body underneath. These are the figures of the original pediment and yet, for all that they are carved out of Parian marble, certain features are characteristic of the bronze-caster's art. From this we may reasonably deduce the presence of a sophisticated bronze industry on Aegina.

Fig. 143 Clearly the later east pediment, begun about 490 and completed in the following decade, is designed by a master in the same tradition as the west pediment. And yet we notice a new power in the figure of 167, 166 Herakles the Archer as compared with the archer of the earlier work. The curves of the shoulder and

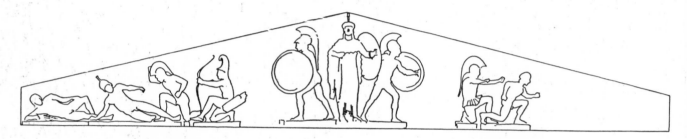

142 Aegina, so-called Temple of Aphaia. Reconstruction of the west pediment (after Schmidt 1959)

thigh muscles seem to express the purposeful tension of the body; the mighty head and short neck enhance the impression of power. This pediment marks the discovery by the Greek artist of a new world of expression. The forms now move and turn in the depth of the field and are no longer set as if in a frieze; the earlier lightness and charm has given place to a new seriousness of purpose. The Archaic warriors who had departed 165, 164 this life smiling are followed by men who no longer conceal their agony as they look with glazed eyes on the grim reality of death. There are fewer figures but they fill the composition with more intense dynamic power. The action flows more uniformly from the centre of the pediment towards the sides, over the struggling embattled forms to the fallen warriors in the corners of the field.

It would seem that this new style was not confined to the island of Aegina. An almost life-sized bronze 168 head from the Acropolis (Athens, National Museum 6446) is the work of a leading master and immediately invites comparison with the heads of the east pediment of the Aphaia Temple. A remarkably worked helmet covered the head; the flat areas of the face are bounded and emphasized by sharp lines; the eyebrows project like ridges, the lips like polished knife-edges; another sharp line bounds the lower edge of the moustache.

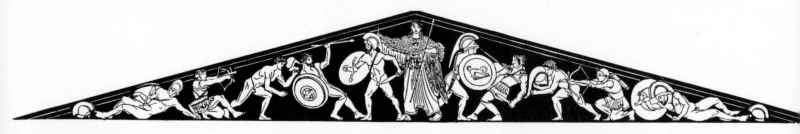

143 Aegina, so-called Temple of Aphaia. Reconstruction of the east pediment (after Furtwängler 1906)

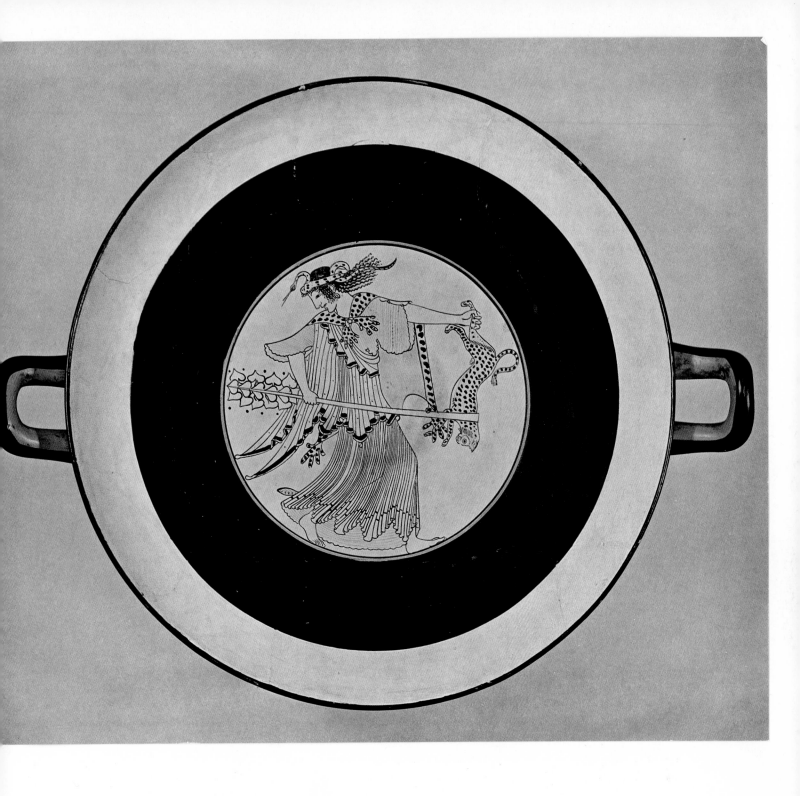

XXV Brygos Painter. Interior of cup. Dancing maenad. Diameter of cup 28·5 cm. Ca. 490 B.C. Munich, Staatliche
Antikensammlungen 2645

Precisely defined curls frame the forehead in a bold curve. Inscriptions offer further evidence that sculptors from Aegina worked at Athens on the Acropolis. Three of these works were ostensibly[11] produced in the workshop of

KALON OF AEGINA

who, according to early records, was a pupil of Tektaios and Angelion. Other traditions suggest that he was a younger contemporary of Kanachos of Sikyon and Ageladas of Argos. Kalon's name is also found coupled with that of Hegesias who is known to have worked at the same period as Kritios and Nesiotes. A statue of Kore or Demeter beneath a giant tripod in the Amyklaion, near Sparta, is attributed to Kalon.

169 right This work was probably the inspiration of the great Figure with the Double Cloak in Corinth. A horse protome near the right foot of the replica in the Palazzo Mocenigo in Venice shows the bronze original to have been a chthonic deity. However, this can hardly have been the Demeter Melaina, made by Onatas for Phigalia, about which Pausanias was able to glean so little information. This statue, which is believed to have represented a seated figure, was destroyed in the collapse of the sacred grotto of Phigalia in the first century A.D., and it is unlikely that there were Roman copies of it.

There were in the Amyklaion, besides the Kore or Demeter by Kalon, an Aphrodite and an Artemis by Gitiades under two further tripods. The sculptor is known to have designed the temple and cult statue of Athena Poliouchos or Chalkioikos on the Spartan acropolis, and is also mentioned as a poet. Copies of the two bronze figures by Gitiades appear to survive in the cloaked figure Corinth-Capitol and the cloaked figure of the type Torlonia 495-Hierapytna.[12] The quiver and fastening suggest that the replica (Hierapytna or Hierapetra) found on Crete represents Artemis. It can hardly be without significance that fragments of all three figures have been found at Corinth; indeed the circumstances suggest that all three bronze originals constituted a single votive group. The close artistic correlations between the Demeter or Kore of Kalon of Aegina and the Aphrodite and Artemis of Gitiades suggest that the Spartan Gitiades should be reckoned a member of the Aeginetan school—either a pupil of Kalon or a fellow student with him under Tektaios and Angelion. On the evidence available, however, the suggestion must remain tentative.

An as yet unpublished Roman copy from the Athenian Acropolis,[13] most probably of a statue of Athena, may well represent another work by Kalon.

170 The same sculptor is obviously the creator of the original of the numerous replicas of the so-called Aspasia, one of which is inscribed as Europa. Roman copies from Pylos, in Messenia, prompt the supposition that the bronze original by Kalon was made for Pylos.

169 left The headless Athena in the Prado (24E) represents another significant work of the school of Aegina. The goddess, wearing a chiton and peplos and carrying the aegis, stands with legs set close, like a tall stele. The left arm bore a shield, the right was upraised, grasping a spear. The bold tubular folds of the drapery on the supporting leg emphasize the restfulness of the pose. The economical folds of the draperies on the free leg can be compared with those of the so-called Aspasia, while the hanging folds of the full peplos have a parallel in the draperies between the right hand and right knee of that figure. It is known that Kalon made a Xoanon of the Sthenias-Athena for the Acropolis of Troizen; coins of the Imperial period carry devices which seem to be based on this work and lend weight to the supposition that the Athena in Madrid is a marble copy of the famous original by Kalon in Troizen.

ONATAS

was the next most famous and prolific sculptor from Aegina. An inscription on the foot of a pillar, which once supported a bronze horse, indicates that Onatas sent works to Athens. But the influence of his work on Aegina spread throughout the Greek world. For example, a small marble head from Tarentum (Boston 00.307)[14] can be related to the Athena on the west pediment at Aegina, and a small marble head in the Barracco Collection, Rome,[15] and a terracotta head in the Loeb Collection[16] both show connections with

171 the Athena of the later east pediment. The Berlin Enthroned Goddess, completed in the early years of the second decade of the century, shows the influence of the west pediment Athena in the treatment of the draperies and the ringlets of hair on the forehead. The ornamentally treated garments tend to conceal the generous lines of the body, yet the divine dignity of the figure is vividly expressed by the erect posture and the rich decoration of the throne. The statue is obviously the work of a master from Tarentum who

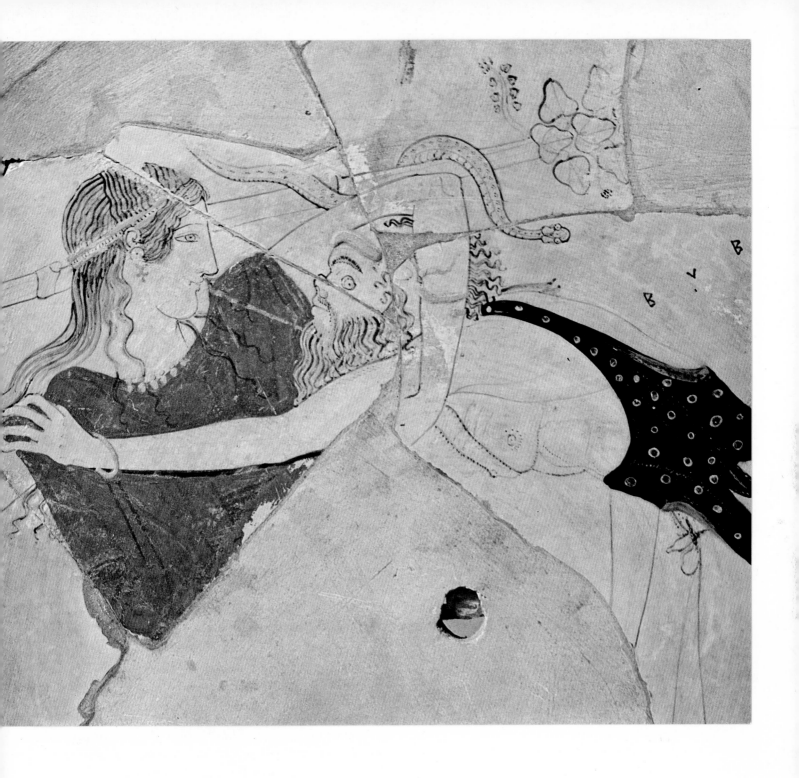

XXVI Pistoxenos Painter. Fragment of a cup, interior. Satyr and maenad. Diameter of cup about 35 cm. Ca. 465/460 B.C.
Taranto, Museo Archeologico

harked back nostalgically to the good old days of the late sixth century and carried an outdated 'subarchaic'

172, XXVII style into the fifth century. Even the Charioteer of Delphi, commissioned by a Sicilian tyrant from a master of Magna Graecia, shows important Aeginetan traits.

Such contemporary works, although related in style, cannot give us any precise idea of the personal style of Onatas, son of Mikon, but we can be sure that many of the copies which survive from antiquity are in fact based on originals by this prolific master. The most reliable guide to Onatas's style is a work on an unusual theme which can be connected with his name.

Pausanias (5.27.8) describes the votive offering of the Arcadian Pheneates, at Olympia, as a statue of Hermes wearing a chiton, a chlamys and a felt hat (kyne), and carrying a ram under his arm. It was thought until recently that this work of Onatas might have been the prototype of the Boiotian terracotta figure of Hermes Kriophoros. The god is certainly portrayed as a young herdsman but he wears only a chlamys; if this work was in fact copied from the Onatas Hermes at Olympia, then Pausanias's description was inaccurate. However,

173 right a little-noticed bronze figurine in the Cabinet des Médailles in Paris fits the description in every detail. The god is dressed in a smooth-falling chiton; the chlamys is shown as a short shepherd's cloak, caught up at the breast and sweeping its hem in a great curve to the elbows. The ram on his left arm he grips by the forelegs with his hand; the right hand is broken, but obviously held a kerykeion. A helmet-like kyne is pulled down well on the forehead. This figurine continues the Peloponnesian tradition of the bearded Kriophoros; it can, however, scarcely have been produced before the beginning of the second quarter of the fifth century. The determined, concise style and the generous treatment of the chiton and chlamys not only reveal the influence of Aegina but more specifically point to the Hermes Kriophoros of Onatas. The assistant, Kalliteles, Pausanias took to be a pupil or son of Onatas. It is possible that the bearded head No.

173 left 2344 from the Acropolis is a Roman copy of that of the Hermes. The bronze statue of a god, probably
174/175, XXVIII Poseidon, found in the sea and now in the National Museum, Athens, may well be a later work from the workshop of Onatas. It shows affinities with the copy from the Acropolis not only in the treatment of the pigtail plaited round the back of the head, but also in the modelling of the lips and eyes and in the small cheeks, framed by the beard. The statue was discovered off Cape Artemision and it is assumed that it was being transported to Constantinople from its original site, possibly on the Isthmus of Corinth.

176 right The sculptor of the Poseidon statue may also have produced the Doric Omphalos Apollo,[17] one of the most famous of the masterpieces of the Late Severe style, to judge from the number of surviving replicas. It is not just that there are similarities in certain details such as the pigtail on the back of the head, or even in the carving of the face or the curtain-like locks of hair over the forehead. It is in the proportions that a far deeper affinity is to be found between the athletically agile and the youthful god standing poised and relaxed. Both the Apollo and the Poseidon figures have high, slender thighs supporting the vigorous torso; the well-defined supporting lines and the rendering of the rib-cage and the musculature of the breast all betray the hand of the same master. Because of their outstanding quality, the two works have often been ascribed to an Attic master, yet Pausanias observed that Onatas was in no way inferior to the Attic sculptors. In order to satisfy oneself that they are both Aeginetan in style one has only to compare them with the only slightly later original marble sphinx[18] which was found on the island, and whose Aeginetan provenance can no longer be doubted. There is a family likeness between the severe and reserved expression of the sphinx's face and that of the Apollo. The masses of soft and full hair framing the forehead and temples of the sphinx's female head are a still stronger indication that the sculptor was close to Onatas. The bronze original of the Omphalos Apollo was, presumably, made for Aegina. With the conquest of the island in 210 B.C. the statue seems to have been taken away, as booty, to Pergamon where, Pausanias tells us, it was admired not simply for its great size but also for its artistic qualities. A statue base discovered at Pergamon may be the very one made to receive the Apollo. Unfortunately the figure groups made by Onatas for Delphi and Olympia have long since been dispersed and the surviving antique copies possibly based on

XXVII Charioteer. Votive offering of the tyrant Polyzalos of Gela, from the Apollo Sanctuary in Delphi. Bronze. Height 1·80 m. Ca. 470 B.C. Delphi, Museum. Cf. plate 156

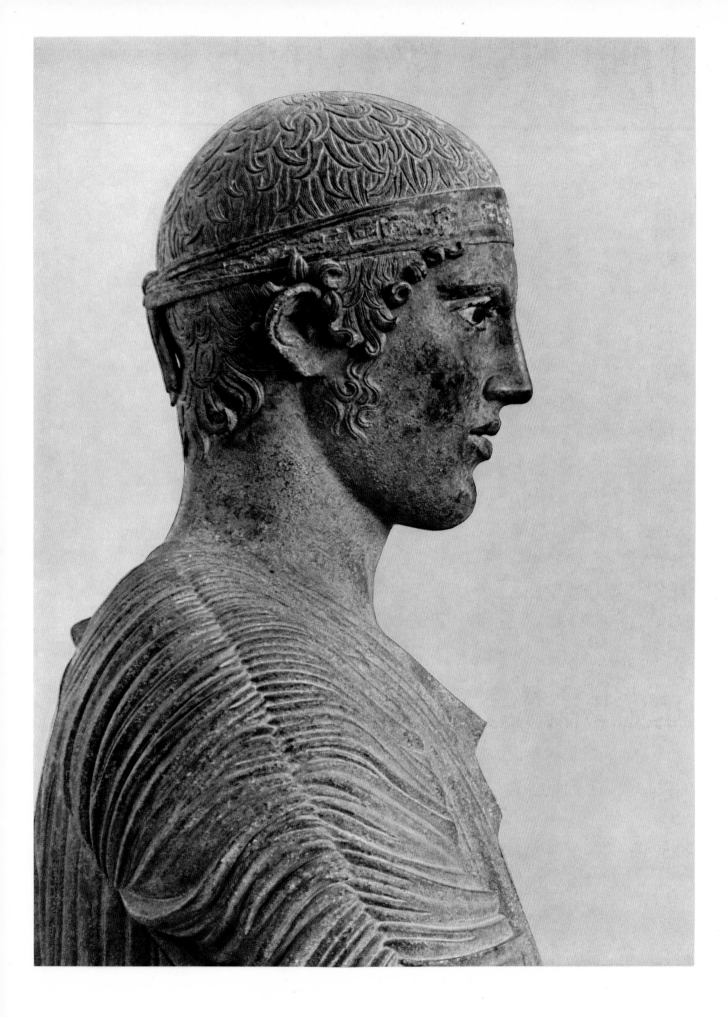

single figures in these groups are widely scattered. Nevertheless, stylistic considerations suggest connections between the Omphalos Apollo and the Poseidon and other isolated figures.

KRITIOS AND NESIOTES

It is with these two names that the beginning of the Severe style in Attica is associated; Kritios was certainly an Athenian but the native city of Nesiotes is unknown. Both apparently worked in the studio of Antenor. *177* They were commissioned to produce a new memorial to the Tyrannicides, Harmodios and Aristogeiton, to replace the one plundered by the Persians; the new statue is known to have been set up in Athens in 477/476. This date is a fixed point of incalculable value in all the problematical questions of dating for this period. In 1859 Friederichs, comparing reproductions on coins and the reliefs on a throne now in Broomhall, identified two Roman copies based on the group of Kritios and Nesiotes. These statues were discovered in Rome at the beginning of the sixteenth century and brought to Naples with the Farnese Collection. The *XXIX* discovery was followed by the identification of other replicas and versions of the subject on vases; all the copies can be traced back to the work of the Early Classical masters and we therefore have no grounds for the frequent assumption that the original work was in fact simply a bronze group by Antenor. The young beardless Harmodios storms into the tyrant's presence, sword flashing as he brandishes it above his head; his bearded friend, the somewhat older Aristogeiton, follows—the head and torso of the figure have been separated at some earlier stage but we can be confident that they belong together. The chlamys over his left arm covered the back of the young protagonist ahead of him. The vigour of these tense figures, the precise lines of their musculature, show clearly that the marble copies derived from bronze originals.

Whilst there is no doubt that the two Roman statues are copies of the figures of the Tyrannicides, controversy still rages over the correct arrangement of the now separated forms. The Roman sculptor has set his two heroes on individual bases, and so destroyed the unity of the original grouping, in order that the figures could be placed in some decorative scheme, for example, on either side of a monumental portico. Almost every possible arrangement, and some impossible ones, have found advocates and still more opponents. The antithetical placing of Athena and Marsyas in the group by Myron is cited as the strongest evidence for the Classical principles of group composition and despite the wide differences in time is suggested as the solution of the problem of the Tyrannicides of Kritios and Nesiotes and even for works by Antenor! A truly Homeric contest! Yet despite the diversity of reasons, most scholars favour some form *177* of wedge-shaped grouping, with the figures both advancing to the front, such as is adopted in the Naples National Museum. It has been estimated that the base of the group was 1·5 metres wide and fragments have been found in the Agora at Athens. The fact that many of the two-dimensional representations of the group would seem to suggest a different arrangement of the figures is explained if one accepts the freedom of the artist to picture his three-dimensional subject from any view-point. The larger than life-sized figures of the two friends stride heroically forward, unannounced and unexpected, into the Tyrants' presence; their lateral positioning possibly echoes the Archaic principle of ranging the figures in rows. The event is depicted at its climax and not treated in the diffuse style of epic narrative; the dramatic moment can be taken in at a glance in all its intensity. The juxtaposition of the figures of Harmodios and Aristogeiton, the violent gesture of the younger man and the protective attitude of the other, the contrasted stress and strain of the two bodies, corresponds to the early contraposto which was beginning to be achieved in single figures about 480 B.C.

The collaboration of Kritios and Nesiotes is confirmed in half a dozen inscriptions. A boy's figure from *178* the Acropolis has been attributed to Kritios alone and is known as the Kritios Boy. Stylistic affinities are to be seen not only in the body, but above all in the heavy chin and the somewhat severe expression. Features such as the eyes, originally inset coloured stones, and the hair rolled into a band above the brow, indicate that the sculptor worked primarily in bronze. Whether the figure was in fact found in the so-called 'Persian debris' is not certain; undoubtedly the work is calmer, more restrained and somewhat earlier in manner than the Harmodios. Possibly the Kritios Boy was part of a votive offering made by Kallias, son of Didymias, victor of the Panathenaic Games of 482; the statue was set up on the Acropolis about the year 480 B.C.

This statue is a world away from the youths of the Archaic period, with the left leg invariably set forward. Here this leg takes the weight, while the right is relaxed. The contrast between the weight-bearing and the

free leg is continued throughout the body. The left hip is slightly higher and the contour of the lower part of the musculature of the chest falls in barely discernible diagonals from left to right.

As the sun enriches Attic soil so the art of Kritios and Nesiotes fructified Attic art, even to the far lands of western Magna Graecia. The origin of the youthful head acquired in Rome by the sculptor Steinhäuser, and now in the Archaeological Collection of the University of Strasbourg,[19] is unknown; we do not know whether it is by an Attic master or whether it represents the influence of Kritios and Nesiotes in some other city. Certainly a fragment of a head, thought to have been Orpheus, in the Museo Barracco,[20] which was made in southern Italy and must date from ca. 470 B.C., could have been produced only by a sculptor who was aware of the work of Kritios's studio. The new freedom achieved by the Attic masters is reflected in the fragment of a relief stele from Sounion. The subject, a youthful athlete placing the victory wreath on *179* his head, suggests that it may represent the young hero Stephanephoros. The bowed head is in straight profile but the body is presented with bold foreshortenings. The Archaic technique of presentation and extension in one plane has given place to a new optical unity which shows the body in three-quarters profile.

An example of the purest Attic art is the so-called Mourning Athena. The stone before which she stands *186* is probably a marker for the races in the Stadion and the stele itself a votive offering by a victorious athlete to the patron deity of Athens, shown as a thoughtful young girl dressed in the Attic peplos and resting her helmeted head upon her lance. The sculptor has boldly alternated full profile views with foreshortened ones in three-quarters profile. In works such as those described we can see promise of the glories to be attained in the High Classicism of the Parthenon reliefs.

Through Roman copies we can get some idea of a series of important peplos figures produced by masters from the north-eastern parts of the Peloponnese. How much they influenced Attic sculptors working in the period between Marathon and Salamis can be seen in the 'Blond Head', a boy's head in Pentelic marble, *180* so called after the colour of the hair. The heavy build of the head itself, the pensive earnestness of the expression, and also such details as the eyes, lips and nose, all link it with the Euthydikos Kore. The head *181* of a bronze figurine from the Acropolis is probably the work of an Argive master. The heavy-set *182* countenance is aggressively emphasized by the detailing of the hair roll, the eyebrows, the wide-rimmed eyelids and lips, and by means of the broad vertical formed by the bridge of the nose. Unfortunately the body of the figurine is lost, and only a small portion of the lower back has been identified as belonging to the Blond Head; even in this fragmentary state, however, the work can be recognized as a direct fore-runner of the Polykleitan canon. The art of the north-east Peloponnese made its impact in the Greek world at large, just as that of the Aeginetan and Attic masters had done. This is understandable enough when it is remembered that the Argive master Ageladas produced the figure group of horsemen and female prisoners which the city of Tarentum dedicated at Delphi as a votive offering for its victory over the Messapians.

The sculptors of the Cyclades, whose islands had been virtually untouched by the tumult of the Persian wars, were naturally enough little affected by the earnest approach, the more oppressive self-awareness of the new style. The majestic Nike of Paros proclaims the Ionian school's independence of the new Severe *183* style, although one must admit that this is something of a special case. The subject herself, the winged goddess, is by her very nature free from the burdens and laws of this world. The magical and untroubled flight of the winged, erect form is expressed in the most restrained manner, the flanks of the body and the rippling folds of the peplos interacting most delicately upon each other. The softness of the garment and its gentle folds emphasizes the restfulness of the figure, which, its movement not withstanding, calls to mind the goddess of Archermos. *123*

A similar sense of floating in space is conveyed by the main scene on the so-called Ludovisi Throne; a goddess, aided by two girl attendants, is rising from a cleft in the ground. The clinging draperies of the *184 below* youthful trio reveal all the springtide vigour of the bodies beneath, and their rippling folds lend the relief an indescribably delicate surface texture. This magnificent and mysterious scene is clearly the work of a master from some district of Magna Graecia. The portion of a relief tondo showing a woman's head in *184 above*

profile to the right is probably a representation of the moon-goddess, Selene. The delicate interplay of the forms, unhampered by any sharply defined axial structure, conveys the magical effect of the moon shining full in the skies of the Aegean.

The genre of pictorial grave stelai, suppressed by law in the Athens of the late sixth century, continued to flourish in the Islands. One such, narrowing towards the top, and practically intact except for the crowning *185 left* palmette, was that of an athlete, found on the island of Nisyros. The legs are shown in profile facing right, the left one slightly bent, the right straight; the soles of both feet are firmly planted on the ground. The body is turned at the hips and despite its comparatively low relief gives something of the illusion of a fully modelled figure. Whereas the master of the Sounion stele aimed at a delicate smoothness of finish, the Ionian sculptor has given full play to the musculature of the chest and the arch of the shoulders; the interior modelling provides variations on the harmonious counterplay of the contours.

XXX A bronze figurine from Adrano in Sicily provides a three-dimensional equivalent of the athlete on the Nisyros stele. The right hand probably held a libation vessel; the eyes were of inset coloured stone. The victor is engaged in the devotional ritual of the sacrifice. The work would seem to be that of a Sicilian sculptor seeking to emulate the great achievements of contemporary monumental carving. The figure has in common with the Nisyros stele such features as a cap-like treatment of the hair, long legs and a realistic rendering of the musculature of the belly, breast and shoulders, which border on the harsh.

185 right The lyrical manner of the Giustiniani stele in Berlin offers a marked contrast. It depicts a standing girl with bowed head; at her feet is a box, from which she has just taken an object, perhaps some favourite piece of jewellery—originally picked out with painted decoration—which she holds in her outstretched right hand. In the left she holds the lid of the box. The figure is confined to the extreme left-hand side of the tall rectangle of the picture area, so that only the right foot and the two arms cross the central axis; the placing emphasizes the quiet dialogue of the dead girl with the object from her earthly life. The piece is presumably the work of an artist from the island of Paros and dates from about the middle of the century; in its more intimate genre it matches the earlier Parian master's superb Nike.

187 The mortally wounded daughter of Niobe in the Museo delle Terme takes us already into the third quarter of the century. As she flees before the missiles of the vengeful Letoides, her dress slips from her shoulders and slides in rippling folds from her back, down over the right leg. The contrast between the concealed and the bared parts enhances the delicacy with which the sculptor has rendered the stricken young body. The Dying Niobid is clearly part of a larger pediment composition, which presumably crowned a temple in Magna Graecia.

THE OLYMPIA MASTER

The Severe style reached an astonishing peak of achievement in the sculptures of the Temple of Zeus at *Fig. 144/145* Olympia. The work was completed in 456 B.C. but must have been started some two decades earlier. The *Fig. 146/147* vast programme, which comprised the six metopes over the two ends of the cella as well as the groups of larger than life-sized figures in the two pediments, was carried through with such an over-all sense of unity and coherence that one must presuppose the directing genius of a single great artist. It is also evident that a considerable number of assistants, at all levels, took part in this immense undertaking, which at every turn exhibits the living interplay between inspired design and actual execution. The twelve metopes of the cella depicted the twelve Labours of Herakles.

Fig. 144 The east group of six metopes was completed first, but doubtless the whole series had been planned beforehand, those twelve having been chosen from the rich corpus of Herakles's adventures which were to form the canonic cycle. Pausanias's description, read in the light of the remains disclosed by the German excavations, gives us a clear idea of this master-plan; it has also enabled us to tell how the individual scenes were arranged on the building. The series begins with the capture of the Erymanthian Boar; Herakles, with the beast on his shoulders, strides towards his task-master, King Eurystheus, who has sought refuge in a

XXVIII Poseidon. Probably by Onatas of Aegina. Bronze original, found in the sea off Cape Artemision. Total height 2·09 m.
Shortly before 450 B.C. Athens, National Museum 15161. Cf. plate 159

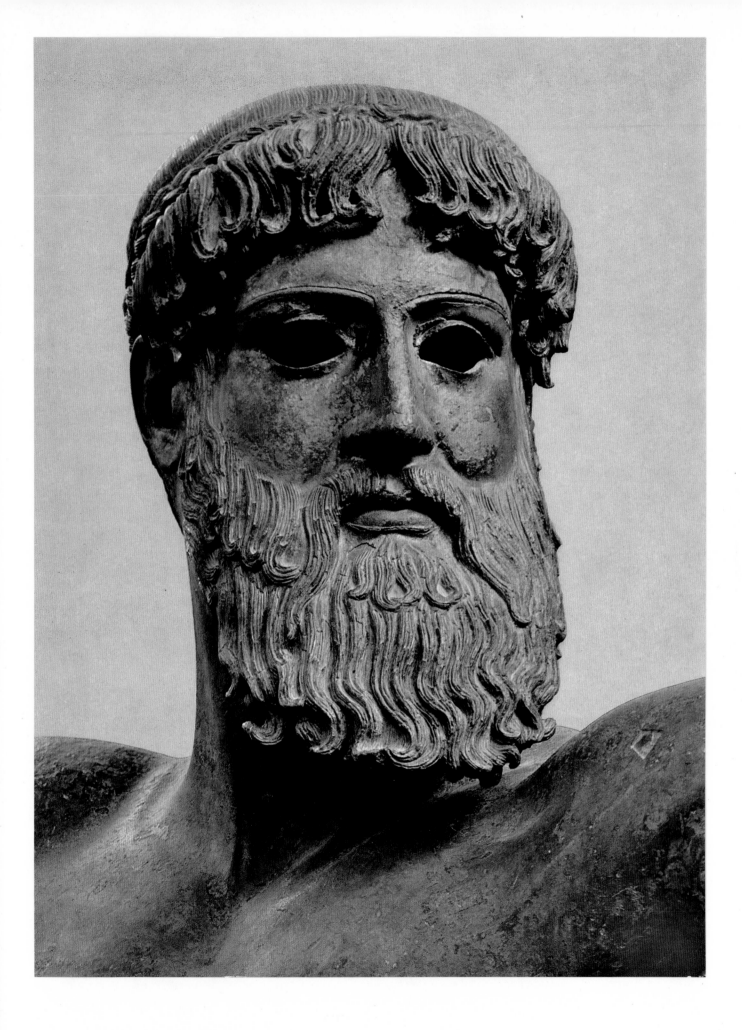

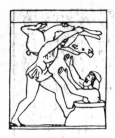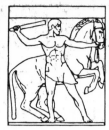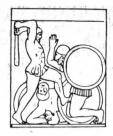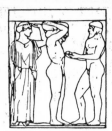

144 Olympia, Temple of Zeus. The six metopes from the east end of the cella, showing the Labours of Herakles. From left to right: Herakles with the Erymanthian Boar; Herakles with one of the Horses of Diomedes; Herakles battles with Geryon; Herakles brings the Golden Apples of the Hesperides to Athena; Herakles and Kerberos; Herakles cleans out the Augean stables

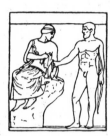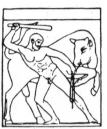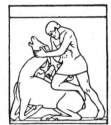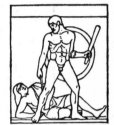

145 Olympia, Temple of Zeus. The six metopes from the west end of the cella, showing the Labours of Herakles. From left to right: Herakles overcomes the Nemean Lion; Herakles battles with the Hydra of Lerna; Herakles brings the Stymphalian Birds to Athena; Herakles captures the Cretan Bull; Herakles tames the Keryneian Hind; Herakles overpowers the Amazon queen Hippolyte in order to win her girdle for Admete, the daughter of Eurystheus

large jar—a scene familiar in the work of artists of the Archaic period. The next metope shows Herakles, presented full-face, struggling with the Horses of Diomedes; in the one after that he is wielding his mighty club in battle with the third body of the monster Geryon. The fourth metope, a static three-figure composition, achieves real inner tension and drama. This, the theme of Herakles and Atlas, had been handled before, as the black-figured lekythos in Athens, 1132, by the Athena Painter proves. There the hero, with sagging knees, is supporting the arch of the heavens represented by part of the architrave painted with stars. The massive form of the Titan makes even the mighty Herakles look something of a weakling; his eyes are upon the Golden Apples of the Hesperides which Atlas is holding out and is presumably working out the scheme which shall see the heavens safely back on the shoulders of Atlas and the apples in his own hands. Perhaps Atlas will be so good as to relieve him for a moment of the accustomed load, while he, Herakles, goes to collect a cushion? No sooner said than done; our hero, with the apples safely in his possession, takes his leave. This lekythos was probably painted in the 'sixties and seems to derive from a Late Archaic poem, possibly by Stesichoros. The Olympia Master has transformed this picaresque novelette into a great composition. Herakles is standing upright, the cushion is already on the nape of his neck and his raised hand is supporting the vault of the heavens which will have been plastically indicated in abbreviated form. Possibly Atlas is still making conditions, but unseen by him Athena stands behind her protégé, holding up the sky with one hand, and her presence leaves no doubt as to Herakles's successful termination of the adventure.

Great two-figure compositions appear at the east end of the cella. Under the protection of a Hermes (now surviving only in fragments), Herakles leads the three-headed dog Cerberus, keeper of the gates of Hell, up from the Underworld. The hero moves with infinite caution as he conducts his dangerous charge. In the northernmost of this east series of metopes, we see the wise Athena, who appears to be advising Herakles on the best way to achieve his next task—the cleansing of the Augean Stables.

XXIX Panathenaic amphora, Kuban group. Athena, with shield device of the Tyrannicides, after the group of Kritios and Nesiotes. Height 67 cm. End of 5th century B.C. London, British Museum B605

284

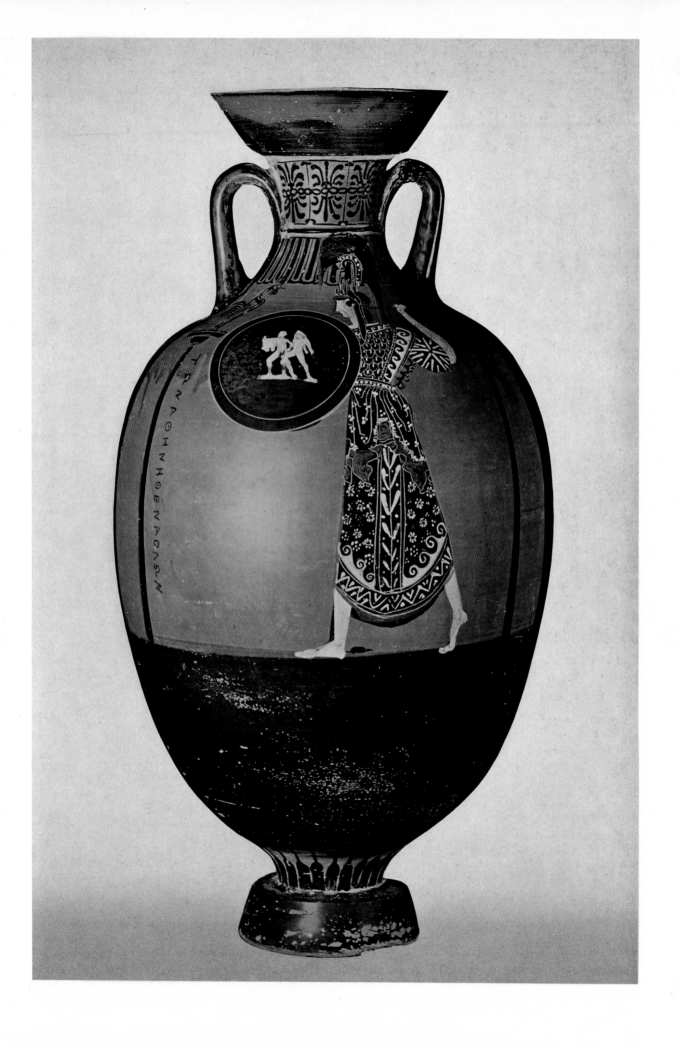

Fig. 145 The west metopes continue the theme of the earlier series but in a new manner; one must not, however, overlook the unifying motifs envisaged in the original grand design. The Amazon and Bull metopes reflect the compositional structure of the metope dealing with the Horses of Diomedes; the Lion metope can be compared to that of the three-figure Atlas relief, while the scene showing the battle with the Hydra recalls the Geryon metopes. And yet, on closer scrutiny, we find that each scene has been remodelled and is inspired with a new sense of drama or a new restful balance. The inherent verve of the Augean Stables metope on the east side is intensified still further in the Bull scene. Even the Hydra episode, which reflects the charm of earlier styles in the disposition of the snake-like bodies of the monster, surpasses not only the Cerberus but even the Geryon metopes of the east end by virtue of its free, flowing style. The incomparable landscape setting of the Stymphalian Birds metope excels all others in the series and, in its luminous quality, seems to open the way to the world of High Classicism. Athena, usually so stern, has seated herself on a small outcrop 189 of rock beside Lake Stymphalos and with maidenly modesty turns her head towards Herakles who, respectfully but with obvious pride, holds out the bodies of the gruesome birds. To appreciate the way in which this portrayal of the scene breaks with all conventions, one should think back to the versions by Archaic artists which show Herakles with his bow, in the thick of the swarming monsters.

146 Olympia, Temple of Zeus. East pediment. Reconstruction (after Studniczka). A 'Alpheios'; B seer; C Myrtilos with Oinomaos's chariot; D youth; E Sterope; F Oinomaos; G Zeus; H Pelops; J Hippodameia; K girl in front of Pelops's chariot; L seer; M squatting youth; N 'Kladeos'

147 Olympia, Temple of Zeus. West pediment. Reconstruction (after Treu). A, B two Lapith women; C, D, E northern three-figure group: Lapith rescues Lapith woman from attack by a Centaur; F, G Centaur assaults a Lapith boy; H, J, K Perithoös protects his bride from a Centaur; L Apollo; M, N, O Theseus battles with a Centaur for a Lapith woman; P, Q Centaur sinks his teeth in a Lapith boy's arm; R, S, T southern three-figure group; Lapith protects a Lapith woman from attack by a Centaur; U, V Lapith women watching the battle

Fig. 146/147 To follow these 'show pieces', as they have been called, we have the pediments earnestly conceived and 190/191 superbly executed. The artist presents the pious worshipper with a crowded stage. On the east pediment we are shown the household of King Oinomaos of Elis. According to tradition, he had determined to grant his daughter's hand in marriage only to the suitor who could beat him in the chariot race; those who lost were to forfeit their lives. The king felt the more confident since he had a team of racing horses given to him by the god Ares. The two quadrigas at the centre of the composition are auguries of the life and death struggle which is impending; something far more than mere preparations for the race is depicted. The horses are in harness, the air is not filled with the shouting of ostlers and grooms but is ominously still before the storm which is to come. In the corners of the pediment lie two young Elians,[21] thought by Pausanias to represent the two river-gods, Alpheios and Kladeos, who watch the fateful encounter in the centre between King Oinomaos and Pelops, the foreign guest on the left. The movement of the composition itself flows

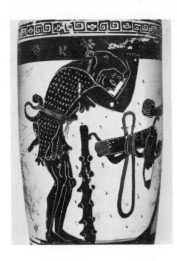

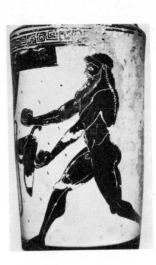

148 Athena Painter. Herakles carries the vault of Heaven, whilst Atlas fetches the Golden Apples from the Garden of the Hesperides, from a lekythos. Ca. 480/470 B.C. Athens, National Museum 1132

from these corners towards the centre; two seers, seated behind the chariots, foresee the fall of their king. At the centre of the pediment stands Zeus, unseen by the two contestants and elevated above their sphere. *190* Their upright spears, flanking the god, emphasize this separation in physical terms. His head is turned towards Oinomaos, his right hand is clenched in his cloak in lordly wrath; for it is he who will seal the *191* fate of the proud king. The valiant stranger, too, has a team given by one of the gods, the great Poseidon, and he it is who will win the race and the beautiful Hippodameia, who stands between him and his chariot.

By way of contrast to the ominous quiet of this scene we have the violent conflict of the west pediment. *192–196* The Lapith king, Peirithoös, invited as guests to his wedding Theseus, his friend from Attica, and also the Centaurs. Intoxicated with wine, these allowed their animal nature to get the better of them; they set upon the women and boys at the feast, even attempting to rape the bride herself. The two- and three-figure groups *192* are united in various postures of embrace and rebuff; the action flows like an irresistible landslide from the *195* centre of the pediment to the corners. Apollo stands at the centre of the composition, his arms outstretched *193* in a gesture of command for the tumult to cease; he matches the figure of Zeus in the east pediment, the highest realization of the Greek idea of fate.

The Olympia Master's art comprehends all the range of human experience from the events of everyday life, expressed in the boy playing with his toes, the servant of Hippodameia and the groom of Oinomaos on the east pediment, to the dreadful assault on innocence of the west pediment and the lofty intervention of the gods themselves. The origins of the master have been much debated. There can be little doubt that he was a native of the Peloponnese, just as it is clear that he knew the Attic tragedy and the world of Ionian painting of Polygnotos of Thasos. We do not know his name; the names of the masters Alkamenes and Paionios, advanced by Pausanias, obviously derive from a misunderstanding. His style combines Doric strength in its rendering of the structure of the human form, with the delicacy, the gay lightness and tender opulence of Ionia. This is not a question of grafting one discipline upon another; no Ionian master, that is to say, who became acquainted with Doric styles while working in Elis. Yet neither is the unique quality of the Olympia Master satisfactorily explained by postulating a Doric artist influenced by Attic tragedy and the monumental painting of a Polygnotos. The indissoluble unity of the diverse elements which go to make up his style would point rather to some place of origin where the Doric and Ionian elements were present in equal strength. Laconia suggests itself, since poets and sculptors from Asia Minor and the Islands had settled here from the seventh century on. As a youth in Sparta our artist could have seen and admired the work of a Bathykles of Magnesia or a Theodoros of Samos, or again, that of similar masters from the north-east Peloponnese. His resolution of these disparate styles into the mighty music of Olympia remains the secret of his genius. His actual name could hardly have a more noble ring than the one posterity has bestowed on him by virtue of his own work. After having beheld the Sistine ceiling, Goethe confessed that Nature herself had lost something of her piquancy, since he would never be able to experience her so fully as Michelangelo had done; these words could equally apply to the work of the Olympia Master.

In the early part of the fifth century the Greek world produced a plentiful array of masterly work: this applies no less to coin-engraving than to sculpture and the other representational arts. In this period it is Sicily which takes pride of place. The ambitious spirit of the Western Greeks, which urged them not to take second place to the mother-country in any respect, led Sicily to achieve a position of positive pre-eminence in the realm of coinage. Inasmuch as they are closely connected with important historical events and thus can be securely dated, these coinages are of special interest for the history of stylistic development.

From the numismatic point of view, as in other ways, Syracuse was the leading city of Sicily, though other cities of both Doric and Ionian foundation also produced coins of the highest quality. From 485 B.C., Gelon was lord of Syracuse: already a general of cavalry under Hippokrates, the tyrant of Gela, he made himself ruler of that city in 491 on the death of the latter; in 485 B.C. he obtained possession of Syracuse by exploiting the rivalry between the nobility and the popular faction, and forthwith transferred his seat of *138 (9–11)* power thither. In the last twenty years of the Archaic period Syracuse, as we have seen, possessed notable die-engravers, and on the coins we have already described from around 500 B.C. the head of Arethusa with *138 (11)* four circling dolphins dominated the whole area of the coin. Leading on from these, there now comes a whole series, almost all tetradrachms, of which each and every example is a masterpiece. On the obverse we still have the four-horse chariot throughout the fifth century, and on the reverse once more the head of the water-nymph Arethusa, who may at a quite early date have become to some extent fused with the concept of the city-goddess Artemis.

Directly after his assumption of power at Syracuse, Gelon had the discernment not only to develop the city as a military power but also to invest it with very considerable political prestige. Syracuse virtually dominated the whole of Sicily, to find herself driven with positively explosive force to take a place in world commerce and attain great prosperity. The lavish supply of silver which the city was able to procure facilitated the mass-production of coins in line with the wide range of her commercial activity. Like Athens and like Cyzicus in Asia Minor, Syracuse dominated the money market of the ancient world. Also, her silver enabled Syracuse to mobilize great armies with whose help she was able to meet the clash with Carthage as it gradually became inevitable, and to lead the Greeks of Sicily to victory in that struggle. In such mass-production of coins—from the period between 485 and 480 B.C. we know of some 271 tetradrachm types struck from 132 obverse dies and 191 reverse dies—it is true to say that artistic quality had on occasion to take second place to the demand for sheer output.

But with the day of victory at Himera in 480 B.C. the quality of die-engraving at Syracuse reverted again to a very high level of artistic competence. It was considered to be a matter of the greatest importance to *197 (1)* have dies engraved for the great decadrachms—intended not only to celebrate the victory at Himera, won by Gelon in conjunction with Theron of Acragas, but to demonstrate the might of Syracuse to the whole of the Greek world, as the coins passed from hand to hand. And an artist was found who knew how to do full justice to the glory of this victory, which meant as much to the Western Greeks as did that of Salamis to the Greeks of the mainland and Asia Minor. This impressive issue of coins was made possible by the generosity of the princess Demarete, Gelon's wife and daughter of Theron of Acragas. To this proud lady had come the Carthaginian peace-envoys to express their gratitude for her intervention on behalf of the enemy wounded and captured on the field of Himera, offering her a golden crown to the value of 100 talents (= 600,000 drachms). This crown she had sold for the benefit of the common weal and from its proceeds were struck those coins, the greater proportion of them in the form of decadrachms, that now bear the name Demareteia, in allusion to the princess's name. According to the ancient sources, this money was used first and foremost to repay the forced loans which Gelon had exacted from the citizens to finance his preparations for the defensive war against Carthage. Just as the coins of Athens after Marathon and Salamis *198 (4)* show the helmet of Pallas adorned with three olive leaves, so the head of Arethusa, who stands for Syracuse,

XXX Athlete, from Adrano. Bronze figurine. Height 1·95 m. Ca. 460 B.C. Syracuse, Museo Nazionale Archeologico

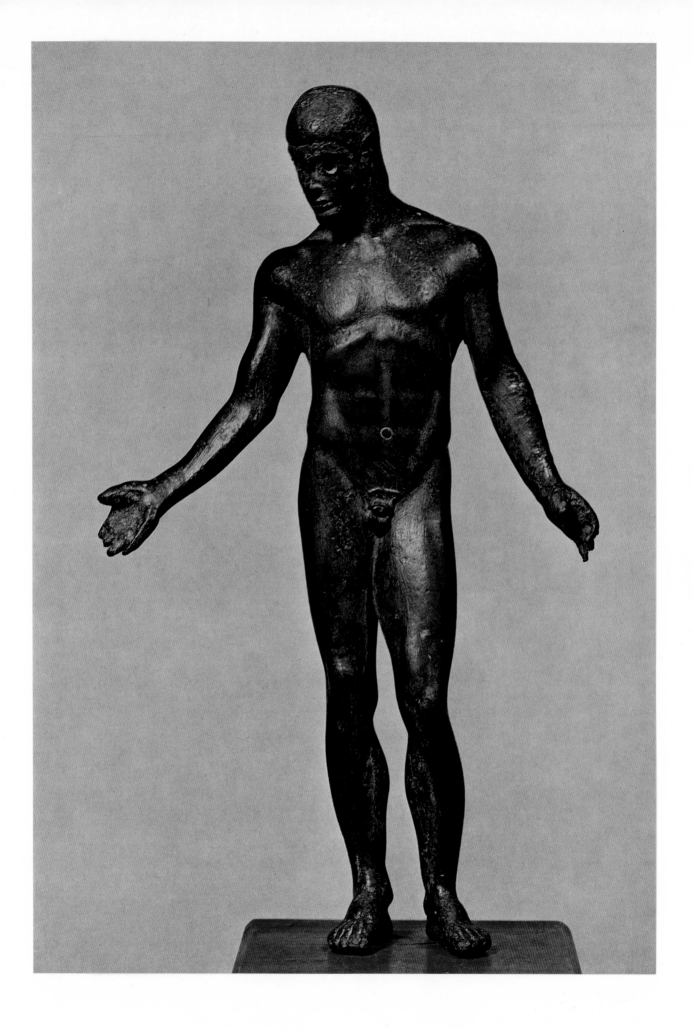

has her hair secured by a crown of olive as an emblem of victory. The dolphins who are her constant companions as they circle around her head seem by their massive proportions to give special expression to the idea of Syracusan sea-power—as was fitting, now that the Syracusan fleet had free access to every part of the Mediterranean as a result of the Carthaginian collapse. The nobility of this reverse is well matched by the grandeur with which the victorious chariot on the obverse is conceived. The horses are royal indeed as they step out proudly, irresistibly urging their chariot towards victory, yet firmly controlled by the hand of the charioteer, who is shown bending forwards to harmonize with the circular composition. Never was a chariot team depicted with such economy of line and yet at the same time with such fluency of form and such fine feeling.

In the exergue below the ground line is set the image of a leaping lion, emblematic of close ties with Ainesidemos of Leontini and of gratitude felt towards him for his brave intervention at Himera. As father of Theron of Acragas and so as grandfather to Demarete, Ainesidemos drew all three cities together into a real unity by the tie of personal kinship.

Leontini itself was one of the Ionian colonies which came under the hegemony of Dorian Syracuse, and must already have been striking coins at this time. The events already touched on may have provided the initial impetus. In any case the franchise of minting enjoyed by Leontini resulted in the appearance of one *197 (2)* of the most splendid tetradrachms dating to the time of the Himera victory; it features a head of Apollo that is fresh, youthful and sublime. Both obverse and reverse show the leaping lion, symbol of the 'lion' city, on a small scale but complete as on the Demareteion obverse. On all the other coins of Leontini since *47* 485 B.C. the reverse is taken up with a lion's head, as varied in form as the waterspouts on a temple sima: and the head is encircled by four barley-corns, symbolizing the rich fertility of the wide plain that extended from the foot of the rocky ridge where Leontini stood right up to Mount Aetna.

Gela was founded in 689 B.C. by Dorians from Lindos in Rhodes and from Crete, and now achieved her *197 (3)* first coinage under her ruler Hippokrates, whom we have already mentioned, towards 495 B.C. These coins were didrachms whose obverse rings the changes on the theme of a horseman armed with a spear, while the reverse shows the protome of a bull with a human head. This bull is symbolic of the primal force of the River Gelas beside which the city stood. In spite of the small scale of the coins, the horseman, now brandishing, now thrusting with his spear, is portrayed in a most vivid manner, full of acute observation from life, and with die-engraving of the highest quality.

We have already remarked how the Dorian element in Sicily gradually established a leading position and how in the process the Ionian colonies were deprived of their freedom in many respects. Thus Naxos, the *138 (8)* oldest Greek colony on Sicilian soil—it was founded in 735 B.C.—and after Syracuse the first to mint coins, was overthrown by Hippokrates of Gela shortly before his death in 491 B.C.; and the same fate befell other *Fig. 134 (1/2)* Ionian settlements such as Zankle and Himera, who were compelled to cease minting their own coinages at about this time after doing so for two to three decades.

Catana was overtaken by a particularly hard fate. This city was founded in 729 B.C. at the foot of Mount Aetna as an offshoot of Naxos. After the death of Gelon in 478 B.C. his brother Hieron I came to power, and introduced an extreme policy of Dorian supremacy and complete subjection for the Ionians. This had its effect on Catana, whose inhabitants, together with those of Naxos, were forcibly uprooted and moved to Leontini where the tyrant thought to have them more securely under his watchful eye. The city of Catana was then resettled with 10,000 Dorians, partly from Syracuse and partly from the Peloponnese, and its name was changed to Aetna. Hieron was inordinately proud of his new foundation and had himself celebrated as 'Hieron of Aetna'. To the circumstances of the time we owe at least the existence of one of the most wonderful and impressive examples of the art of coinage in Sicily and one which can be closely *197 (4)* dated by reason of the foundation carried out in 476 B.C. This is the unique tetradrachm preserved today in Brussels. On its obverse we see a satyr's head so powerfully executed that it seems to burst out of the confines imposed on it by the shape of the coin, while the features express utter animal ferocity. Under the truncation of the neck there is added a large dung-beetle (scarabaeus), a clear reminder that these insects are extremely plentiful in the region of Aetna and have since antiquity been celebrated for their exceptional size. The reverse type of the coin is equally unusual; it shows Zeus seated on his lordly throne, thunderbolt

290

in hand, a grandly conceived figure dominating the universe and unapproachable by mere mortals. Before him, perched on a fir-tree,[22] sits the eagle, his sacred bird, turned not towards the god but away from him, at instant readiness to fly off through the world bearing the god's commands.

At the end of 467 B.C. Hieron I died: and soon after, Thrasyboulos, his brother and successor, was driven out. This saw the end of the dynasty of the Deinomenids whose lineage reaches back as far as the first Deinomenes of Lindos, co-founder with Cretan help of the colony of Gela in 689 B.C. In 466–465 B.C. democracy was restored at Syracuse, and the individual cities recovered their freedom.

We have mentioned that since 520 B.C. there had been minted at Selinus didrachms showing the feathery *Fig. 134 (4)* leaf of the selinon or wild celery as the canting emblem of the city. Now in 467 B.C., just before the fall of the Deinomenids, this city which since the end of the sixth century had had no experience of a tyranny inaugurated her coinage of tetradrachms. These show on the obverse four horses drawing a divine chariot in which stand Apollo shooting with his bow and, as charioteer, his sister Artemis. On the reverse we see the city of Selinus manifested in the person of the river-god Selinus: he is in the act of sacrificing from a *197 (5)* phiale over an altar within a sacred precinct, indicated by the statue of a bull. Both these types contain an allusion to history. It seems that about the beginning of the century the waters of the River Selinus, on whose left bank the city stood, had brought into existence stagnant lakes which turned into great marshes, and

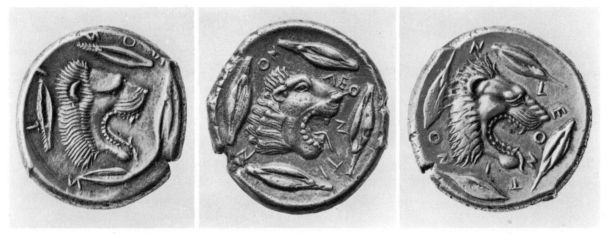

149 Leontini. Reverses of three tetradrachms of 485, 480/475 and 466/460 B.C. respectively. All 2:1

that it was due to Empedokles of Acragas that the stagnant water was dispersed by the construction of canals to make it flow away.

In 461 B.C., four years after the fall of the Deinomenids, all the Ionians who had been transplanted by the tyrant Hieron I were able to return once more to their native cities. The 10,000 Dorians of Catana, now uprooted in their turn, betook themselves to a place called Inessa on the slopes of Aetna.

The new coinage of Naxos began in 461 B.C. with a celebrated tetradrachm on the obverse of which *197 (6)* is portrayed the traditional deity Dionysos, while on the reverse the vine-branch of the Archaic coinage is now replaced by the figure of a squatting satyr, conceived in the grand manner. Quite unexcelled by any other coin type on a similar theme, this squatting figure could well have served as inspiration to Rodin himself. The benevolent, affable aspect of the god's countenance on the obverse, even as it had appeared *138 (8)* on the Archaic coins, is characteristic of the 'Meilichios' side of his nature—here he is not the god that drives men to frenzy but the gentle god who leads towards purity and inner peace.

At about the time that Naxos resumed the minting of these coins—they remain of great artistic significance down to the end of 403 B.C.—Catana made a beginning with her own coinage. The river-god Amenanos *197 (8)* is depicted by the obverse type, once again in the guise of a bull, the symbolic expression of the menacing force with which the river could assault the city when swollen with winter rain. Above the river-god there is a flying Nike or a water-bird, in the exergue below a sea-monster or else a fish, as symbol of the sea on whose shore the city stands. The reverse of the coin shows a Nike, flying or running, with a wreath of victory in her hands. These types that are found on the first coins are of splendid appearance and unsurpassed

by any others of their kind, though—with the single exception of the specimen in the British Museum, which, however, seems by comparison the less forceful—they give the impression of being older than they really are, owing to a certain lack of finesse in execution. So it has come about that the series has often been dated before 476 B.C., that is, before the date at which the population of Catana was transplanted to Leontini. But there is no historical justification for this. It may well be, on the other hand, that we have to do with an artist whose style was firmly rooted in that of the first decade of the century and who thus seems old-fashioned beside the master of the Naxos tetradrachms, somewhat awkward as a die-engraver and yet able to think on the grand scale.

197 (11) Himera regained its liberty in 472 B.C. after the expulsion and death of Thrasydaios, who like his father had been lord of both Acragas and Himera. Some ten years later was issued the well-known and stylistically noteworthy tetradrachm showing on the obverse Pelops in a racing chariot drawn by four horses, and on the reverse the nymph Himera. The body of the nymph—with small hips, broad shoulders and shapely breasts that are scarcely concealed by her scanty peplos—has a classic beauty. She stands there, a sublime, even commanding, figure with her right hand holding on to the edge of her cloak that flows out below her in a wide sweep. It is the work of a very great artist.

Fig. 165

197 (9/10) We must now turn to some pieces on which the head of Apollo is represented; the engraving of these dies, of rare beauty, was contemporaneous with the pedimental sculptures at Olympia. At Leontini, the head is shown on the obverse of the coins; the lion's head, the canting symbol of the city, is now relegated to the reverse. At Catana the series of coins which we have already described, with the river-god Amenanos in the form of a bull on the obverse and the Nike on the reverse, came to an end: thereupon a chariot was adopted as the obverse type, and before long this type attains a dramatic sense of movement, seen at its most intense on the coins dating from the last decade of the fifth century. At Catana, as at Leontini, we encounter the Apollo head from the sixties of the fifth century onwards in a number of different and always impressive versions. Both the pieces here illustrated are masterpieces among the Greek coins of this time.

At Syracuse, when democracy was restored after the fall of the Deinomenids in 465 B.C., countless coins of the finest quality immediately appeared. The obverse still displays the walking horse-team with the light chariot. The Ketos in the exergue continues for many years to commemorate the decisive sea-battle of 474/473 B.C., in which Hieron shortly before his death won a great victory over the Etruscan fleet before Kyme—an event that was as significant as the defeat of the Carthaginians at Himera for the historical development of the Western Greeks. It does credit to the magnanimity of the Syracusans that even after the expulsion of the last Deinomenids, those unworthy successors of Gelon and Hieron, the sea-monster in the exergue was retained until nearly 450 B.C. on the obverse of the tetradrachms (of which some forty-six varieties are known, together with many smaller coins). Thus the memory of the great naval victory was preserved and the victor indirectly honoured.

197 (7, 12) As for the Arethusa heads that were engraved on the reverses at this period, these are among the most attractive types in the whole of Greek coinage, particularly those of the sixties and fifties of the century. They are of inexhaustible beauty and sensitivity, keen and youthful, yet at the same time possessing a rich individuality so that they seem almost to be a series of fine portraits. It is as if the new democratic spirit was capable of being extended to everything however small and insignificant, when we see how even the

197 (12) coiffures of these beautiful girls have a quite unfettered variety. The magnificent Arethusa head of 450 B.C. that marks the transition to the full Classical style is of characteristic nobility.

Of the coinage of the Sicilian cities in the first half of the fifth century B.C. we have shown here the finest examples, yet these account for only a very small part of the total output. By comparison the production of coins by the south Italian Greeks at this period is much more limited. Clearly the use of money, at some of the cities where coins were struck in the middle of the sixth century, was not very widespread and in fact the older issues were extended to fulfil requirements in the first half of the following century. There

198 (1a/b) was thus little incentive for the preparation of new dies. Caulonia is noteworthy for a new type of coin: the striding Apollo on a stater minted shortly before the middle of the century gives a remarkable though rather severe version of the god, but the stag on the reverse is attractive. Interesting for their bearing

292

on Greek religion are certain staters of Metapontum of the years soon before 450 B.C., showing a standing Herakles, or the river-god Acheloös, or Apollo Lykaios. But for the most part this city, too, was among those that continued to make use until nearly 450 B.C. of the old incuse staters and smaller pieces which had been minted in the sixth century from a great number of different dies.

The coins minted at Taras were of very considerable artistic merit. After the destruction of Siris in 550 and of Sybaris in 510 B.C., Taras was left as one of the most important south Italian cities and her far-flung commerce had naturally unleashed a great deal of minting activity in these decades, all the greater by contrast with that which preceded it. The types of the obverse are now devoted to the figure of Taras Oikistes, depicted in an original form with numerous variations as founder of the colony. He has a kantharos or staff in one hand and a spindle in the other. Artistically, the most important die is the earliest of the whole rich series which began about 485 B.C. The reverse carries the type of Taras/Phalanthos, and *198 (2a/b)* this is closely bound up with the foundation-myth; according to the most usual form of the story, Taras, the son of Poseidon and the nymph Satyra, suffered shipwreck and was brought safely to land by the help of a dolphin sent to him by his divine father. On the stater shown here, the figure of Taras expresses the transition from the Ripe Archaic to the Early Classical style: originally conceived for the few staters made after the middle of the sixth century, this type continued through all changes of style down to the year 272 B.C. when Tarentum had to surrender to the Romans, and even beyond that for some decades down to the occupation by Hannibal in 212–209 B.C. A special type is exemplified by the small staters of Taras from the years 492–486 B.C., on which is shown, within a circular frame, a small head very finely executed, sometimes certainly a female, who must be the nymph Satyra; in other cases, however, as on the piece illustrated here, we have a male head, perhaps Apollo. This seems reasonable in view of the fact that the *198 (3)* figure of Apollo Hyakinthios appeared on the incuse staters of the earlier Archaic period.

The Greek mainland, by contrast with south Italy, is prolific in important coins during the first half of the fifth century. But the high artistic merit of the Sicilian coinage is here rarely met with, and certainly not the superlative quality of the die-engraving that characterizes the Sicilian coins throughout the Classical period. The outstanding achievement of the second decade of the century is the decadrachm of Athens. Its *198 (4)* exact date is disputed. For a long time it was thought that it was designed to commemorate the victory at Marathon, and so within a few years of 490 B.C.; but more recent opinion has seemed to favour the belief that it was produced after the victory of Salamis, thus making it almost contemporary with the Syracusan Demareteion of about 480/479 B.C. If this is so, we may feel some surprise at the comparative coarseness *197 (1)* of the engraving: it is as if an effort was being made to get away from the imaginative and perhaps over-sensitive quality of the art immediately preceding the Persian Wars. Certainly the divine head of the young Pallas, for all its clarity and boldness of form, is not an outright masterpiece. It is comparable with the heads of the latest korai from the Acropolis shortly before the Persian invasion. The stark simplicity of the owl with its outspread wings is unprecedented and highly impressive.

The innumerable tetradrachms struck at Athens after 480 B.C. found their way into circulation through the whole wide area of Athenian trade and constituted a universal medium of currency. It is clear that no one ever doubted the reliability of their standard weight and the purity of the silver which they contained. Their appearance was maintained unchanged from 480 B.C. right down to the collapse of Athens at the end of the tragic Peloponnesian War in 404 B.C. Throughout the decades of the High Classical period, we have a type that is almost Archaic, even down to a detail like the eye, rendered in Archaic fashion, being engraved and re-engraved with virtually no alteration. It is the same with the owl on the reverse. By contrast with *198 (5)* the decadrachms and in continuation of the pieces minted just previously, the owl is shown standing with closed wings, and though there are endless slight variations of detail, in general form it is always the same. The half-moon shown beside the owl's right eye may express the gratitude of Athens towards Artemis Munychia, whose lunar emblem the Athenians had seen before their eyes in its waning phase during the early hours of the battle of Salamis. But in giving such interpretations one must not overlook the fact that there are also some tetradrachms soon after 527–520 B.C. on which a similar moon is shown on the other side of the owl's head and further away from it.

In northern Greece, continuing those coinages of the Archaic period that had been so rich in variety and content, the cities of Macedonia and Thrace have further spectacular achievements to their credit. Some of the images that appear on the coins now have a more heraldic aspect, as for instance at Aigai, the ancient Edessa. This city remained for a long time the burial place of the Macedonian kings. A stater struck there 198 (7) shows the *type parlant* of the city, the goat: the animal is depicted with one knee bent, an attitude that is admirably adapted to the circular flan of the coin. This piece may well have been made during the earliest 198 (6) years of the first Macedonian king, Alexander I (ca. 495–450/440 B.C.). Another Macedonian city, Neapolis, the modern Kavalla, minted coins with a considerable variety of Medusa heads from about 500 B.C. 198 (10) onwards. At Abdera we see the griffin type now shown in Classical style on the tetradrachms. Thasos, the Thracian island, had in the Archaic period filled the obverse of her coins with images of the love-play of satyrs and maenads based on the Dionysiac cult, and now in the year 465 B.C. proceeded to issue coins of a really splendid type. Essentially we have the same theme that goes back to the later decades of the sixth century—the satyr lovingly embracing the maenad. The piece here illustrated vividly conveys the satyr's 198 (8) desire for the girl, who attempts to defend herself and does so more convincingly than at any other period 198 (11) before or after. At Sermyle on the Chalcidic peninsula the only known tetradrachm has a type that is both full of action and finely drawn: a huntsman on horseback brandishing a spear and accompanied by his hunting dogs. The frontal treatment of the rider's torso stems strongly from Archaic conventions, a circumstance that seems intelligible enough for the years soon after the beginning of the century, if we 138 (10) recall that this feature had already been fully mastered in the figure of a rider leading a second horse who appears on the Syracusan didrachms around 515 B.C.

A very special place in the repertoire of coin types is held by the tridrachm of Delphi, which must have been minted shortly after the decisive victory over the Persians in 479 B.C. and which is certainly a special 198 (12) commemorative piece. The greater part of the obverse area is taken up with two rhyta, clearly representing some of the gold offerings dedicated after the victory in Apollo's Delphic shrine. Above these, in a sort of upper exergue, are placed two wheeling dolphins appropriate because they belong to the cult of Apollo who was worshipped, among his other names, as Delphinios; according to the Homeric Hymn to Apollo, the god even had the power of assuming the form of a dolphin.

Towards the end of the period we are discussing here, a coinage began to be minted at Ainos on the Delta of the River Hebros, the present-day Maritza in eastern Thrace. Some of these coins displaying the head of Hermes in his pestasos can compare with the sublime style of the Apollo heads on the splendid coins of Leontini and Catana. In them, moreover, we can see a reflection of the great achievements of the metopes and pediments of the Temple of Zeus at Olympia. On the reverse of the very first Ainos coin is shown the 198 (9) caduceus alone, but after this we have the figure of a goat, the sacred animal of Hermes, as well as smaller symbols of various kinds—the piece here illustrated shows a xoanon of the god standing on a low throne with the caduceus in front.

The coins of the Greek cities in Asia Minor during the first half of the fifth century make a sad contrast to their achievements in Archaic times, and to the developments which were to come in the fourth century. In the earlier fifth century we see the abandonment of many fine and interesting types. Yet we may point 198 (13) to the continuing series of didrachms of Knidos, where each coin is an example of the finest work of a Greek artist presenting his own expressive version of a beautiful and graceful head of Aphrodite. Excellent too is the lion protome, in spite of the small scale of the coins. A drachm of Lampsacus of about 480 B.C. should also be mentioned. The reverse type of this piece, Athena in a Corinthian helmet, carries a slight overtone of politics at a time when everything was moving in the direction of close Athenian influence; the 198 (15) obverse gives a fine pair of conjoined female heads decorated with hair-band, earring and necklace. This double-head has no connection with Janus, who was a purely Roman deity: we find a similar pair of heads, those of Zeus and Hera, on staters of Tenedos, but it has never been established which deities form the double-head of the Lampsacus coin. Finally, there is a stater of the Lycian dynast Tethiveibi (ca. 480–460 198 (14) B.C.) which is exceptionally fine. It shows a head of Aphrodite in comparatively low relief: it possesses grandeur and feminine charm alike, and is indeed a masterpiece which distils all the astringent magic of the style of its time.

294

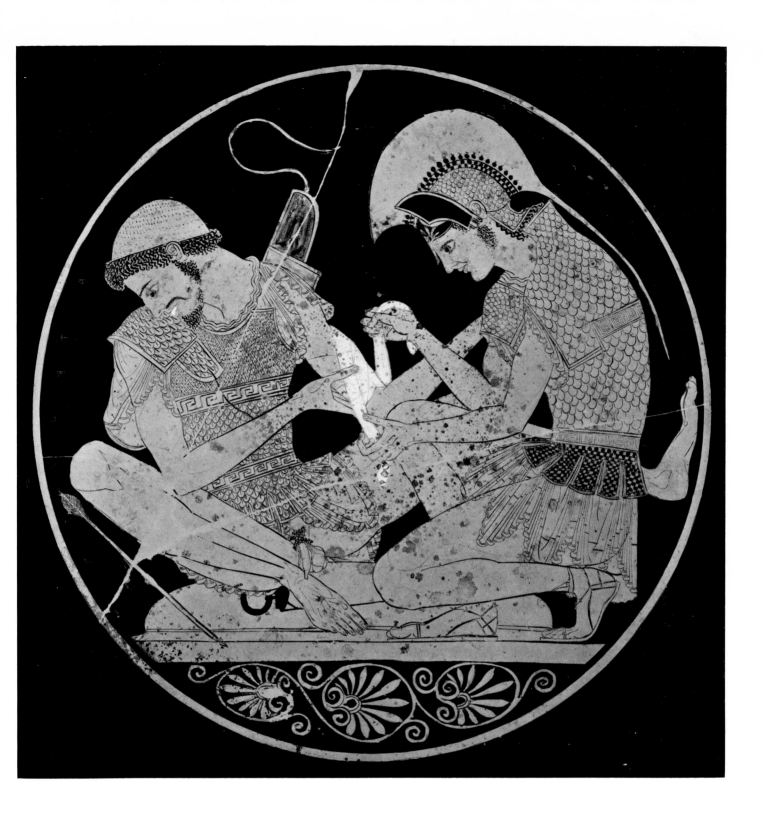

139 Sosias Painter. Interior of a cup. Achilles bandaging Patroklos.
Diam. 32 cm. Ca. 500 B.C. Berlin, Staatliche Museen F 2278

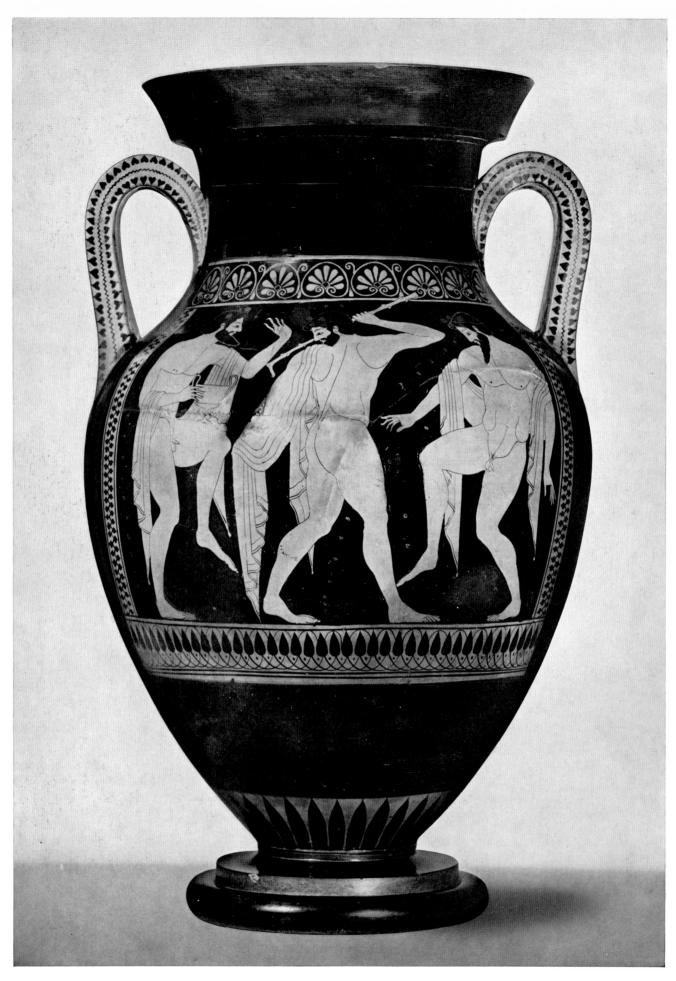

140 Euthymides. Amphora. Reverse. Male revellers.
Height 60 cm. Ca. 510/500 B.C. Munich, Staatliche Antikensammlungen 2307

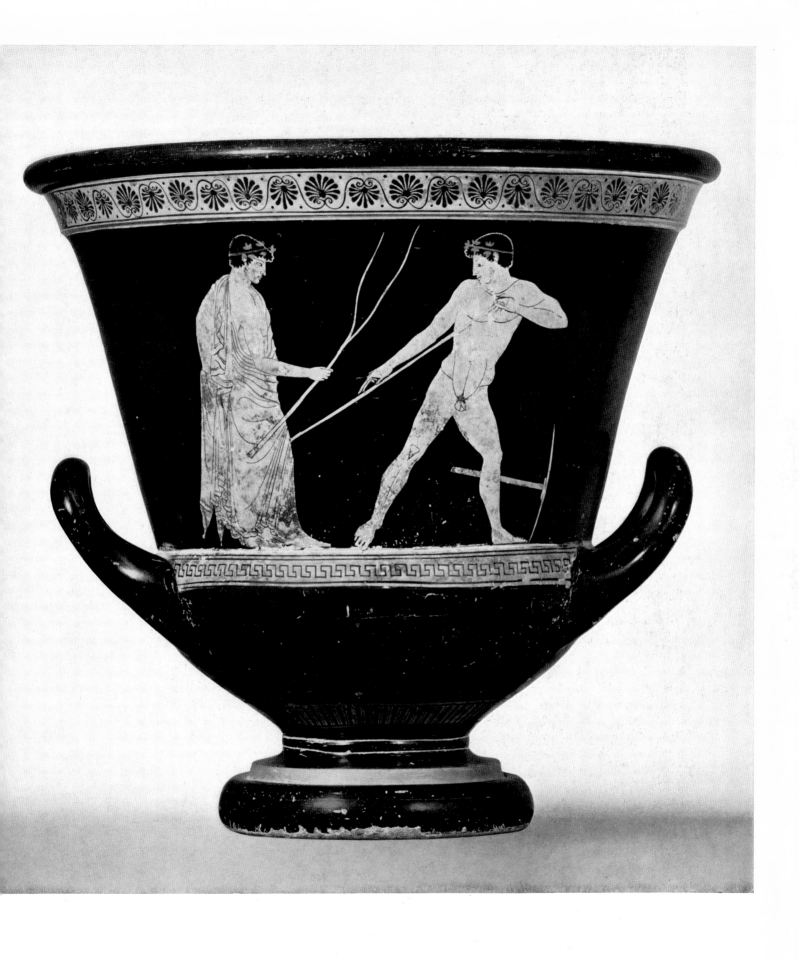

141 Kleophrades Painter. Calyx-krater. Javelin-thrower and trainer.
Height 45 cm. Ca. 500/490 B.C. Tarquinia Museum RC 4196

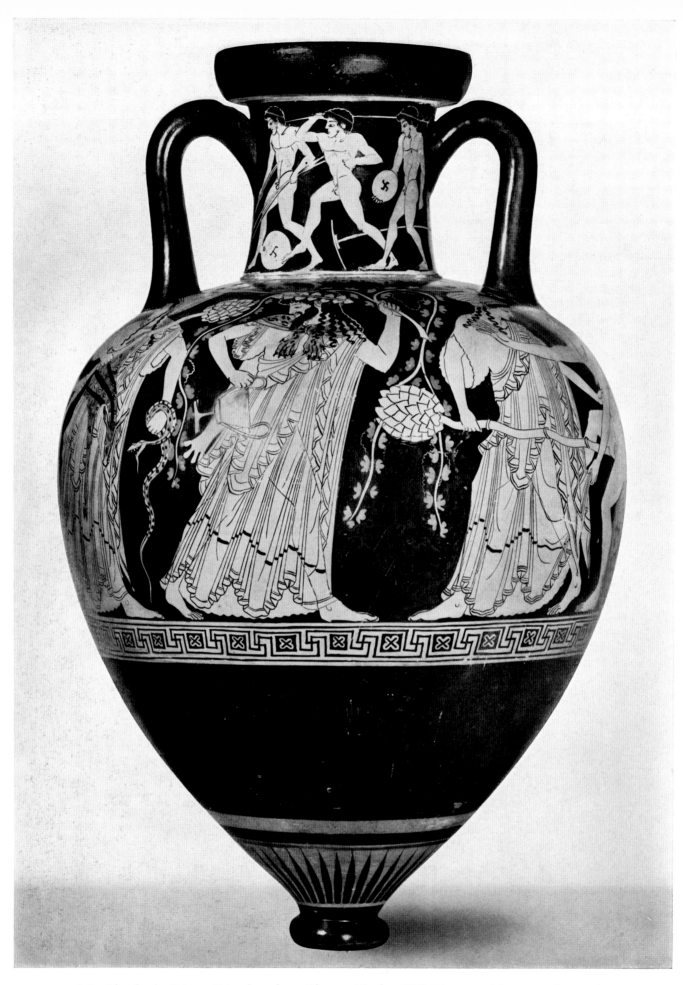

142 Kleophrades Painter. Pointed amphora. Obverse. Cf. plate XXI. Dionysos with satyrs and maenads.
On neck: Athletes. Height 56 cm. Ca. 500/490 B.C. Munich, Staatliche Antikensammlungen 2344

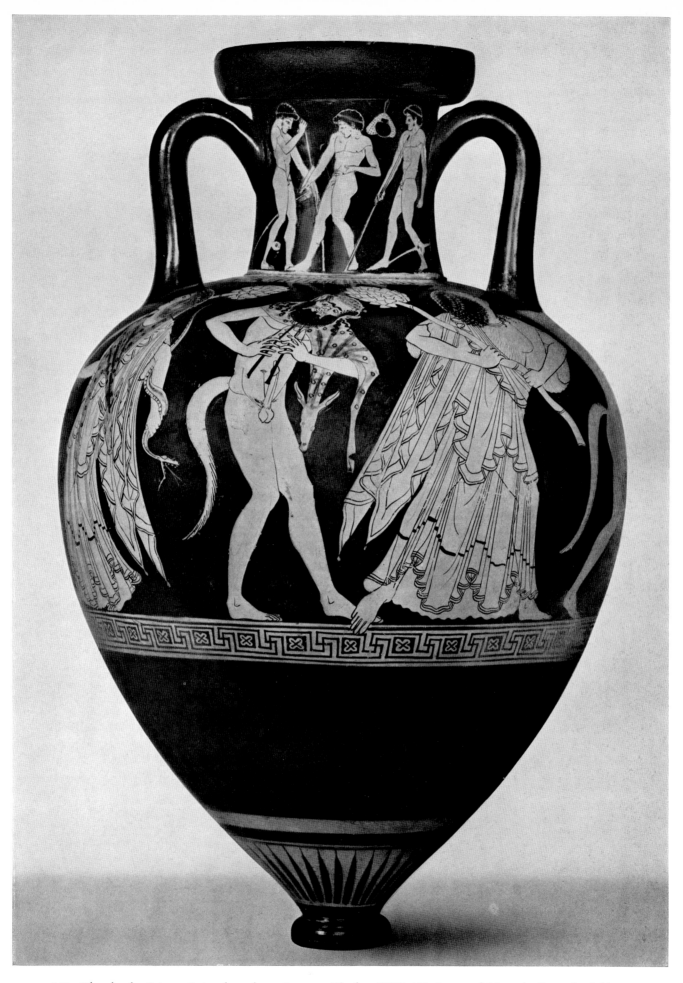

143 Kleophrades Painter. Pointed amphora. Reverse. Cf. plate XXII, 142. Satyr and Maenads. On neck: Athletes

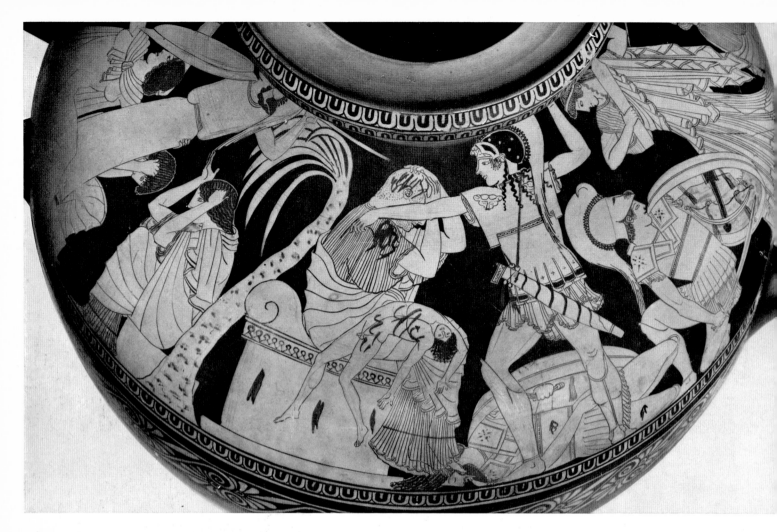

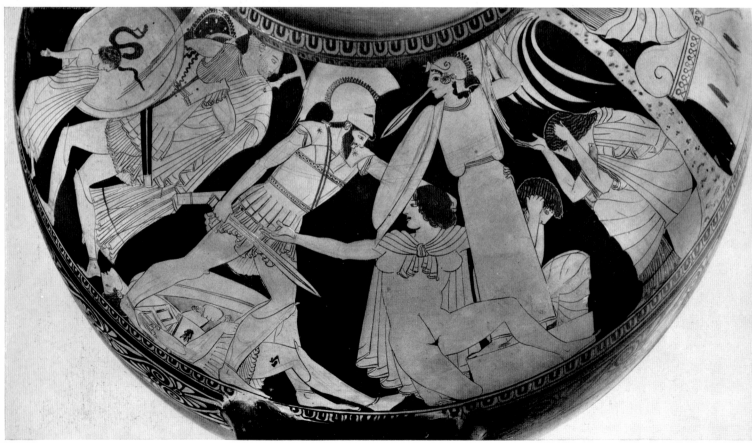

144 Kleophrades Painter. Hydria.
Above: The death of Priam; below: Kassandra, threatened by Ajax, clasps the image of Athena, the Palladion.
Height 42 cm. Ca. 480 B.C. Naples, Museo Nazionale Archeologico 2422

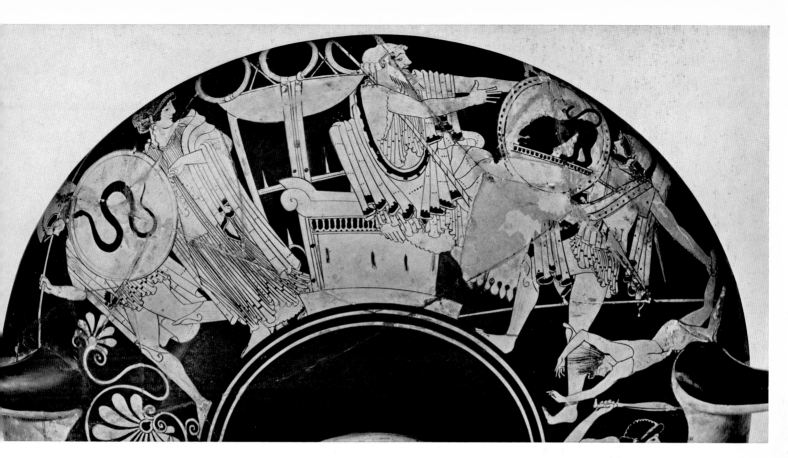

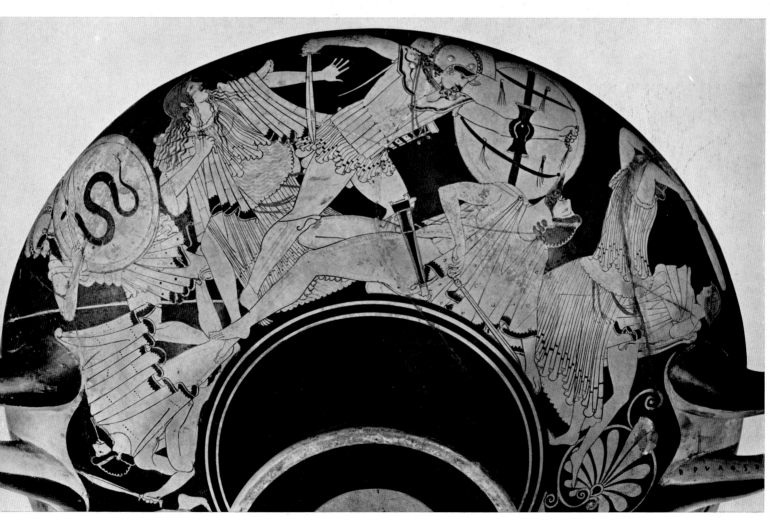

145 Brygos Painter. Outside of a cup. Sack of Troy. (Above, the death of Priam).
Diam. 32.5 cm. Ca. 490 B.C. Paris, Louvre G 152

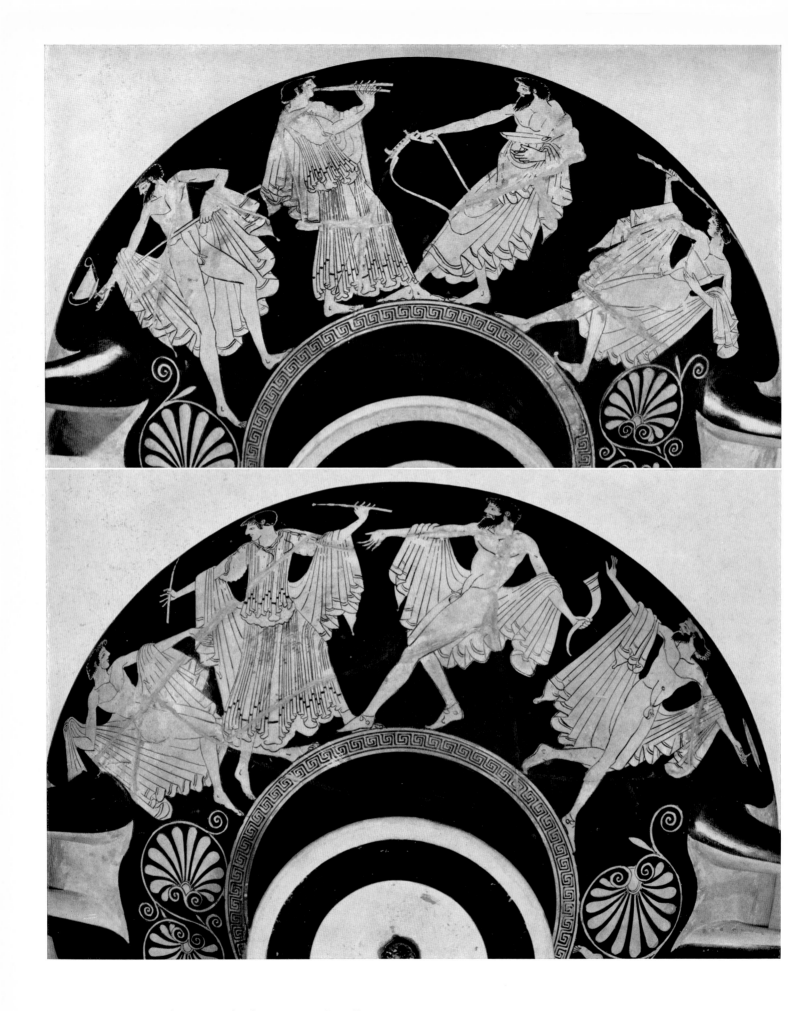

146 Makron. Outside of cup. Scenes of revelling. Diam. 32.5 cm. Ca. 490 B.C. Rome, Museo Villa Giulia 50369

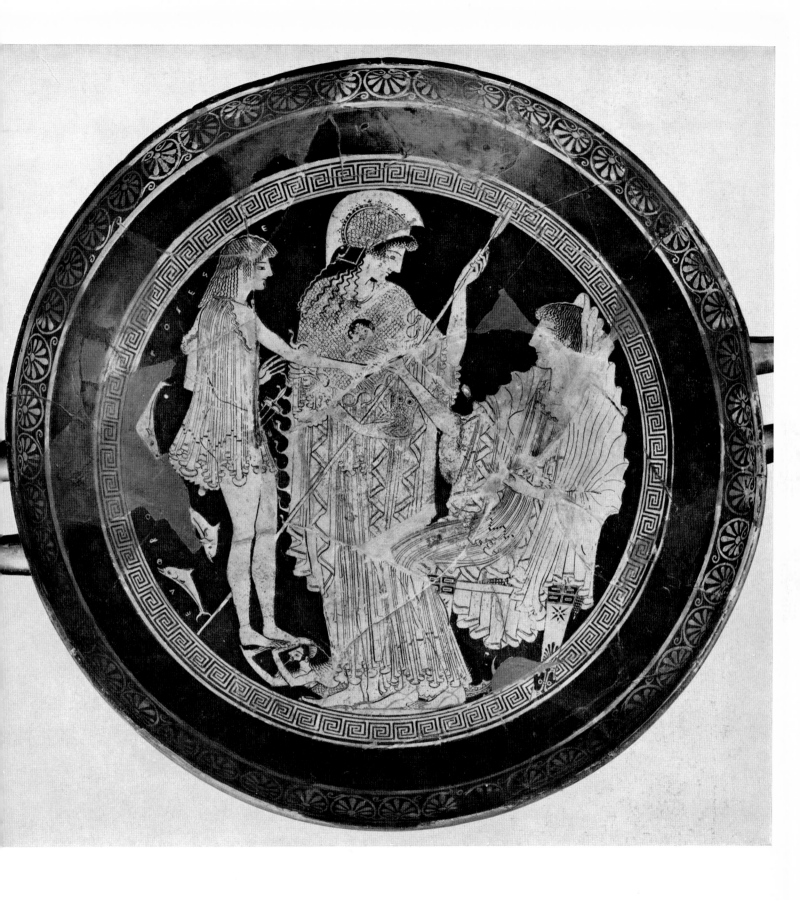

147 Panaitios Painter. Interior of cup. Theseus in the realm of Amphitrite.
Diam. 40 cm. Ca. 500/490 B.C. Paris, Louvre G 104

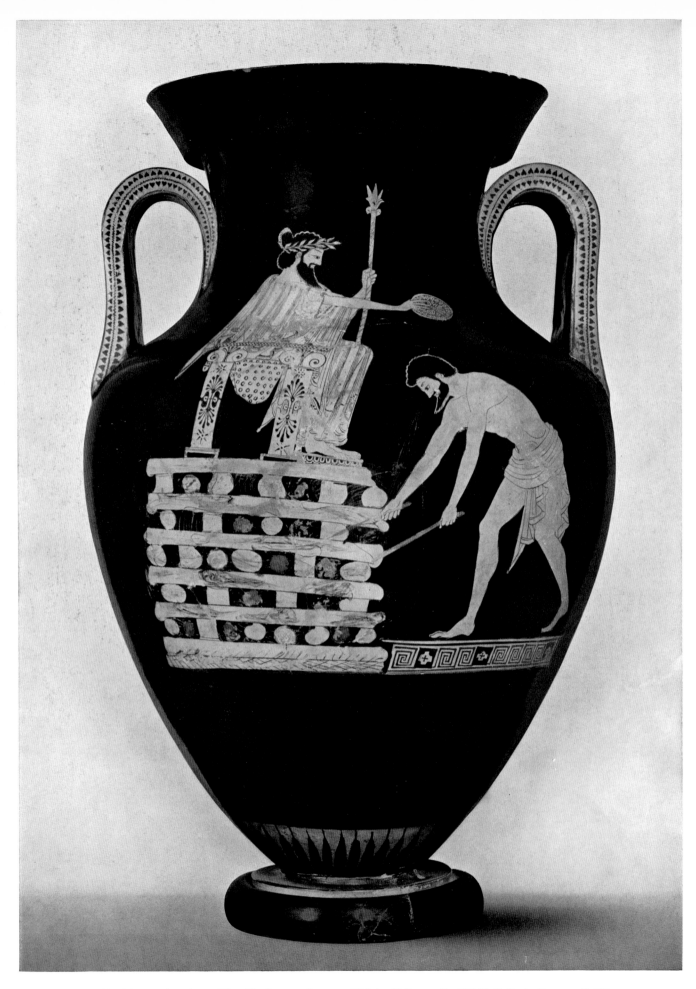

148 Myson. Amphora. King Kroisos on the pyre. Height 58.5 cm. Ca. 500 B.C. Paris, Louvre G 197

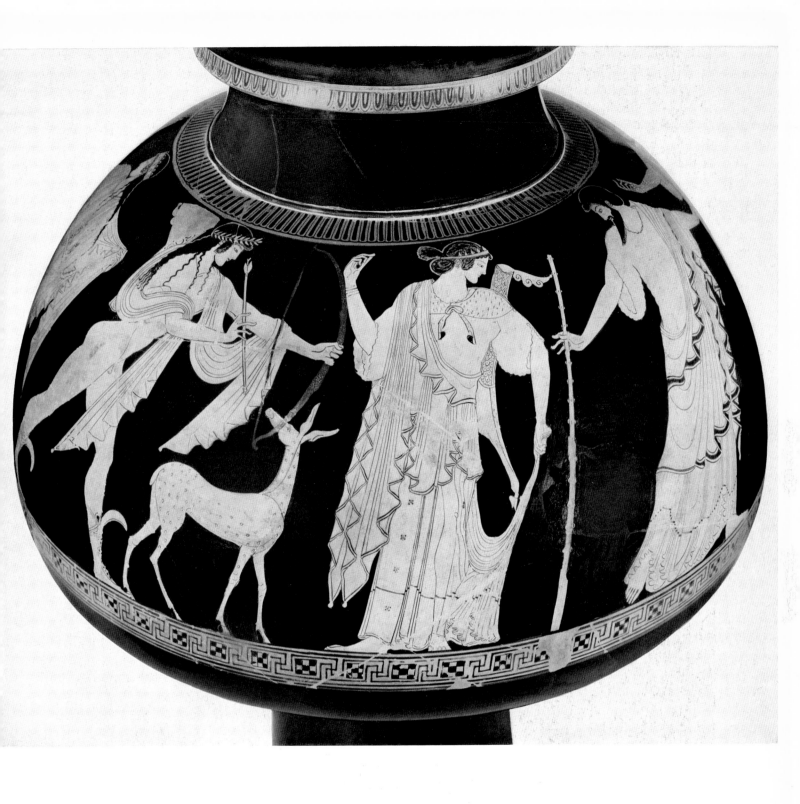

149 Pan Painter. Psykter (wine-cooler). Apollo and Artemis. Over-all height 34.5 cm. Ca. 490 B.C.
Munich, Staatliche Antikensammlungen 2417

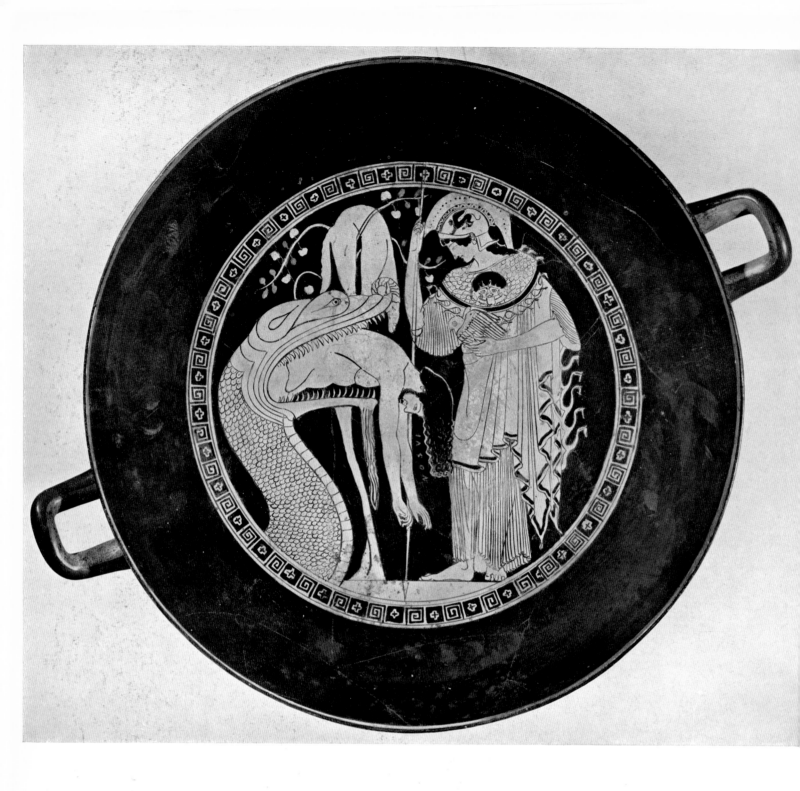

150 Douris. Interior of cup. Jason being disgorged by the dragon guarding the Golden Fleece, and Athena.
Diam. 30 cm. Ca. 480/470 B.C. Vatican Museum

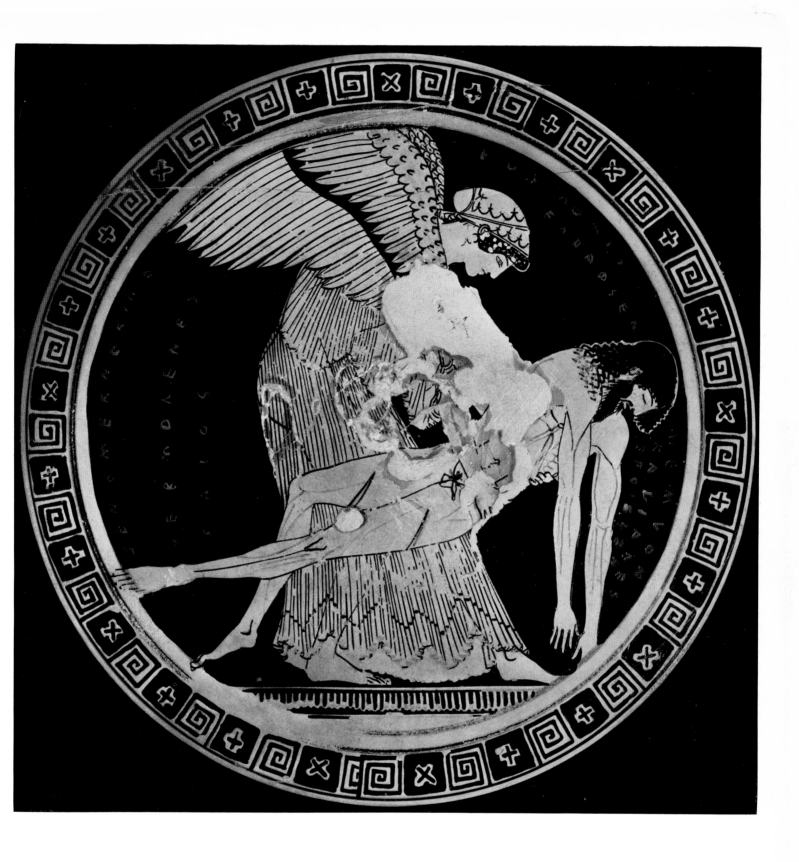

151 Douris. Interior of cup. Eos and Memnon. Diam. 26 cm. Ca. 490 B.C. Paris, Louvre G 115

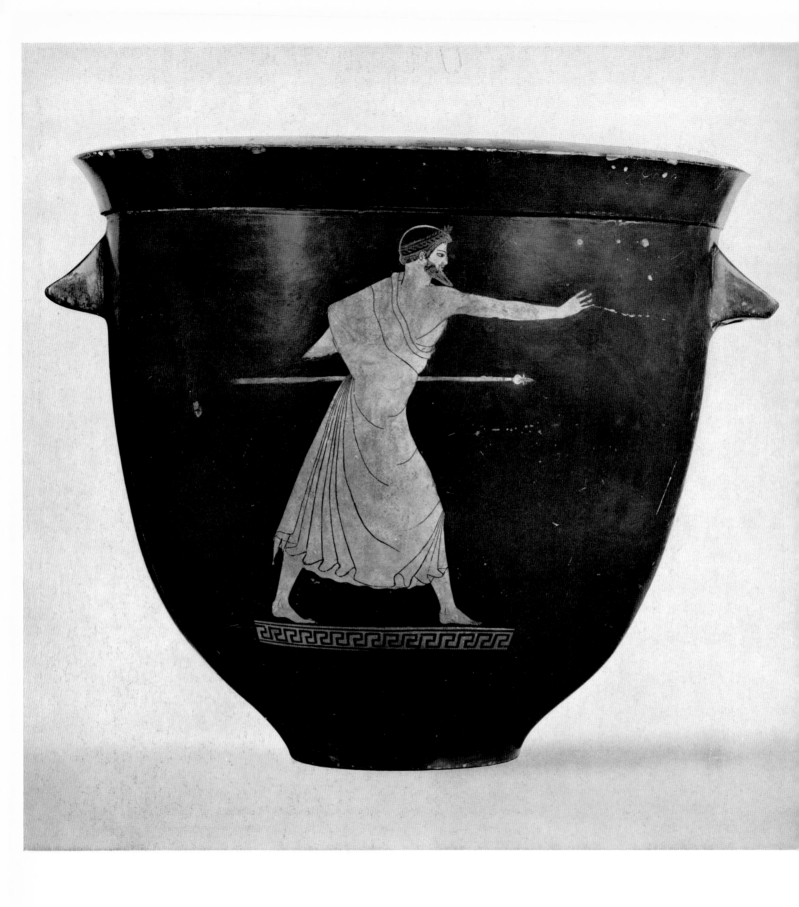

152 Berlin Painter. Bell-krater. Obverse. Zeus pursuing Ganymede.
Height 33 cm. Ca. 490/480 B.C. Paris, Louvre G 175

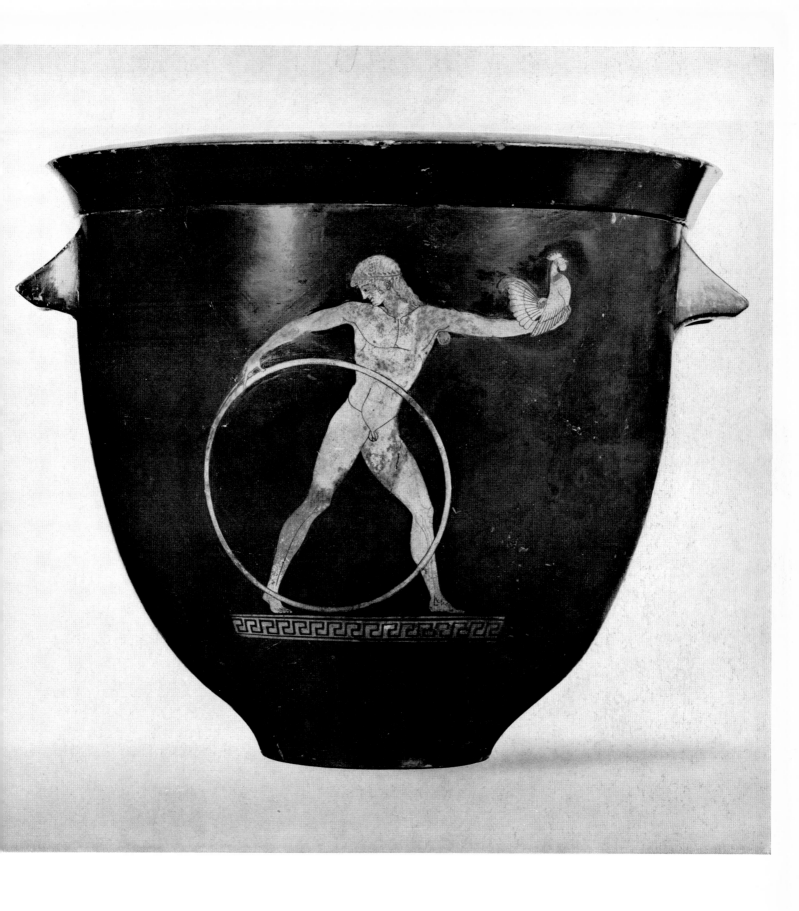

153 Berlin Painter. Bell-krater. Reverse. Ganymede. Cf. plate 152

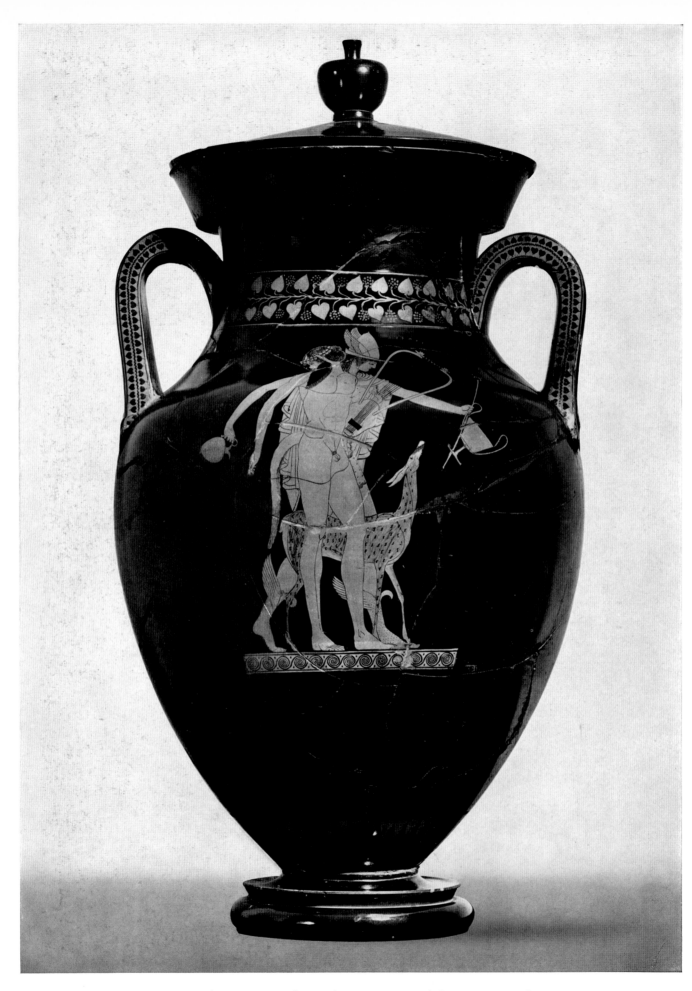

154 Berlin Painter. Amphora. Obverse. Hermes and the satyr Oreimachos.
Height 69 cm. Ca. 490 B.C. Berlin, Staatliche Museen F 2160

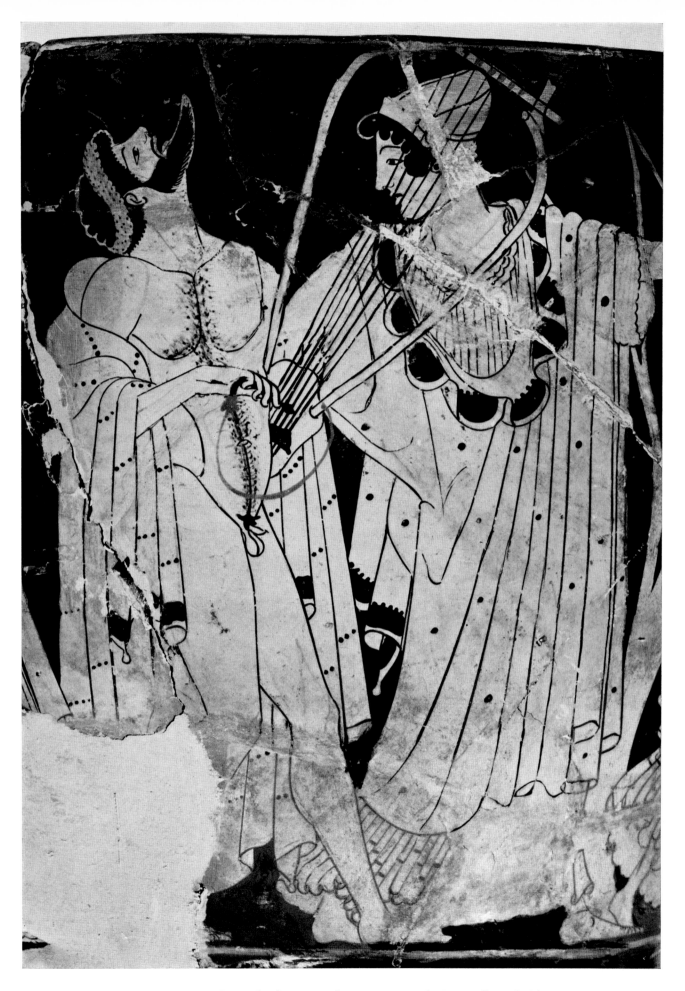

155 Brygos Painter. Skyphos. From the reverse. Lyre-playing reveller and girl.
Height 19.5 cm. Ca. 490 B.C. Paris, Louvre G 156

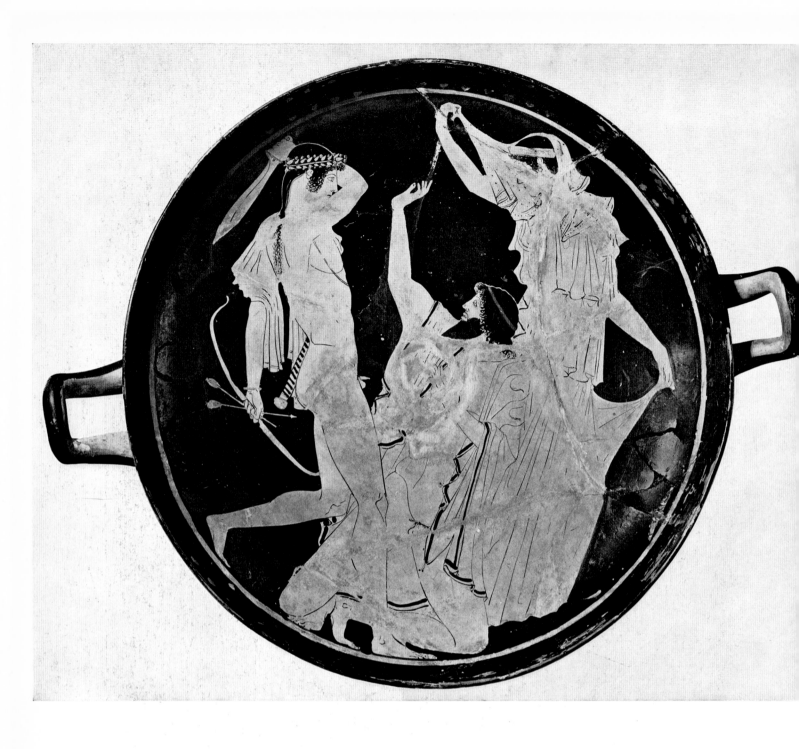

156 Penthesilea Painter. Interior of cup. Apollo killing Tityos. Diam. 40 cm.
Ca. 455 B.C. Munich, Staatliche Antikensammlungen 2689

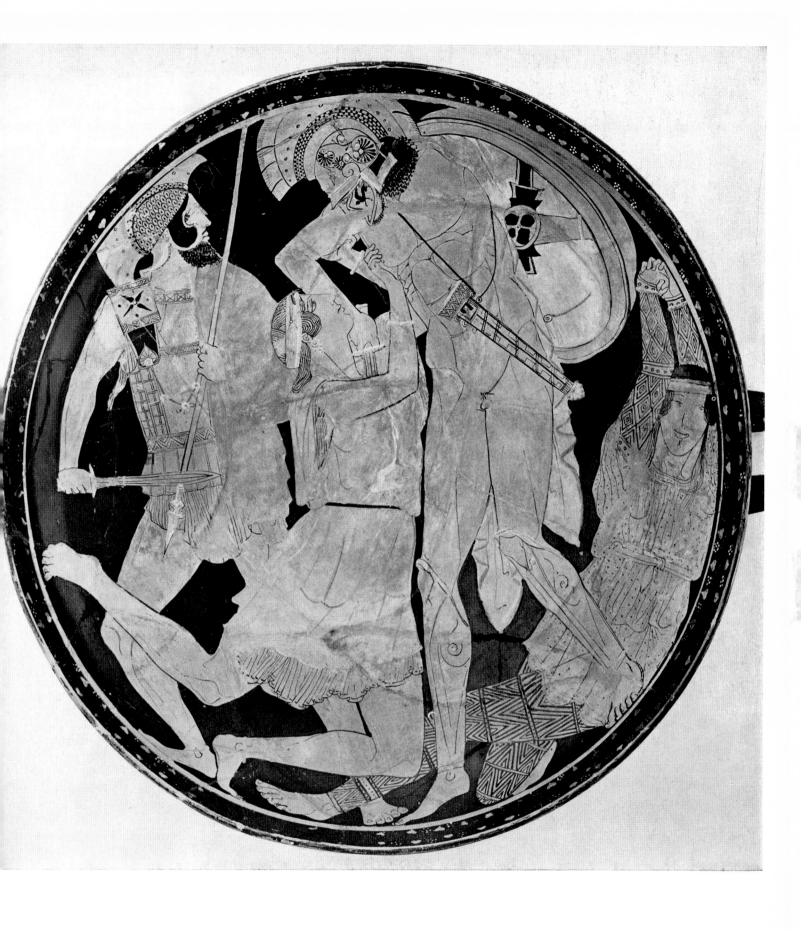

157 Penthesilea Painter. Interior of cup. Greek killing Amazon, probably Achilles and Penthesilea.
Diam. 43 cm. Ca. 455 B.C. Munich, Staatliche Antikensammlungen 2688

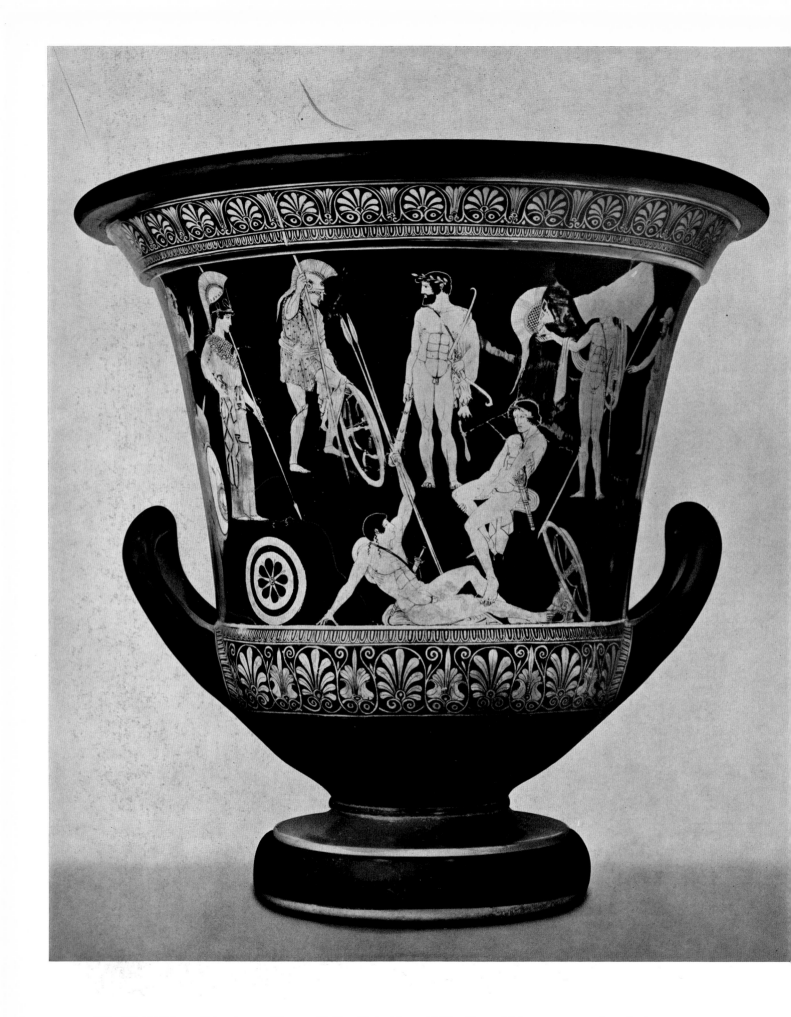

158 Niobid Painter. Calyx-krater. Obverse. Unidentified subject with Herakles and Athena present, perhaps the Argonauts at Lemnos.
Height 54 cm. Ca. 455/450 B.C. Paris, Louvre G 341

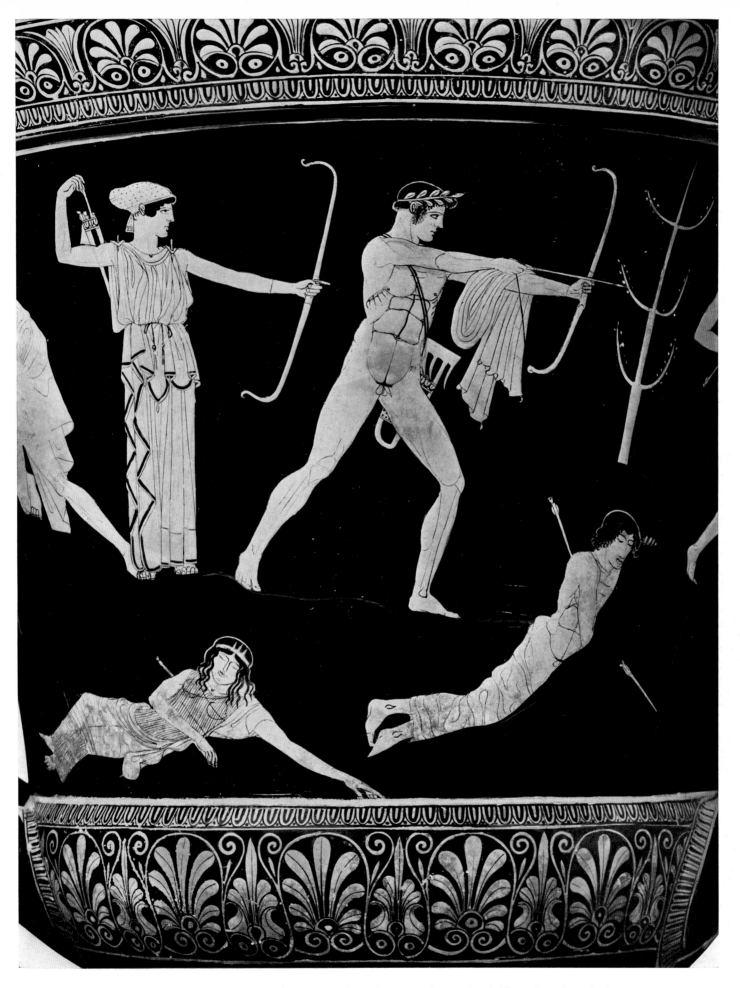

159 Niobid Painter. Calyx-krater. Reverse. Apollo and Artemis slaying the children of Niobe. Cf. plate 158

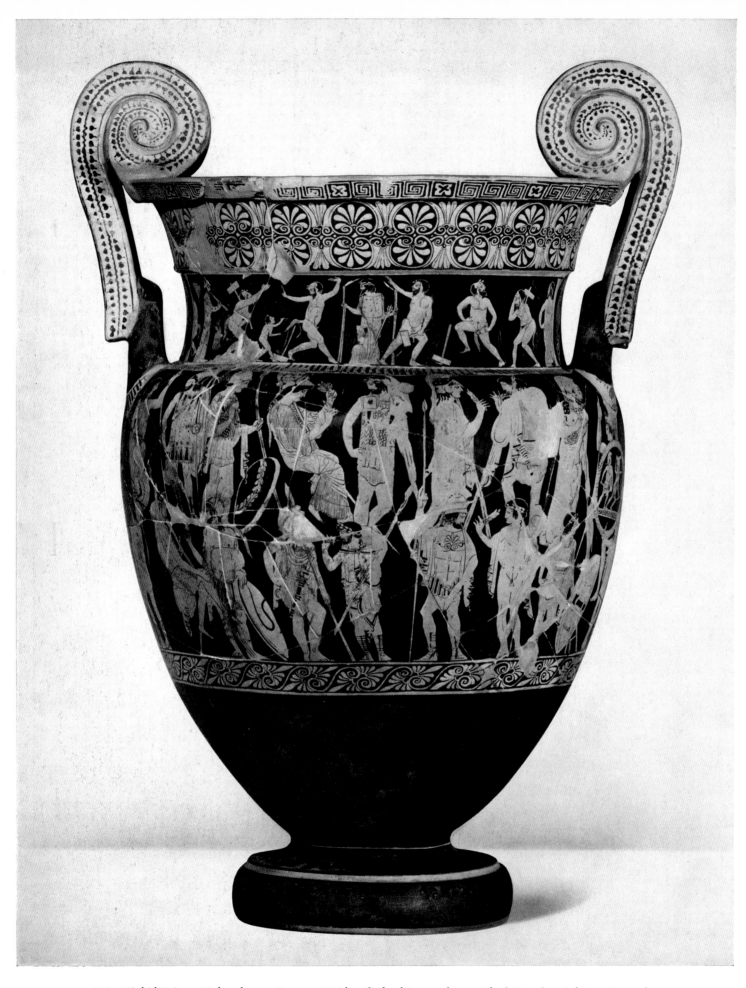

160 Niobid Painter. Volute-krater. Reverse. Unidentified subject, perhaps trial of Ajax for violating Cassandra.
On the neck, the birth of Pandora. Cf. plate 161

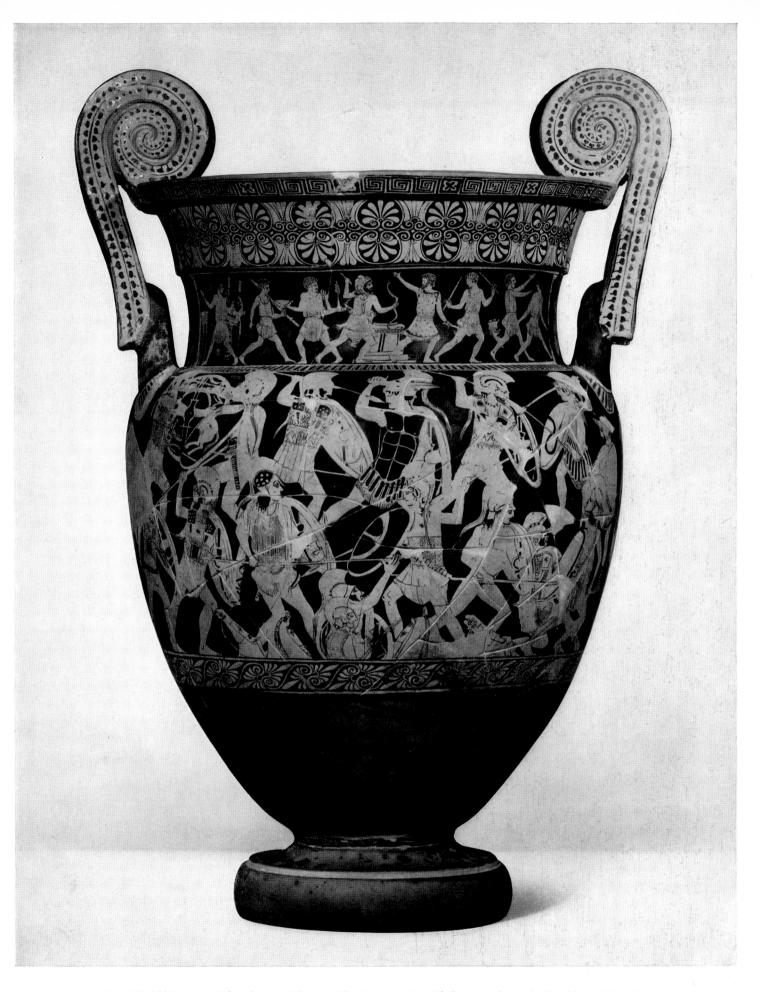

161 Niobid Painter. Volute-krater. Obverse. The Seven against Thebes. On the neck, Herakles and Busiris.
Height 62.5 cm. Ca. 440 B.C. Ferrara, Museo Etrusco 579

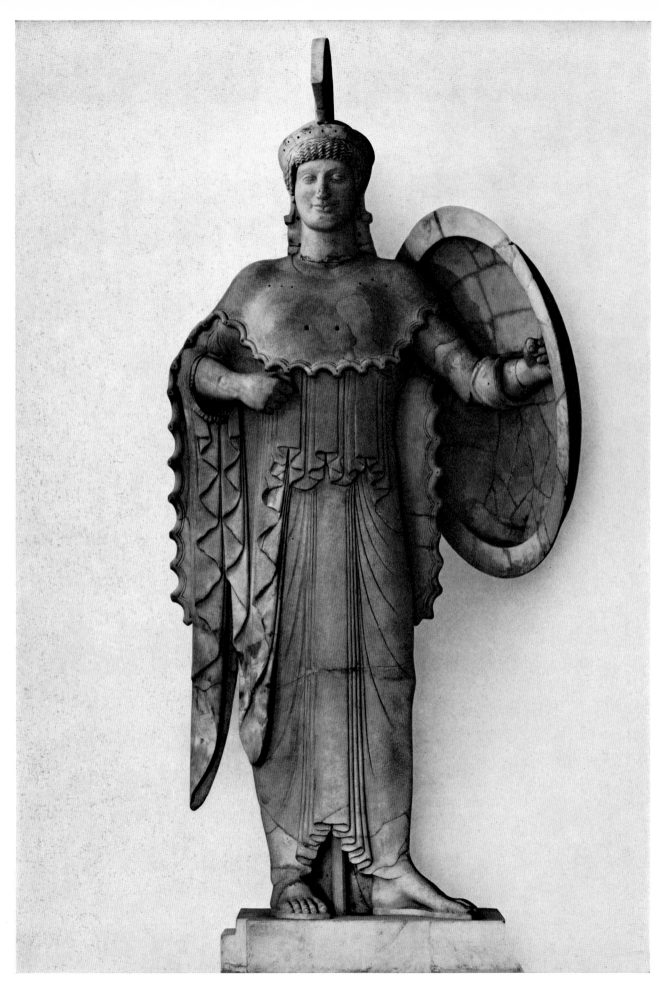

162 From the west pediment of the Temple of Aphaia on Aegina. Athena.
Parian marble. Height 1.68 m. End of 6th century B.C. Munich, Glyptothek 74

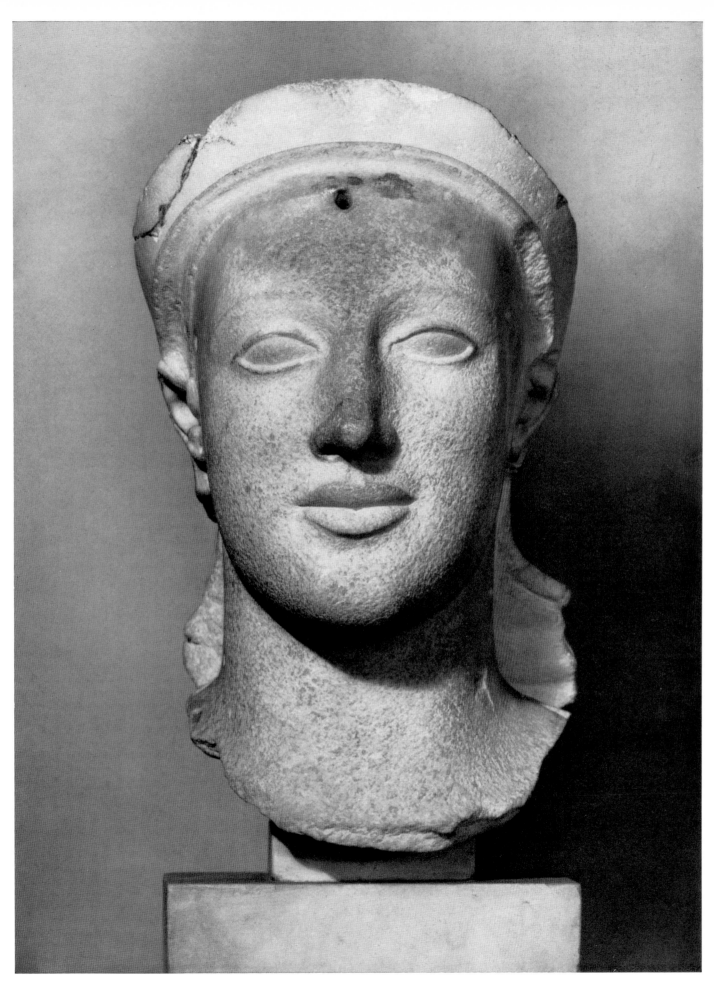

163 From the east pediment of the Temple of Aphaia on Aegina. Head of Athena.
Parian marble. Height 31 cm. Ca. 490/480 B.C. Munich, Glyptothek 89

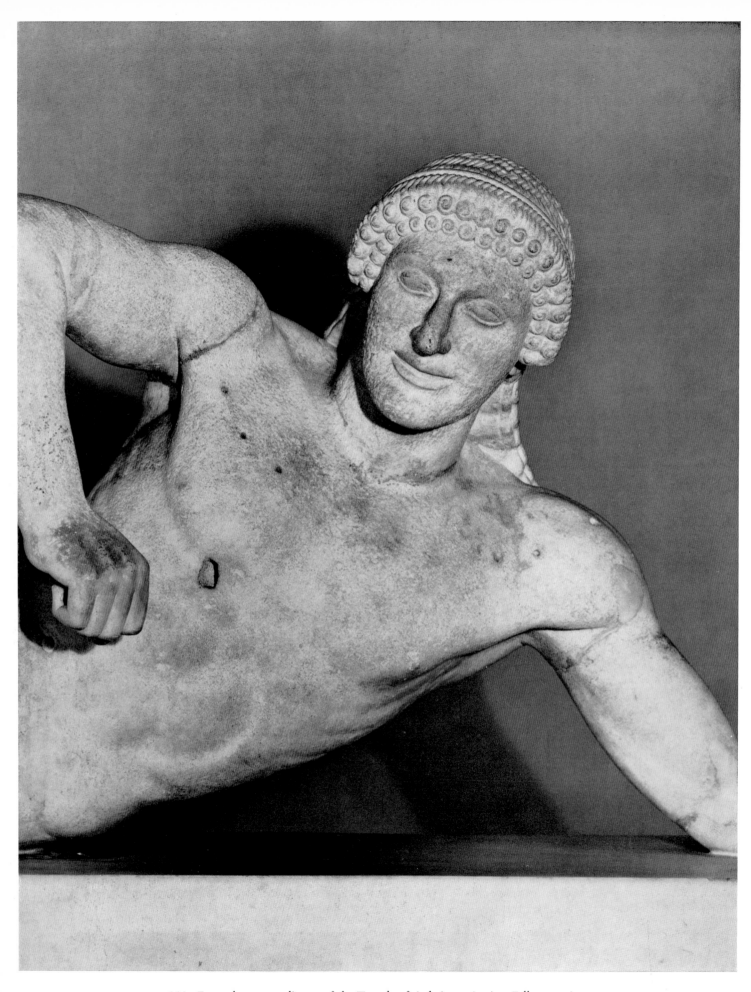

164 From the west pediment of the Temple of Aphaia on Aegina. Fallen warrior.
Parian marble. Length 1.59 m. End of 6th century B.C. Munich, Glyptothek 79

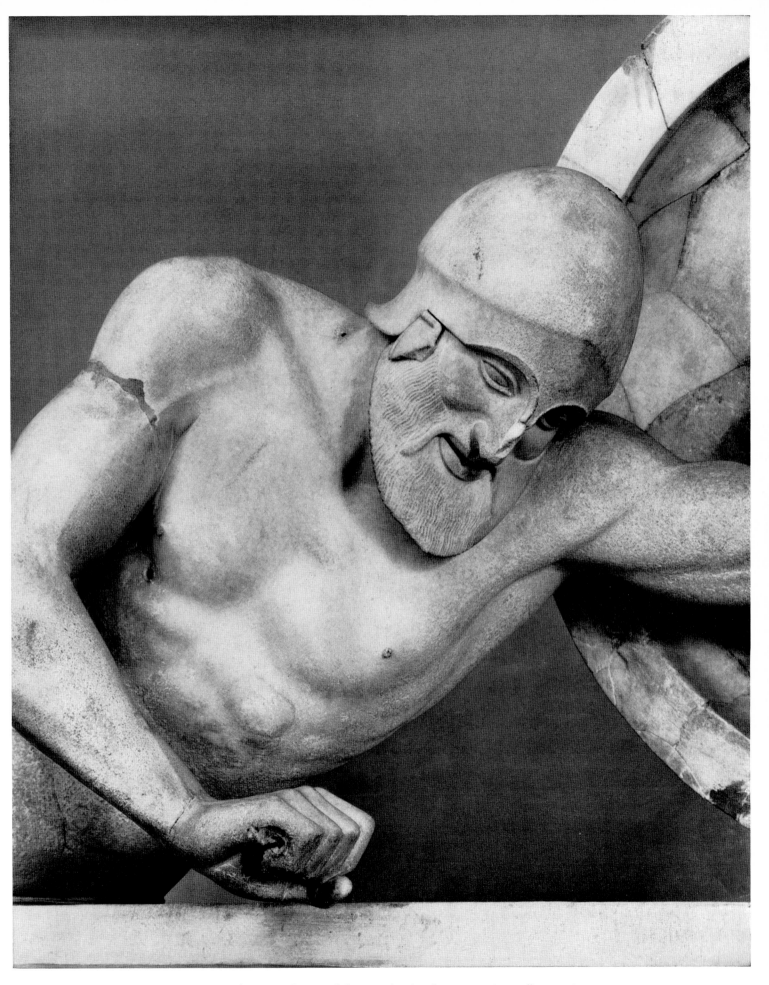

165 From the east pediment of the Temple of Aphaia on Aegina. Fallen warrior.
Parian marble. Length 1.85 m. Ca. 490/480 B.C. Munich, Glyptothek 85

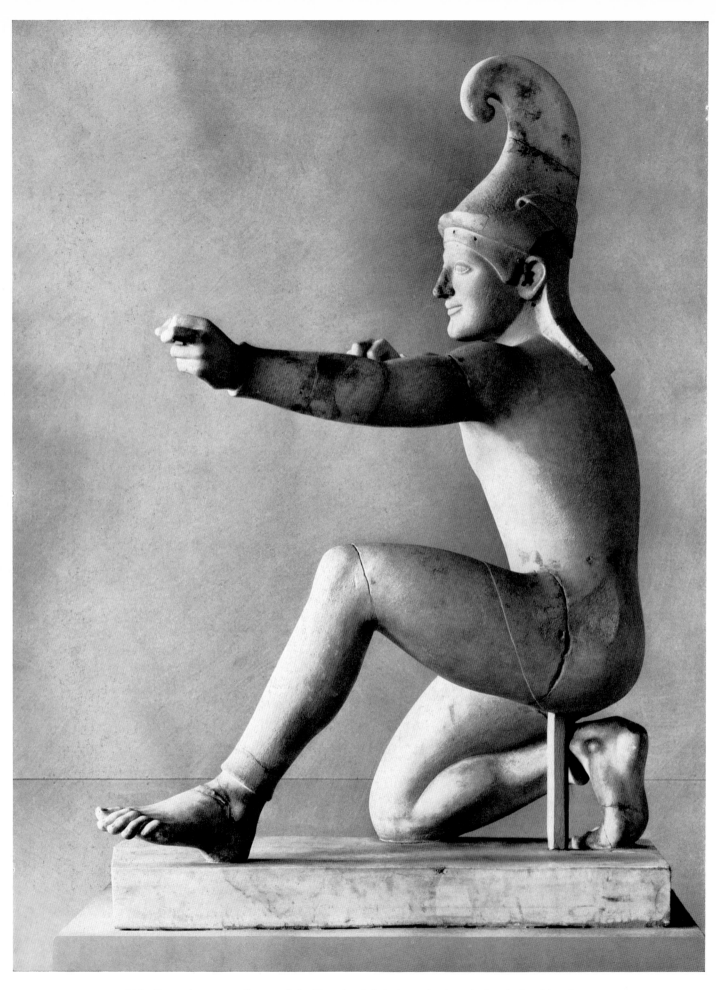

166 From the west pediment of the Temple of Aphaia on Aegina. Archer in Scythian dress.
Parian marble. Height 1.04 m. End of 6th century B.C. Munich, Glyptothek 81

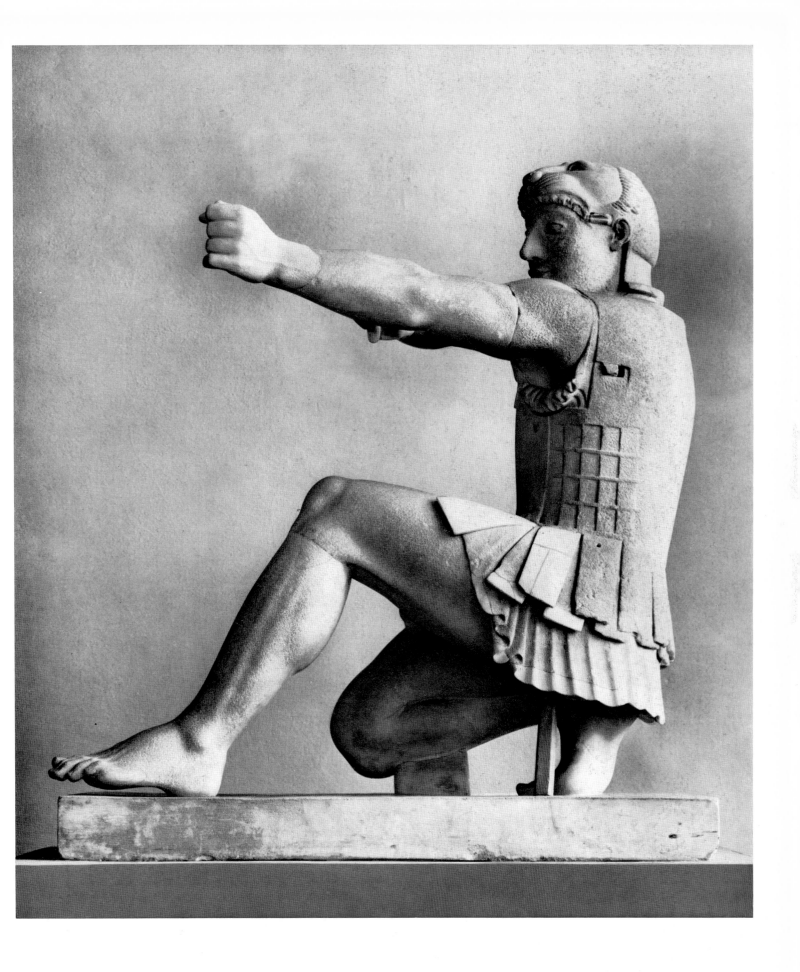

167 From the east pediment of the Temple of Aphaia on Aegina. Herakles as an archer.
Parian marble. Height 79 cm. Ca. 490/480 B.C. Munich, Glyptothek 84

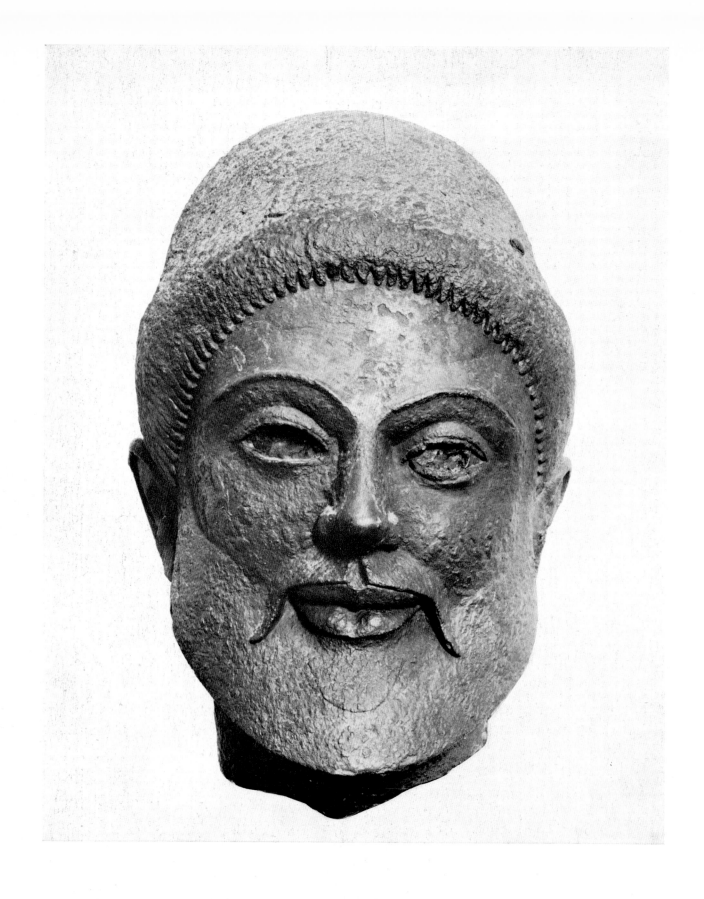

168 Bearded head. Bronze. Height about 25 cm. Ca. 480 B.C. Athens, National Museum 6446

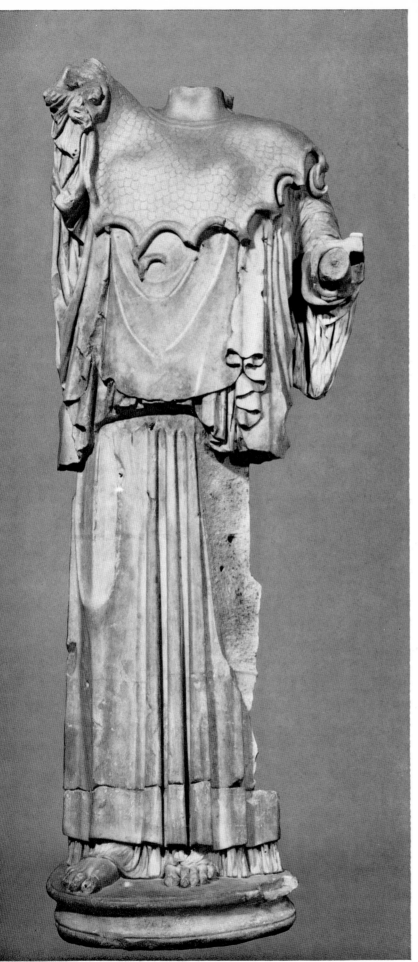
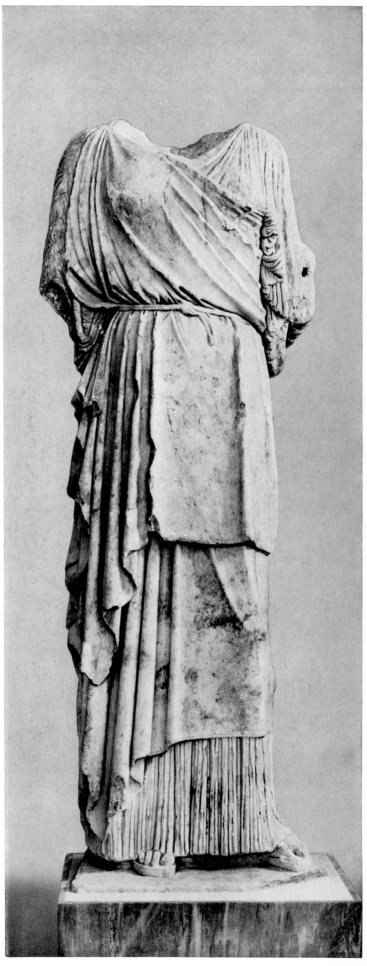

169 Right: Kore, or possibly Demeter, from Corinth. Probably by Kalon of Aegina. Marble. Height (excluding the head) 2.02 m.
Ca. 460 B.C. Corinth Museum. Left: Athena with chiton, peplos and aegis.
Second-century A.D. copy after a work from the Aeginetan school of ca. 470/460 B.C. Marble. Height 1.86 m. Madrid, Prado

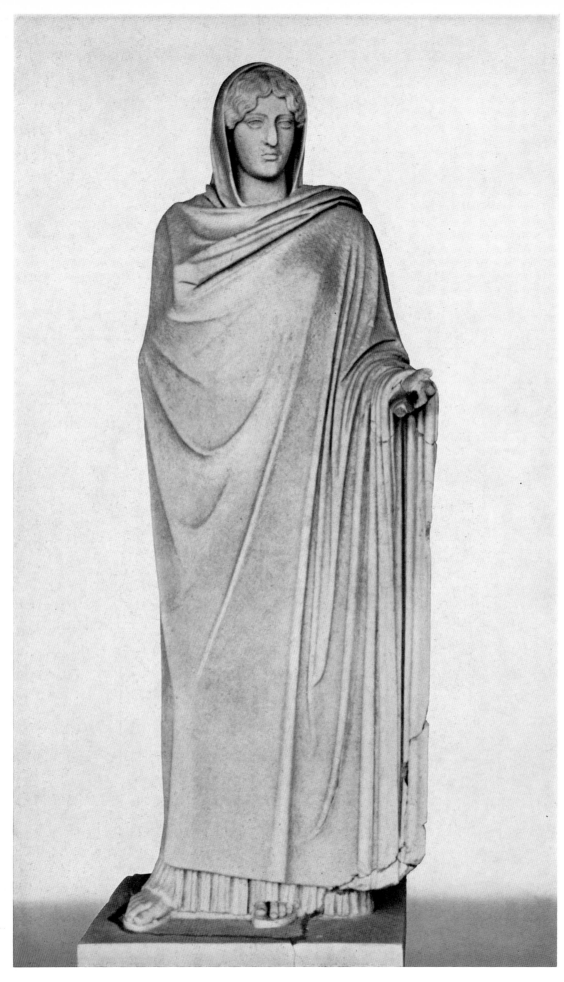

170 The so-called Aspasia. After a statue by Kalon of Aegina of ca. 460 B.C. Replica from Baiae.
Marble. Height 1.97 m.

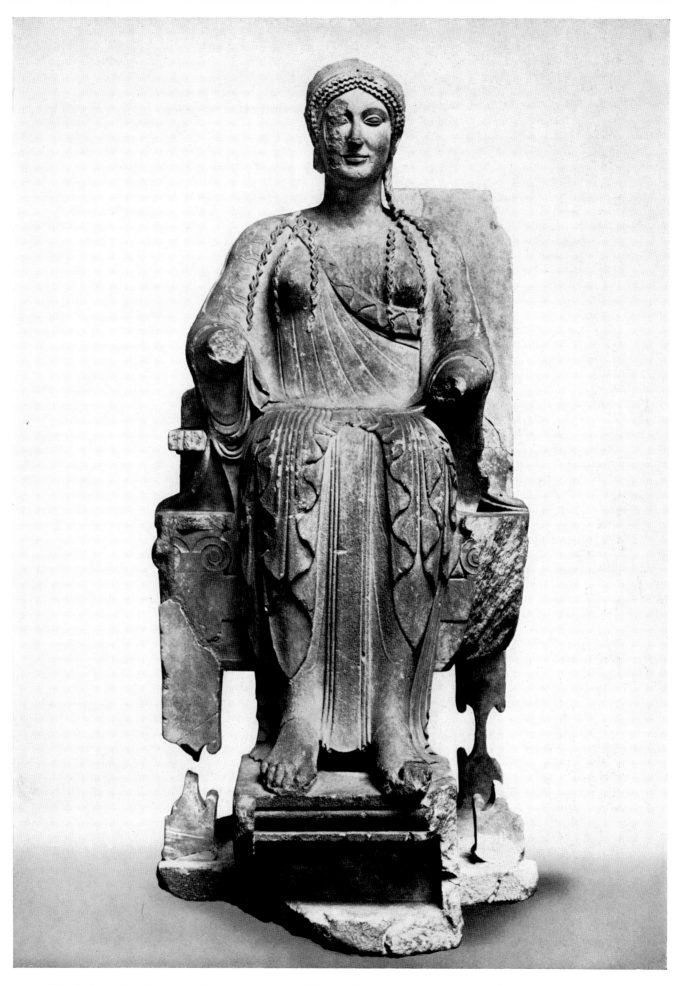

171 Enthroned goddess, from Taranto. Parian marble. Height 1.51 m. Ca. 470 B.C. Berlin, Staatliche Museen A 17

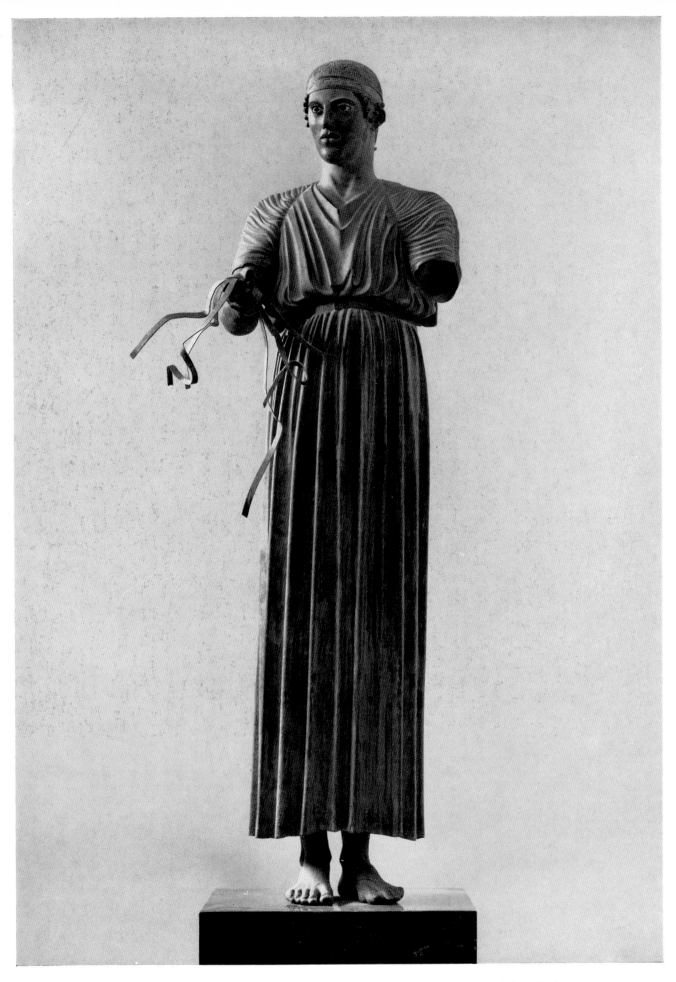

172 Charioteer, votive offering of Polyzalos of Gela from the Apollo sanctuary at Delphi. Cf. plate XXVII.
Bronze. Height 1.80 m. Ca. 470 B.C. Delphi Museum

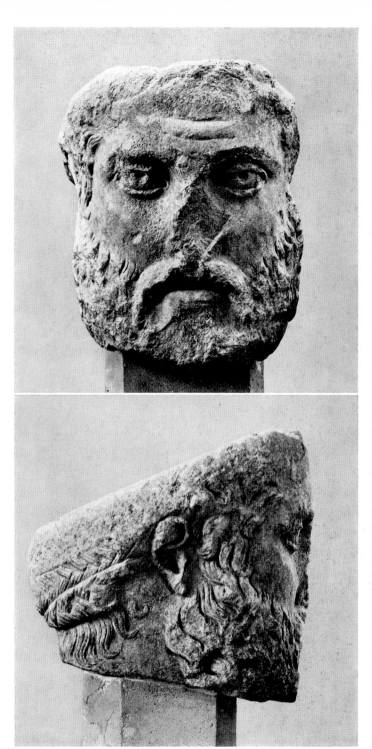

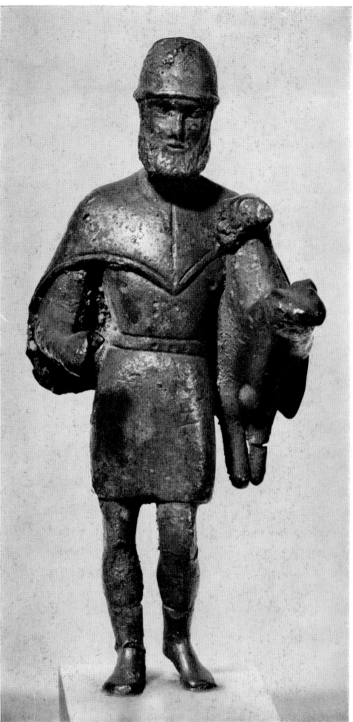

173 Right: Hermes Kriophoros. Bronze statuette copying the votive offering dedicated at Olympia by the Pheneates and made by Onatas of Aegina and Kalliteles. Height 8.6 cm. Second quarter of 5th century B.C. Paris, Cabinet des Médailles 313.
Left: Roman marble copy of the head. Athens, Acropolis Museum 2344

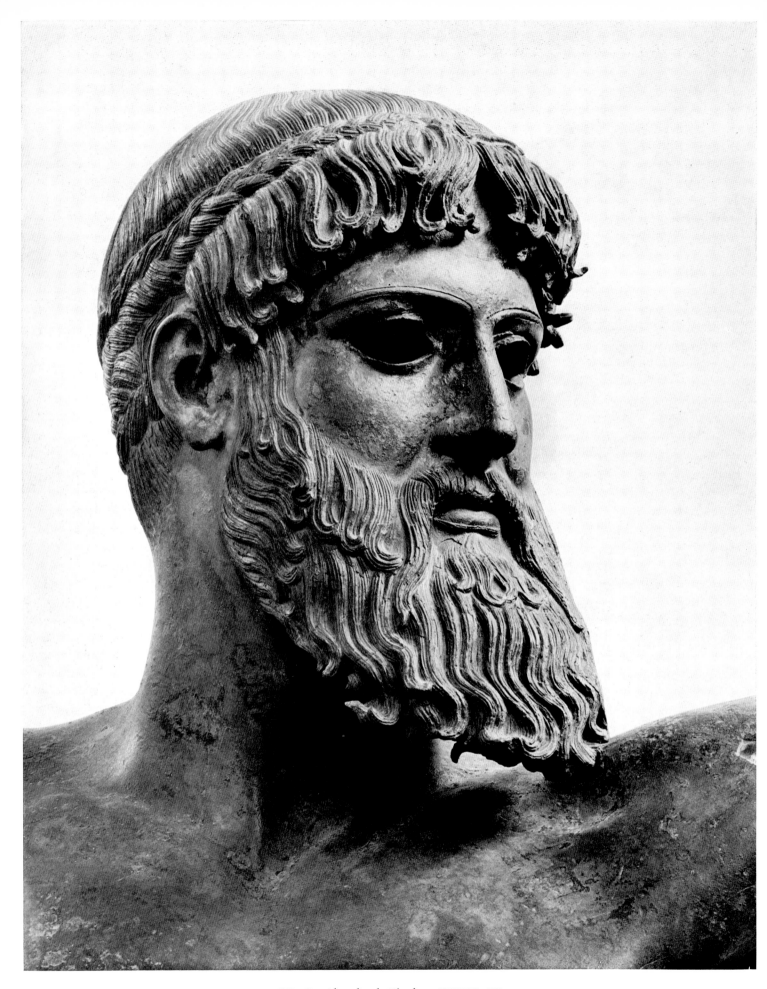

174 Poseidon, head. Cf. plates XXVIII, 175

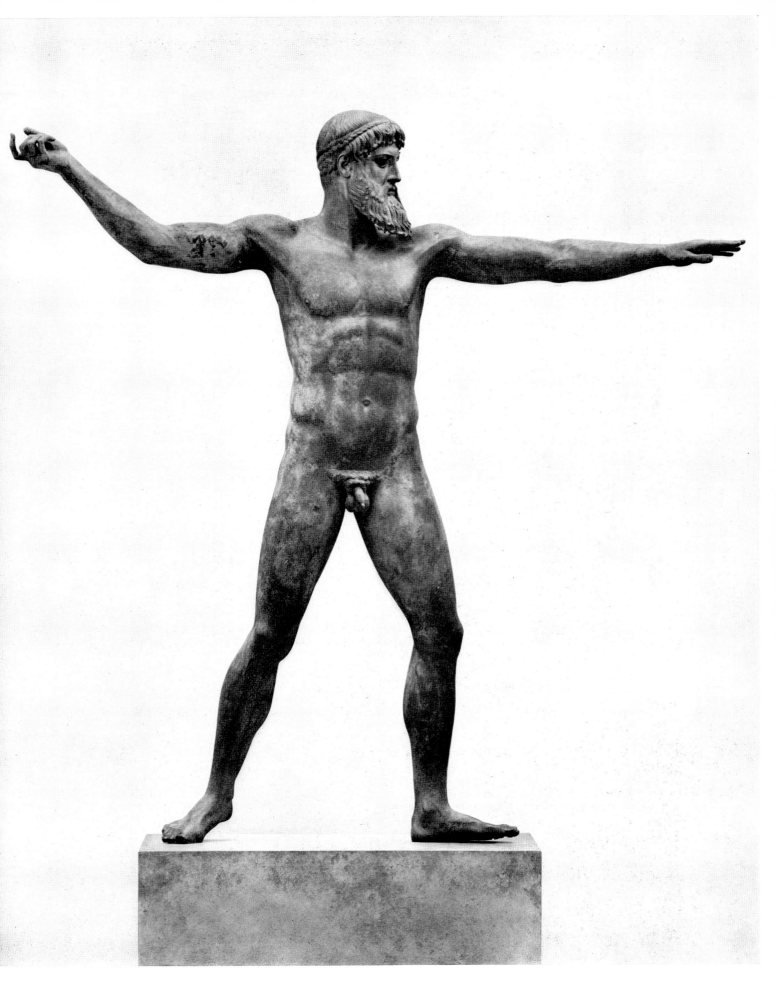

175 Poseidon, found in the sea off Cape Artemision. Most probably the work of Onatas of Aegina.
Bronze. Height 2.09 m. Shortly before 450 B.C. Athens, National Museum 15161

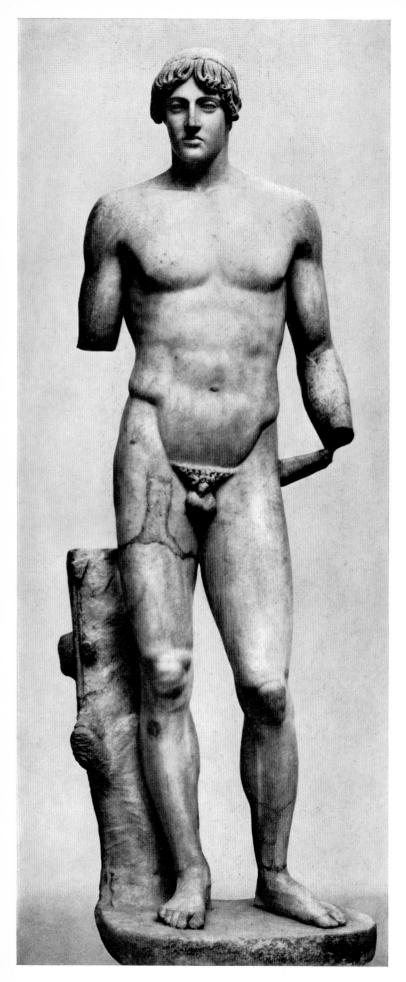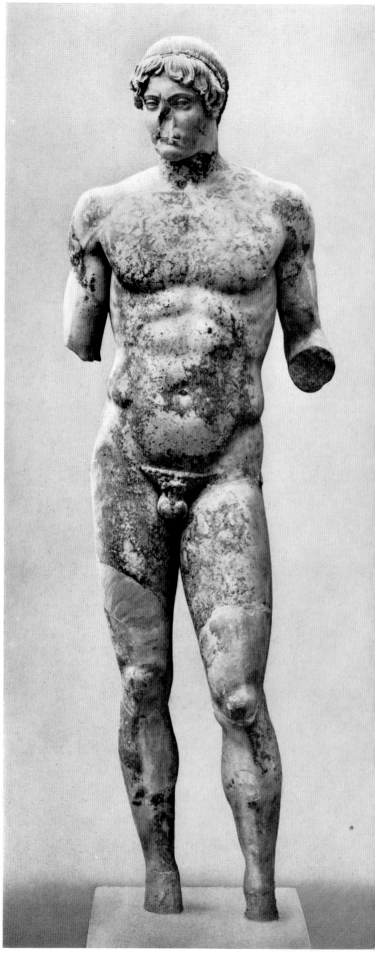

176 Left: The so-called Apollo Choiseul Gouffier. Marble copy of a bronze original, probably by Onatas of Aegina.
Ca. 460 B.C. Height 1.78 m. London, British Museum 209. Right: The so-called Omphalos Apollo.
Second-century A.D. marble copy of the same bronze original. Height 1.76 m. Athens, National Museum 45

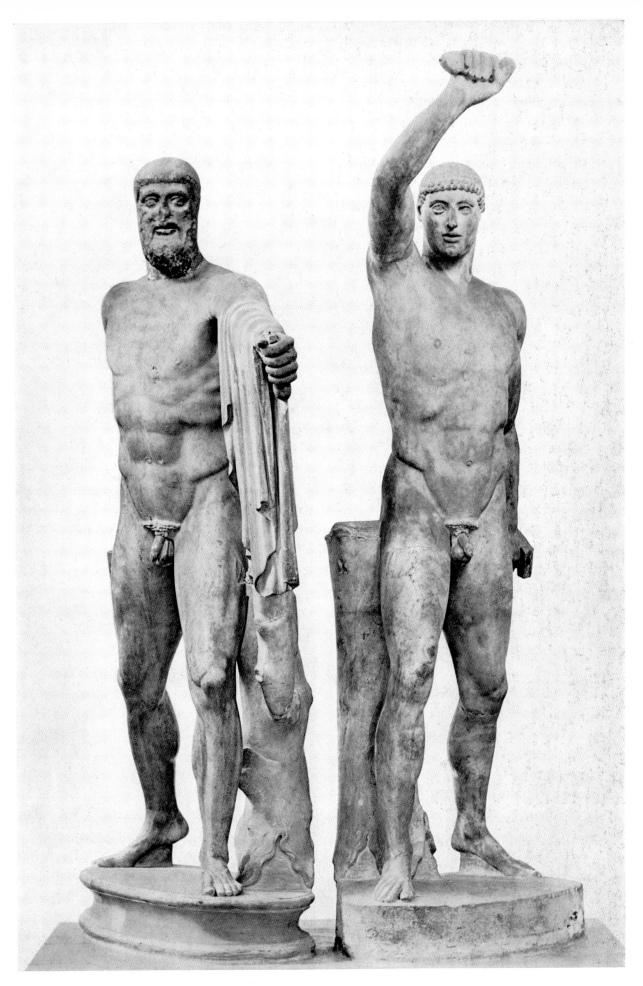

177 The Tyrannicides. Marble copy of a bronze group by Kritios and Nesiotes of 477–6 B.C.
Height 1.95 m. Naples, Museo Nazionale Archeologico G 103/104

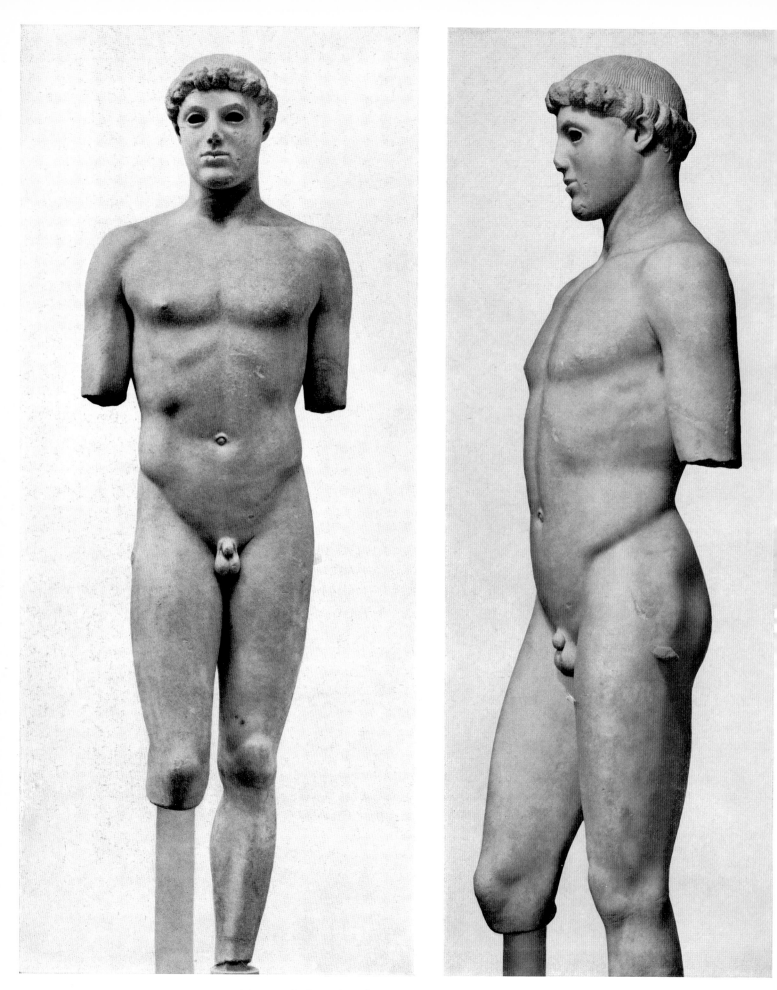

178 Youth, from the Athenian Acropolis (the 'Kritian boy').
Parian marble. Height 86 cm. Ca. 480 B.C. Athens, Acropolis Museum 698

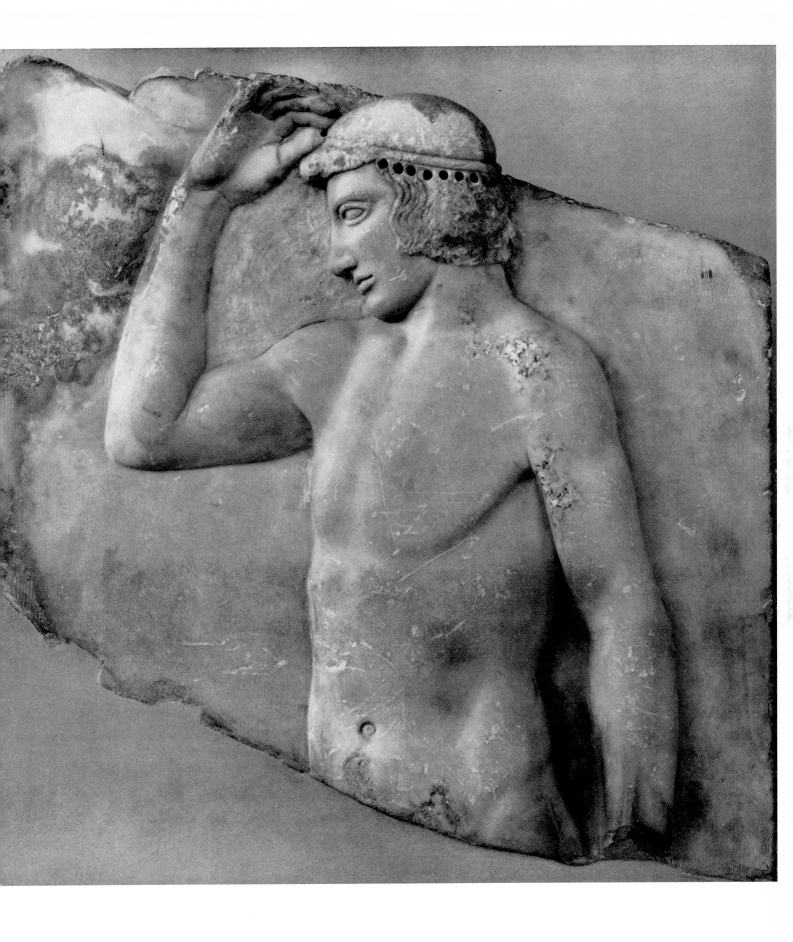

179 Votive stele of a victorious youth, from the Athena sanctuary at Sounion.
Parian marble. Height 61 cm. Shortly after 480 B.C. Athens, National Museum 3344

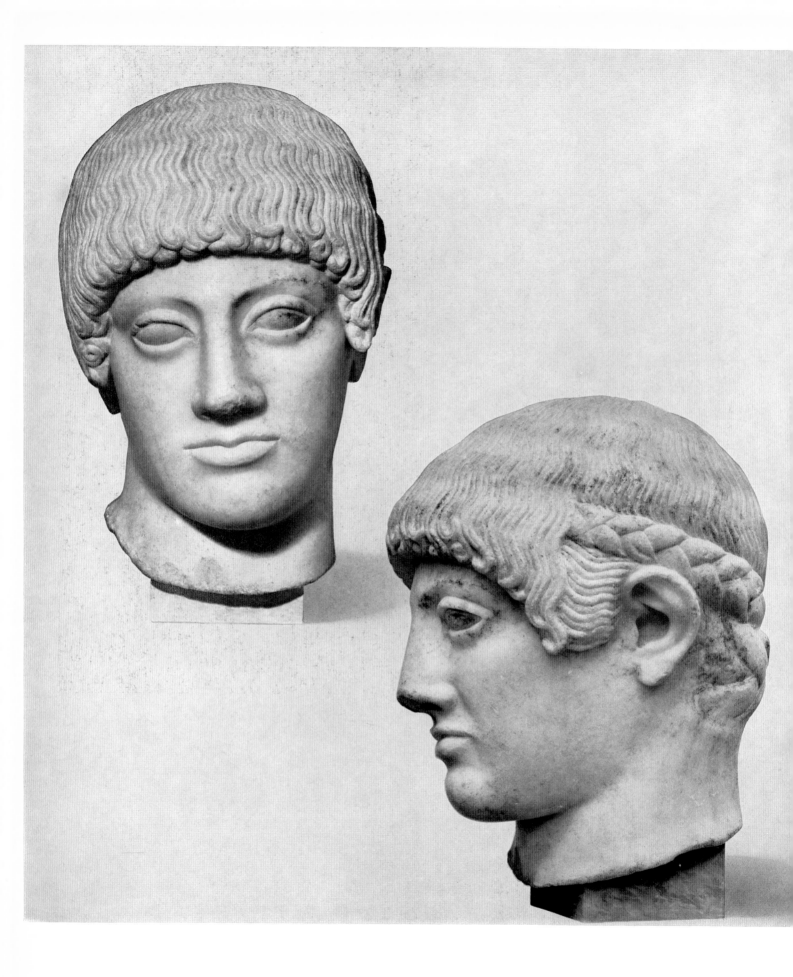

180 The so-called Blond Boy. Marble. Height 25 cm. Ca. 490/480 B.C. Athens, Acropolis Museum 689

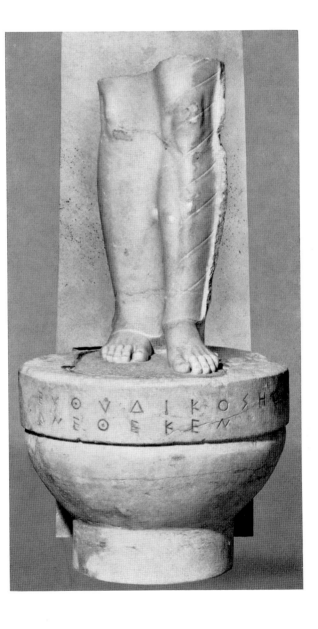

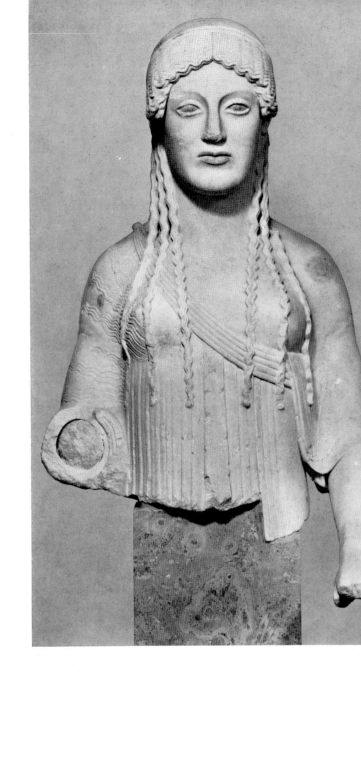

181 Kore, votive offering by Euthydikos. Marble. Height: upper body with hand 58 cm., lower surviving part 41.5 cm.
Ca. 480 B.C. Athens, Acropolis Museum 686

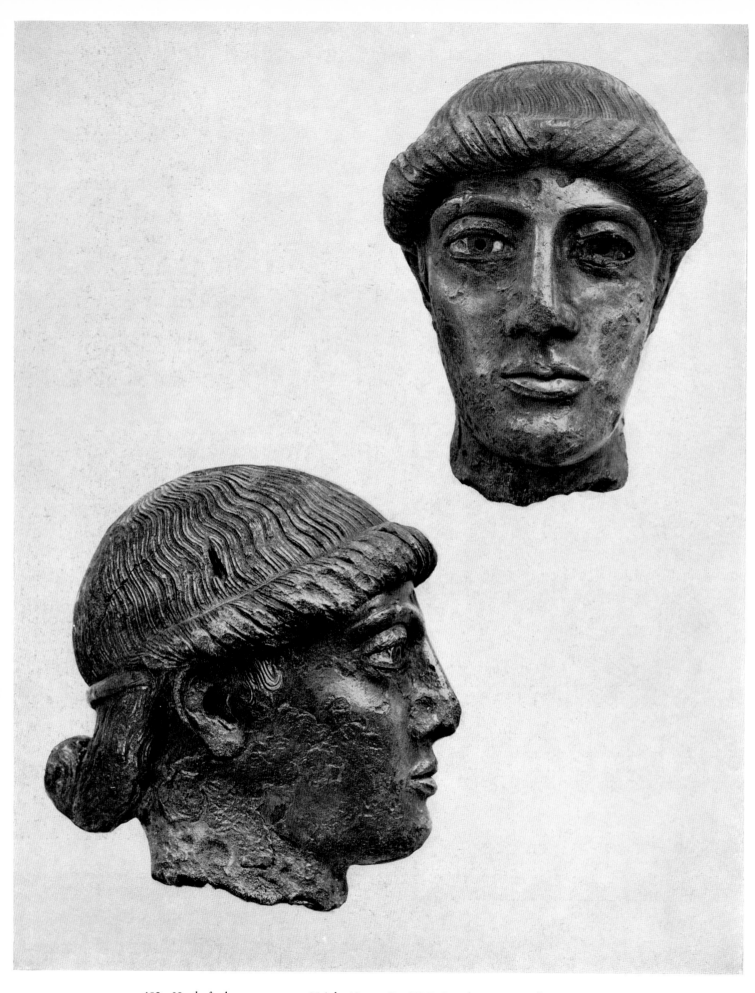

182 Head of a bronze statuette. Height 12 cm. Ca. 470 B.C. Athens, National Museum 6590

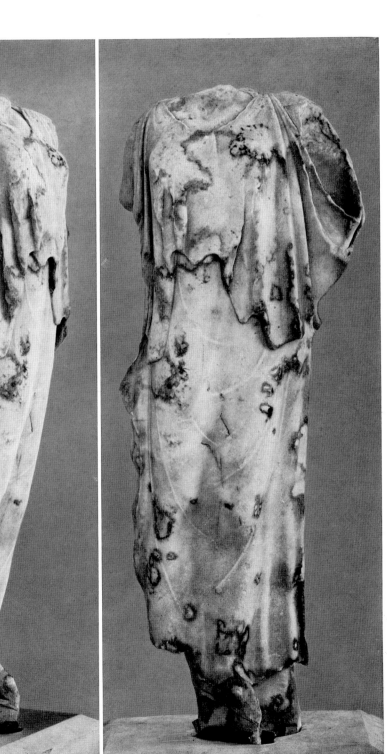
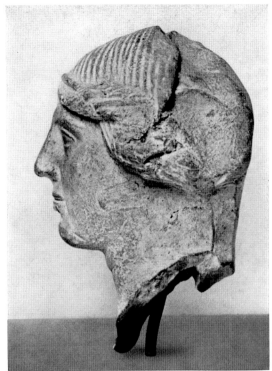
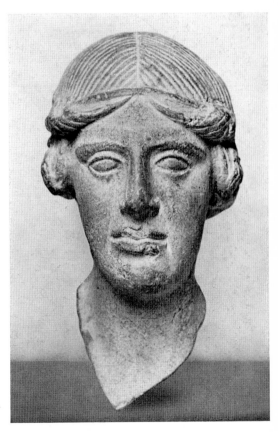

183 Left: Nike, from Paros. Marble. Height 1.38 m. Ca. 470/460 B.C. Paros, Museum.
Right: Female terracotta head. Second quarter of 5th century B.C. Oxford, Ashmolean Museum

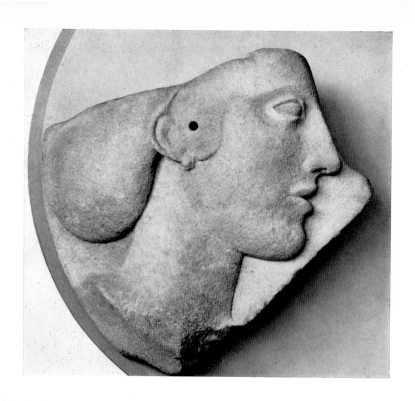

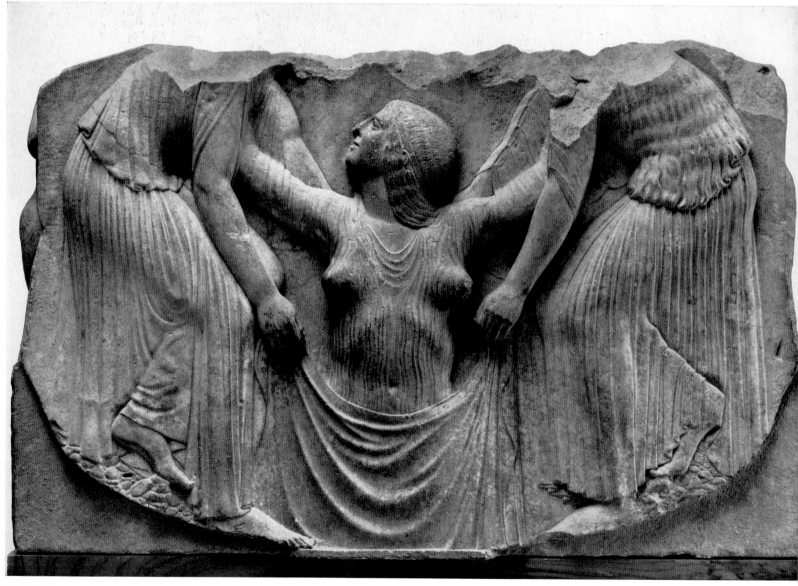

184 Above: Votive relief tondo, from Melos. Parian marble. Height 32.5 cm. Ca. 460 B.C. Athens, National Museum 3990.
Below: 'Ludovisi throne'. Centre panel. Birth of Aphrodite from the sea.
Parian marble. Height 87 cm. Ca. 460 B.C. Rome, Museo delle Terme 152

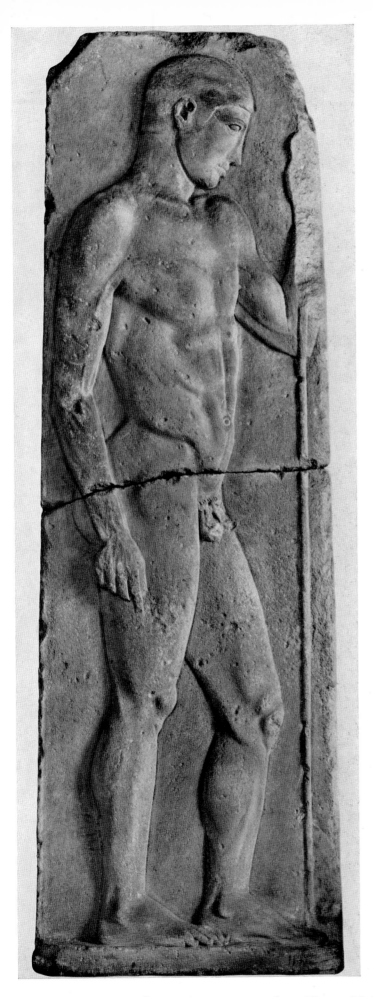
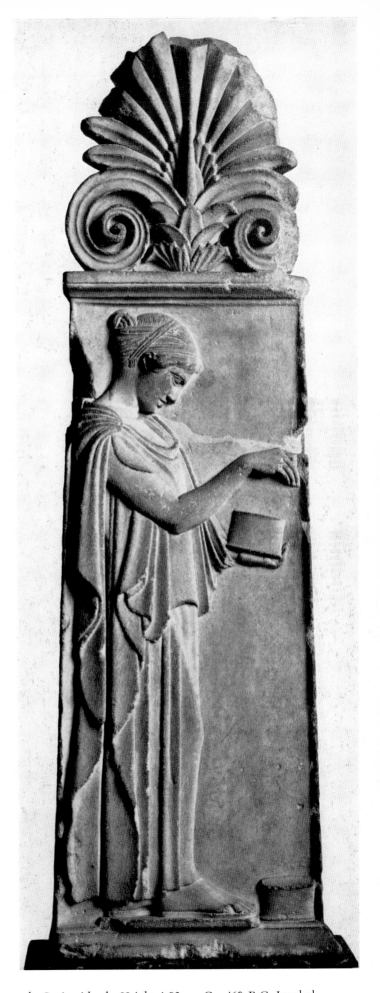

185 Left: Tombstone of a young man, from Nisyros. Marble from the Ionian islands. Height 1.83 m. Ca. 460 B.C. Istanbul, Archaeological Museum 1142. Right: Tombstone of a girl, the 'Giustiniani stele'. Parian marble. Height 1.43 m. Ca. 450 B.C. Berlin, Staatliche Museen K 19

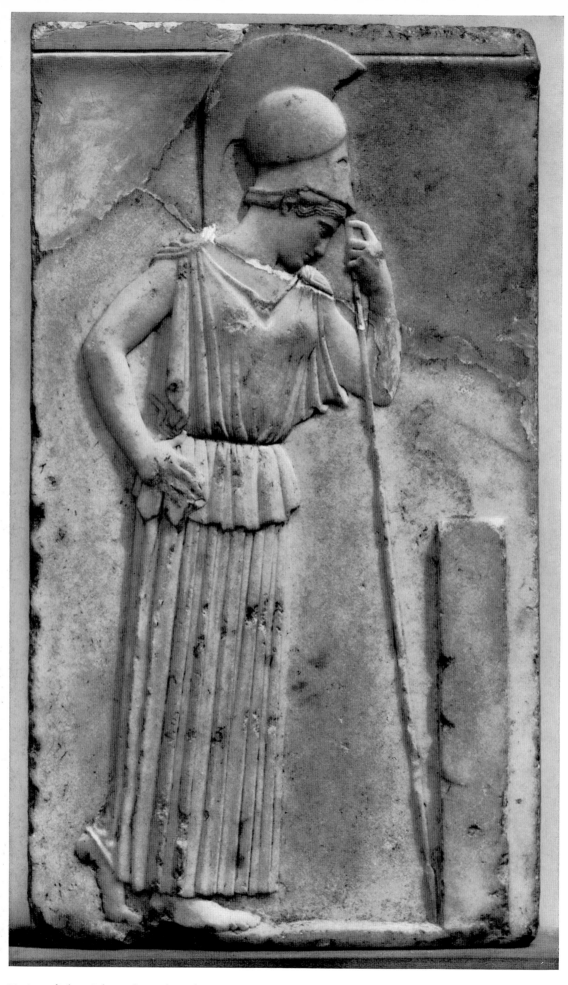

186 Votive relief to Athena, from the Athenian Acropolis. Marble. Height 54 cm. Second quarter of 5th century B.C.
Athens, Acropolis Museum 645

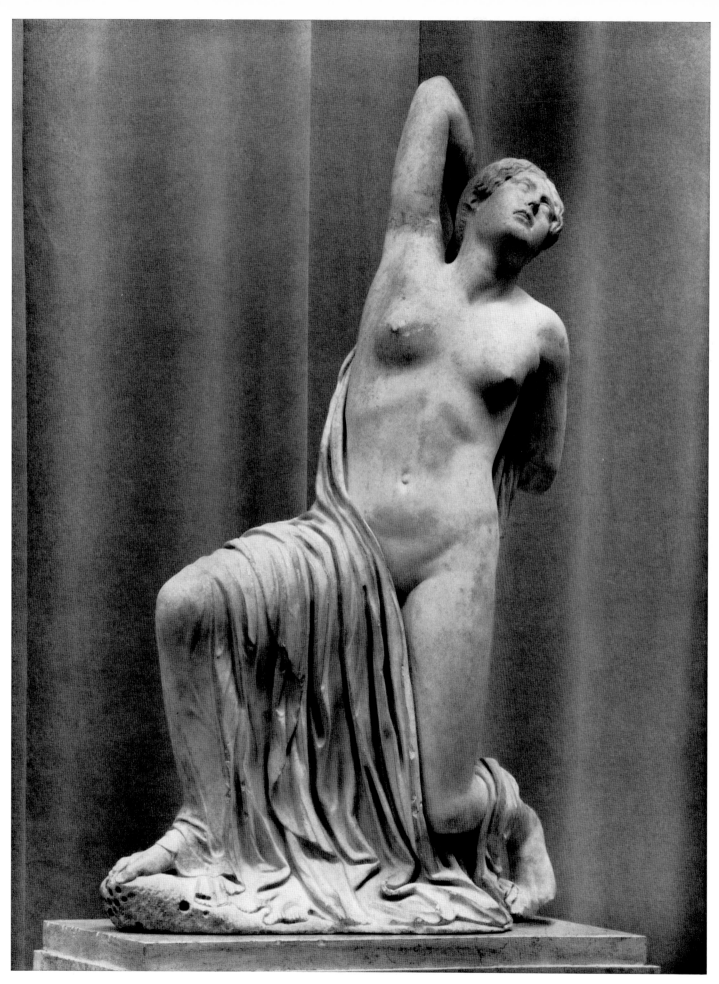

187 Dying Niobe. Original marble sculpture. Peloponesian/Ionian influence.
Height 1.49 m. Ca. 450/445 B.C. Rome, Museo delle Terme

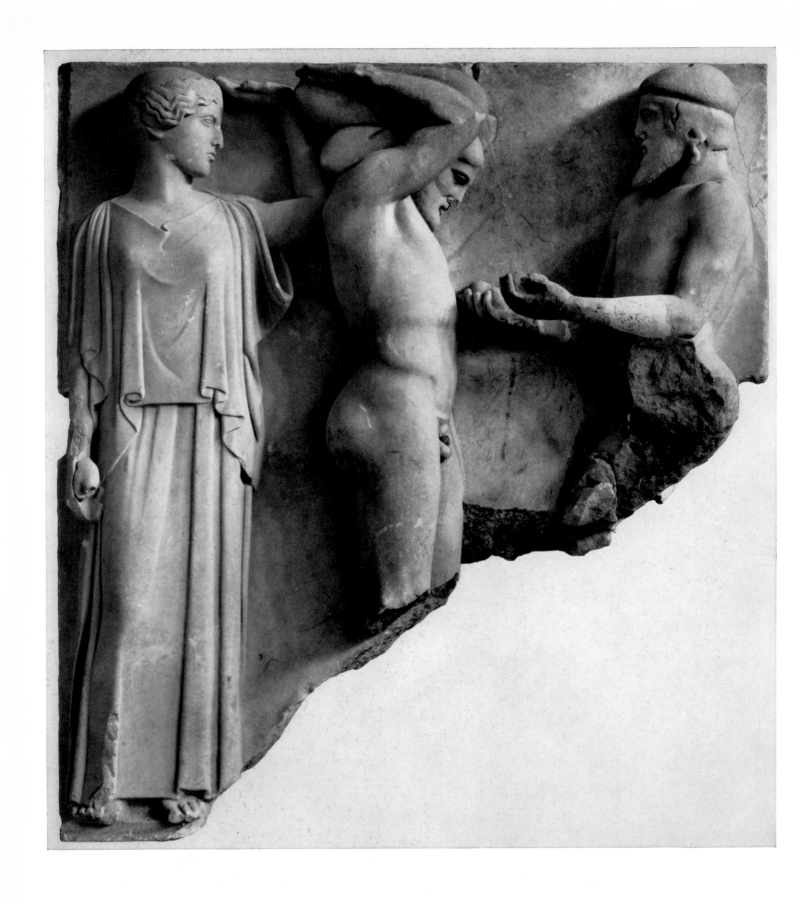

188 Metope from the east end of Temple of Zeus at Olympia. Atlas brings Herakles the Apples of the Hesperides in the presence
of Athena. Parian marble. Height 1.60 m. Ca. 460 B.C. Olympia Museum

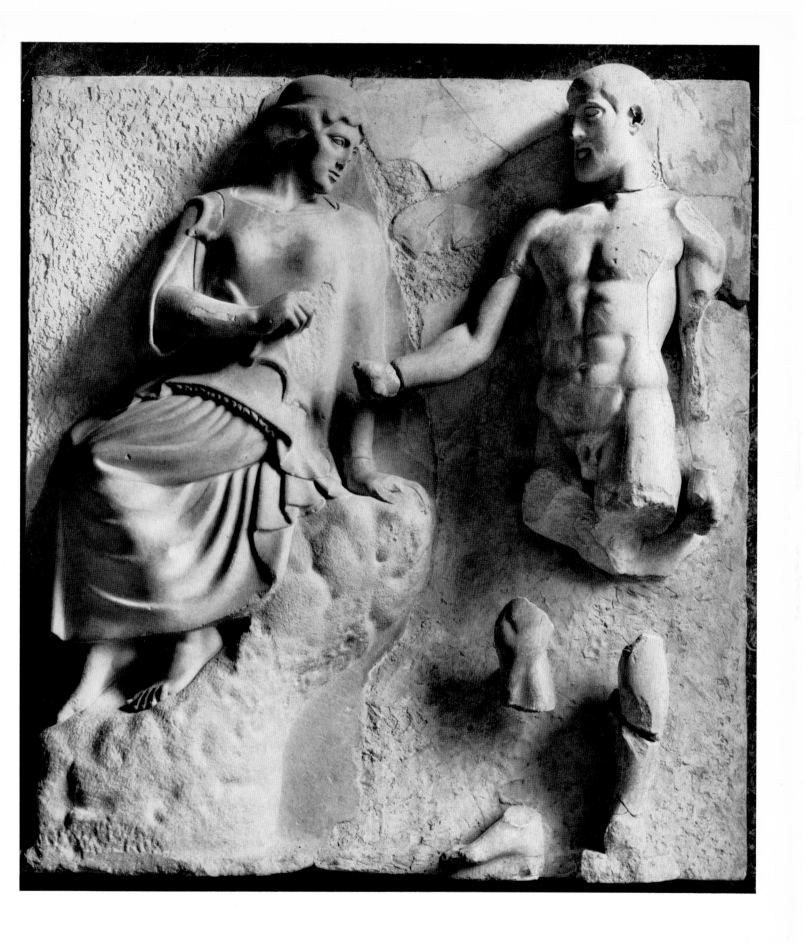

189 Metope from the west side of the Temple of Zeus at Olympia. Herakles brings Athena the Stymphalian Birds. Parian marble.
Height 1.60 m. Ca. 460 B.C. Paris, Louvre

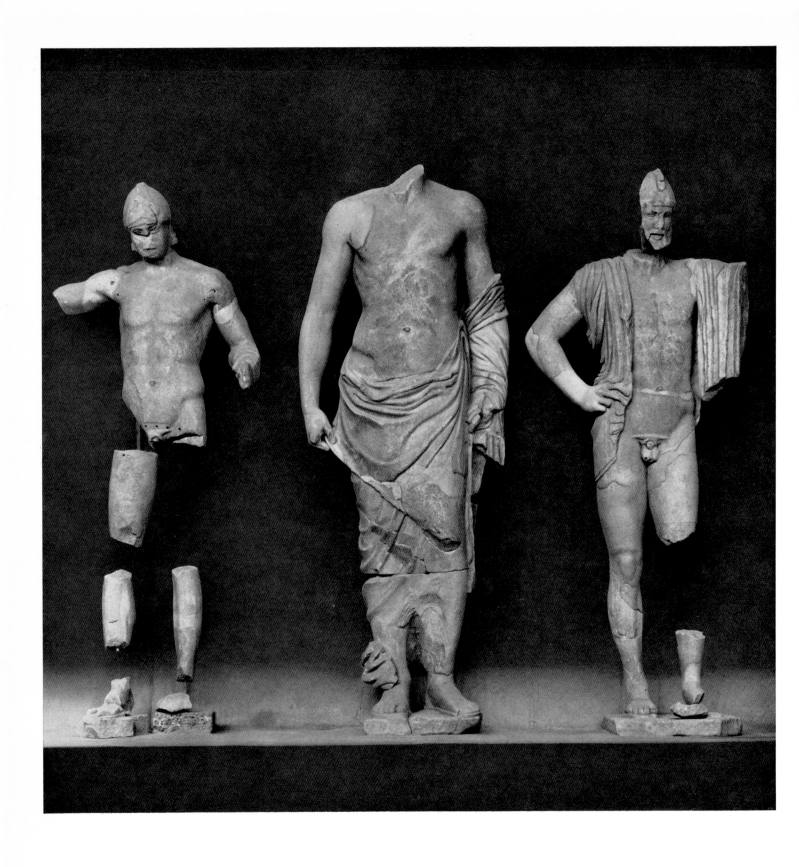

190 From the east pediment of the Temple of Zeus at Olympia, central group. Zeus between Oinomaos and Pelops,
here erroneously shown on the left; the figures should be transposed. Parian marble. Length of the pediment 26.4 m., height 3.3 m. Ca. 460 B.C.
Olympia Museum

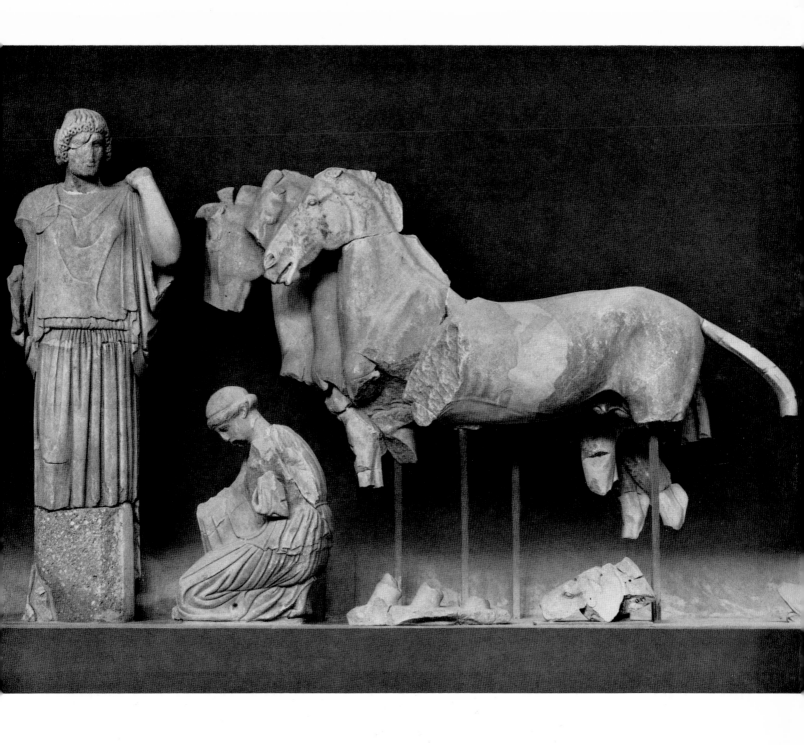

191 From the east pediment of the Temple of Zeus at Olympia. To the right of the central group. Right: Kneeling girl and horses from the quadriga of Pelops; left: Sterope (instead of Hippodameia, who should be beside Pelops). Cf. plate 190

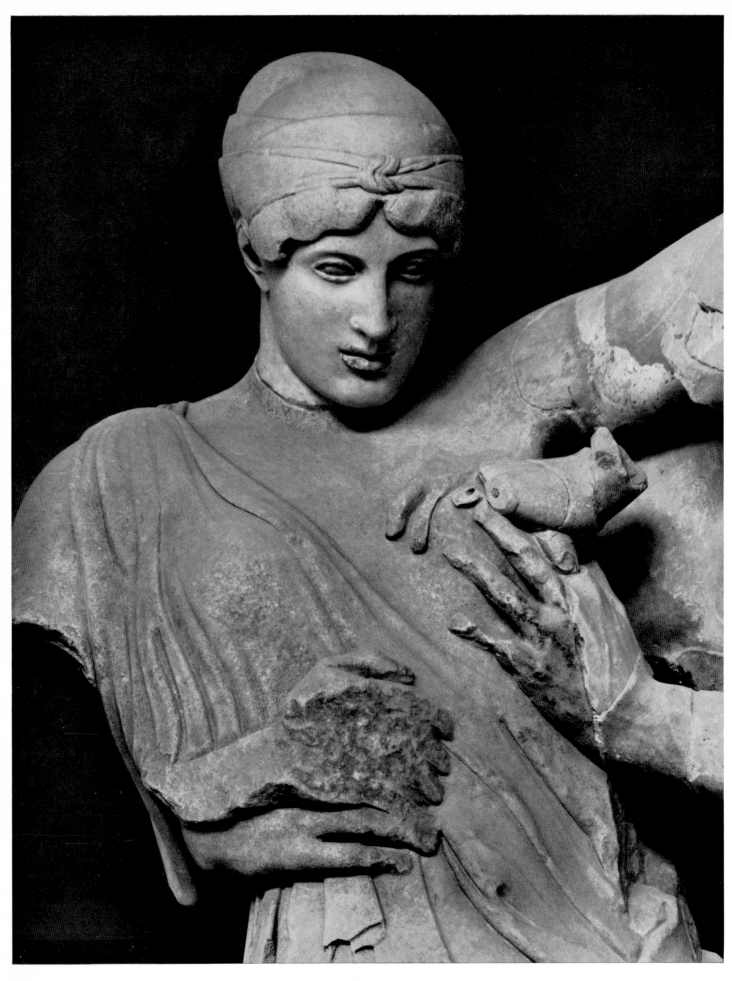

192 From the west pediment of the Temple of Zeus at Olympia, left end. The bride of the Lapith King Peirithoös attacked by a Centaur. Parian marble. Length of the pediment 26.4 m., height 3.3 m. Ca. 460 B.C. Olympia Museum

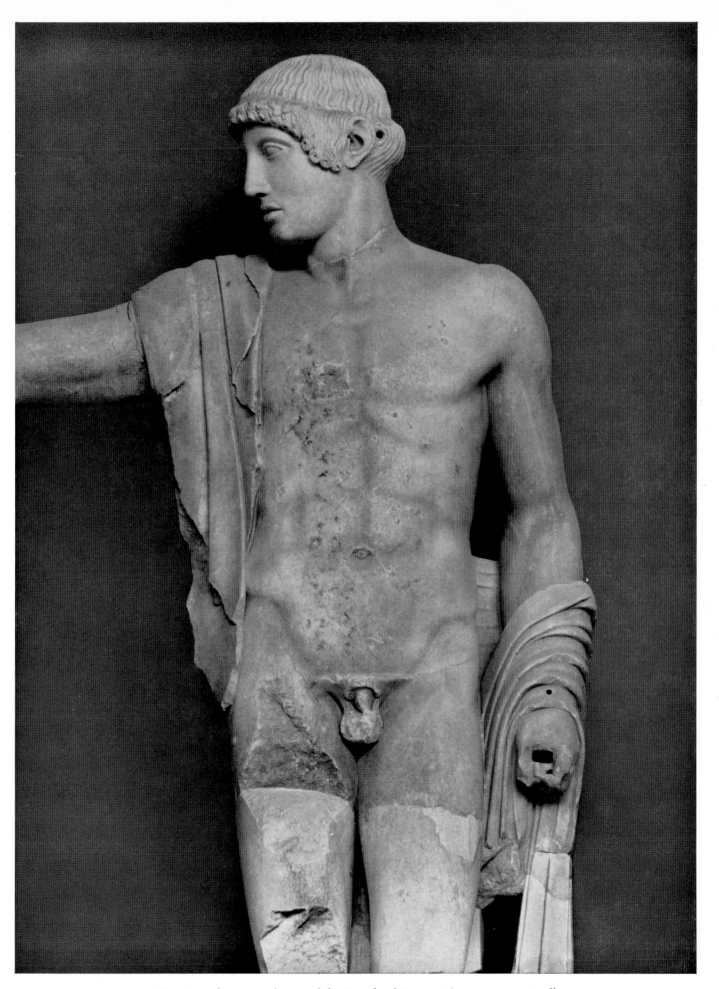

193 From the west pediment of the Temple of Zeus at Olympia, centre. Apollo

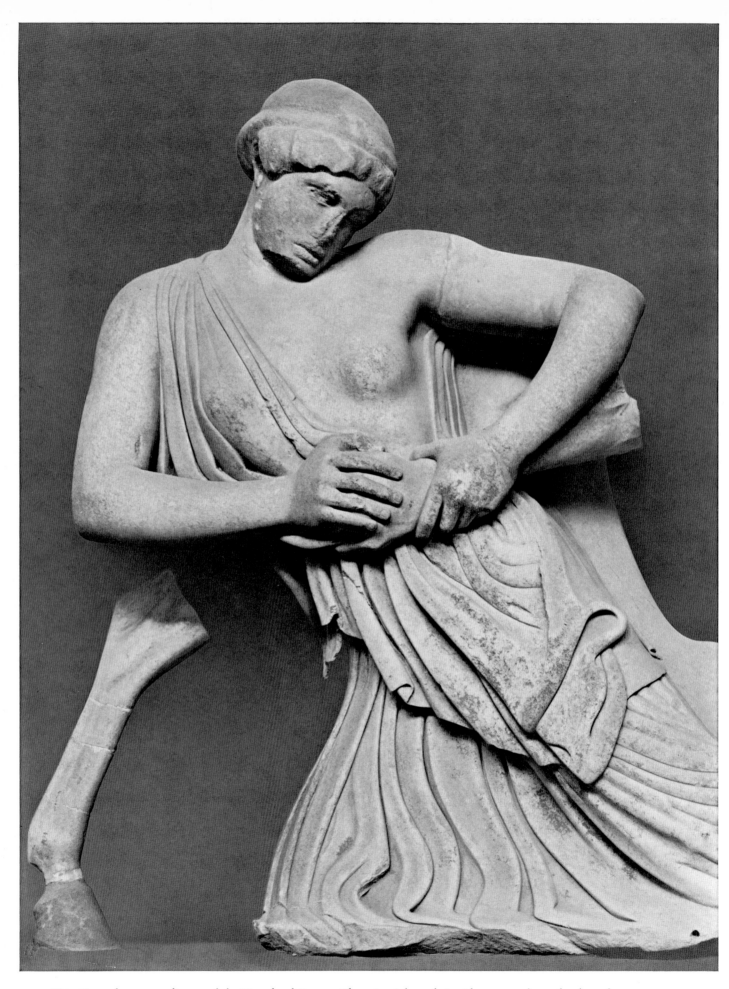

194 From the west pediment of the Temple of Zeus at Olympia, right end. Lapith woman, from the three-figure group.
Cf. plate 195 below

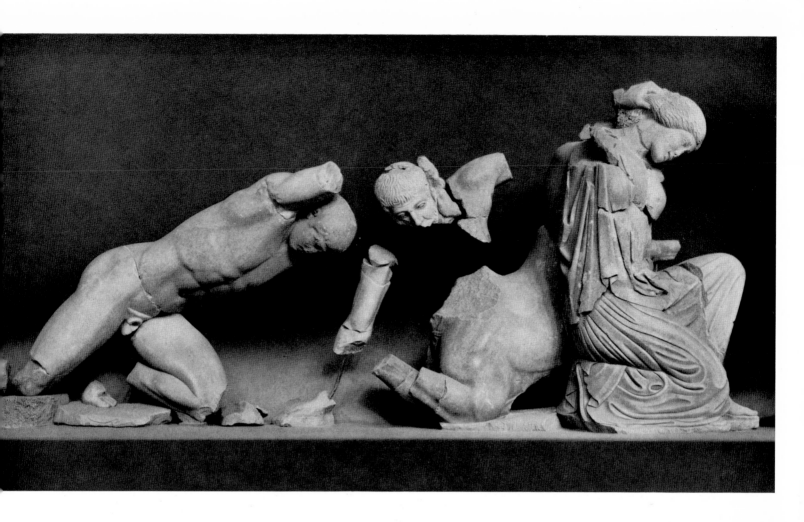

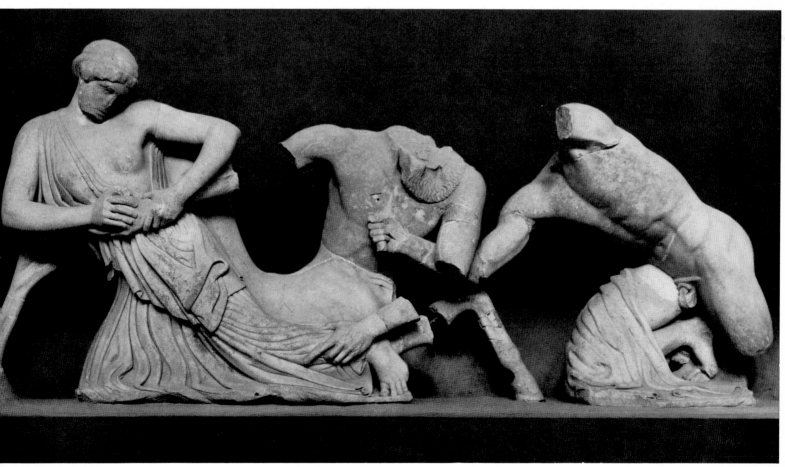

195 From the west pediment of the Temple of Zeus at Olympia. The two three-figure groups. Above: From the left half of the pediment; below: From the right half of the pediment, a Lapith and a Lapith woman fighting a Centaur.

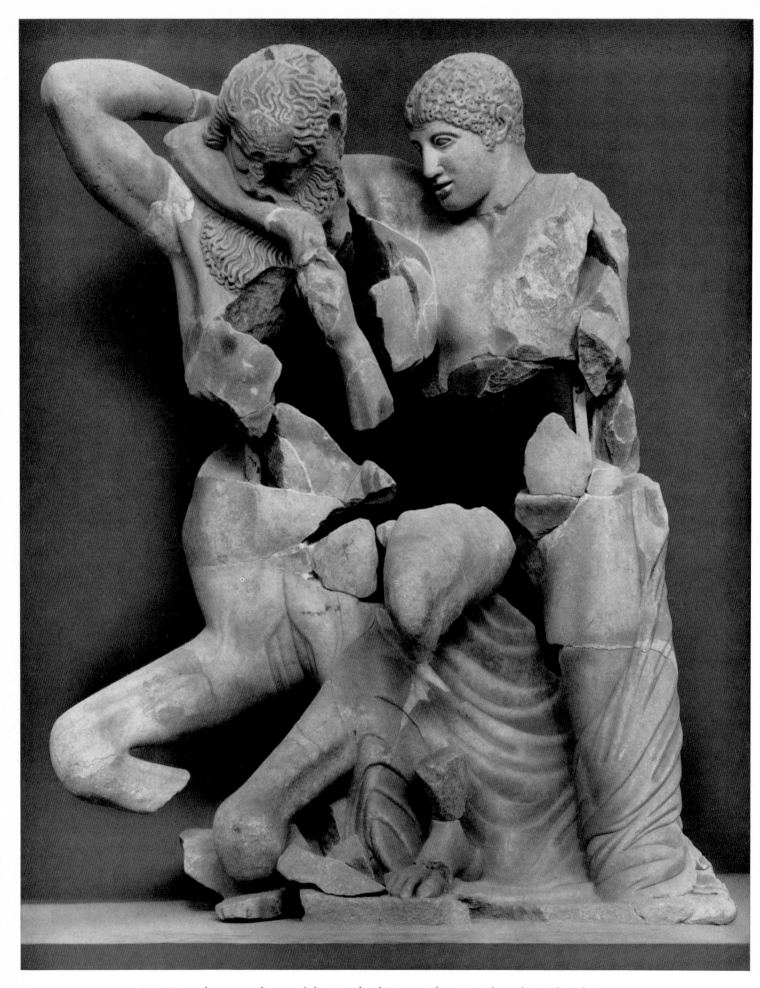

196 From the west pediment of the Temple of Zeus at Olympia, right end. Lapith and Centaur.

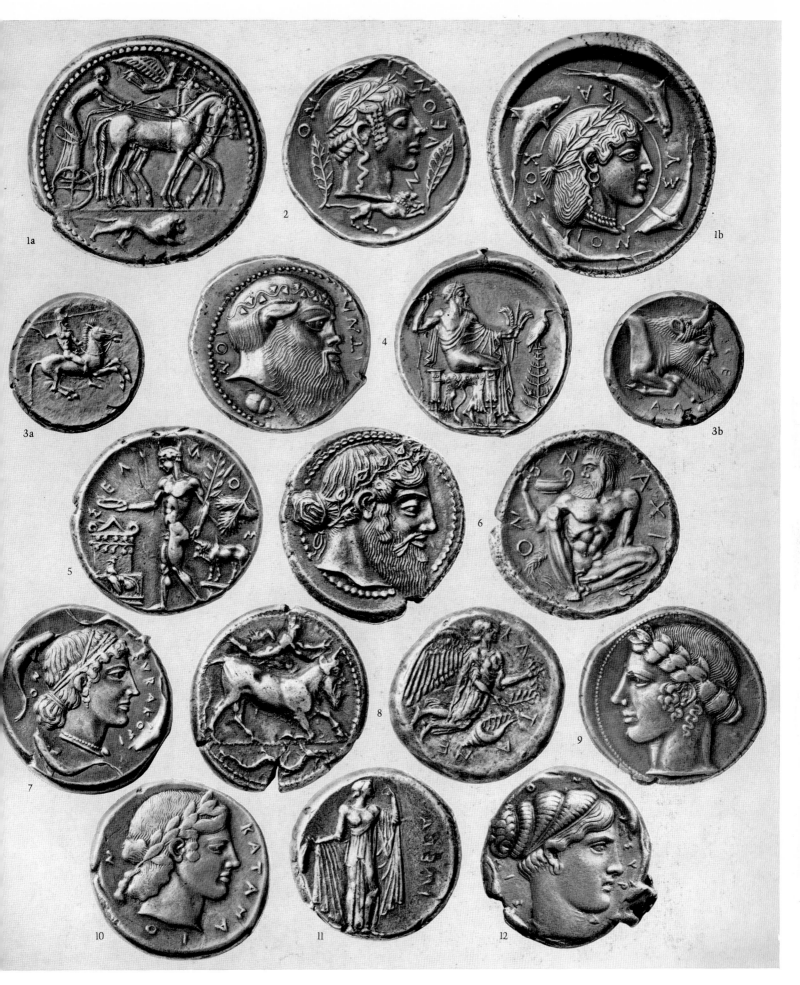

97 Greek coins of the first half of the fifth century (Period of the Severe Style). Sicily: 1 Syracuse, 480–479 B.C. 2 Leontini, ca. 479. 3 Gela, ca. 495.
4 Aetna, ca. 476–473. 5 Selinus, ca. 467. 6 Naxos, ca. 461. 7 Syracuse, ca. 460. 8, 10 Catana, 8 ca. 461, 10 ca. 460–450. 9 Leontini, ca. 466.
11 Himera, ca. 462. 12 Syracuse, ca. 450. All 2:1

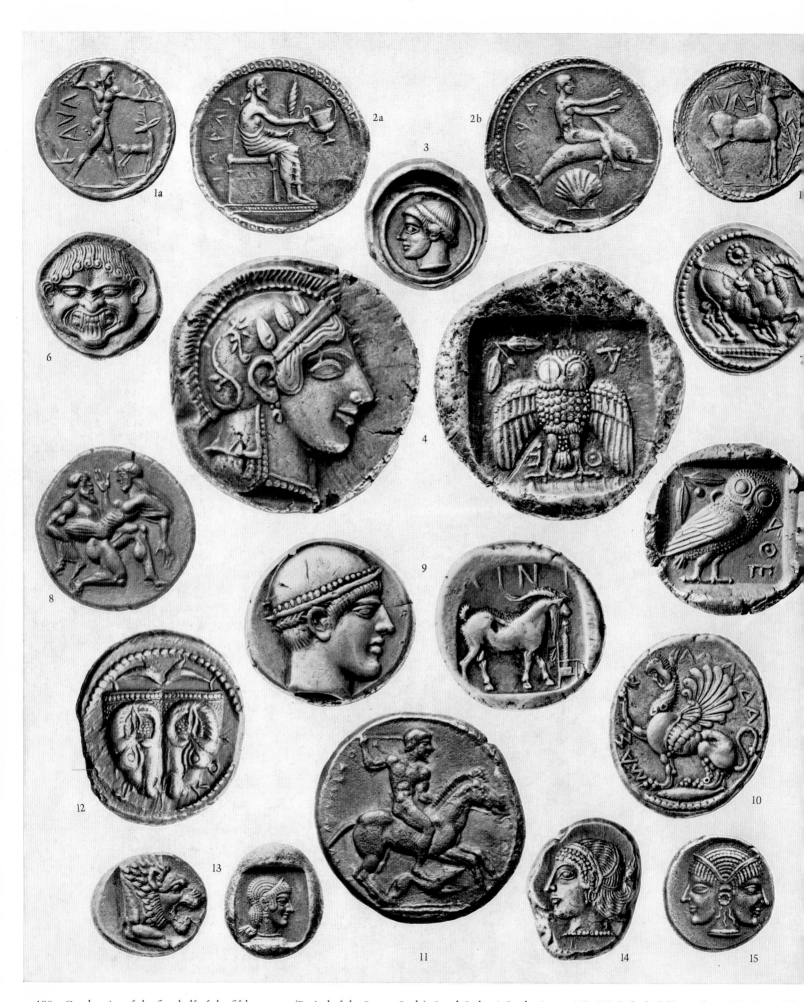

198 Greek coins of the first half of the fifth century (Period of the Severe Style). South Italy: 1 Caulonia, ca. 460–455 B.C. 2, 3 Taras, 2 ca. 485, 3 ca. 492–
Greece: 4, 5 Athens, 4 ca. 490–480, 5 ca. 480–460. 6 Neapolis Datenon, ca. 500–480. 7 Aegae, ca. 500–480. 8 Thasos, ca. 465. 9 Aenos, ca. 455–453.
10 Abdera, ca. 473–470. 11 Sermyle, ca. 500–480. 12 Delphi, ca. 479. Asia: 13 Knidos, ca. 500–480. 14 Lycia, ca. 480–460. 15 Lampsacus, ca. 480. All

HIGH CLASSICISM · 450–400 B.C.

In the middle years of the fifth century, Greek art conquered new territories. It achieved a timeless repose and a heightened intensity which combined to produce a new inner freedom and flexibility. It becomes difficult to tell whether a figure is in movement or at rest, whether it is preparing to walk or is holding itself poised in an attitude of forward movement. The ineffable divine moment is the favourite subject of the artist; the present is measured with a new 'plumb-line' (Buschor), the fleeting instant is seized and presented as an enduring fragment of eternity.

THE SCULPTORS

The transition was effected in Athens, which had already given birth to the Severe style and was now rapidly asserting its ascendancy in all spheres of life and of art. Above all it was in the buildings and sculptures of the Periclean Acropolis that the style of High Classicism was born. More specifically its origins are associated with the name of

PHEIDIAS, SON OF CHARMIDES

It was he who received from his friend Pericles the over-all commission for the sculptures on the Parthenon, that superb building (448–432) which epitomized the High Classical style. Pheidias himself is described by ancient writers as the greatest sculptor in the world, and there can be no doubt that he was the creator of Greek Classical art. His teachers were reputed to have been Hegesias and Ageladas, and from this we may assume that Pheidias's first work was done in the Severe style. His 'Apollo', now represented by a replica *199* in the Museum at Kassel, dates from before the middle of the century. The figure springs from a narrow base; on the left side of the body, the long slender supporting leg, the curve of the thigh and the raised left arm holding the bow unite to form a single mighty curve, while the line of the right side falls sheer from the armpit to the foot of the slightly advanced free leg like a taut bowstring. The head is turned towards the left shoulder. A fluent unity of line runs through the whole composition and supersedes the athletic muscularity and strength of the earlier Doric Omphalos Apollo. The traditional figure of Apollo the Archer appears in the noble form of an Athenian youth. The theme of the statue is not any specific event but rather the very essence of Apollo's being. The bow in the left hand symbolizes the purifying might of the vengeful god; he is not taking aim, yet his eyes seem to be trained on some distant target. The laurel wreath in the right hand symbolizes another of the god's attributes. Obviously none of the many reproductions are imbued with the depth of inspiration of the original Apollo Parnopios which Pheidias made for the Acropolis; and yet we can only be grateful for the copies which have survived from Imperial Rome, when we attempt to reconstruct the work of the Greek masters: 'the power of the Apollonian spirit, which shaped their external form, shines through, pure, cool and crystal-clear'. (Pfeiff)[1]

The statue of Anakreon, dedicated on the Acropolis by Pericles, together with a portrait statue of his *202* father Xanthippos, victor at the battle of Mykale, is somewhat later. Ancient sources do not expressly mention Pheidias as the artist, but comparison with other contemporary sculptures validates the attribution on stylistic grounds, not to mention the close friendship which existed between Pheidias and Pericles. Despite their widely different themes, the Apollonian and the Dionysiac, the Kassel Apollo and the Anakreon betray the hand of the same master in the suppleness of their forms. Admittedly the figure of the singing bard, in contrast to the Apollonian moderation of the somewhat earlier statue, has an unsuspected freedom of stance and self-abandon. Long undulating lines give the form a unique double rhythm which admirably expresses the drunken movements of the subject. The short cape over the shoulders hampers the arms of the lyre-player, so it has been brusquely thrown back. The formal structure is varied by the placing of the head. The whole statue expresses the enthusiasm and delight which the Greeks felt for this poet; numerous vase

paintings further testify to the esteem in which he was held. In his bronze statuette of Anakreon for the votive offering of Pericles, Pheidias transfigures the historical poet of the late sixth century into a figure of mythology.

200 The beautiful statue of Athena Lemnia, brilliantly reassembled by Furtwängler from a torso replica in Dresden and a head in Bologna, must date from the early 'fifties. Furtwängler's sharp-sightedness has been vindicated despite objections and attacks. The goddess is characterized by the Gorgon aegis; the left hand rests on her spear while the right holds out her helmet to the worshippers in a charming gesture. The severe grandeur of the Apollo Parnopios is transmuted in this delightful and innocent picture of the virgin goddess. The date and subject of the bronze original suggest that it was made for the Lemnia which the *klerouchoi*, sent out to protect the island of Lemnos, dedicated on the Acropolis at Athens. The statue was signed by Pheidias himself, and the fact that it received the sobriquet of 'the Beautiful' bears witness to the admiration it won.

 In the year in which he completed Athena Lemnia, Pheidias began work on the colossal chryselephantine statue of Athena Parthenos, which was installed in the Parthenon ten years later, in 438 B.C. Of the numerous reproductions, whether in the form of figurines or life-sized statues, the figurine found at the
201 Varvakeion in Athens, although only 94 cm. high without its base, is the most faithful to the original.

 The Athena Parthenos represents a direct development from the Lemnia, the sculptor having enhanced the statue of the goddess, not only by giving her impressive, larger than life-sized proportions, but by investing her too with something of the sublime. The choice ornamentation of the statue presented Athena with her attributes, Athena the Virgin, the Warlike, the Protectress of the city, and the Bestower of Victory. The relief on the base depicted the birth of Pandora; that on the outer side of the shield, an Amazonomachy. The inner side of the shield was decorated with the battle of the Olympians against the Giants. Fragments
Fig. 150 of a calyx-krater in Naples preserve a reproduction of part of this great composition. The helmet was embellished with sphinx, horse and deer protomes in shimmering gold sheet. The right hand rested on a column whose capital conformed to none of the established orders. In the palm of this hand the goddess

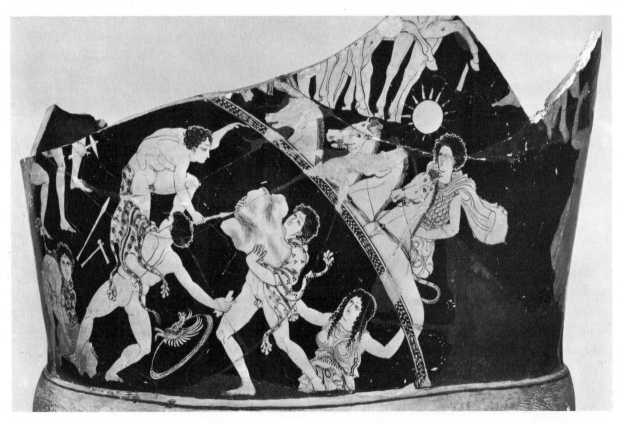

150 Circle of the Pronomos Painter. Fragment of calyx-krater. Battle of the Giants. Ca. 410 B.C. Naples, Museo Nazionale Archeologico

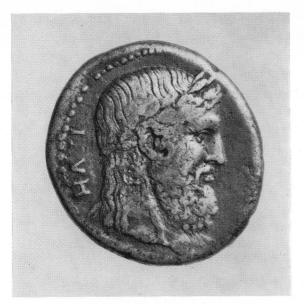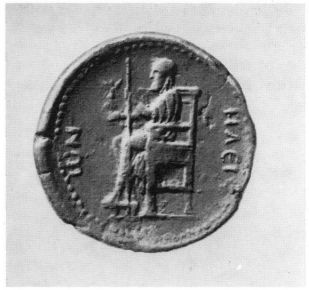

151/152 Head of Zeus, and enthroned Zeus, by Pheidias. Obverse and reverse respectively of a sestertius minted by the emperor Hadrian to celebrate the 228th Olympiad in A.D. 133. 151 after the original in the Staatliche Münzkabinett, Berlin; 152 after the plaster cast of a sestertius in the Museo Nazionale Archeologico, Florence. Both 2:1

held a patera from which soared up a smaller figure of Nike, personification of victory, with a fillet in her hands.

The religious imagery is even more far-reaching in the relief and painted decoration of Pheidias's statue of Zeus in the temple at Olympia; unfortunately no reproductions of it survive. For our knowledge of this we must rely entirely on the descriptions of Pausanias and a number of Elian coins. The god sat on an elaborately ornamented throne, holding a sceptre crowned with an eagle in his left hand, and in the right *Fig. 151/152* a Nike. The two arm-rests were decorated with a scene showing naked youths being attacked by sphinxes. Two Roman copies, in dark stone, of one of the groups were found at Ephesos by an Austrian expedition and are now in Vienna; earlier finds are in London. Eichler[2] has conducted lengthy researches in an attempt to reconstruct the original composition. The panels beneath the arm-rests depicted the slaughter of the children of Niobe by Apollo and Artemis. This great work was also embellished with paintings by Panainos of the Labours of Herakles and scenes from the Trojan War. The base showed the birth of Aphrodite, framed by Helios and Selene. The meticulous attention to the smallest details is manifested by the clay matrices for sections of the drapery, moulds for the glass palmettes and other parts, ivory chippings and tools unearthed by the German excavations of Pheidias's workshop at Olympia. Ancient tradition held that nobody who had set eyes on this stupendous statue of Zeus would be dogged by misfortune. When we take into account his numerous other works, such as the Amazon group (Mattei–Villa Adriana), the Marathon votive *221* group at Delphi, the Athena Promachos and the Athena Areia of Plataea, we can only marvel that this same sculptor was wholly in charge of work on the Parthenon marbles.

The sculptures of the Parthenon, comprising as they did 92 metopes, a 160-metre length of frieze, together with the two great pediments, must rank as the work of Pheidias even though, on the evidence of surviving fragments, his part in the actual carving was small. There were 14 metopes at the ends and 32 along each side of the temple. The metopes at the east end show the battle of the Olympians and the Giants in twelve scenes each one depicting a god and his opponent, framed by Helios and Selene at either end. The west end carries battle scenes of the Greeks against the Amazons; the north side the Sack of Troy; the south side, the fight of the Lapiths and Centaurs at the wedding of Peirithoös. The well-preserved south metopes, in London, give us an insight into the method of work. It is obvious that the two battle scenes were executed by a number of sculptors who were permitted considerable freedom of expression. Some of the compositions are in a stiff and earlier style, and excellently depict the action—the wild interlocking of limbs and the violent clash of bodies—the sullen animal nature of the Centaurs being characterized by

their furrowed brows, hooked noses and long, unkempt hair. The work of younger masters can be detected in the bold treatment of some of the Lapith figures which stand out in a fully plastic manner from the plane
204 of the relief. On the south metope XXVII a draped cloak forms a backdrop for the action; metope XXVIII
203 displays an unrestrained freedom in the rearing figure of a Centaur triumphing over the body of a dead
205 Lapith. Metope XXX in this series is filled with the new calm of the High Classical style. Here the Centaur who, following the dictates of his hybrid nature, has struck down one of the Lapiths, nevertheless has taken on the features of the wise and benevolent Chiron, the Centaur friendly towards men. The fruitful influence of Attic tragedy is evident in such representations.

203–205 The metopes were completed between 448 and 442. The conscription of all available man-power brought together on the same site sculptors of the older generation and young pioneering artists. The true secret of the whole mighty achievement lies in the continuous collaboration of such men, their progressive understanding of how to interpret Pheidias's design and the success with which he gently led them on to the fullest exploitation and unfolding of their own powers.

206–209 The 160-metres-long frieze, which encircles the exterior of the cella like a crown, likewise reveals the harmonious co-operation of the individual workers in their common endeavour; and that, even though it is possible that the numbers employed were greater than those on the metopes. The subject of the whole frieze is the Panathenaic procession which brought the goddess her new peplos. The west frieze shows the
206/207 knights assembling, arming themselves and mounting their horses. The procession of two- and four-horse chariots, people on foot leading the sacrificial animals, oxen and rams, bearing other offerings or playing musical instruments, moves eastwards towards the east end of the Parthenon where the actual procession ended. On each side young girls approach with measured step, and form the head of the procession. But now the scene changes. The mortals give place to the ten heroes of the Attic phylai (tribes) who in turn
208/209 lead on to the twelve Olympians, arranged in two groups of six, seated on thrones or stools; Iris stands next to the divine consort, Hera, and Eros is shown nestling at the knees of Aphrodite. This solemn assembly of the gods is located on the east side and is centred upon another scene from the actual ritual of the procession. Here the priestess accepts the gifts brought by two of the Athenian women to the citadel; near
209 above by a bearded man, probably a treasurer of the temple, is helped by a boy as he folds the peplos woven by the maidens of Attica, which constitutes the chief offering to the goddess.

However, the focal point of the procession is unquestionably the two groups of deities, even though they remain aloof from the ceremonial presentation enacted in their midst and are unseen by the participants. Yet they have foregathered, as it were, before the house of Athena, daughter of Zeus, and are present at the festival. Their seated figures fill the height of the frieze and tower above those of the mortals. It is their presence which gives the Panathenaic festival its splendour and its unique significance. It is as if Pheidias had effortlessly opened the gate of Olympus and, for the duration of the festival, the citadel of Athens had
208 below become the citadel of the gods. Pheidias himself was probably the sculptor of the figures of Zeus and Hera. Zeus rests his left arm on the back of the throne; Hera is turned towards him and, holding back her veil, looks into his eyes.

In every sense, the great work is crowned by the two pediments. But the ravages of time, and above all the explosion of 1687, have played havoc with these great compositions; Lord Elgin's well-intentioned endeavour to save what little was left, also led to dispersal. With the permission of the Turkish administration he shipped a whole series of the most magnificent of the marbles back to London. Because of this, Goethe in his last years, advised his friends and other artists to tour, not Italy, but England for their education. A
Fig. 153/154 general view of the whole composition is now possible only on paper, or in the mind's eye.

Approaching from the west, the first thing to catch the pilgrim's eye would be a representation of the Acropolis itself set in the incomparable Attic landscape. The west pediment confronts him with the struggle
214/215 of Athena and Poseidon for the land of Attica, surrounded by heroes and heroines who watch the contest. Poseidon has struck the ground with his trident and a salt spring is gushing forth; at the touch of Athena's lance, an olive tree, the symbol of the wealth of Attica, has sprung up from the barren ground. It is possible to reconstruct the central group, to a certain extent, from old drawings and surviving fragments. In gestures of violent hostility, the two deities move away from the centre of the pediment, Athena to the left, Poseidon

358

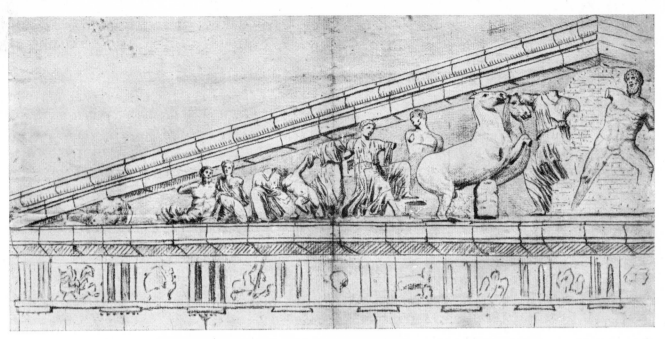

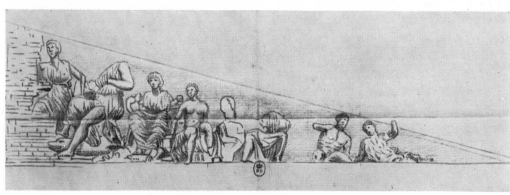

153/154 West pediment of the Parthenon, in A.D. 1674. After drawings by Jacques Carrey. Paris, Bibliothèque Nationale

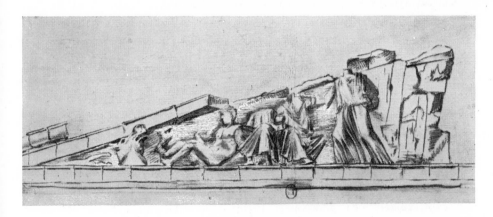

155/156 East pediment of the Parthenon, in A.D. 1674. After drawings by Jacques Carrey. Paris, Bibliothèque Nationale

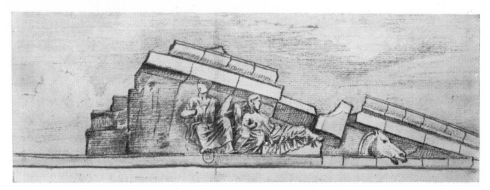

359

to the right. A V-shaped composition makes the interplay between the two opponents immediately apparent; Athena leaves the field, acclaimed unanimously as victor. Were he to approach from the Propylaea, the devotee would first have encountered the figure of the triumphant goddess.

Fig. 155/156 The east pediment depicts the Birth of Athena. The gods are all assembled; on the left, Helios drives his fiery team up into the sky and on the right, Selene, the moon-goddess, descends in her chariot beneath
213 the horizon. The group includes the mysterious horse's head (now in London) which Goethe described as the 'primeval spirit of the horse'. To left of centre stands Zeus, the figure behind him being probably Hera. Hephaistos stumbles back in astonishment at the sight of the fully-grown, armed figure of Athena which he has just freed from the skull of Zeus with his axe. The Goddess of Victory, a young maid with the victor's wreath turns back towards Zeus. Wonder at the miraculous birth has communicated itself to all the gods,
210–212 whose standing, seated or reclining forms fill the great field of the pediment. In order to grasp the unique and revolutionary vision of Pheidias, one should compare this scene with the numerous versions of the subject in the art of Greece from the Archaic period onwards. Interest is no longer concentrated on the bizarre moment in which Hephaistos had split open the skull of Zeus, but rather the instant just after the birth and its effect on the assembled gods.

The sculptures of the Parthenon together formed a unified and powerful compendium of religious truth, of which the cult statue of Athena Parthenos inside the temple was part. Every detail was thought through to its conclusion. The majestic events depicted on the pediments form the essential preparation to the ceremonial procession on the frieze round the cella. It is not by chance that the preparations for the procession that set out every four years from the Pompeion in the Kerameikos are so placed as to appear below the struggle between the two gods for Athens. The Birth of Athena corresponds to the Assembly of the Olympians on the east frieze. The goddess's operations among the immortals begin immediately after her birth, with the war against the Giants; indeed ancient legend told that Zeus had given birth to his warrior daughter to help him in this struggle. According to literary sources one single man only, by the name of Pheidias, was the presiding genius of the Parthenon sculptures, and every fragment of them which survives bears this out. Never before or since has any artist portrayed the gods, the heroes and mankind in their many-sided natures and fateful encounters, more profoundly than he did.

KALAMIS

is thought to have been a Boiotian, like Myron of Eleutherai; for several of his works were set up in that province: his Hermes Kriophoros and his marble Dionysos in Tanagra, and in Thebes his Zeus Ammon
217 which Pindar dedicated. There are reasons too for believing that the statue of Alkmene attributed to Kalamis was commissioned by one of the Boiotian towns which revered this heroine or laid claim to her grave. For neighbouring Phokis Kalamis made a statue of Iphitos, and for Delphi a statue of Hermione commissioned by the Lakedaimonians. While still quite young he will have gone to Athens to find himself a teacher. Maybe he got to know Onatas, and it is possible that he was taken on by the latter's workshop in Aegina. At all events we know that from 466 to 464 B.C. he worked together with Onatas on a votive group statue which Deinomenes dedicated as a lasting memorial to the Olympic victory of his father, Hieron of Syracuse. Pausanias had seen the work in Olympia and stated (VI.12.1) that the four-in-hand and the driver were by Onatas, the youthful rider and the horses ranged on either side by Kalamis. Yet in the inscriptions noted by Pausanias (VIII, 42.9, 10) only the victor, Hieron, the dedicator, Deinomenes, and Onatas, as the artist, are mentioned. This would seem to suggest that Kalamis had not yet qualified as an artist in his own right, entitled to sign his name on the work. Since he was soon to become a famous sculptor, however, there is nothing surprising in the fact that knowledge of his participation in this statue persisted into Roman times.

About the middle of the fifth century, Kalamis produced for far-off Apollonia on the Black Sea a statue of Apollo which is reproduced on coins of the late second and early first centuries B.C. The god was shown holding his bow in one hand, the other arm stretched out with the hand clasping the slim stem of a laurel-tree growing up close to Apollo's supporting leg. The same pose and like attributes are to be found in an Apollo known to us from numerous copies and designated Tiber-Apollo-Cherchel[3] after the find-sites of the best-preserved examples. The coins, however, show the figure in reverse. But that is no reason why we should question the identity of the prototypes; for in his negative mould the coin-engraver simply portrayed

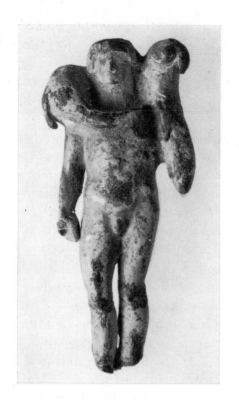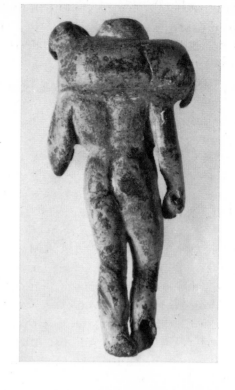

157/158 Lead figurine from shortly before 450 B.C., based on the Hermes Kriophoros of Kalamis, at one time erected in Tanagra. Swiss private collection

the god as he saw him in the bronze original. Nor should the existence of copies of the Apollo of Apollonia surprise us, for the huge statue by Kalamis was taken away to Rome during the first century B.C. and set up on the Capitol.

The Hermes Kriophoros of Tanagra, which we again know from coins of Imperial Roman times and *Fig. 157/158* from a small lead figurine now in a private collection in Basle, may be a little earlier. The head of this boyish Hermes is ostensibly preserved in the double herm in the Barracco Collection.[4] Each year the handsomest lad would be chosen to carry a ram around the walls of Tanagra on his shoulders. We are probably justified, therefore, in assuming that Kalamis too portrayed the god as a stripling. Stylistically, the Barracco-Wörlitz type of head, as it is called, is a direct precursor of the Tiber-Apollo head.

Towards the middle of the 'forties, Kalamis finished the Aphrodite commissioned by Kallias, who had concluded the thirty-year peace with Sparta in 446 B.C., and which was set up near the Propylaea on the Athenian Acropolis. It is from a fragment of the inscription that the name of the sculptor of this highly prized statue is known to us, as well as that of the dedicator and its date of origin, around 445 B.C.

The so-called Demeter of Cherchel, known from numerous copies, would appear to reproduce the *216* Kalamis Aphrodite, not only because she belongs to the same period as the pedestal inscription, but also because stylistically she has every sign of being a younger sister of the Tiber Apollo. Furtwängler recognized in the Cherchel goddess a work of the 'Kalamis line, running parallel with Pheidias'. But the drapery also is in keeping with Aphrodite; for contemporary vase paintings invariably show this goddess discreetly draped, often with a veil drawn over the head. Believed to date from the same decade is an Ammon-type head known to us as from nine separate copies, some of them reversed. One of these was recently acquired for the State Art Collections in Kassel. It clearly points to the original having been a famous masterpiece in the incipient High Classical style, which is in marked contrast to the neo-Classical products of Roman times. So it would be strange indeed were this single genuine Classical Ammon-head not to be identified with the single work of Kalamis concerning which we possess literary evidence. It is to be assumed that Pindar's veneration of Ammon derives from Kyrene. In all probability, too, it was substantial money grants by King Arkesilas IV of Kyrene—Pindar celebrated the chariot victories of his brother-in-law, Karrhotos, of 462 B.C. in the fourth and fifth Olympiads—that encouraged the poet to undertake this dedicatory work. Owing to the fact that the building of the Ammon temple and the setting-up of the cult statue by Kalamis was involved, and, moreover, that in the 'fifties Boiotia was waging war with Athens, the completion of

Kalamis's Ammon statue appears to have dragged on into the final years of Pindar's life. At all events, the prototype of the Kassel Ammon-head must be of later date than the Anakreon of Pheidias. These are as artistically akin and as stylistically divergent as is the Tiber Apollo by comparison with the Kassel Apollo. Berger's suggestion,[5] that there is a connection between the latter and a waist-length herm in the Museo delle Terme (8267) in Rome, speaks in favour of a close stylistic affinity with further works which, we believe on other grounds, can be ascribed to Kalamis.

The so-called Barberini Suppliant, which was acquired by the Louvre thirty years ago, undoubtedly qualifies as the finest extant replica of an important masterpiece of the period round 440 B.C. or soon after. The workmanship is so outstanding, that it is frequently taken to be a marble original from Classical times. Yet, like its more modest copies in the Vatican and the Hermitage in Leningrad, it seems to be based on a bronze. Whilst few antique statues have been so variously interpreted as has the Suppliant, the correct identification as Alkmene modestly put forward some time ago by the art historian C. Robert, in a note, has never found the recognition which is its due. The stone seat to which the heroine has retreated is patently an altar. The young woman is unable to realize that she could be accused of deceitfulness. Piteously she gazes into the distance of happier memories. Three vase paintings from the turn of the fifth to the fourth century depict the sequence of dramatic events that ensues. Amphitryon has a pyre built up around the altar, so as to smoke out the alleged adulteress. Nevertheless, the thunderbolt of Zeus or the rain from the hydriai of the Nephelai will bring divine succour to the unjustly persecuted young woman. The Boiotian skyphos in the Athens National Museum (12593), which was produced as a decisive argument for the interpretation of the Barberini Suppliant as a Titian-like Danaë—one that understandably met with much support—itself lends weight to our Alkmene hypothesis; for no less an authority than Pindar intimates that this skyphos shows not Danaë but Alkmene. He knew from the old Boiotian legends (Isthm. 7.5) that Alkmene conceived Herakles, the son of Zeus, in a golden shower (the usual form of the story concerns Danaë conceiving Perseus in this way). The hydria shown beside the object of Zeus's love confirms our interpretation; for it is no doubt the vessel that Amphitryon, returning from his campaign against the Teleboans, hoped to present to Alkmene, but which his divine rival had put to his own prior use as his go-between.

There is written evidence for an Alkmene statue by Kalamis. That the so-called Suppliant is a copy of this bronze is suggested too by the stylistic affinity of her head with the Barracco double herm, the Tiber Apollo and the Cherchel goddess. Moreover, the beautiful head of a woman in the Hermitage (264) in Leningrad, which can presumably be traced back to the same master's Hermione, has similarly waved hair on either side of the forehead and wears a like expression of sorrow and distress.

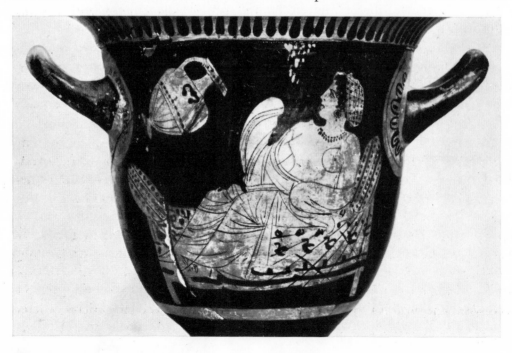

159 Boiotian skyphos with a picture of Alkmene conceiving Herakles from a shower of gold sent by Zeus. Athens, National Museum 12593

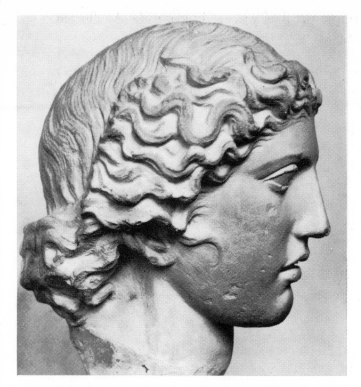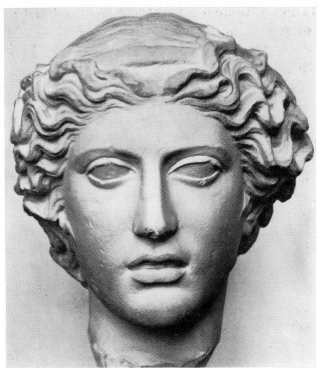

160/161 Female head, probably a copy of Kalamis's head of Hermione. Plaster cast of the head in the Hermitage, Leningrad

Of still later date will be the Dionysos of Tanagra, which has come down to us in the form of coins of this town struck in Imperial Roman times. These enable us to trace back to Kalamis two torso replicas, in Berlin K4 and in the Palazzo d'Avossa in Salerno, since they depict the god—always allowing for their reproduction in reverse—in precisely the same attitude. Dionysos held the kantharos in his left hand, while behind the slack leg the thyrsos could be seen resting in his lower right hand. According to Pausanias, the Dionysos of Tanagra was carved in marble; yet the furrowed style of his half-length chiton closely resembles that of the Alkmene, which was probably cast in bronze. Despite the span of some fifteen years that separates them, the balance and weight distribution of the Tanagra figure directly recall the Tiber Apollo. Kalamis, it is true, had his roots in the Severe style, yet he produced his most mature works in the Parthenon period. This accounts for the fact that Roman writers saw fit to mention him in the same breath with Myron, Polykleitos, Pheidias and Kallimachos.

MYRON OF ELEUTHERAI

is thought to have been a pupil of the Argive sculptor Ageladas. Pausanias described him as an Athenian. He certainly produced many works for Athens, but was in fact a native of Eleutherai, on the border between Attica and Boiotia. Although he assimilated many of the artistic elements of his adopted city, he never became fully Athenian in his manner, and never entirely lost the traces of his origin.

His famous Diskobolos survives in many reproductions, the most complete one being the Lancelotti copy in the Museo delle Terme, Rome. A brief description by Lucian enables us to identify the work beyond *218* all doubt as by Myron. The description runs as follows: 'The figure is bent to the throw, the face turned towards the hand holding the discus and the legs bent as if the athlete were just about to straighten up into the throw.'

A slender, naked athlete, powerful and tensed, bends far forward, the right hand with the discus at the topmost point of its backward swing. It is the culmination of the powerful swinging curve which flows from the trailing left foot, through the left arm and up to the shoulders. The swing of the movement leads back through the line of the body to the right foot, which was the statue's sole support—the tree stump is an addition by the Roman copyist. The head is turned back and emphasizes the closed and strictly ordered quality of the composition, which combines the intensity of movement with statuesque repose. In terms

363

of the palaistra, the moment of action shown in the statue was immediately followed by a 180° turn for the throw itself. The sculptor has chosen the moment of climax in the action, when the hand has reached its fullest swing. In this moment, before the body is made to rotate and the hand begins its flashing downward arc, everything is for a split second at rest; it is this moment that the sculptor has captured for all time. The figure gives more the impression of a relief; the modelling of the back and sides of the body reveals an astonishing understanding of the muscular structure, but these aspects play no real part in the artistic effect for the statue manifests itself fully in a single plane. From the front view the whole wealth of vigour and flexibility is apparent; the traditional placing of the legs, used in the Archaic period to represent swift
123 movement of the flight of divine figures (cf. Archermos's Delos goddess), is taken up again and achieves an irresistible dramatic force in this High Classical work.

We do not know which town commissioned the bronze original of the Diskobolos, which must have
219 far excelled any of the surviving copies. In the 440s, Myron completed the Athena and Marsyas group for the Acropolis at Athens. Ancient literary sources, vase paintings and coins have made it possible to set casts of the two figures—which survive, often separately, in many copies—in their original compositional relationship. Here again the sculptor has chosen to depict a single dramatic moment of the legend. The goddess Athena was thought to have invented the pipe, but seeing her reflection in a puddle and how the instrument distorted her beautiful face, she threw it away in disgust. The satyr Marsyas picked up the discarded pipe and learnt to play it. In the statue group, a stately young Athena, characterized by her Corinthian helmet and spear as the Warrior Goddess, but wearing a homely peplos, stands calmly by as Marsyas, who has stealthily followed the sound of the pipe, recoils before the warning gesture of Athena while looking longingly at the fallen instrument, and hops about in his attempts to reach it. The harmonious curves of the Diskobolos composition have given place to an angular zigzag movement, but the two works are related in the relief-like disposition of the forms in the plane and the freezing of the action at a moment
186 of balance. Despite her abrupt, forceful gestures the youthful goddess recalls the so-called Mourning Athena on the only slightly earlier Acropolis relief, but the figure's stance and the treatment of the peplos betray the influence of the Athena Parthenos of Pheidias. The head of Marsyas, in its turn, shows stylistic affinities with Centaurs' heads from the south metopes of the Parthenon. The group must date from the early 'forties, and one might perhaps connect it with the enmity between Athens and Boiotia during the period 457–447; perhaps a joke is intended against the pipe-playing Boiotians and hence a partisan gesture by the sculptor in favour of his adoptive home. Myron's work brought a new dynamism to group sculpture. The Archaic
Fig. 129 artists had simply set the figures in rows, as on the Geneleos base, and even Antenor, in his work on the
Fig. 131 east pediment at Delphi, placed the statues in a simple sequence. The somewhat later Tyrannicides of Kritios
177 and Nesiotes offers a comparatively simple composition—the two heroes advancing along the same line. But in Myron's groups, the figures respond to one another in a dramatic counterpoint which, by the very distinction between the units of the composition, lends the works a dynamic plastic unity.

The Athena and Marsyas group demonstrates impressively the range of Myron's art. On purely stylistic grounds it would be difficult to ascribe the figure of the girlish Athena to the artist of the Diskobolos. The streaming hair which frames the face and temples of the former seem in too marked a contrast to the close cropped hair of the discus-thrower or to the Athlete fastening a strap, probably by Myron and reconstructed by Amelung.

Myron was obviously in Athens during the years in which the Parthenon was built. Pheidias must have provided an important stimulus for his work, but Myron himself had a strong influence on the sculptors working on the great project, and without his inspiration the compositions of some of the south metopes would have been unthinkable. Indeed, some have seen the hand of Myron in the first of these metopes still
205 *in situ*. In the beautiful fourth and thirtieth metopes, the generous way in which the bodies of the opponents are treated on the relief area, with their limbs extended, encourage one to make a similar attribution; in

XXXI Achilles Painter. From an amphora depicting Achilles on obverse and Briseis on reverse. Achilles. Total height of vessel
60 cm. Ca. 445/440 B.C. Vatican Museum

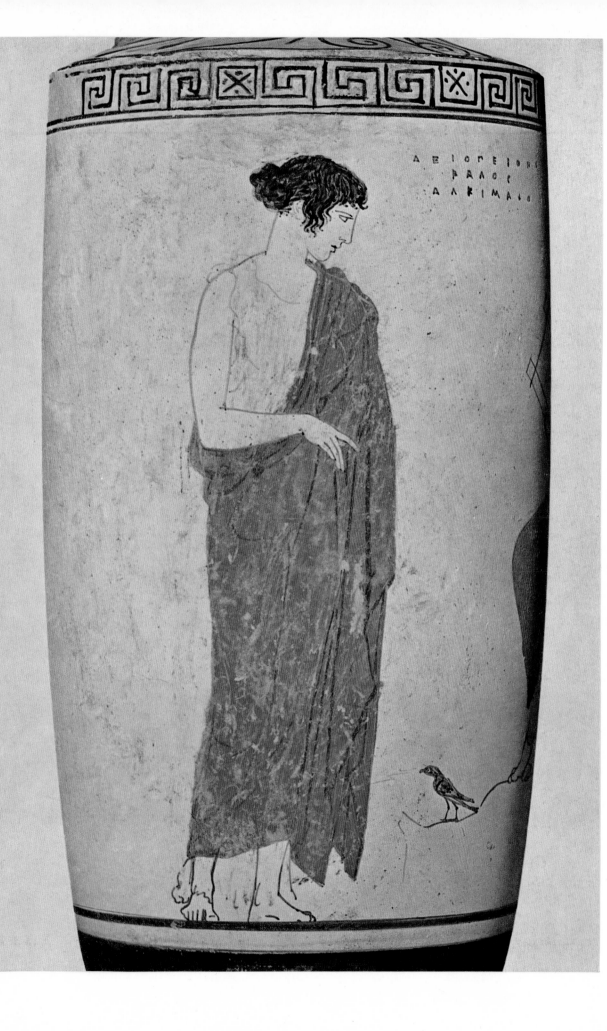

Polykleitos will reveal the full contrast between the freer, more open stance of the former and the weightier posture of the latter. In the Mattei Amazon the line rises in a single sweep up the right side of the body, from the supporting leg to the upraised right arm; the statue by Polykleitos is more stolid and thick-set, stress and strain being deployed in an almost architectural manner.

223 The third Amazon figure, called the Villa Sciarra Amazon after its former situation in Rome, is still more harmoniously composed. Many scholars ascribe it to Polykleitos, and there are unmistakable signs of influence from earlier works by the Argive master. A pillar supports the left arm, and by this device the upper body is inclined towards the side of the free leg, the whole figure describing a graceful curve. In fact the pillar here fulfils the same function as the spear in the statue by Pheidias. The curve of the free leg, set back, counterbalances the right hand which is resting on the head. The pain of the wound is concentrated in the head; the almost weightless body seems untouched by it, and indeed the gesture of the right hand seems to contradict any wound on the right side of the body. A certain formalism of expression is betrayed in the beautiful play of the folds of the chiton which exposes both breasts. The Sciarra Amazon has been attributed to Polykleitos and to Pheidias alike; and yet the correct ascription must be to Kresilas from Kydonia in Crete. This sculptor settled in Athens in the period of High Classicism and produced, among other works, a portrait statue of Pericles and a statue of a wounded warrior for the Acropolis. The one has survived in a bronze figurine copy, in America, and there are numerous replicas of the head; the other 224 is represented by a bronze figurine from Bavai.

 The athlete holding a discus in his lowered left hand, which survives in many replicas, is the oldest known 225 work by Polykleitos. This work has been linked with a bronze figurine in the Louvre, the right hand of which appears to have held a libation vessel; surviving Roman copies can give us no more than an approximate idea of what Polykleitos's original looked like.

 Undoubtedly Polykleitos's masterpiece was the Doryphoros (spear-bearer), numerous reproductions of 226 which survive. Using the most complete of these, the one in Naples, and the finest of the additional fragments, the sculptor Georg Römer, under the supervision of Wolters, has produced a modern cast described by the latter as 'a resurrection of the original work'.[6] The huge dimensions of the statue make it clear that the subject was no mortal athlete but rather one of the heroes, probably Achilles. The full weight of the naked figure rests on the supporting right leg, the left being set well back with the toes barely touching the ground. The raised left arm, which takes the weight of the great spear, balances the supporting right leg, while the curve of the pendent right arm echoes that of the free left leg. Such a composition is described as a chiasmus (after the Greek letter chi, which is represented by X); all movement has been reduced to a state of balanced rest.

 Polykleitos is known to have written a treatise on his art, called *The Canon*, of which only fragments have survived. We can, however, reasonably assume that the Doryphoros is the practical embodiment of his theoretical system of proportions. The individual limbs were in exact proportion to the whole body, the foot forming a sixth part of the body's length, while the head represented an eighth, the foot a tenth part of the height of the whole figure. Albeit such proportions were worked out with artistic precision, the sculptor's achievement is certainly no matter of mere mathematics. The surviving fragments of his treatise make clear his view that a work of art must have an irrational element, incapable of exact definition or measurement, an 'approximate' quality summed up in the words Παρὰ μικρόν. Elsewhere, he speaks of the difficulties of his art—modelling is not simply a matter of large, easily manipulated volumes but of hair's-breadth accuracy.

 Other works besides the Doryphoros include a Young Herakles (Barracco)[7] and a Hermes (Boboli);[8] 227 above all, the Diadoumenos, probably dating from the last quarter of the century and again the subject of many reproductions. The subject, a young man placing the victory fillet on his head, is unlikely, from the enormous size of the statue, to have been a mortal athlete. Possibly Apollo, the Protector of Youth, is

XXXIII Achilles Painter. From a white-ground lekythos. Deceased woman, elevated to a Muse, sits playing the kithara on Mt Helikon. Cf. plate XXXII

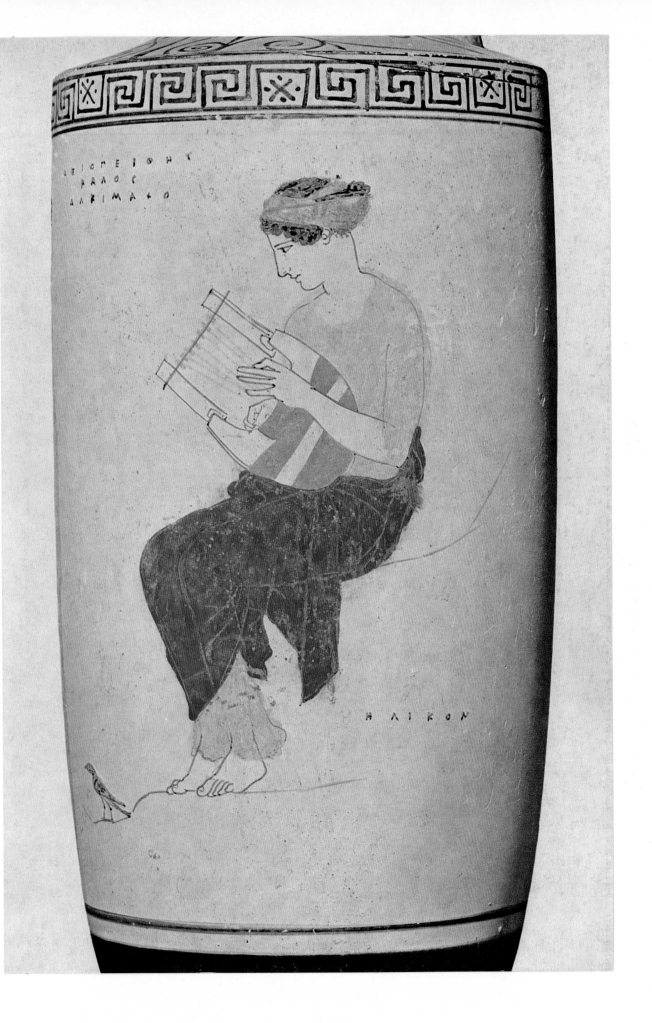

intended. Not only does the pose correspond to that of the Doryphoros, but the two figures are also closely related in the firm clear modelling of the forms. Indeed, one can to some degree understand the carping criticism made of Polykleitos in antiquity, that his figures were all produced to the same fixed plan, '*paene ad unum exemplum*'. Yet the two arms and the inclined head suffice to give the form a completely new

222 freedom and rhythm which exceeds that of the Capitoline Amazon.

Later opinion regarded Polykleitos far less highly than Pheidias. And it must be admitted that the Attic master outstripped him, not only in the sheer number of his works and variety of techniques, but also in the scope of his subject-matter which covered the full range of experience. The charge of monotony, however, cannot be levelled at Polykleitos. His works display a logical consistency and restraint of execution of which only a master is capable. The admiration which he excited is apparent, not only from the large numbers of Roman copies of his work, but also from the considerable school of followers which he inspired. No less an artist than Lysippos claimed the Doryphoros of Polykleitos as his truest teacher, and more than one work by the Attic school, the very antithesis of his art, betrays the extent of his influence.

228 The Chairedemos, a grave stele discovered on Salamis, is so reminiscent of the work of Polykleitos, that it has been ascribed to a Peloponnesian sculptor. Two warriors carrying spears and great round shields walk together towards the right. Lykeas is dressed in a short chiton; Chairedemos is portrayed in heroic nudity and is strongly emphasized at the expense of his brother in arms. This stele is an unusual example of the genre both in its subject—two young heroes who died in battle—and in the unified rather than contrasted motion of the figures. Despite strong Doric influence, the style of the carving follows on from that of the Parthenon frieze.

After his death Pheidias's work was continued by colleagues and pupils. It was his favourite pupil Agorakritos of Paros who carved the cult statue of Nemesis of Rhamnus, of which fragments of the head are in London and numerous pieces from the relief on the base are in the National Museum at Athens. Alkamenes, rival of Pheidias and Agorakritos, may well have made the surviving original marble group of

229 left Prokne and Itys, said by Pausanias to have been dedicated on the Acropolis by a certain Alkamenes, who is almost certainly the great sculptor himself. Roman copies survive of his Hekate Epipyrgidia and the herm of the Hermes Propylaia, named thus after their original positions on the Acropolis. The so-called Borghese

229 right Ares, now in the Louvre, has been identified as the cult statue for the Temple of Ares in Athens, mentioned by Pausanias. A few Roman bronze figurines, a Roman lamp and a copy of the head in the Vatican, give us some idea of Alkamenes's cult statue of Hephaistos, while fragments of the frieze of the Temple of Ares are obviously from his workshop. The style of Alkamenes is far removed from the delightful charm of Agorakritos, being weightier, more restrained, even reserved. This expresses itself in the sombre intensity of the Hephaistos and the Ares, still more in the mental anguish of Prokne. Itys, with childish innocence, snuggles up to his mother's knee, while she grasps the sword in her left hand preparing to slay her child on the altar of revenge.

HIGH CLASSICAL PAINTING

In the Classical period it was the Achilles Painter who continued the Severe style, notably that of the Berlin Painter. Not only did he prefer large vases, such as amphorae, pelikai and stamnoi, but decorated them usually with two figures quietly confronting one another; the forms have a clear, easeful firmness and

XXXI plasticity. The Achilles on the name-amphora in the Vatican invites comparison with that of Polykleitos; but the Achilles Painter also produced a number of white-ground lekythoi, very popular as grave ornaments, from which we can deduce something of the nature of the monumental painting of the period. They are

XXXII, inspired by a poetry of their own which obliterates time and space. A two-figure lekythos in Lugano, depicts

XXXIII the idyllic setting of Mount Helikon, named in the inscription. A Muse, dressed in saffron-yellow chiton and red cloak, sits with head bowed over her lyre. A song bird is to be seen at her feet, and in front of her

XXXIV Phiale Painter. White-ground calyx-krater. Story of the young Dionysos, the child of Zeus and Semele: Hermes hands over the child to Papposilenos and the nymphs of Nysa. Height 35 cm. Ca. 440/435 B.C. Vatican Museum 559

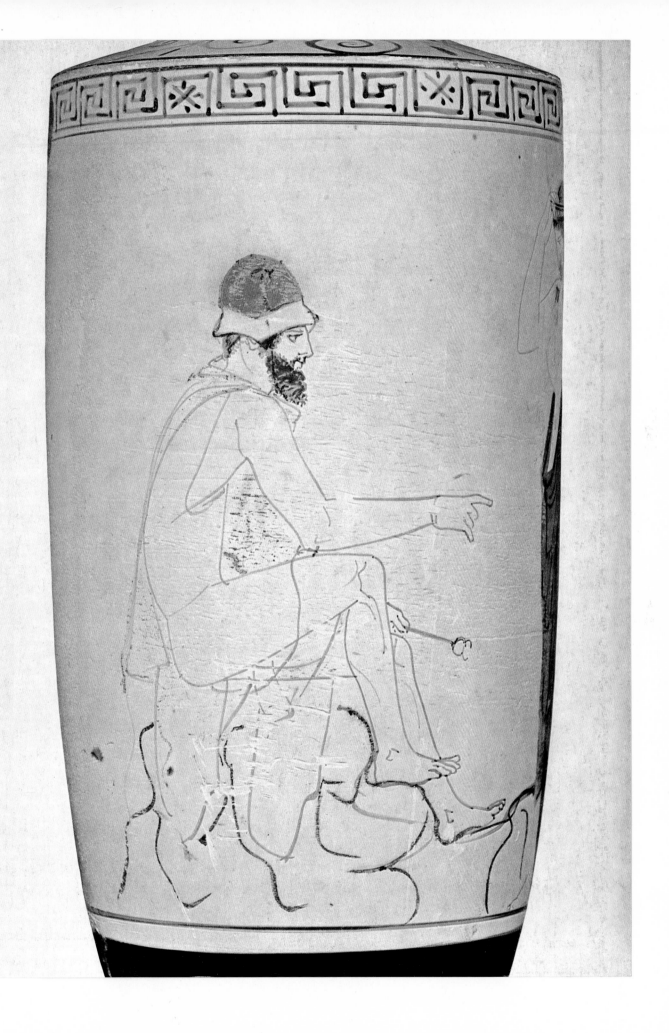

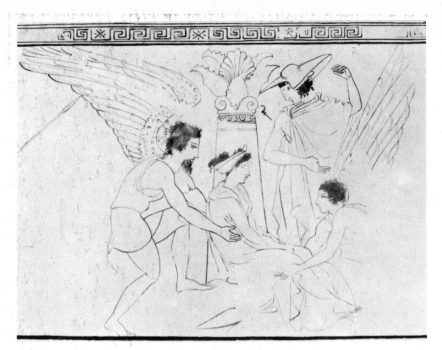

162 From a lekythos by the Thanatos Painter. Sleep and Death carry a young Athenian woman to the grave; behind them, Hermes. Ca. 440/435 B.C. Athens, National Museum 1830

a girl in yellow chiton and red cloak stands listening to the music of the goddess. There is nothing to suggest that she is a poetess—say, Corinna or Sappho; she resembles more some Athenian girl transported by death to the luminous heights of Helikon.

The frontier between men and Muses has dissolved, the step from life into death has lost its terror. In one scene a waiting girl hands a trinket box to her mistress. In another, an armed warrior turns towards his seated wife; the two are looking steadfastly at one another and somehow this scene of leave-taking for the wars betokens the deeper theme of leave-taking from this world. In pictures like these, the living and *XXXIV,* the departed seem to be united beyond the boundary of death. The Painter of the Boston Phiale treats the *XXXV* subject of the last journey still more pointedly on a lekythos in Munich. The stately figure of a girl adjusts the diadem on her head, while in the background we can see a gravestone, garlanded with a wreath of mourning, clearly her own. On a near-by rock sits Hermes, waiting to lead her down the stony path to the Underworld. The girl is completing her toilet at leisure; she is not one of the heroines of legend, yet she looks steadily and without fear at the messenger of death, rather as if he were a friend.

In these pictures the dead are shown transfigured, conversing with gods and heroes. Sleep and Death *230* appear as beneficent spirits, raising the body of a dead Athenian, just as they were depicted in Archaic times carrying the body of Memnon, son of Eos, from the battlefield. Any remaining doubt as to whether these *Fig. 162* scenes deal with mortals, and not with figures of myth, is dispelled by a lekythos by the Thanatos Painter in Athens. It depicts a young Athenian woman being laid to her final rest by the two brothers, Death and Sleep, watched by Hermes.

The effortless interpenetration that we encounter in countless vase paintings of the realms of mortals, heroes and gods, can hardly have been the invention of the vase painters themselves. We must, rather, assume the influence of the painter Panainos and his brother Pheidias, the sculptor; the results which the latter achieved in the east frieze on the Parthenon must have been of decisive importance for the painters of these funerary lekythoi.

Classical vase-painting was, of course, not restricted to this genre. A stamnos by the Kleophon Painter *231* depicts a warrior taking leave of his family; the scene fully expresses the sorrows of parting, but there is no indication that the vessel was intended for funerary use. Mother and father look on as they make their farewells; the wife modestly bows her head, while her husband, with the farewell cup at his lips looks earnestly at his young wife before he drinks.

XXXV Phiale Painter. From a white-ground lekythos. Hermes waiting for deceased woman. Total height of vessel 36 cm. Height of picture zone about 15·5 cm. Ca. 440/430 B.C. Munich, Staatliche Antikensammlungen 2797. Cf. plate XXXVI

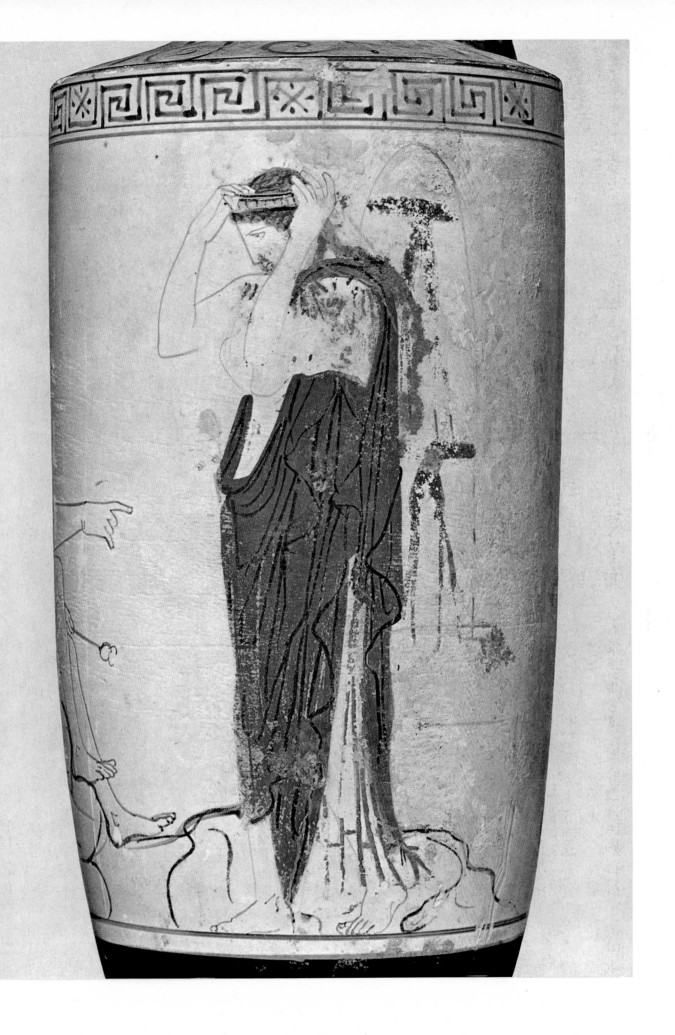

Nor was the white-ground technique exclusively confined to the funerary lekythoi. It is used, for example, *XXXVI* on a calyx-krater in the Vatican by the Klio Painter, to depict the bringing of the new-born Dionysos to the nymphs of Nysa. Wise old Silenos receives the child from Hermes, seated on a rock, while nymphs frame the idyllic scene. The back of the krater shows two Muses listening as a third plays the kithara. It is possible that these pictures are based on Sophocles's satyr play, the *Dionyskos*. Stylistically, the scene of the Muses enlarges on the charming idyll of Mount Helikon by the Achilles Painter, while the figure of Hermes in the main picture looks forward to the Hermes of Praxiteles.

In the last quarter of the fifth century, more disturbed forms and swirling draperies break upon the calm and repose of the Classical style of vase painting. The Polygnotan placing of figures is revived and used to give the illusion of spatial depth. The supple bodies are clothed in rich, rippling garments; choice cloaks with patterns inwoven, jewellery, diadems, arm- and earrings invest the pictures with festive splendour.

The new style is represented in the works of the Eretria, Meidias, Dinos and Pronomos Painters and the Washing Painter. The roots of the new style in vase painting lie obviously in the monumental painting of *Fig. 150* the Classical period; the point is convincingly demonstrated by the Naples calyx-krater, decorated with the *234* gigantomachy from the shield of the Athena Parthenos. The Dinos Painter has been called the Brygos of the later fifth century, yet his Dionysiac maenads on the Naples stamnos lack the elemental power of the earlier work. The Dionysiac frenzy is conveyed with a new sensitivity of expression. The intimate nature of this 'florid' style as it is sometimes termed, is reflected in its preference for female subjects. This extends *232* even to material things, as the epinetron by the Eretria Painter shows. (The epinetron is a protective device for the knee, used while roughening the thread in spinning.) The decoration on it shows scenes from the lives of female mythical figures. The frieze on the right-hand long side depicts the wedding preparations of Harmonia, who sits attended by Peitho and Kore; to the left sits Aphrodite, the bride's mother, holding a trinket which she has taken from the box held by the winged boy in front of her. Hebe and Himeros frame the right side of the picture; Kadmos, the bridegroom, is not depicted. The opposite side of the epinetron shows another famous bride, Alkestis. Again the bridegroom, Admetos, is absent and the subject is probably the Epaulia, the ceremonial welcome of the new lady of the house on the morning after the wedding. The young lady is leaning on a couch in the entrance hall; opposite, her sister Asterope leans over the third sister Hippolyte who is playing with a bird. A third frieze shows the abduction of Thetis by Peleus. The whole decorative scheme describes the triumphs of love, and the front end of the epinetron, where it fitted over the knee, carries a relief bust of Aphrodite herself.

Love, abduction, and the ceremonial of marriage; the enchantments of music and the abandon of the dance are the favourite subjects of masters of the florid style. In a picture richly embellished with gold, the *233* Meidias Painter depicts the story of Phaon. Originally a grizzled old ferryman, he had taken Aphrodite, disguised as an old woman, across the Straits of Lesbos, refusing to accept any payment. As a reward, the *XXXVII* goddess transformed him into an eternally handsome youth, irresistible to women. He is shown playing the kithara, seated beneath a wreath-like branch of laurel, with Demonassa. Himeros, the figure of love's desire flies towards him on golden wings; to the right stand Leto and Apollo, and to the left the nymphs Leura and Chrysogeneia; above them glides Aphrodite herself in a chariot drawn by the winged boys Himeros and Pothos. To her right are Hygieia and Eudaimonia, the embodiment of Health and Good Fortune respectively, and to her left Pannychis and Erosora, All-night Feasting and Love's Springtime. Further development, even the continuance, of this style was not feasible; even the Meidias Painter himself avoided the dangers of sugary sentimentalism only through the power and nobility of his drawing. A volute-krater in Taranto, 8263, which dates from the last decades of the fifth century, is the work of an artist from Magna Graecia, possibly from Taranto itself, who obviously wished to emulate the Eretria and Meidias Painters. His subject is the Karneian festival, but his treatment misses the full brilliance and charm of his models; it is only his religious earnestness which validates this continuation of the florid style in the western Greek

XXXVI Phiale Painter. From a white-ground lekythos. Young woman, preparing for the journey to the Underworld. Cf. plate XXXV

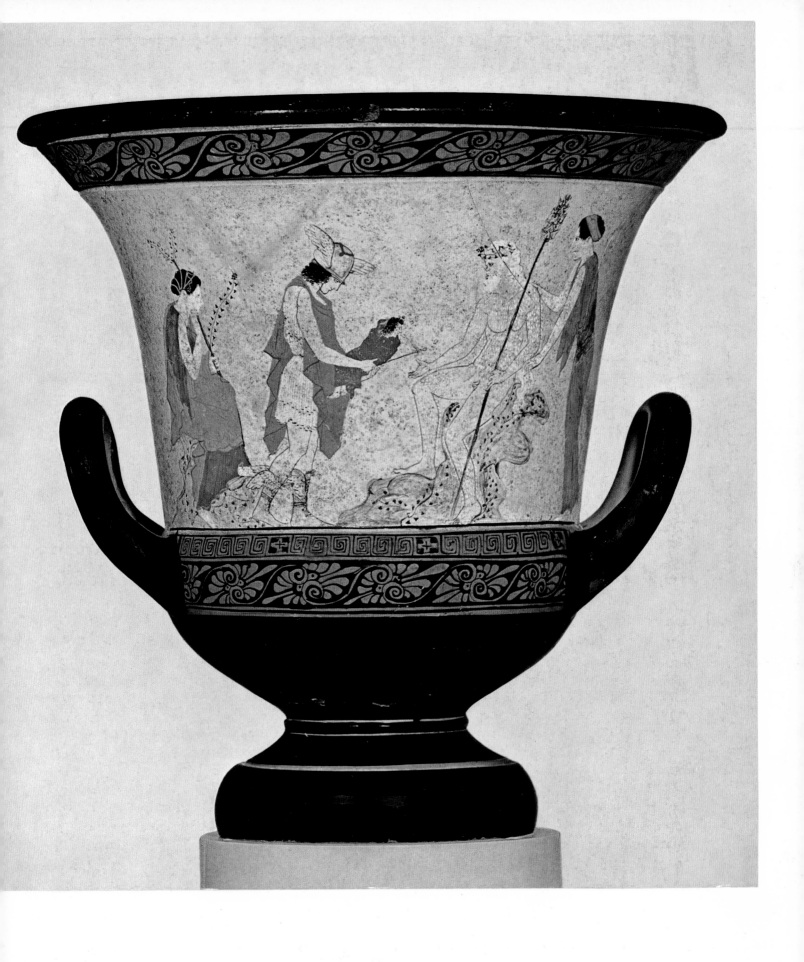

cities. In Attica, Dionysiac themes continue to appear on vases and mirrors into the first quarter of the new century, but the delicate painting and hovering cloud-like forms of the Meidias Painter and his circle represent the twilight of the Parthenon period.

From literary sources it is apparent that during the last third of the fifth century major painting occupied an extremely important position. The names of the leading painters, Apollodoros of Athens, Agatharchos of Samos, Parrhasios of Ephesos and Zeuxis of Heraklea, have been handed down by tradition, surrounded by a haze of anecdote and legend which may, occasionally, be based on fact.

PARRHASIOS

Whereas Apollodoros and Zeuxis, whose style he attacked in epigrams, made greater use of colour, Parrhasios seems to have relied on contour and the plastic use of line to achieve the illusion of reality. We *Fig. 163* can gain some idea of his style from a south Italian sherd in the British Museum, based on his painting of a Thracian nurse. A baby is at her breast but the fluttering garment and the anxious look on the nurse's face indicate the presence of danger. This superb fragment goes some way towards illuminating the fine achievements of Parrhasios; even the titles of other pictures suggest this. One portrayed the feigned anger of Odysseus. The way he conveyed character in his picture showing the Athenian Demos won particular

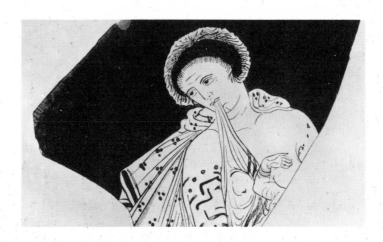

163 South Italian sherd show-
ing a Thracian nurse, based on
a painting by Parrhasios. Ca.
420 B.C. London, British
Museum

admiration. 'In this picture he depicts all the varying moods of the crowd; changeable, angry, unfair, fickle, yet also generous to the suppliant, benevolent and sympathetic, bragging and on occasion noble, unruly and volatile.' (Pliny, *Natural History* 35. 69) Even in his small pictures of intimate love scenes he displayed a preference for heightened emotional effects. It is characteristic of the age that a painter of the stature of Parrhasios should have returned to those sixth-century themes which had been avoided by the Classical artists.

Some appreciation of the work of Parrhasios can be gained from white-ground lekythoi such as the one in Athens by the Reed Painter; this work, in its economy and intensity of line, reveals the hand of a master and the conclusion of the style of outline drawing. Such a picture explains Parrhasios's statement that he had reached the very frontiers of art as he understood it.

APOLLODOROS

Apollodoros of Athens is traditionally the man who made the paint-brush a major tool of artistic expression; indeed in his use and mixing of colour and the gradations of light and shade in his work, he can be regarded as the father of painting in the true sense of the word. Earlier painting, which Parrhasios in this respect continued, was based on the contour line enclosing colour areas. This is not, however, to say that Archaic and Early Classical painting was simply a form of drawing. As early as Polygnotos, painters had used body-colour to characterize their figures; he portrayed the drunken Locrian Ajax with skin as red and as raw as a 'shipwrecked sailor tanned with the sea salt air'. The fish in his picture, at Delphi, of the ocean under the world seemed more like shadows because they were fish in the world of shades. Furthermore, we know of pictures from this period where shadow was indicated by the use of broader brush-strokes. Nevertheless, it was a revolutionary step when the local colour of objects and figures was subordinated to a single system of

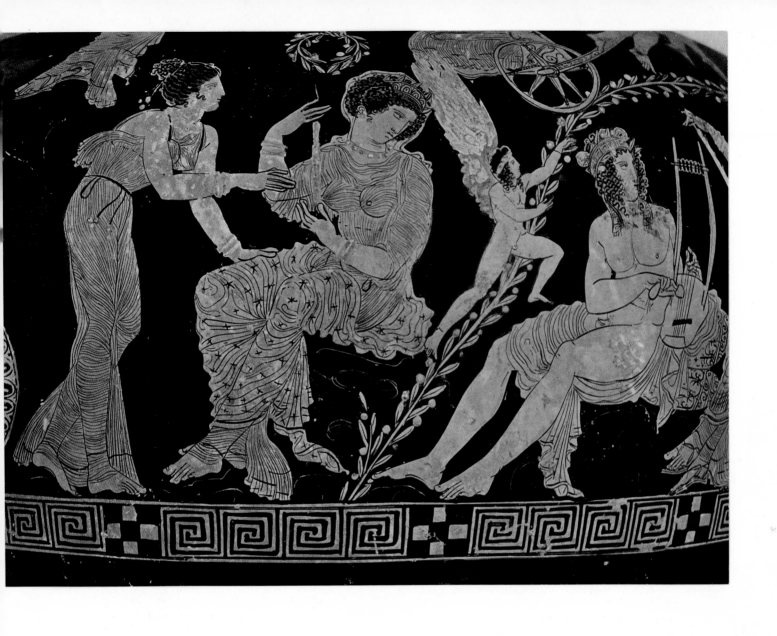

XXXVII Meidias Painter. From a hydria. From the story of Phaon: the nymphs Leura and Chrysogeneia; Himeros and Phaon.
Height of detail about 17 cm. Ca. 410 B.C. Florence, Museo Archeologico 81947. Cf. plate 217

light and shade applied to the whole picture, and when the individual forms were subjected to modelling by gradations of light and colour in accordance with this system. Apollodoros can be regarded as the inventor of this new style; he was known in his own day as the 'shadow painter'. These works are lost to us, but like those of other painters, their nature can be in part deduced from surviving white-ground lekythoi. His paintings included: Priest at Prayer, Odysseus, The Heraklids Seeking Refuge from Eurystheus in Athens and Ajax Struck by Lightning.

Such a subject as the last, handled by a painter renowned for his treatment of light and shadow, must surely have been spectacular. But the work is irretrievably lost and there is nothing, vase painting or fragment, to help us elucidate that brief, fascinating title, *'Aiax fulmine incensus'*. Apollodoros was fully aware of the significance of his own work, as is shown by his somewhat tetchy comment on Zeuxis, 'who has stridden through the door which I opened and has claimed my discoveries as his own'. Yet his contemporaries and posterity recognized his achievements, as even the feud which Parrhasios wages against Apollodoros and his style indirectly attests.

ZEUXIS OF HERAKLEIA

Zeuxis was, nevertheless, the most engaging personality among the florid-style painters. He came to Athens from Herakleia as a young man and soon gained influential admirers, both by his art and by his winning manner. Socrates was happy to claim him as a personal friend and, in Xenophon's *Symposion*, describes him as a complete gentleman. The artist himself had a healthy pride in his achievements and is reputed to have signed a picture of an athlete with the comment that it would be easier to blame the work than to imitate it. When the stage-scenery painter Agatharchos of Samos prided himself on his speed of execution, Zeuxis is said to have commented drily, that for his own part he needed time to bring his works to perfection. The Greek Πολλῷ κρόνῳ contains an untranslatable play on words but the general sense is that, whereas the Samian worked for the present, he, Zeuxis, painted for the stage of eternity. One of the numerous anecdotes surrounding the period tells of the rivalry between Zeuxis and Parrhasios. Zeuxis had painted a scene showing a bunch of grapes which were so realistic that they were continually attacked by birds. Not to be outdone, Parrhasios, in his turn, painted a curtain similar to the blinds which were used to protect the colours of a painting from the sun. Wishing to inspect the work of his rival, Zeuxis tried to lift the curtains. Apparently another such curtain carried the name of Zeuxis in gold letters, and this may have given rise to the legend that the painter once appeared at Olympia, wearing the most expensive clothes on which his name was embroidered in gold, simply to show off his wealth. He may well have become extremely rich, and no doubt in later life he occasionally gave away pictures to clients and patrons—like many an artist after him. Zeuxis, however, appears to have an explanation for this too, for he is credited with saying that he preferred giving his paintings away to accepting a price which, no matter how great, could not match their true worth.

It is definitely known that Zeuxis used live models. When painting a picture of Helen for the town of Kroton, he was allowed to select five of the town's prettiest girls. With Raphael he may well have said 'In order to paint one beautiful woman, my mind must be able to draw on its experience of many.' Surprisingly enough, legend has nothing to say on this. We do know, however, that Zeuxis depicted Helen as an hetaira. But this was only fitting, since he charged an admission fee at the work's first public exhibition.

Ancient literary sources refer to a superb Zeus Enthroned, Surrounded by Gods, and to a Pan which the artist gave to King Archelaos. For the Agrigentines he painted Herakles as a child strangling a snake which had attacked him, while his mother Alkmene, accompanied by Amphitryon, looks on in horror. His Penelope, on the other hand, is reputed to have been the embodiment of womanly modesty. It is told of Zeuxis that he died of laughter on looking at one of his own paintings of an old woman.

His most famous work, certainly to posterity, was a painting of a Centaur. Our knowledge of the work comes from Lucian, the Syrian peripatetic lecturer of the second century A.D. In his teaching of rhetoric, Lucian emphasized that the speaker must grip the attention of his audience by using startling themes. To

XXXVIII Reed Painter. From a white-ground lekythos. Warrior by the grave. Total height of lekythos 48 cm. End of 5th century B.C. Athens, National Museum 1816

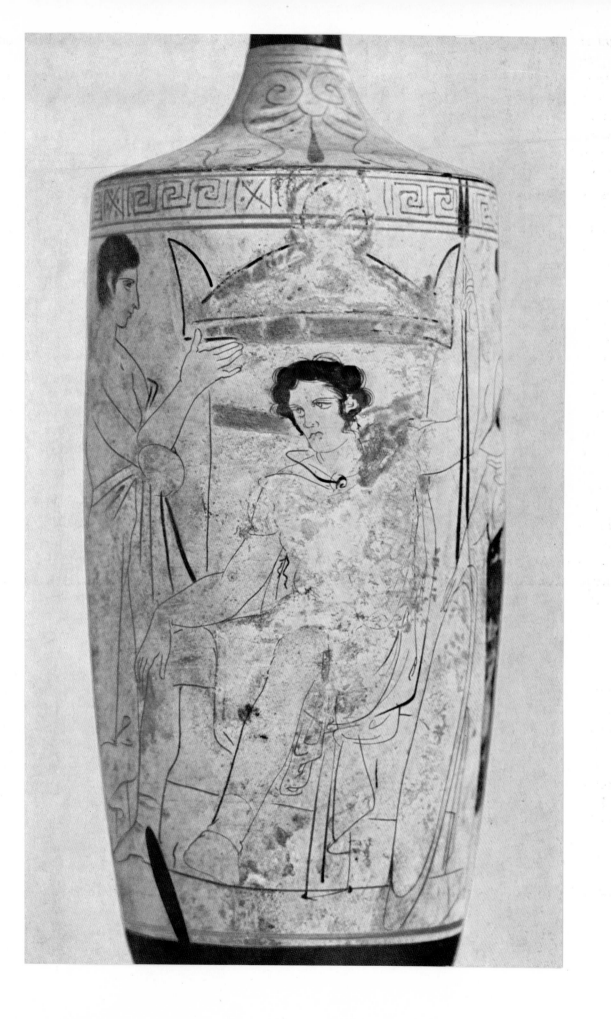

illustrate the point, he quoted the painting by Zeuxis which showed a Centaur mother suckling two of her children, one at her breast and one at her udder. The father leans over the group dangling a dead lion cub, in fun, before his children's eyes.

192, 195/196, Yet, what a vivid contrast to the wild and brutal Centaurs of the Olympia pediment and the Parthenon
203-205 metopes this presents! It would no doubt amuse Lucian to know that his comments on this painting are still accepted in their literal sense by scholars in whose eyes Zeuxis was something of a charlatan who had the sudden inspiration to think up this unusual domestic scene. Yet the point of the picture was not sensationalism at any price. For the Centaurs, though quarrelsome and lascivious in their cups, were, when sober, friendly towards man. The wise Chiron, Achilles' tutor, is one of the subjects of Classical vase painting, and Sophocles refers to the Centaur Nessos as the friendly ferryman who carried the souls of the dead over the River Euenos. Pictorial representations of this theme are found only in Magna Graecia. Numerous plaques from Taranto show Centaurs, in one case a female, carrying human figures on their backs. These are clearly intended to suggest the journey of the initiates across the great waters to the blissful After World on whose borders the Centaurs, according to Vergil and Dante, live.

164 From an Italiote sherd, now lost. Female Centaur, suckling, based on a painting by Zeuxis. Last quarter of the 5th century B.C.

Fig. 164 A fifth-century Italiote sherd, now lost, depicted a female Centaur, though it is not known whether she was suckling or not. But this theme is known on Roman gems which, although they show the young being suckled at the human breast only, may derive from the Zeuxis painting. A fragment from another gem shows a drunken Centaur having his cup refilled by a Centaur girl, and this may go back to a late-fifth-century original. Rubens must have known this fragment, since his *Amorous Centaurs* unmistakably adapts the ancient model to the new title. Although the terracottas and vase fragments from Magna Graecia are certainly not the work of Zeuxis himself, it is interesting that ancient sources state that he did produce *figlina opera* in clay. But these fragments show that the Centaurs retained their religious significance in the popular beliefs of Magna Graecia. Together with many other works by Zeuxis for towns in southern Italy and Sicily, they confirm that the artist's birthplace was the Herakleia in Lucania, and not one of the many other towns of that name. Yet far more important, they prove that his Centaur picture was not merely an artistic or 'sophistic' joke, but rested on sacred traditions, *hieroi logoi*. For this reason his Centaur mother is found on many Roman sarcophagi. That Vergil, Dante, Rubens, Goethe in his *Faust* and Boecklin in his Berlin picture, *The Elysian Fields*, have all used the theme of the Centaurs as the soul's companions to the Underworld and to the Islands of the Blest is evidence of the power of Zeuxis's lost painting.

SCULPTURE OF THE RICH STYLE

After the death of Pheidias, even the sculptors became fascinated by the lights and shadows of the new
25, 235 painting. The charming caryatids of the Erechtheion seem to be oblivious of the heavy weight of the architrave they must carry. With their free, open stance and supple forms they almost seem to be floating in space. Their garments have a shimmering life of their own, heightened by the play of light on their

many deep folds. Agorakritos of Paros must have used the modelling effects of light still more boldly in his Nemesis of Rhamnus.

Ionian artists seem to have been especially captivated by the play of light on surface textures. In his Nike at Olympia, Paionios of Mende has almost abandoned himself to it. The figure, very nearly 3 metres high, was originally on a three-sided pillar some 9 metres in height. The goddess sweeps through the air on great pinions; her left foot, placed somewhat forward, rests on a cloud through which sails an eagle, the bird of Zeus. The gentle curves of her body swell beneath the garments pressed against her by the wind. The cloak, which she held in her outstretched left hand, must have looked like a billowing sail, while the draperies streaming out behind her legs seem almost like the bow wave curling out from the prow of a ship. On high, with light streaming down onto her, she must indeed have appeared as a miraculous visitation. *236*

A series of such winged figures decorated a balustrade set up in the last decade of the fifth century on the high bastion of the Sanctuary of Athena Nike on the Acropolis at Athens. The temple side was smooth, but on the outer side ran a frieze, about 100 metres long, showing about fifty figures in a variety of poses, celebrating the theme of victory. The seated figure of Athena is repeated throughout the composition; she is surrounded by subordinate figures shown erecting trophies or decking them out, leading up sacrificial bulls or preparing the sacrifice. Despite the number and variety of the contributory elements, the whole festive scene achieves a harmonious unity and provides a sonorous finale to the century of High Classicism and the conclusion to the Periclean programme for the Acropolis.

Of all the surviving figures from this frieze of victory, the Nike bending to fasten her sandal is the most arresting. The natural charm of her pose and action expresses itself in circular movements; her chiton is loosened at the right shoulder while its rippling folds emphasize the beauty of the body beneath. The ridged *237* folds across the right leg and between the thighs, which then follow the line of the left leg, heighten the harmonious effect of this enchanting form.

Tombstone reliefs of about this time, which had revived in importance during the Classical period, inhabit a calmer world. The dead are portrayed as they looked during their lifetime. One shows a seated woman with a baby in one hand, a little bird in the other. The sad, silent dialogue of the two figures would suggest that they were mother and daughter, but a memorial epigram explains the case. Ampharete is saying, 'She is the darling child of my daughter. Just as in life, when we two looked on the light of the sun, I held her on my knee; so now in death.' An atmosphere of calm and nobility surrounds the figures of Hegeso and her servant in silent discourse with one another. The mistress has taken a trinket out of the jewel box and looks down at it with bowed head. She is shown sitting in her boudoir, as in life, not as a mere shadowy figure of Hades, receiving the respectful homage of the living.

COINS OF THE HIGH CLASSICAL PERIOD

A high standard of artistic achievement in die-engraving gave a special lustre to the coins of Sicily, and a special place in the coinage of the Greek world as a whole; and what is true for the earlier fifth century is again the distinguishing feature of the later fifth century. The richness of the coin types is evidence of remarkable vitality of spirit, and the actual engraving of the dies is characterized by a masterly precision, *239* to which the Sicilian coins of this period owe their outstanding beauty.

Syracuse stands pre-eminent among all the cities. Since the turn of the century, during the time of the great tyrants Gelon and Hieron, and again in the early years of the democracy from 465 B.C. onwards, a profusion of high-quality dies was in use. It was especially for the tetradrachms, showing a quadriga on the obverse and the head of Arethusa on the reverse, that these dies were made. The great tradition was fully maintained in all the exuberant variety with which the heads of Arethusa were depicted. From about 435 B.C. onwards, as if to emphasize even more the individual personalities of the artists, many of the tetra-drachms bear their signature. On the hair-band or below the truncation of the neck we find the names of Sosion and of the prolific Eumenes (who often signs both sides of the coin): soon these were joined by Euainetos and Eukleidas, who were working until the last decade of the fifth century and around 400 B.C., *239 (2/3)* respectively. On one, signed EYΘ (Euth . . .), there is a lively presentation of a chariot, seen in three-quarter view. This die is used in conjunction with three distinct Arethusa heads, one by Phrygillos and two by *Fig. 165 (1)*

Eumenes. A similar variety of pairings appears in the case of two chariot dies by Euainetos (to give only two further examples), one of which is paired with three Arethusa dies by Eumenes, the other with no less than four dies from the hand of Eukleidas. The use of an obverse die in conjunction with a number of reverse dies, which were apt to suffer more from wear in the striking of the coins, had been customary since the very first beginnings of coinage. It is interesting to see, however, that the execution of the dies for the obverse and reverse of the same coin could be entrusted to two or more artists. Euarchidas is known to *Fig. 165 (2)* have made the die for a splendid chariot, though he seldom signed his pieces. There are also engravers of some very fine heads who signed themselves IM and ΠΑΡΜΕ, respectively.

239 (6) The tetradrachm coinage of Syracuse reaches a climax with two pieces showing a head full-face. The creator of one of these, with a sublime head of Pallas Athena, was Eukleidas; the other, where the head of *239 (10)* the water-nymph Arethusa is rendered with every kind of girlish charm, was fashioned by Kimon. Both these artists must be regarded as pioneers; for within a few years of the appearance of these full-face heads in 413/412 B.C., the same treatment was accorded deities and mythological personages, inspiring enthusiastic *239 (7)* and widespread acceptance. Not far away, in Catana, the artist Herakleidas made his impressive full-face *239 (8)* Apollo and even a drachm with a frontal satyr's head. Then again from about 410–409 B.C. Thebes in Boiotia *240 (13)* adopted the frontal view for the head of Kabeiros; the northern Greek cities of Amphipolis and Ainos were *269 (6, 13)* not slow to follow suit, and their example produced an even wider range of imitations during the first half of the fourth century, as is shown by the coins of Thessalian Larissa in 395–343 B.C. and of Pherai in *270 (15/16)* 369–358 B.C. Moreover we encounter facing heads in Asia Minor, at Clazomenae, in Caria under Maussollos, at Rhodes, Lesbos, Lampsacus and Heraclea in Pontos, and finally on the coast of North Africa at Cyrene. A little before the middle of the fourth century the frontal pose of the head was adopted also in southern *270 (6, 13)* Italy, at Croton about 360, at Hyele about 350 and at Metapontum about 334 B.C.: this is not surprising in view of the proximity of these places to Sicily.

 It may be argued that to render a head in frontal view is scarcely consistent with the practical purposes of coinage. Yet it may be recalled that the facing pose of the Medusa head even in the sixth century was quite *137 (4)* a natural occurrence, as is shown by coins of Athens of 500–480 B.C. As early as the middle of the century, what is more, Chalkis in Euboia had the temerity to depict a whole quadriga in frontal view. Then again there were bulls' heads seen *en face*, at Athens 530–520 and Phokis 520–480 B.C. Likewise a facing lion's *240 (1), 270 (14)* scalp had been familiar at Samos as early as 600 and appears again at Rhegion after 461 B.C.

 The corresponding chariots on the Syracusan tetradrachms of Eukleidas and Kimon are very variously treated. Of the two chariots which go with the Pallas head by Eukleidas, one, though unsigned, is certainly *Fig. 165 (2)* the work of Euarchidas and shows a divine charioteer who must be Artemis Phosphoros holding a long torch in her right hand. The dynamic quality of the composition notwithstanding, a noble self-restraint *239 (10)* characterizes this goddess-driven chariot. By contrast, Kimon's chariot, on one of his two dies, conveys an unparalleled sense of strenuous movement, though the other die is less full of action. In the first there is at the same time a wonderful contrast between the head of the Nike, hovering in godlike and harmonious tranquillity above the head of the charioteer and the mounting excitement that possesses him and the horses, keyed up to fever pitch and surging forward in such a way as to give a quite explosive force to the composition.

239 (10) Kimon's full-face Arethusa head is unique among the coins of Syracuse in that both dies contain the name of the water-nymph written out in full. It is thus made quite plain that here at least she, and no other, is represented. Arethusa, seeking to flee the embraces of Alpheios the river-god of Elis, was transformed by Artemis into a stream which flowed under the sea to Sicily and which re-emerged on the Syracusan peninsula of Ortygia. Hence the water-nymph on Kimon's die is shown with her hair still floating as if in the water and with dolphins playing in and out of the loose locks. By a gradual process of assimilation, as we saw above (p. 288), the nymph came to be identified with Artemis, the original city-goddess and protectress of Syracuse. In another and earlier version of the myth, as we may see from Pindar's *First Nemean Ode*, it was not Arethusa but Artemis herself whom Alpheios tried to embrace in Ortygia: in which case Artemis must have been the goddess of the spring. Later on, as the concept of Artemis as a deity of natural fecundity receded and more prominence was given to her virginity, Arethusa appeared again as the beloved of Alpheios and the freshwater spring that bubbles up on sea-girt Ortygia became once again her own.[9]

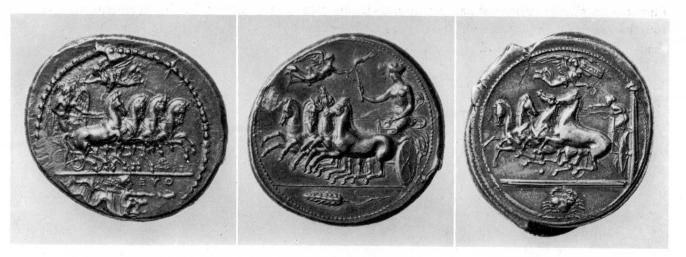

165　Tetradrachms with chariot types from the period of artists' signatures. 1 Syracuse, ca. 413/412 B.C. (signed Euth . . .).
2 Syracuse, ca. 412/410 B.C. (Euarchidas, but not signed). 3 Catana, ca. 410 (Euainetos). All 2:1

We still have to look at the Syracusan decadrachms. Even before Kimon's renowned Arethusa tetradrachms appeared, it seems that the first of the decadrachms engraved by Éuainetos had been issued. The *239 (9)* precise year of their origin is disputed but the end of the issue must have been in the year 393 B.C. By and large, it was a mass-production coinage whose total sum may be reckoned as approximately a million and a half drachmai, of which some four hundred and twenty-four pieces are still extant. Having regard to the enormous number of pieces minted, and also on stylistic grounds, it is more than likely that this coinage was inaugurated when Syracuse was at the very height of her power and the zenith of her political influence: in other words, about 422 B.C., two years after the congress of Gela at which Syracuse, thanks to her statesman Hermokrates, played the leading role. This same year saw the conquest of wealthy Leontini, as a consequence of which Syracuse's wealth was vastly augmented. Nine years later, in 413 B.C., the victories over Athens in the great harbour and on the Assinaros further increased—at least indirectly—the influential position and the resources of the city. All this leads to the conclusion that the great bulk of the Euainetos decadrachms was minted during the last two decades of the fifth century. A comparative study of their style *239 (11)* seems to point directly to these very years, when the rich full-blown Classical style was in its heyday. It would be misleading to assign the whole issue to the years of absolute rule by Dionysios I (394–370 B.C.) as has sometimes been done: the resources of the Syracusan economy at that time were not strong enough to make possible the issue of over a million and a half decadrachms.

It must have been roughly at the same time as the Arethusa tetradrachms, around 413 B.C., that the decadrachms engraved by Kimon were introduced. Thus the first dies appeared immediately after the overwhelming victory over Athens. The whole of this coinage can have lasted little more than five years, and the quantity of the Kimon decadrachms issued makes up barely one-third of those by Euainetos, some 152 specimens being accounted for at the present day. It is scarcely reasonable to place the beginning of this coinage as late as 405 B.C., the year in which Dionysios I had himself proclaimed στρατηγὸς αὐτοκράτωρ. He rose to be tyrant of Syracuse in spite of military defeats at the hands of the Carthaginians under Himilko, which had involved the abandonment of Gela and Camarina, the last cities on the south coast of Sicily that had remained after the fall of Selinus in 409 and of Acragas in 406 B.C. Stylistically, the Kimon decadrachms clearly point to a date in the years immediately preceding the last decade of the fifth century.

Of the 48 Arethusa dies of the Euainetos decadrachm series, 20 are signed by the master, always in a space below the truncation of the neck. The remaining 28 dies are products of his workshop and its milieu, but are often no less beautiful and splendidly executed. On all of them the main composition is virtually the same. The head is turned to the left and the hair, elaborately rendered, is adorned with a wreath of reeds, its sole decoration. Prominent is a large pendant earring, while around the neck hangs a pearl necklace. The earliest of these wonderful heads are the most charming and from them emanates an endlessly youthful, *239 (9)* virginal magic. The heads on Kimon's dies show more grandeur and restraint; the hair is made to look

more life-like through bolder cutting, and a meticulously rendered hair-net encloses a mass of locks that curve in towards the nape of the neck. This is the beauty of a more mature woman than Euainetos portrays. The high relief in which the heads by both artists are executed lends a perfection to the work that makes us inclined to forget that we have before our eyes simply a head on a coin and not a piece of full-scale sculpture. Where the chariots on the obverses are concerned, there is more moderation, even though the horses on many of Euainetos's pieces are shown galloping. On the Kimon decadrachms, indeed, the horse-team seems to move in a quite relaxed manner and to be carried along in a wonderfully even flow. On most of his dies Kimon worked his signature in minute letters on the edge of the ground-line. Below this, on the decadrachms of both artists, appear the ΑΘΛΑ in the shape of cuirass, helmet, shield and greaves. These give an indication of the prizes that the victor could expect to win in many contests, just as the chariot groups reflect how greatly a city rich in horses prided herself on her many chariot victories.

Finally, both Euainetos and Kimon participated in the engraving of dies for the gold hundred-litra pieces: these in monetary terms were, like the decadrachms, of very high value. Once again we see the head of *239 (5a)* Arethusa in profile, but now on the obverse, the reverse being given over to a group of Herakles in combat with the lion. The head of the nymph is invested with great charm; at the same time, in spite of the exigencies of space on a coin of barely 1·5 centimetres diameter, the struggle with the lion is dramatically *239 (5b)* conveyed in a manner that gives force and weight to the composition. The minting of these coins must be ascribed once again to the years of victory over Athens, continuing down to the first decade of the regime of Dionysios; that is, until about 395 B.C. To date this issue, as some have attempted to do, to the later part of Dionysios's reign, during the years 390–380, scarcely accords with considerations of style and history. At a period when the Syracusans were obliged to terminate their issue of tetradrachms and smaller coins, they are very unlikely to have undertaken a vast minting of decadrachms and hundred-litra pieces, which could only be used for bulk payments and not for ordinary daily currency.

We must turn now to the other Sicilian cities. The small Ionian town of Naxos produced at the time of *239 (1)* the Parthenon another exceptional coinage with the head of Dionysos on the obverse and a satyr on the reverse. Of the head, Furtwängler has remarked that it seems to be 'a fragment from the Parthenon', and Cahn that 'in fact it is very close to certain heads from the Parthenon frieze'.[10] It is, however, among the most important Sicilian coins of the years 430–420 B.C. and accordingly shows more affinity with the sculpture and vase painting of the end of the 'thirties than with the Parthenon frieze itself. Here Dionysos is shown as a mature man, though on the coins of the last years before the destruction of the city in 403 B.C. his face becomes beardless and takes on an almost girlish aspect.

Camarina produced a number of dies of the highest quality during the last decade of her existence, before being besieged by the Carthaginians and having her population transferred to Syracuse in 405 B.C. There

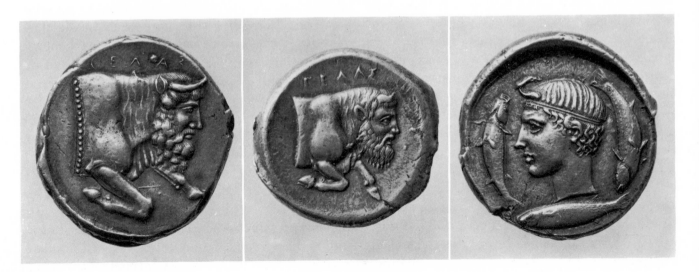

166 Gela. Tetradrachm reverses with the type of the river-god Gelas. 1 ca. 460 B.C. 2/3 ca. 420 B.C. All 2:1

384

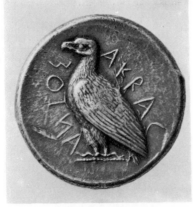

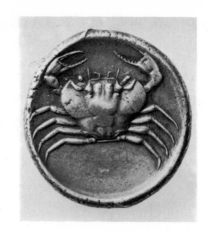

167 Acragas. 1/2 Obverse and reverse of tetradrachm, ca. 450 B.C. 3/4 Obverse and reverse respectively of two tetradrachms, ca. 420/415 B.C. 1.75:1

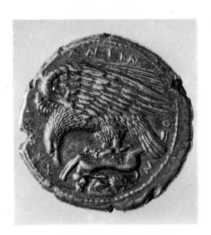

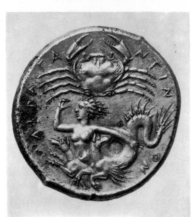

are chariots from the hand of Exakestidas, and also the head of the river-god Hipparis. Then there are chariots in rapid motion with Pallas Athena depicted as charioteer, and a head of Herakles on the reverse by Echekrates, signed EXE, in whose impressive style we still distinguish an echo of the Parthenon spirit. *239 (4)*

At Gela, too, work of considerable merit was produced in the latter part of the fifth century. The type of a bull's head with human face, symbolizing the River Gelas, is one that appears in a variety of renderings *197 (3)* from the reverses of the first coinage of ca. 495 B.C. until the destruction of the city in 405. Thus we have *Fig. 166* impressive testimony of the development of style over a span of some eighty years. Towards the end, around 420 B.C., comes a youthful head of the river-god where only the presence of a tiny horn serves as a reminder of the old human-headed bull. In spite of an interval of about fifty years, this tetradrachm of about 420 seems to reflect—consciously or unconsciously—some aspects of the Charioteer of Delphi, which had formed part of a dedication by Polyzalos of Gela.

Finally, particular mention must be made of Acragas. From the beginning of her coinage around 520 *Fig. 134 (3)* B.C., the types used were the eagle of Zeus and the sea-crab, on obverse and reverse respectively. These simple designs reached their artistic peak about 460–450 B.C. and thereafter remained unaltered until about *Fig. 167 (1/2)* 420. The fabulous wealth of this city and the vital energy of her citizens had enabled her to erect the first of her great temples barely fifty years after the foundation in 582 B.C., followed by a further dozen temples and shrines. In the same way the coinage received a fresh impetus, and from 420 B.C. until the tragic destruction of the city by the Carthaginians in 406 the products of the mint of Acragas must be accounted some of the most spectacular in Sicily. The eagle, which for a hundred years had appeared standing quiet and aloof, is now shown perched with open wings above its prey, the pregnant hare: and soon the single *Fig. 167 (3)* eagle gives place to a pair.

Instead of the crab alone there now appears a crab accompanied by a spiny fish and shortly afterwards *Fig. 167 (4)* by a Skylla. Then comes a further change. The pair of eagles is put on the reverse, while on the obverse

appears a victorious quadriga, notably on a die signed MYP. One of the dies with the pair of eagles bears

239 (12) the signature ΠΟΛΥ [ΚΡ] . . . , that of Polykrates. From the hands of these two artists come the unsigned dies of the famous decadrachms. These were minted to celebrate the Olympic victory of Exainetos, who brought glory to the city by winning the chariot race at Olympia in 412 B.C. and who on his return to Acragas was escorted by the leading citizens in two hundred chariots drawn by white horses.

239 (12a) The eagle of Zeus hovers above the chariot on the decadrachm. The driver of the four fiery steeds seems like one who has the Olympian gods for escort, and his fine body is peaceful and relaxed. The other side

239 (12b) with the pair of eagles is equally impressive. But similar types on the tetradrachms of this period, even the dies signed by Myron himself, cannot compare with the decadrachms.

The decadrachms of Acragas must have come into being in response to the desire of her ostentatious citizens to rival the rich and powerful Syracuse, with its many splendid decadrachms from the hand of Euainetos and Kimon. The Olympic victory of Exainetos provided just the right occasion. Posterity acclaims the ambitious spirit of the Acragantines which resulted in the production of one of the most splendid coins in the whole of the Greek world. Yet five years later the city was razed to the ground. A traitor from within succeeded in opening one of the city gates to the enemy at dead of night. In this same night one of the greatest cities in the whole of Greece fell in dust and ashes.

Three years before, in 409 B.C., the same fate had over taken Selinus, a city likewise resplendent in the beauty of her seven great temples and her numerous smaller shrines. Selinus continued to produce a fine coinage up to the day of her destruction. On the reverse of the tetradrachms there is still the river-god

197 (5) Selinus who continued to be the main coin type known from 467 B.C. onwards. Here we reproduce a die which shows particularly fine modelling in the body of the young god, in the true spirit of the developed

239 (13) style current in 417–409 B.C. From 467 on, the obverse was adorned with a quadriga driven by Artemis and Apollo: the latest die, made in the very year of the city's annihilation, is illustrated here; the horses, in semi-profile, are seen galloping, but instead of being driven by the two healing and propitious deities as before, Nike holds the reins. This must commemorate the victory over Athens in 413 B.C., when Selinus, according to Thucydides, was a stout ally of Syracuse. Yet this very victory spelt the overthrow of Selinus: for Syracuse had after the victory claimed for Selinus a large area of territory in the vicinity of Segesta, which was closely allied to Athens. Segesta, however, turned to Carthage, the arch-enemy of the Sicilian Greeks: and Carthage then appeared in overwhelming strength to take up the struggle against them. Selinus was the first of the Greek cities to fall.

South Italy produced some important coinages in the second half of the fifth century. A number of these belong to the very years when the Parthenon sculptures were being made. After 461 B.C., the year when the sons of the tyrant Anaxilas (who died in 476) had been driven out, Rhegion chose to replace the mule-

270 (14) chariot, connected with Anaxilas's Olympic victory in the mule-race in 480, by a lion's scalp that was

240 (1) thereafter retained until the end of the tetradrachm series in 356–351 B.C. The tetradrachm we illustrate was made about 435 B.C.: on the reverse it shows Iokastos, the mythical founder of the city. For nearly forty years from 461 onwards he was almost always depicted as an old man, but just at the time of the Parthenon he is given a splendid form that recalls the seated deities on the eastern side of the Parthenon frieze.

Terina, a foundation from Croton, started to mint staters about 480–460 B.C.; at first their workmanship is rather stiff, but then from 445 until the end of the coinage shortly before the middle of the fourth century comes a dazzling collection of gem-like pieces. On the obverses of these, we have a superb head of the nymph

240 (2/3) Terina resulting from die-engraving of unsurpassed delicacy. The reverse types, which always depict Nike, are perhaps the most fascinating work of all. The florid style that we know from the vase paintings of the

240 (3) Eretria Painter of around 420 B.C. was already being applied to staters of 425–420 B.C. such as those here illustrated. Seated on a hydria, with caduceus in her right hand, Nike dallies in the most graceful manner with a little bird that perches fluttering its wings on the finger of her left. The corresponding obverse with the head of the nymph is signed φ, the initial of the name Phrygillos; this, together with the bird, a finch (φρυγίλος), on the reverse type, points to an artist of this name who made various dies for Terina during

386

the years 425–420 B.C. He also appears on the early staters of Thurii and is probably the same man who engraved three important Arethusa head dies for Syracuse (see p. 383).

Taras with her coin dies showing Taras Oikistes, the earlier examples of which were mentioned in our *198 (2)* treatment of the coins of the earlier fifth century, went on to produce a magnificent series during the years of the Parthenon: according to Vlasto, the best authority on these coins, the greatest of them is the one *240 (5)* which we illustrate. This version of Taras seems to come somewhere near the quality of Pheidias himself.

For a coinage of truly noble character we may look to Thurii. This panhellenic colony was founded from Athens under the influence of Pericles in 443 B.C. on the site of Sybaris, the Achaean city destroyed by Croton in 510 B.C., whereupon the old Sybarite emblem, the bull, was transformed and given a new *138 (3)* lease of life on the reverse of the Thurian coins. The obverses, continuing down to the cessation of minting at the time of the siege by the Romans in 282 B.C., show the head of Pallas Athena. Perhaps the most outstanding dies are those used for staters issued around 425 B.C. soon after the foundation, showing the head of Athena in a helmet decorated with a wreath of olive. The example reproduced here is the work of *240 (4)* Phrygillos whose acquaintance we have made at Terina. On the reverse, his signature occurs in two forms— below the bull is a finch (phrygillos) and on the upper part of its hind leg is a letter φ. The distaters too, which apart from the very first were minted after 413 B.C. and during the fourth century, are often of very high artistic merit, not only as regards the Athena head but also the butting bull, powerfully portrayed. Many of these distaters, too, carry artists' signatures. Only the earliest shows the olive wreath on Athena's helmet whereas all the rest, which clearly began after 413, have a large figure of Skylla in that position. The olive wreath was the symbol of victory after Marathon and Salamis, and if its appearance on the helmet of Pallas is an allusion to the power and influence of Athena as foundress of the city, then we should view the Skylla as an apotropaic emblem—for, from 413 B.C. onwards the military and naval might of Athena was progressively destroyed.

In Asia Minor, for the period which we are discussing, there are no momentous developments to record, apart from the further evolution, often in very beautiful forms, of motifs that had already been in use on earlier coins. The Greek mainland, however, in spite of the interruption of minting in most of the cities consequent upon the Athenian decrees prohibiting coinage by members of the Delian league, did produce a number of coin types of the greatest importance, at least in those areas which were unaffected by the Athenian decrees.

Elis had started her coinage around 510 B.C., but it is clear that the issue was by no means continuous, since it was made intermittently at four-year intervals corresponding to the Olympic Games which drew competitors from all over the Greek world. The rarity of the coinage which survives strongly suggests that it consisted, not of money in the sense of normal currency, but rather of commemorative pieces made up in the form and weight of regular silver staters, for the use of the competitors and spectators of the games present at Elis. The needs of a festival that had special prominence in the Greek mainland would seem to be met by these pieces, which show a richly ornamented thunderbolt. We have already seen the eagle of Zeus on a superb die from the earliest period of coinage around 510 B.C., and this and the *137 (7)* thunderbolt on the reverse together constitute the earliest coin themes. These were, however, soon joined by representations of Nike, who here, of course, does not stand as symbol of victory in war but success in the great athletic competitions. The flying Nike, holding a victory wreath in her hands, dates from the years *240 (6)* 452–448 B.C., taking in the 87th or 88th Olympiad, and thus belongs to the turning-point of the High Classical style: she is one of the most splendid and vital examples in the whole range of the Elean coinage. Hardly a whit inferior is the stater of the years 432–420 B.C. showing Nike resting on a plinth and with *240 (7)* a palm branch in her hands.

After 438 B.C. Pheidias was summoned to Olympia to make the chryselephantine statue of Zeus Enthroned. This became one of the most renowned works of art of antiquity, one of the seven wonders of the world. Perhaps the truest image of this head we possess appears on a sestertius of the time of Hadrian *Fig. 151* (see p. 357). The years that saw the birth of Pheidias's work also witnessed the minting of a stater with the head of Zeus, which we illustrate here—the first Zeus head in the series of Elean coins. Over thirty years *240 (8)*

earlier a stater showing the older, pre-Pheidian cult image, a striding Zeus wielding a thunderbolt, was minted; this survives in a unique example recently found. The Zeus head on the coins has a noble look and a piercing gaze but we miss the kindly nod (κατανεύειν) that comforts and uplifts human beings in their need and to which the Pheidian statue must have given such wonderful expression.

240 (9) Of special beauty is the stater with the great eagle's head, also from around 421 B.C. Nowhere else in the range of Greek coinage is the head of the royal bird, sacred to Zeus, endowed with such stern grandeur.

At about this time a second mint was set up at Elis in connection with the Temple of Hera. We reproduce
240 (10) here one of its first staters, all of which portray on the obverse the head of Hera, consort of Zeus; the reverse carries the thunderbolt for some four decades and then, from 385 B.C., the eagle of Zeus.

240 (18) Before leaving the area of the Peloponnese, we must mention some of the staters of Corinth from the
137 (2) years 450–440 B.C. This wealthy city was conservative in the types of its coins, on whose obverse Pegasus appears; on the reverse, from the last decades of the sixth century onwards, the original incuse square turned more or less into the shape of a swastika was replaced by a head of Pallas Athena in a Corinthian helmet.
186 The stater shown here calls to mind the 'Mourning Athena' from the relief of the Athenian Acropolis even though the latter, whose expression is more intensely spiritual, may have been made a little later. Nevertheless, we can detect a distinct affinity.

The staters of Melos dating to the third quarter of the fifth century display types such as a Hermes head,
240 (19) a Gorgon and the apple (melon) as the canting emblem of the island city: also a ram's head that is a particularly fine piece of work.

Many of the coins of Crete, though somewhat rough in execution, were boldly conceived; and this
240 (20) applies to the group of Europa on the bull, designed at Gortyna about 450 B.C. Here, beneath a giant plane-tree, Zeus consummated his love with Europa whom he had found playing on a Phoenician shore, and assuming the form of a bull, had carried away to Crete.

Thebes, as a direct result of the oligarchic revolution in Boiotia and the victory over Athens at Koroneia in 447 B.C., had liberated the whole of Boiotia (except Plataia) from Athenian domination. With the new constitution of the Boiotian league, a small number of remarkable dies were made for Theban staters such as those showing Harmonia, the wife of Kadmos, mythical founder of the city, or those with Herakles
240 (11/12) exerting his muscle-power to string his bow. The idea behind these coins brings in memories of Kadmos, and the legendary past of Thebes is evoked by the representations of Herakles, who had been sired by Zeus on Alkmene the wife of the Theban prince Amphitryon. The figure of Herakles is, however, given prominence here not merely on account of his special connection with Thebes but more still as exemplifying victorious male strength and thus as a symbol of the victory of Koroneia. These types make a strong contrast to the normal rather monotonous character of the Boiotian coins, which from the middle of the sixth century right down to the third century B.C. regularly display on the obverse a shield—an emblem that is related to the manufacture of shields from the hides of cattle, thus making a verbal play on the word βοῦς, an ox, from which the name of the Boiotians was derived. Once again, the monotony was interrupted about 426 B.C. by a head of Herakles seen in frontal view and rendered in low relief, and by a facing head of
240 (13) Kabeiros—here portrayed in very similar guise to Dionysos—who had a famous sanctuary near Thebes. Made in 410 B.C., this is the oldest coin type produced on the soil of the Greek mainland showing the clear influence of Kimon's Arethusa, Eukleidas's Pallas and Herakleidas's Apollo.

In the region of northern Greece, Mende in Chalcidice produced a rich series of splendidly engraved coin
240 (15) types towards the middle of the fifth century. These show Dionysos riding on his donkey, drowsy with wine yet still managing to appear truly godlike. Thasos, the Thracian island, had from Archaic times onwards
198 (8) displayed on her coins the love-play of satyr and maenad: and a specially fine tetradrachm from the Early
240 (16) Classical period is reproduced here. We see the traditional scene adopted to the full Classical style; less crude than the earliest dies and less full of masculine vigour than those of around 465 B.C., this is work of an essentially restrained character.

198 (9) Ainos in Thrace, whose Hermes from the time of the Olympia sculptures we have already seen, achieves one of the happiest versions of this head in the period of developed fifth-century style, about 412–410 B.C. By contrast, the effect produced by the contemporary head of Apollo on the tetradrachms of Olynthos is

388

more astringent. Olynthos was the centre of the Chalcidian league, and its tetradrachms are to be dated 240 (17) from the decade after the league's foundation, about 420 B.C., lasting until the destruction of the city by Philip II of Macedonia in 348. These tetradrachms give us a rich series of Apollo heads in renderings of the greatest vitality, and the series as a whole brilliantly illustrates the gradual transformation which took place between the style of the late fifth century and the developed style of the fourth. 269 (4/5)

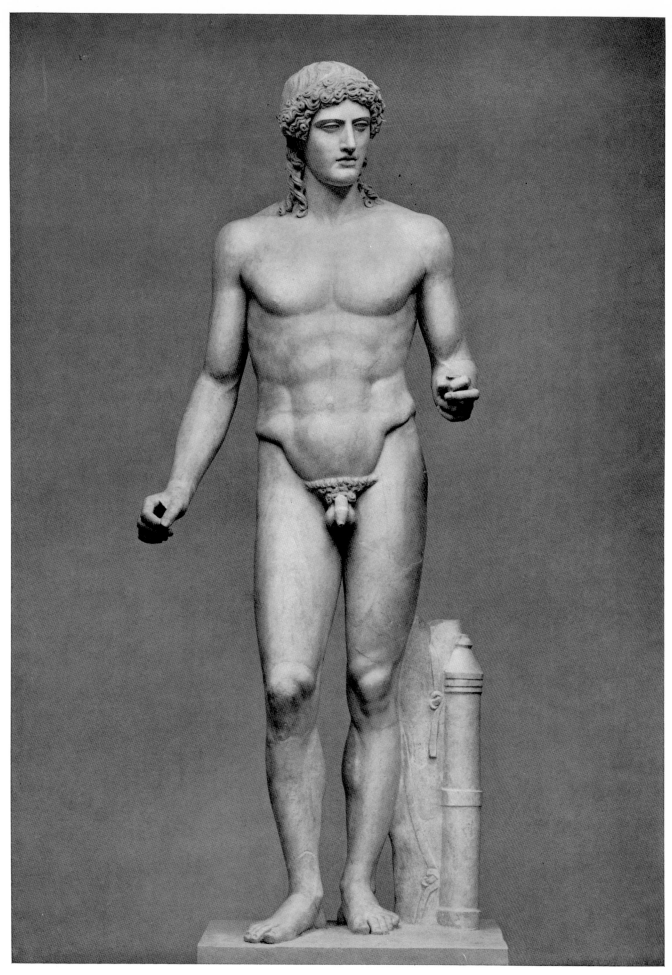

199 Apollo. Marble replica of an original bronze by Pheidias of before 450 B.C.
Height 1.97 m. Kassel

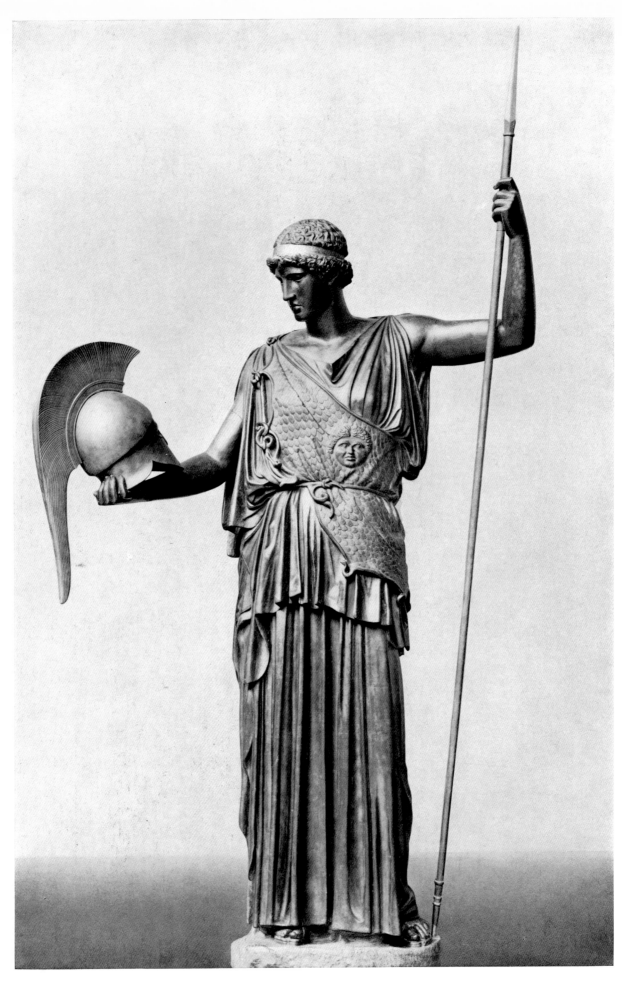

200 Athena Lemnia. Marble replica of a bronze statue by Pheidias of before 450 B.C.
Height 2.00 m. Dresden, Staatliche Kunstsammlungen

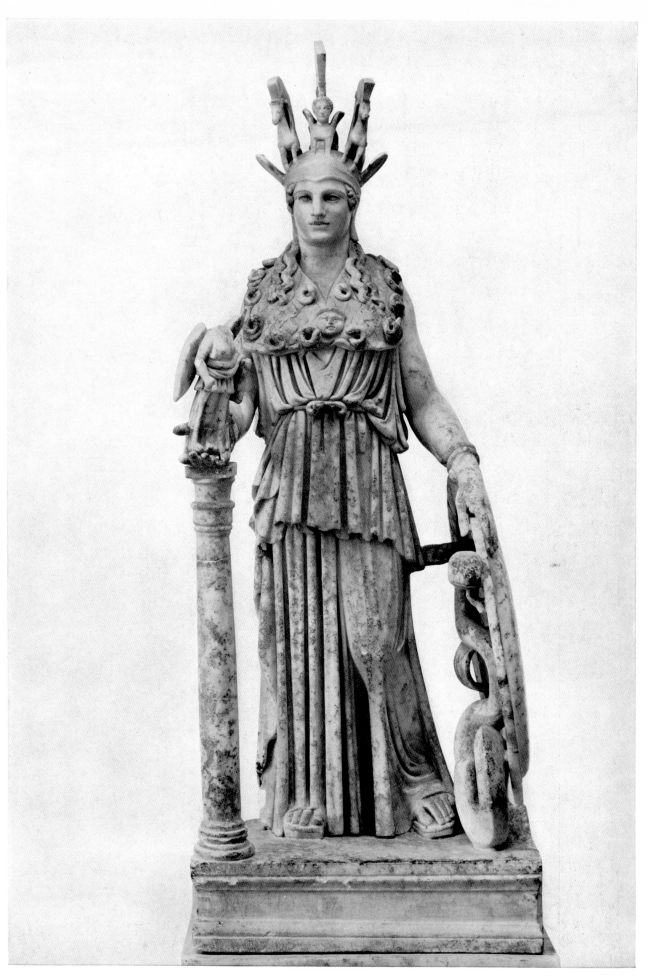

201 Athena Parthenos. A very small-scale marble replica (the so-called Athena Varvakeion) of the chryselephantine statue, formerly in the Parthenon, by Pheidias who completed it in 438 B.C.
Height 1.05 m. Athens, National Museum 129

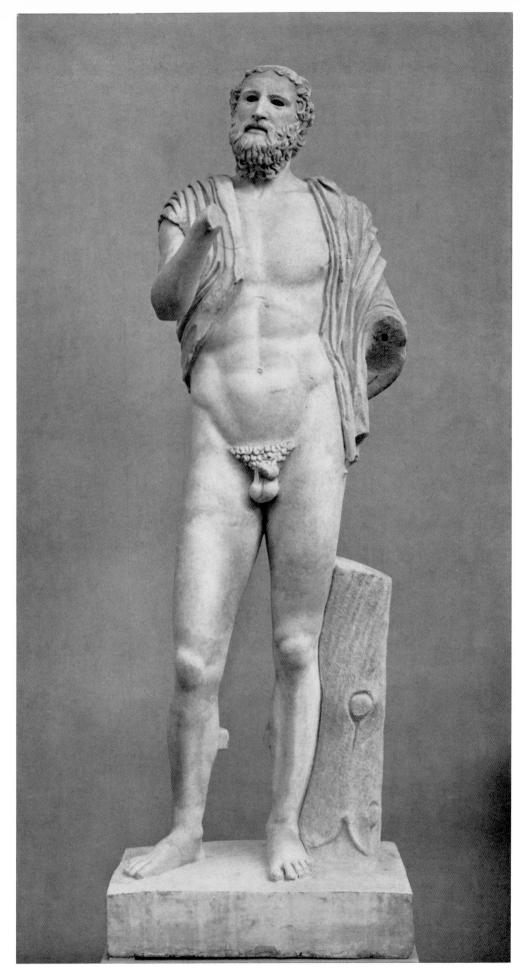

202 Anakreon. Marble replica of a bronze statue by Pheidias of shortly after 450 B.C.
Height, excluding plinth, 1.98 m. Copenhagen, Ny Carlsberg Glyptotek 409

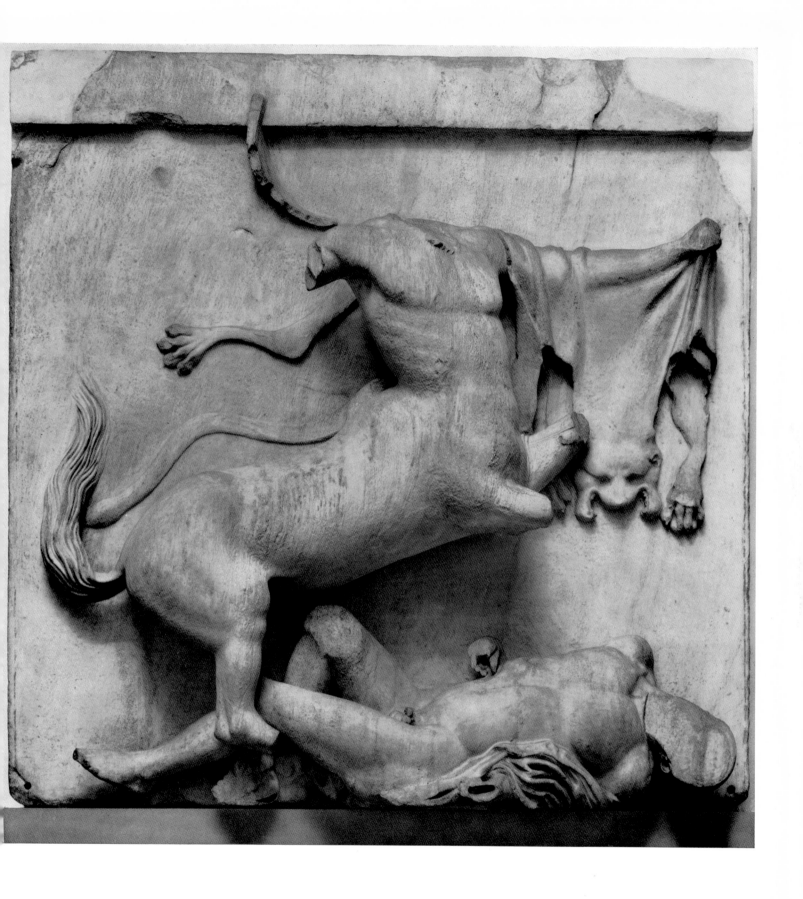

203 Metope XXVIII from south face of the Parthenon on the Athenian Acropolis. Centaur triumphing over a dead Lapith. Pentelic marble. Height 1.34 m. Ca. 448–442 B.C. London, British Museum

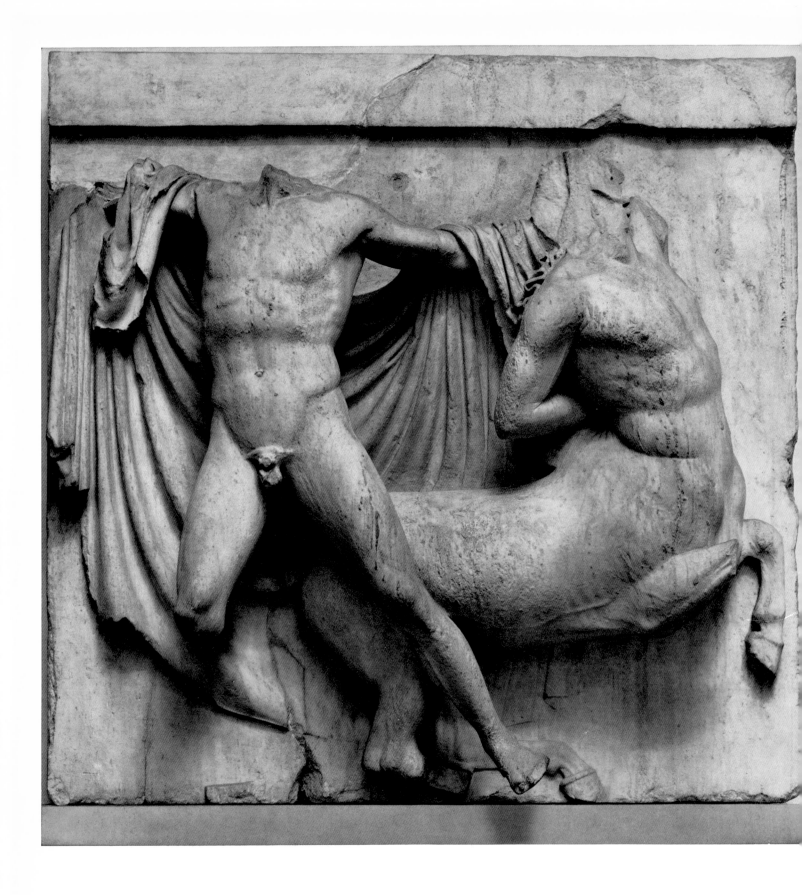

204 Metope XXVII from south face of the Parthenon on the Athenian Acropolis. Lapith fighting with a Centaur.
Pentelic marble. Height 1.34 m. Ca. 448–442 B.C. London, British Museum

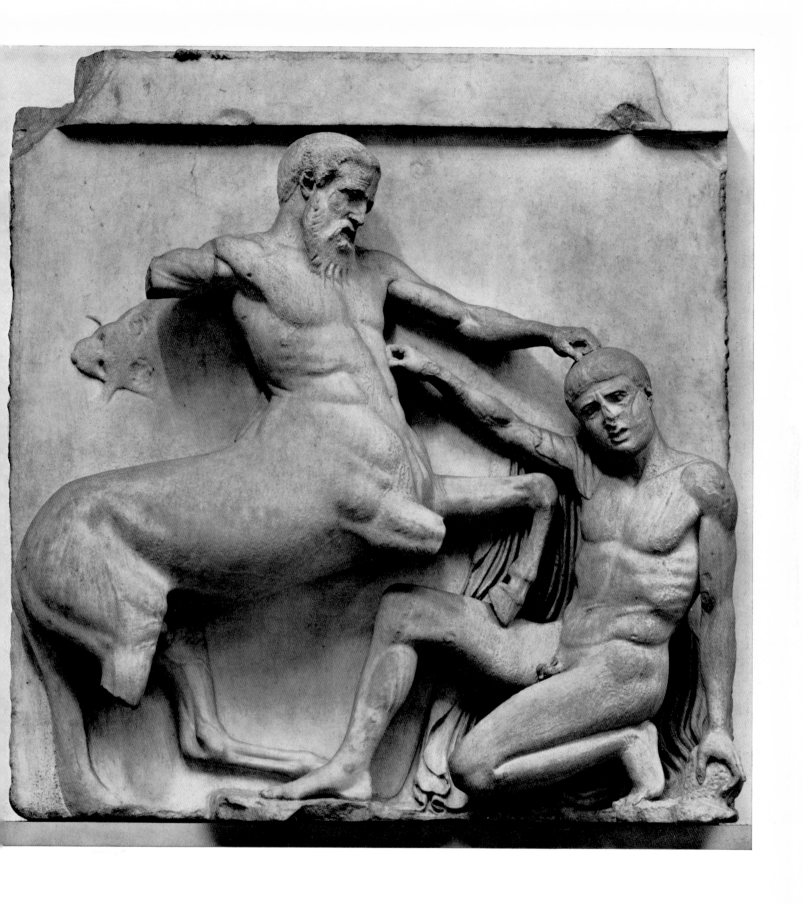

205 Metope XXX from south face of the Parthenon on the Athenian Acropolis. Centaur fighting a Lapith who has dropped on one knee. Pentelic marble. Height 1.34 m. Ca. 448–442 B.C. London, British Museum

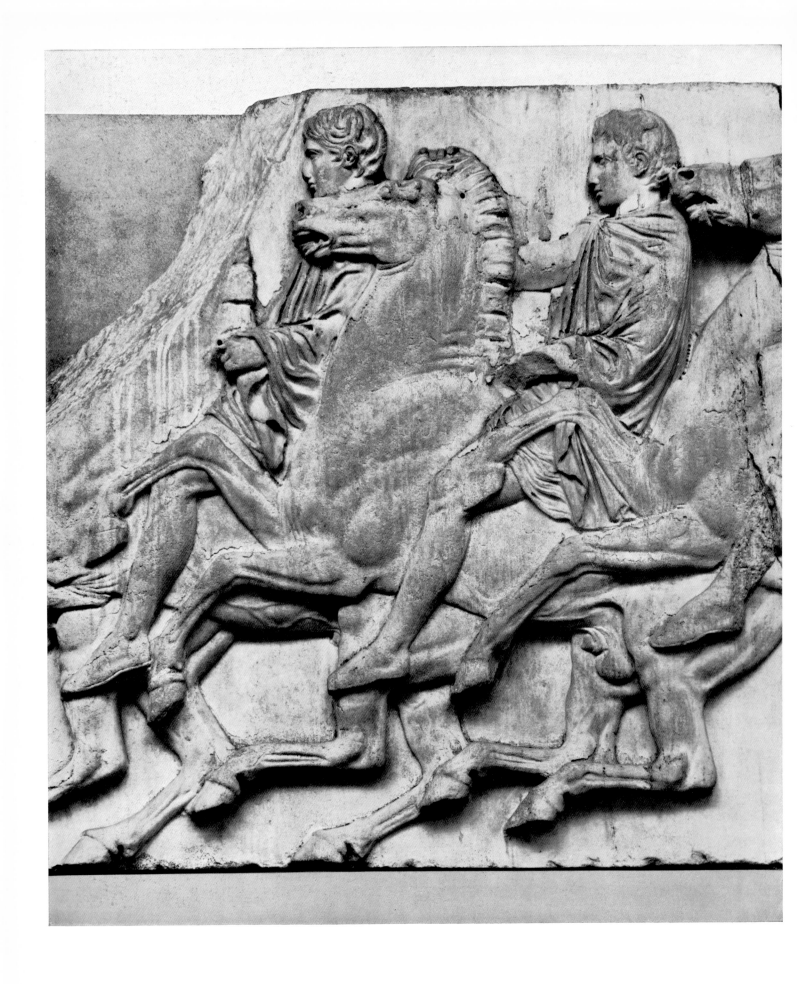

206 From north frieze of the Parthenon on the Athenian Acropolis, slab XXXVII/114–115. Equestrian group.
Pentelic marble. Height 1.06 m. Ca. 442–438 B.C. London, British Museum

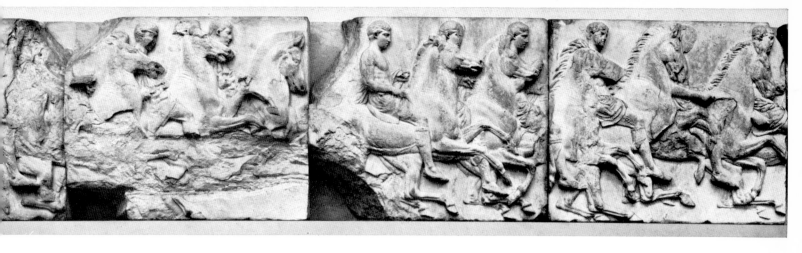

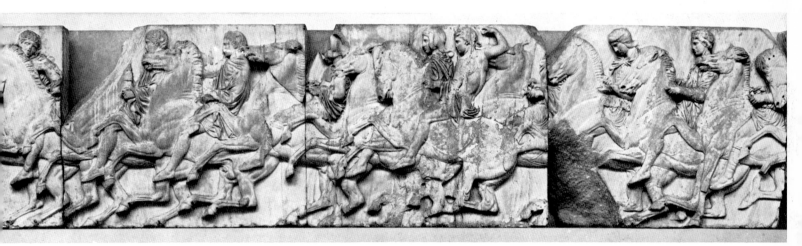

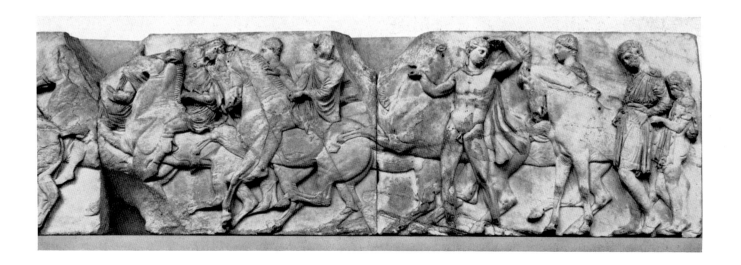

207 From the friezes of the Parthenon on the Athenian Acropolis. Equestrian groups.
Above: from south face, slabs VIII–XI/22–31;
middle and below: from north face, slabs XXVI–XXIX/112–122 and XLI–XLII/126–134.
Pentelic marble. Height 1.06 m. Ca. 442–438 B.C. London, British Museum

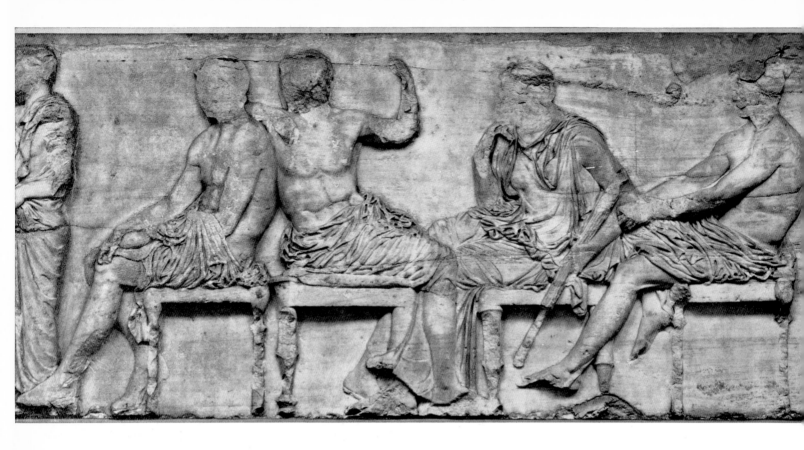

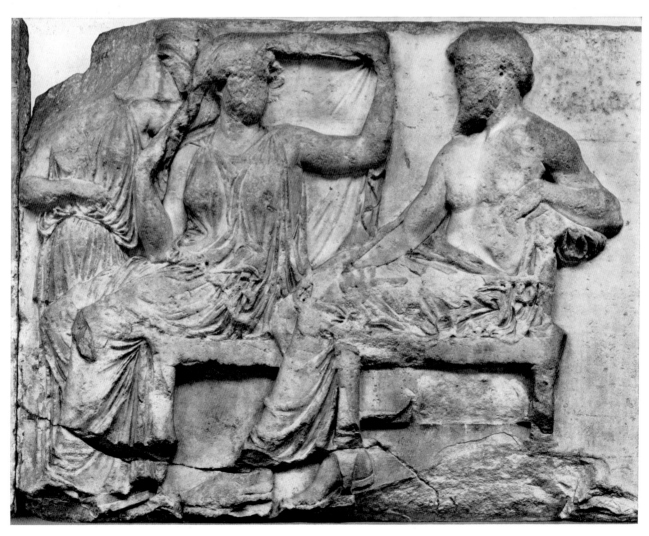

208 From east frieze of the Parthenon on the Athenian Acropolis. Main part of Panathenaic procession.
Above: Deities Hermes, Dionysos, Demeter, and Ares, slab IV/24–27; below: Hera with Iris and Zeus, slab V/28–30.
Marble. Height 1.06 m. Ca. 442–438 B.C. London, British Museum

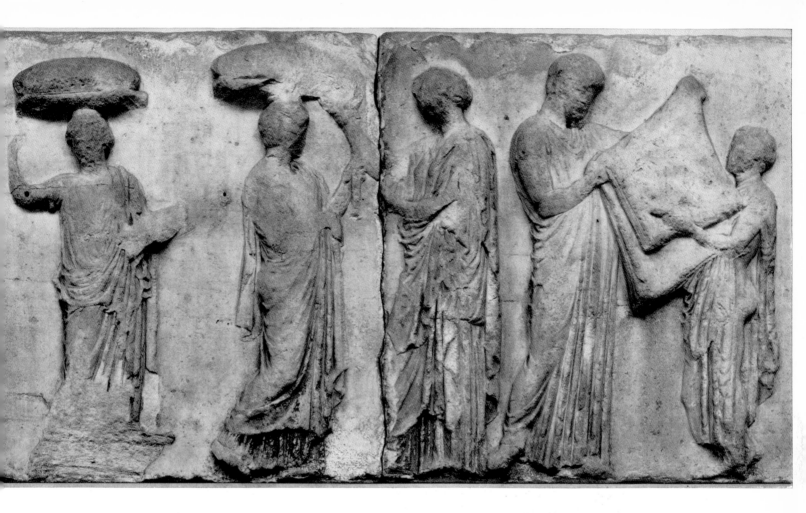

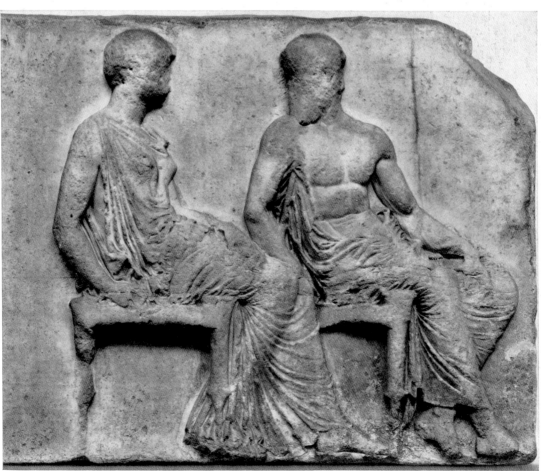

209 From the east frieze of the Parthenon on the Athenian Acropolis. Main part of Panathenaic procession, continued.
Above: Priests and attendant with the peplos ready for presentation to Athena, slab V/31–35;
below: Athena and Hephaistos, slab V/36–37. Marble. Height 1.06 m. Ca. 442–438 B.C. London, British Museum

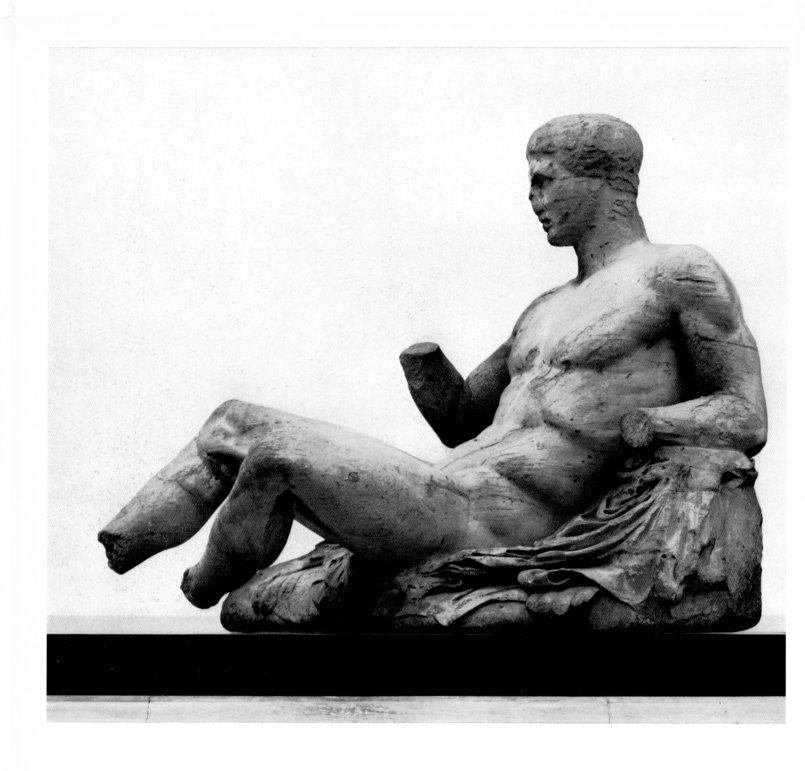

210 From the east pediment of the Parthenon on the Athenian Acropolis. Dionysos.
Pentelic marble. Height 1.21 m. Ca. 437–432 B.C. London, British Museum

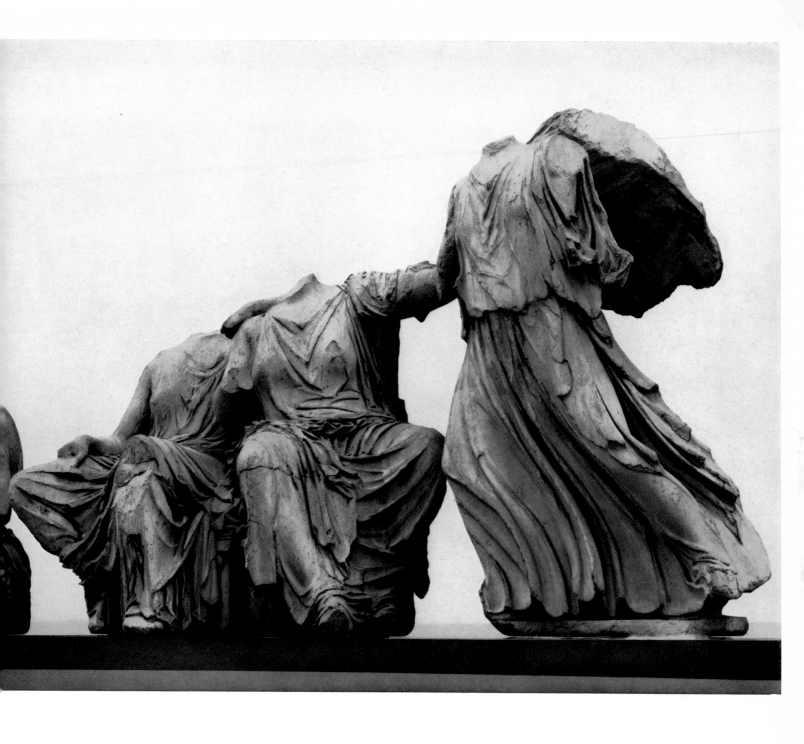

211 From the east pediment of the Parthenon on the Athenian Acropolis. Kore, Demeter and Hebe. Pentelic marble. Maximum height, with plinth, 1.73 m. Ca. 437–432 B.C. London, British Museum

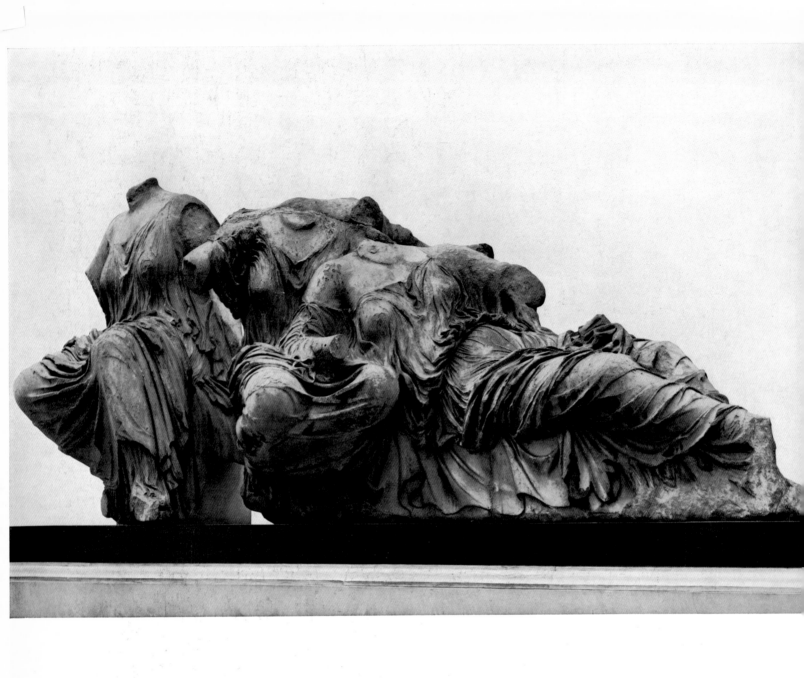

212 From the east pediment of the Parthenon on the Athenian Acropolis. Leto, Dione, and Aphrodite.
Pentelic marble. Height 1.00 m. Ca. 437–432 B.C. London, British Museum

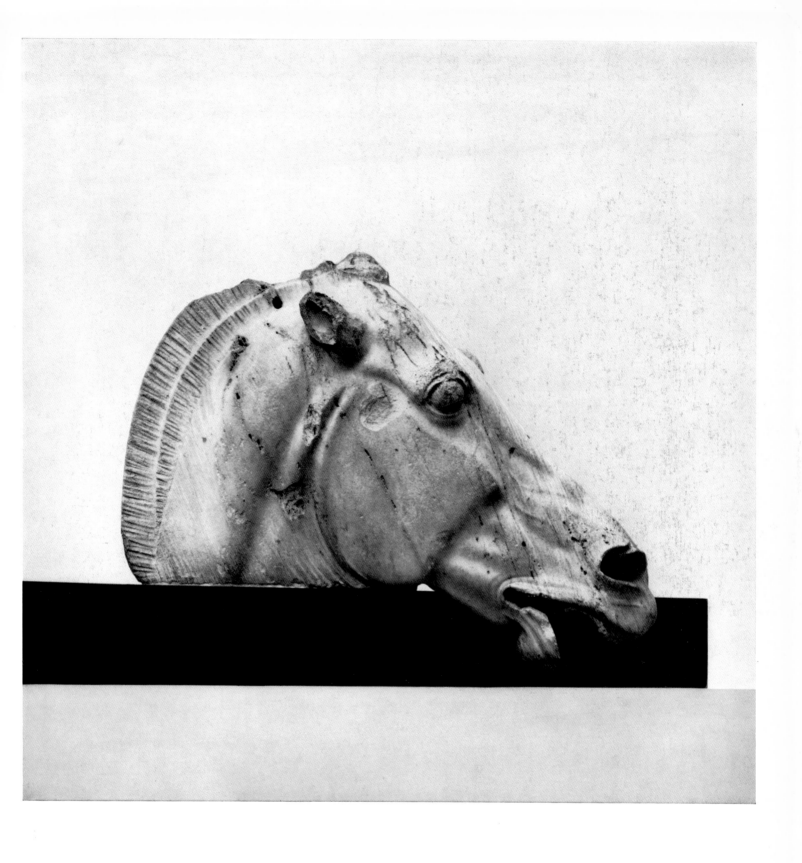

213 From the east pediment of the Parthenon on the Athenian Acropolis. Horse's head from Selene's quadriga.
Pentelic marble. Ca. 437–432 B.C. London, British Museum

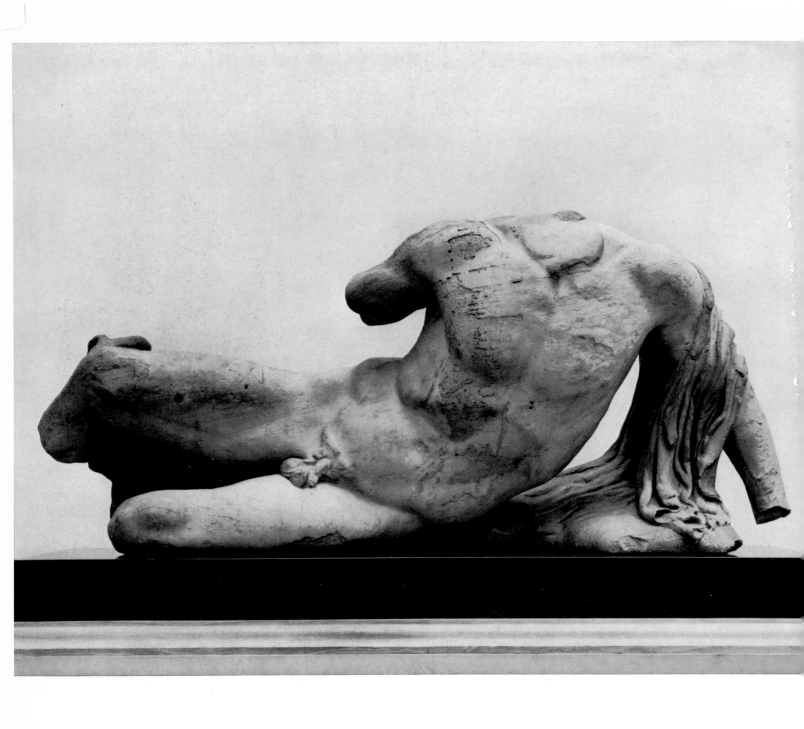

214 From the west pediment of the Parthenon on the Athenian Acropolis. 'Ilissos'.
Pentelic marble. Height 82 cm. 437–432 B.C. London, British Museum

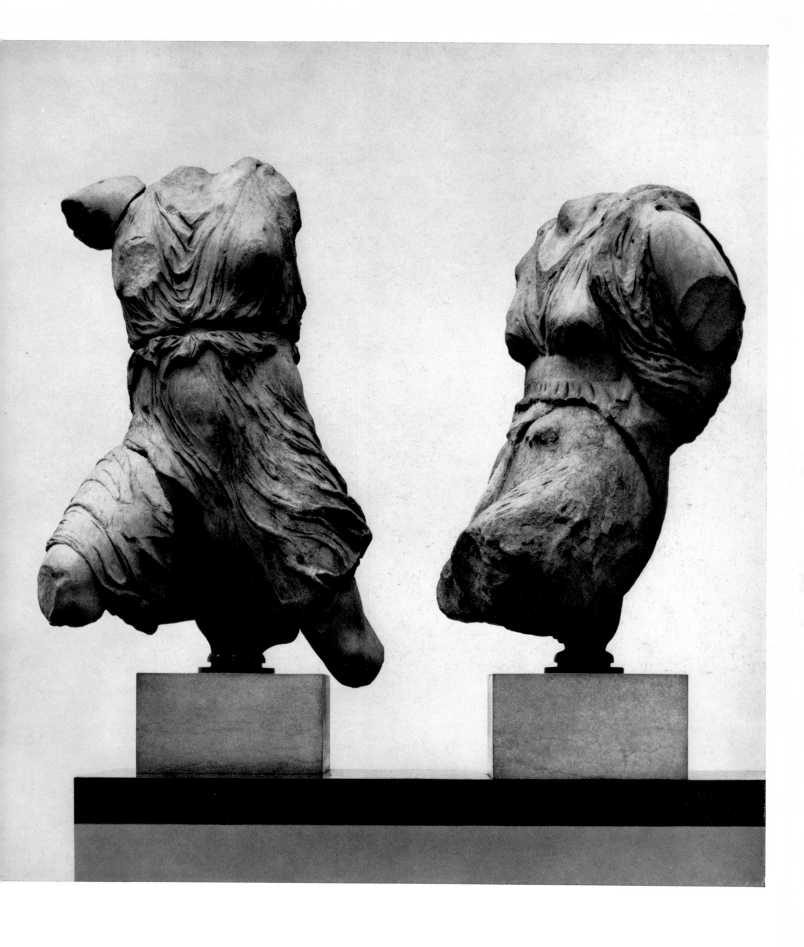

215 From the west pediment of the Parthenon on the Athenian Acropolis. Iris (left) and Amphitrite (right).
Pentelic marble. Height 1.25 m. Ca. 437–432 B.C. London, British Museum

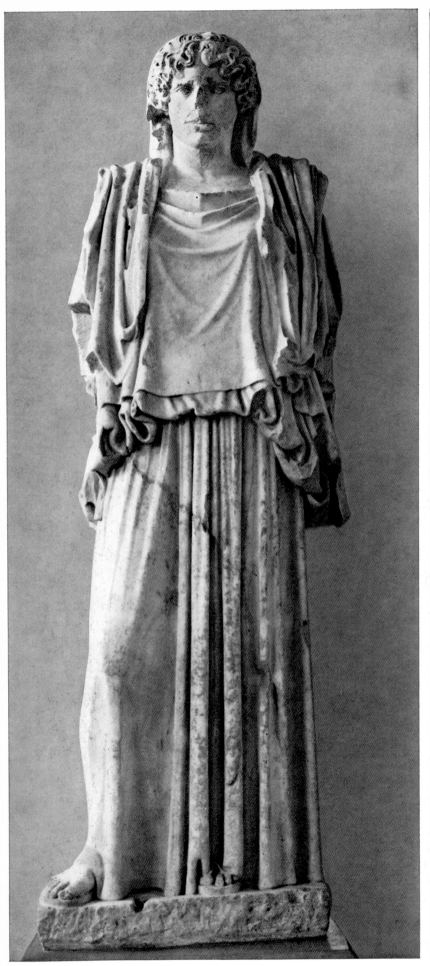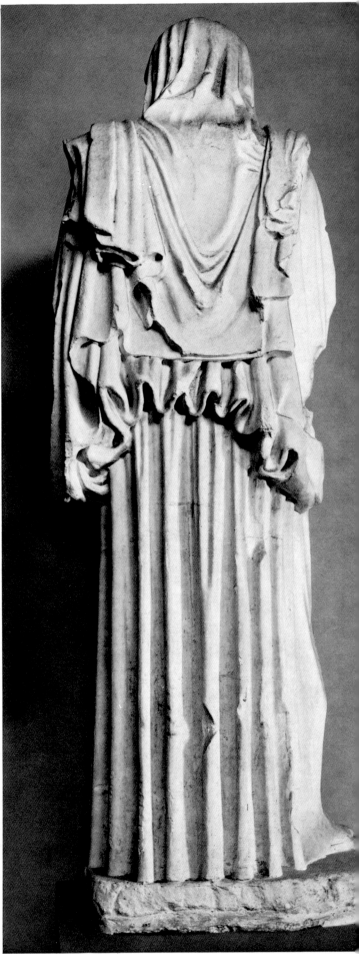

216 Aphrodite, the so-called Cherchel Demeter. Marble replica of bronze statue made by Kalamis ca. 445 B.C. for Kallias and set up on the Athenian Acropolis. Height 2.10 m. Cherchel (Algiers) Museum

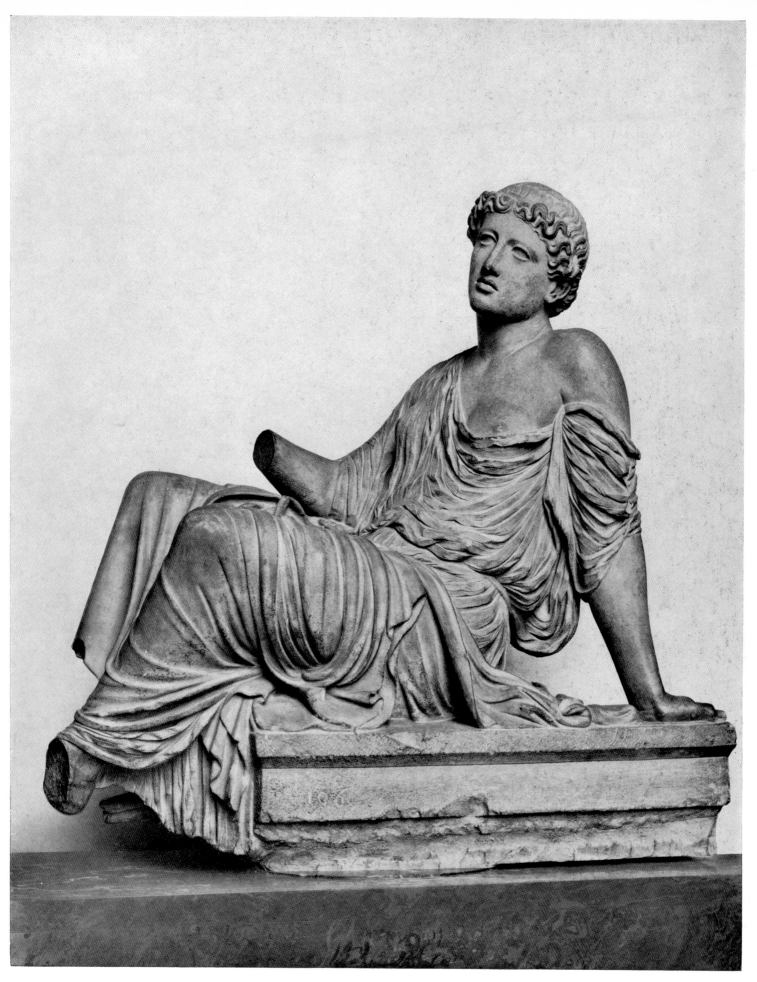

217 Alkmene, the so-called Barberini supplicant. After an original bronze by Kalamis of 440–435 B.C.
Marble. Height 98 cm. Paris, Louvre 3433

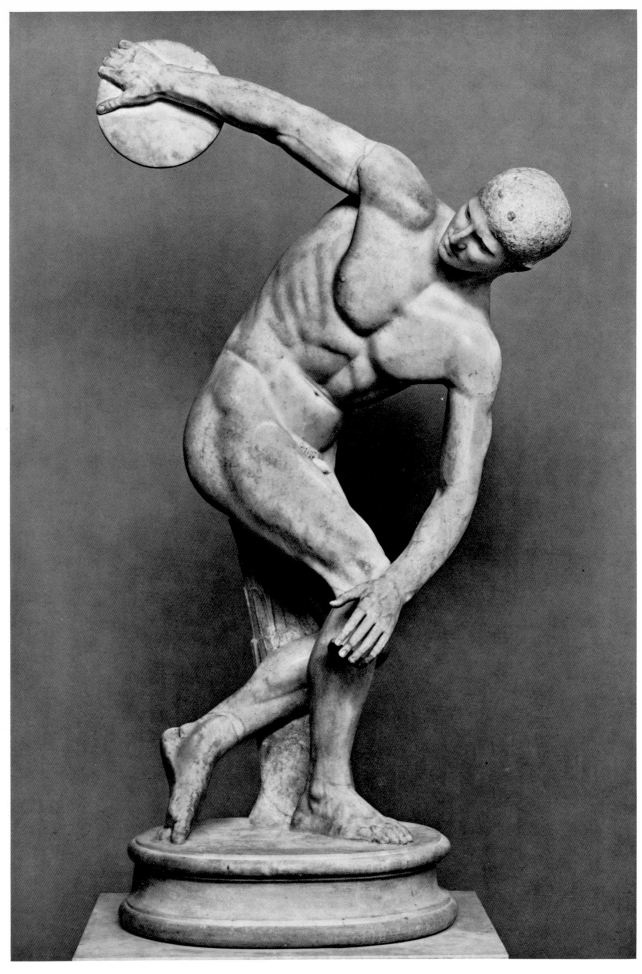

218 So-called Lancelotti Diskobolos. Marble replica of a bronze original by Myron of the mid 5th century B.C.
Height 1.53 m. Rome, Museo delle Terme

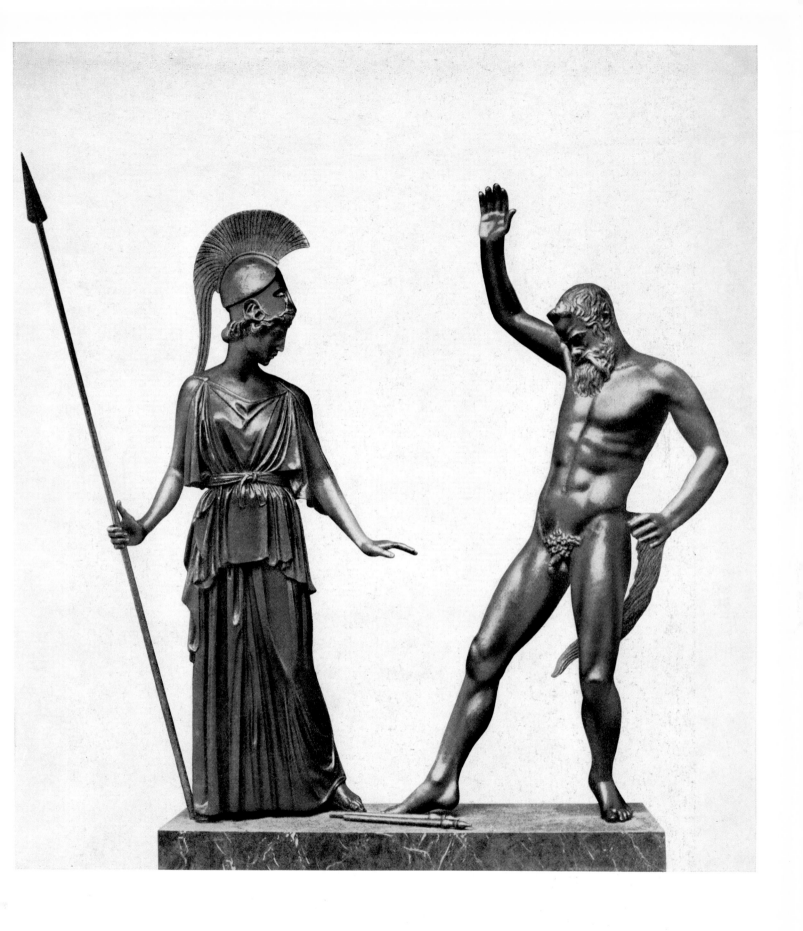

219 Athena and Marsyas. Bronze cast from a bronze original by Myron from after 450 B.C., on the Athenian Acropolis.
Height of Marsyas, about 1.60 m. Formerly Stettin, Museum

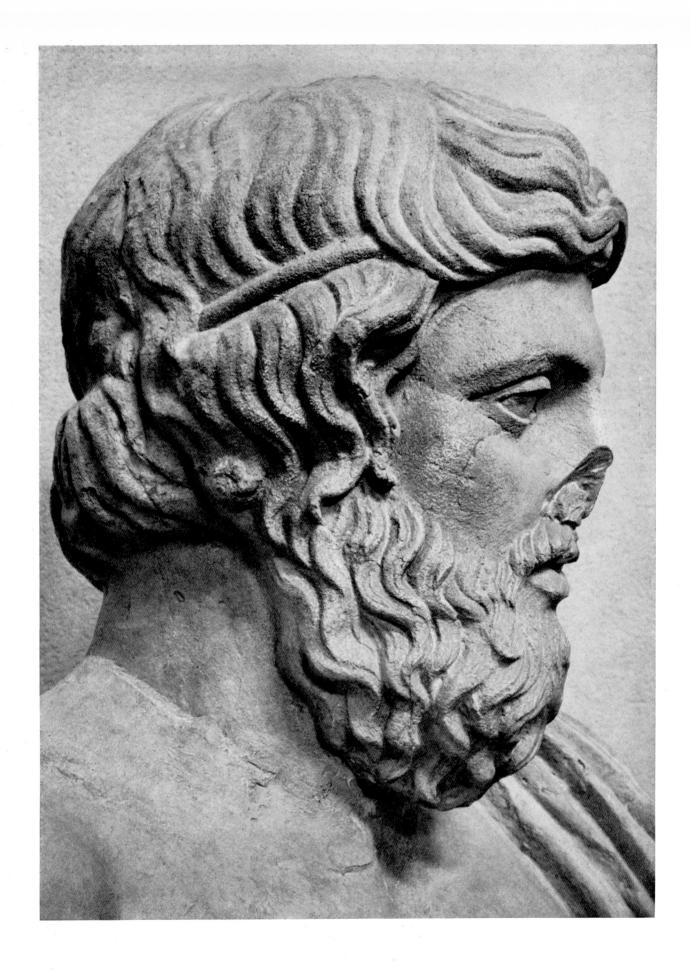

220 Head of Erechtheus. Marble copy of a bronze statue by Myron of ca. 450–440 B.C.,
believed to be from the Agora in Athens. Height from top of head to break 54 cm. Florence, Giardino Boboli

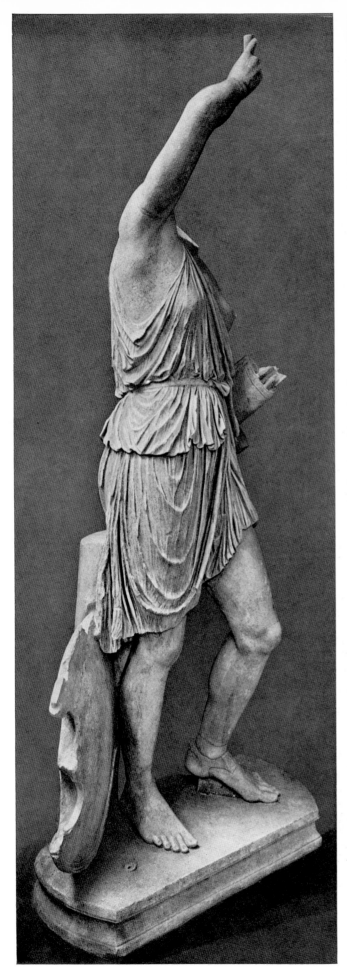
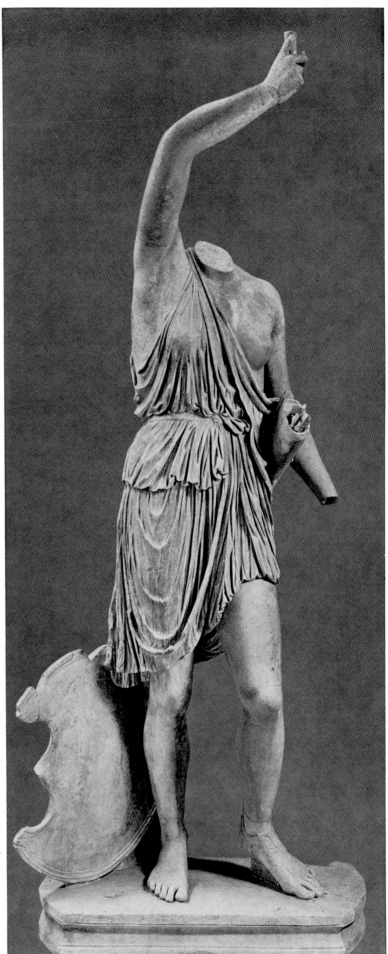

221 So-called Mattei Amazon. Roman copy of a bronze original by Pheidias of ca. 440–430 B.C. set up in the Artemision at Ephesos. Tivoli, Hadrian's Villa

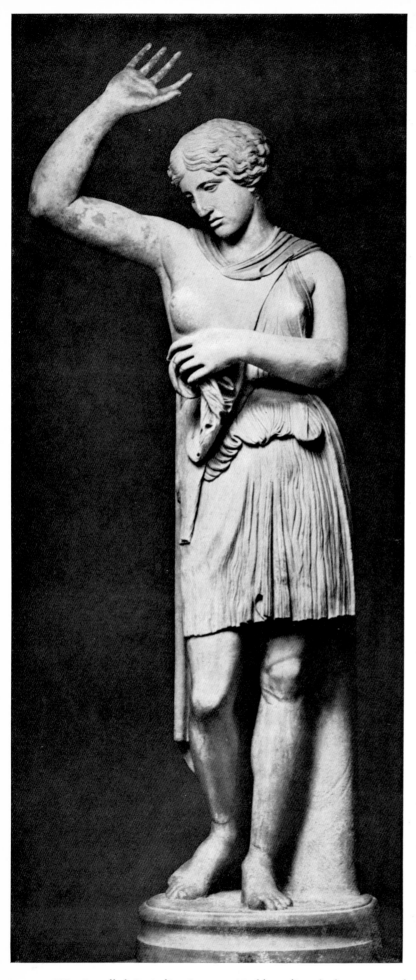
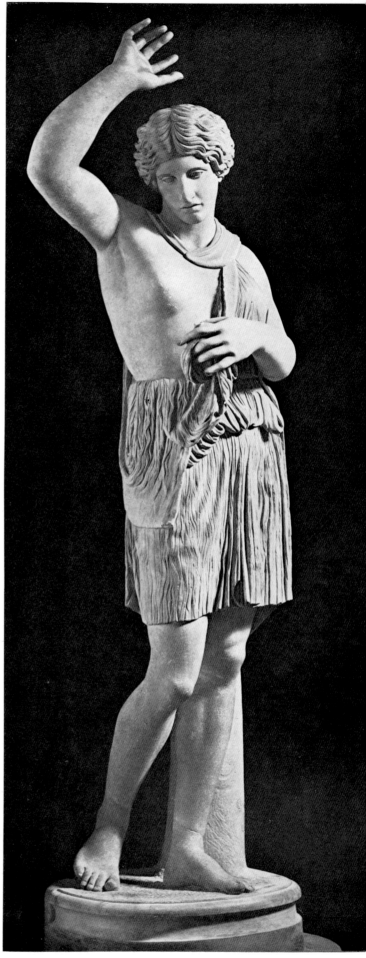

222 So-called Capitoline Amazon. Marble replica of a bronze statue by Polykleitos of ca. 430 B.C. set up in the Artemision at Ephesos.
Height 2.02 m. Rome, Capitoline Museum

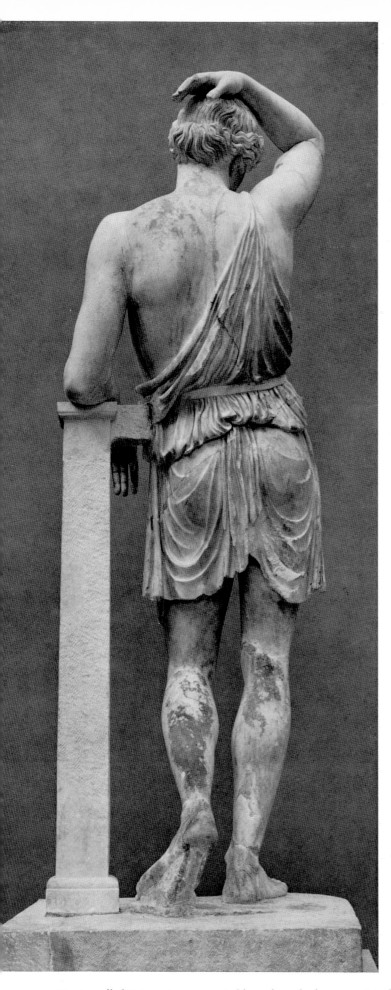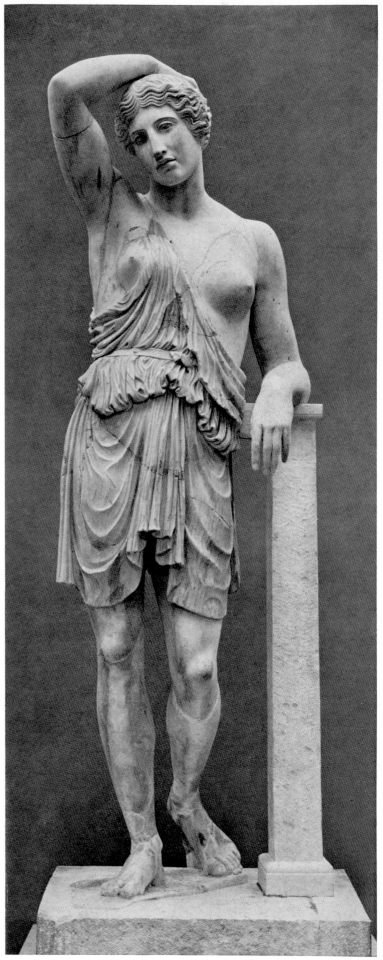

223 So-called Sciarra Amazon. Marble replica of a bronze original by Kresilas of ca. 430 B.C. set up in the Artemision at Ephesos. Height 1.83 m. Copenhagen, Ny Carlsberg Glyptotek

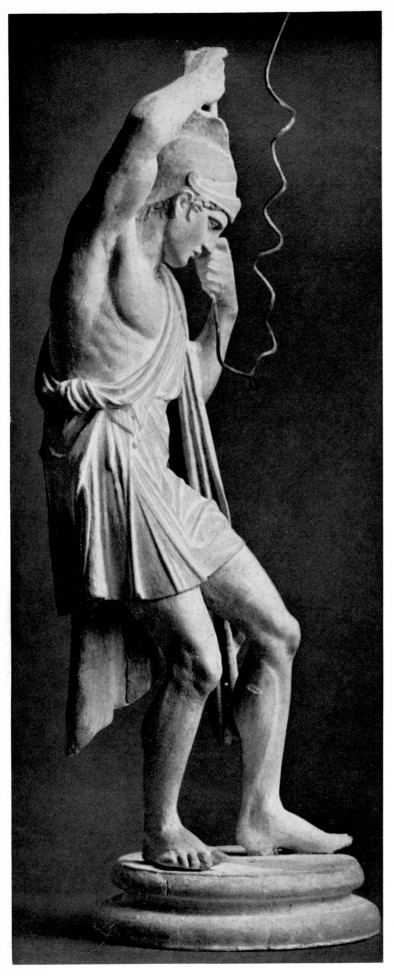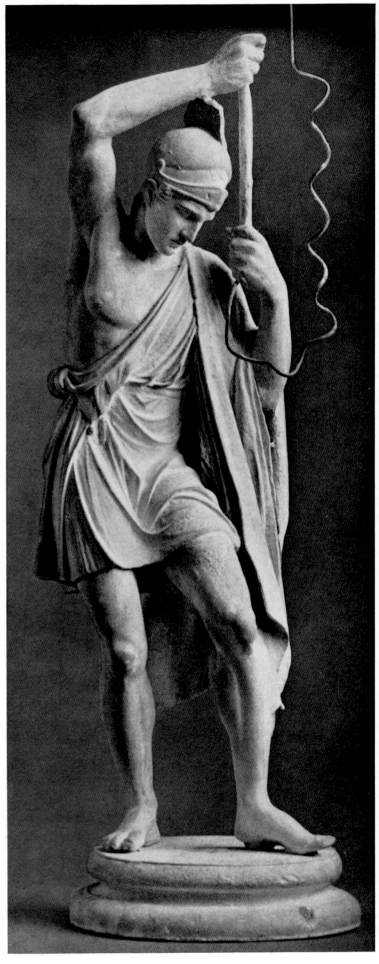

224 Wounded warrior 'of Bavai'. Bronze figurine based on a bronze statue by Kresilas of ca. 430 B.C., on the Athenian Acropolis.
Height 35 cm. St Germain-en-Laye

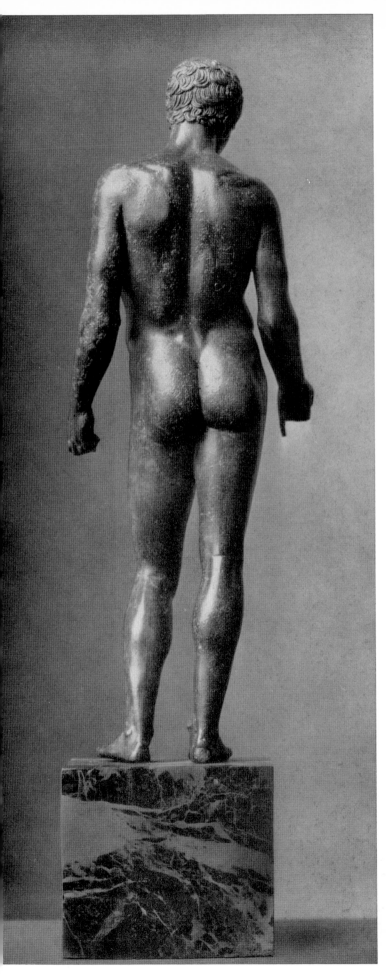
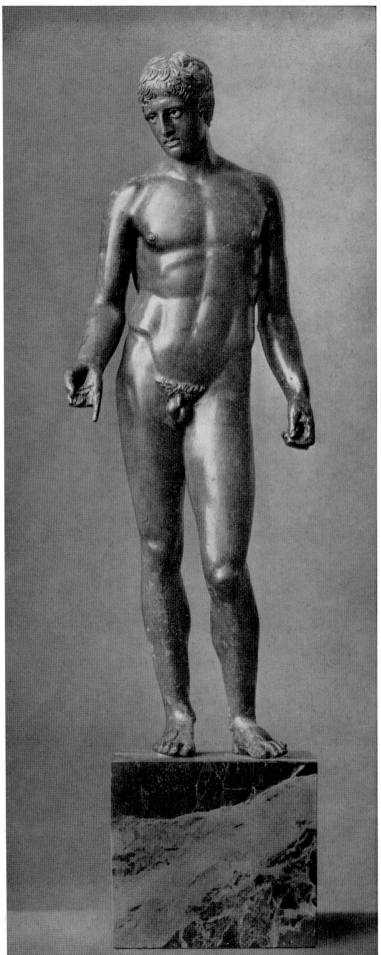

225 Diskophoros. Bronze figurine after a bronze statue of Polykleitos of ca. 440 B.C.
Height 21 cm. Paris, Louvre 183

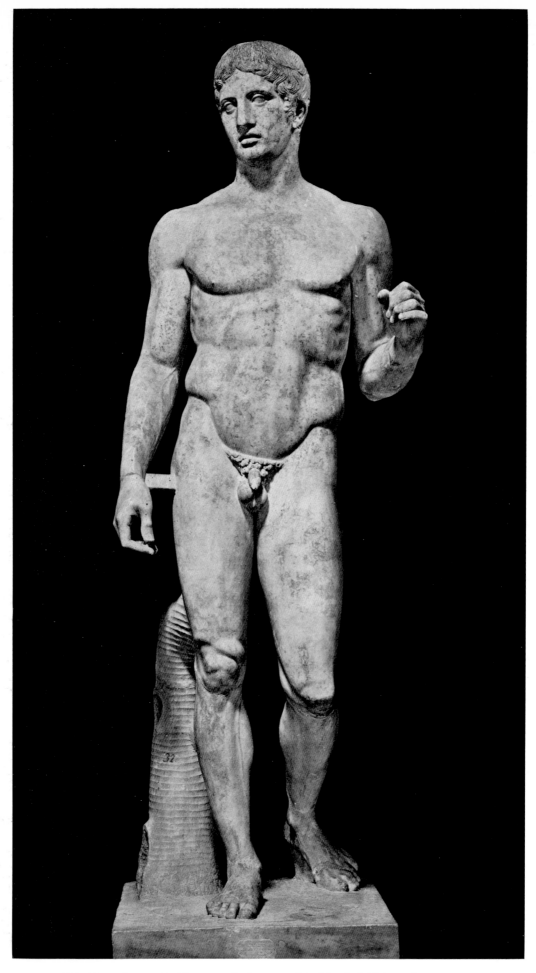

226 Doryphoros. Marble copy of a bronze original by Polykleitos of ca. 440 B.C.
Height 2.12 m. Naples, Museo Nazionale Archeologico 6146

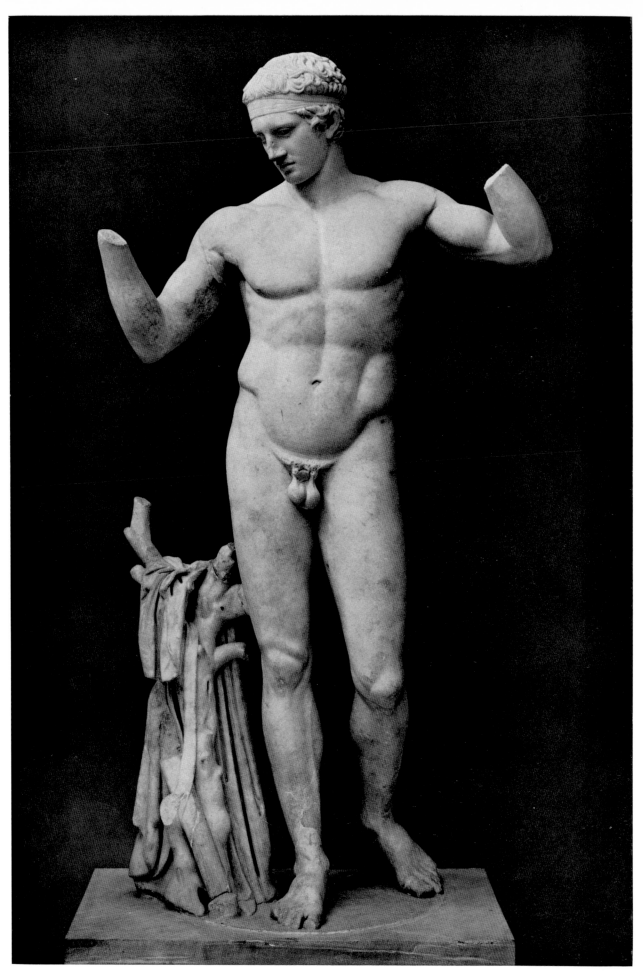

227 Diadumenos. Marble copy of a bronze original by Polykleitos of ca. 420 B.C., from Delos.
Height 1.86 m. Athens, National Museum

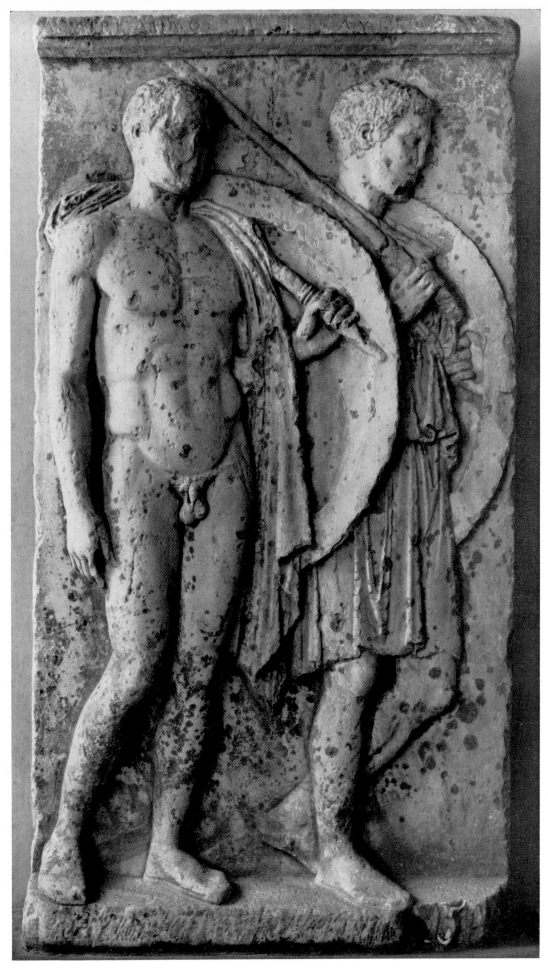

228 Tombstone relief of Chairedemos and Lykeas, from Salamis.
Marble. Height 1.81 m. Late 5th century B.C. Piraeus Museum 229

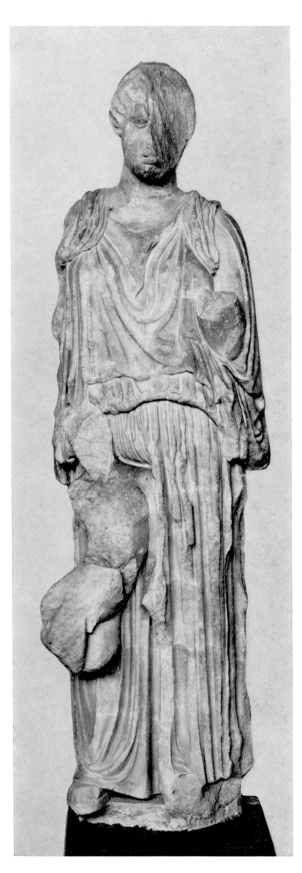

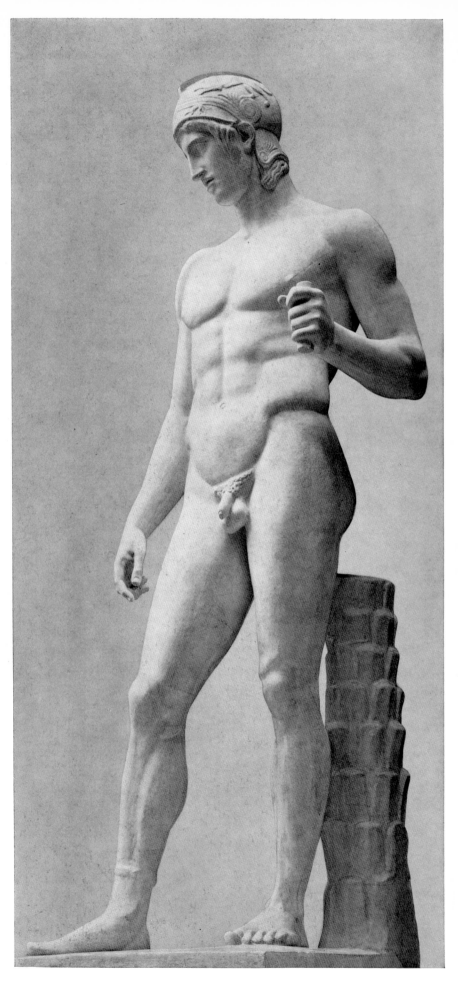

229 Left: Prokne with Itys. Marble original by Alkamenes and dedicated by him on the Athenian Acropolis. Height about 1.93 m
Ca. 430 B.C. Athens, Acropolis Museum 1358. Right: So-called Borghese Ares. Roman marble copy of the bronze original by
Alkamenes of ca. 420 B.C. in the Ares Temple of the Agora in Athens. Height 2.12 m. Paris, Louvre 866

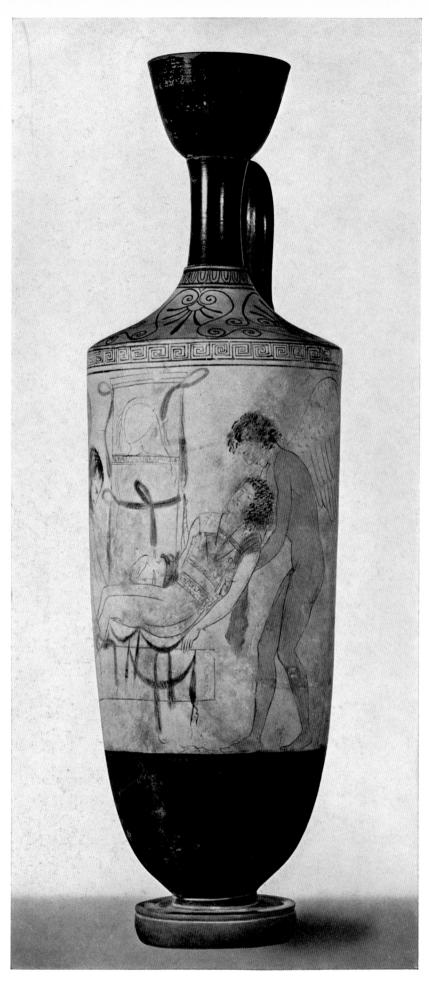

230 Thanatos Painter. White-ground lekythos. Sleep and Death raising the body of a warrior.
Height 48.8 cm. Ca. 440–435 B.C. London, British Museum D 58

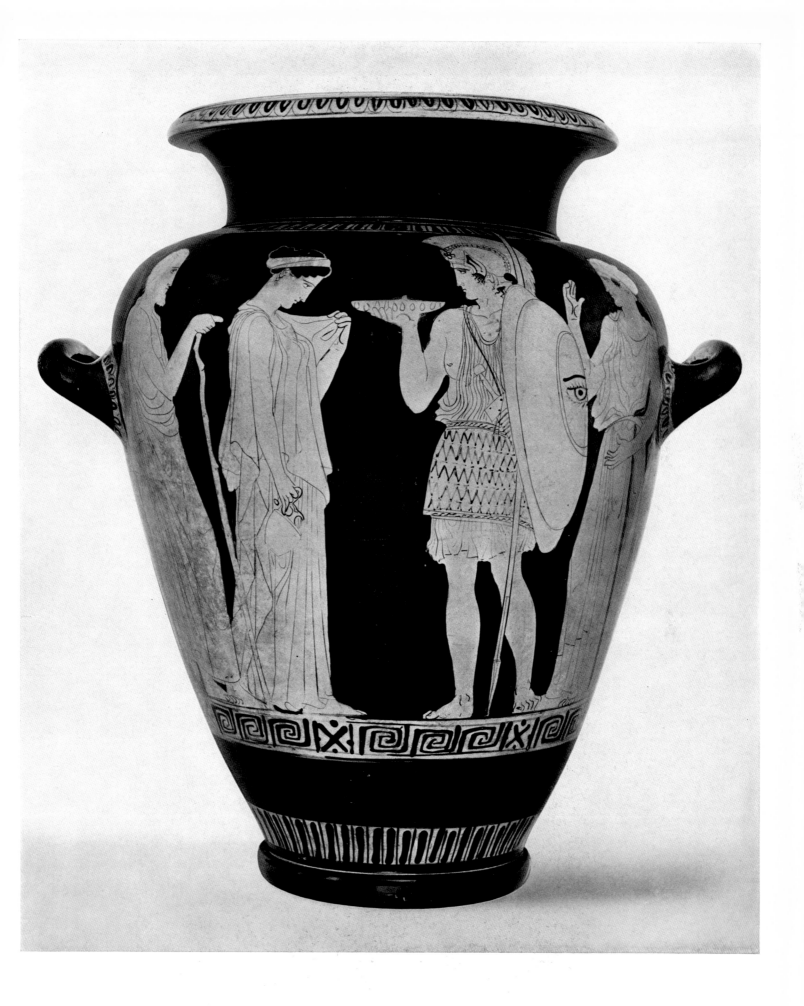

231 Kleophon Painter. Stamnos. Warrior's departure from home. Height 44 cm. Ca. 430 B.C.
Munich, Staatliche Antikensammlungen 2415

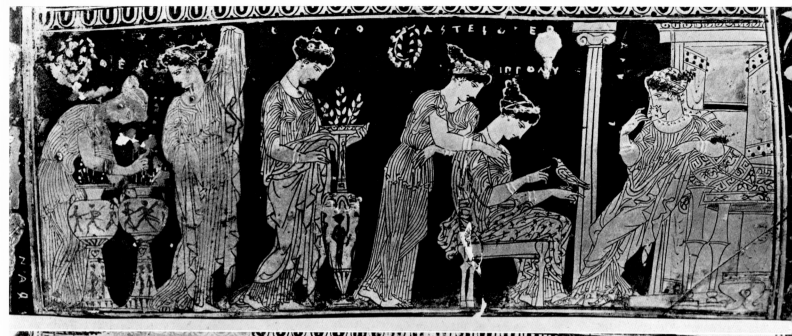

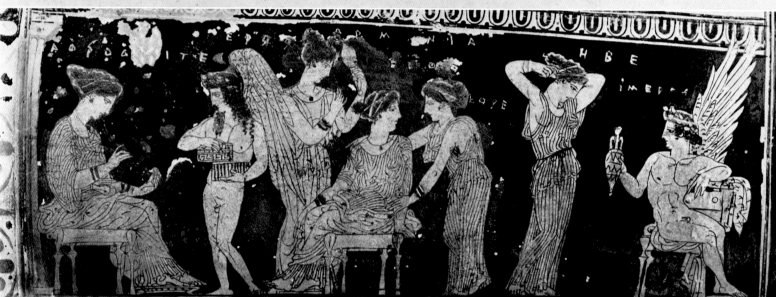

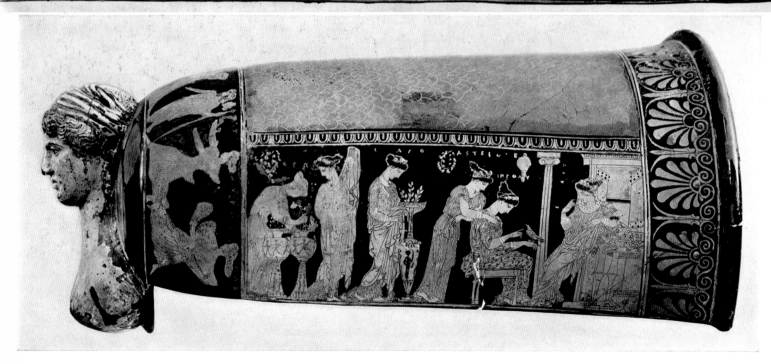

232　Eretria Painter. Epinetron. Scenes of Alkestis in her bridal chamber. Length 29 cm. Ca. 430–420 B.C.
Athens, National Museum 1629

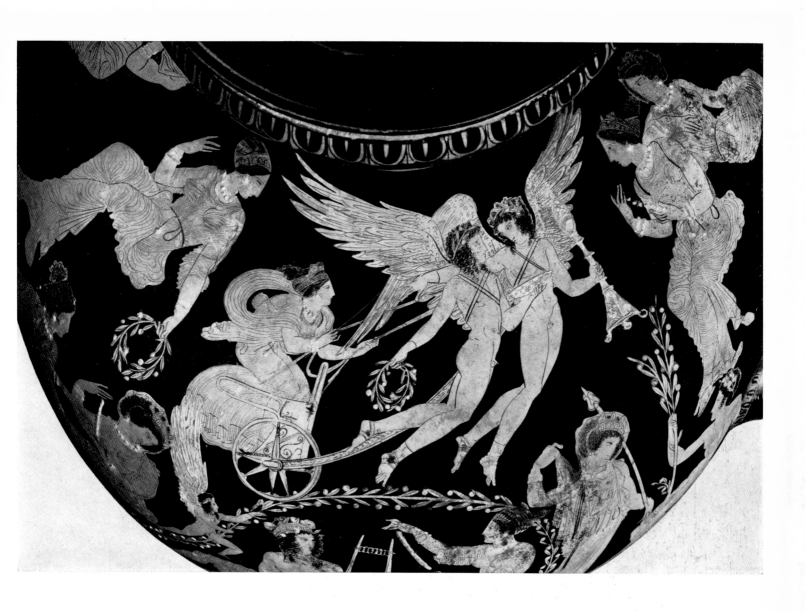

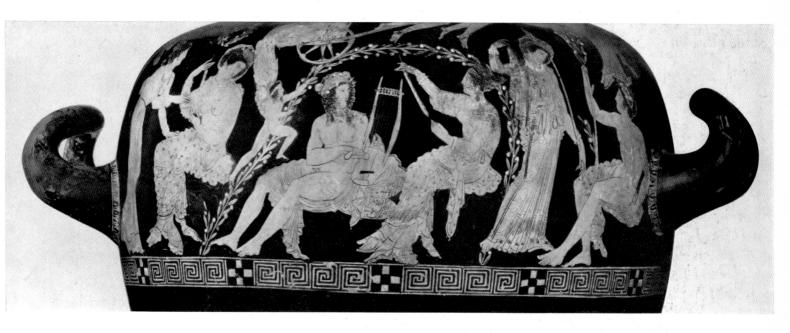

233 Meidias Painter. Hydria. Story of Phaon. Cf. plate XXXVII. Above: (on the shoulder of the hydria) Aphrodite
crossing the heavens in a chariot drawn by Himeros and Pothos; below: (on the body of the hydria): middle: Phaon in a bower with Demonassa;
right: Leto and Apollo; left: Himeros, with the nymphs Leura and Chrysogeneia behind.
Height 47 cm. Ca. 410 B.C. Florence, Museo Archeologico 81947

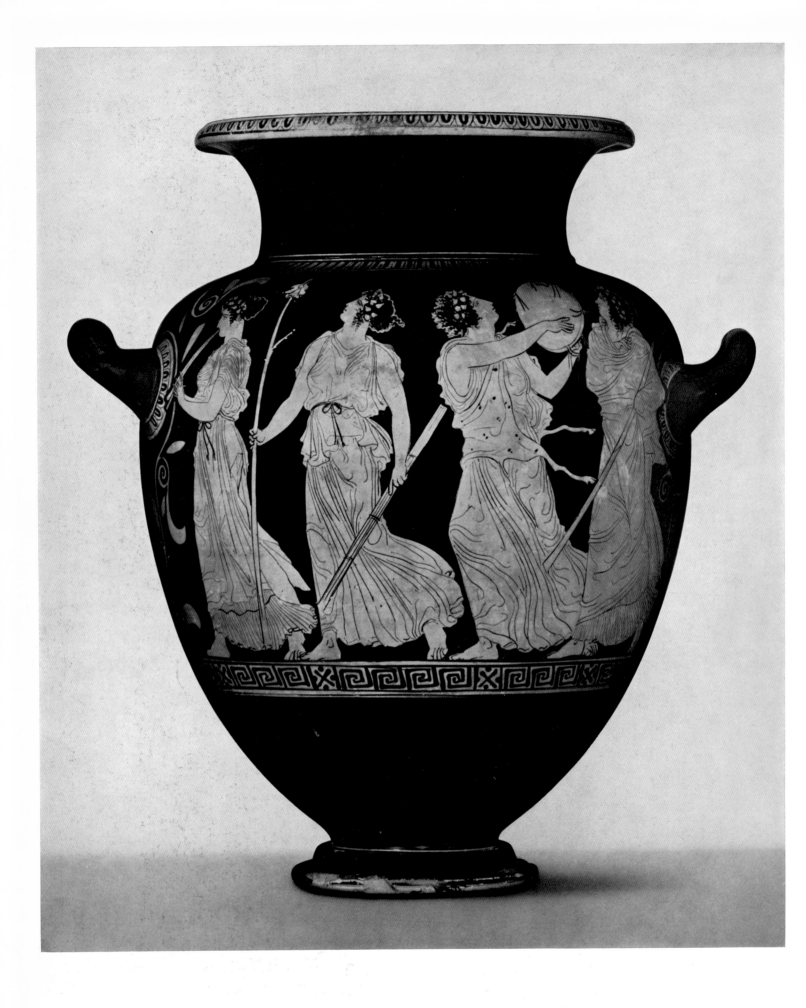

234 Dinos Painter. Stamnos. Maenads dancing at festival of Dionysos. Height 49 cm. Ca. 420 B.C.
Naples, Museo Nazionale Archeologico 2419

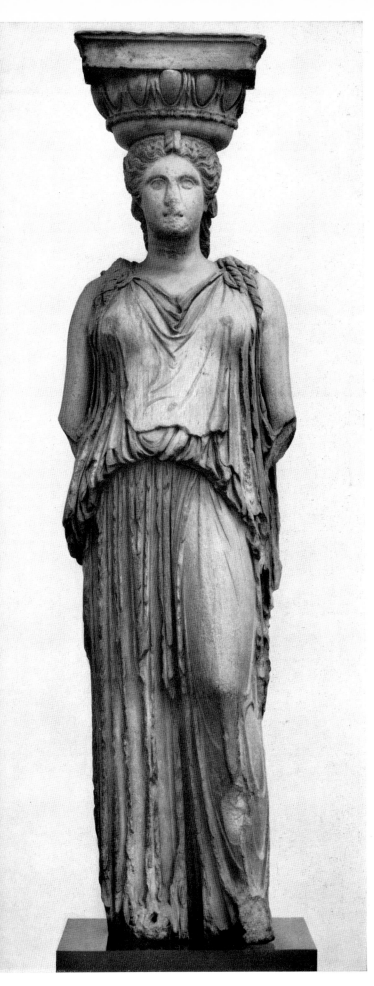
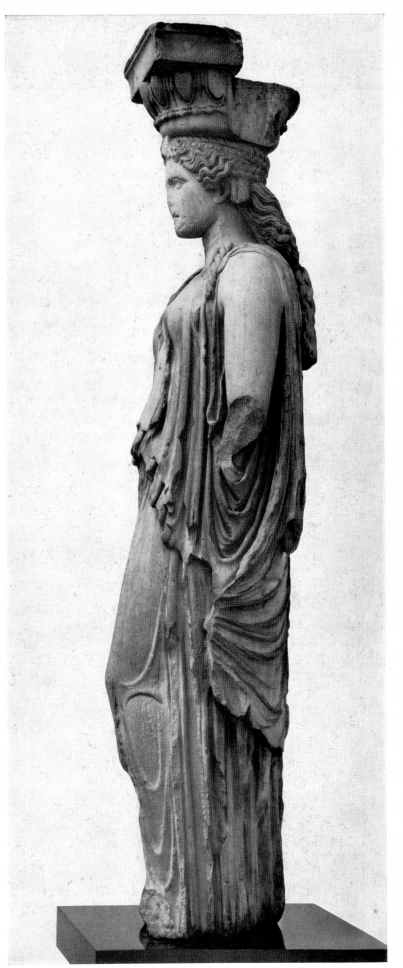

235 Original of second kore on front of caryatid porch in the Erechtheion on the Athenian Acropolis.
Marble. Height 2.31 m. Penultimate decade of 5th century B.C. London, British Museum

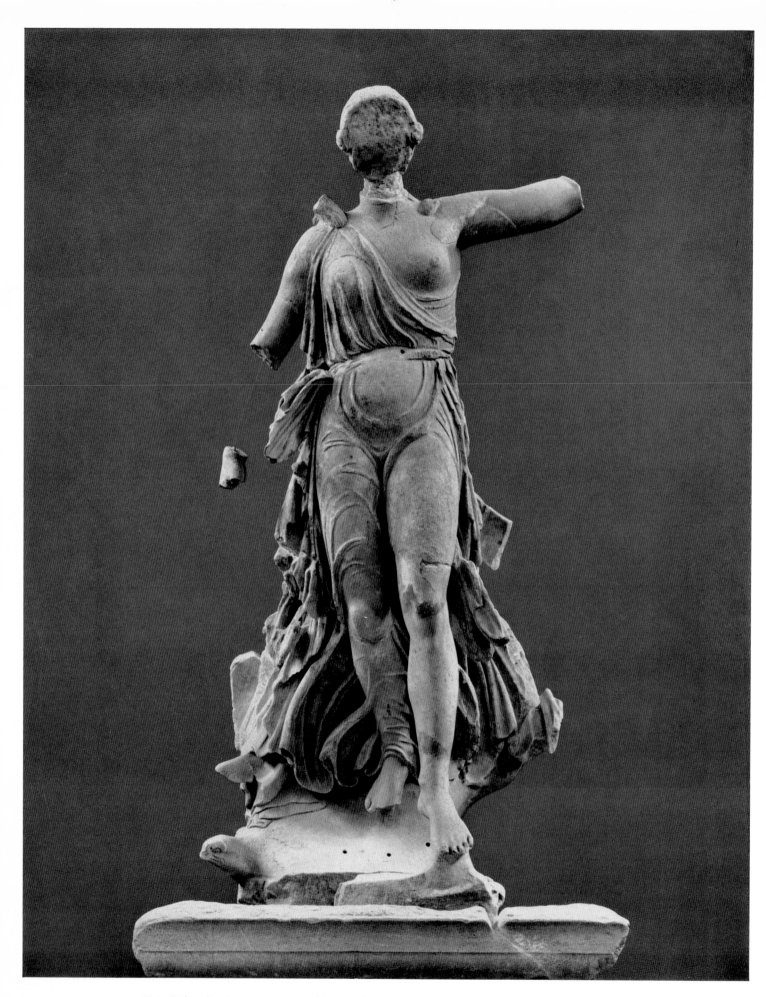

236 Nike of Paionios. Parian marble. Height 2.16 m. Shortly after 421 B.C. Olympia Museum

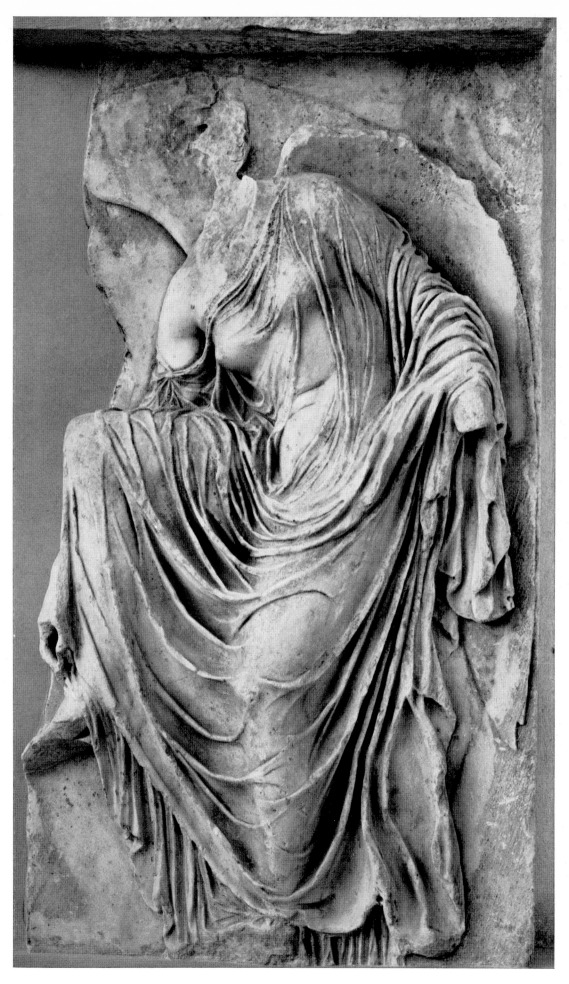

237 Winged Nike fastening a sandal. From the balustrade round the Temple of Athena Nike on the Athenian Acropolis.
Pentelic marble. Height 1.06 m. Shortly after 410/409 B.C. Athens, Acropolis Museum

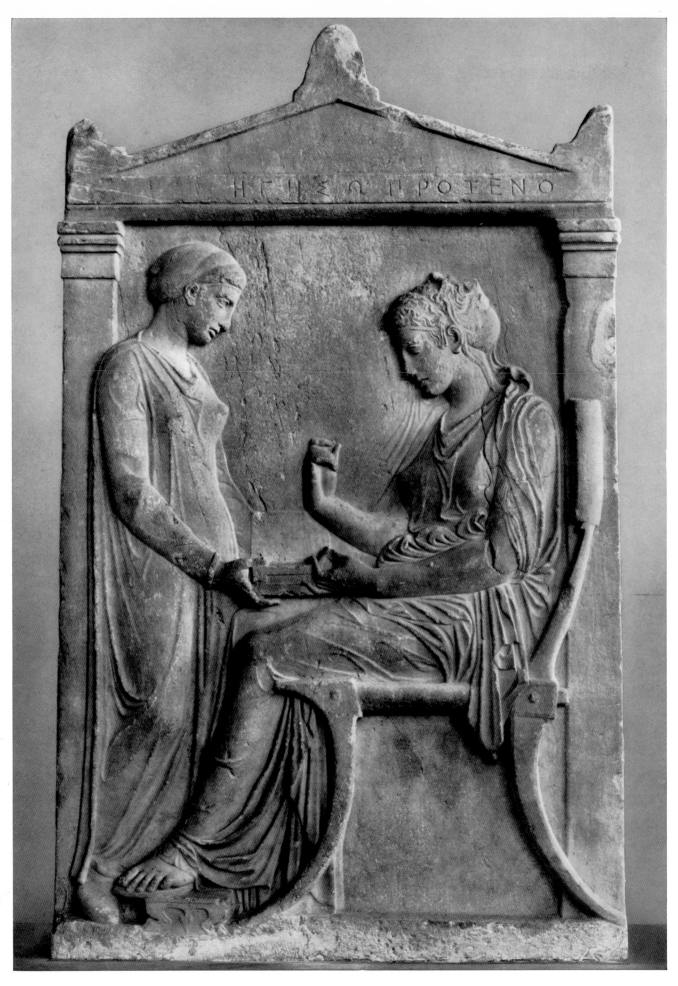

238 Sepulchral monument of Hegeso. Pentelic marble. Height 1.49 m. Shortly before 400 B.C.
Athens, National Museum 3624

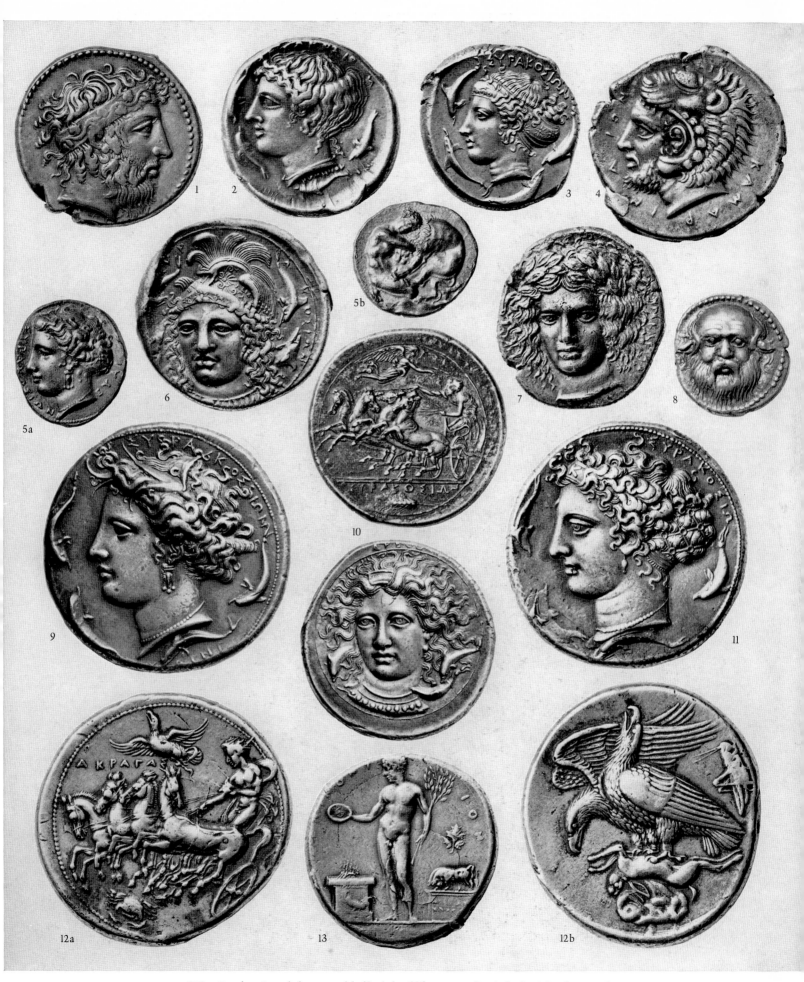

239 Greek coins of the second half of the fifth century (Period of High Classicism).
Sicily: 1 Naxos, ca. 430–420 B.C. 2, 3 Syracuse, 2 ca. 435–425 signed by Eumenes, 3 ca. 425–415 signed by Euainetos. 4 Camarina, ca. 415.
5, 6 Syracuse, 5 ca. 413–406, gold, signed by Euainetos, 6 412–410 signed by Eukleidas. 7, 8 Catana, 7 410–403 signed by Herakleidas, 8 ca. 420–410.
9–11 Syracuse, 9 422–412 signed by Euainetos, 10 ca. 412, 11 ca. 411 both signed by Kimon. 12 Acragas, 412–411. 13 Selinus, 417–409. All 2:1

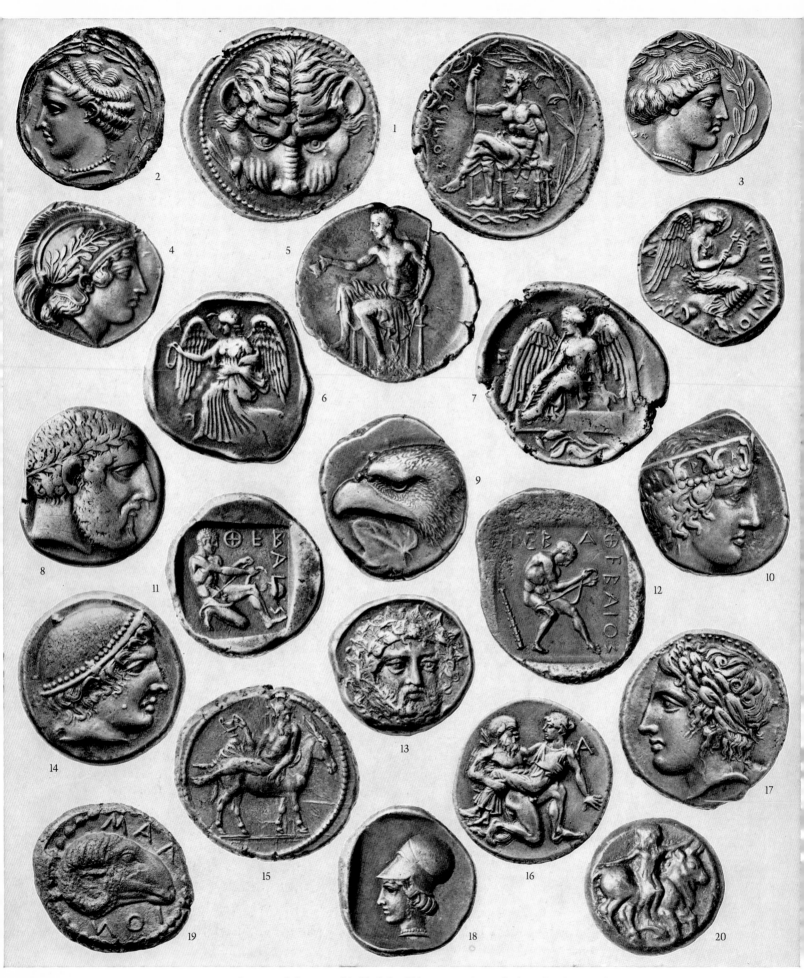

240 Greek coins of the second half of the fifth century (Period of High Classicism).
South Italy: 1 Rhegion, 435–425 B.C. 2, 3 Terina, 2 445–440, 3 425–420. 4 Thurii, 420–415. 5 Taras, 446–443.
Greece: 6–10 Elis, 6 ca. 450–430, 7 ca. 432–421, 8, 10 ca. 421, 9 after 421. 11–13 Thebes, 11, 12 446–426, 13 410–400. 14 Aenos, 412–410. 15 Mende, ca. 425.
16 Thasos, ca. 420. 17 Chalcidian League, 412–410. 18 Corinth, 450–440. 19 Melos (Cyclades), ca. 420–416. 20 Gortyna (Crete), ca. 450. All 2:1

in Winckelmann's words, 'saw a second flowering' of Classical art, the Late Classical as we now call it. Of course there are, especially from the age of Alexander on, significant pointers to the ensuing Hellenistic style nor can we deny that the fifth century was born in the achievements of the sixth. And yet the fifth and fourth centuries do constitute a unified period of Classicism. In the former, buds which emerged in the age of High Classicism burst into flower. For the most part the themes continue in an unbroken development. The grave reliefs of the period of High Classicism continued in rich profusion throughout the fourth century. Despite their meagre artistic achievement, or indeed, perhaps for this very reason, they are of great importance in deciding questions of dating since they themselves can often be dated to an exact year from their inscriptions and the archon-names mentioned. The building of new temples, or the reconstruction of old ones, presented even the Late Classical sculptor with the old problems of the triangular field of the pediment, the cult statue and the victory dedication. The vase painters found new markets in Cyrenaica and above all in the area that is now southern Russia. Major painting received a powerful new impetus from the work of such men as Nikias of Athens, Protogenes of Rhodes, and Apelles, the court painter of Alexander the Great. The art of coin-engraving won even wider popularity.

From the first the artists of the fourth century recognized the achievements of the previous century as their models. With this admiration for High Classicism went a respect for the achievements of earlier Classicism; the models were copied. The archaism introduced into the florid style by Alkamenes with his Hekate and Hermes Propylaios was maintained in the fourth century, in particular in the Panathenaic amphorae. There is a marked element of romanticism in the art of the fourth century; indeed it stands in relation to the fifth century as the 'golden twilight' (Buschor) of the florid style did to the period of High Classicism.

Up to a point this kind of comparison is justified, yet it would be mistaken to regard fourth-century art simply as an echo of the great achievements of the earlier epoch. The spirit of a new age is apparent in every department; like the ordinary individual, the artist gained an unprecedented independence. The artist had achieved the same kind of mastery in his own realm as his royal patrons enjoyed in theirs. They freed their gods from the calm repose of High Classicism and for this reason raised them more and more conspicuously above the matter-of-fact realm of daily life to an ideal and imaginary plane of existence. The new generation no longer saw in the gods the sum of their qualities, but rather the extent of their influence on man. The relationship of Late Classical to Classical art is that of dream to reality.

THE SCULPTORS

The new respect for the artist and the creative mind laid the foundations for new methods of portraiture. True, the Archaic period had produced funerary statues showing individual characteristics, while the fifth century had introduced idealized portrait statues of its great men: Themistocles, victor of Salamis; Leonidas and Pausanias, generals of Sparta; Pericles, the Athenian statesman. Yet the artist had been concerned with general human qualities which transcend the individual. The fourth century discovered the actual personality of a man, dictated by his birth, his talents and his environment. From the first decade of the fourth century comes the tombstone of Dexileos of Thorikos, who fell at Corinth in the year 394 B.C., aged twenty. He is shown on his horse, which rears above a fallen enemy. He is in the very act of delivering the death blow *241* with the spear held in the right hand, yet his composed features reveal his awareness of the fate reserved for him. The scene recalls the horsemen of the Panathenaic frieze on the Parthenon. But the emphasis of the *206/207* diagonal axes, and the parallel lines of the lower side of the horse's body and right flank of the fallen warrior, give this relief a cool, smooth quality, far removed from the battlefield.

the son of Mothon, was born at Argos. Pliny allots him the date 396 B.C., but it is not clear on which work he bases this since it is known that the sculptor was working in the last decades of the fifth century. The gold and ivory statue of Hebe, in Argos, companion work to the chryselephantine statue of Hera, produced after 423, probably by Polykleitos II, his elder brother, is certainly by Naukydes. Argive coins give us only a vague idea of the statue. Besides a series of athlete figures, he produced a Hekate, likewise for Argos; there was also a bronze statue of the Lesbian poetess Erinna. The Diskobolos mentioned by Pliny was identified by Visconti,[1] in 1819, as the statue of a youth in the Sala della Biga in the Vatican. Goethe saw this statue on his Italian journey of 1788 and described it as the 'tranquil Diskobolos', distinguishing it from the figure by Myron, shown in vigorous action. An athlete not yet quite mature, is shaping up for the throw; the soles of both feet are on the ground; the left leg is somewhat set back, the right far advanced; the splayed toes of both feet are straining for a firm foothold. He holds the discus in his left hand. The boy's restful, balanced stance cannot hide his inner agitation; everything is ready for the throw, and his whole mien expresses the sequence of actions to be unleashed in the very next moment. The right arm seems to presage the violent turning movement he is about to make.

Visconti's ascription of the work to Naukydes is reinforced by the existence of many copies of the same subject; these show the bronze original, which had no support, to have been a major work. The Pitti-Lansdowne Hermes, with its many replicas, narrows the field still further; for not only do both the Diskobolos and the Hermes bear the stamp of Polykleitos's successors, but there are stylistic similarities between the two works that point to their being by the same sculptor. Moreover, it is known from literary sources that Naukydes produced a Hermes. Since, then, we have two works each on a subject known to have been treated by Naukydes, from the hands of a major sculptor of his period, the most likely supposition is that he is the sculptor in question. The Nelson athlete's head in Boston must also derive from some work by the same Argive master; whether of the dolichos runner Cheimon, the wrestler Baukis, or the boxer Eukles, is not clear. An inscription from the Acropolis at Athens is probably from the Man sacrificing a ram by Naukydes, which Pausanias (I.24.2) identified as Phrixos.

DAIDALOS

In the first decade of the century Daidalos made the Trophy which the Elians dedicated at Olympia, in thanksgiving for their victory over the Lakedaimonians (ca. 400). Some time after 368, he produced his Nike and the hero Arkas for the figure group of the Tegean votive offering at Delphi; there was an Artemis by him at Monogissa, in Caria, and a Zeus Stratios at Nikomedia, in Bithynia; it is also known that he made a number of likenesses of victorious athletes. Several marble replicas survive of one of the two Apoxyomenoi by Daidalos; the Kunsthistorisches Museum in Vienna has a Roman bronze copy of the subject. This figure was restored from fragments following the better preserved marble copies. A youthful figure of powerful compact forms stands with his weight on the right leg, the ball of the left free foot just resting on the plinth. In his right hand he holds the curved strigil (scraper) which he is cleaning out with his left thumb. The subject, an athlete scraping his limbs free of their accumulation of oil and dust, was a common enough sight at the palaistra. Yet the unvarnished naturalistic treatment expresses the toil and tensions of the contest no less than the sense of glory which victory inspires in the young athlete, elevating him above ordinary men. This Apoxymenos must date from the period of Daidalos's collaboration on the votive offering of the Tegeatans at Delphi around the year 360 or soon after; together with the Diskobolos of Naukydes, it determined the objective style of the fourth century which constitutes the peculiar charm of the period's art. Naukydes concentrates on the preparations for the contest, Daidalos encompasses the thoughts and feelings of the victor.

The so-called 'Oil-pourer', Dresden 67–Florence, dates from midway between these two works and represents a somewhat maturer period of the same master's work. It and the Apoxyomenos from Ephesos may be connected, on stylistic grounds, with the beardless head of a man, possibly the young Herakles crowning himself with a wreath (Dresden 132).

With the youth found in the sea off Antikythera, which was meticulously pieced together from countless fragments, we reach a stage beyond the Ephesian Apoxyomenos. The line of the supporting leg is carried

434

up in a steep curve to where the left hip projects. The right leg, held in a free manner to one side, is also set back a little; two toes only touch the ground. The great muscular body rises up in a powerful sweep from the slender thighs. The head is turned slightly to one side—the side of the slack leg. The right hand would seem to have grasped a spherical object of some kind, and the way the arm is thrust out sideways and upwards underlines the open composition of the whole. This bronze statue of an athlete was in all likelihood made by a Peloponnesian sculptor just after the middle of the fourth century B.C. His name is not known to us, but there is a stylistic affinity with the leaning youth of the Ilissos stele, the so-called *264* Lansdowne Herakles and the head of a youth from Tegea in the National Museum, Athens (180), which *Fig. 170* points to a Doric fellow artist of Skopas who worked with him on the pediment sculptures of the Temple of Athena at Tegea.

TIMOTHEOS

may have come from the north-east Peloponnese, possibly Epidauros; his native city is not given on the inscriptions relating to the erection of the Asklepieion there on which he worked. The Temple of Asklepios was built in the first quarter of the century and was completed within five years, under the direction of Theodotos. The sculptor Timotheos received 900 drachmae for the design of the pediment sculptures, sketching them possibly in clay or in wax; the execution rested with three or four chief sculptors and 50 or so stone-masons, working under them. Theodotos, as architect, reserved to himself the acroteria of the west pediment, while Timotheos completed those on the east with his own hands. From these survives a Nike fragment in the National Museum, Athens 162, as evidence for the outstanding talent of the sculptor. *244 above* the shoulder, serves as a foil to the slight body, the left is set stiffly to the wind. The right hand was raised, apparently in an effort to free the himation, which has got caught up in the wing. This work, even in its fragmentary state, reveals the roots of Timotheos's manner in the florid style and the strong influence of Ionian art on his work; but it also shows to what extent he explored new fields. Whereas the Nike of Paionios showed the effect of flight, Timotheos investigates its origins. He obviously observed birds in flight *236* and noticed the various ways in which they brace their wings against the wind. But above all, he observed how closely the bird's body is integrated with its wing structure.

The west pediment of the Asklepieion at Epidauros depicted the Trojan Amazonomachy; the east, of which a reconstruction has been attempted by Schlörb,[2] the Sack of Troy. We reproduce the modified *Fig. 168* reconstruction of Immo Beyer which arranges the figures in the field according to the dictates of the sloping lines of the pediment. To the right of centre is the vigorous battle group of Priam and Neoptolemos; hurrying from the left, the beardless Greek has seized the aged king by his hair and is about to stab him in the side. Behind Priam, in the right side of the pediment, is a female figure, possibly Hekabe; having followed her husband, she now turns to help one of her stricken sons, holding him in her arms as he sinks to the ground. The crouching figure behind is perhaps Andromache who has snatched her young son from the hands of a Greek soldier. Dead Trojans lie prostrate in the corners of the pediment. To the left, a youthful figure bends forward in an attempt to ward off the arrow of the archer who is taking aim. To the left of the middle group kneels Cassandra, embracing an image in supplication with her right arm, while raising the left hand in a grand gesture. Ajax, unmoved, steps up behind her to drag her from the sanctuary.[3] The fragments and heads which survive can only convey the dimmest impression of the whole homogeneous work, which brought within its compass all the gestures and poses of horror, fear, revulsion, lust for conquest and cruelty. Certainly no earlier representation of the Ilioupersis showed the sufferings of the women and mothers with such immediacy.

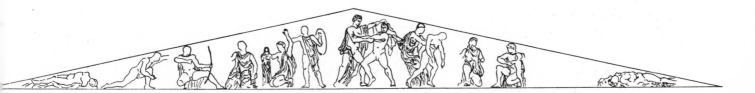

168 Epidauros, Temple of Asklepios. East pediment. The Sack of Troy (after the reconstruction by Schlörb 1965)

Among the other works of Timotheos must be numbered the marble original of a goddess, found in the
245 Asklepieion at Epidauros; her identification as Hygieia is, though questioned in some quarters, almost certainly correct. The left foot rests on a tree stump; to her left coils a snake which would originally have reared up to the left knee (where there is a puntello);[4] perhaps the goddess was feeding the holy chthonic beast from a cup in her outstretched hands. The chiton has slipped off the shoulder, to expose the whole of the left flank. The young body is draped in a cloak whose large folds run from the left shoulder, over the back to the left knee. Side on, the composition invites comparison with the Nike fastening her sandal
237 on the Nike balustrade at Athens, carved thirty years before. In the earlier work, body and drapery form a harmonious unity, whereas the heavy mantle of Hygieia, falling from the right arm, serves an independent function, abruptly dividing the right side of the body from the background. The drapery over the left knee flows between the mobile legs like a waterfall, but the wave-like movement that wells about the Sandal Nike is here frozen to an opaque mass. The contrasting effects of the garment, alternately covering and revealing the body, heighten the allure of the astringent young form. The statue is undoubtedly sister to the Nike on the acroteria at Epidauros.

246 The most mature example of the art of Timotheos is the Leda. It survives in about 20 copies, all just less than life-size, the best of which is the Capitoline version. The piquant eroticism of the subject, which so fascinated Renaissance artists, is ignored in favour of the wily nature of Zeus's courtship. The god has changed himself into a swan; he sends his eagle in pursuit of the white bird, for only by this ruse can Zeus draw Leda's attention to his disguise. True, the eagle is not actually depicted, but the object of the god's desire is anxiously craning her head upwards, while she holds aloft her cloak, billowing out like a sail, to protect the frightened victim from the bird of prey. The swan nestles against her bosom and she holds him to her with her right arm. Zeus's ruse has succeeded. Earlier representations of this theme are known to us but none equals this for naïve pathos and enchantment of mood. Indeed, Timotheos is unmatched in his characterization of women, above all the dawning beauty of girlhood; he delights in the charm of their movements and the fleeting expressions that mirror the feelings of these volatile beings. In this too he is in tune with the florid style; but all-embracing nature is made manifest in his figures and groups in a way which is quite new. The simple act of Leda is full of symbolic import. She protects a weak bird from danger, but is in far greater danger herself, not from the attacker but from the very object of her compassion. These girlish forms by Timotheos are ringed with the promises of springtime; the work of Praxiteles brought them to maturity.

PRAXITELES

247 was an Athenian, the son of the sculptor Kephisodotos, whose Eirene survives in well-authenticated copies; it was placed in the Agora, probably at the beginning of the second quarter of the century. The embodiment of peace is portrayed as a motherly figure in heavy peplos with an overfall. Her right hand rested on a sceptre; in her left she holds the boyish figure of Ploutos, the personification of Wealth. She inclines her head lovingly in his direction; yet, despite the human intimacy of the scene, the group has great dignity which is underlined by the matronly presence of Eirene and harmoniously echoed by the draperies. The florid style has been completely superseded and this, the first Madonna of western art, in her *sacra conversasione*, is endowed with a serious quality that is quite new. In this representation of peace, Kephisodotos strives to emulate the Classical exaltation of the Olympian goddesses as they appeared in the art of the previous century. There is no hesitancy in the conception, which is indeed a significant augury of the Hermes of Praxiteles.

248 *left* At about the same time as his father produced the Eirene group, Praxiteles carved the Satyr pouring wine, his earliest work, of which copies still survive. There is no trace of the subject's animal nature, he is presented in all the charm and beauty of his youth. The left hand held a cup and the right a jug from which the satyr poured out his wine. One must compare this idyll with the somewhat later Dresden athlete

XXXIX From a bronze statue of a youth, found in the sea off Marathon. Total height 1·30 m. Ca. 330–325 B.C. Athens, National Museum 15118. Cf. Plate 235

251

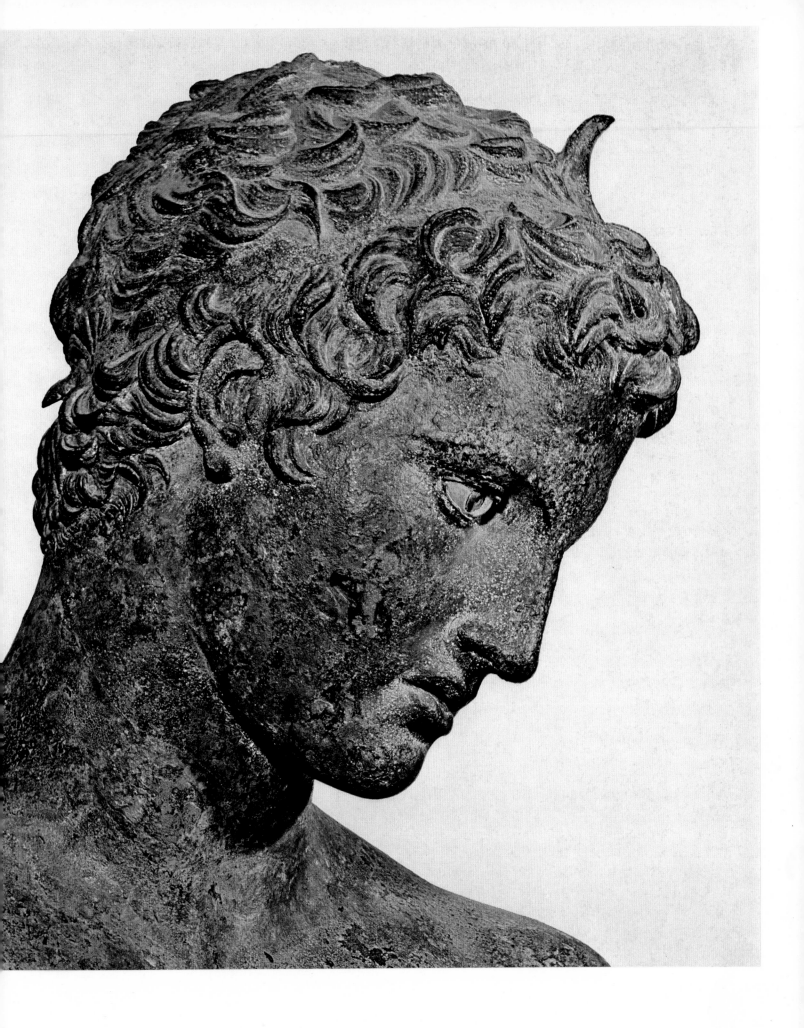

by the Doric artist Daidalos, to appreciate the Attic freedom and rhythm of the satyr. The charming integration of the forms of the body provides a further point of contrast with the clearly defined boundaries in the musculature of the Doric work.

The so-called Sauroktonos is somewhat later. The stance is freer, the curving lines of the body more supple, while the arms are deployed in wider movements. Apollo is shown as a boy who has stalked his victim as far as a tree. With his left arm he has barred the lizard's way up the trunk, and in his right he holds an arrow. The dignity of Pheidias's Apollo Parnopios on the Acropolis is far removed from this boy by Praxiteles. The sculptors of the Early Classical style sought to bring out the sublime element in their figures of the gods, while 'Praxiteles has also given expression to the blissfulness of divine existence' (Rodenwaldt).[5]

249 The Olympia Hermes, completed about mid century, is the only work of Praxiteles to have survived in the original. Even though alterations and cleaning in the modern period may have damaged the surface, it still conveys an immediate sense of the glory of marble and of the matchless splendour and completeness of Praxitelean sculpture. Hermes, messenger of the gods, holds the diminutive Dionysos in his left arm. They are on the way to the nymphs of Nysa who are to bring up the young god, but Hermes pauses for a moment to entertain his little half-brother. In his right hand, Hermes the god of thieves, holds up a bunch of grapes which he has just plucked from the vine, and the baby god of wine snatches at it with pudgy little hands. This delightful ploy constitutes the culminating-point of a composition which, with its upward-curving lines, translates the spectator into the trouble-free land of the gods. Here dream and reality become one.

248 right One of the most famous of all ancient statues was the Knidian Aphrodite. Praxiteles was at the height of his fame when he made his work for the city of Knidos; the statue was probably set up in a circular building, so that it could be viewed from all sides. The Knidians decorated their coins with reproductions of it and in Roman times its immense popularity led to a thriving industry turning out copies of all kinds— inevitably causing quality to suffer at the expense of quantity. Not one of the surviving copies conveys a true sense of the masterpiece, and the best version we have is a plaster figure using the body in the Vatican and the Kaufmann head.[6] The goddess stands before us in the full beauty of her naked form; on the ground at her feet stands a hydria with the water for her bath; her clothes slip to the ground from her left hand. The goddess believes herself to be unobserved, and herself subsequently expressed her astonishment that Praxiteles had so faithfully represented her in her own divine environment:

> Paphian Kythereia came through the waves to Cnidus, wishing to see her
> own image; and having viewed it from all sides in its open shrine she cried,
> 'Where did Praxiteles see me naked?' (*Anthology*, 16.160)

Earlier sculptors had always depicted Aphrodite in rich vestments; indeed the Aphrodite of Kalamis, dating from the mid fifth century, veils even her head. Praxiteles showed the goddess of love, for the first time in sculpture, in her unveiled perfection. She is a mature young woman, her fully-developed figure quite unlike the girlish forms of Timotheos. Every line of her body proclaims the theme of love, but such is the nobility of the work there is no hint of lascivious sensuality.[7]

251, XXXIX At about the end of the third quarter of the century, the so-called Marathon Boy revives the poetic and dreamlike quality of the Satyr, the Sauroktonos, and the Hermes of Olympia. The almost life-sized bronze original was found in the sea off Marathon. It is not clear what the youth was holding in the palm of his left hand. Was it perhaps a cup into which he was pouring a libation from a rhyton held in his right hand? Or was it a box from which he had taken a riband? Possibly the boy is intended to represent the god Hermes himself and originally, as in vase painting of Magna Graecia, he was holding a tortoise which he had tethered to a string; if this was the case, then the subject would have been Hermes as the inventor of the lyre, since the shell of the tortoise was often used as the sound-box of this instrument. Be that as it may, the unknown sculptor was, stylistically, a disciple of the school of Praxiteles. Indeed, in the free inter-penetration of space by the relaxed, outstretched arms, and the use of supple modelling and flowing lines for the body, he even advances beyond Praxiteles. It is clear that he knew the work of his contemporary, Leochares.

438

The seated goddess from Knidos, in the British Museum, is undoubtedly a marble original of the first 252
decade of the second half of the century and occupies a similar position half-way between Praxiteles and
Leochares. The matronly form is tightly wrapped about by the heavy cloak, one end of which has been
brought up to cover the head—a sign of mourning; the eyes look into the distance. The subject is probably
Demeter, mourning the loss of her daughter Persephone.

LEOCHARES

was, like Praxiteles, an Athenian and many of his works stood in the capital city. Pliny refers to him as a
sculptor in the early 'sixties (372–369) and he is described in the 13th Letter of Plato as having been a youth
in 365; his portrait statue of Isokrates must have been done before 356. As a young man he seems to have
experienced the transition from the florid style to the simple style of the second quarter of the century; his
bronze Ganymede must have been roughly contemporary with Timotheos's Leda. 246

The favourite of Zeus is no longer being pursued by the Lord of the Gods, as in the vase painting of the
early fifth century, or being carried off by him, as in the terracotta acroterion from Olympia; instead, Zeus
has sent his eagle to bring the beautiful boy to Olympus. Pliny, who describes the Ganymede for us, says
that the eagle, realizing who the boy was and to whom he was to take him, lifted him by his clothes, so as
not to harm the delicate body. The work has been identified in a heavily restored Roman copy used as a
decorative motif on the foot of a dish; a more immediate impression is to be derived from a bronze relief
on a mirror in Berlin, obviously worked in the 'sixties under the strong influence of Leochares's work. 244 below
The regal bird carefully grips the garment fluttering in the wind, while the boy himself holds on to the
animal and buries his head in its neck. The blissful abduction which Leochares depicts is a significant
indication of the spirit of the century of Late Classicism. The gods no longer appear in the simple naturalism
of the Parthenon frieze; rather, they reveal themselves in the form of numinous beings—the eagle, the
swan—or in their own transfigured supernatural manifestations. The fourth century is inspired with longings
for the bliss and exaltation of the gods. Praxiteles and Leochares discovered afresh the 'gods living in bliss'
(Rodenwaldt),[8] and exalted them above the world of men.

In the Apollo Belvedere, which originally stood before the Temple of Apollo Patroös in the market-place 253
at Athens, next to the Apollo of Kalamis, Leochares brings the weightless, hovering quality and the smooth
momentum of Greek sculpture to its zenith. The youthful, long-legged god strides out light of foot; from
the side he looks as though he were an arrow in flight. But the outstretched left arm, which carries the bow
and is draped with the folds of the god's cloak, and the head, turned abruptly to the left, arrest the movement,
and this heightens the effect of a moment captured for all time. Winckelmann recognized the lost work of
Leochares as of major importance even in its dull reflection in Roman copies, and gave it due praise. The
Steinhäuser copy of the head in Basle, despite its translation into the marble style of the Neronic period,
revives something of the original. Since the body is lost, one must perforce combine a cast of it with the
body of the Vatican statue.

SKOPAS

Parian by birth, Skopas had a fiery temperament but, though his genius was powerful and masculine, was
a sensitive artist; he was a fitting successor to the passionate poet, Archilochos. Skopas was Praxiteles's rival
and, indeed, Horace described him as the finest sculptor in marble. It is not known when his creative career
began; there are no fully authenticated versions of his numerous statues of the gods. He was summoned to
Halikarnassos in the middle years of the century and must have achieved some reputation by this time; we
can therefore look to the second quarter of the century for the beginnings of his art. He must have had a
hand in designing the panels on the east side of the Mausoleum; the Amazon leaning back with divided 254
chiton is almost certainly his. Her young body, boldly executed, is shown in a turning movement, and is
almost naked save for the short garment that sweeps round the hips and thighs away from the spectator.
In her right arm she brandishes a weapon against the naked but helmeted Greek who hovers menacingly
near by.

The design of the Mausoleum frieze seems to have been as little predetermined, as to its closer details, as
that of the Parthenon. The design of the master-sculptors was carried out by an army of assistants, and
during the work on this tomb, which was to become one of the wonders of the ancient world, Halikarnassos

became a focus for the most diverse artistic temperaments. In the course of their collaboration and their rivalry, there evolved a common Halikarnassian style which transcended the individual details and obscured the boundaries between the work of one master and that of another. According to Pliny, Skopas carved the reliefs on the east face, Bryaxis those on the north, Timotheos those on the south, and Leochares those on the west. The state of the surviving panels suggests a more complex mode of working and calls into question such a simple scheme of allocation. We should not, therefore, rely too heavily on these reliefs when trying to assess the individual styles of the four great sculptors.

It is much wiser to start with their major statues and to deduce from these their contributions to the 255 Mausoleum carvings. In the case of Skopas, this starting-point should perhaps be his Maenad, celebrated in numerous epigrams and described in detail by Kallistratos. All accounts praise the ecstatic abandon of the figure; even Dionysos himself could not have aroused a wilder passion. From the description of Kallistratos, rhetorical as it is, there can be no doubt that the marble Maenad in Dresden (133) is a Roman copy of the Skopas figure.

> ... and so strikingly there shone from it, fashioned by art in a manner not to be described, all the signs of passion which a soul goaded by madness displays. The hair fell free to be tossed by the wind and was divided to show the glory of each lock, which thing indeed most transcended reason, seeing that solid stone lent itself to the lightness of hair and yielded to imitation of tresses, and though void of life it nevertheless had vitality. Indeed you might say that art has brought to its aid the impulses of growing life, so unbelievable is what you see, so visible is what you do not believe. Nay, it actually showed hands in motion—for it was not waving the Dionysiac thyrsos, but it carried a victim as if it were uttering the Evian cry, the token of a more bitter madness; and the figure of the kid was livid in colour, for the stone assumed the appearance of dead flesh; and though the material was one and the same it severally imitated life and death, for it made one part instinct with life and as though eager for Kithairon, and another part brought to death by Dionysiac frenzy, its keen senses withered away.

In order to satisfy ourselves that this description applies to the statue whose copy is in Dresden, we have only to examine the vigorous Amazon with exposed left flank on the Mausoleum panel (1015), and, above all, make a comparison with the pediment sculptures from Tegea, now surviving only in fragments. It is apparent that Skopas not only was the architect of the Temple of Athena Alea in Tegea, which replaced the one destroyed by fire in 395 B.C., but also designed its pediment sculptures. The execution of the carving was entrusted to other hands, but even the Peloponnesian sculptors who worked on the project were touched with something of the fire of Skopas. He himself may have produced the head of Herakles wearing the lion's pelt, restored from two fragments, that seems to have belonged to the central group.

Fig. 169 The west pediment showed the combat between Achilles and Telephos in the plain of Kaikos. On their way to the Trojan War the Greeks landed first at Mysia, which they mistook for the Troad and accordingly laid waste. Telephos, lord of Mysia, led an army against them; the son of Polyneikes was killed and Patroklos wounded. Thereupon Achilles led the counter-attack and Telephos was driven back. Dionysos

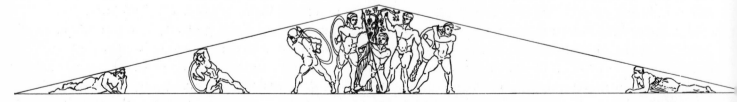

169 Temple of Athena Alea in Tegea. West pediment. Combat between Achilles and Telephos in the plain of Kaikos. Reconstruction

440

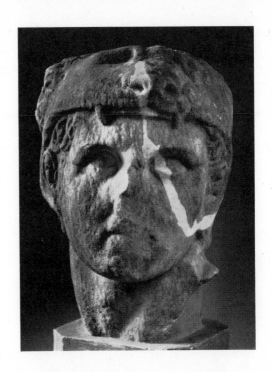

170 Skopas. Head of Achilles from the middle group of the west pediment of the Temple of Athena Alea in Tegea. Athens, National Museum 180

intervened during the retreat by causing a vine to spring up at Telephos's feet so as to trip him up, and as he stumbled Achilles thrust home with his spear. The middle group of the pediment seems to have depicted this incident. The helmeted head, No. 180, in the National Museum, Athens, is probably from the figure *Fig. 170* of Achilles and, to judge by its size and the flattening of the helmet, must have been immediately to the right of the central figure of the stumbling Telephos. His pose may have been similar to that of the Alba Youth,[9] who on stylistic grounds, in Bulle's opinion,[10] came originally from the sculpture on the Temple of Athena Alea, at Tegea. The figure immediately to left of centre was probably Herakles starting back in astonishment at the sudden appearance of the vine shoot; to place him on the side of Achilles would have him fighting against his own son. It is said that when Herakles was in Tegea he had a child by Auge, daughter of King Aleos of Arcadia. Whereupon Aleos disowned her and set mother and child adrift on the sea, in a chest. However, they made landfall in Teuthrania, where they received a friendly reception; Teuthras made Telephos his heir and he became king in due course—hence his soubriquet, the Mysian.

By convention, success in combat is in Greek art signalized by making the victor attack from the left, and by here placing Achilles on the right the sculptor implies that his thrust at Telephos will not be fatal. In fact the struggle was broken off and the two warriors were later reconciled. Despite the truly exiguous nature of the fragments, one is justified in attempting to restore the original composition; for, as Buschor has said, 'to be content with the fragments alone would be a greater self-deception than the most mistaken reconstruction'.[11] The corners of the pediment were filled with the prostrate forms of women, clearly Mysians, who are following the battle with lively interest. The east pediment showed the hunt of the Calydonian Boar; Pausanias (VIII.45.4) names all the figures in his description. 'The boar itself is in the centre; to one side stand Atalanta, Meleager, Theseus, Telemon, Peleus and Polydeukes—who was present at most of the Labours of Herakles—and the sons of Thestios, the brothers of Althaia, Prothoös and Kometes. On the other side of the boar is Epochos, supporting Ankaios, who has already been wounded and lets his axe slip from his hand; next to him are Kastor and Amphiaraos, the son of Oikles, and beyond them Hippothoös, the son of Kerkyon, the son of Agamedes, the son of Stymphalos; the last figure is that of Peirithoös.'

A convincing connection has been established between the Maenad, which probably stood in Sikyon *255* with the young Herakles wearing the Poplar Wreath in his Hair, and the single surviving Roman copy of the Tritoness from Ostia. The upper part of the body has been preserved and the late-second-century copyist *Fig. 171* has managed to imbue it with something of the bloom found in the naked female forms of the Parian master himself. Her head is thrown back like the Maenad's, and the direction of her glance continues the spiralling line of the composition. The wet strands of hair festoon down over the shoulders as far as her breasts; small

441

171 Skopas. Tritoness, from the many-figured group of sea-creatures. Roman copy, based on the original of 335 B.C. Ostia, Museum

fishes can be seen caught up in the hair, and the tail of a larger one falls across the right shoulder-blade. The Tritoness from Ostia probably belonged to the many-figured group of sea-creatures brought by Domitius Ahenobarbus from Bithynia and set up in the Circus Flaminius in Rome. The main theme of the group was the conveyance of the weapons which Hephaistos wrought for Achilles. Pliny expressly records (36.26) that the same master hand was apparent in all the parts of this complex group.

The central group was probably of Poseidon, Achilles and Thetis; on one side it was flanked by Nereids riding dolphins and other sea-animals, on the other by Tritons, the chorus of Phorkys and other similar creatures. The whole composition will have transcended the pediment sculpture at Tegea just as these far outstripped the Mausoleum frieze. The 'baroque' profusion of gods and creatures seems to have been given impetus by the rise of the young Alexander the Great of Macedon. In this mature creation which glories in the play of the waves and peoples the wide sea with gods, the art of Skopas, native of the sea-girt island of Paros, may be regarded as having fulfilled itself.

BRYAXIS

as his name suggests, came from Caria, in Asia Minor, where he did most of his work. In early youth he came to Athens to learn his trade and in this sense, admittedly he could be called an Athenian. The base of one of his statues, decorated with a now damaged relief of horsemen and tripods, dates from before the middle of the century (Athens, 1733). Unfortunately the statue itself is lost. Bryaxis, like Timotheos, Leochares and Skopas, came to take part in the work at Halikarnassos, somewhere near the middle of the

442

century; as mentioned above, Pliny ascribes the northern frieze to him. From his workshop comes slab 1019, now in London. The Amazon 64 and her horse should be compared with the horsemen on the base of the Athenian statue, although here all is in turmoil. The placing and overlapping of the figures gives a sense of spatial depth, absent from the earlier work. The contestants are shown in arresting postures and seem to be battling not only with their opponents but also with the strong wind which catches and billows out their cloaks.

The colossal figure of a Carian prince, excavated by a British expedition and brought to the British *256* Museum in 1857, can certainly be ascribed to Bryaxis. The statue which was found on the north side of the Mausoleum, has been taken to represent Maussollos himself. It is executed in a manner that clearly distinguishes itself from the Attic of Leochares, the Parian of Skopas and the Doric/Ionic of Timotheos. The prince's heavy features, his full cheeks, deep-set eyes under bushy eyebrows, luxuriant hair, thick lips, double chin and sturdy neck, betray an appreciation of Carian physiognomy that suggests a native sculptor. The ruler stands before us relaxed and self-confident. The long robe, reaching to the feet, and the heavy cloak round the body, enhance the dignity of the figure. At the same time, the deep-cut folds of the drapery produce shifting light and shadow effects, while individual cross-folds of the lower garment introduce sharp tension-lines. The fragment of a horseman, British Museum 1045, and the sitting figure 1047, are from similar massive, heavily swathed forms.

SILANION

was self-taught and seemingly interested in art theory, since there is a treatise on the subject by a certain Silanion, and the two are almost certainly one and the same. It is possible that his family came to Athens from Megara. The peak year of his achievement is given as 328, yet he would seem to have been a contemporary of Leochares, since his portrait statue of Plato, dedicated by Mithridates, one of the philosopher's pupils, must have been completed before 363. The head has come down to us in many *257 above* replicas.

Unlike those of his Attic and Peloponnesian contemporaries, Silanion's talents ran more in the direction of portraiture than images of deities. He made a Theseus statue for Athens, of which the Ince Blundell Hall 43 is thought to be a copy. His Dying Jocasta was probably commissioned in Boiotia; it is said that for this statue he alloyed the bronze with silver to achieve the pallor of death more realistically. A fragment of a copied head is in Budapest. We also know that he produced a Corinna, probably for Tanagra, and a Sappho for Syracuse.

Some knowledge of a portrait statue of the sculptor Apollodoros gained the soubriquet 'Insanus' from his Herculaneum which reproduces the head (Naples 6154). *257 below* Apollodoros gained the soubriquet 'Insanus' from his habit of destroying those of his completed works which did not come up to his own high standards. Silanion's statue was intended less as a portrait of the sculptor than as a picture of angry passion; if the appearance is realistic, the intention is allegorical, much as in the roughly contemporary Kairos by Lysippos. To judge *261 above* how personal, not to say subjective, is this 'Apollodoros', one should compare it with the bronze portrait head in London. [12]

A tragic mask, found in the Piraeus in 1959, is closely *Fig. 172* related to this portrayal of self-destructive anger and passion. The eyebrows, like the arms of an anchor, converge on the nose which in turn extends almost to the upper lip. The circular eye-sockets and grief-distorted mouth give the face a demonic expression;

172 Silanion. Tragic mask. Bronze. Ca. 350 B.C. Piraeus, Museum

443

the beard is represented here by a cluster of furrowed twists. The restrained flat area of the lower face forms an effective contrast to the unruly head of hair which, down to the closest detail, can be seen to bear a *257 below* striking resemblance—irrespective of original and copy—to that of the 'madman'.

XL The original bronze Head of a Boxer, found at Olympia, is in the same manner. Admittedly, the curls of the beard are disposed more freely, they are more tightly rolled and stick out almost like spikes, yet the treatment of the moustache, the thin upper lip, and the way the face is brought into focus by the framing hair and beard, continue the style of the mask and the 'Insanus'. The small slit eyes of the boxer are similarly close-set under the line of the brow. The Boxer is probably the latest of the works named, dating from the 'thirties. It has been suggested, therefore, that it may be the head of Silanion's statue of the boxer Satyros of Elis,[13] who was victor at Oropos in 335/334. This, the sculptor's most mature work, demonstrates impressively the violent contrast, undoubtedly intentional, between his work and the idyllic enchantment of Praxiteles's gods on the one hand and the poetic transfiguration and sublimity of the figures of Leochares on the other. Silanion took his subjects from the here and now of man's earthly life, not from the world of eternity. He chose mortal heroes of the past like Theseus and Achilles, or poetesses like Sappho, the 'tenth muse', and Corinna. In the 'Madman', his ostensible portrait of the sculptor Apollodoros, he presented the eternal struggle of the artist to achieve Form, thereby symbolizing his own desperate, Michelangelesque, conflict. He saw the heroes of legend and of inspiration in terms of this earthly life, which he himself had experienced. Yet at the same time he realized that the eternal qualities could manifest themselves in everyday life as well as in the heightened condition of the possessed. In this he was closer to the Doric successors to Polykleitos, than to his Attic colleagues, Leochares and Praxiteles.

LYSIPPOS

was born in the first decade of the fourth century, in Sikyon. He would have known the work of Polykleitos and his followers, Naukydes, Polykleitos II, Daidalos, Alypos, and Antiphanes, even though he later claimed to be self-taught. Nature was the only teacher he acknowledged, although he admitted the Doryphoros of *226* Polykleitos to be his one model from the world of man. He must have already had a considerable reputation in the early 'sixties, to have won the commission for a portrait sculpture of the Theban general, Pelopidas. This statue can be dated between the years 369, when Pelopidas defeated the Spartans at Leuktra, and 364, the year of his death—since the inscription on the base refers to him as being alive.

Lysippos's working life spanned almost three-quarters of the century. Sometime after the founding of Kassandreia (316), he designed for King Kassander special vases for the wine of Mende, while a statue inscribed to 'King' Seleukos cannot be earlier than 308 B.C., the year in which Selukos assumed the royal title. An epigram referring to him as 'hoary' is further evidence of his great age. There are stories to the effect that he lavished so much painstaking care on his works, that the resultant slow progress led to his dying of penury. According to another, he had, at the time of his death, amassed 1500 gold pieces by saving one from each payment he received. He seems to have been a very prolific artist and must have run a considerable workshop. A school was carried on by sons and colleagues of his after his death.

Lysippos's output included numerous statues of victorious athletes, likenesses of great men and statues of heroes and gods, many larger than life-sized. Like Pheidias, Michelangelo and Leonardo da Vinci, he was an artist in the fullest sense of the word. The study of his work was greatly facilitated by Braun's identification, in 1849, of a recently discovered athlete-figure from Trastevere and now in the Vatican Museum, as the famous Apoxyomenos of Lysippos. This statue had been brought to Rome by Agrippa and set up in front of the public baths he built for the city; the emperor Tiberius removed it to his own palace but popular outcry and demonstrations in the circus obliged him to reinstate the statue to its former position. *258* The statue is attributed to Lysippos, not only on account of its subject—an athlete with strigil—but more particularly because of its conformity with the Lysippan proportions as described in ancient texts. The youth's agile, slender body is supported by long, tensed thighs. The supporting left leg is straight, while

XL Head of a boxer. Probably part of a bronze statue of Satyros of Elis, who was champion boxer in Oropos 335/334. By Silanion. Height 28 cm. Ca. 335/330 B.C. Athens, National Museum 6439

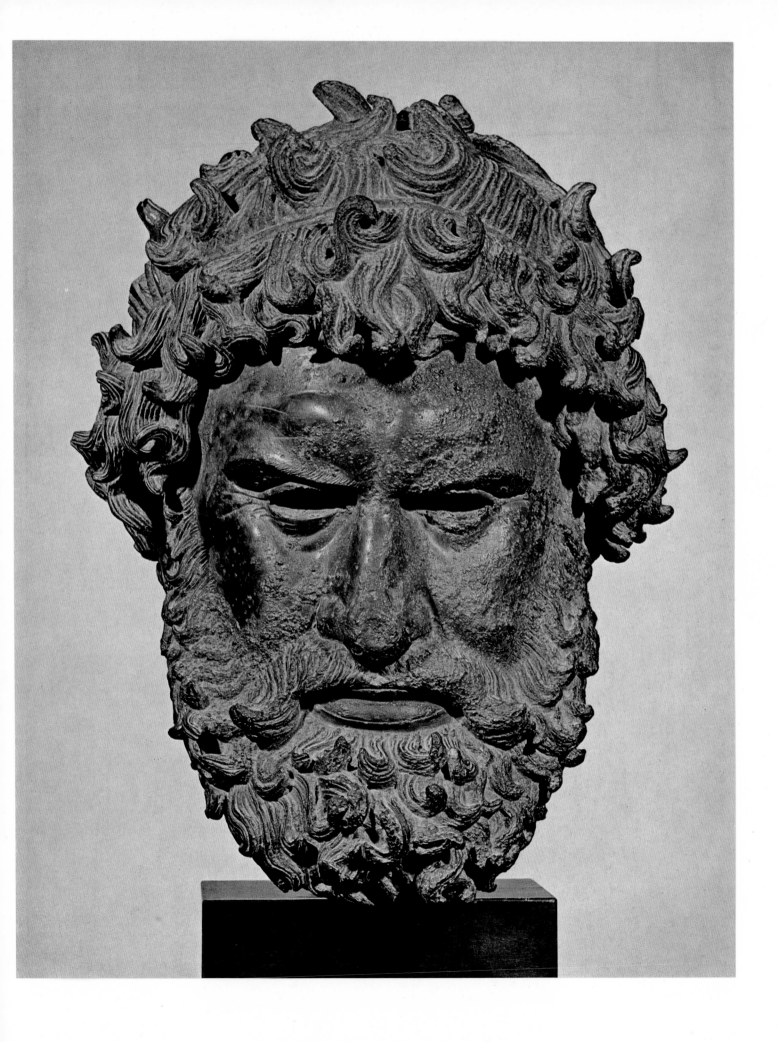

the free right leg is set back with only the toes touching the ground. The left hand is holding the strigil with which the athlete scrapes the coagulated dust and sweat from the outstretched right arm. The action is concentrated on the right side of the torso and forms a counterweight to the pillar-like left leg, while the right leg echoes the bend of the left arm. The dynamic displacement of the centre of gravity, and the emphasis of the functions of the limbs, lends the form freedom and rhythm. The outstretched arms, the free right leg and the far look in the eyes all penetrate the surrounding space. Even the spaces within the composition itself are subordinate to the over-all form and express its corporeal integrity within its environment. Lysippos is reported to have said that whereas earlier sculptors presented men as they are, he *258, 226* showed them as they appeared to be; a comparison of the Apoxyomenos with the Doryphoros of Polykleitos lends weight to his dictum.

The Apoxyomenos dates from the last quarter of the century and may represent the athlete Cheilon of Patras. The importance of the bronze original of the Vatican statue has recently received further confirmation from a statuette replica in Fiesole. On the other hand the torso of an athlete in the Athens National Museum (1626) is not a reproduction of the Vatican-Fiesole Apoxyomenos even though the subject is similar. The sparser, more restrained modelling suggests a dating close to the Satyr pouring wine by Praxiteles; it is probably roughly contemporary with the Pelopidas statue. Nevertheless, for all that they are separated in time by fifty years or so, the bold movement, the conflicting axes and the powerful arching shoulders make this athlete stylistically akin to the Cheilon of Lysippos. We can assume that it is a youthful work of his.

This leads us to the Resting Herakles, which survives in many replicas, and dates from the middle of the century. The huge Farnese Herakles in Naples is known, from the inscription on a replica in Florence, to *259 right* be after a work by Lysippos and should be compared with the Copenhagen figure of Herakles with right arm on hip. Glykon, the sculptor of the Naples copy, has dramatically exaggerated the arching musculature *259 left* of the original, which is more faithfully represented by the 'Steinhauser bust' in Basle. Numismatic evidence shows that the bronze original itself stood in Sikyon, the sculptor's native town; it was undoubtedly one of his later works and dates most probably from the first decade of the third century.

Lysippos's numerous statues of Herakles reflect the veneration in which he held the demi-god hero. The Copenhagen-Dresden Herakles represents the artist's mature period and shows the heroic figure at rest but *Fig. 173* in a state of dynamic preparedness. The Herakles Epitrapezios (ca. 330) takes the form of a divine reveller, presiding over a ceremonial feast; the original was undoubtedly a statue of considerable size. Wishing to make out that a certain Roman figurine was in fact Lysippos's original, Roman collectors seized on the title 'Epitrapezios' (at table), as evidence that the figurine was intended as a piece of table furniture; some modern scholars have even suggested that it was the salt of Alexander the Great. The resting Farnese-Florence-Basle Herakles, done after the death of Alexander, shows the hero tired, as if overwhelmed by his *Fig. 174* formidable labours. An enormous statue in Taranto showed him exhausted by his superhuman efforts, sitting on the basket he had used in clearing the channel to carry the river into the Augean stables. The bronze original was taken to Constantinople and set up in the Hippodrome there in the fourth century A.D. Byzantine accounts describe the figure somewhat emotionally as its sculptor's last work, and it must be admitted that surviving reduced copies, and marble copies of the head tend to support this view. The statue was a mighty embodiment of human woe. With his right hand supporting his head, the hero looked up despairingly to heaven, to his father Zeus who had made no move to save him from his humiliating lot. The mood of an ineluctable fate, given its fullest expression in the Taranto Herakles, also characterizes the Apoxyomenos, though here it is more restrained. The melancholy, the longing for the new, the unaccustomed (*pothos*), that was the hall-mark of the period of Alexander is transmuted in the works Lysippos produced after the emperor's death, into a mood of deep suffering (pathos) and painful testing.

The portrait works of Lysippos, among which can be numbered the young bearded athlete's head in *260* Copenhagen, 118, and the Socrates statuette in the British Museum, show the sculptor's deep insight into the arbitrary nature of man's destiny. Socrates, the untiring questioner, is shown walking through the streets of Athens in his search for interlocutors. His hands are empty, since a book would be unbecoming to the great teacher who wrote nothing, but based his philosophy on immediate contact and discussion. His hands grasp his cloak, and his faun's face reflects his eager intensity in the pursuit of the truth. Lysippos,

446

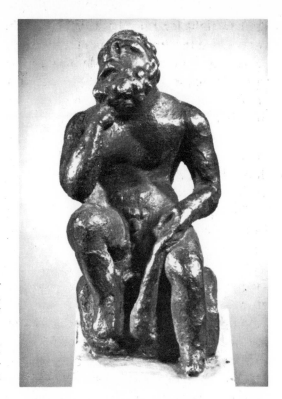

173 Herakles Epitrapezios. Bronze statuette, base on a statue by Lysippos

174 Bronze statuette, based on Lysippos's Herakles colossus at Tarentum

who sensed the secrets of eternity in the fleeting moment, must have felt a powerful affinity with the watchful spirit of Socrates, darting hither and thither, yet always in search of life's basic truths.

In his Kairos, the embodiment of the fleeting moment, Lysippos seems to offer us his personal credo. The original statue, now known only in Roman relief copies, probably stood in the sculptor's house. A nimble, running boy personifies the flying instant which the artist must seize lest it slip by unused. We cannot be sure whether the original had the full complement of attributes found in the copies; the wings, the scales balanced on a razor's edge, the head bald at the back, offering no grip to a pursuer. In this statue Lysippos was not falling back on Polykleitos's characterization of the artistic intuition as the 'approximate', nor was he seeking, at all costs, to endow an abstract concept with plastic reality; rather, he aimed to symbolize, in poetic terms, a far-reaching human and artistic experience. The Kairos sums up the thought and work of Lysippos as *The Canon* did that of Polykleitos. He did not concern himself with the timeless existence of gods and men, but was intent upon catching the momentary flash of the eternal in the temporal. He himself seems to have called the Kairos, quite simply, the Creator of Beauty.

The Eros Bending his Bow, of which numerous relics only are extant, is very close in style to the Kairos and probably by the same hand. The left arm is held across the body in the same manner as in the youthful work of Lysippos, the Kairos and the Apoxyomenos of the last quarter of the century. The god of love was in the act of unstringing his bow after having loosed one of his arrows.

Lucian refers to a statue of Dionysos by Lysippos. This may be the one seen by Pausanias (IX.30.1) on Helikon, which he describes as forming a marked contrast to the standing Dionysos by Myron at the same place. Presumably, therefore, Lysippos's version showed the god sitting or lying down. A beardless head of Dionysos, in the Bibliotheca Marciana, Venice, may be a copy from Lysippos's statue, since it is similar to the Vatican Apoxyomenos in many respects—the egg-shaped skull, the arching of the eyebrows, the full cheeks and the furrowed brow. In contrast to the athlete, the god's hair is in long tresses like that of the Alexander portrait head in Istanbul, a Late Hellenistic work based on an original by Lysippos. Alexander's court artist. Lysippos's œuvre also included important examples of group statues. Among them was the Labours of Herakles set up at Alyzia but removed to Rome by a Roman general, who claimed that no one saw it on its original site. Krateros, the companion of Alexander who came to his rescue during the lion hunt, dedicated at Delphi a statue group of the incident by Lysippos. We can gain an idea of the lost bronze original from a relief from Messene, in the Louvre; from the hunting relief on the so-called Alexander

261 above

258

261 below

305

Fig. 175

447

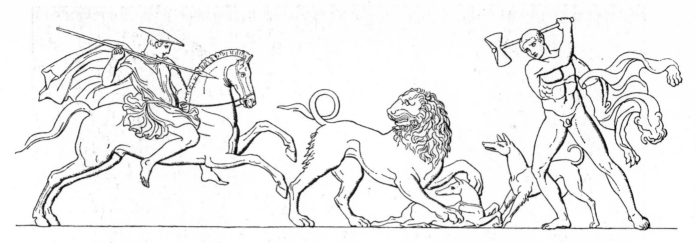

175　Relief base from Messene, dedicated by Krateros—shown here with Alexander the Great fighting a lion—at Delphi. Sketch (after Kleiner) of the relief in the Louvre, Paris

XLVI, XLV Sarcophagus in Istanbul; and from a mosaic, recently found at Pella in Macedonia. It showed Alexander and his hounds fighting off an attack by lions with Krateros hurrying to the rescue.

Besides the subjects already discussed, Lysippos produced no less than four statues of Zeus. The earliest of these stood in the agora of his home town of Sikyon. Coins and figurines from the period of Imperial Rome preserve the memory of the lost work. The weight was carried by the right leg, the left, relaxed, was held to one side; the right hand rested on the sceptre, the left, on the thunderbolt. The finest reproduction *262 below, left* is the Roman bronze figurine in the Bibliothèque Nationale, No. 15. Some of these miniatures have been identified as copies of the Zeus Brontaios by Leochares, thought, until recently, to have been the only important Late Classical sculptor of statues of gods. Again from Roman coins, we can get some impression of Lysippos's statue of Zeus at Megara. With the raised right hand he held the thunderbolt, while stretching *174/175,* out his left arm for balance. The posture is reminiscent of the God from the Sea of a century before (the *XXVIII* so-called 'Poseidon') in the National Museum, Athens.

263 left　A bronze figurine in the Bibliothèque Nationale, No. 1, copied from an original of the third decade of the third century, is possibly a version of this Megara Zeus.

259 right　The Zeus of Argos continues the compositional theme of the Resting Herakles (Copenhagen-Dresden). Coins show the god with the right leg supporting and the left leg free; the right hand rested on the sceptre, the left on the hip. Figurine copies in London (1540) and Delos show the Lysippan Poseidon in reverse. There is, however, no reliable numismatic evidence for Lysippos's most important statue of Zeus, the *262 right* colossus at Taranto. But one may be on safer ground with the superb Zeus, possibly Roman, acquired for Furtwängler by Curtius and now in the Liebighaus at Frankfurt, which is so obviously in the style of *262 above, left* Lysippos. Most welcome confirmation of this supposition comes from a Tarentine clay head in the Vlastos Collection in the National Museum, Athens. This appears to date from the second decade of the third century and to have been produced under the immediate influence of the recently erected colossus by Lysippos.

263 right　The Lysippan portrait statue of Alexander the Great, surviving in an 'Atticizing' bronze figurine copy in the Louvre, was influenced by the Zeus of Argos; moreover, the way in which the weight is distributed *258* recalls the Apoxyomeos. The left leg, slightly turned out, supports the body, the right leg being set to one side, with the toes just touching the ground. The taut line of the left leg carries on up to the face, passionate in its intensity, but suffused with a mood of peacefulness. The upraised left hand held the sceptre, the lowered right hand the thunderbolt. The arrow-like effect is impressively heightened by the outward movement of the left arm; the compositional flow continues down the right side of the body to the tip of the right

XLI　Aurora Painter. Faliscan volute-krater. Peleus and Thetis. Height 59·2 cm. Ca. 340 B.C. Rome, Museo Villa Giulia 2491

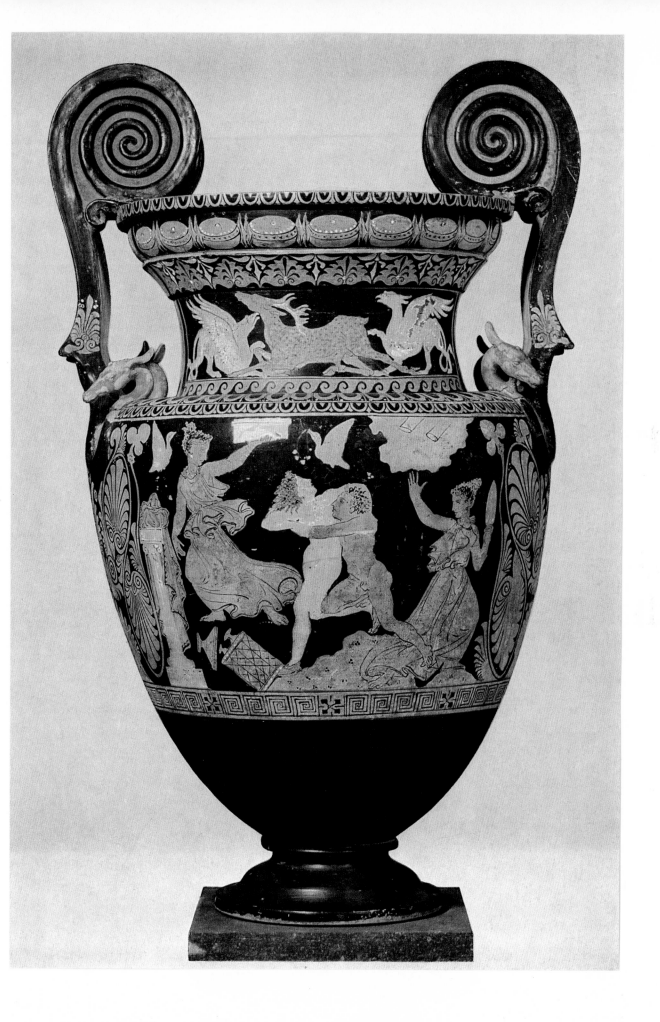

foot, in a wide swinging S-curve. The lightness of the free stance gives the figure an astonishing sense of the captured moment; the god himself resembles a lightning flash. One can understand why Alexander the Great should have chosen the artist of such powerful statues of Zeus as his court sculptor. Quite clearly he wished to present to his contemporaries and to posterity no less impressive an aspect than the Zeus of Lysippos. In the strictest sense, it is only these statues of gods which can give us a 'true appreciation of the mighty genius of Lysippos, whose only rival in his own time was Alexander the Great, and who has no serious rivals among the artists of posterity' (Lippold).

The tombstones of the late fourth century sum up the attitudes of Late Classicism: the transfiguration of existence and the elevation of the dead to a transcendental state. The sculptor of the Ilissos stele was evidently
264 a follower of Skopas. A naked youth reclines against his own tombstone, at his feet sits a little boy, benumbed by grief and suffering while a dog casts about for his master's scent. A bearded figure, the young man's father, looks at him as if at a dream or a memory; they are sundered by the gulf between life and death. And yet there is something here of the interpenetration of dream and reality, of enchantment and actuality, of the soul-stirring quality of the century of Late Classicism.
265 The Rhamnus stele, from the late 'twenties, shows a man and woman earnestly confronting one another. The tall, slender forms with their small heads reveal the influence of Lysippos on the Attic sculptor of this boldly modelled high relief. The dead woman is presented frontally, a pose used in the Archaic period to depict the manifestation of divine beings. Here the father or husband of the departed girl seems to see her again in his mind's eye; but the simple isolation of the figures, the way in which their eyes look past one another, together serve to emphasize the unbridgeable gulf between them and confirm their irrevocable isolation and loneliness.

LATE CLASSICAL PAINTING

Aphrodite, Dionysos and their companions are the main subjects of Late Classical painting. The florid style continued into the first quarter of the fourth century and themes from myth gain a new lease of life; an example of this is provided by the fight between the gods and the giants on the neck-amphora of the Suessula Painter, in the Louvre.[14] 'The gods and giants battle in Dionysiac abandon . . . and it is not by mere chance that Dionysos takes the place of honour next to Zeus.' (Buschor) On the back we see Aphrodite serving as charioteer to her husband, Ares, while he, with a theatrical gesture, thrusts with his lance at Porphyrion; crouching on the back of one of the horses is Eros, taking aim at the giants. From Kul Oba come fragments
Fig. 176 (now in the Hermitage, Leningrad) of a drawing on ivory of the Judgment of Paris. He stands before Hera and, bewildered by the heavenly brilliance, lays his right arm upon his head; the virgin Athena, with her weapons, lance and helmet, turns from the arbiter to watch their sister Aphrodite who is quietly conversing with the stripling Eros.
266 The cup of the Meleager Painter, in London, depicts an utterly blissful scene; Dionysos and Ariadne embrace one another as they walk, followed by Eros with a tambourine. Scenes of lovers' pursuits and abductions, so popular in the early fifth century, gave way during the rich style to intimate scenes of the life of women. The earlier subject is revived in the Late Classical volute-krater by the Etruscan Aurora Painter. Eos, the goddess of dawn, drives her quadriga over the sea, preceded by the winged figure of the morning star; in the chariot with her stands the young, abducted Kephalos. Boyishly delighted by the dolphins and sea-monsters, the glimmering dawn and the outstretched pinions of the birds, he lays his hand on the shoulder of the goddess in a gesture recalling the slightly earlier Ganymede group by Leochares.
XLI The scene on the reverse depicts Thetis struggling to free herself from Peleus. In the struggle a cista containing two alabastra has been knocked over; her sisters flee terrified from the scene as Thetis looks up, as if for help, to a dove flying overhead with a wreath in its mouth.

XLII Apulian calyx-krater. Maenad and satyr. Height 53 cm. Mid 4th century B.C. Lipari, Museo Eoliano 2241

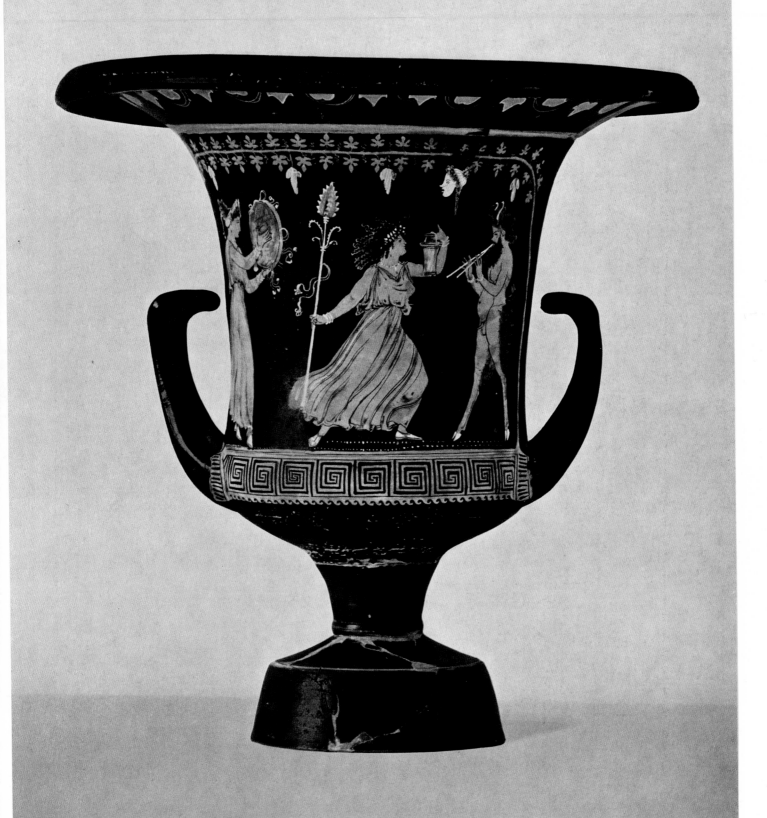

176 The Judgement of Paris. Drawing on ivory, from Kul Oba. From left to right: Hera, Athena, Aphrodite with Eros; the extensively damaged figure of Paris (far left) is not reproduced. Leningrad, Hermitage

The pathos of this scene is somewhat theatrical, an effect that is wholly avoided on an oinochoe in New York which glorifies Pompe, the personification of the ceremonial procession. 'Dionysos sits on a podium, as if in some divine auditorium, and looks back at the goddess of the procession who is ceremonially dressed and has already prepared the basket for the sacrifice; Eros, or more correctly in this case, a genius of the festival is lacing up his shoes. A wreath runs round the neck of the vase. The group is instinct with a new sense of intercommunion; it is as if the Dionysiac rapture had withdrawn from the teeming multitudes into the figures themselves, and inspired them with a new life which seems to bridge the gulf between them. The god and goddess and the Eros seem to spread out fanwise from one another, thus heightening the releasing effect caused by the globular shape of the vase.' (Buschor)

XLIII Marsyas Painter. Pelike. Peleus takes Thetis by surprise while bathing in the sea, to abduct her with the help of Aphrodite.
Height 42·5 cm. Ca. 350–340 B.C. London, British Museum 424

452

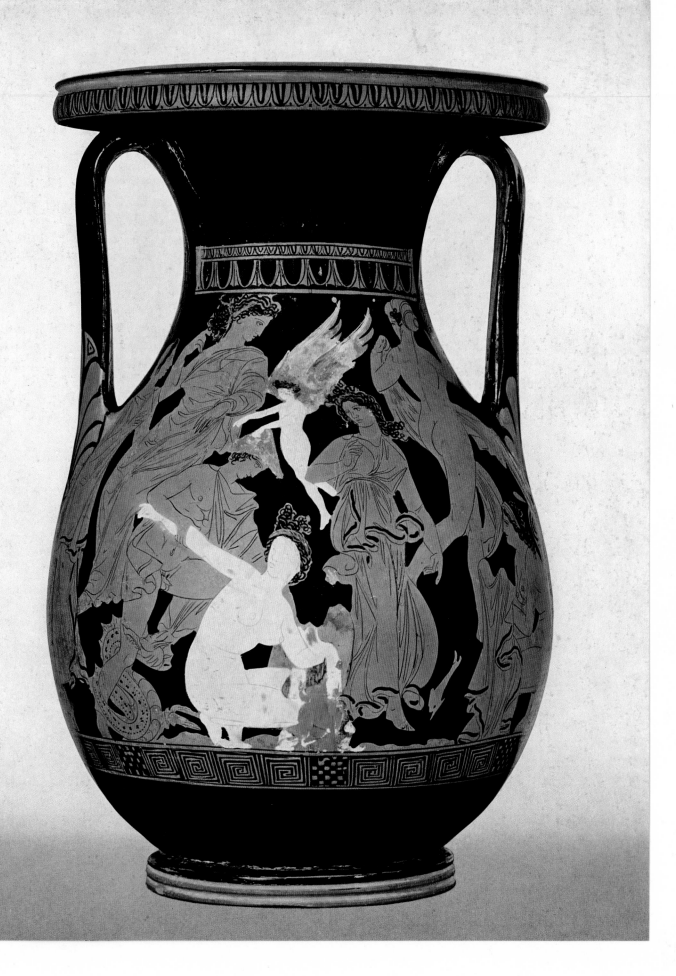

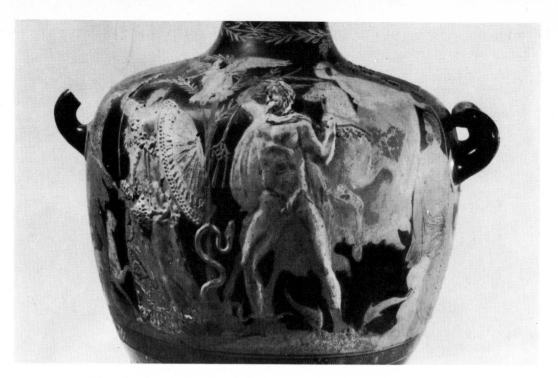

177 Athena battling with Poseidon for Attica, from a hydria in the Hermitage, Leningrad

In its perfection, the charm and dignity of the figure and the community of feeling which unites them,
267 the New York oinochoe shows that the red-figure style is in danger. The simple relationship between figures and ground, so typical of the florid style, has been superseded. Vase painting, possibly under the influence of major painting, has gained a life of its own, the figures a weight and presence which threaten to break through the surface they decorate. Apulian painters sought to avoid the danger by working in the large format of the earlier funerary vases of the Geometric style. These display vessels were decorated with picture registers set one above the other and overlapping in the manner of monumental painting. The themes preferred were representations of funerary rites and the Underworld, Homeric scenes, the journey of the Argonauts and historical subjects such as Darius with his advisers, or scenes from the battles of Alexander.

It is no coincidence that other painters from Magna Graecia began to abandon the red-figure style. A
XLII calyx-krater from Lipari has a painted black ground which carries tendrils, with masks and bunches of grapes, and dancing maenads. The figures stand out from the black ground with a delicate effect like silver appliqué decoration. Soon figured decoration disappears entirely from these vases which come to rely on the elegance and perfection of the vase shape itself.

Attic vase painting enjoyed a final lease of life in the so-called Kerch vases, named after their chief find-place at Kerch, ancient Pantikapaion, in South Russia. Even the finest creations in this style cannot conceal a romantic longing for the achievements of the Classical period.

Fig. 177 A hydria in Leningrad, depicting the struggle between Athena and Poseidon for the land of Attica, is a particularly good example of this fourth-century Classicism in Attic vase-painting. The two main figures are obviously modelled on the central group of the west pediment of the Parthenon and stand out in relief treatment from the other painted forms of the picture. This is not merely a case of quoting from the original but shows that the artist also recognized the limitations of Late Classical vase painting. Attic vase painters had made use of all kinds of devices, such as foreshortening of limbs and bold rear views, to give the figures a plastic quality and create an impression of depth in space; the occasional use of actual relief is one of the consequences of the decay of the red-figure style.

Nevertheless, some of the most important Attic painters carried the florid style into the third decade of
XLIII the fourth century; for example, the pelike in London, No. 424, showing the story of Peleus and Thetis.

454

Aphrodite sits to the upper left of the picture as the protectress of the young Peleus as he tries to seize the beautiful Thetis who is emerging from the sea. The violence of the scene in earlier versions has been toned down; there are fewer main figures and they convey more of an inward drama. Thetis, emphasized by her white skin, kneels in the centre of the scene; she is taken unawares by Peleus's sudden attack which she cannot evade, while her sisters run away trying to hide their nakedness. Above, an Eros, with blue and gold wings like a victory goddess, swoops down to crown Peleus. The figures cover the surface of the pelike like a carpet, and their placing follows the curving sides of the vase.

A nuptial lebes, painted by the Marsyas Painter in the 'thirties and now in Leningrad, is encircled by an *268* unbroken frieze, showing the Epaulia, the bringing of gifts to the young bride the morning after the wedding. The scene is familar from the epinetron by the Eretria Painter who depicted Alkestis as the bride; on the *232* Leningrad lebes, the betrothed is an Athenian lady receiving friends who bring her gifts. Yet she sits like a goddess in the centre of the front of the vase, fondling a white-painted stripling. Her young nubile friend strokes the wings of Eros, as if to convince herself that he is not an apparition. Two Erotes, as gracious as Aphrodite herself, hover about the head of the young wife whose himation, decorated with gold rings, is wrapped about her body but falls away to reveal the shoulders and bosom. In front of her, a little girl holds out a lidded cup. The procession of guests and servants bringing presents is made up of a series of magnificent female figures which are reminiscent of the marble sculptures of Praxiteles and the bronzes of Lysippos and his circle.

EUPHRANOR OF THE ISTHMOS

In the fourth century, Corinthian painting received a fresh impetus, associated with Euphranor of the Isthmos who was equally famous as a sculptor. We know little of his pictures save their titles, though the symmetry and interrelation of his figures appealed to the artistic taste of his day; like Zeuxis, however, he was criticized for painting the heads too large. Euphranor is said to have remarked that, whereas his Theseus obviously lived on steak, the Theseus of Parrhasios had the appearance of having been brought up on rose petals.

Euphranor's Theseus was part of his wall painting in the Hall of Zeus Eleutherios in the Athenian Agora. He was depicted in the company of Demos and Demokratia; next came a picture of the twelve Olympians, of which Zeus was particularly famous, and finally, we are told, a cavalry action. We can perhaps get some idea of the figures of Demos and Demokratia from the incised picture on a Corinthian mirror case; this

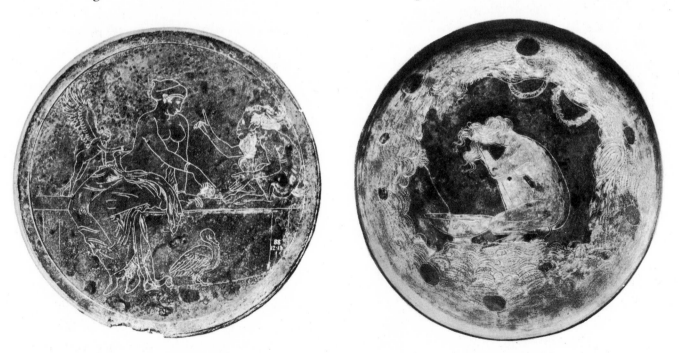

178 Aphrodite, Eros and Pan, from an engraved bronze mirror. London, British Museum
179 Nymph bathing, from an engraved bronze mirror. Berlin, Staatliche Museen

455

shows the legendary lords of Corinth enthroned like Zeus, attended by the embodiment of the island of Leukas. Euphranor was also renowned as a metalworker and could be compared to Pheidias in his versatility.

Fig. 178 His workshop produced the bronze mirror decorated with a scene of Aphrodite and Pan quarrelling over a throw in their game of knuckle-bones; the engraver has used short strokes of the burin on the hybrid figure of Pan and on the gown wrapped round the lower part of the body of Aphrodite.

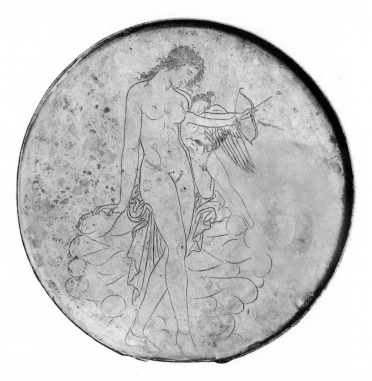

180 Aphrodite and Eros, from an engraved bronze mirror. Paris, Louvre

Fig. 179 Another bronze mirror, of Corinthian or Sikyonian origin, shows an enchanting landscape scene with Aphrodite bathing. The goddess, at the centre of the picture, is kneeling in front of a basin as she arranges her disordered hair. She has withdrawn into the dappled shadow of a grotto in the rocks; near by a thin stream of water plays from the mouth of a lion's-head waterspout carved in the rock, while above her, from a crevice in the rock, the lecherous head of Pan views the scene. The goddess has apparently not seen him and yet one feels that she has already sensed his wild breath. Behind her are her clothes and at the entrance of the grotto hang wreaths, betokening a sanctuary of Aphrodite. The artist has placed himself, as it were, at the back of the cave, but, unlike the unchained prisoners of Plato's famous simile, he does not need an artificial fire to illuminate the forms—Aphrodite appears to him as the epitome of ideal beauty, shining more brilliantly than the light of day outside. Similarly decorated mirrors were made at other centres. One, from a workshop in some part of Magna Graecia, shows a standing Aphrodite with Eros,

Fig. 180 leaning against her as he lets off an arrow; the naked contours of the slender girl and of the kneeling Eros form a charming and harmonious picture of youthful beauty.

 Like Corinth, Sikyon made an important contribution to painting in the fourth century. Pamphilos of Amphipolis ran an Academy of the Arts there, charging the fee of one talent. For this he taught not only drawing, but also arithmetic and geometry which he considered indispensable for an artistic training. He seems to have been more important as a theoretician than as a practising artist, writing treatises on drawing, painting and agriculture. His pupils included Melanthios, who also produced theoretical writings, and Pausias, who won considerable fame with a picture of Glykera plaiting a wreath. Another of his works showed a sacrifice of a bull, in which the black animal appeared full-face and foreshortened without the use of high-lights. He achieved bold mirror-effects in his picture of Methe in Epidauros, in which the face, the embodiment of drunkenness, was depicted through the glass.

456

Undoubtedly the most famous pupil of the academy was Apelles, the son of Pytheas of Kolophon. He was the only painter, as Lysippos was the only sculptor, whom Alexander the Great allowed to portray him from the life. Many pictures of the emperor are mentioned, some showing him on his own, some accompanied by his horse, and some characterizing him as the son of Zeus, when he is shown holding a thunderbolt.

Apelles is the subject of more anecdotes than any other painter of antiquity. They tell us little of his art, but offer a sympathetic picture of a man generous to his friends and modest about his own achievements. He was always prepared to recognize other men's qualities, while fully aware of his own. When things were going badly for the Rhodian painter, Protogenes, Apelles set going a rumour that he intended to buy up all Protogenes's pictures and sell them as his own at a much higher price. Things went better for Protogenes after this.

On another occasion, Apelles exhibited a single line in the guise of a picture; this was greatly admired as a work of art, particularly by other artists. The story goes that this very object led to Apelles and Protogenes striking up their friendship. Apelles had gone to Rhodes to meet his fellow artist, who was out when he called; seeing a panel prepared for a painting, he drew a single line on it and left. When Protogenes returned, he immediately recognized the hand and drew a second line, choosing a second colour, and left in his turn. Hoping to find the artist at home, Apelles came back but found only the panel with its addition, whereupon he added a third line which left no room for further refinements. Thereupon Protogenes, admitting defeat, gave up the game and sought out his famous colleague.

Apelles did not let a day go by without practising drawing, *nulla dies sine linea*. He set up his finished works in his shop window, where they could be easily seen. The story goes that he then hid himself within ear-shot of the comments of passers-by. On one occasion he heard a cobbler complaining to his friend that a buckle was missing from a shoe in one of the pictures. Apelles put this right. However, when the cobbler, feeling himself vindicated as the judge of a painting, proceeded to criticize the ankle, Apelles emerged in a temper to comment: 'Let the cobbler stick to his last!' It seems that Apelles did not produce any wall

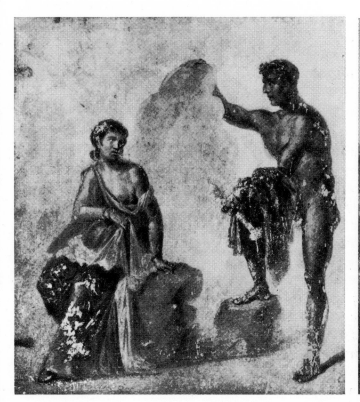
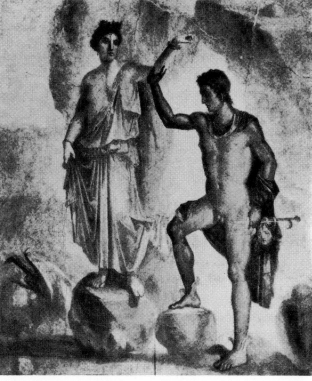

181/182 Wall paintings from Pompeii, derived from paintings by Nikias of the 4th century B.C. 181 Argos and Io. 182 Perseus freeing Andromeda. Naples, Museo Nazionale Archeologico

pictures, though it must be admitted that we have no visual record whatsoever of his work. From descriptions we know that his Aphrodite Anadyomene of Kos, later removed to Rome, was emerging from the water and squeezing her hair dry with both hands, perhaps something like the kneeling Aphrodite in a *Fig. 179* grotto on the bronze mirror in Berlin. We have no visual evidence of his Calumny, yet it appears to have contained more figures than any of his other pictures. Basing his work on a description by Lucian, Botticelli attempted a rival version of the same subject, now in the Uffizi, Florence.

Several pictures ostensibly dating from the fourth century survive at Pompeii but very rarely can we connect them with the names of individual painters and then only on supposition. One, of which many *Fig. 181* variations and copies exist, has been identified as an Argos and Io by Nikias. In over-all composition a *Fig. 182* picture of Perseus freeing Andromeda is closely akin to it. Moreover, since Pliny specifically mentions a Calypso, an Io and an Andromeda, besides pictures showing Alexander, as being by Nikias, the identification seems justified. However, nothing is known of Nikias's individual style and the surviving reproductions do not even provide us with a firm basis for reaching any conclusions as to the general composition of the pictures.

The composition of a painting by Nikomachos of a Nike flying aloft in a chariot is known to us from Roman coins and a cameo; the original on which they were based was taken to the capitol in Rome by L. Munatius Plancus.

THE ALEXANDER MOSAIC

Of one major painting of the fourth century we do have a copy and it far transcends any of the accurately *XLIV* proportioned statue copies of the Roman period. This is the 'Alexander Mosaic', measuring 5·82 by 3·13 metres, probably the size of the original; it was set in the floor of the Casa del Fauno, or the Casa di Goethe. Goethe's son was in fact present at the beginning of the excavations in Pompeii on the 7th October 1830; the comments of the then aged poet on the picture itself are still valid: 'No other survival from antiquity parallels the painterly composition and imagination of this work', and 'Neither the present nor the past can do justice in words to such a work of art and after observing deeply and examining closely we can only fall back on simple wonder.'

The mosaic was damaged in antiquity, presumably in the earthquake of A.D. 63, and there is little hope that the lost fragments will ever be restored; the gaps are filled out with chalk rubble and in this state it was buried in the eruption of Vesuvius in A.D. 79. For the last thirty years this floor mosaic has been displayed on a wall, as was the original painting, in the National Museum, Naples.

The scene is the battlefield, on which the bodies of dead Persians, their riderless horses and the debris of broken weapons lie scattered. A leafless tree is the only sign of landscape and provides at the same time important evidence as to the season. We can now be certain that the subject was the battle on the Issos in the early winter of 333 B.C. The lion-hearted Alexander, in his Greek armour decorated with a gorgoneion, storms into the battle from the left of the picture until he is in a position to threaten the Persian king, who as Curtius commented, 'dominates the composition and moral content of the picture'. The long spears which in the background surround Darius so menacingly are Macedonian; the Persian army is surrounded and the advance guard falls back to warn Darius of the danger. With great presence of mind, his charioteer has begun to turn the chariot; the two black horses have swivelled round so that they face the spectator, while the charioteer is using reins and goad to bring the two bays round. Darius himself does not seem to recognize the peril. With a noble gesture he turns towards one of his loyal comrades whom Alexander has cut down, dismayed that he cannot help him, since he has spent all his arrows. Here Alexander's great enemy is shown in his full stature as man and ruler, ignoring the opportunities of flight still open to him and remaining at the side of the young hero who has saved him by his death.

Although the artist of the Naples mosaic employed the four-colour technique of the fourth century, the strong impression of colour and modelling it conveys makes one forget its limitations. The remarkable

XLIV Alexander the Great facing Darius at the Battle of Issos, 333 B.C. Floor mosaic (total area 2·71 × 5·15 m.) after a Greek painting, found in the House of the Faun in Pompeii. Above: entire scene as far as it is preserved; below: Alexander the Great

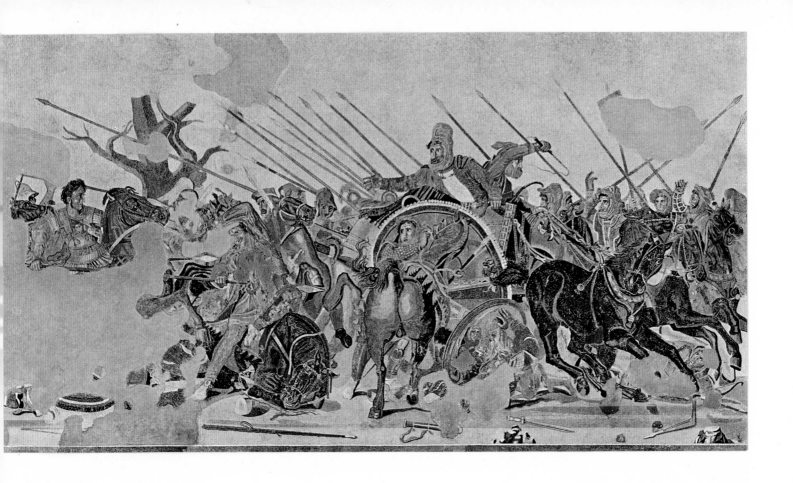

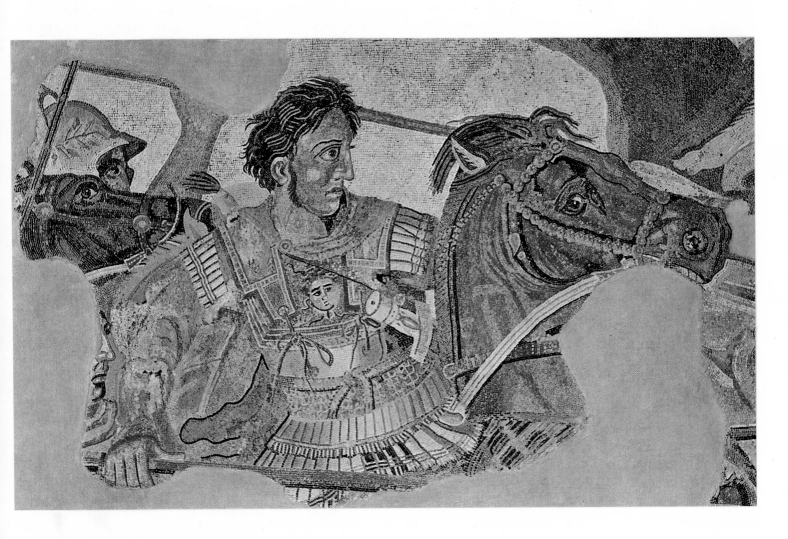

sense of depth is achieved not by receding picture planes but by the spatial displacement of the figures, as we can see from the largely intact right half. Here a Persian soldier is attempting to control a stray horse, shown in bold foreshortening and with brilliant use of high-lights, while a prostrate Persian is reflected in his colleague's shield. At the same time the two soldiers form a pivot for the turning movement of Darius's chariot, which looks as though it will relentlessly crush them.

Undoubtedly the original was the work of one of the great masters of the late fourth century. Pliny mentions a version of the subject, showing Alexander with Darius, by Philoxenos of Eretria; yet in the same sentence he comments that Philoxenos was, like his master Nikomachos, a very fast worker, a description which hardly matches the care and attention to detail of the Alexander Mosaic. On the other hand it must be admitted that we know virtually nothing about Philoxenos, and two lines from Pliny are perhaps not sufficient to condemn him. Others said to have done versions of the subject include a woman painter named Helen, and according to Aristotle, the great Apelles.

THE MOSAICS OF PELLA IN MACEDONIA

XLV Excavations at Pella over the last few years have brought to light a number of fourth-century mosaics. They are on such themes as the hunt of a hind, a lion hunt, the abduction of Helen by Theseus and the god Dionysos riding on a panther. The technique is pebble mosaic and the colours are consequently dull, the contours of the figures being marked by inlaid metal wires. The scene of the abduction of Helen shows that by this time shadows were being used for female figures, an advance due possibly to the Athenian painter Nikias. These mosaics were obviously not unaffected by developments in painting, yet it is equally obvious that they were originally designed as mosaics. They attempt nothing of the richness of colour effect that is to be seen in the Alexander Mosaic, which for its part uses the barest means to achieve a full chromatic register.

COINS IN THE FOURTH CENTURY B.C.

The far-reaching political developments which occurred throughout the Greek world, in the mainland and Asia Minor at the turn of the century and in the Peloponnese about thirty years later, were all of decisive importance for the coinage.

Following the double victory of Kimon on the Eurymedon in 469–466 B.C. the naval league was formed which with each year that passed gave Athens an ever more dominant role and which by about 425 B.C. embraced more than four hundred cities in the Aegean, from Chalcidice to Rhodes and from Euboia to the south coast of Asia Minor. From the middle of the fifth century on, the notorious Athenian currency decree effectively denied to the allied cities the right to strike their own silver coins. The Athenian tetradrachm was to be the league's exclusive currency; it was intended, moreover, for use all over the Mediterranean world. But after 413 B.C., the year of the defeat in Sicily, the Athenian decree cannot have continued to be universally effective; after Aigospotamoi and the end of the Peloponnesian War with the surrender in 404, the fall of Athens was complete. Freedom of coining rights was restored by the so-called 'King's peace' in 387 B.C., that harsh settlement imposed on the Greeks by the Persian king in Sardes, whose implementation was entrusted to the care of Sparta, but whose apparent intention was that the Greek cities, great and small, should be autonomous. This 'freedom' of the individual cities, whose sinister purpose really envisaged the total political dismemberment of the Greek world, nevertheless gave free rein to each city's creative ability in regard to coinage. Finally, Epameinondas's victory at Leuktra in 371 B.C. and the same great general's four campaigns in the Peloponnese between 371 and 363 B.C. brought about the demolition of Sparta's over-all hegemony in the Greek world of the time and specifically that over the Peloponnesian cities; as a result, the Peloponnese too was able to revive coinages of real significance. In sum, all over Greece and Asia Minor coins were now being minted in cities where such activities had ceased long before, or had not previously taken place; on the other hand there were inland or north Greek cities that had never come under the sway of the Delian league who were naturally proceeding with their own particular coinages.

We have already made the acquaintance of the staters of Thasos, the island rich in gold, not only those 198 (8) of ca. 500 but the beautiful specimens of 465 B.C., when Thasos fell away from Athens and severed her

460

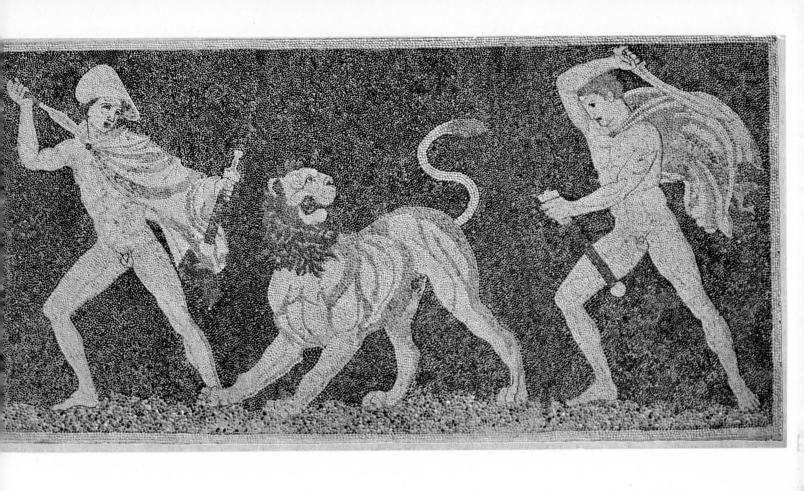

XLV Lion-hunt of Alexander the Great and his General Krateros. A pebble-mosaic from Pella, north-west of Thessaloniki.
Length 4·90 m.

connection with the Delian league, and finally those of the developed fifth-century style. At the turn of the
240 (16) century Thasos once again comes to our notice with a fine type of coin showing on the obverse the head
269 (1) of her god Dionysos, wreathed in ivy and quite Zeus-like in aspect, while the reverse shows a figure of
Herakles the Archer who was also the god of the city gates and is derived from an Archaic relief mounted
there.

In Olynthos, which was referred to earlier, the years after the turn of the century saw the introduction
of a series of tetradrachms with the head of Apollo and these maintained their exceptional artistic quality
and a brilliance of engraving over a period of several decades. On the issues of 395–392 B.C. the head has
269 (4) the powerful masculine character of a great bronze statue, whereas on the specimens of 379–376 B.C. in
269 (5) conformity with the style of the time, the features have become softer and almost boyish.

Amphipolis, the city lying between the two arms of the River Strymon, was founded by Athens in 437
269 (6) B.C. Her coins, from their beginning around 400 B.C., make use of a frontal version of the head of Apollo,
and the renderings were superb. The city was conquered by Philip II in 357 B.C. and then became the most
important mint-city of the Macedonian kingdom, a position which it maintained even in the time of
Alexander the Great's vast empire with its profusion of minting centres.

198 (9) Ainos in Thrace, situated at the mouth of the River Hebros, had coined her first tetradrachm with the
240 (14) Hermes head in the early part of the fifth century, ca. 474–472 B.C.; we have already shown a piece from
455–453, and now reproduce another from the fully developed Classical period, ca. 412–410 B.C. About
400–398 the step was taken of introducing the Hermes head in frontal view, and though at this time the
effect is somewhat dour and remote, there is a later version that is more sensitive and lively, as on the
269 (13) drachms of 357–342 B.C. Instead of wearing the petasos, as in the earlier versions of the head, the youthful
god is here shown with the broad-brimmed hat very similar to that on a head at Sybrita in Crete of around
360 B.C.

269 (14) At about this time Pantikapaion (modern Kerch) began to mint her attractive gold staters with the head
of Pan, the god after whom the city was named. The head is on rare occasions depicted *en face* though the
majority of these staters have a profile head. On the reverse is a griffin, the guardian of the vast treasure
which Kerch possessed, thanks to the near-by gold-mines, in the act of devouring a spear-head, presumably
that of an attacking enemy. In place of a ground line the beast stands on a corn-ear, symbolizing the region's
wealth in those cereals which were of such fundamental importance for the Greek world as a whole and in
particular for the grain supply of Athens.

Safeguarded by the army of Philip II, the Amphiktyons of Delphi, the associated cities bordering on her
territory, were in 346 B.C. able to resume their protection of the Sanctuary of Apollo. To commemorate
269 (7) their restoration, they proceeded to mint staters with the head of Demeter crowned with corn-ears and
veiled, on the obverse; and on the reverse, Apollo, holding the Pythian laurel and kithara, enthroned on the
omphalos, the centre-point of the world. It was just at this time that Praxiteles carved the wonderful Hermes
still to be seen at Olympia and also the Knidian Demeter which the head on the Delphic staters so vividly
recalls.

We have already looked at the earliest coins of Elis with the head of Zeus, dating from ca. 421 B.C.;
269 (3) now around 363, we see the introduction of coins with a Zeus head in the style typical of the mid fourth
century, whose grandeur of conception is matched by masterly engraving. Preceding these by only a few
years there was the coin with the head of Zeus Lykaios, minted at Megalopolis, the seat of the Arcadian
269 (2) league, around 370–363 B.C. This is one of the Peloponnesian coins which could be struck after the victories
of Erameinondas. The coins of Megalopolis were adorned on the reverse with the figure of the Arcadian
god Pan seated on a rock. At the same time staters of the Arcadian cities of Pheneos and Stymphalos carry
types harking back to Arcadian myths—compositions conceived entirely in the spirit of the years around
269 (8) 362 B.C. when they were produced. On the stater of Pheneos we have Hermes carrying the infant Arcas,
269 (9) child of Zeus and the nymph Kallisto. The Stymphalos stater shows Herakles in the act of carrying out one
of the twelve Labours imposed on him by Eurystheus—the struggle against the Stymphalian Birds. This is
a composition whose dramatic quality immediately calls to mind the work of the four sculptors who made
the frieze of the Mausoleum of Halikarnassos. As for the obverse of the two staters, which are not illustrated

462

here, that of Pheneos shows a head of Persephone strongly influenced by the Euainetos decadrachms of 239 (9) Syracuse; that of Stymphalos has a head of Artemis Stymphalia which is stylistically far finer and in full accord with contemporary work, whereas the Pheneos head gives the impression of being a mere echo of the past.

The island of Crete produced a number of coin dies in the second half of the fourth century that are of real artistic importance, though as always in Cretan work the actual engraving lags behind that of the coins in other Greek lands. On the stater of Phaistos, Herakles is again found engaged on one of the Labours— this time his combat with the Hydra of Lerna. This type has a close relevance to its place of origin, as 269 (12) Herakles was reckoned to be the father of Phaistos after whom the city near Mount Ida was named. The big crab by the hero's feet is explained by the myth according to which a crab vainly attempted to fasten on Herakles's foot in order to afford some assistance to the Hydra. The style of these pieces is strongly reminiscent of the Stymphalos coins.

Superbly poetic is the Gortynian type of Europa, as she meditates amid the branches of the great plane-tree 269 (10) in whose shade she had been embraced by Zeus. The stater of Sybrita conveys a positively Lysippan feeling: here we see Hermes, binding his sandal, and within the almost flat relief planes of the coin we find expressed 269 (11) that three-dimensional quality so characteristic of the sculptor. From the point of view of the art of coin design as such, this is an achievement without equal. On the reverse of the two coins of Phaistos and Gortyna mentioned above, there is a bull: the former is certainly the great Cretan beast that Herakles and Theseus captured, while the latter is perhaps the bull whose shape Zeus assumed in order to carry Europa to the island of Crete. The obverse of the Sybritan stater, however, shows us the unusual coin type of Dionysos riding on a panther.

In the kingdom of Macedonia, whose first monarch ascended the throne in 495 B.C., immense coin issues were made by Philip II (359–336 B.C.) and by Alexander the Great, which we can notice only briefly here. Philip's tetradrachms regularly have the head of Zeus on the obverse: the Macedonian king's endeavour to 269 (15) rival the Greeks in everything is well known, and these heads, in spite of the quantity in which the coins were minted, are often outstandingly beautiful and magnificently engraved, in fact scarcely inferior to the best pieces from Elis. The reverse is at first taken up with the type of the Macedonian leader mounted on horseback wearing chalmys and kausia: then, after his victory at Olympia which Plutarch records, there appears an ephebos riding a powerful horse, signifying the king's pride in his Olympic victories. The gold 269 (16) staters (not illustrated here) are also connected with Olympic victories by reason of the two-horse chariot shown on the reverse; while on the obverse we have the laurel-wreathed head of Apollo. The tetradrachms and drachms of Alexander the Great were minted both during his own lifetime and also posthumously under his successors, and in the cities of Asia Minor as well so long as they possessed minting rights; some of the latter coins continued until about 220 B.C. The coins portray on the obverse the head of Herakles wearing the lion's scalp, and the image of this hero doubtless symbolizes the unexampled trials and labours which the king, like the mythical hero, had taken upon himself in order to build up his vast empire. Not infrequently the face of Herakles seems to bear the monarch's features. On the reverse is shown Zeus 269 (17) Enthroned. Assuming that the likeness on the Hadrianic sestertius is an accurate one, which is scarcely to be Fig. 152 doubted, it must be admitted that the representation of this figure in the time of Alexander differs in many particulars from that of the Pheidian statue in Olympia. Nevertheless, the Zeus depicted on the best Alexander tetradrachms is a sublime figure and we may yet detect in its style some hint of the great sculptor's work.

Looking at the Greek world as a whole, it is clear that Sicily had at this period suffered an almost total eclipse in the field of coinage; the mints of all the cities, even of Syracuse itself, were no longer active. It was in the time of Dionysios I, when the tyrant embarked on many wars, most of them unsuccessful, that the strength of this once seemingly great city began to ebb away. The process continued in the time of his son Dionysios II who succeeded to the throne in 367 B.C., only to be driven out in 344 and to die in exile. Of the few tetradrachms, which were all the coins that were minted after the turn of the century, the only one that achieved distinction is that engraved by Eukleidas in 399 B.C. The reverse shows the head of 270 (1) Arethusa in a compelling rendering as is to be expected in the work of this great master. Above the head

of the water-nymph the hair appears to float aloft as if she were submerged in the waters of her own sacred spring.

After the vicissitudes of Dionysios II and in spite of the vain attempt at a restoration by Dion, who was soon after murdered in a despicable manner, the city of Syracuse fell into complete anarchy. Finally, at the request of the Syracusans, Timoleon was sent out by the mother-city Corinth in 344 B.C. to act as 'arbitrator': and it was he who at last turned the tide, set limits to the continuous threat from Carthage and as a result of his victory at the Krimissos once again restored Syracuse's position of dominance. From this period, as final evidence of the art of die-engraving at Syracuse, come the coins with an obverse showing a fine head of *270 (2)* Zeus Eleutherios, the liberator from all the misfortunes of the last forty years, and on the reverse repeating the Pegasus type of the mother-city Corinth. Part of this coinage consists of gold 30-litra pieces and part of bronze half-litrai, which like the gold are of very high quality. In the Hellenistic period, some important *280 right* coins were still minted, and these are the work of Agathokles. They find their ultimate successors in the *320 (2)* time of Hieron II (275–215 B.C.) where we have a portrait of the ruler and of his wife Philistis which are often of wonderful quality. But in the time of the last democracy (215–212 B.C.) all this comes to an end.

The Carthaginian invasion of Sicily and the conquest of the cities on the south coast (Selinus in 409, Acragas in 406, Gela and Camarina in 405 B.C.) led to the appearance of coinages in the cities of the north and west of the island, at Motya, Solus, Panormos and Kephaloidion. These pieces, though relying for *239 (9)* inspiration on imitating many of the Syracusan types, and especially the Euainetos decadrachms, now include inscriptions in Punic lettering instead of Greek. By the period 380–370 B.C. there began that remarkable military coinage that is known to the numismatist mainly under the heading of 'Siculo-Punic', and which bears legends in Punic script reading 'people of the camp' or simply 'of the camp' or 'in the (overseas) *270 (3)* territory'. The types of the reverse display the date-palm, *Phoinix*, as a canting emblem of the Carthaginians and their Phoenician origins; also the horse, an animal which plays a part in the foundation-myth of Carthage (as we know by reference to the war-horse in the *Aeneid* I.144 ff.). Later, the horse was temporarily replaced *270 (5)* by a lion. On the earliest of the Siculo-Punic coins, a Nike hovers above a leaping horse and the date-palm takes up the whole of the reverse; but otherwise the obverse regularly shows a female head, closely similar to the Arethusa on the Syracusan decadrachms of Euainetos, but freely adapted to the style and conception *270 (3)* of some fifty years later. Heads such as that which we illustrate are among the most attractive in the Late Classical style. Alongside these, to be sure, are many feeble imitations. Towards the middle of the century there appears a head that may perhaps be identified as Dido or as a moon-goddess. However that may be, *270 (4/5)* the three versions of this head which are known, and two of which we reproduce, are examples of consummate die-engraving and masterpieces of feminine beauty. Although they originated at the behest of the Carthaginians, and although they possess a certain rather exotic quality these coins are certainly the work of a Greek hand and may be ranked as in no wise inferior to the finest artistic examples of Syracusan coinage.

In South Italy, political relationships underwent conspicuous changes during the course of the fourth century B.C. The indigenous Italic peoples from the mountains increasingly threatened the Greek colonies situated along the coastlines, whilst other colonies such as Caulonia and Rhegion were destroyed by *138 (4)* Dionysios I of Syracuse.

Poseidonia, whose incuse staters minted in the last three decades of the sixth century B.C. are artistically among the most important of their kind from the Archaic period, had ever since the last decade of the fifth century increasingly borne the brunt of attacks by the Lucanians and eventually succumbed to them. The name of Dossenos which appears on the latest stater, one which is of very fine workmanship, is clearly Italic, whether it is in fact the name of the artist or whether it refers to some Lucanian chief or magistrate of the time.

Near-by Hyele, founded by Phocaeans in 535 B.C., and a minting city since the early fifth century, escaped the fate of Poseidonia and during the fourth and even the third century became ever more prominent as one of the most active mints in South Italy. The head of the nymph Hyele on the obverse of her coins was replaced in 400 B.C. by that of Pallas Athena: while on the reverse there is in some rare cases an owl,

but more usually a lion, either alone or overpowering a stag. Towards 350 B.C. there appeared the stater with the signature of Kleudoros showing the head of the goddess in frontal view, full of youthful charm *270 (13)* and beautifully engraved.

Metapontum also lay in the Lucanian realm but on the east coast, situated deep in the Gulf of Taras. Her coin type was the ear of barley, symbol of the vast wealth of corn which her hinterland produced and to *Fig. 183* which she owed her prosperity through the centuries. Similarly the corn-ear was used as the decoration for the great incuse staters whose issue had begun around 550 B.C. and remained the regular type of all her coins until the end of the third century. From the time of the abandonment of the incuse form of stater in the middle of the fifth century the corn-ear was transferred to the reverse of the coins while the obverse was given over to the mythological figures mentioned above (p. 292). After this came heads of Apollo Karneios and of Kore, and in the fourth century predominantly that of Kore: but in addition there are heads of Leukippos, the founder of the colony, Dionysos and Zeus. A stater signed by Aristoxenos with the head of Kore and another with Dionysos bearing the letters ΣΠ and Γ may serve as examples of this *270 (11)* extremely varied and often extremely beautiful coinage of about 350 B.C. In the years 334–330 B.C. *270 (12)* Alexander the Molossian, who was married to Cleopatra, sister of Alexander the Great, arrived in Italy to succour Metapontum and Taras who were being threatened by the Italic tribesmen, Lucanians, Bruttians

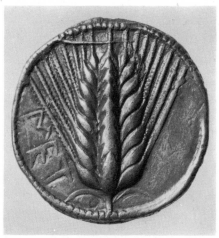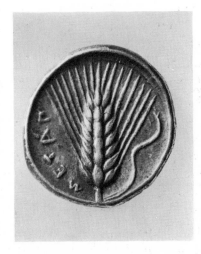

183 Metapontum. Staters with the type of a corn-ear. Centre, ca. 550/530 B.C.; left, ca. 420/400 B.C.; right, ca. 350 B.C.
All 2:1

and Messapians. His victories, together with those of the Metapontines, are commemorated by a facing head of Nike on some pieces of Metapontum.

At Croton, as we have seen, incuse staters were minted from 550/530 B.C. onwards and, as at *138 (2)* Metapontum, continued to be issued until nearly 450 B.C. After this Croton's coinage was in the doldrums for a time, and only at the turn of the century did it spring into new life. Now there appears on the obverse the fine image of a standing eagle while the tripod goes over to the reverse. There is an interesting *270 (6)* stater of 420 B.C. showing Apollo taking cover behind a huge tripod as he shoots at the Python with his bow: on the obverse of this coin we see Herakles, the mythical founder of the colony, peacefully seated. A similar type in the style of the mid fourth century is to be seen on the reverse of another stater, on the obverse of which we have the head of Hera Lakinia in frontal view, a real masterpiece on the best of the dies.

We have followed the coins of Taras through previous periods, and we have been able to single out the *138 (5), 198 (2/3),* most remarkable. Taras, though many times threatened by hostile attack, maintained for a long period an *240 (5)* extremely rich and fine coinage. Some of those made in the fourth century were real gems, as for instance the series of staters issued 380–345 B.C.: on the obverse is shown Taras on horseback, sometimes almost at rest, at other times leaping energetically from a galloping steed, or, again, armed with helmet and shield: *270 (7)*

270 (8) the corresponding reverses have a fine series of types of Taras on the dolphin. Such versions of the types continued through almost the whole of the fourth century. Some artists' signatures appear in abbreviated form, such as KAΛ, the name of one of the leading masters at Taras, also API, an artist whom we also encounter at Metapontum and Heraclea. It is on coins of this time that Taras almost always appears as an armed figure, and this is only a reflection of those warlike encounters in which the city was involved ever since the foundation of Thurii. The dispute was principally concerned with the territory of the old city of Siris which lay half-way between Sybaris-Thurii and Taras on the coast of the Tarentine gulf, but it is possible that some racial hostility was also involved, Taras being a Spartan colony—the only such—and Thurii a new foundation from Athens. After the death in 345 B.C. of the philosopher-statesman Archytas, who had been seven times elected strategos and had brought considerable prosperity to the state, Taras

270 (9) underwent a period of severe trial. Her plight found moving expression in a gold stater of 344–334 B.C. on the reverse of which the infant Taras holds out his hands in supplication to his father Poseidon, imploring his help. It was as a last resort that this appeal for assistance was made to the mother-city of Sparta. Dating from the period in which Alexander the Molossian, son of Neoptolemos (whom we have mentioned already

270 (10) in connection with Metapontum), came to the aid of the Greeks in Italy, is the gold stater with the marvellous head of Zeus Dodonaios: this example clearly has some bearing on the famous Sanctuary of Dodona in Epeiros.

Rhegion was destroyed by Dionysios I in 387 B.C. while vainly pursuing his aim to extend his power over the south of Italy. But the city was restored again by his son Dionysios II in 360–350 B.C. To her last

270 (14) series of tetradrachms of the years 356–351 there belongs a splendidly modelled head of Apollo and a lion's scalp shown in a quite new fashion.

We have already remarked that in many of the cities of Asia Minor the so-called 'King's peace' of 387

270 (15) B.C. enabled important coin-engravers to resume work. Outstanding among them was Theodotos of Clazomenae: particularly noteworthy are his tetradrachms on whose obverse appears a majestic head of Apollo with encircling locks, and on the reverse a beautifully drawn swan, one of the many creatures sacred to this god.

Rhodes, capital of the great island of the same name, was a city founded in 408 B.C. out of the amalgamation of the older cities of Kameiros, Ialysos and Lindos. The patron god of the new city was Helios, in whose honour the famous so-called 'Colossus' was erected in 283 B.C. by the entrance of the harbour—a statue of vast size that constituted one of the seven wonders of the world. It is the head of Helios, always shown full-face, which appears on the obverse of the coins from the time of the foundation of Rhodes. The reverse is taken up with the image of a rose, seen as a bud and in side view; only in the first century B.C. do we find it shown as a full-blown rose and seen from above. On many of the great tetradrachms are to be found,

270 (16) right down to the third century, Helios heads of consummate artistry; an outstanding example is a gold stater of the year 375 B.C.

It was in 394 B.C. that Lampsacus began to mint gold staters of rich and varied types. These staters are of pure gold, as opposed to the electrum staters of near-by Cyzicus, which were eventually unable to hold out against the new universal standard gold currency created by the Macedonian kings, Philip II and Alexander the Great. From the many fine Lampsacene types we have chosen for illustration the serious,

270 (17) pensive head of Zeus which dates to about the middle of the century. A highly attractive coinage was also produced about 380 B.C. at Heraclea in Pontos: the obverse shows a facing head of Herakles and the

270 (18) reverse a Nike of wonderful quality who is seen inscribing the name of the city with her own hand around the edge of the coin.

We close our brief survey of the coins of the fourth century with a glance at Cyrene in North Africa.

Fig. 135 Harking back to the coins of Archaic times minted at this Greek city on Libyan soil, we find the recurrent image of the silphium plant[15] shown throughout the whole series of her coinages. This plant was ascribed to the beneficent agency of the divine Aristaios, son of Apollo, and of the nymph Cyrene: and its medicinal properties together with its value as vegetable, the use of its grains for a spice and its flowers for the

466

preparation of perfumes, made silphium a versatile product of importance for the whole of the ancient world. Its image appears constantly on the obverse of the coins not only of Cyrene but also of near-by Barke. The reverse of all the later tetradrachms bears the head of Zeus-Ammon, and the example reproduced here shows a fine sensibility that characterizes the emergent fourth-century style. Perhaps too the art of *270 (19)* the Parthenon still lingers on here, despite the fact that the Cyrene coin came almost forty years later. Zeus-Ammon is the god whose concept was ultimately based on that of the greatest of the Egyptian deities of the Middle Kingdom, and which the Greeks took over and assimilated to their own Zeus at the time when they colonized Cyrene from the Cycladic island of Thera in 630 B.C. Ammon had his oracle in the Libyan oasis of Siwa: thither Alexander journeyed after his conquest of Egypt in 332 B.C., and it was this oracle that expressly proclaimed the youthful conqueror as the 'son of god'.

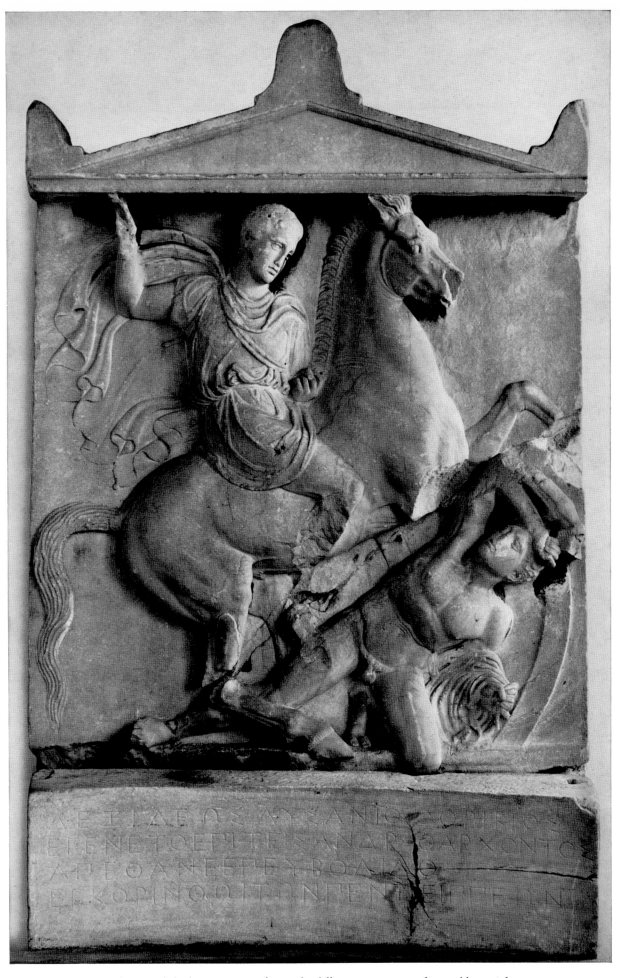

241 Tombstone of the horseman Dexileos, who fell in 394 B.C. Pentelic marble. Height 1.75 m.
Athens, Kerameikos Museum

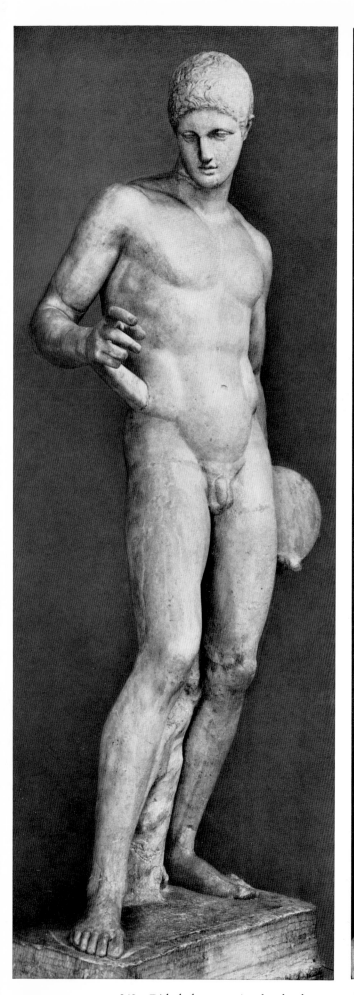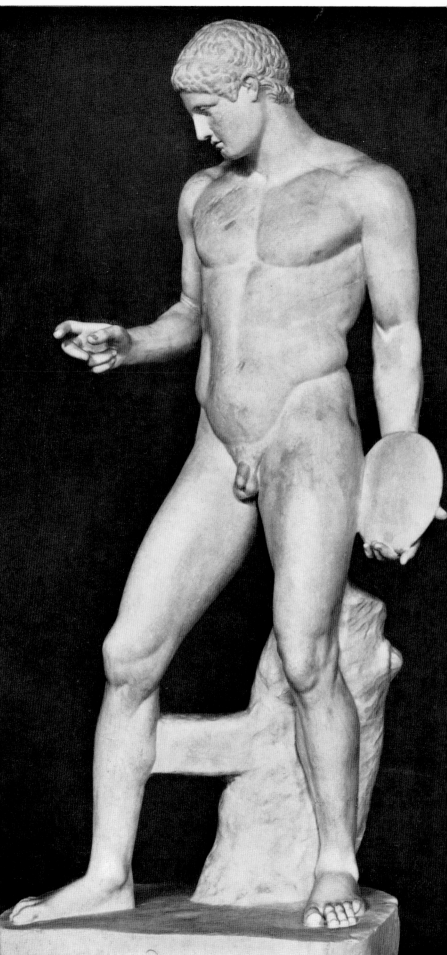

242 Diskobolos preparing for the throw. Marble copy of a work by Naukydes from the end of the 5th century B.C.
Height (without plinth) 1.66 m. Vatican Museum 615

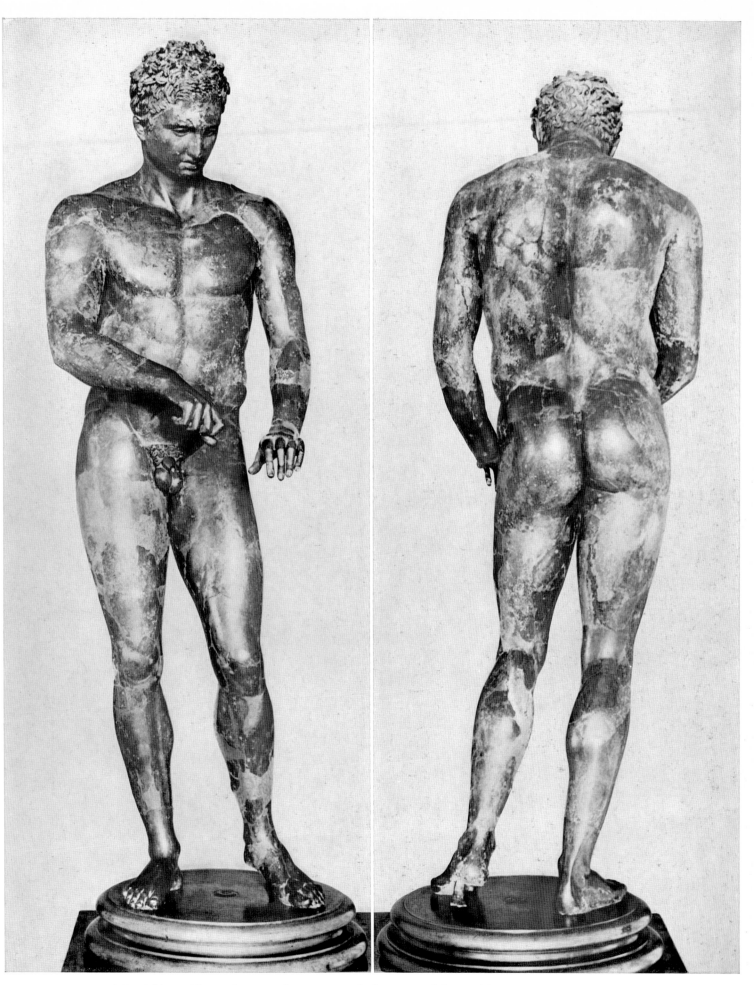

243 Athlete with strigil. Roman bronze copy of a bronze work by Daidalos of Sikyon of ca. 360 B.C.
Height 1.92 m. Vienna, Kunsthistorisches Museum 3168

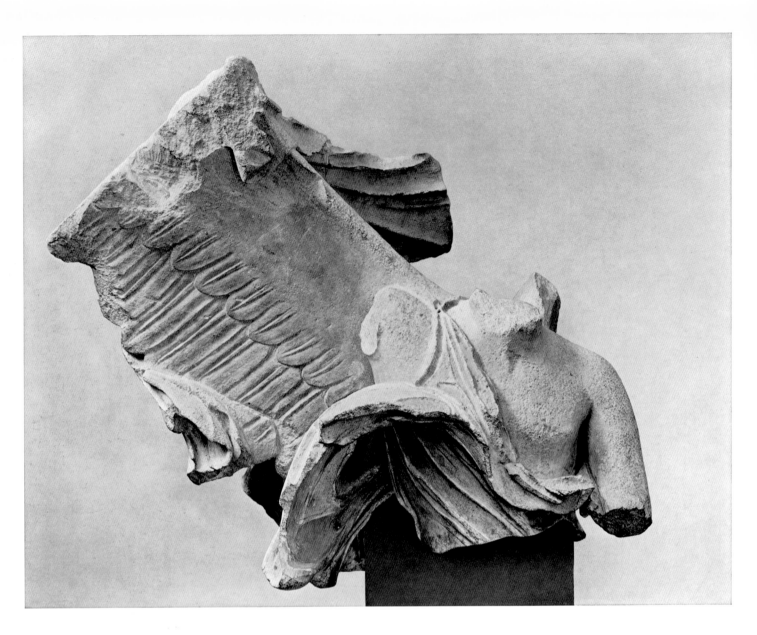

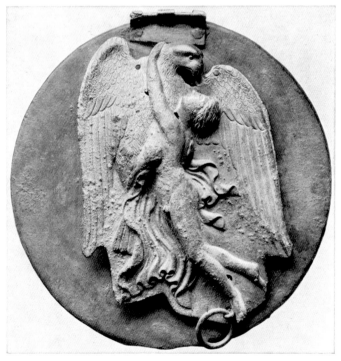

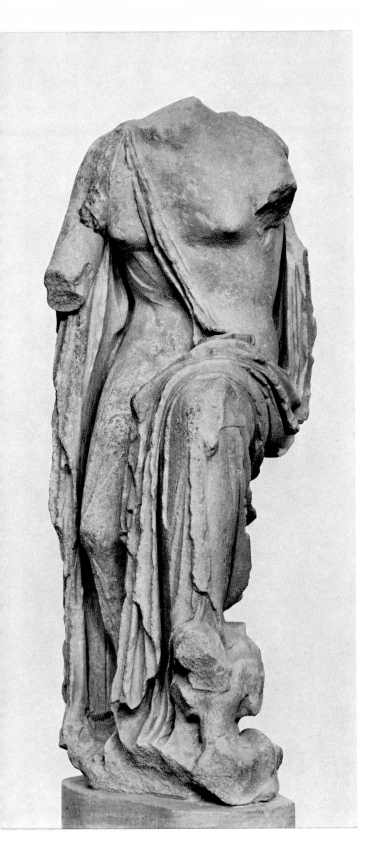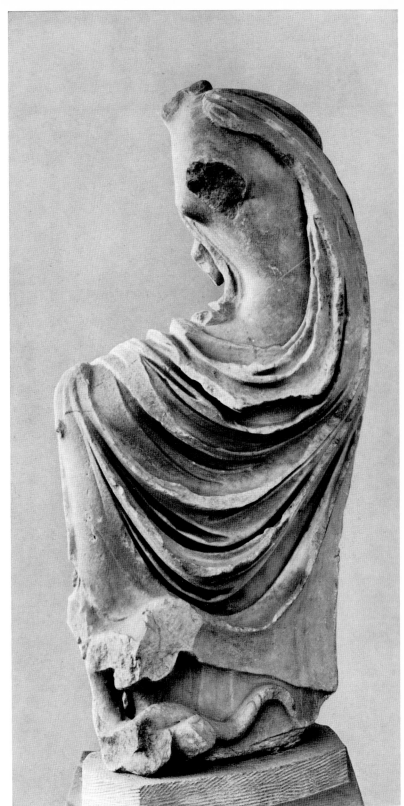

244 Above: Nike of Timotheos. Akroterion from the east pediment of the Temple of Asklepios in Epidauros.
Marble. Height of upper part of body 25 cm. Ca. 390–380 B.C. Athens, National Museum 162.
Below: Ganymede carried off by an eagle. Bronze relief from a folding mirror. Obviously influenced by the
Ganymede group by Leochares. Diameter 15.5 cm. Ca. 370 B.C. Berlin, Staatliche Museen 7928

245 Hygieia of Timotheos. Marble original from the temple of Asklepios in Epidauros.
Height 90 cm. Ca. 380 B.C. Athens, National Museum 299

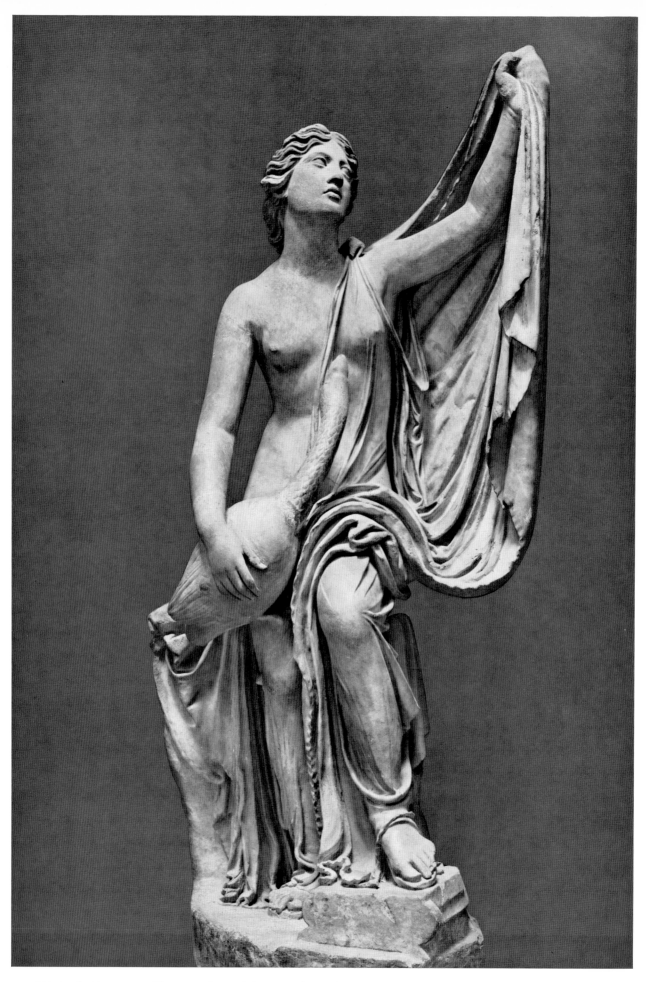

246 Leda. Roman marble copy of a work by Timotheos of 370 B.C. Height 1.32 m. Rome, Capitoline Museum

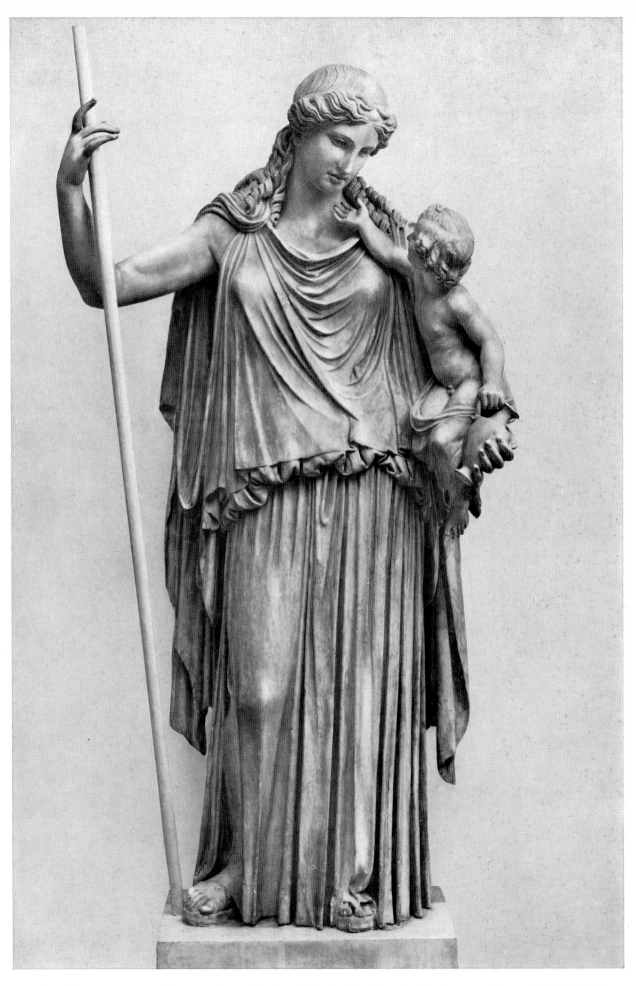

247 Eirene. Roman marble copy of an original work by Kephisodotos for the Agora at Athens of 375–370 B.C.
Height 1.99 m. Munich, Glyptothek

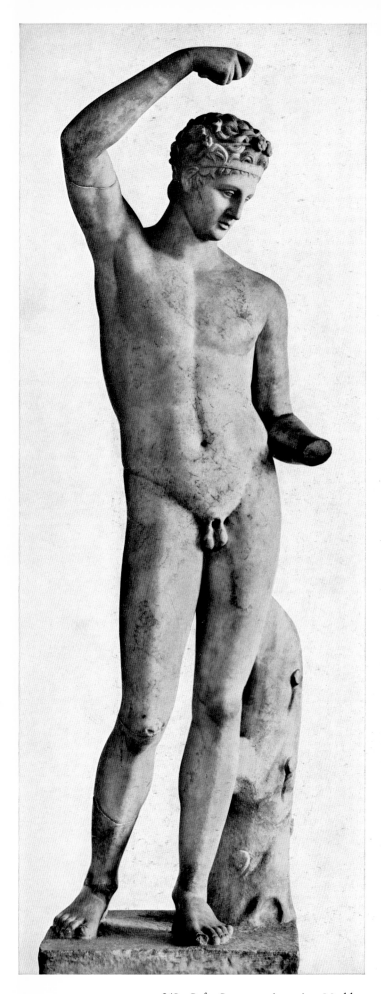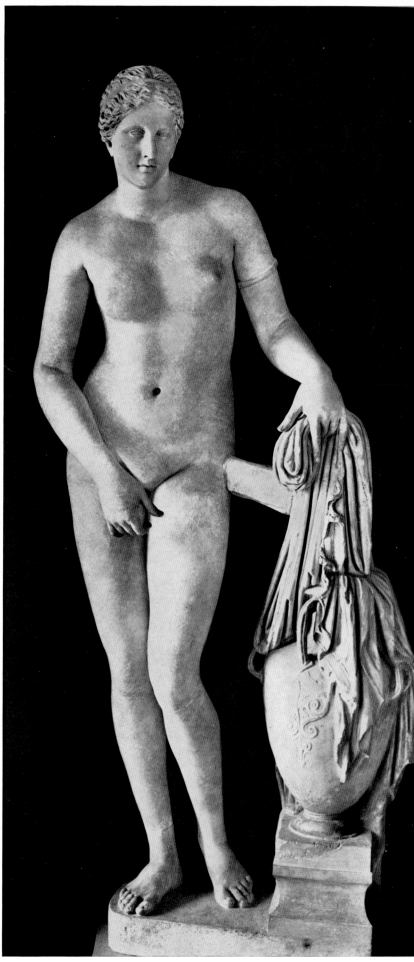

248 Left: Satyr pouring wine. Marble copy of the bronze original by Praxiteles of ca. 375–370 B.C.
Height 1.45 m. Dresden, Staatliche Kunstsammlungen. Right: Aphrodite of Knidos.
Roman marble copy of a marble original by Praxiteles for the town of Knidos, ca. 350 B.C. Height 2.05 m. Vatican Museum

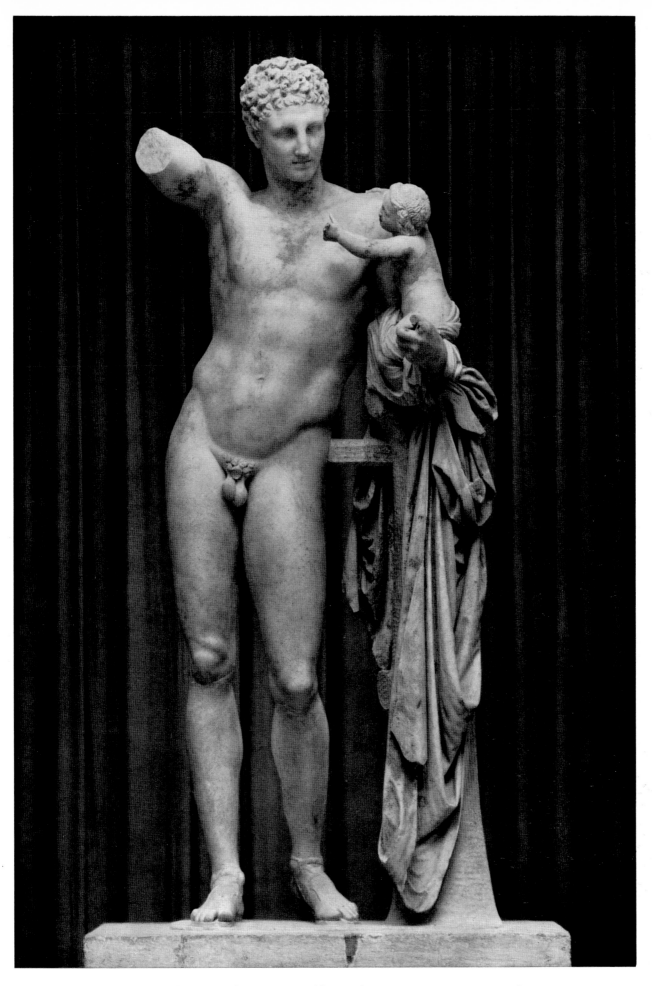

249 Hermes of Praxiteles. Original, in Parian marble. Height 2.15 m. Ca. 350–340 B.C. Olympia Museum

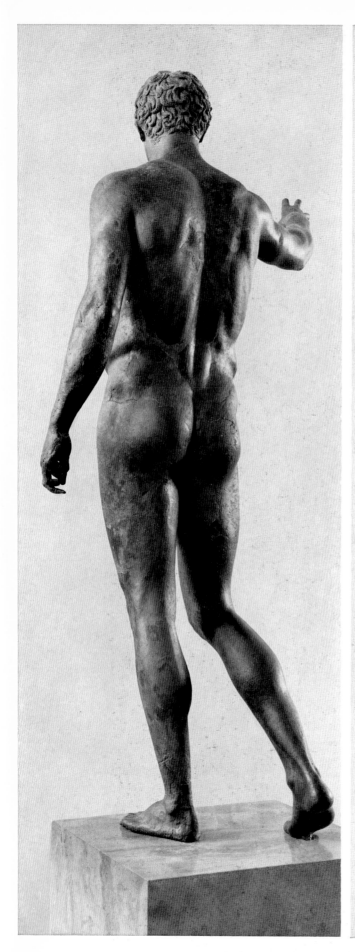
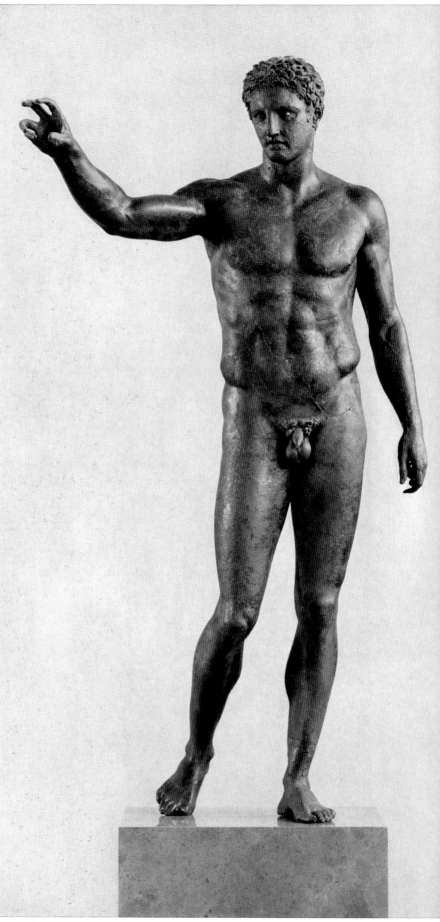

250 Bronze statue of a young man, found in the sea off Antikythera. Height 1.94 m.
Ca. 340 B.C. Athens, National Museum 13396

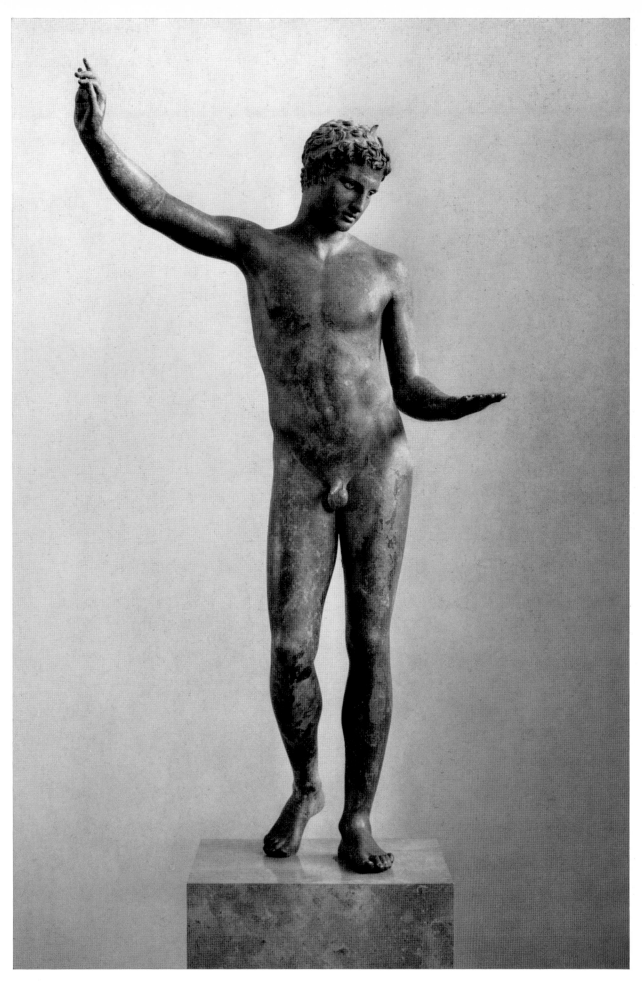

251 Bronze statue of a youth, found in the sea off Marathon. Cf. plate XXXIX. Height 1.30 m.
Ca. 330–325 B.C. Athens, National Museum 15118

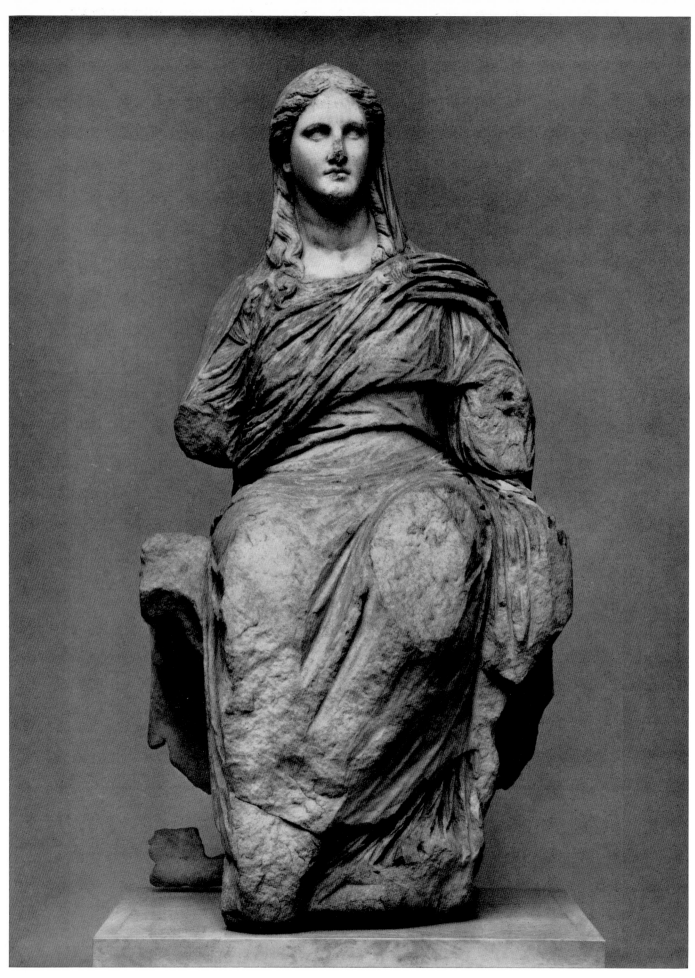

252 Demeter. Marble statue from the sanctuary of Demeter at Knidos. Height 1.53 m.
Ca. 350–340 B.C. London, British Museum 1300

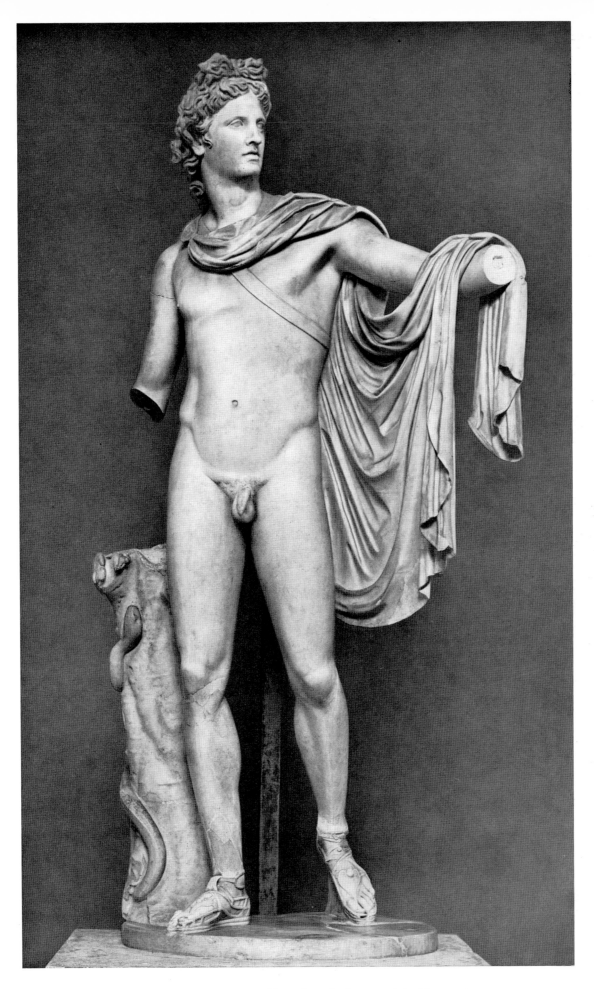

253 Apollo of Belvedere. Marble replica of a bronze original by Leochares
of ca. 330 B.C. Height 2.24 m. Vatican Museum

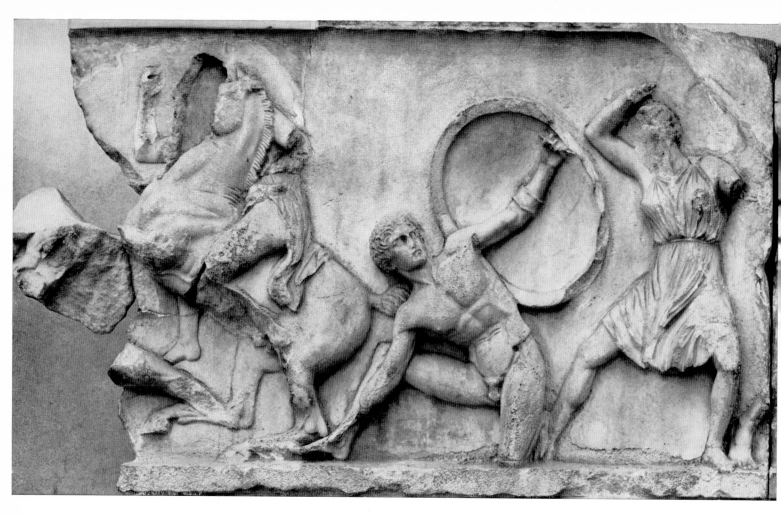

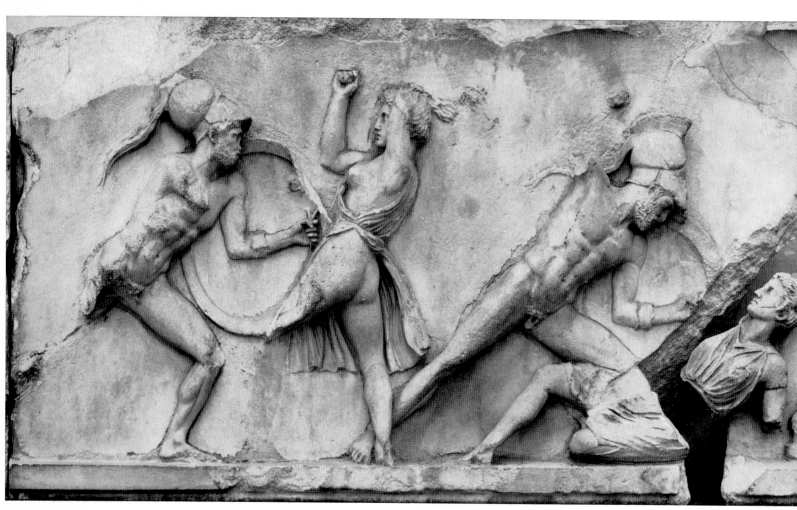

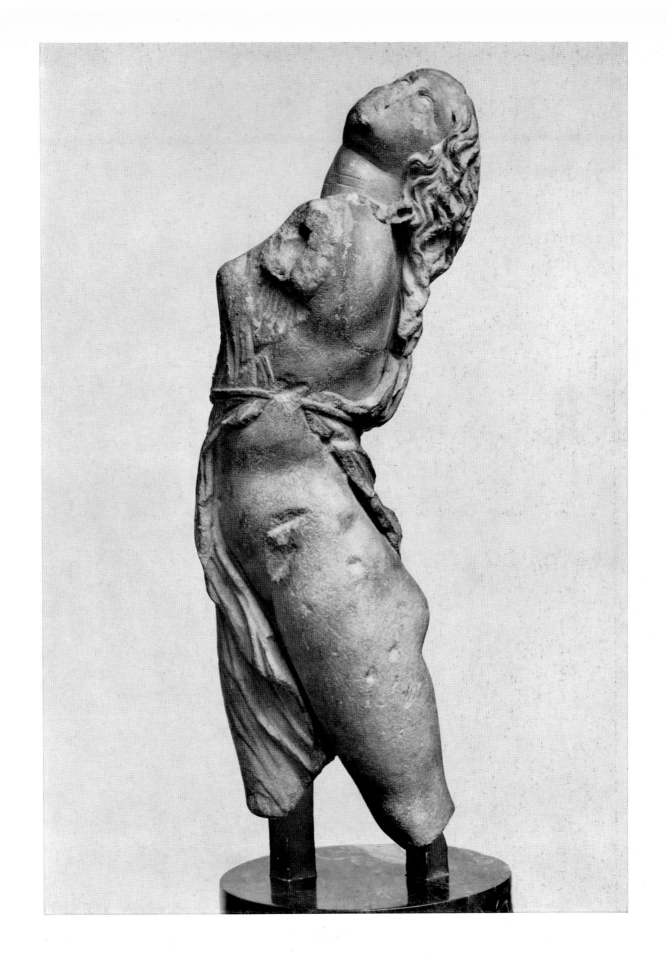

254 Greeks fighting the Amazons. From east side of the Mausoleum at Halikarnassos.
Based on a plan of Skopas of 350 B.C. Marble. Height 89 cm. London, British Museum 1013, 1014

255 Maenad. Roman marble copy of a work by Skopas of 340 B.C. Height 45 cm.
Dresden, Staatliche Kunstsammlungen 133

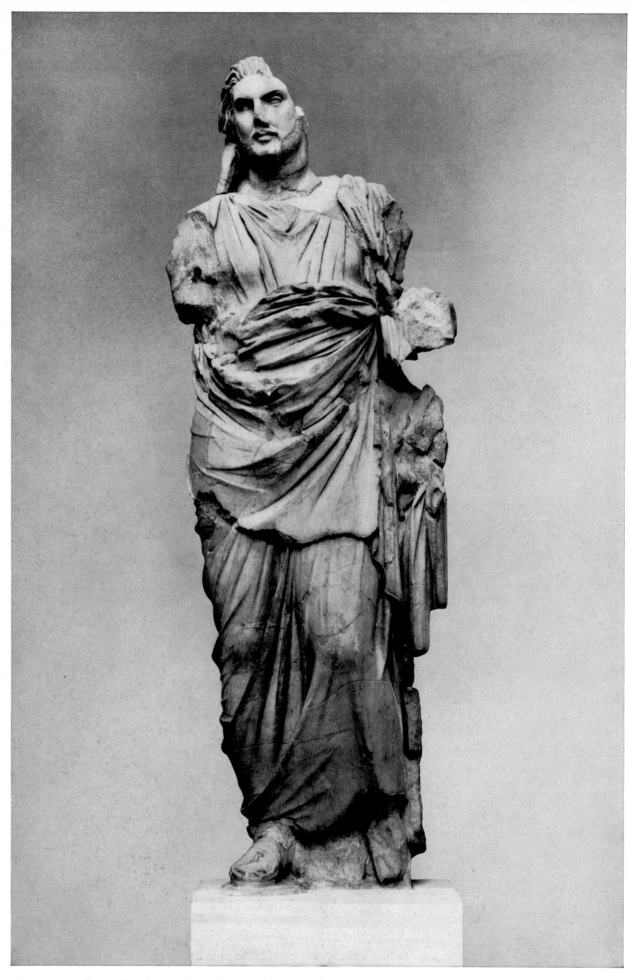

256 Maussollos. Colossal statue from the Mausoleum in Halikarnassos. Work by Bryaxis of the mid 4th century B.C.
Marble. Height 3 m. London, British Museum 1000

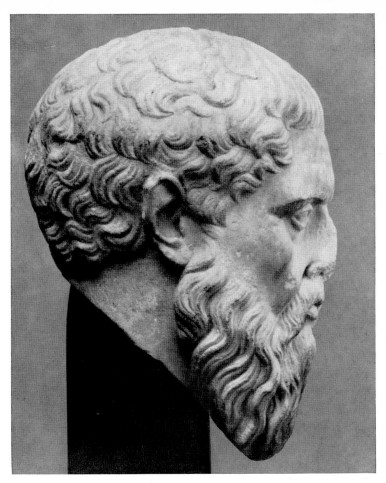
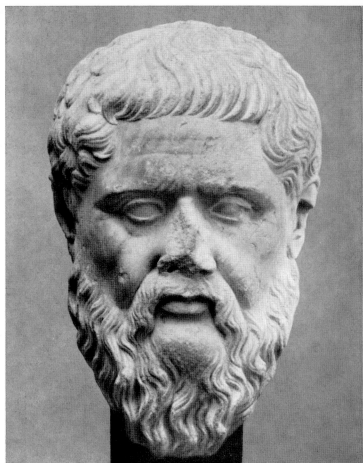
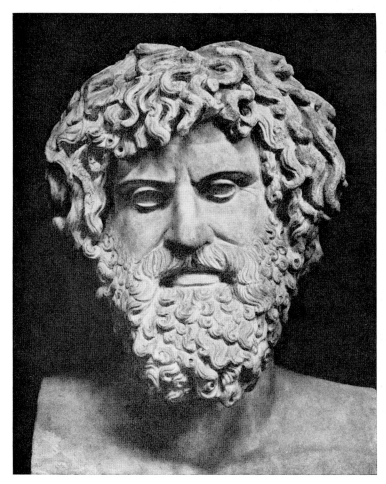
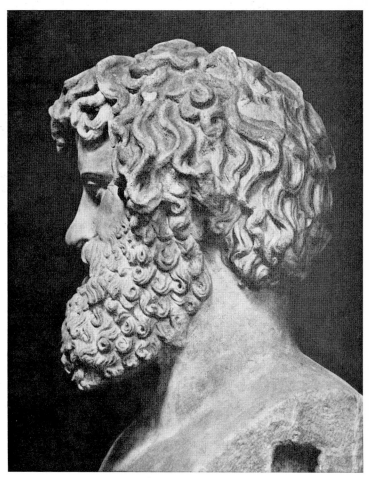

257 Above: Plato. Marble copy from the early imperial period of an earlier portrait statue by Silanion
of ca. 370 B.C. Height 35 cm. Switzerland, Private Collection. Below: Portrait head of the sculptor Apollodoros.
Marble herm from Herculaneum after a portrait statue by Silanion.
Ca. 350 B.C. Naples, Museo Nazionale Archeologico 6154

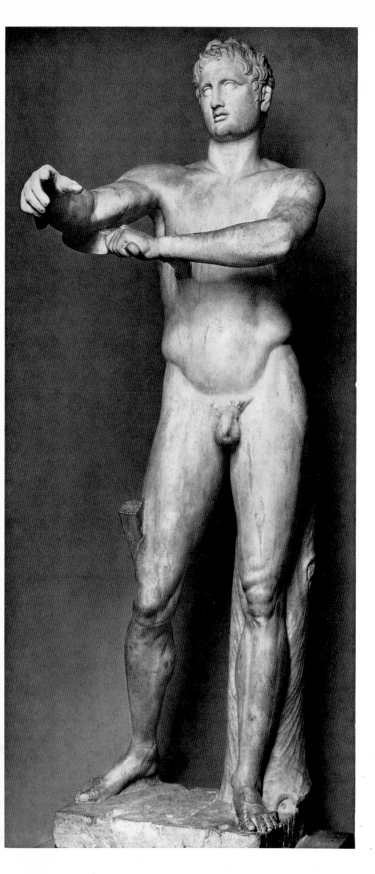
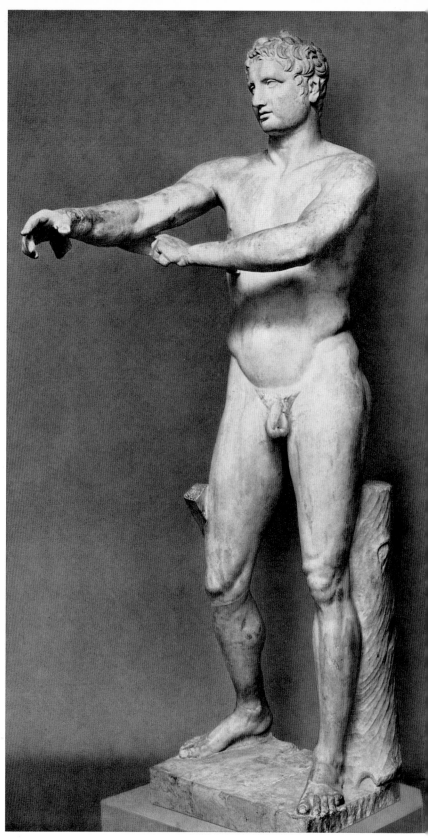

258 Athlete with strigil (Apoxyomenos). Victory statue of Cheilon of Patras?
Roman marble copy of a bronze statue by Lysippos of ca. 320 B.C. Height 2.05 m. Vatican Museum

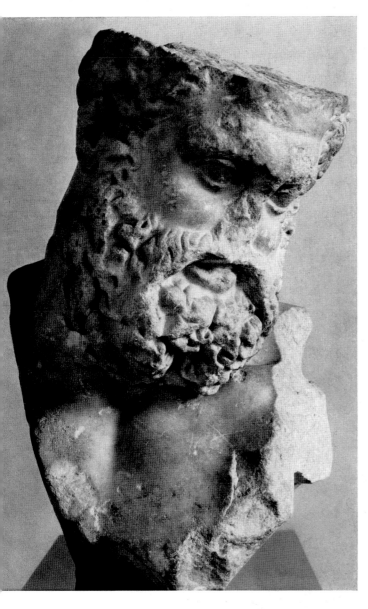

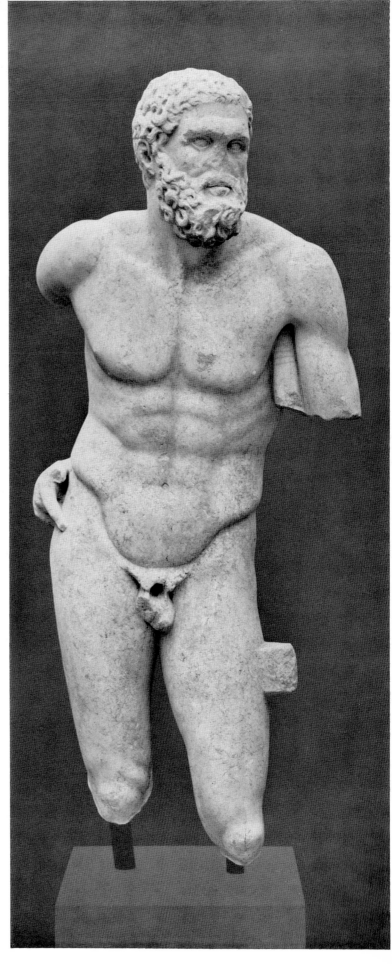

259 Right: Resting Herakles.
Marble replica of a bronze original by Lysippos of ca. 350–340 B.C.
Height 1.79 m. Copenhagen, Ny Carlsberg Glyptotek 250.
Left: Farnese Herakles. Bust replica of the bronze statue at Sikyon of
ca. 320–310 B.C. Marble. Height 63 cm. Basle, Antikenmuseum

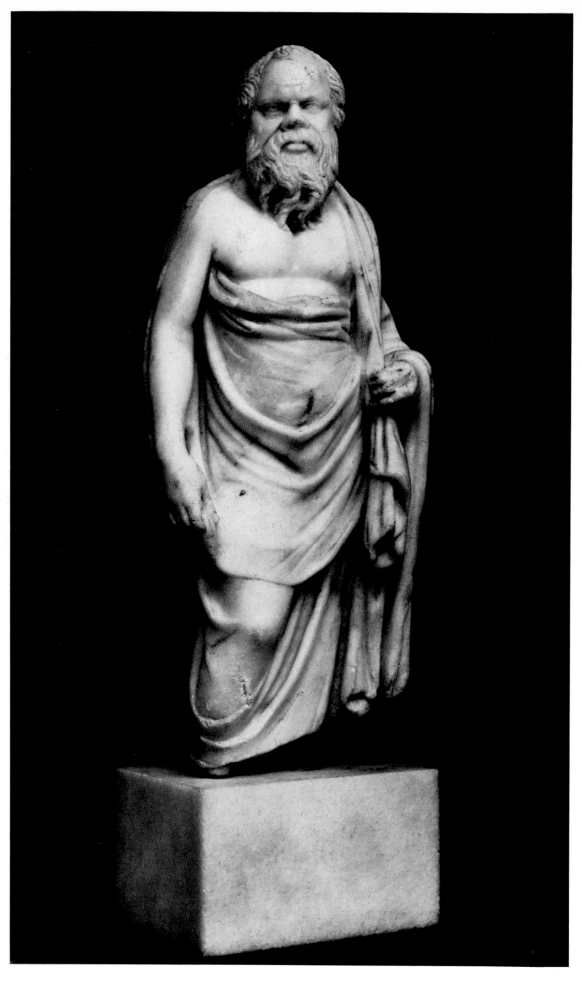

260 Sokrates. Marble copy from the Antonine period, probably based on the bronze original by Lysippos
in the Pompeion, Athens. Height 27.5 cm. London, British Museum

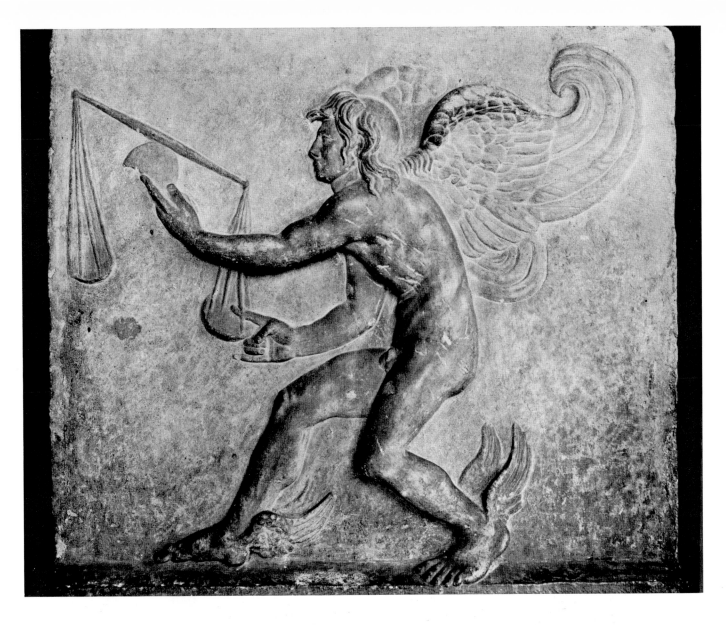

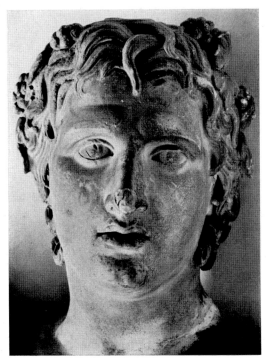 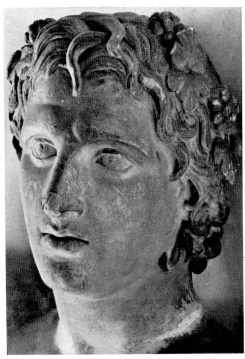

261 Above: Kairos. Roman relief copy of a statue by Lysippos of 330 B.C. Height 60 cm. Turin Museum 317.
Below: Dionysos. Marble copy of the bronze statue of the god on Helikon by Lysippos.
Ca. 340–330 B.C. Height about 33 cm. Venice, Bibliotheca Marciana

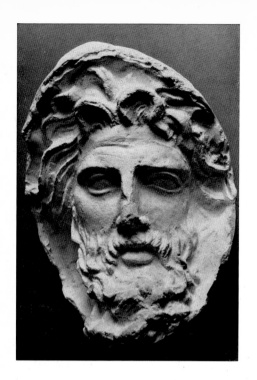

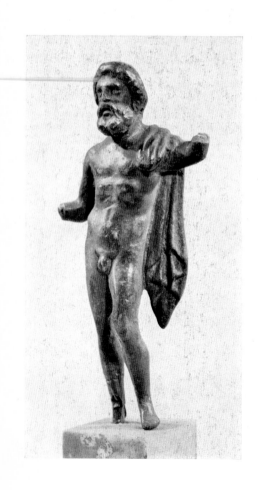

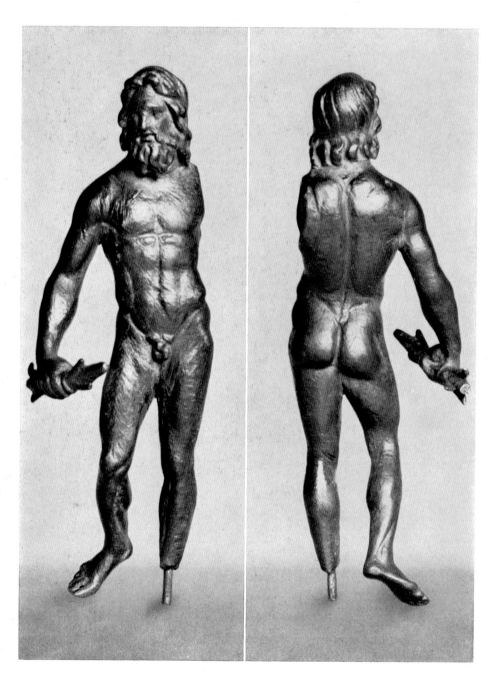

262 Right: Bronze figurine after the Zeus of Tarentum by Lysippos. Height 10.5 cm. Frankfurt, Liebieg-Haus.
Above left: Head of the Zeus of Tarentum by Lysippos. Cast from the clay mould in the Vlastos Collection.
Below left: Bronze figurine based on the Zeus of Sikyon by Lysippos. Height 6.4 cm. Paris, Cabinet des Médailles 15

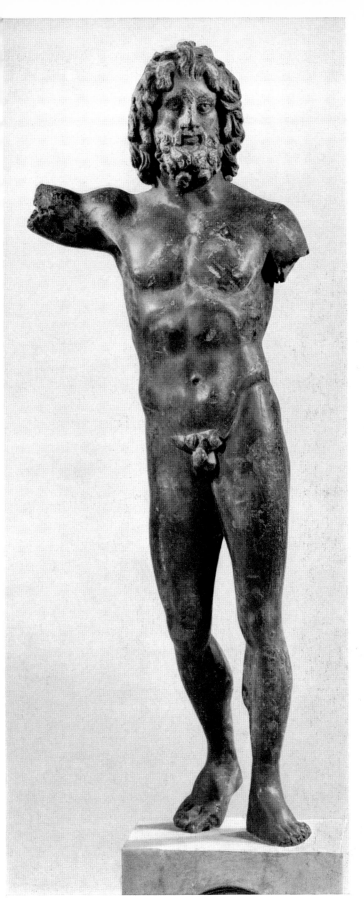 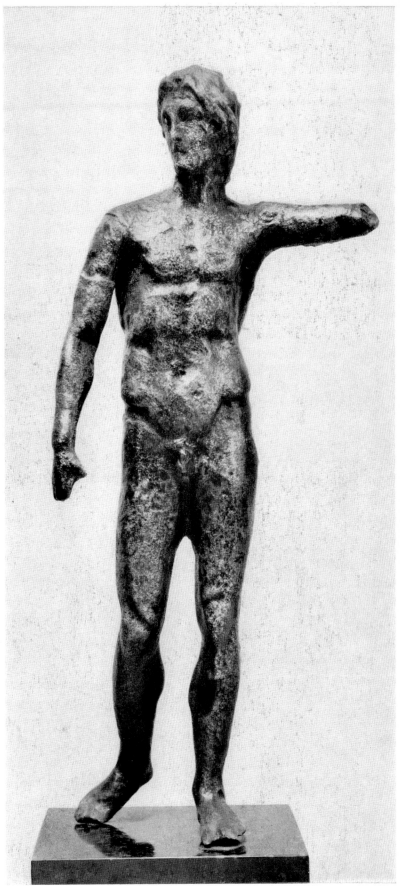

263 Left: Bronze figurine based on the Zeus of Megara by Lysippos. Height 31 cm. Paris, Cabinet des Médailles 1.
Right: Alexander the Great. Bronze figurine based on a work by Lysippos. Height 16.5 cm. Paris, Louvre 370

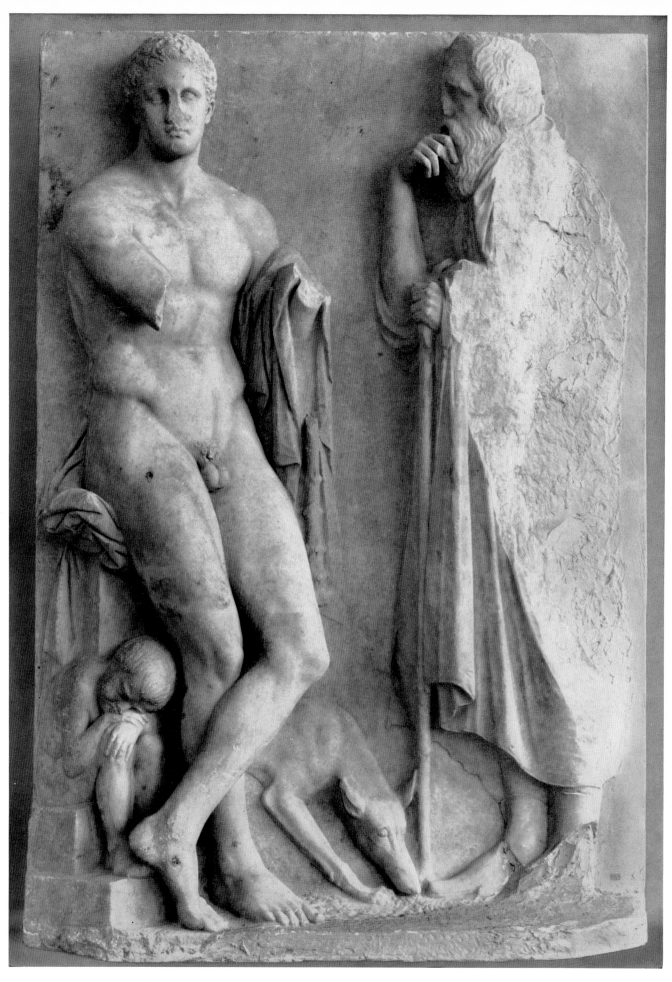

264 Sepulchral monument of a youth, from the Ilissos at Athens. Pentelic marble. Height 1.68 m.
Ca. 340–330 B.C. Athens, National Museum 869

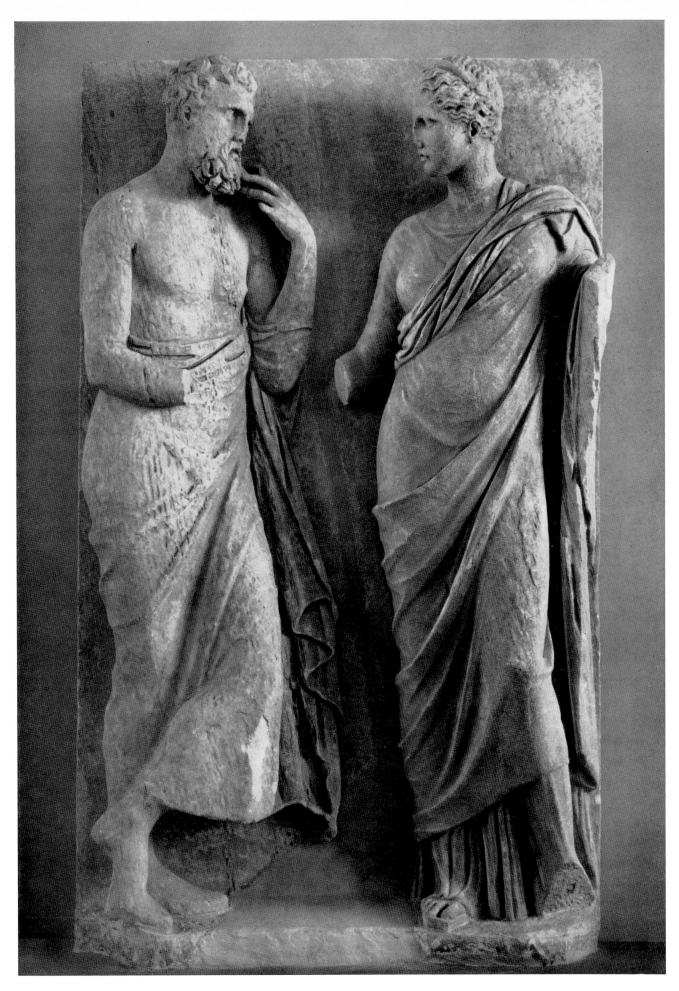

265 Attic sepulchral relief, from Rhamnus in Attica. Pentelic marble. Height 1.75 m.
Ca. 330–320 B.C. Athens, National Museum 833

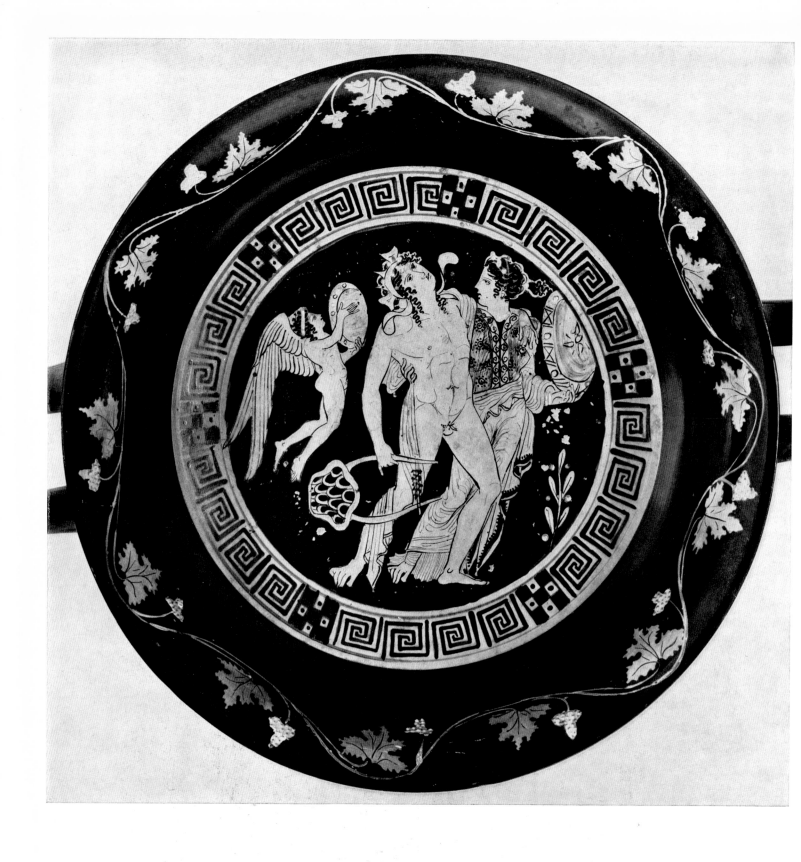

266 Meleager Painter. Stemless cup, interior. Dionysos with Ariadne. Diameter of cup 24.4 cm.
Beginning of 4th century B.C. London, British Museum E 129

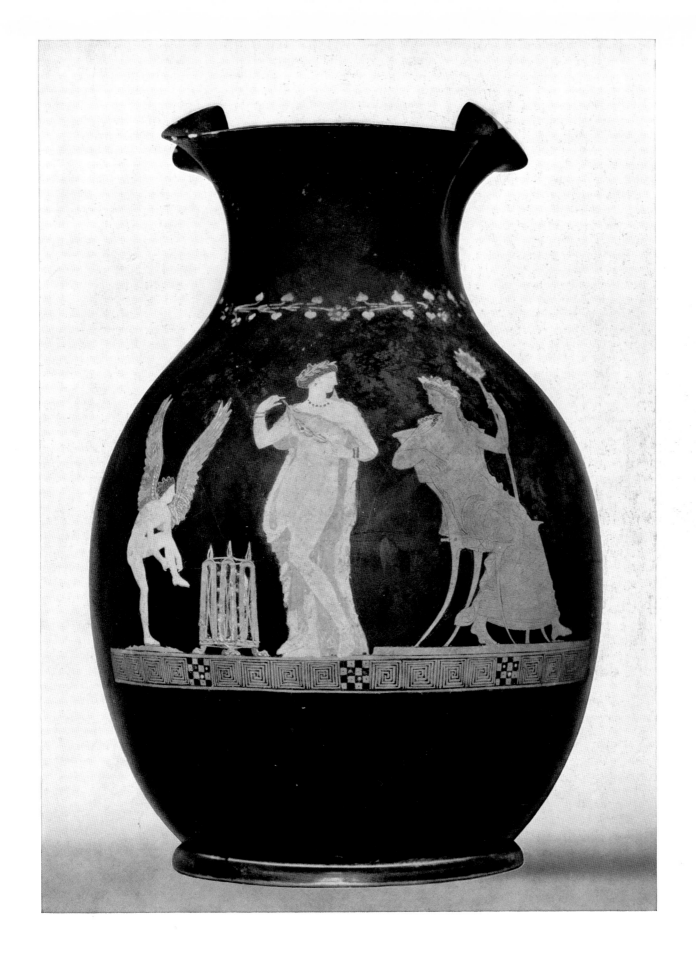

267 Helena Painter. Oinochoe. Festival dedicated to Dionysos. Pompe is turning towards Dionysos; on her left, Eros.
Height 23.5 cm. Mid 4th century B.C. New York, Metropolitan Museum of Art 25.190

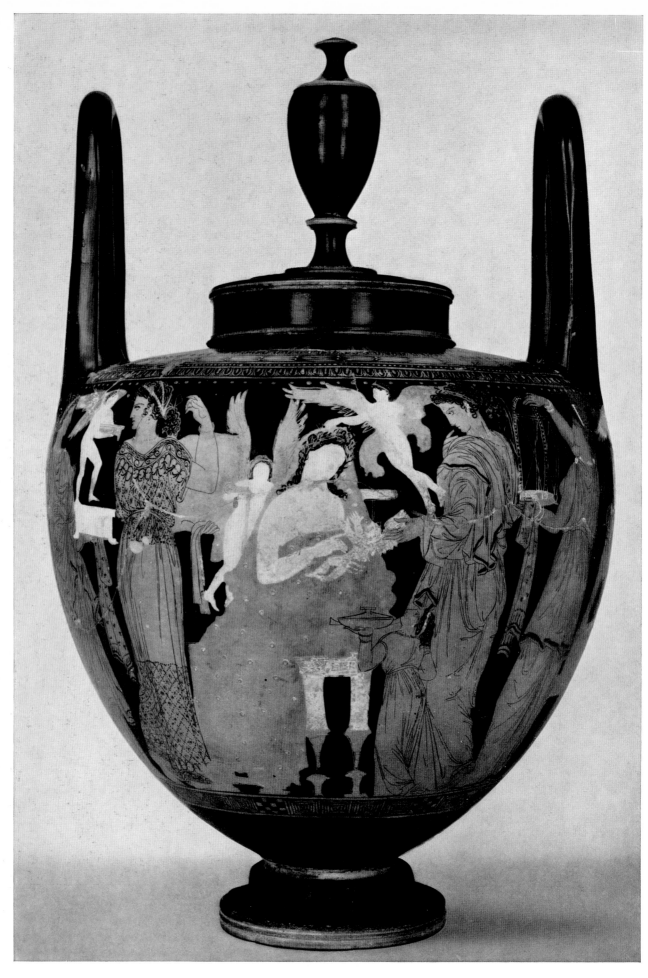

268 Marsyas Painter. Nuptial lebes. Epaulia: Bringing of gifts to the bride the morning after the wedding.
Height 46 cm. Mid 4th century B.C. Leningrad, Hermitage 15592

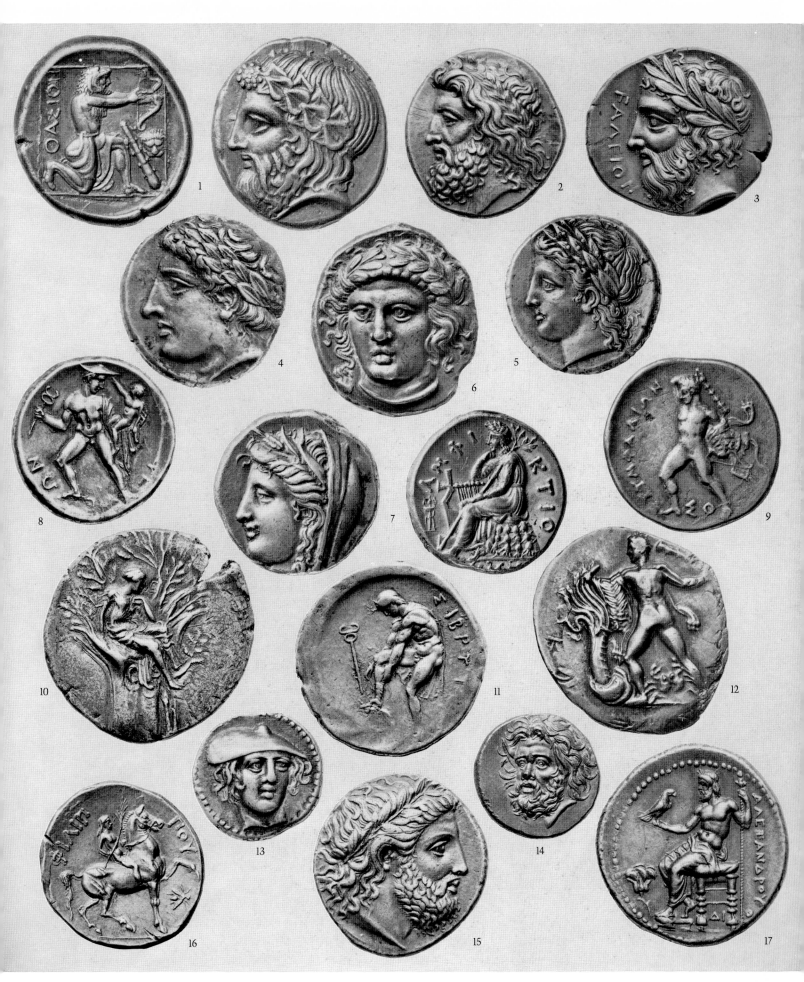

269 Greek coins from 400–323 B.C. (Period of Late Classicism). Greece: 1 Thasos, ca. 380–370 B.C. 2 Arcadian League, 370–363. 3 Elis, ca. 363.
4, 5 Chalcidian League, 4 ca. 395–392, 5 ca. 379–376. 6 Amphipolis, ca. 400. 7 Delphi, ca. 346–339. 8 Pheneos, ca. 362–360.
9 Stymphalos, ca. 362–350. 10 Gortyna (Crete), ca. 325. 11 Sybrita (Crete), ca. 330. 12 Phaistos (Crete), ca. 325. 13 Aenos, 357–342. 14 Panticapaeum, gold,
ca. 350. 15–17 Kingdom of Macedonia: 15, 16 Philip II, 359–336, 17 Alexander the Great, 336–323. All 2:1.

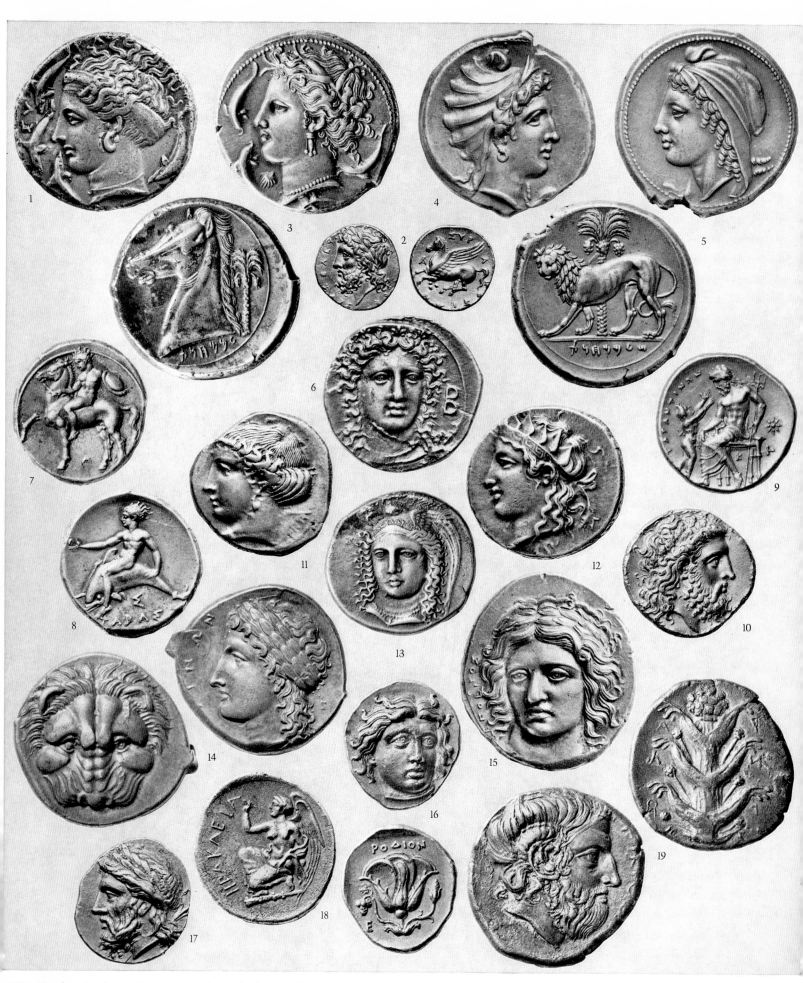

270　Greek coins from 400–323 B.C. (Period of Late Classicism). Sicily: 1, 2 Syracuse, 1 399 B.C. signed by Eukleidas, 2 ca. 354, gold. 3–5 Siculo-Punic, 3 ca. 380–350, 4 ca. 340, 5 ca. 360. South Italy: 6 Croton, ca. 360. 7–10 Taras, 7, 8 ca. 380–345, 9 ca. 344–334, gold, 10 334–331, gold. 11, 12 Metapontum, 11 ca. 400–380 signed by Aristoxenos, 12 ca. 350. 13 Hyele, ca. 350 signed by Kleudoros. 14 Rhegion, 356–351. Asia: 15 Clazomenae, ca. 375 signed by Theodotos. 16 Rhodes, gold, ca. 375. 17 Lampsacus, gold, ca. 350–340. 18 Heraclea Pontica, ca. 380–360. Africa: 19 Cyrene, ca. 400. All 2:1

HELLENISTIC ART · 323–31 B.C.[1]

The term Hellenistic, used now also by classical archaeologists, was first applied by the historian J. G. Droysen to the epoch from the death of Alexander the Great to the battle of Actium in 31 B.C. The period is marked by two great developments. On the one hand, the spread of Greek culture into Egypt and Asia attended by a growing influence in Greece itself of oriental and Egyptian ideas and cults, such as the Isis cult; on the other hand, the rise of Rome as the dominant political power in the Mediterranean. At the same time, following the conquests of Alexander which in the short period 336 to 323 B.C. brought down the Persian Empire and extended Greek power to the Indus, the political and cultural centres of the Greek world shifted to the periphery of the Mediterranean.

Following Alexander's death the vast empire which he had built up soon split up into a number of smaller units of which the dominant four were: Egypt under the Ptolemies, Syria under the Seleucids, Pergamon under the Attalids and the Macedon of the Antigonids. In 279 B.C. the Celtic Galatian tribes broke into Greece and crossed into Asia Minor; there they were defeated by the Attalid armies. In the west the new power of Rome, following its defeat of Carthage, annexed the territories of Magna Graecia and the island of Sicily (a Roman province from 227 B.C.). The victory of L. Aemilius Paullus over Perseus, the last king of Macedon, at the battle of Pydna in 168 B.C., added the province of Macedon to Rome's empire and the rest of mainland Greece followed in 146 B.C. when Mummius destroyed the city of Corinth. The childless Attalos III of Pergamon bequeathed his kingdom to Rome in 133 B.C. and by the year 63 most of the Greek territories of Asia were in Roman hands. Of the Greek Empire only the kingdom of Egypt remained and at the Battle of Actium this too became incorporated into it.

During the Hellenistic period, artistic activity gravitated more and more to the centres of political power, the courts of the rulers, and at the same time gradually lost sight of its religious origins. Parallel with the rise of major states under monarchic rule, there developed a bourgeois ethos whose beginnings go back to the fourth century; it is exemplified by the comedies of Menander (343–293 B.C.), the philosophy of Epicurus (342/341–271 B.C.), concerned with the well-being of the individual, and the philosophy of Zeno (in Athens from 315 B.C.) directed to the search for universals. In the great centres of Alexandria, Antioch, Rhodes and Athens, life and thought assumed a markedly cosmopolitan character; the *polis*, or city-state, the true social unit of Greek life, was thus sapped of its vitality and only the shadow of the institution persisted.

The widening of the horizons of thought was paralleled in art by a new spaciousness of conception. Town architecture for the first time achieved homogeneity with uniformly large squares surrounded by colonnaded halls; a new style of sculpture, concerned with the ordering of broad planes and large-scale effects, developed; landscape became a major interest in painting while the mythological figures central to Classical art were relegated to a role of secondary importance. At the same time, and by contrast, we find a predilection for miniatures, an enthusiasm for still-life and the minor arts; the formal language of Hellenistic art was a dialogue between the spacious and the confined, noisy violence and sudden calm, the moving and the idyllic. The popularity of small-scale sculpture is shown by the terracotta figurines, often masterpieces, found all over the Greek-speaking world. Small votive figures in fired clay were a feature of Greek art from its earliest flowering, but in the Hellenistic period they acquire a new significance. Occasionally they even served to advance the study of forms, and also masters of toreutic art sometimes made models for the mass production of terracotta figurines.

The artists travelled and with them artistic ideas. The concentration of power at the courts of the great kingdoms, as at Pergamon or Alexandria, led to the development of a court art which aimed both at a popular and a grandiose style. The rulers made rich endowments at the ancient centres of art such as Athens

and Delos and also in the Kabirion sanctuary in Samothrace which first flourished in this period. Such endowments contributed not a little to the rich artistic achievement of the period.

Later art historians, exclusively interested in true 'classicism', ignored the rich complexity of the Hellenistic epoch. In his *Natural History* (34. 52) Pliny opined that sculpture in bronze died with the sons of Lysippos about 296 B.C. and was only reborn with the 156th Olympiad (156–153 B.C.): *Deinde cessavit ars ac rursus olympiade CLVI revixit*. Indeed, the judgement, it seems, is meant to apply not simply to major work in bronze but to all Hellenistic sculpture. Ancient sources have virtually nothing to say about the superb grandeur of the marble sculpture of the Great Altar of Pergamon. The bold and dynamic achievement of the masters of the High Hellenistic style was rejected by generations educated in the ideals of classicism and is reflected only in Roman copies from the period of the Flavians, of Antoninus Pius or Marcus Aurelius, by artists of a similarly 'baroque' persuasion. The later classicists failed to see that the very attempt by the Hellenistic sculptor to overcome the stubbornness of his material by introducing dynamic movement, and to break with the formal by representing an instant of action, was a summit of achievement in sculpture even though it was later judged to have been a failure. The attempt to activate the sluggish marble masses by showing figures in actual frenzied movement ended in a form of naturalism which can hardly have been the original intention. But the attempt to hold fast to reality *as* reality, to capture the elusive quality of life and to give form to the instantaneous, found the artist tripped up by life itself, so to speak, and threw him back on the pathetic grimace, hollow rhetoric and superficiality. The form coagulates, melts, becomes fluid and unstable, and only in exceptional cases reaches out to the original model. In his stiff, concentrated style the Archaic sculptor got nearer to reality than the Hellenistic artist even if he took a life mask of the face to make his portrait sculptures more 'true to life', as Lysistratos, brother of Lysippos, was first reported to have done.

Just because naturalism in art has become suspect nowadays, one should emphasize that behind the superficial and stressed 'naturalism' of High Hellenistic sculpture there is a powerful dynamic drive seeking to express energy in terms of form—form which apprehends nature down to the smallest detail. This results, according to Kaschnitz von Weinberg,[2] in the reappearance of an irrational dynamism such as first manifested itself on Greek soil in the earliest spiral decoration of the Early Helladic culture.

Whereas Archaic and Classical art aimed at the representation of the objective world and actual happenings, Hellenistic art was devoted to expressing emotion, suffering and its endurance—or the carefree idyll. If one can in fact distinguish between an active and passive pathos in art, it is the Hellenistic period which first made such a distinction possible. A basic element in the Hellenistic attitude to art is revealed in the moving lines of Vergil, in the first book of the *Aeneid* (lines 461 f.) spoken by Aeneas when, at his meeting with Dido in the Temple of Juno, he sees the paintings of the Trojan War: '*En Priamus. Sunt hic etiam sua praemia laudi; sunt lacrimae rerum et mentem mortalia tangunt*'—'There is Priam! Here too worth finds its reward, here too there are tears for human fortune and hearts are touched by mortality.' It is not the things themselves, but the tears they cause; the human reaction to events and the way they stir the emotions—these represent the objective aims of a very subjective art. Almost every work of Hellenistic art is secretly touched by these *lacrimae rerum*, the tears that things provoke and find an effective form in the work of art. Not that Hellenistic art was lachrymose; on the contrary it achieves a genuine, often exalted pathos. That in itself is characteristic of the style. The Early Classical period opened with the statue group of the Tyrannicides, Harmodios and Aristogeiton, by Kritios and Nesiotes. The work was intended as a symbol of the freedom of Attic democracy and so the murdered tyrant, Hipparchos, is not shown. In the great monuments commemorating the victory of the Attalids of Pergamon over the Gauls, however, it is the victors who are omitted. The spectator experiences the victory only through sympathy with the vanquished—the dying trumpeter or the proud Gaulish chieftain who kills himself and his wife, preferring death to shame and slavery. The painfulness of defeat takes the place of elemental power and confidence in victory, the splendid pitting of strength that was the hall-mark of Classical art.

Hellenistic art does not constitute a grand unity as does Classical; it is, in the first place, the art of the Hellenistic era. The essence of Hellenism resides in the penetration of the then known world by the Greek language, the Greek spirit and its modes of expression. In this sense the term 'Greek culture' comes

137

288

289

to apply, not to a nation but rather to a whole civilization. The Greek world was made up of all those who shared in Greek culture.

Two trends are observable in Hellenistic art: the modernistic, directed towards artistic effect, and the conservative-traditional, found above all in Athenian work, which can be generally described as classicism.

Nevertheless, in both trends the calm presence of Classical form turns into a conscious search for effect.

It goes without saying that relatively few examples of our rich heritage of Hellenistic works of art can be shown and discussed in detail here, but those chosen are intended to give an over-all picture of the main formal developments. This is not to deny that the Hellenistic centuries still constitute, in a very real sense, a 'dark age', despite the essential preparatory studies of Bernard Ashmole, Margarethe Bieber, Ernst Buschor, Rudolf Horn, Heinz Kähler, Gerhard Kleiner, Gerhard Krahmer and Bernhard Schweitzer. There are few other artistic epochs for which the dating of individual works is so much in dispute. The field offers much scope for individual judgement which must be exercised with the most scrupulous care.

EARLY HELLENISTIC ART · 323–ca. 225 B.C.

The age of Alexander marked both the completion of the formal language of Late Classicism and the break-through into the Hellenistic style. The violence and power of the new approach finds expression in the portrait of the king himself on the Alexander Sarcophagus from Sidon, now in Istanbul; the monument is well preserved and in parts even the paint survives. From the left, the hero, wearing a lion's-head cap, *XLVI* charges the Persians, holding in his upraised right hand a spear which, like the reins and the bridle, was *271* fitted metal. Details such as the intensity of Alexander's gaze, boring into his enemies, the tautness of his frame, the compact power of the beautiful body of Boukephalos, Alexander's horse, with its slightly bull-like head—all these stem almost self-evidently from the artistic tradition of the Late Classical and yet are inspired by the new Hellenistic dynamism which was shaping the formal language of art from the end of the fourth century. The trend is carried still further in the head of Alexander the Great from Pergamon, *305* now in Istanbul, from the years just before the middle of the second century B.C.

A well-known story in Strabo (XIV. 641) tells how it was that the later Artemision at Ephesos remained unfinished under Alexander the Great. Though Alexander wished to complete the temple in a most splendid manner after his victory at Granikos in 334 B.C., the Ephesians, so the story goes, refused his generosity, saying that it would not be 'seemly for one god to build a temple to another'. A section of a rectangular anta base, dating from about 330 B.C., comes most probably from the temple at Ephesos. It depicts a group, *272* not fully explained, of a man kneeling on the ground, the upper part of his body erect and clothed in a pelt; beyond the angle, a woman is straining towards the right, either trying to help him up—or to elude his grasp. This superb female figure is quite obviously a simplified version of the Nike leading a Bull, from the balustrade of the Temple of Athena Nike on the Athenian Acropolis. The new trends of Early Hellenistic art are unmistakable, in the energetic and concentrated treatment of the peplos and the deep folds of the draperies articulated by sharp angular cross-folds. The points of comparison with the earlier Nike make it clear that the artist was an Athenian not far removed from the studio of Leochares; one should also compare the drapery with the folds on the chlamys of the Apollo Belvedere. The tendency to simplify and at the *253* same time dramatize the draperies reveals the roots from which the Hellenistic style grew.

The new inspiration did not 'take' everywhere to the same extent. For example the school of Praxiteles developed the delicate Praxitelean form to its fullest extent. The chief example of this is the statue head of a young girl in repose, possibly Aphrodite, from Chios, now in Boston. Traces of stucco for the hair show *273* that there was not enough of the costly marble. The forms merge into one another in incredible delicate curves, the soft eyes are set deep beneath the sharp brows while a gentle smile plays about lips and cheeks. The handling of the marble is so light that it is clear that we have here a sculptor of extreme delicacy inclined towards a pictorial style. Thus in the Praxitelean school and at the hands of the sons of Praxiteles, the early Hellenistic style acquires a markedly painterly character.

Of the sculptors of the school of Lysippos one of the most noteworthy was Eutychides, who carved the seated Tyche of Antioch on the Orontes, representing the town's goddess. We know it from various Roman copies.

The air of agitated yet controlled pathos that characterizes the Lysippan idiom of the early third century B.C. is excellently illustrated by the huge bronze head of the youthful hero in Madrid, which possesses Alexander-traits too and may be an idealized portrait of a Diadochos. Unfortunately this head, which came from Italy, has been pressed out of shape; nevertheless the beetling brow, the firm, straight nose, the full and slightly parted lips, and the determined chin still convey their unmistakable message. The full force of the statue's emotional appeal lay in the eyes, whose sockets are now empty but which once had coloured inlay; the interlocking strands of the beautifully wavy hair also contribute to this heightened atmosphere. Note, too, how arresting is the span between the nose and the small, delicately shaped ear, when the head is viewed in profile. Numerous rectangular and rounded repairs of casting errors now disfigure the face; we may, however, on technical grounds, assume that these were carried out in the Early Hellenistic period.

In other respects, however, the Athens of the third century avoided further development of the 'baroque' tendencies which emerged elsewhere in the period of Alexander. Instead, at the beginning of this century, a simple realistic style is adopted, distinguished by its substantiality and its clearly defined plastic masses. A characteristic example is the portrait statue of Demosthenes done by Polyeuktos, an otherwise unknown sculptor, in 280 B.C., that is, about forty years after the death of the famous Attic orator and statesman. The original was a bronze statue which survives only in numerous Roman marble copies and small bronzes. Demosthenes, democrat and enemy of tyranny, stands in a composed manner, but his clasped hands reveal the depth of his repressed emotion as he mourns the passing of liberty. The harsh vertical and horizontal folds of the drapery cross one another like chains around the meagre, sparely built figure. The wasted and furrowed face burns with an unquenchable fire. The formal vocabulary is dry, taut and angular, the sculptor's intention being to find the antithesis to the harmonious beauty of Classical form.

Man's weakness and loneliness are mercilessly revealed. The Classical harmony between figure and space is absent: the figure withholds itself in hostile isolation from the space surrounding it. This tragic mien expresses the same basic ethos as that which underlies the Early Hellenistic portraits of rulers, now represented mainly by versions on their coins. The figure of the great orator shows a man powerless and alone; the rulers stand like gods, isolated by their omnipotence.

The statue of Demosthenes stood in the Agora at Athens near to the Altar of the Twelve Gods and was set up during the archonship of Gorgias (280–279 B.C.) on a commission from Demochares. On the base was the famous epigram which so well reflected the convictions of Demosthenes himself: 'Had your views, O Demosthenes, but carried the day, the Greeks would never have been subject to the sword of Macedon.'

From the spare, hard style of this statue by Polyeuktos the attention turns to that of the Philosopher from Delphi, probably also by a sculptor of the Attic school. The block-like nature of the figure has become more marked, the volumes more obtrusive. It stands obstinately four-square with legs astride, the himation envelops the whole body save for the right shoulder and the breast. The bearded head, slightly bowed, reveals the strength and dominating will of the subject. The right hand is stretched out as if to emphasize a point in his discourse, the left grips the cloak the corner of which is hanging down from the left shoulder. The sandals with their rich strap-work show that the philosopher was not one of the Cynics, who went barefoot; yet the whole aura of the figure suggests a man deeply concerned with morals and ethical questions who wishes to play an active part in life and to change the conduct of his listeners and disciples. Certainly he is not one who pursues the theory of knowledge for its own sake. In this mid-third-century work, Hellenistic art achieves its first true peak, even before the developments at Pergamon. The form comes to grips with life, is active, though still offering resistance to the surrounding atmosphere, the presence of which the deep folds and substantiality of the garment betray. There is a lively play of light and shadow over the whole surface, in the folds of the himation, the lines of the face, the deep-set eyes and the forked beard.

From the beginning of the third century B.C. comes the famous cult statue for the Temple of Themis at Rhamnus, signed by the Attic sculptor Chairestratos, son of Chairedemos. The goddess, who wears ceremonial garments, is shown in front view with the non-supporting right leg placed wide to one side. The close-textured chiton is gathered high up beneath her bosom and falls in fine folds, while the heavy cloak is wound over the left shoulder and round the hips so that her lower body is fully enveloped. The

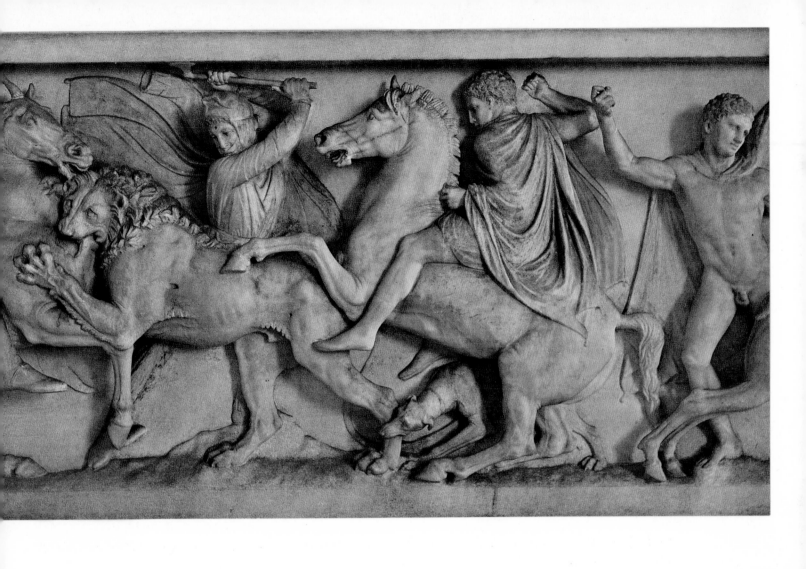

XLVI Hunting scene. From a relief on one of the long sides of the Alexander Sarcophagus from Sidon. Marble. Height about 70 cm. Ca. 310 B.C. Istanbul, Archaeological Museum 68

folds of the free end of the cloak falling from her outstretched left arm emphasize the vertical. The firm mould of the face is quite impersonal and forms a painterly contrast to the disordered hair. The formal vocabulary of face and drapery owes an undoubted debt to the Late Classical art of Praxiteles, but the painterly softness of that style has been frozen and numbed; the figure shares with the contemporary Demosthenes statue a marked hostility to surrounding space. The hard four-square treatment uncompromisingly presents the nature of the goddess of Decree and Law.

279 We have only to glance at the figure of the Priestess Nikokleia, made in the years just after the mid third century B.C., for the Sanctuary of Demeter and Kore in Knidos, to become aware of its greater solidity. The under-garment, the pleated chiton, is only visible below the knee, while the rest of the figure is enveloped in a close-textured cloak; originally the right hand and left lower arm projected from its folds, but they were applied as separate units and are both now lost. The deep folds on the left side of the body were likewise applied. Above these organized masses of the body, veiled by the folds of the drapery, the solemn head of the priestess is set upon a powerful neck, the face marked by lines of sorrow. The head is no longer humbly bowed like the heads of Classical votive figures but lifted stubbornly, demanding as much respect for the priestess herself as for the goddess.

 The material of the clothes is treated with conscientious realism; the chiton falls in tassel-like folds, while the diagonal folds of the cloak resulting from the hang of the garment are crossed by the horizontal creases acquired when it was folded away. The block-like treatment of the masses is still further developed. The figure stands like a remote stranger, unrelated to surrounding space; she is alone with her goddess. The theme of human loneliness, expressed in the Demosthenes statue is here further emphasized.

280 left With the silver relief of a Nike in a victory dance, carrying a trophy with armour attached to its wooden shaft, we enter the third century. The trophy (*tropaion*) was always set up by the Greeks as a victory monument at the place where the enemy first turned in flight (*trope*). The figure is shown in the act of rotating so that, while the naked torso is directly turned towards the spectator, the head appears in three-quarter profile. The ornamentally waved hair is gilded as are the arm-bands and the great wings which stand out against the silver-grey of the body, serving with their finely incised feathers as a foil to the movement of the figure. Possibly the relief, oval in shape, was designed for a ceremonial harness.

280 above, right / 280 below, right The motif comes straight from the Late Classical realm of harmoniously blended figures; this the Nike on the tetradrachm of Agathokles from Syracuse, for the year 305 B.C., underlines. Here the Nike, shown in an even more marked three-quarter profile, holds a nail in her left hand and is preparing to drive it into the erect trophy with the hammer in her right. A gold stater of Pyrrhos for the years 278–276 B.C. also shows a dancing goddess of victory, fully clothed and holding the trophy in her left hand and a great wreath in her right.

 Regarded in the context of these coins, the significance of the Nike on the silver relief becomes clearer; she too is affected by the reaction of the Early Hellenistic against the Late Classical style. She too is self-contained, is withdrawn from the surrounding space and remains, despite her apparent nearness to the spectator, eternally remote.

L This silver relief has been attributed on sound grounds to a workshop in Tarentum, and it probably dates from the mid second century. Since the work uses devices originating around 300 B.C., it can be introduced at this point. Stylistically, however, it is to be placed just before the mid-second-century silver relief of a Nereid on a Sea-monster. The theme of the flying Nike carrying a trophy seems to have first appeared on the funeral chariot of Alexander the Great (Diodorus XVIII. 26).

281 Another piece reminiscent of the period of Alexander is the group of Girls or Nymphs playing Knuckle-bones; it survives in a number of versions, among them the terracotta group (*ca.* 300 B.C.) from Capua, now in the British Museum. On a high base, the two figures are shown crouching, eagerly engrossed in their game, popular in southern Italy down to the turn of the last century. One of them holds the astragal in her right hand ready for the throw; in the left, like her friend, she is holding her winnings. Her opponent

XLVII Terracotta statue of a young woman, from Tanagra. Height 24 cm. End of 4th century B.C. Berlin, Staatliche Museen TC 7674

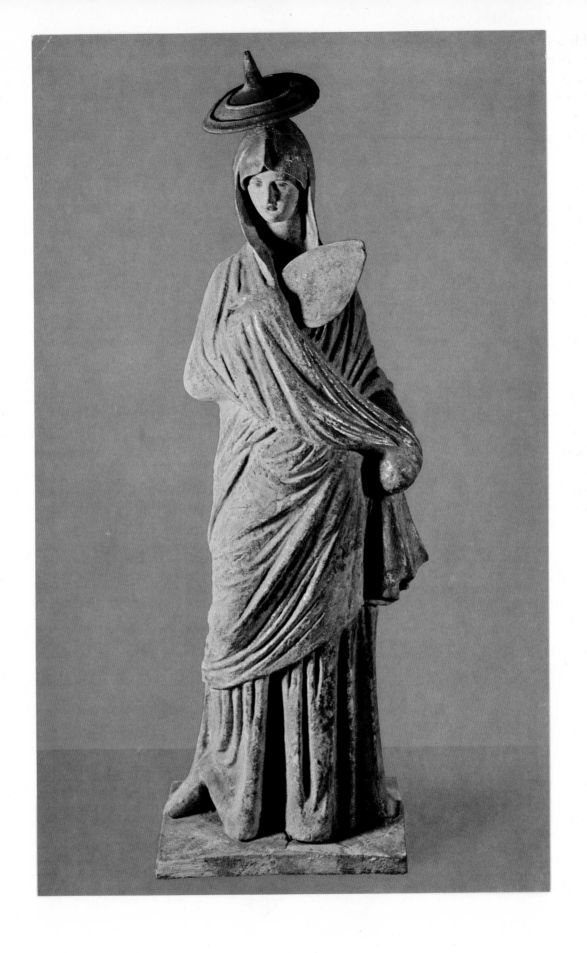

has just played and picked up the bones. There is a smooth blending of the two figures; the curves of their bodies and the taut yet undulating folds of the draperies run in an uninterrupted line and the group is given even greater unity by a rhythm that is typically Late Classical. Slight differences between the gestures of the arms and the set of the hair enrich the composition. The over-all conception, too, derives from Late Classical harmony and perhaps had its origins in painting, being taken up by the Early Hellenistic artists as a subject for three-dimensional sculpture.

285 This may be an instance of small-scale sculpture providing themes for major art; not only does this apply to the Knuckle-bone players in large sculpture, but also to the Crouching Aphrodite by Doidalsas and similar figures for which terracotta groups may have provided the original inspiration.

XLVII Only a little earlier than the London group is the 'Girl from Tanagra' (ca. 300 B.C.) with a fan and a sun hat. The name became current at the end of the last century when numerous similar terracottas were found in the cemeteries of Tanagra in Boiotia. They fetched very high prices on the art market and thus became subject to numerous attempts at forgery.

This standing female figure still bears vivid traces of its original painted decoration. The form grows naturally out of a broad-based stance, the right foot being placed well to one side; the rich cloak, drawn over the head somewhat like a veil, envelops the whole figure above the knees and interrupts the upward sweep with two opposed diagonal lines—the lower edge of the cloak itself and the folds stretching from the right arm, across the breast, to the left hand, which the cloak wholly conceals. The inclination and gentle turn of the head with its disk-like hat, gives the whole figure a sensitive, outward-curving rhythm, deriving from the Late Classical tradition represented by the marble statues of the so-called Herculaneum women in Dresden. The Early Hellenistic configuration, however, is betrayed in the tense, in part angular,
276 treatment of the folds, which are in contrast to the rather more rounded body. As with the Demosthenes of Polyeuktos, the drapery shackles the formal shape and braces the figure, which is conceived as a block and defined by the natural angularities of the body, the right elbow, the knee and the bent left hand. Corporeal mass and folds of drapery, organic rhythm and inorganic movement, are set in conflict and define these figures which, despite all their fragility, reveal a consciously organized power. They are subdued and withdrawn, showing from the outset evidence of the Hellenistic idiom.

282 Various dates have been proposed for the figure of the Boy from Tralles in Karia, now in the Istanbul Museum, but the period between 280/270 B.C. and the middle of the century seems most probable. The early years of the classicizing first century B.C. might suggest themselves as a possibility, but the unpretentious and simple handling and the way in which the figure is shut off from the surrounding space do not really agree with such a dating. Furthermore, terracottas from Tanagra point to the motif itself being third-century. It is almost more correct to describe the statue as a group, of which the second member is the slender, smooth pillar against which the boy is leaning. He is clothed in a heavy chlamys and a short under-garment of which we can see the right sleeve and the hem above the left knee. It is probably his gravestone, as a hole pierced in the upper edge of the pillar indicates that there was originally a palmette finial attached. The head is bowed in sorrow, the hair is delicately incised in the Polykleitan manner but both the sparseness of the over-all form and the expression of the face with its parted lips depart from it. The legs are crossed loosely but the possibilities such a stance offers for movement in depth are not exploited; rather, the figure's posture is determined by the restricting front plane.

The strapwork of the boots comes up to the calves, and this, together with the heavy woollen chlamys, suggests that the boy has prepared himself for a winter journey. A cavity for a joint shows that the front part of the right foot was separately attached. The powerful, spare treatment of the draperies, the relaxed stance, the sorrowful pose, the detailed carving of the head and the plain surface of the gravestone in the background—these contrasting elements are welded into an effective unity. Involuntarily the glance returns again and again to the youthful face, and the spectator finds himself trying to guess the nature of the troubled thoughts reflected there. The Hellenistic artist is so well able to convey self-absorption that all the work needs is the observer to bring it to life. The whole expression of the figure is nothing less than the realization of the *lacrimae rerum*, tears over the imperfect beauty of this world and the senselessness of early death.

506

Hellenistic sculpture achieved success in an important new field, namely the representation of the child. Archaic art and the Classical art of the fifth century portrayed children simply as adults on a small scale. The second half of the fourth century saw the development of a true understanding of the nature of the child-form, which was not, however, to find its full expression until the Hellenistic period of the third and second centuries.

A moving example of such a child-figure is the bronze statue of a little girl of about four years old *283* in the Palazzo Grazioli, Rome. She is standing, quiet and composed, with the left leg set a little behind her; her sleeveless chiton is caught high up, and the overfall reaches down to the top of her thighs. Her thick, finely waved hair is arranged in a so-called 'melon' coiffure and her outstretched hands held some plaything, perhaps a top or a wheel on a string; she is smiling, engrossed in her game. The eye-sockets, now hollow, once contained some other material—ivory, semi-precious stone or coloured paste; the belt buckle and the earrings, for which the lobes have been pierced, were perhaps originally of some precious metal.

The garment envelops the figure like a bell, cascading in folds around the little child's ankles. The dating of the work to the later part of the third century, that is, the High Hellenistic period, is confirmed above all by the contrasting play of light and shadow in the deep folds and ridges of the drapery. At the same time the sculptor has retained much from the Early Hellenistic style: only the manner in which the accents are applied to the folds of the garment so that one sets off the other reveals that the impression of restful simplicity is based on a complex design.

The statue dates from about 230 B.C., only a few years later than the Girl from Antium in the Museo *284* delle Terme, Rome. There is far more movement in this figure of a young woman than in that of the child. The whole figure is dominated by the superb rhythm of the line from the outstretched foot, over the right hip and up to the bowed head; she gazes intently on the dish of offerings in her hands. The contrast between the pleated, crêpe-like material of the chiton and the bunched cloak with its heavy roll about the waist is very marked; the head and the naked shoulder are carved from a separate piece of marble. A metallic brilliance encompasses the figure, kindling even the unruly strands of hair which seem to contradict the mood of quiet concentration. It is disputed whether the surviving statue is an original of the period or a copy from a bronze original. But the work is so far in advance of any other copies in quality, that it seems more likely to be an original of about the year 240 B.C. The over-all simplicity of this portrayal of youthful dedication and self-forgetful abstraction is made up of innumerable small restless rhythms, which the sculptor has brilliantly harmonized.

The deepening of the artist's psychological perception as the third century progressed is revealed to us by the vigorous bronze head of a philosopher, found in the sea of Antikythera; it dates from only a very *XLVIII* few years after the statue of the Philosopher in Delphi. Unfortunately very little of the rest of the statue survives, but the fragments we have make it clear that the feet were shod in sandals and from this we can deduce that the philosopher was not a Cynic. The wrinkled and lined face, with its slit eyes, broad nose, beard and satyr-like twinkle, demonstrates the mastery of the unknown artist; the spectator almost seems to hear the laughter and conversation of the Epicureans. This deepening trend towards realism is as typical of the art of the second half of the third century as the calm absorbed pose of the Maid of Antium.

The middle years of this century also produced the Crouching Aphrodite, the original of which was *285* probably a bronze by the Bithynian sculptor Doidalsas; this original composition may have shown an Eros holding a mirror for the goddess. Here is another example of a theme first expressed in small-scale sculpture being taken over by the major art. The turn of the body is most realistically rendered by the folds of the flesh; one hand probably covered the lap while the other was possibly adjusting the hair, the head being turned to one side. Apart from the turn of the head, facing over the right shoulder, the figure's crouching attitude is contained within itself and emphasizes again the concentration of form characteristic of mid-third-century works.

In treatment of the head and face and the shaping of the hair we find remarkable similarities to the Maid of Antium, but these are not close enough to warrant the attribution of both pieces to the same artist. At the same time it should be said that such differences of treatment would not be out of place for an artist of this period.

286 The votive relief for Kybele and Attis in Venice stands on the threshold of the transition to the 'high baroque' form. The centre of the composition is dominated by the powerful but quite isolated figure of Attis, the Phrygian follower of the great goddess, wearing the characteristic trousers and Phrygian cap with flaps hanging down. Kybele holds a sceptre in her right hand, and in her left the great tympanon; her head is crowned with the polos, the symbol of divinity. A lion, the animal sacred to her, rears up at her feet. The goddess, standing on the left, faces the other end of the hall where the donor and her daughter or possibly a serving maid, carrying a plate with the offering, have entered through the great open door of the sanctuary. The woman, who carries a casket for the incense in her left hand, raises her right in a gesture of adoration. The mortals are shown much smaller in size than the goddess and her attendant and only in their figures are the stylistic peculiarities of the period evident: their crêpe chitons and heavy cloaks envelop them in the

283 same bell-like manner already seen on the bronze statue of a girl in the Palazzo Grazioli. The restless play of light and shadow flickers over the forms of the mortals but the goddess and her attendant are represented in the style of the fourth century, in ceremonial, stiff and frozen postures which have lost the rhythm of the earlier models. Between the goddess and her worshipper stands the gloomy figure of Attis. Only he, who died mutilated and young, to be exalted by the goddess, may share in her glory. This important votive relief was carved about the year 230 B.C. in Asia Minor.

287 From these years too comes the votive relief to the Nymphs from Camaro near Messina in Sicily, now in the Museum at Syracuse. The three figures are presented in a solemn frontal pose, the treatment of the clothes being almost the same in each case; each has the right hand held across the bosom while from the somewhat lower left arm the folds of the heavy cloaks fall to the ground. They stand like pillars, the heads held stiff and erect, their crowns shaped like the polos; there is something solemn and unapproachable about these figures, quite different from the intimate world of the nymphs depicted on Late Classical reliefs where the goddesses are shown to the worshipper in a round-dance with Hermes. The simple manner of treating the drapery that characterizes the terracottas from about 300 B.C. here undergoes an almost 'baroque' transformation. The masses are set more closely together, the verticals are heavily emphasized and the folds are carved in high relief creating strong chiaroscuro effects. An hieratic style developed in Magna Graecia which is hardly met with at all in Greece itself; there is the same great divide between gods and men as between the deified rulers of the earthly kingdoms and their subjects.

The works described so far have provided a picture of the development of the simple phase of Hellenistic art into the third quarter of the third century B.C. Common to all of them is a new spiritual quality whereby a sense of remote isolation is conveyed; the figure is shown withdrawn from the surrounding space, the block-like nature of the plastic form being emphasized. This was to be opened up and to some extent destroyed by the 'baroque' developments which were to follow.

HIGH HELLENISTIC ART · ca. 225–ca. 160 B.C.

From the middle of the third century Hellenistic art displayed an increasingly strong tendency towards the 'baroque', which culminated with the presentation of mass in movement. At the same time a more penetrating comprehension of objective reality becomes apparent, which could be intensified towards realism proper. New areas of artistic expression were opened up, the genre picture and still-life. A typically metropolitan style grew up at Alexandria which expressed itself in the idealization of the pastoral idyll, as in the poetry of Theokritos, and in representations of street scenes. Themes from mythology also continued during this period, but the ancient gods are less potent. Tyche, the Fortuna of the Romans, wayward goddess of fate, rules the destinies of the world, and the mystery religions of the East, such as the Egyptian cult of Isis and Osiris, become more important.

Towards the end of the third quarter of the third century simplicity gives place to a more emotional approach. The development is similar to the transition from Early to High Baroque in more recent times. The withdrawn, introverted form of the Early Hellenistic period provides the stem from which the new shoots reach out. Chiaroscuro effects are still more closely integrated into the plastic form so that it not merely acquires a painterly accent, but seems, as it were, to spring from the painter's imagination. An intense, but always controlled, activation of the simple formal mass to produce manifestations of power can be traced

in each successive work. This tendency came to full fruition in the great frieze of the Altar of Zeus at Pergamon. The work was probably done during the three decades from 190 to 160 B.C., since Pergamon seems to have been the site which had the greatest all-round significance for the developments of the High Hellenistic style.

Unfortunately, the important votive offerings dedicated on the occasion of the defeat of the Gauls by King Attalos I of Pergamon (241–197 B.C.) has not survived in the bronze originals. This was probably set up in the decade from 230 to 220 B.C., but we have only Roman copies, produced, it would appear, during the Antonine period. The theme itself, however, is quite clearly Hellenistic. The subject is no longer the contest of strength on the battlefield but rather the incidence of death or of suicide. The victorious army of Pergamon is entirely ignored; instead, the artist devotes all the considerable power of his psychological insight to the mental and physical suffering, even the pride, of their opponents.

The main group in the Museo delle Terme in Rome (Ludovisi Collection), shows the Gaulish chieftain who, having already killed his wife, is thrusting the sword into his own breast. The prince is striding out 289 manfully, looking back at his pursuers and supporting with the left hand his consort who is sinking to the ground. His features express in their disdainful pride the superiority of the man who has chosen death. He is naked save for a shoulder mantle, secured at the neck and fluttering at his back. In order to appreciate the full measure of the composition, the spectator must view the group, whose pyramidal form integrates and controls the powerful forces within it, from all sides. Particularly impressive is the treatment of the details such as the glazing of the woman's eyes and the death agony on her face, and the blood spurting from the sword-point in the man's breast. Death and suicide are presented with a great depth of feeling in a self-contained unity of composition, while the psychological power in the event is symbolized by the outward-thrusting angular movement. The greatness of the work cannot be gainsaid and the power of the original conception survives even in the smooth rendering of the Roman copy. Behind the work lies the unclassical concept of the isolation and pathos of the defeated. At the same time there is present something of the stoic admiration for suicide as the last irrevocable right of the free man; both the isolation of the individual in the world and his ultimate inviolate liberty.

The sculptor was probably the Pergamene artist, Epigonos, who almost certainly also produced the somewhat later 'Dying Gaul', in the Capitoline Museum. Working from the descriptions of the Celts in 288 Pausanias (X. 19) and Diodoros (V. 28 ff.), the Italian archaeologist Nibby was able to show in 1821 that this 'gladiator' was in fact a dying Gaul, or to use the modern term, Galatian. Then, in 1893 the German archaeologist, Adolf Michaelis, by comparing a passage in Pliny (*Natural History* 34. 87) with an inscription of Epigonos found at Pergamon, demonstrated conclusively that the Dying Gaul, which shows a horn on the plinth, is identical with the work by Epigonos which Pliny called the Tubicen. The Gaul, struggling doggedly with death, is at the same time a brilliant study in anatomy and psychology. The sword wound on the right side beneath the breast is perfectly rendered in plastic terms; the muscles, veins and tendons are at once tense and slack in the moment before death stiffens them. Round the warrior's neck is the plaited torque characteristic of the Celts, and his rough dishevelled hair symbolizes his barbarian nature. Yet the artist, far from despising his subject, gives him an almost noble aspect. On the plinth rest the shield and horn (salpinx) which have fallen from his hands.

The art of Pergamon culminated in the huge complex of the Great Altar of Zeus, probably erected 290–296, 318
Fig. 34 between 180 and 160 B.C. under Eumenes II (197–160/159 B.C.).

The altar is the greatest work of this type from antiquity and, in the arrangement of its halls and the great external staircase, exemplifies a system of planning applied in the Hellenistic period alike to public squares and religious buildings such as this. Typically Hellenistic is the exaggeration of the proportions of the altar itself in the context of the Temenos and the Temple; the whole complex of buildings has been subordinated to the emotional principle of the composition. The great frieze which encircles the base of the altar depicts the battle of the Giants and the Gods. A second smaller one, the so-called Telephos frieze, was in the main Ionic colonnaded court, its subject being the legend of the founding of Pergamon. The superb figures on the acroteria powerfully proclaim the grand conception behind the whole complex, in which the union of architecture and sculpture reaches a new pitch of achievement.

The frenzied movement imparted to the figures on the frieze transcends the natural forms. On the west side are shown the gods of the sea and woods, on the south the gods of the daylight sky, on the north those of the night and the night sky, and on the east the Olympian gods themselves.

292/293 The formal treatment of Zeus and Athena on the east frieze is heavily influenced by the gods of the
214/215 Pheidian west pediment of the Parthenon but the new 'high baroque' form with its emotional undertones is equally apparent. The victorious Athena, surging across towards the right, has seized her winged
293, 318 opponent, Alkyoneus, by the crest and is about to dash him to the ground; with wings spread wide Nike approaches from the right to crown the triumphant goddess. Gaia, the earth-mother, rises up, mourning the death of her sons. The over-all composition of the struggling bodies as they intertwine, seeking their victims or trying to escape, is filled with an unconcealed pathos and a frenzied, almost ruthless drive. The way in which the forms of the high relief virtually obliterate the ground seems to betray an overriding *horror vacui* on the artist's part. The ground of the relief becomes little more than a backdrop for the explosive encounter. In this work, ancient art reached the climax of its 'baroque' phase.

The vast frieze, almost 120 metres long and 2·3 metres high, constitutes a cosmic pantheon; the fundamental Greek experience of a world filled with gods and demons reaches its fullest expression in this great gigantomachy. It is likely that the altar was not dedicated simply to Zeus but to all the deities. The cosmic view of the gods as the powers which animate the natural world rests on a Stoic pantheism; divinity is experienced less in ritual than in the manifestations of nature and their conflicts.

The altar itself rises above the scene of the battle and the eventual banishment of the Titans by the Olympian gods. The mighty figures, which issue from the frieze, are an integral part of the construction and reveal its architectonic strength.

In the composition of the east frieze every device is used to heighten the effect of the dramatic conflict,
294 as for example in the Artemis or the Hekate group, and then by way of the intensification of the dramatic
292 development in the Zeus scene, to the climactic tension of the Athena-Alkyoneus group.

292/293 Derivations from Classical models are discernible not only in the figures of Zeus and Athena but also
253 in the Apollo of the east frieze which is hardly explicable without reference to the Apollo Belvedere of Leochares. If we compare the figure of Apollo's opponent with the 'Dying Gaul', we see how far the emotional element of the great frieze has been intensified in a painterly-idealistic direction. The extreme
288 realism of the 'Dying Gaul' is in marked contrast to the idealistic heightening of the form in the frieze; figures like the prostrate Kephissos of the Parthenon's west pediment come to mind.

Here, then, the vocabulary of form has been enhanced to an unprecedented degree. To mark them as children of the earth, some giants have snake-legs, others animal-heads, still others wings; but in some cases they are shown as completely human, to be pitied in defeat after their courageous fight.

A romantic awareness of nature underlies the artistic fantasy behind this wealth of imaginary forms. We notice how natural is the transition from the human thighs of the giants to their scaly legs, how the wings grow straight out of the human backs, and how convincingly the back view of the three-bodied
294 Hekate is rendered. Two of the left arms are hidden by the shield, and bold foreshortenings and overlapping give coherence to the other limbs of the three bodies—the two heads, the three right arms brandishing a torch, a sword and a lance, and the left outstretched hand holding the scabbard. By comparison with the hieratic archaistic representation of the goddess in Late Classical art, this figure achieves such startling naturalism, that without careful analysis its monstrous structure eludes the spectator. The artist's dynamic treatment of the composition imbues these forms with a fluent and convincing movement which is entirely new. Hekate is actually seen attacking her opponent with the great torch while her Molossian dog has seized him by the thigh. To one side of the lightly clad Artemis as she advances over the body of a fallen giant to encounter Otos, son of Earth and Poseidon, another of Hekate's dogs struggles with the giant Aigaion (with his serpent-like legs).

XLVIII Bronze head of a philosopher, found in the sea off Antikythera. Height 29 cm. Third quarter of 3rd century B.C.
Athens, National Museum 13400

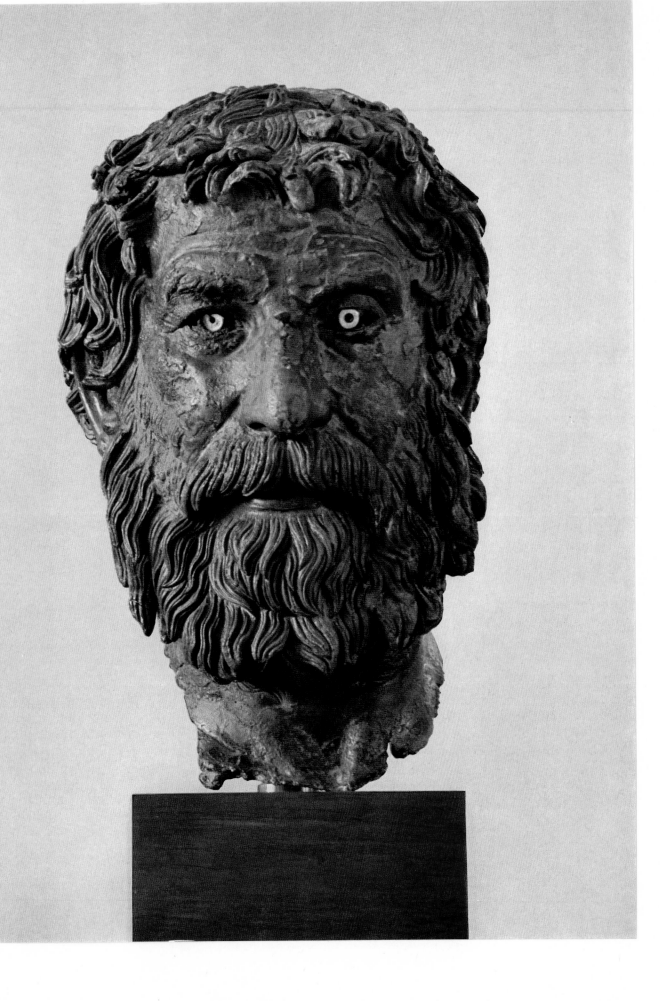

295 Figures such as Nyx, goddess of the night, are given powerful plastic expression. Advancing aggressively upon one of the giants, she is in the act of hurling at him a snake-wreathed vase, symbol of the constellation of the Hydra. The storm-tossed movement of her dress is in vivid contrast with the delicate melancholy of her face which is set off by a flowing veil. The battle is on a cosmic scale: the Goddess of the Night
296 Sky and even the Fates have sided with the Olympians; so too has the Lion-Goddess, symbol of the constellation Leo, who with her attendant beast is shown fighting two of the giants.

318 The full emotional depth of High Hellenistic art is revealed in the head of Alkyoneus, as he groans under the attack of Athena. The face is contorted in agony and even the hair, which like writhing snakes rings this portrait of pain, expresses his tortured suffering. It is one of the achievements of the High Hellenistic exploitation of detail that an ornamental feature such as the hair could be made to play such an expressive role.

In a phrase, the characteristic of the style was the manner in which it triumphed over the solidity of the material in conveying pathos and movement.

The formal language of the Telephos frieze is less rhetorical. The exploitation of landscape further developed the pictorial effect of the relief and, at the same time, one notices the beginnings of a classicizing reaction against the 'baroque' violence of the main frieze. The atmosphere is subdued and painterly, and marks the decline of the High Hellenistic style in the years immediately following 160 B.C.

297 The school of Rhodes occupies an important place beside that of Pergamon. In all probability the famous Nike of Samothrace is the work of a Rhodian sculptor; it was dedicated in the year 190 B.C., probably to mark a Rhodian sea victory over Antiochos III of Syria. It magnificently expresses the powerful yet light movement of the Hellenistic style. Bringer of Victory, the winged goddess hovers on the prow of the admiral's ship, her movement expressed by the swirl of the gown. The thin chiton, pressed against the body by the wind, forms a sharp ridge along the contours of the breast; the high girdle emphasizes the elegance of the turning body. We can only lament the loss of the head which must have crowned the triumphant movement of the body and which not even the boldest flights of fancy can restore to us.

299 High Hellenistic sculpture evolved new motifs, such as that of the hanging body, so common in art of the Christian era, but found in Hellenistic representations of the flayed Marsyas. Marsyas dared to challenge Apollo to a musical contest because he thought the tones of his flute were superior to those of Apollo's lyre.

298 The figure seated on the ground first made its appearance in free-standing sculpture during this period. The famous marble sculpture of the Drunken Old Woman dates from the last third of the century. The debilitated figure sits on the ground, between her knees a wine-bottle (lagynos) of a shape which points to an Alexandrian origin, her head, gnarled with wrinkles and veins, thrown back in drunken abandon. The cloak has slipped off the shoulder to reveal the decrepit old body, and spreads out over the ground in ruffled folds. This realistic genre subject is contained within a strict pyramidal composition. Realism and formalism are here fused in heightened tension. Maybe this decayed old hag, her teeth rotting in her jaws, was once a priestess of Dionysos who immersed herself in the cult to the point of exorcism. The ivy wreath modelled on the side of the vase could indicate as much. Probably the figure derives from the *anus ebria*, worked by one Myron of Thebes in the last third of the third century B.C. Pliny (*Natural History* 36. 32) confuses him with his famous Classical namesake.

299 The partiality of High Hellenistic art for the extreme statement of anatomical problems is clearly expressed in the form of the hanging Marsyas being flayed alive by a kneeling Scythian. The figure, like
285, 281 the Crouching Aphrodite by Doidalsas, is probably influenced by the Knuckle-bone Players in small-scale sculpture. The satyr's torment is so vividly expressed that it arouses the observer's sympathy. The lines of the joints and muscles stand out horribly under the stretched skin. This impressive psychological and anatomical study is the work of an unknown artist from Asia Minor from the years around 200 B.C. The figures of the group survive only in various Roman copies.

300/301 The Sleeping Satyr, the famous 'Barberini Faun', belongs to a quite different artistic trend. Heavy with wine, the satyr has sunk down onto a rock and fallen asleep; he has spread out his panther-skin over the rock and part of it hangs over his left upper arm. The right leg has been restored in modern times by Pacetti

512

following earlier attempts by Bernini, but the foot must originally have been lower. Only the left side of his back leans against the rock and beyond on this side his horse's tail can be seen hanging. The right arm rests on the side of the head which leans on the left shoulder and is partly supported in sleep by the relaxed right hand; the powerful forms of the body are in uneasy tension. The sullen face, framed by the flowing hair and the ivy wreath with its clusters, reflects the sensual dreams which torment the sleeping satyr.

The air of satiated repose, wholly encompassed it would seem by the sensual world of the powerful body, is only accentuated and underlined by the sharp thrusts of the elbow and the knee into the surrounding space. In this work, an original not a copy, the artist has brilliantly captured the Dionysiac pulse of the enchanted dreamer.

This statue, whose confidently carved forms so well express the sullen sensuality of the subject, must date from about the year 220 B.C. To a degree achieved by virtually no other Hellenistic work it embodies one of the fundamental concepts of existence: the Dionysiac state between sleep and dream, of drunken enchantment or, as Winckelmann expressed it in his *History of Art* (Book V, 1, paragraph 6), 'a picture of elemental nature left to itself'.

From the firm moulding of the head and the formal organization of the body, which show a relationship to the work of Pheidias (for example the reclining 'Kephissos' of the west pediment of the Parthenon), it is clear that the sculptor of the 'Barberini Faun' was not closely involved with the East Greek school of Asia Minor, but was influenced by Attic art and may himself have been an Athenian. The clear, pithy idiom, so different from the outward-thrusting nature of Pergamene art, lends added weight to this assumption. Even parts of the great frieze at Pergamon itself, for example the Apollo group on the east face, possess *291* certain features which could suggest that Attic sculptors had been recruited for the work.

The telling way in which the surrounding atmosphere seems to depress the 'Faun's' body into a cavity, so that the satyr is so to speak a prisoner of his own sleep, is yet another manifestation of High Hellenistic art.

The attribution of this statue to an Attic artist of the late third century gains credence when we compare it with the relief of a Negro Boy leading a Horse, found since the war and now in the National Museum, Athens. The boy's head shows close similarities to that of the 'Faun' and the saddle-cloth of the horse is strongly reminiscent of the panther-skin draped over the rock. From all this it seems possible that Attic art of the late third century had already taken certain decisive steps towards the High Hellenistic style which reached its triumphant goal in the great frieze at Pergamon. Future discoveries may well compel a complete reassessment of Attic art during this period and accord it a standing it has been denied up to now.

LATE HELLENISTIC ART · ca. 160–31 B.C.

The High Hellenistic phase reached a climax in the great frieze of the Pergamene altar. At this stage what had hitherto been a unified development divided up into three separate major styles which themselves display conflicting tendencies. This split led to a further formal distension in the 'late baroque' centrifugal style: this, in turn, generated its antithesis—a centripetal form closed in upon itself against the surrounding space. These two styles, developed from Hellenistic awareness of space, gave rise in the middle of the second century to a classicizing reaction, based on Athens, determinedly two-dimensional in style. After the Great Altar at Pergamon, Greek art entered a period of stylistic indecision which, understandably, caused a return to Classical models, to end in the slavish copying of Classical originals. As has been noticed, elements of classicism had begun to appear and disturb the 'baroque' style as early as the small Telephos frieze at Pergamon, dating from the decade 160–150 B.C.

The stylistic phase reached by the Telephos frieze is also respresented by a votive relief in Munich, *Fig. 184* allegedly of Corinthian provenance, but in fact Attic both in the style and the marble used. A family, approaching from the left, brings an offering to two divinities, one a powerful god enthroned and holding a sceptre, the other a goddess, somewhat smaller but also with a sceptre in her right hand, leaning against a pillar. In the centre of the scene stands the great, four-square altar. The deities are set before a curtain which is attached to a bough of a plane-tree. Sacred garlands are wound around its trunk. Near by, on a high pillar, are two small statues of Apollo and Artemis in the 'archaistic' style. Even the two main divinities are less like

living beings than cult statues; the posture and style of the god goes back to a Classical model, the goddess to a Hellenistic type which has survived in other versions in three-dimensional sculpture. Owing to the loss of the inscription and the lack of any exact information concerning the relief, there is no way of telling who they are—whether Dionysos and Ariadne, Asklepios and Hygieia, or Sarapis and Isis.

The relief is contained within a box-like space, defined by the projecting anta frame and the architrave, like an abbreviated view of the long side of a temple roof. A basic rule of Greek relief sculpture, observed even on the great Pergamon frieze, that the projecting parts of the relief should extend to a common plane so as to form an ideal surface, is dispensed with here. Only the altar and parts of the enthroned god extend to the forward edge of the antae, the figures being placed arbitrarily in the field. The unified background of the Classical relief is pushed back by the tree and the slope of the pillar against which the goddess is leaning, while the recession in depth is interrupted by the hanging curtain. With the aid of certain part-perspective techniques, such as the slant of the pillar and the representation of the altar, the artist has created an atmospheric landscape in which the figures, notably the human family, move freely. The whole nature of this idyllic scene proclaims the influence of a school of painting. This Munich votive relief from the middle of the second century B.C. may be taken as typifying Late Hellenistic relief work; the Telephos frieze had already shown a very similar treatment of separate scenes in separate pictures.

The mid second century B.C. is associated with the name of Damophon of Messene, whose well-known group of cult images from the Temple of Despoina Lykosoura has come down to us. He is a master who revelled in the 'baroque' idiom, familiar to us from the Great Frieze of the Pergamon Altar, though he invested it with neo-classical undertones. In his own Messene, the Mavromati of the present day, many of his works are still to be found. Pausanias rated him above all other Messenian artists. The later excavations
303 of Professor Orlandos have yielded a rich harvest of sculptures. For example, in 1962 a head was found which the young Greek archaeologist Despinis recognized as being by Damophon and identified[3] as that of the Apollo statue in the Asklepieion of Messene mentioned by Pausanias (IV. 31. 10).

The head, which is in all probability slightly later than the cult images of Lykosoura and may be dated to about 130 B.C., conveys an impression of power. It originally had eyes of special inlay and wore a wreath of golden leaves. The well-rounded face with its sparsely formulated features—note the close-set eyes and the full, slightly parted lips—is characteristic of the already neo-classical features in Damophon's work.

304 From the middle of the second century B.C. comes a colossal head of Helios, found at Rhodes. It may be an imitation or a copy of the famous Colossus of Rhodes which stood at the entrance of the harbour, and which Chares of Lindos, a pupil of Lysippos, made in the early third century. The head, whose features
305 are faintly reminiscent of Alexander the Great, is turned sharply to the right. The face is surrounded by locks of hair which was partly finished in stucco and in which there are fifteen small holes to receive the golden rays of the aureole, while an unfinished area at the back of the head indicates where the fluttering veil was attached. The emotional element so characteristic of the Hellenistic idiom is here subdued, and we can see the beginnings of the classicizing tendency.

The technique of the carving, and the fact that large parts of the back of the head and the tresses of the hair were completed in stucco, suggest Alexandria as the place of origin, since there marble was in short supply and this technique was probably first developed. We can only touch briefly on Alexandrian art, but
298, 302 representative of the prevailing taste are such works as the Drunken Old Women and the Negro Boy, who may originally have carried an elephant's tusk over his right shoulder. This figurine has been variously dated to the early third, the late third, and the first century B.C. It seems to me, however, that the strongly arched, balanced and elegant rhythm is typical of the centripetal style which is here combined in a quite remarkable way with centrifugal strength; examples of this are the left leg, which in the side view can be seen to protrude, and the sideways-glancing head, which extends beyond the figure's main axis. Such a posture, which combines Alexandrian complexity with crass realism, is comprehensible only in terms of the second century. Yet the firm modelling of the head would seem to go back to the third-century models.
307 From the same period comes one of the most famous of all the works of antiquity, the Venus de Milo. The wide outward swing of the right hip and the sharp forward thrust of the left knee which characterize

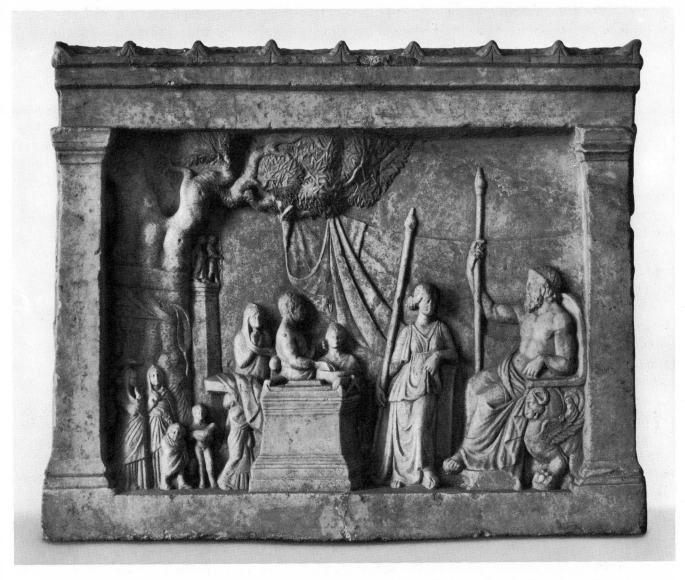

184 Votive relief. Offering in a rural sanctuary. Attic, ca. 150 B.C. Height 61 cm. Munich, Glyptothek 206

the stance bear a certain resemblance to those of the Negro Boy. The motif, however, seems to derive from a late fourth-century model, but one with genuine Late Hellenistic traits introduced by the complicated stance referred to, and involving the spatial displacement of the clothed lower part of the body. The vigorous counterplay of the drapery folds is delicately contrasted with the smooth fullness of the female form above. The head, with its dream-like harmony and sweet melancholy, is an almost literal copy of a late Praxitelean model. The whole figure breathes an unmistakable sensuousness, the patina of an over-rich art which has seen many changes. There is now no means of determining in what position her arms were shown: was the goddess perhaps holding the shield of Ares up before her as a mirror, with upraised left hand and the right hand in front of her body?

A purer example of the tendency for the figure to turn upon a central axis is found in the delightfully fresh terracotta of Aphrodite, formerly in the Heyl Collection and now in Berlin. It has much in common *306* with the Venus de Milo, even the affinity with a fourth-century work, though this time one from the circle of Timotheos. The figure dates from the middle years of the second century B.C. and is the work of a sensitive artistic personality; the thin cloak falls away from the shoulders and breasts and forms a decorative frame rather than a covering for the supple limbs. The left leg is raised and the arms are stretched out to the left towards some object now lost. Her head is turned and answers the curve of the hip above the supporting right leg. The rich complexity of the axes of movement is concealed by the pliant folds of the

515

draperies and a magnificent over-all unity achieved. Delicately wrought figures of this kind are the justification of Wilhelm Klein's application of the term 'rococo' to the style which followed the 'high baroque' of the great Pergamon frieze.

The centrifugal nature of sculptures dating from the middle and later third century B.C. is exemplified by the bronze figurine of Poseidon in Munich. Yet classicizing tendencies are already apparent in this figure which derives ultimately from the statues of the gods by Lysippos, while two terracottas from Taranto and 308 left Centuripe are purer examples of the full outward drive of the centrifugal style. The satyr from Taranto strides out to battle like a Herakles, his right hand raised, a panther-skin knotted across his chest and wrapped round the left arm to serve as a shield. The sense of unrestrained movement seems to have been even more 308 right marked in the badly damaged Satyr from Centuripe, where the violent turn of the body shows at the same time the influence of the centripetal structure.

309 From the late second century comes a terracotta group of Pan and a Nymph. It is conceived frontally and is contained within a triangle whose shortest side is the base of the statue. Pan has crept up behind the Nymph, who has just emerged from her bath; over her left leg is draped her garment, or it may be the towel with which she has been drying herself. Her body is locked by the goat-legs of the god, as in a vice; he has seized her left breast in his left hand. Her left arm is raised, apparently to ward off the attack but in fact pulling the seducer down towards her. The mysterious face of the horned god is instinct with sensuality, the over-all treatment, in particular the wedge-shaped beard, showing its kinship with High Classical forms. This group, expressing the fusion of animal and divine love, probably came from a grave; with its emphasis on the vertical, and meant as it is to be viewed from the front, it probably dates from the last years of the 310 second century B.C., having certain affinities with the group of Aphrodite and Pan from Delos.

In the Delos group the contrast between the unconcealed beauty of Aphrodite and the uncouth and lustful figure of the goat-legged god is starkly emphasized. In her right hand Aphrodite wields a sandal but her coquettish glance and her ploy with the little Eros makes it appear unlikely that she intends to hit anyone with it. Pan has apparently surprised her at her bath, for her hair is still partly tucked into a bath cap. Despite the inward-turning figure of Pan, the group is intended to be viewed from the front. This classicist tendency to two-dimensionality is observable too in the form of Aphrodite. It is in the contrast between the beautiful body of the woman and the ugly, cloven-hoofed creature that the intellectual atmosphere at the turn of the second century finds expression.

311 The statues of Dioskourides and his wife Cleopatra, in Delos, again emphasizing the frontal view, date from 138–137 B.C., somewhat earlier than the Pan Aphrodite group. The female figure rises from the broad bell-like base formed by the fall of her gown, while the free left leg is placed to one side, offsetting the right leg of her husband. In both figures there is a noticeable harking back to the third century.

The vertical folds of the woman's chiton can be seen through the thin silk of her gown while her right arm, crossed just below her breasts, causes them to lift piquantly. The artist has successfully fused the centrifugal thrust of the broad stance with the centripetally encompassed upper body. The new surface technique is expressed in the shallow rippling folds of the draperies which have lost their former plastic quality. This accounts for the years around 130 B.C. being referred to as the period of 'exhaustion' in Hellenistic art.

At the same time there are vigorous works from the middle of the century, for example the bronze statue 312 of a ruler in the Museo delle Terme in Rome; the figure owes its strength and assured stance to the artist's understanding of the Lysippan form of the Late Classical period. From this too derives the treatment of the musculature, the divergent axes of the body with the energetic supporting motif of the right hand and the vigorous outward turn of the head with its eyes gazing into the distance. The lines of the head retain traces of the emotionally heightened style of High Hellenistic art. The detailed and individual treatment of the face does not agree with the compact form of the body nor do the heroic pretensions of this deified Hellenistic ruler, possibly Demetrios I of Syria (162–150 B.C.), relate to the political realities of the mid second century when Rome was already the dominant power.

313 The Poseidon from Melos, which dates from the late second century, perhaps around 130 B.C., still retains something of the moving quality of the Pergamon frieze, but the powerful movement of the body

XLIX Sleeping maenad. From a grave by the church of SS. Francesco e Paola near Taranto. Terracotta. Length 30 cm.
Ca. 130 B.C. Taranto, Museo Nazionale

is now more histrionic. The god's stance, his right hand grasping the trident, while imposing, contains an element of display. The pretensions of the divine presence do not carry the self-evident conviction of Classical statues and despite the mighty gesture of the right arm and the self-conscious placing of the left hand on the hip, the plastic power of the work is deployed wholly in the plane. The three-dimensionality of the Classical style has been surrendered in favour of an emphasis on the front view, which is deliberately conceived as such and in the restless excitement of its surface betrays the after-effects of the centrifugal form of an earlier period.

XLIX A terracotta figurine of a sleeping maenad, from a Tarentine grave, exemplifies the centripetal structure in its purest form. With its great diagonals and curves the body almost seems to be wound into a spiral. In common with many works of the period extending from the middle to the second half of the second century, from the Sleeping Hermaphrodite in the Museo delle Terme, Rome, to the figures of reclining Nymphs and Nereids, the figure presents its naked back to the spectator. The lilac-coloured gown reaches only to the upper part of the thighs and the otherwise slender form is dominated by the voluptuously swelling buttocks; the back is divided by the lilac-coloured strap of the bodice. In the attitude betokening 300/301 sleep, the head rests on the left lower arm while the hand, like that of the 'Barberini Faun', hangs down loosely.

 The treatment of the back is much tauter on the silver-gilt pyxis lid from Canosa di Puglia, depicting a L Nereid riding a sea-serpent. The serpent, with its frightening head, coiled scaly body and fan-like fins, is picked out in gold as are the stylized waves and the hair, gown and bracelet of the Nereid; the effect is to heighten the bold centripetal curve made by the foreshortened back. This exquisite piece of Tarentine workmanship from around 130 B.C. reveals the degree to which the artists of the city retained their skill even during the period of Roman rule.

315 The Crouching Aphrodite of Rhodes, an original work from about 100 B.C., exemplifies the third basic form-structure of the second half of the second century B.C.—a pronounced neo-Classical two-dimensionalism. Aphrodite is shown, having just emerged from her bath, wringing the water from her hair; the lower part of her body is in profile to the spectator, the head and upper part being turned and 285 presented frontally. The work is fairly obviously a variant on the Crouching Aphrodite by Doidalsas. The penchant for classicizing reproductions was at first extended even to Early Hellenistic works as fit subjects for imitation and adaptation, and it is interesting to observe the delicate 'rococo' figure into which the sensitive sculptor has transformed Doidalsas's original study of the female body.

 One of the greatest of the Late Hellenistic masters, equally at home in all genres, appears to have been Boethos of Chalcedon. His most important works are the pyramidal group of the Boy with the Goose and Fig. 185 the Eros Enagonios from Mahdia. He may have worked in Athens in later life and after his death his estate was probably auctioned to a rich Roman. Part of the collection has come down to us through having been preserved in the wreck of its transport ship when it foundered off Mahdia on the coast of Tunisia. From this great quantity of statues, we have chosen for 316 illustration the female figure of a Grotesque Dancer, which shows that Boethos was apparently influenced by Alexandrian styles.

185 Eros Enagonios, from Mahdia. Reconstruction drawing, based on the statue by Boethos of Chalcedon

 The stunted figure, clothed in a thick cloak, dances with head thrown back, hammering out the rhythm with her castanets. The contours of her body show through the garment. The stumpy arms and legs are in grotesque contrast to the exaggerated size of the head, whose lines suggest a rather more robust and sprightly 298 version of that of the Drunken Old Woman. The body is shown in a twisting movement broken by the line of the flung-back head and the left leg. Once again, in a single work, we have the combination of the

518

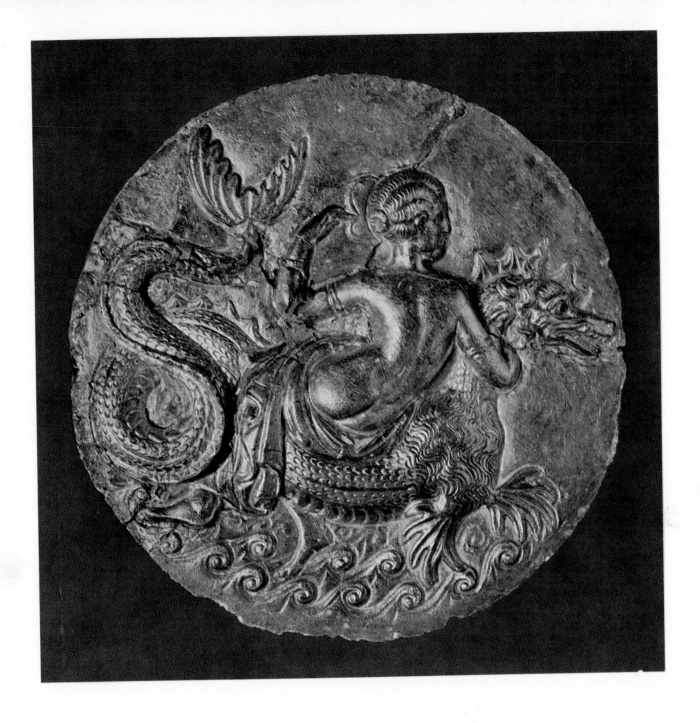

L Nereid on Ketos. Silver relief, part gilt, from the lid of a pyxis, from Canosa di Puglia, near Taranto. Diameter 10·3 cm.
Ca. 130 B.C. Taranto, Museo Nazionale

two contrary principles of Late Hellenistic art although too strong a conflict is prevented by the enveloping cloak. The strangely inhibited movement of the dance is conveyed by the thrust of the left leg through the folds of the garment, which hinders the dancer's movements as though she were in a sack race.

Boethos of Chalcedon is perhaps one of the Late Hellenistic masters who carried through the transition to the so-called neo-Attic manner. These neo-Attic sculptors, working from the middle of the second century B.C. on, undertook commissions to copy and imitate Classical models, first from the Hellenistic rulers and later from the Romans who took over this aspect of the Greek inheritance as well. For the first time in history the word 'art' acquired its modern connotation as a symbol of education and wealth. Just as the educated man strove to build up his own library by commissioning copyists to provide him with books, so he aimed to build up his own art gallery.

Under the direction of experts and scholars, education in this period laid increasingly heavy stress on Classical works as the only ones deserving of respect or emulation. The neo-Attic sculptors emerged as the custodians of Classical art. The result, from the late second century on, was a quite remarkable quality and freshness in statues and reliefs, such as the Diadoumenos of Delos, a copy of the original bronze by 314 Polykleitos, and the relief of a Maenad in the Palazzo di Conservatori in Rome, a copy of a relief by Kallimachos. Indeed the quality of the Maenad relief is so outstanding that for a long time it was regarded as a fifth-century original.

The curvature of the Maenad relief shows it to have been part of a circular monument, probably a round base. The original from which the surviving copy is derived decorated a similar base carrying the tripod won by the 'Bacchai' in the contest held in 406 B.C., after the death of Euripides, and dedicated by the 'choregos'.

The maenad dances in drunken frenzy, her right hand, which holds a knife, arched over her head; with it she also grasps a corner of her dress, which, in a broad upward-swinging curve, serves as a foil to the movement of her body. She swings her left hand behind her; in it can be seen half the body of a goat which she has torn apart in her delirium. The folds of the thin peplos both envelop and reveal the firm limbs beneath. The figure expresses the vital Late Classical contrast between the sensuous warmth of the body's structure and the cool elegance of its draperies. The work achieves a calligraphic power equal to that found in the Nike balustrade and possesses the high formal qualities of the art of Kallimachos who alone transformed the Pheidian idiom into a new and rich style by the extension of the figures in the plane.

Only the smallest details betray it as a copy and not the original. For example, there is no differentiation as between the folds of the peplos and those of the cloak; they run smoothly into one another, and there is a certain metallic hardness about the whole execution. At the same time one can well appreciate that the Roman possessors of such products looked upon them as Greek originals and learnt from them the nature of a power new to them—the power of art.

> *Graeca capta ferum cepit victorem et artis*
> *Intulit agresti Latio.*
>
> Conquered Greece took captive her wild conquerors
> Bringing art to the peasant land of Latium.
> (Horace, *Epistles* II, 1, 156 f.)

317 The bronze figure of a seated boxer in the Museo delle Terme, Rome, probably by Apollonios, son of Nestoros of Athens, sculptor of the famous Belvedere marble torso, shows that these new Attic artists were quite capable of producing original works for their Roman patrons. The ascription to Apollonios stands, even if the remains of the presumed signature on one of the glove straps should prove to be deceptive. The rugged figure, worked with great artistry, is far removed from the world of the Greek palaistra and the XL mighty head of the boxer from Olympia; it breathes instead the atmosphere of the Roman amphitheatre with its brutal gladiatorial displays. Seeking the applause of the arena, the boxer jerks his head from side to side; his superbly developed physique proclaims his ascendancy as a professional who has defeated countless opponents. At the same time this body, in its sure artistic organization, deploys the full resources

of Greek art. With its block-like tautness, the legs jutting forward, it definitely suggests the use of a third-century, Early Hellenistic model. The twist of the neck, which this figure shares with the somewhat earlier Borghese Gladiator, confirms the dating of Apollonios to the second quarter of the first century B.C. within the Late Hellenistic period. We seem to enter an eclectic phase with the work of the neo-Attic artists; art of all periods shows affinities with earlier styles, but now these borrowings are no longer integrated in a single great new mode of expression, but are piled up on one another haphazardly. This theme of eclecticism runs like a refrain through the whole of the succeeding Roman art.

The powerful political influence of Rome in Mediterranean affairs left its traces in art, above all in portraiture. A male portrait from Delos, dating from the beginning of the first century, exemplifies this *LI* complex stylistic situation since it is not certain whether it represents a Greek or a Roman. We can be sure only that the artist was a Greek, most probably the Ephesian sculptor Agasias, son of Dositheos, as Gerhard Kleiner suggests. At about the same time, this artist is known to have produced the Borghese Gladiator. The mouth of the Delian head has eloquently parted lips and the pathos of the Late Hellenistic style plays about the features. To judge from the pronounced twist of the powerful neck, the original figure must have been built around conflicting axes. The relatively small eyes point to acute powers of observation rather than great inner energy, while the whole head is characterized by a weary and troubled mien. Maybe the subject was a Greek or Syrian supporter of Mithradates IV in his hopeless struggle against the Romans.

The extent to which the 'baroque' Late Hellenistic style persisted into the first century B.C. is revealed by the famous Laokoön group made by the Rhodian *Fig. 186* sculptors Hagesandros, Polydoros and Athanadoros,[4] probably in the middle of the century.

The formal idiom of Pergamon is still used. The fate of the priest of Apollo and his sons, though this is a free-standing sculpture group, is rendered in a manner *319* akin to painting. For disobeying the orders of Apollo, Laokoön was killed, together with his sons, while serving at the altar. By the time this group was carved the myth had been variously interpreted; the cause of Laokoön's fate, his disobedience to the god, is no longer the artist's theme; it is, rather, the death-struggle itself of the father and sons against the demonic serpents, the agents of Apollo. The statue, after its rediscovery in 1506, had a deep influence on the art of the Renaissance and succeeding generations. But it was prized already in antiquity, coming into the possession of the emperor Titus and being described by Pliny as 'greater than any other work, whether of painting or sculpture'.

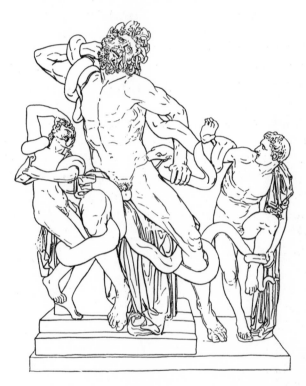

186 Laokoön group (after the new reconstruction by Magi 1960)

The onslaught of the serpents has driven the father and his youngest son against the altar while near by the coiling bodies have already pinned down the eldest son. One snake has sunk its deadly fangs into Laokoön's hip and another has bitten the youngest son in the breast; the glazing eyes of the boy seek the protection of his father, but he too is in the last death throes. The powerful body and forcefully portrayed head are imbued with great expressiveness and depth of feeling. The elder son, struggling to free himself, looks up in horror at his father, and his face reflects the anguish of the dying man. Laokoön's right arm, bent back as he endeavours to force one of the snakes away from his neck, was only recently discovered; an earlier reconstruction had shown it raised, triumphantly grasping the body of the snake. The whole composition is a heart-rending picture of man's helplessness. Despite the cold virtuosity of the execution, the perfection of form stirs the imagination. The group, designed to be viewed from the front alone,

319, 318 embodies both the centrifugal and centripetal tendencies of Greek art; whereas the figure and expression of Laokoön are unmistakably 'baroque', those of his sons are neo-Classical in style, harking back to the formal language of Lysippos.

Based on the recent restoration of the group, several attempts have been made of late to date it to the second century, even prior to the great Pergamon frieze. We have only to compare the head of Laokoön with that of Alkyoneus, Athena's opponent in the gigantomachy, to see immediately how impossible is such a dating. The anguished expression of Alkyoneus is part and parcel of the substance of the face and does not break up the integrated structure of the head, whereas the head of Laokoön carries, as it were, a superimposed mask of pain, grimacing in exaggerated convulsions and contortions, but without a solid nucleus to the form. Any such detailed comparison of the two figures brings out the distance between them. The Laokoön remains the last significant product of Greek art in the Roman period.

PAINTING AND DRAWING

In this outline of Hellenistic art nothing has so far been said about the painting of the period; what follows is a brief account of developments in the field. As described earlier, the red-figure style of vase painting, which up to that time had faithfully reflected developments in large-scale painting, was exhausted by the end of the fourth century B.C. In the course of the third century, vase painting largely gave place to cups

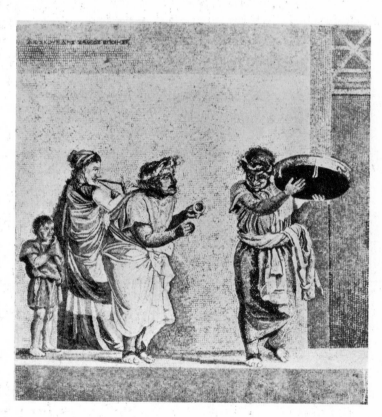

187 Comedy scene by Dioskourides of Samos. Mosaic based on prototype dated to the end of 3rd century B.C. Height 48 cm. Naples, Museo Nazionale Archaeologico

decorated in relief, made in Athens and Megara and generally known as Megarian bowls. Indications of the developments in major painting can be found on tombstones, in particular those from Pagasai, the port of Macedonian Pherai, now in the Volo Museum, but also those from Alexandria in Egypt.

Painted vases were produced only in local workshops, such as the third- and second-century Hadra vases in Alexandria or vases from Lipari and Centuripe in Sicily, all of which types were painted in a matt colour technique.

LI Portrait head, from Delos. Perhaps by Agasias, son of Dositheos, of Ephesos. Bronze. Height 32·5 cm. Ca. 100 B.C. Athens, National Museum 14612

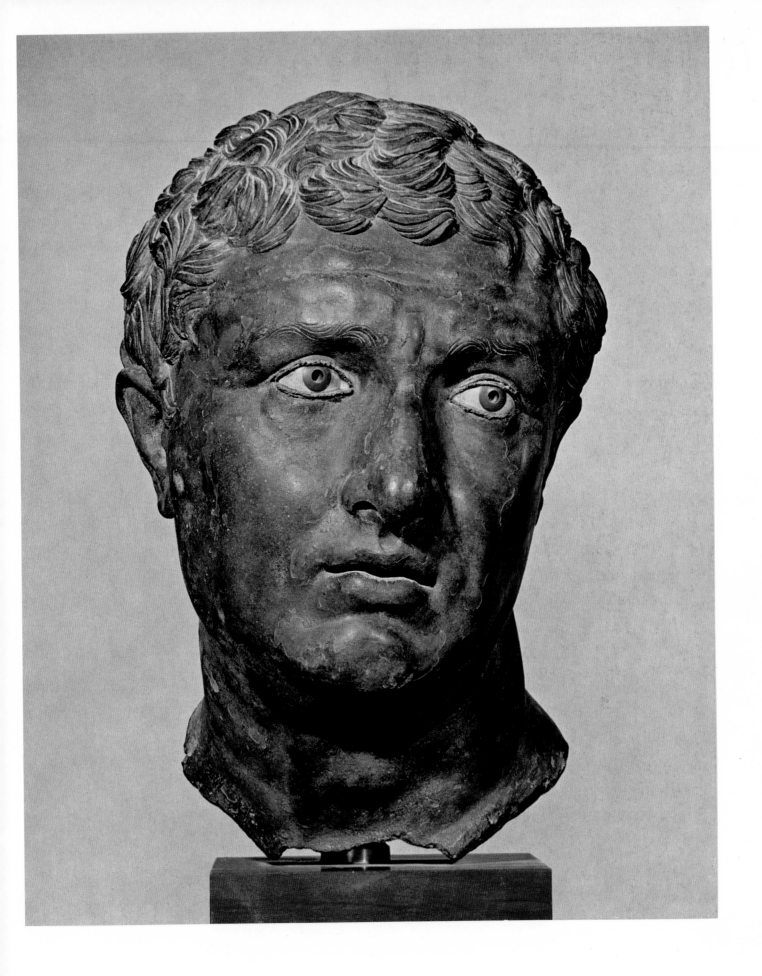

A better impression of Hellenistic painting can be gained from mosaics, the remains of frescoes in burial chambers and, above all, the copies of Hellenistic frescoes found in the villas of the Campanian towns of *Fig. 187* Italy. One of the mosaics of Dioskourides of Samos, found at Pompeii and now in Naples, will serve as an example. Following the fashion of Alexandrian art, it depicts a scene from the theatre. The actors, dressed in the costumes and masks of the later Attic Comedy, are shown in lively action on a narrow box-like stage. A girl flute-player can be discerned as well as a dancing figure and a cymbal-player. The richly ornamental dress with its folds and furbelows is typical of the end of the third century. The originals copied by Dioskourides dated from this period, and from the changing colours of the cloaks, the lively play of the shadows and the strong contrasts of light and dark, they were obviously paintings. From the treatment of the figures and surrounding space, it is evident that these original paintings antedated the Great Frieze at Pergamon.

LII A high-lidded krater from Centuripe, now in the University Museum, Catania, is a good example of the Hellenistic style in painting and its tendency to isolate the figures. A seated lady is attended by her servants, one of whom holds a sun-shade over her while the other hands her a fan. The figures are set against a rose-pink ground and the colouring of their dresses is predominantly blue and yellow. Both the style of the figures and the 'baroque' aspect of the vase, with its wealth of plastic ornament, indicate a date in the late third century B.C.

These two examples are characteristic of the tone and colour elements we associate with Hellenistic painting.

In the representation of the human form and its relationship to space the developments in painting follow lines similar to those in sculpture. Here too the calm existence or 'being' of the classical figures is transmuted into the new dynamic form of Hellenistic art with its hidden pathos which can be detected even in seemingly quiet scenes. Dynamic concentration takes the place of the restful harmony of the Classical form, and this characteristic, which gave art a new dimension, was carried on into Roman art and persisted until the time of Constantine. It was this expansive power of Hellenistic art that led to the spread of Greek forms as far as India and East Asia, with virtually worldwide effects even in antiquity. In the Early Renaissance, Hellenistic form was a not unimportant catalyst of the new art and facilitated the comprehension of natural forms. Basing his judgement on such Hellenistic works as the Belvedere Torso or the Laokoön, and comparing them with the Baroque style of his own time and just before, Winckelmann (1717–68) takes their conscious intent and dynamism for calm existence and peaceful nature, 'noble simplicity and restful grandeur', qualities which the modern scholar attributes rather to the Classical period of Greek art.

COINS IN THE HELLENISTIC PERIOD

The Hellenistic age may be regarded as extending from the death of Alexander the Great (323 B.C.) to the time of the battle of Actium (31 B.C.) and the death of Cleopatra (30 B.C.). Though the Greek cities— or at least those of them who were still minting coins—did contribute a number of important pieces, coinage during these three centuries is mainly the product of the various states that came into being after Alexander's death, and bears the portraits of their rulers.

Hitherto it had not been possible for Greek city-states or confederations to envisage putting the portraits of prominent statesmen on their coins. This was as much for religious and for political purposes; it would have been considered presumptuous and offensive to the gods, and politically as a move towards absolute power. Within the Persian Empire, however, it was otherwise; here, for almost a century before the beginning of the Hellenistic period, the portraits of some of the great satraps appeared on coins. The first *Fig. 188 (1)* of these known to us is Tissaphernes, satrap of Lydia and commander-in-chief of the whole of Asia Minor (455/445–395 B.C.). Of the two surviving versions of his portrait, one appeared about 412/411 and another around 400–395 B.C.; and both are examples of a highly developed art of portraiture. We also have a *Fig. 188 (4)* portrait of Pharnabazos, satrap of Phrygia (413–373 B.C.), on a coin of Sardes dating to 395/394 B.C. and

LII Lidded krater, from Centuripe. Picture of a deceased woman. Height 56 cm. 3rd century B.C. Catania

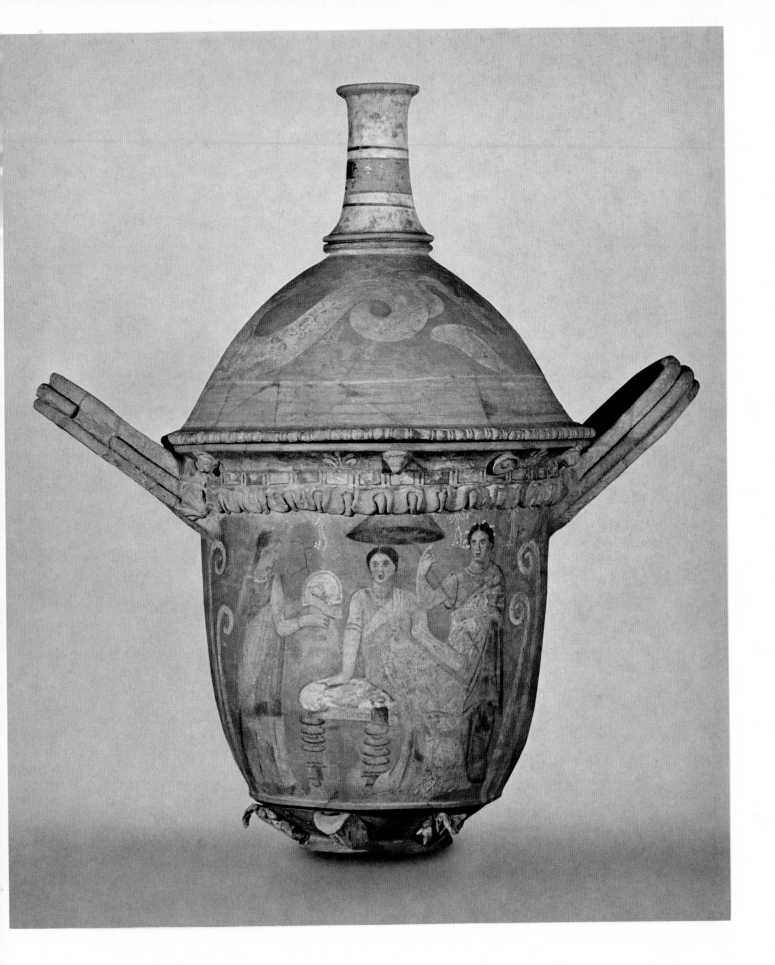

another minted at Cyzicus: there is also the head of the satrap Orontas (363–353 B.C.) on a gold stater of Lampsacus. In addition, there are pieces of exceptional interest from Lydia, in the form of silver staters of the dynasts Mithrapata (400–362 B.C.) and Päriklä of Antiphellos. The head of the Lycian dynast *Fig. 188 (2)* Mithrapata on the various different examples shows a high degree of individualization, while that of *Fig. 188 (3)* Päriklä is an excellent work giving us the portrait of the dynast in frontal view. We can see from this what a wide influence, reaching as far as Asia Minor, was exercised by the first facing heads produced in Sicily by the school of Kimon, Eukleidas and Herakleidas.

But we are here concerned primarily with the portraits of rulers in the Hellenistic period and among *320 (1)* them of course the head of Alexander must take pride of place. This portrait did not originate in his lifetime but appears on the tetradrachms, drachms and gold staters of Lysimachos of Thrace. Lysimachos was bodyguard and trusted friend of Alexander, who after the king's death assumed responsibility for the politically important province of Thrace. In 305 B.C. he took the title of king and in 301 fought beside Seleukos I at the battle of Ipsos, sharing in the victory over Antigonos Monophthalmos and his son Demetrios Poliorketes. This led to Lysimachos adding to his domains the western part of Asia Minor, as far as the Cilician Tauros—only to lose his kingdom and his life on the battlefield of Korupedion in combat against his former ally Seleukos. It was about 297 B.C. that the coinage bearing the head of Alexander the Great began: on it he is represented not yet as the great king, but manifestly as the son of Zeus-Ammon, just as he had been proclaimed by the oracle at Siwa, with the great ram's horn of the god sprouting from his head. In spite of the vast quantities in which the coins of Lysimachos were minted, a surprisingly high artistic level was maintained throughout. When it comes to the portrait, the best of the tetradrachms are distinguished for the way in which they convey both the features and the exuberant vitality of the great warlord whose gigantic exertions won him an empire of unprecedented extent. More rarely do we see the emphasis placed on his nobility of mind and spirit, as on the coin we illustrate: here we can discern his *320 (1)* profound genius and his inherent sensitivity. Clearly this was a man whose mental horizons ranged far beyond those of any of his precursors, a man of such personality that he not only conquered the East but overshadowed even the unconquered West. Rarely has any portrait been endowed with such expressive force.

320 (3) It was in Pergamon that the very rare extant tetradrachms with the portrait of Seleukos I Nikator were minted. Former commander of Alexander's bodyguard, Seleukos received as his share at the division of the empire in 321 B.C. the satrapy of Babylon; but in 316 he fled before Antigonos, taking refuge with Ptolemy, satrap of Egypt. As a result of the latter's naval victory over Demetrios Poliorketes before Gaza in 312—a victory in which Seleukos himself took part—he was able to return to Babylon and to incorporate Media, Persia and Bactria into his dominions. From 305 he became king of the Seleukid realm but used an official era-dating from the year of his return to Babylon in 312. As we have seen, he was allied with Lysimachos of Thrace to win his victory at Ipsos in 301 over Antigonos Monophthalmos, who fell in the battle. This event placed the whole of central Asia Minor in Seleukos's hands, and finally also Lysimachos's empire comprising the whole of western Asia Minor, following the victory of Korupedion in 281 B.C. After this, Seleukos reached out even for Thrace and Macedonia, regarding himself as the rightful heir to the crown. But as he set foot on European soil he was murdered by Ptolemy Keraunos. Seleukos's success in reuniting the heritage of Alexander was phenomenal, for once again an empire of vast proportions had been brought into being. If ever a portrait combined the image of a great creative genius with that of statesman and invincible soldier, it is that of Seleukos. It is preserved on the few portrait coins that have come down to us; these were made at Pergamon, where Seleukos was supreme overlord until his death. Here again we find that loftiness of spirit, combined with the self-assured air of a natural leader of men, that informs the head of Alexander on the Lysimachos tetradrachms. In short, all the characteristics which pertain to the great Hellenistic rulers—genius, inexhaustible energy and irresistible force of personality— are mirrored in this portrait.

Very different is the head of his son and successor Antiochos I Soter (281–261 B.C.) on a coin posthumously *320 (4)* minted at Seleukia by Antiochos II Theos. It is the portrait of a man who indeed bore the burden of the vast empire bequeathed to him by his father, but whose strength was taxed to the limit in the process. His deeply

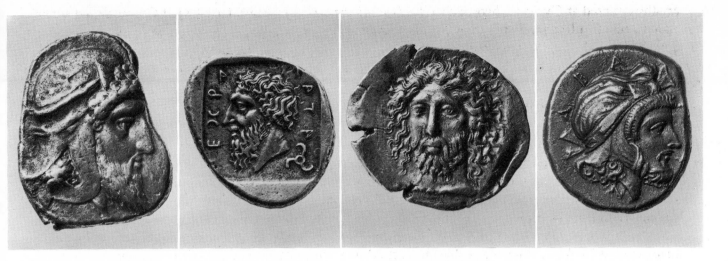

188　Portrait heads of Persian satraps and Lykian dynasts. 1 Tissaphernes (455/445–395 B.C.) ca. 412/411 B.C. 2 Mithrapata (400–362 B.C.) 3 Päriklä of Antiphellos (ca. 380–362 B.C.). 4 Pharnabazos (413–373 B.C.). All 2:1

furrowed brow and the remote look in the eyes are eloquent of the storms which gathered in his time and of the almost overwhelming anxieties which beset the king in his efforts to keep the empire intact.

We find yet another and different expression in the face of Ptolemy I. A contemporary of Alexander and *320 (5)* his bodyguard since 330 B.C., Ptolemy had won special glory on the Indian campaign as leader of an independent expedition against the warlike tribes of eastern Iran; he showed the highest valour, first on the way to the Oxus, then at the invasion of Sogdiana, and finally on the march from Bactria to India. In the very year of Alexander's death, Ptolemy was appointed satrap of Egypt by the assembly of the Macedonian army, whose decision was binding. From this moment, the dynasty of the Lagids, which Ptolemy represented, ruled over Egypt for nearly three hundred years until the death, by her own hand, of Cleopatra. Henceforth, in opposition to the concept of a unified realm advocated primarily by Antigonos Monophthalmos until his death, Ptolemy upheld the necessity for dividing up the empire of Alexander and contented himself with the satrapy of Egypt, devoting himself however to its development on broad statesmanlike lines both before and after his assumption of the royal title in 305 B.C. The genius of his policy lay in the amalgamation of Egypt into the Macedonian world. The well-nigh inexhaustible riches of the country were pressed into the service of the state by an exemplary financial and economic administration. The portraits on his coins—numerous tetradrachms and gold pentadrachms, many of very fine workmanship—represented him as a man of cool and shrewd intelligence. It is proof of the high skill of the portrait artists of his time that they could characterize Ptolemy as at once the great and brave soldier that he had been under Alexander and the prudent clear-sighted king and thoughtful statesman.

From Ptolemy's second marriage with Berenike I, was born his eldest child Arsinoe (II). She in turn was first the wife of Lysimachos of Thrace; then, after his death at Korupedion in 281, of her half-brother Ptolemy Keraunos, the son of Ptolemy by his first marriage with Eurydike. Keraunos had lost his rights of succession owing to his father's second marriage and accordingly had repaired to Macedonia and had himself acclaimed by the army as 'King of the Macedonians'. He proceeded to put to death two of the three sons that Arsinoe II had had by Lysimachos, whereupon she dissolved her marriage with Keraunos—who shortly afterwards assassinated Seleukos—and returned to Egypt. Next she instigated her brother Ptolemy II, eight years her junior, to the judicial murder of his first wife Arsinoe I, so that she could marry him herself, though she was his full sister—thereby giving offence to Greek and Macedonian, but not to Egyptian, morality. However hard it may be for us to understand the attitude of this woman as a human being, as a queen she is an important figure for the history of her country, especially in the domain of cultural achievements. For it was under her influence that Alexandria, the new capital of Egypt founded by Alexander the Great, came to be a great treasure-house of the arts and sciences and indeed one of the cultural centres of the ancient world. In the Museum, or Temple of the Muses, inaugurated by Arsinoe, were

assembled the leading figures of the age, and the Alexandrian library connected with the Museum was the greatest in the world of its day. On gold octodrachms, often of wonderful quality, is to be seen a portrait

320 (6) of Arsinoe that epitomizes her whole nature. A keen intelligence had ruthlessly but surely steered her through many a crisis in her personal life, and this comes across in the face of the ageing queen; but in the fine and discerning line of her mouth, we recognize too the profoundly creative side of her character in everything concerning the sciences and the fine arts.

It is more by virtue of its sheer beauty and the high quality of the engraving that we are drawn to the

320 (7) gold octodrachms with the youthful portrait of Berenike II, the spouse of Ptolemy III Euergetes (246–221 B.C.). It is possible that this piece was minted in the time of Ptolemy II, perhaps in the very year of the marriage of this young princess from Cyrene, whose country was her dowry. One of the constellations which shine in the night sky, the 'Coma Berenices', is named after her beautiful hair—the hair which she had sacrificed in the temple as an offering to the gods for the safe return of her spouse from his war against the Seleukids and which was then caught up heavenwards into the stars. But is it her beauty alone that we admire in this likeness of the young princess, or is it her fate that moves us? For her husband was the son of that Arsinoe (I) whose violent death was brought about by Arsinoe II, and what is more, the accession year of Ptolemy IV Philopator, 221 B.C., was disgraced by the murder of his mother, Berenike herself.

At this point we must turn from the coin types of the Early, to those of the High Hellenistic period. Belonging to the later period of the Macedonian kingdom are the tetradrachms of Philip V (222/221–179 B.C.) and his son Perseus (179–168 B.C.), the last king of Macedonia. The portrait of Philip V is the first to be placed on the coins by a Macedonian king—for even Demetrios Poliorketes, who was king of Macedonia between 294 and 287 B.C., did not venture to show his own head in its natural form on his tetradrachms but only in the guise of a deified son of Poseidon, adorned with the bull's horn. Philip's features seem touched by an awareness of the threat of impending ruin that hung over the Greek world as the Roman legions began to march in. The records show that, early on, he possessed a keen eye for political realities. That he understood the danger that threatened from Rome is shown by the alliance which he entered into in 215 B.C. with Carthage, Rome's arch-enemy; yet he lacked the concentrated energy that was called for in order to put his ideas into practice. An element of uncertainty in his nature is expressed

320 (8) all too clearly in his coin portrait dating from 221–211 B.C. This is even more true of Perseus. As a young king he was lively and active, but he was obsessed by 'an unhealthily fatalistic premonition . . . that the Greeks of his day neither recognized nor cared to advance the historic mission of their racial kin, the Macedonian people' (Bengtson). Like his father, he had to struggle on the one hand against Rome, on the other against the indigenous Greeks—and himself indirectly against Eumenes II and further against the barbarians of the north-west. To the south of Pydna in 168 B.C. the Roman consul Aemilius Paullus struck the decisive blow against Macedonia and Perseus. Abandoning all royal insignia, the latter fled by way of Amphipolis to the Sanctuary of the Kabeiroi in Samothrace, there to be taken prisoner and forced to grace

320 (9) the triumphal march of Aemilius Paullus in 167. The features of his portrait on the tetradrachms, with their meticulous workmanship, mirror the dichotomy between knowledge and impotence in a character that lacked resilience and so, torn this way and that, finally had to succumb.

With Hieron II of Syracuse things were otherwise. He succeeded in finding a balance between the state he ruled and the warlike powers. Acclaimed as strategos by his army after the Sicilian expedition of Pyrrhos (278–276 B.C.) he was able to prosecute the war against the Mamertini and deal with Carthage; by quickly thrusting himself into the position of στρατηγὸς αὐτοκράτωρ and concluding a peace with Carthage, he achieved a glorious victory over the Mamertini. Meanwhile he entered into an alliance with Rome and introduced a period of prosperity for Syracuse and for the whole east coast of Sicily under her aegis. But soon after his death in 215 B.C. at the age of eighty-nine, the city and the territory it still controlled fell into the hands of Rome. The tranquillity surrounding his life owed much to his inherent spirit of resolve, but even more to his shrewd understanding of political realities. All this is reflected in the features of

320 (2) his portrait on the great silver 32-litra piece of the years 269–265 B.C. Here we see a handsome, kingly

528

head; and the storms that had ravaged the greatest rulers of his time have left him untouched, his face is depicted as that of a man undismayed.

If the portrait of Hieron II belongs to the early Hellenistic phase, then we may take as characteristic of its middle phase the Philetairos head on tetradrachms minted in the time of Eumenes II (197–160/159 B.C.), who caused the Great Altar of Pergamon to be built. Throughout the whole period of minting at Pergamon, from the time it was established as an independent state by Antiochos I in 262 B.C. until the end of the Attalids in 133, the coins were dominated by the portrait of Philetairos, founder of the dynasty. To his care Lysimachos had entrusted the treasure of 9000 talents (54 million drachmai) deposited in the impregnable hill fortress of Pergamon. In 284 Philetairos, feeling himself threatened by Lysimachos, manœuvred the fortress and its treasure into the hands of Seleukos I: he, in turn, was content to leave control of Pergamon in the hands of Philetairos on the understanding that his own suzerainty was recognized. Philetairos did not strike any coins bearing his own portrait; they appeared first in the time of his nephew Eumenes I, who succeeded him as king of Pergamon in 263 B.C.

Henceforth all coins were to display the head of the founder, invariably brimming with vitality and often in Eumenes I's time with a downright brutal appearance. Gradually the features became transmuted and the best pieces of the time of Eumenes II attain a high artistic quality and subtlety. Is the portrait still that of Philetairos himself, or can we detect some hint of the features of Eumenes II? This sophisticated ruler had been the ally of Rome in inflicting an annihilating defeat on Antiochos III and further saw to it that in the new division of Asia Minor his Pergamene kingdom was allotted the lion's share. Not content with his

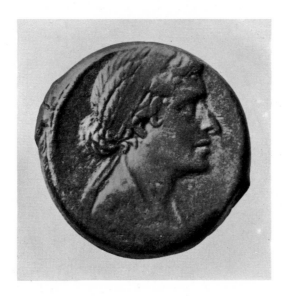

189 Cleopatra VII (51–30 B.C.)
Eighty-litra piece. Bronze. 2:1

political successes, he was impelled by his ambition and by a kind of genius to make of Pergamon a new Athens, a new centre of Hellenistic culture and art. Symbol of a powerful Hellenistic ruler and of a man of the greatest intellect embracing the whole range of the sciences and arts of his time—such is the impression made on us by the tetradrachm of 197–190 B.C. with its massive head set in the frame of the circular coin, *320 (10)* in which force of character and fine qualities of mind are blended in a remarkable way.

With the coinages of Mithradates VI Eupator Dionysos of Pontos we enter the Late Hellenistic period. The political career of this king began when he was not yet twenty years old, with the murder of his father; and his subsequent path was marked by cunning, betrayal, ruthlessness and slaughter. Yet his fiendish nature concealed a remarkably able king and general. He was the last of the great figures in the line of rulers subsequent to Alexander the Great. His policy of expansion knew no bounds, nor did his intense hatred of Rome; and none of Rome's other foes was ever so relentlessly 'formidable and terrifying' as Cicero put it. The appearance of Mithradates on his gold staters and silver tetradrachms accords with historical tradition,

320 (11) perhaps nowhere more dramatically than on the remarkable tetradrachm we illustrate, dating to 75 B.C., when he was in his fifty-seventh year. The Greek artist who engraved the king's barbaric countenance has certainly idealized it somewhat, yet it seems to be bursting with all the pent-up passion and implacable fanaticism that could without scruple make light of the destruction of men by their hundreds of thousands. The king met his death by his own sword at the age of sixty-nine, abandoning his son and his army at the moment when he was planning a fourth campaign to attack Rome from the north across Russia, Pannonia and the Alps.

Fig. 189 The end of the Hellenistic age is marked by the death of the great Cleopatra, the last truly royal figure to occupy the throne of the Ptolemies. With her, at first by the side of Caesar and then, after the Ides of March, by the side of Mark Antony, there appears for the last time in Hellenistic history that dream of the universal empire embracing both East and West and uniting the ancient world into one. An enchanting woman with extraordinary intellectual powers, and one of the most dynamic queens in the world's history, she cherished all through the most critical years with Antony her vision of final victory. With her death by her own hand after the battle of Actium, the epoch of Hellenistic Greece and its cultural achievements comes to an end.

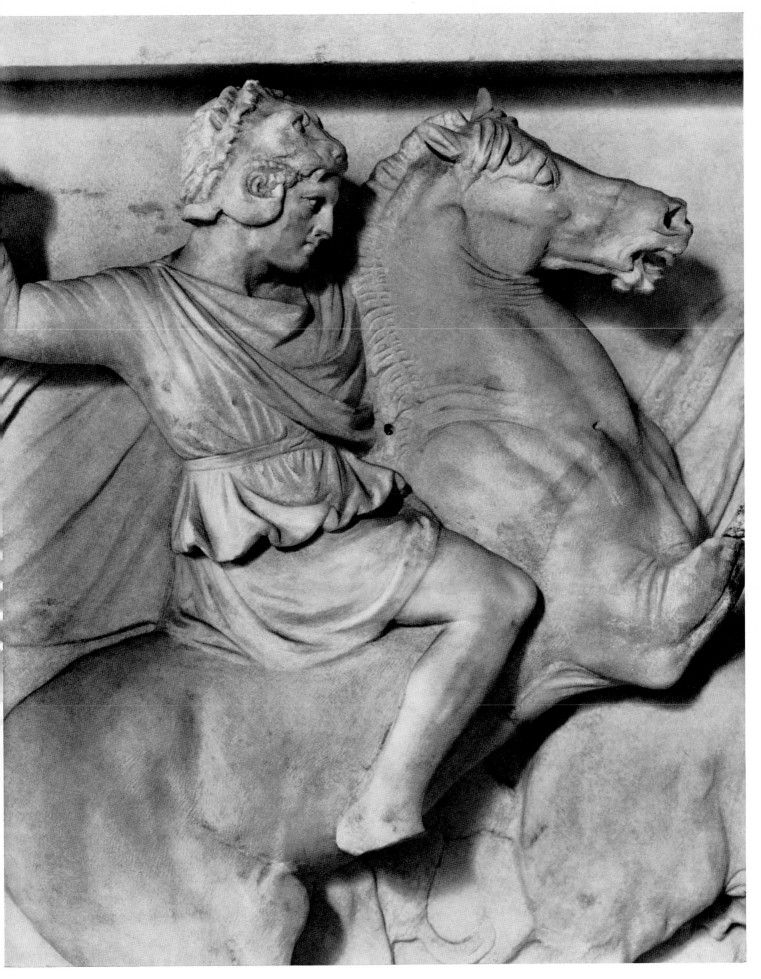

271 The 'Alexander Sarcophagus', from Sidon. Cf. plate XLVI. Alexander the Great, from the Battle between Greeks and Persians.
Pentelic marble. Height 70 cm. Ca. 310 B.C. Istanbul, Archaeological Museum 68

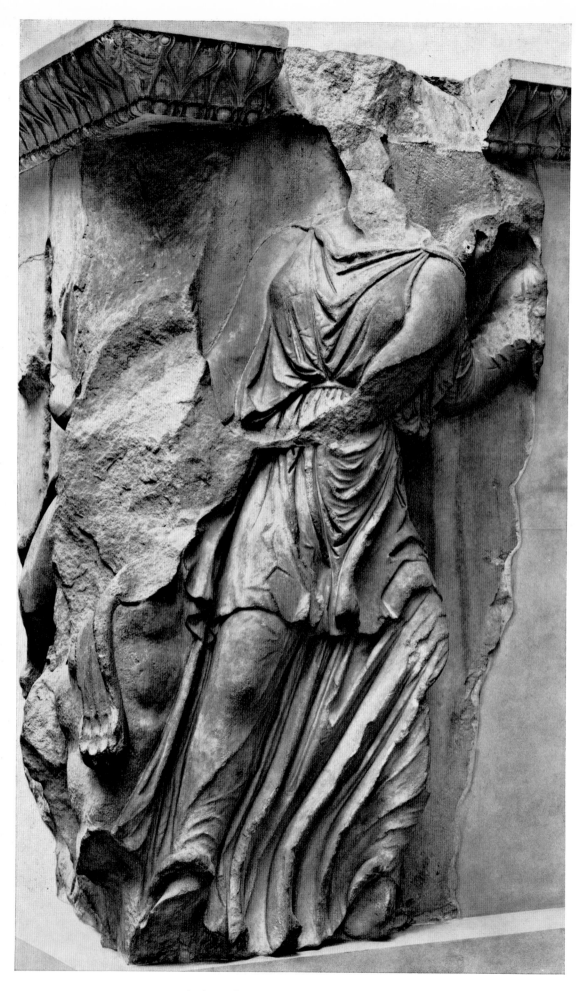

272 From the base of an anta of the later Artemision in Ephesos.
Unspecified scene of a kneeling man and struggling woman.
Marble. Height about 1.85 m. Ca. 330/320 B.C. London, British Museum 1200

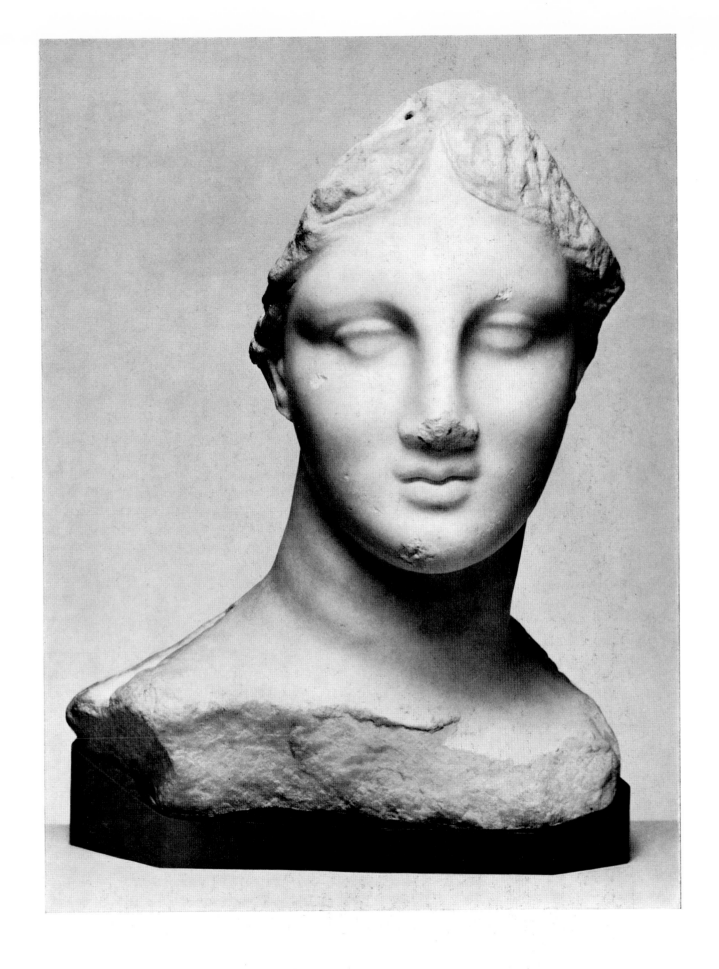

273 Head of a girl, from Chios. Parian marble. Height 36 cm. End of 4th century B.C. Boston, Museum of Fine Arts 29

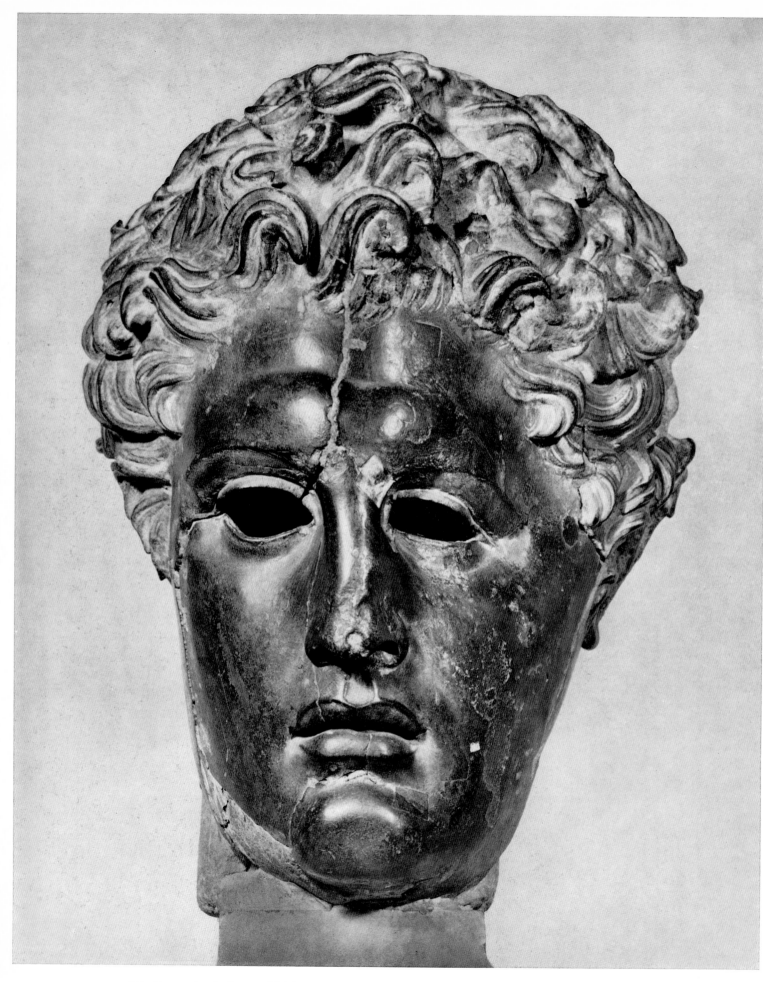

274 Bronze head of a youthful hero. Height 45 cm. Beginning of 3rd century B.C. Madrid, Prado 99

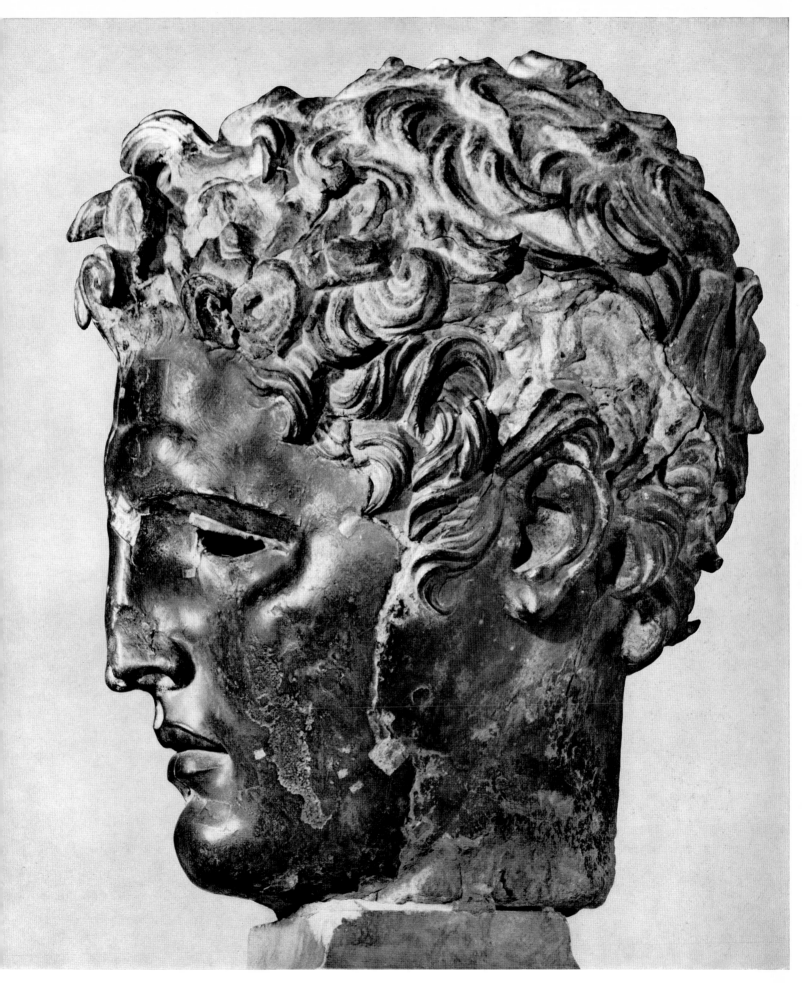

275 Bronze head of a youthful hero. Cf. plate 274

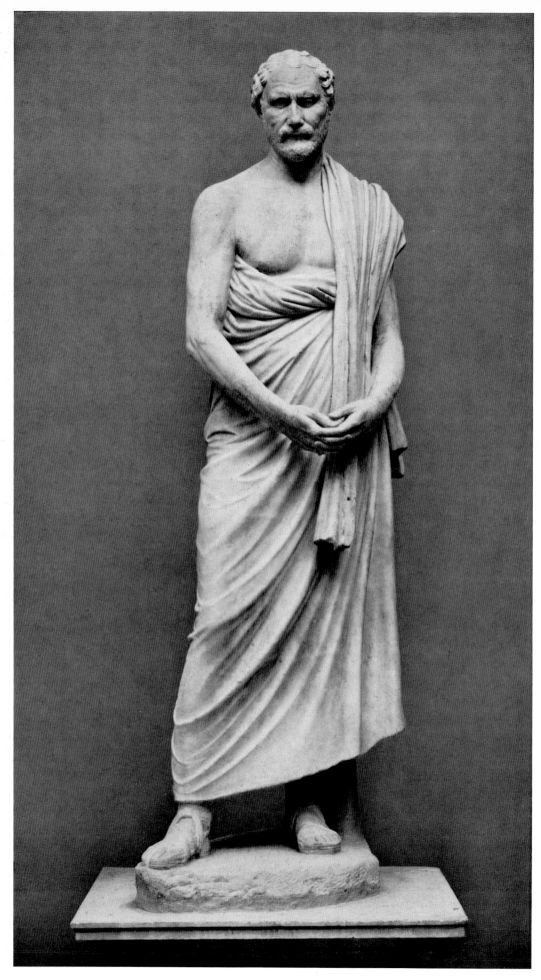

276 Demosthenes. Roman marble copy of a bronze original by Polyeuktos of 280 B.C.
Height (without plinth) 1.92 m. Copenhagen, Ny Carlsberg Glyptotek 436a

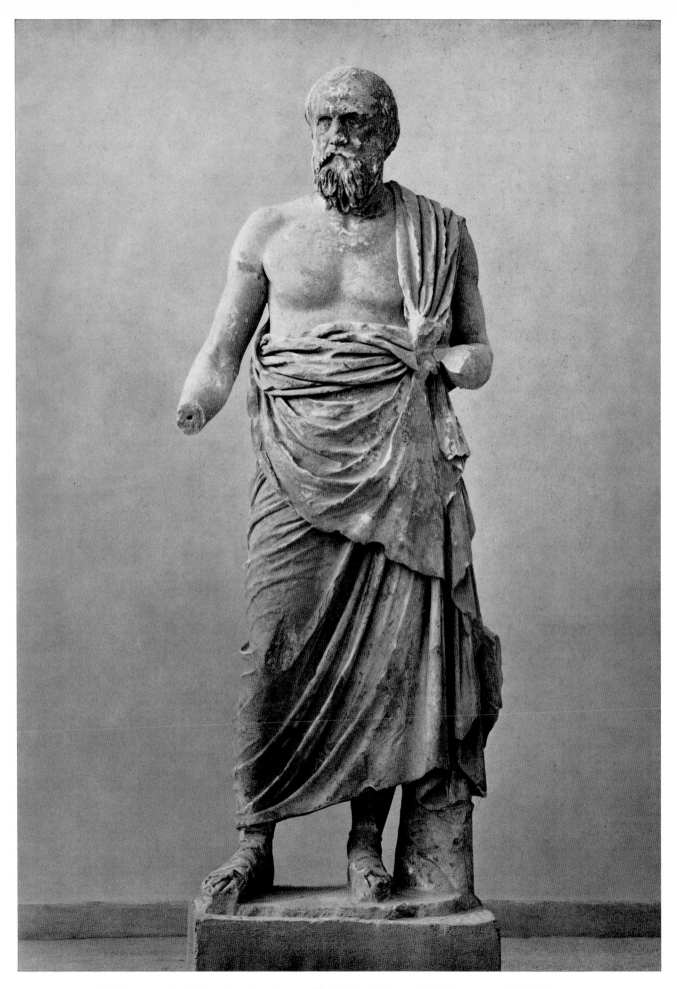

277 Statue of a philosopher. Pentelic marble. Height 2.07 m. Mid 3rd century. Delphi Museum

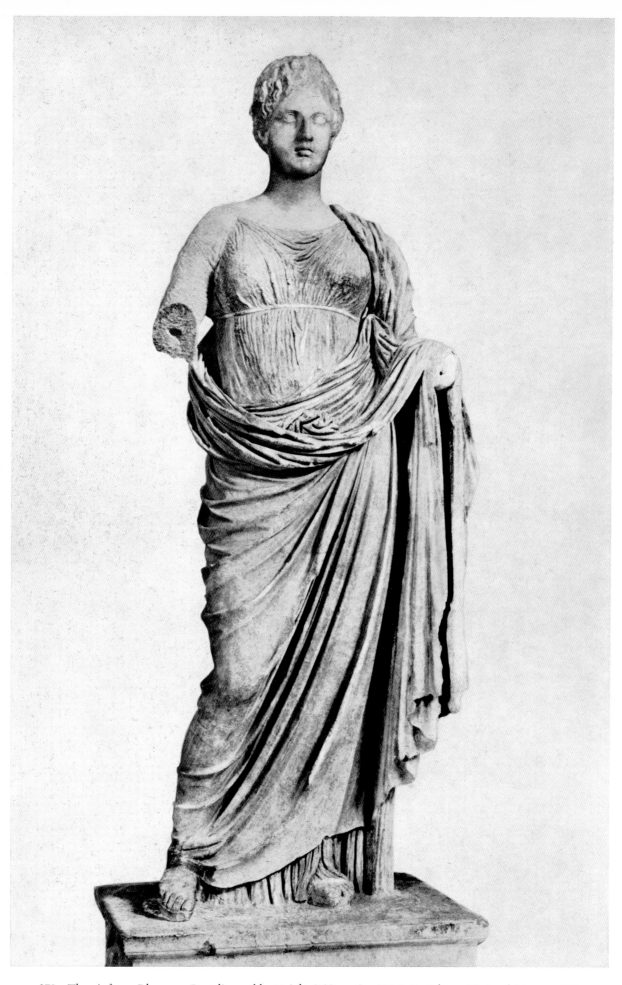

278 Themis from Rhamnus. Pentelic marble. Height 2.22 m. Ca. 280 B.C. Athens, National Museum 231

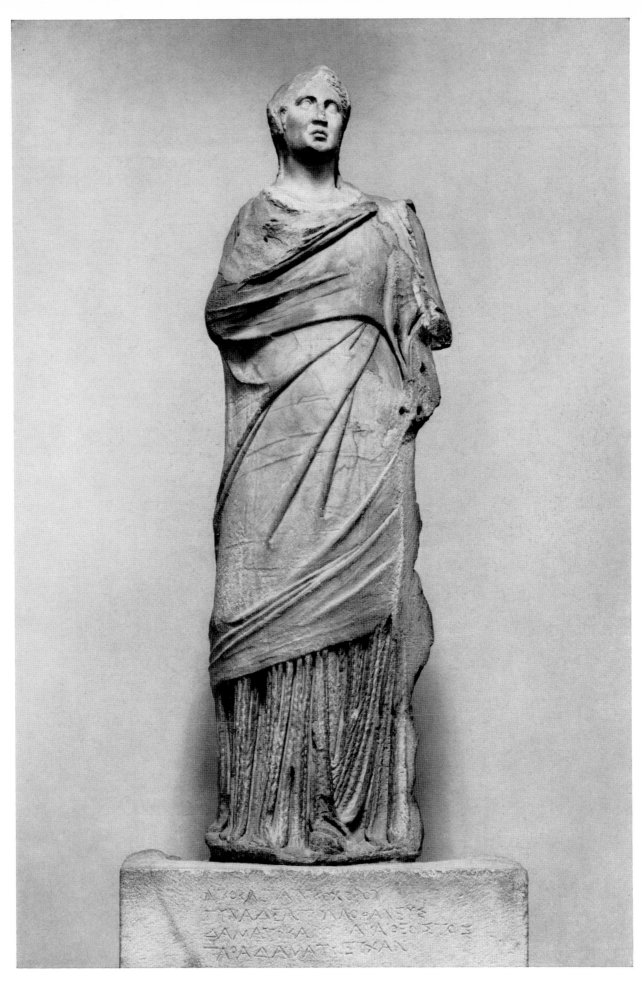

279 Statue of Nikokleia, priestess of Demeter, from Knidos. Marble. Height (without base) 1.57 m.
Third quarter of 3rd century B.C. London, British Museum 1301

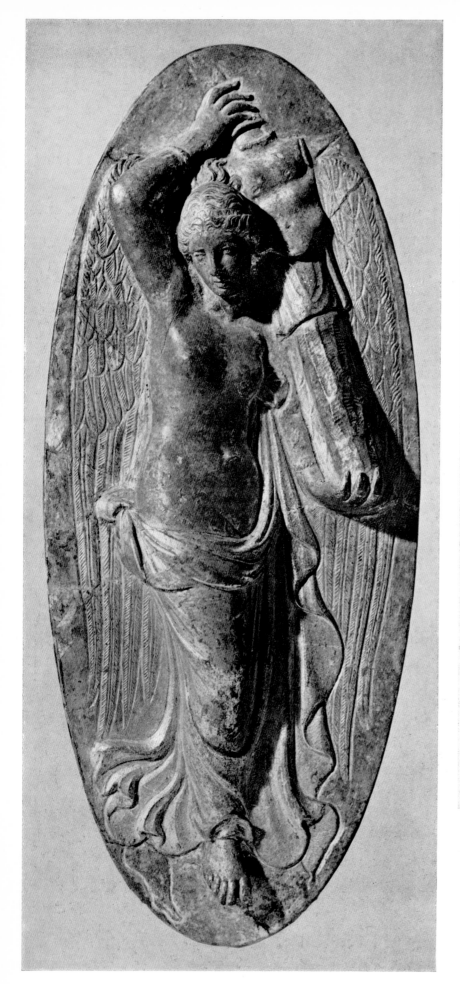

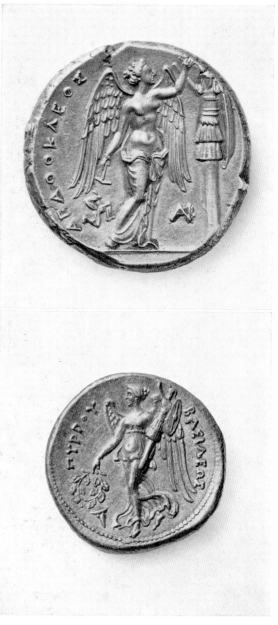

280 Left: Dancing Nike with tropaion, from Tarentum. Silver relief. Height 19 cm. Mid 2nd century B.C. Switzerland, Private Collection.
Right, above: Tetradrachm from Syracuse (310/304 B.C.). Nike adorning the trophy. Private Collection.
Right, below: Gold stater of Pyrrhos of Epeiros (278/276 B.C.). Nike with trophy

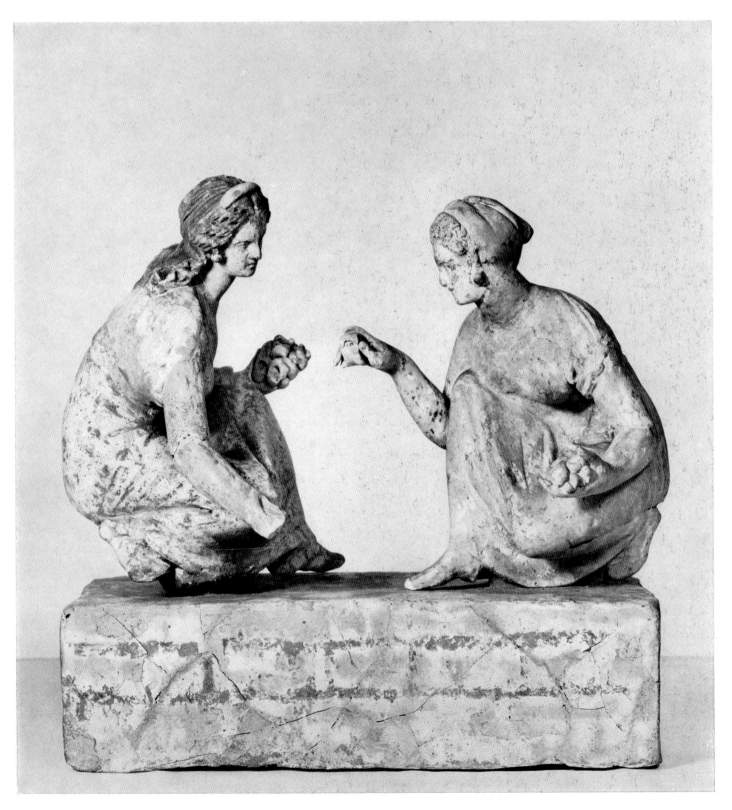

281 Terracotta group with girls playing knuckle-bones, from Capua. Height (with base) 14 cm.
Ca. 300 B.C. London, British Museum D 161

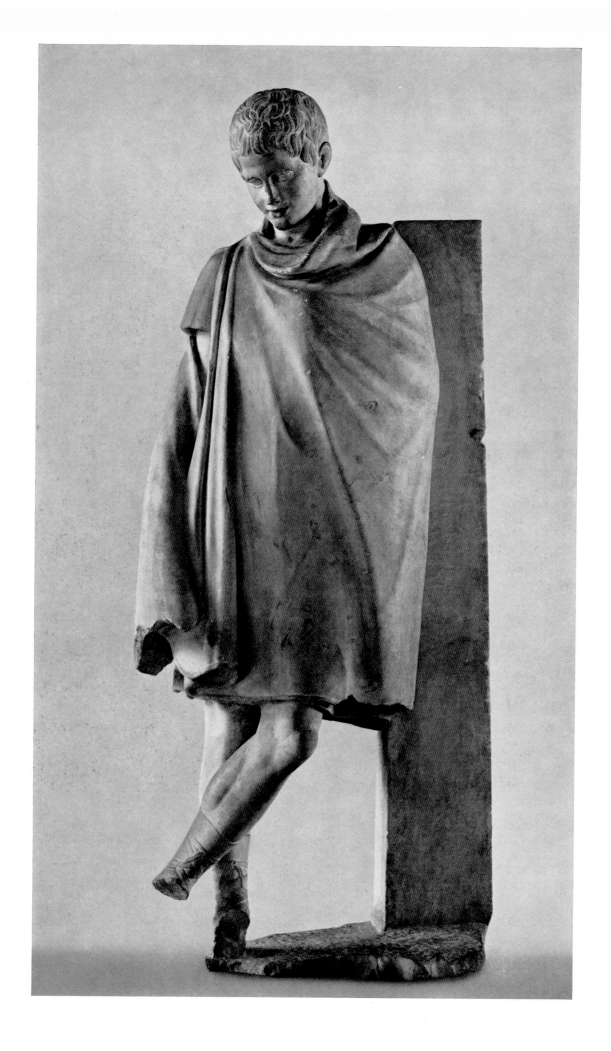

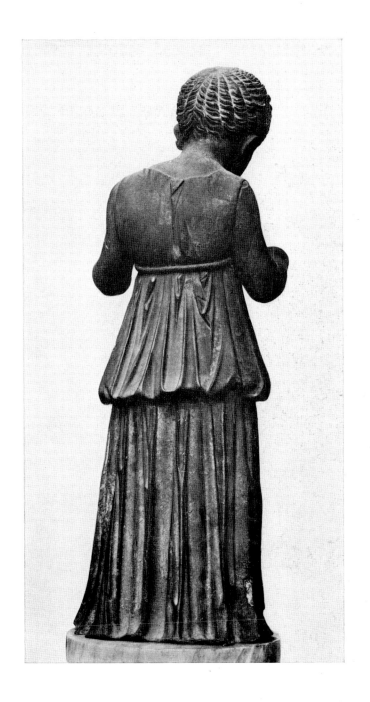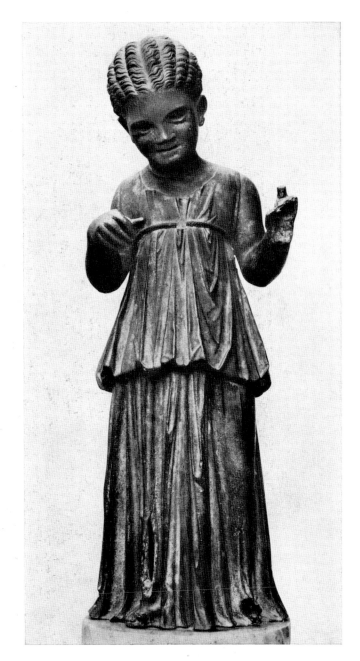

282 Boy in a cloak, from Tralles in Caria. Parian marble. Height (with plinth) 1.47 m.
After a work of the 2nd quarter of the 3rd century B.C. Istanbul, Archaeological Museum 542 (1191)

283 Statue of a young girl. Bronze. Height 76 cm. Ca. 230 B.C. Rome, Palazzo Grazioli

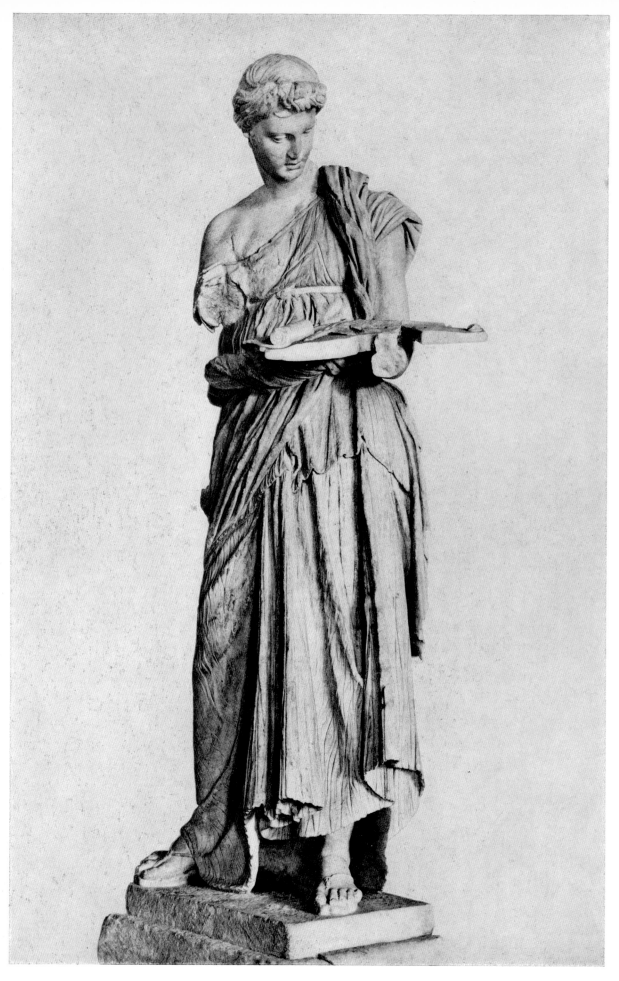

284 Young girl, from Antium. Parian marble. Height 1.70 m. Ca. 240 B.C. Rome, Museo delle Terme 596

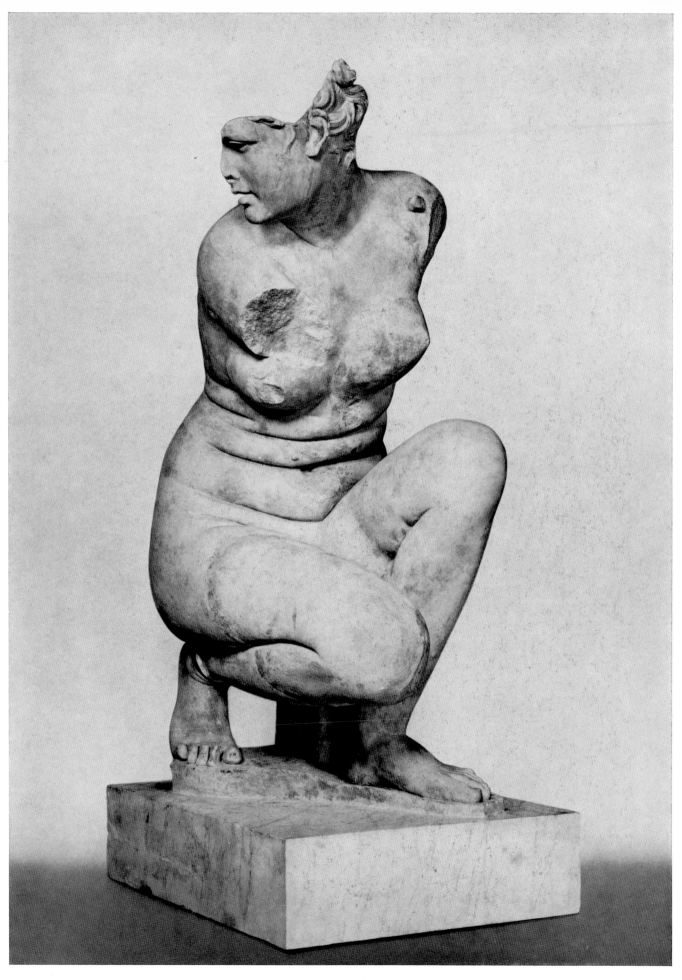

285 Crouching Aphrodite. Hadrianic marble copy of a mid 3rd century B.C. bronze original by Doidalsas of Bithynia.
From Hadrian's Villa. Height 1.02 m. Rome, Museo delle Terme 557

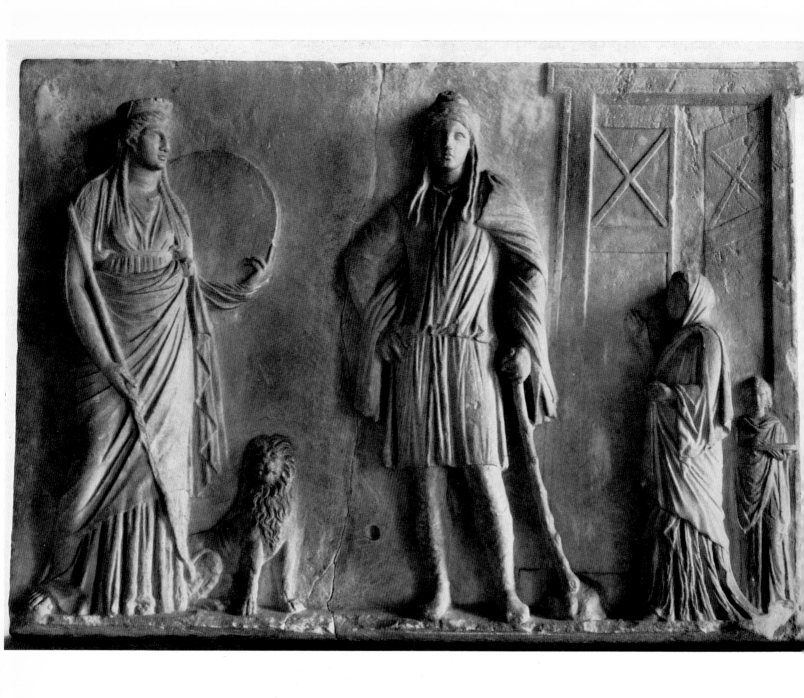

286 Votive relief for Kybele and Attis. Grey marble. Height 57 cm. Ca. 230 B.C. Venice, Museo Archeologico 17

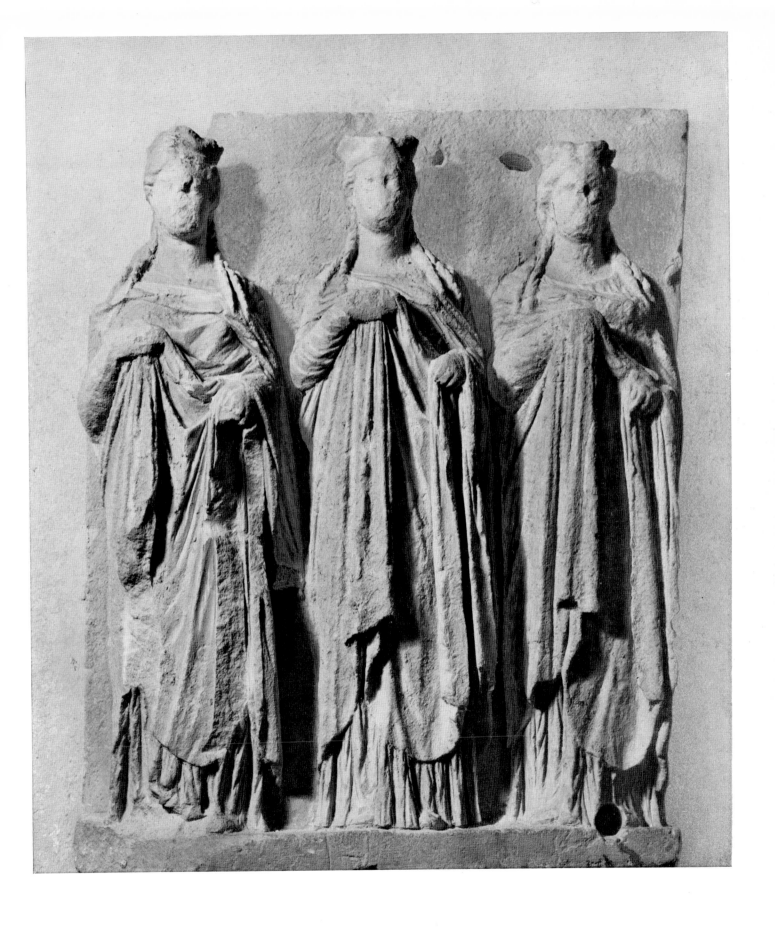

287 Votive relief, from Camaro near Messina. Limestone. Height 52.3 cm.
Ca. 230 B.C. Syracuse, Museo Nazionale Archeologico 30576

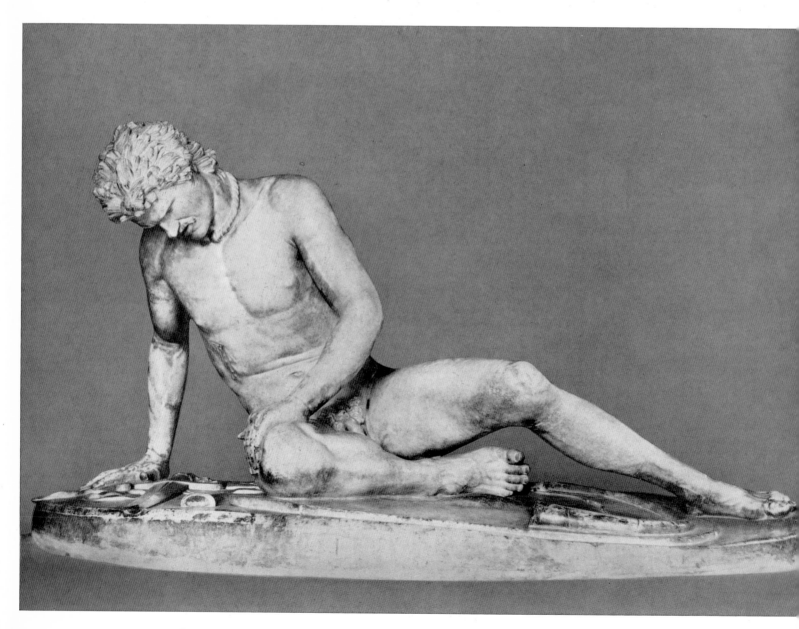

288 Dying Gaul. Marble copy. Height (with plinth) 93 cm. After a bronze original of 220 B.C. Rome, Capitoline Museum

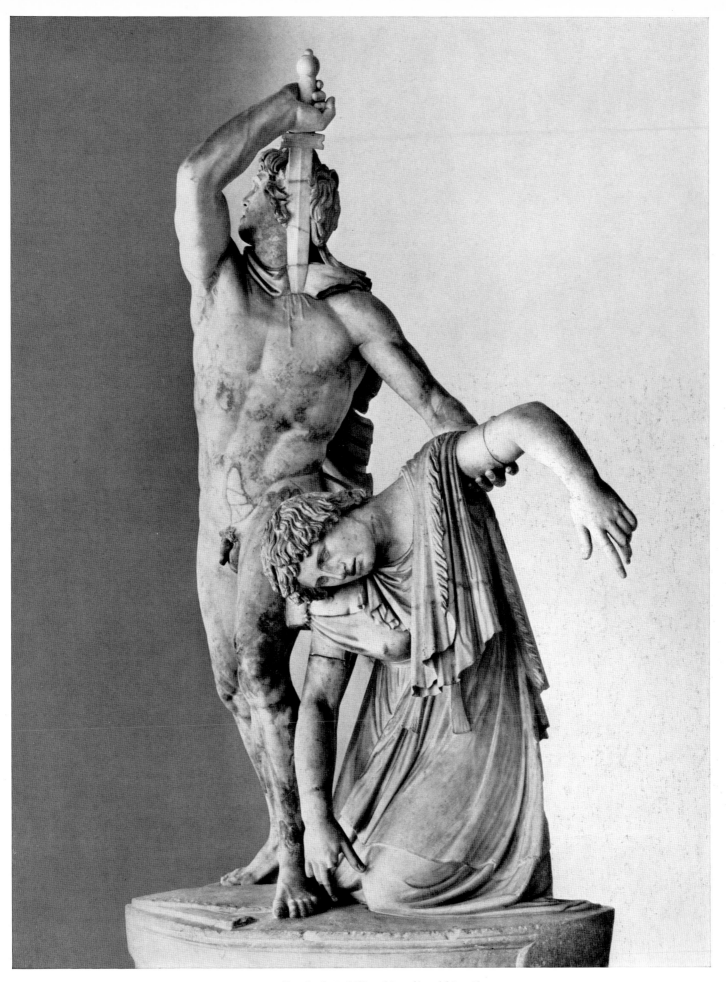

289 Gallic chieftain killing himself and his wife.
Marble. Height 2.11 m. From a bronze original of 230–220 B.C. Rome, Museo delle Terme 144

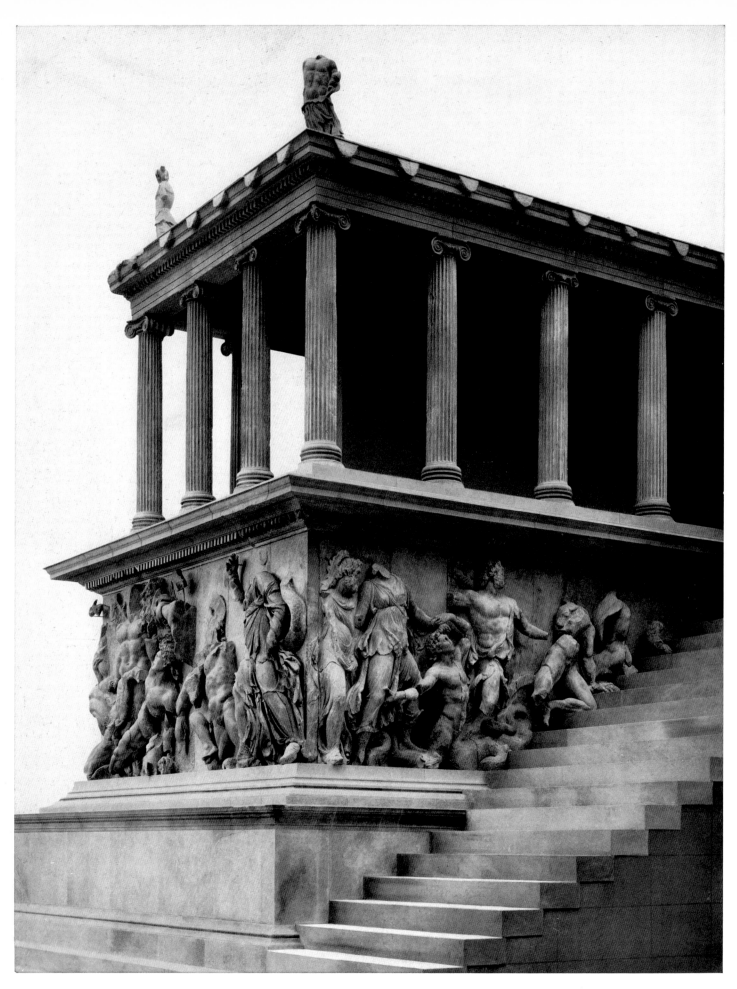

290 Northern projection of the Pergamon Altar. On the front: Triton and Amphitrite;
on the stair side towards the left: Nereus and Doris with an adversary.
Marble. Height of whole frieze 2.30 m. Ca. 180/160 B.C. Berlin, Pergamon Museum

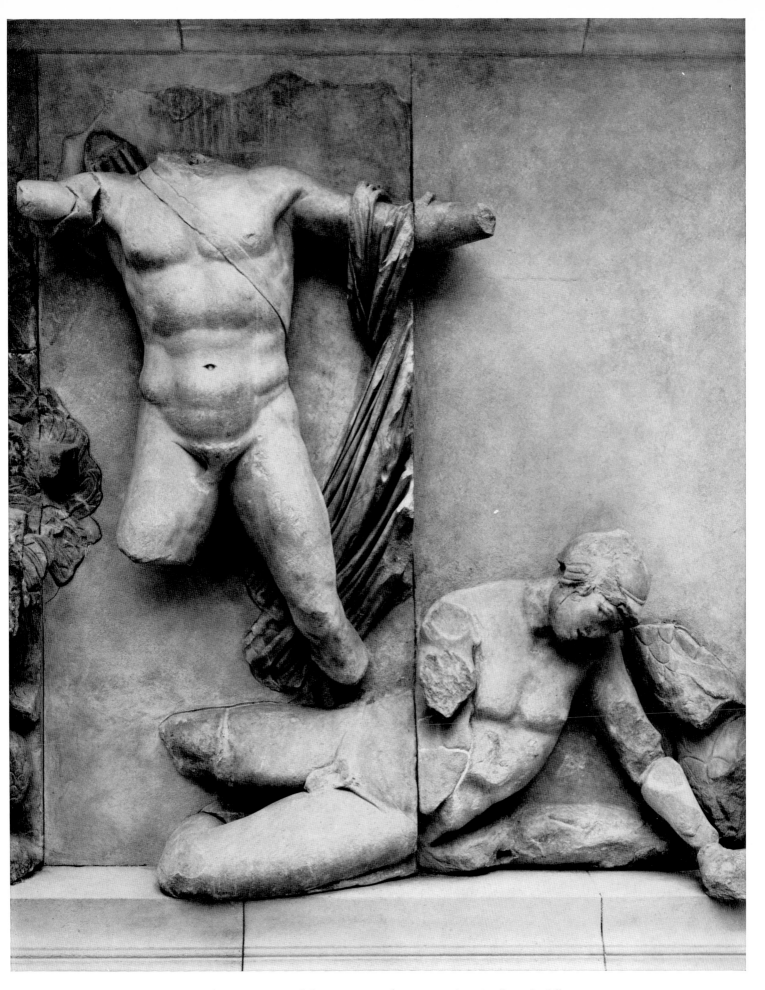

291 From the Great Frieze of the Pergamon Altar, east section. Apollo and a fallen enemy

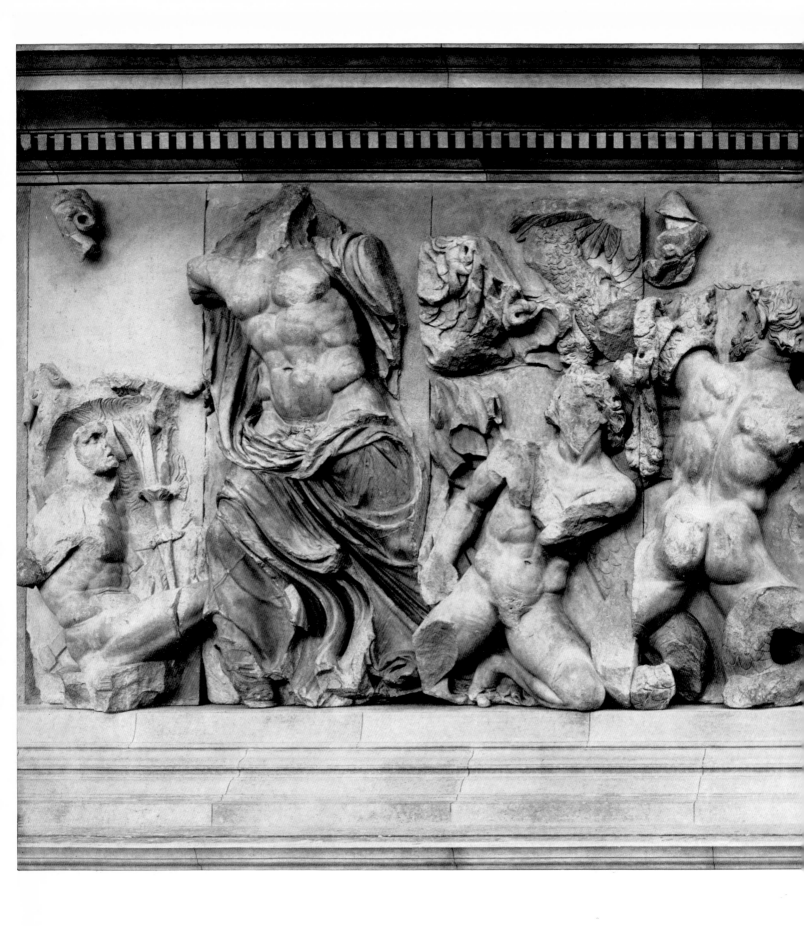

292 From the Great Frieze of the Pergamon Altar, east section. Zeus battling with three giants; on the right, Porphyrion

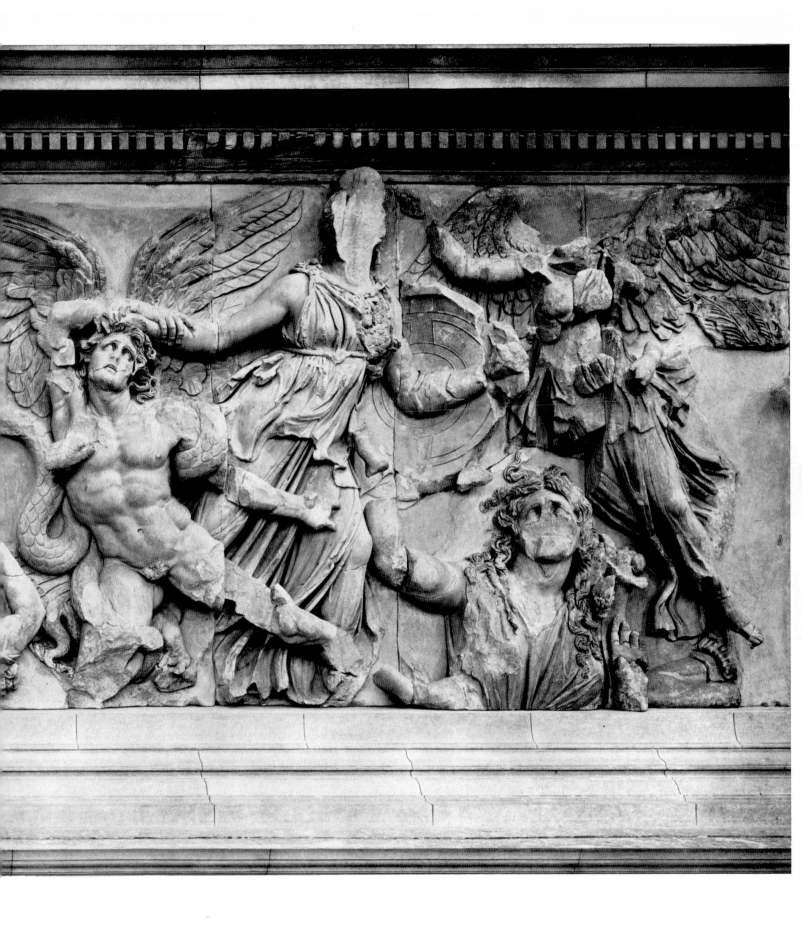

293 From the Great Frieze of the Pergamon Altar, east section. Athena battling with Alkyoneus; bottom right, Gaia

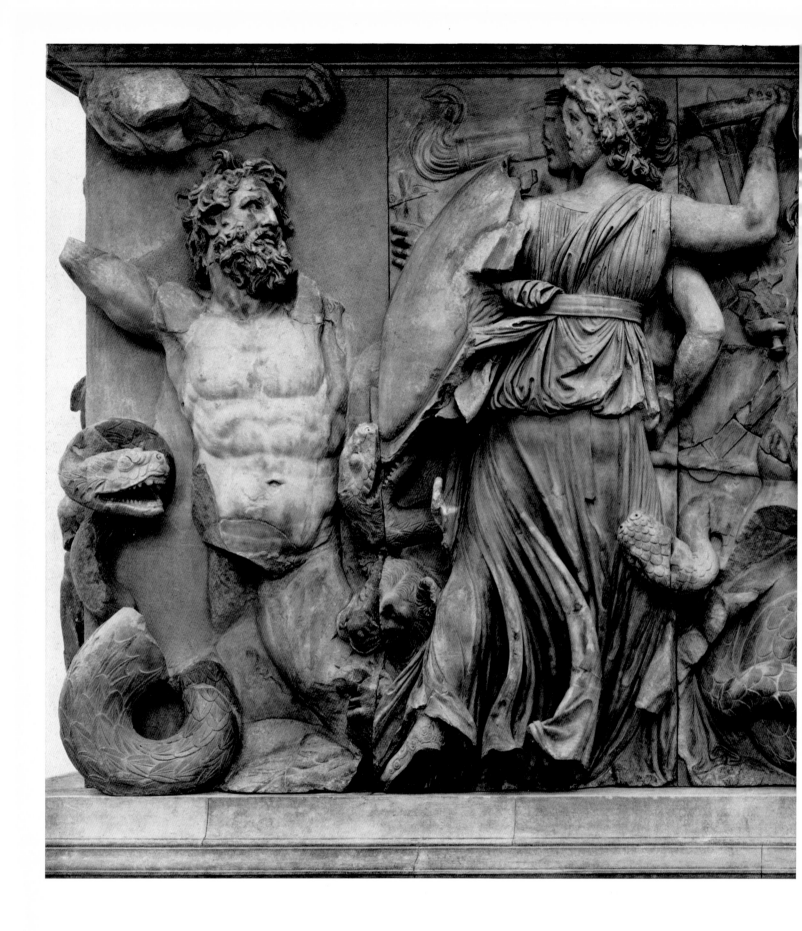

294 From the Great Frieze of the Pergamon Altar, east section. Hekate and her antagonist

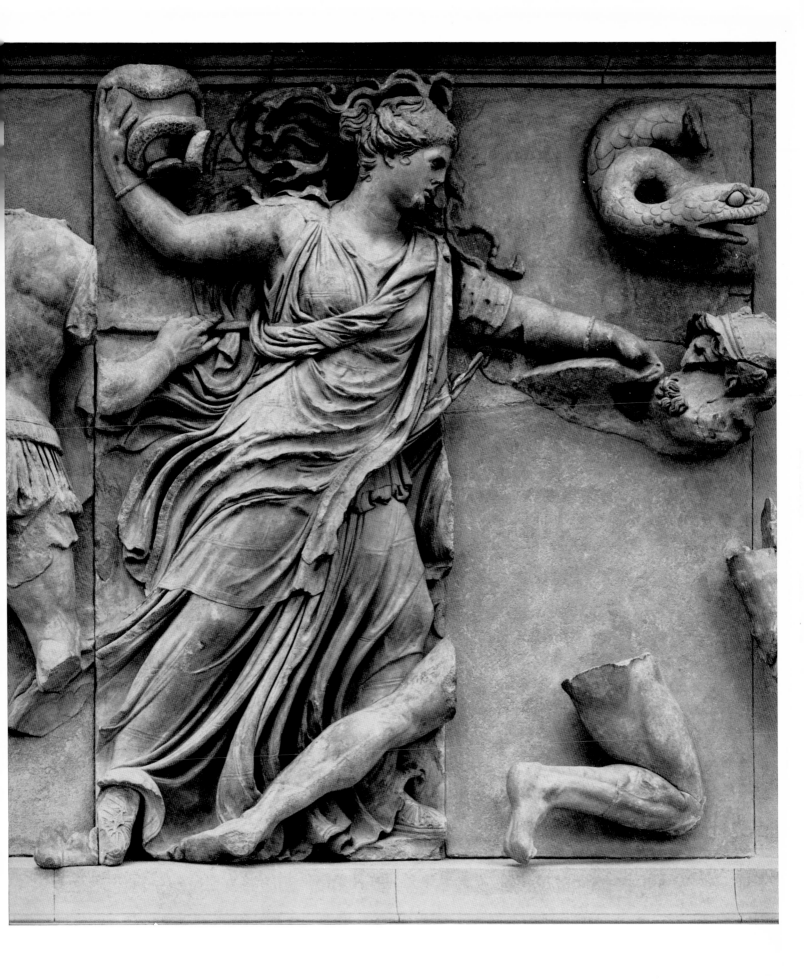

295 From the Great Frieze of the Pergamon Altar, north section. Nyx

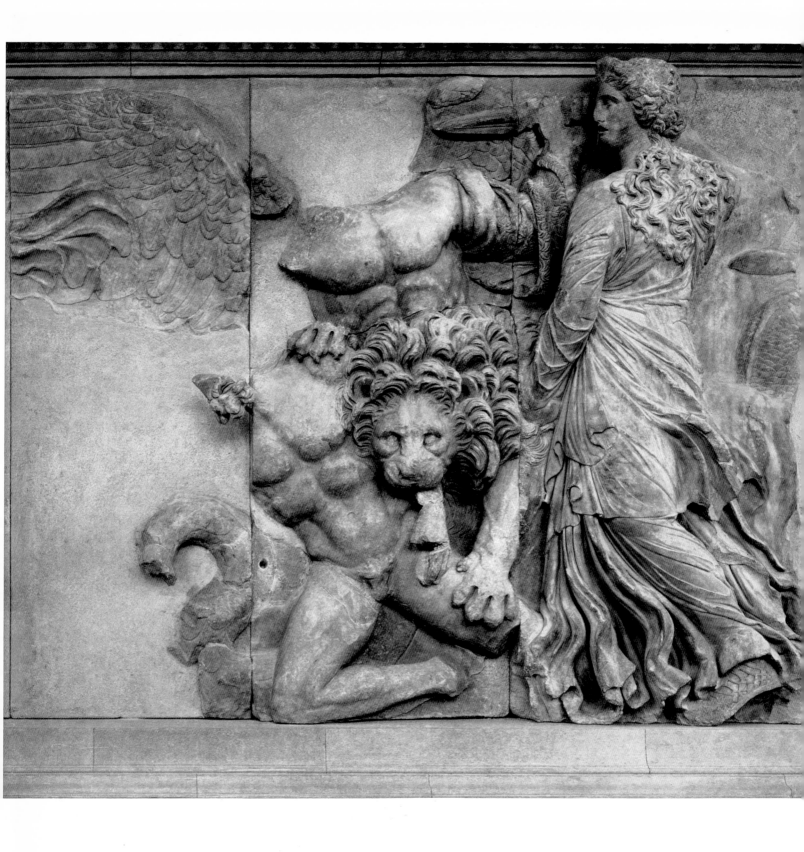

296　From the Great Frieze of the Pergamon Altar, north section. The Lion-Goddess

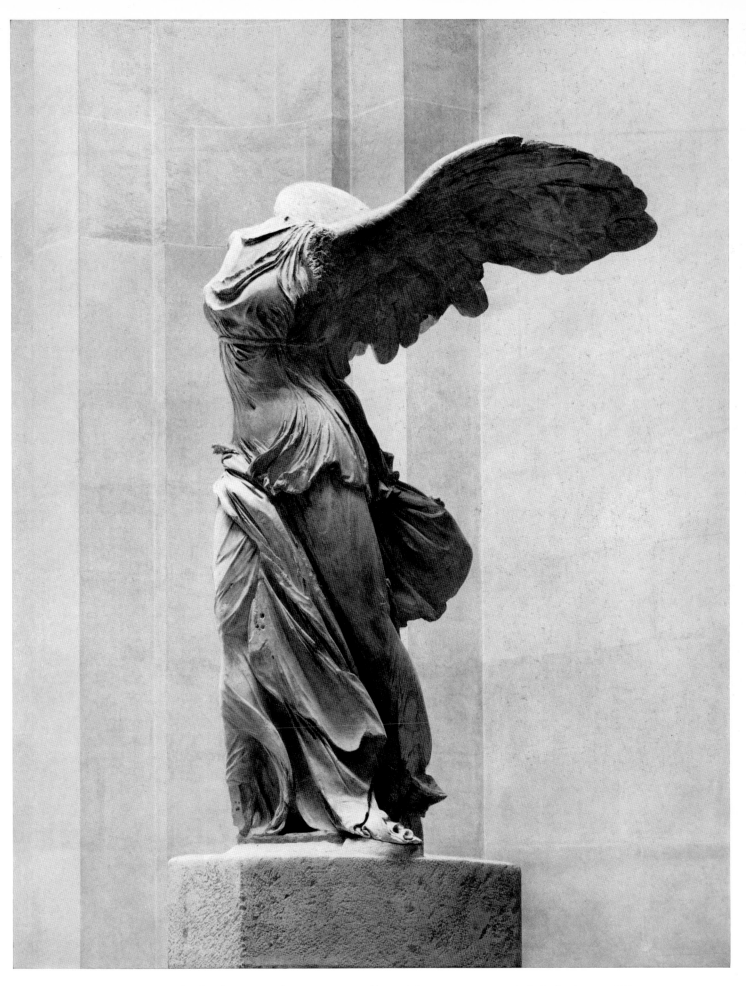

297 Winged Nike, from Samothrace. Parian marble. Height 2.45 m. Ca. 190 B.C. Paris, Louvre 2369

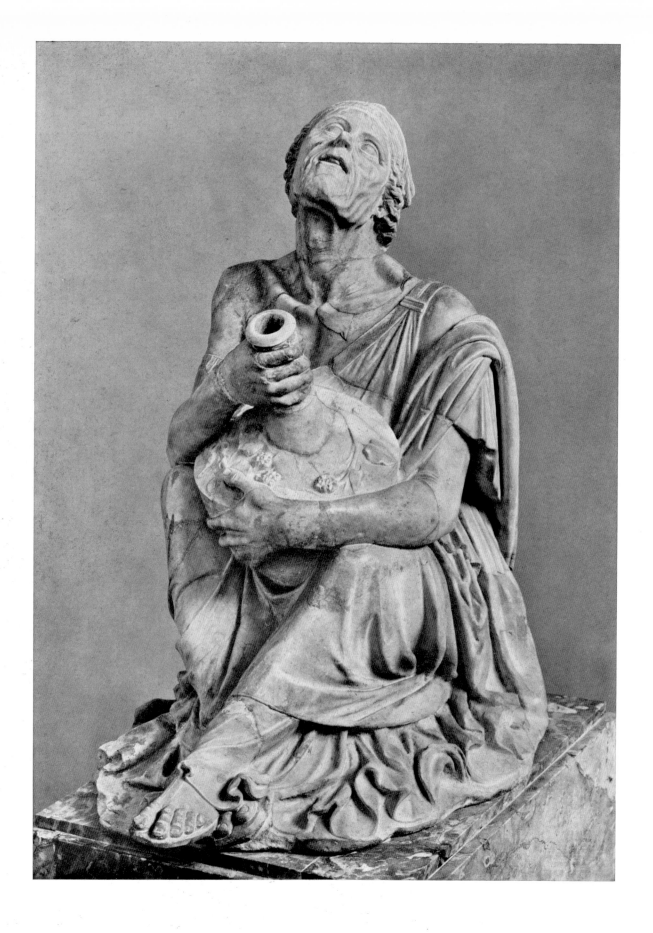

298 Drunken old woman. Parian marble. Height 92 cm.
Roman copy after Myron of Thebes from the last third of the 3rd century B.C. Munich, Glyptothek 467

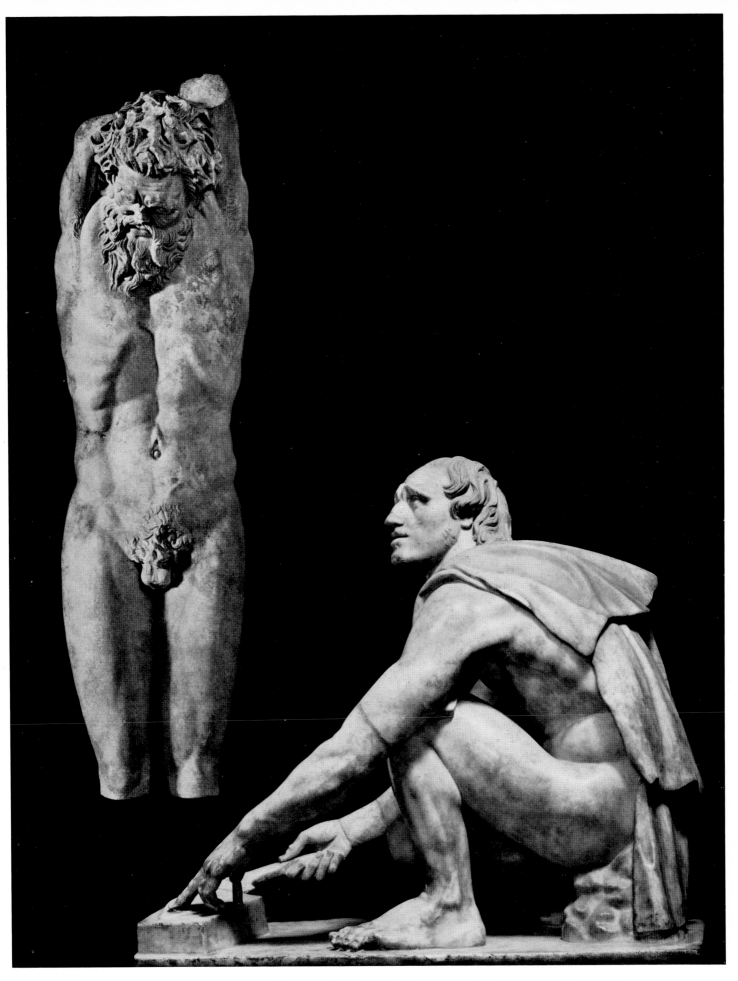

299 Marsyas and a crouching Scythian, grinding a knife. After a group of ca. 200 B.C., from Asia Minor.
Height of Marsyas 1.30 m. Scythian 1.06 m. Istanbul, Archaeological Museum 534 and Florence, Uffizi, respectively

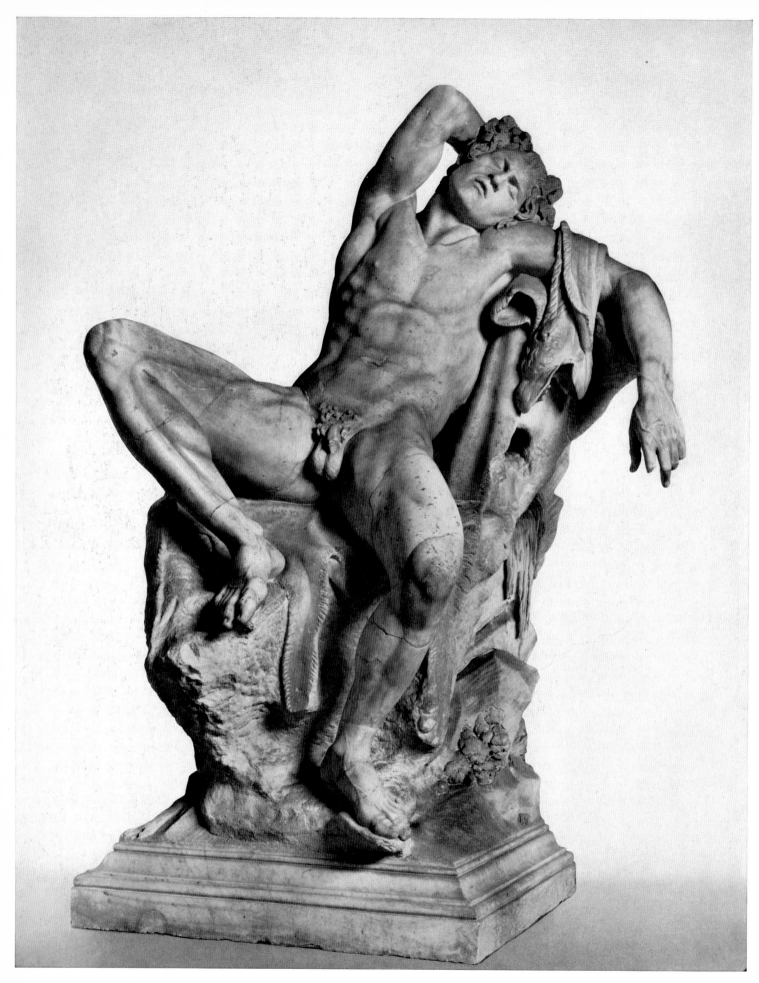

300 Sleeping satyr, the so-called 'Barberini Faun'. Parian marble. Height 2.15 m. Ca. 220 B.C. Munich, Glyptothek 218

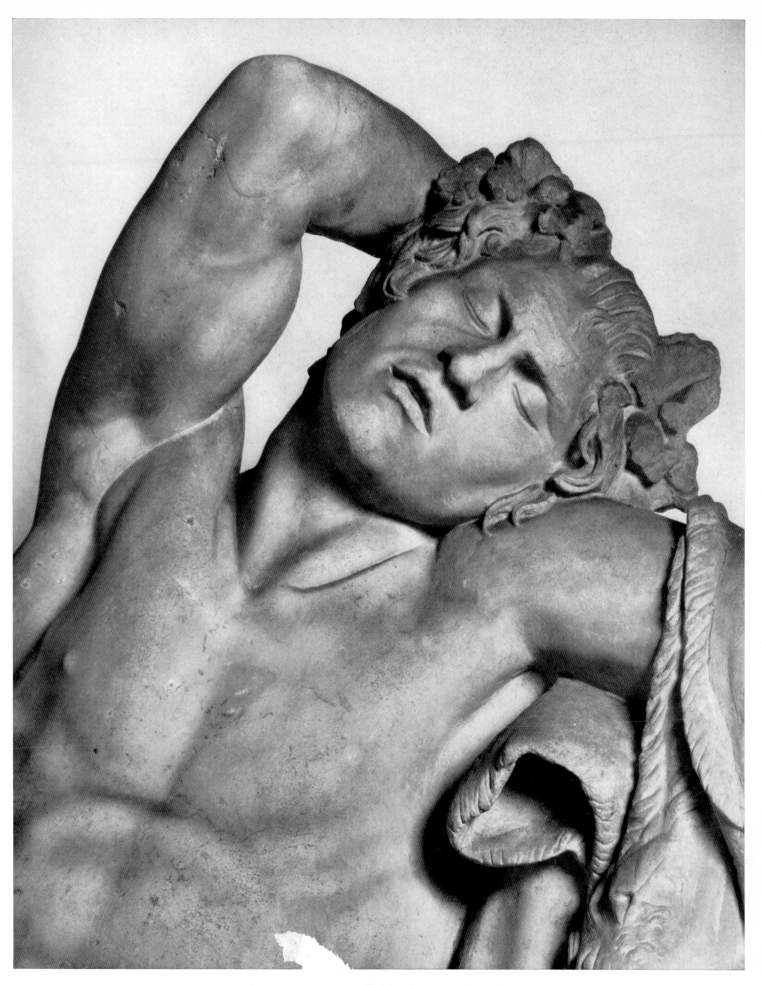

301 Sleeping saty lled 'Barberini Faun'. Cf. plate 300

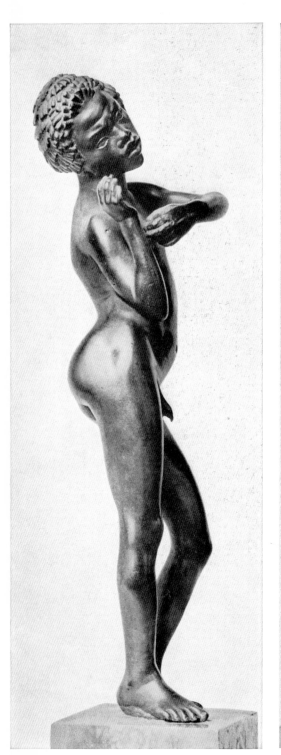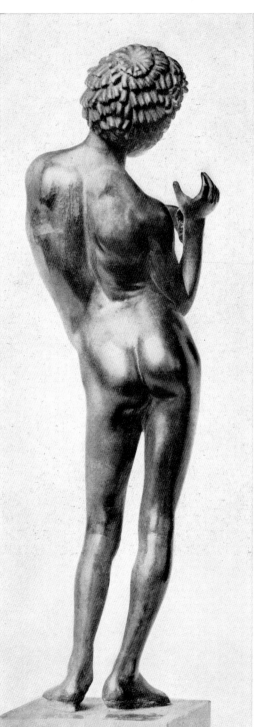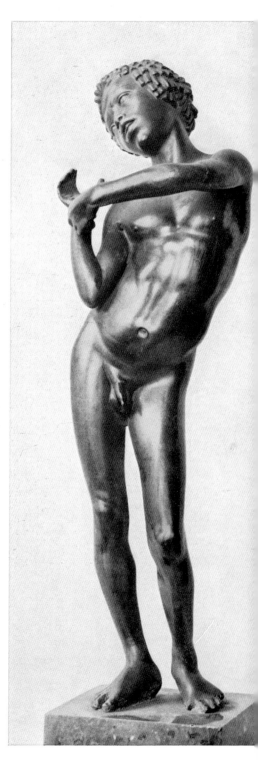

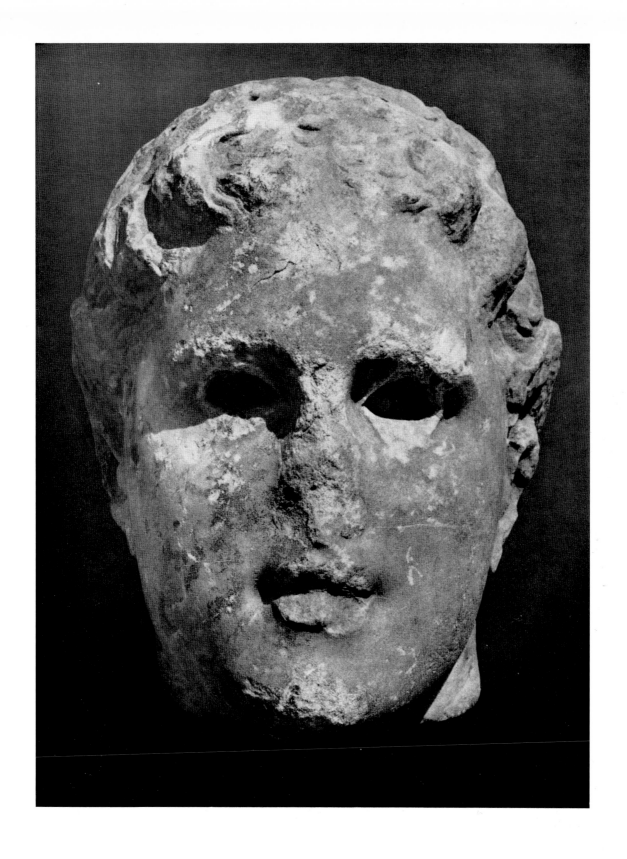

302 Young Negro porter. Bronze figurine. Height 20 cm. Mid 2nd century B.C. Paris, Bibliothèque Nationale 1009

303 Marble head. By Damophon of Messene. Height 33 cm. Mid 2nd century B.C. Mavromati (Messene)

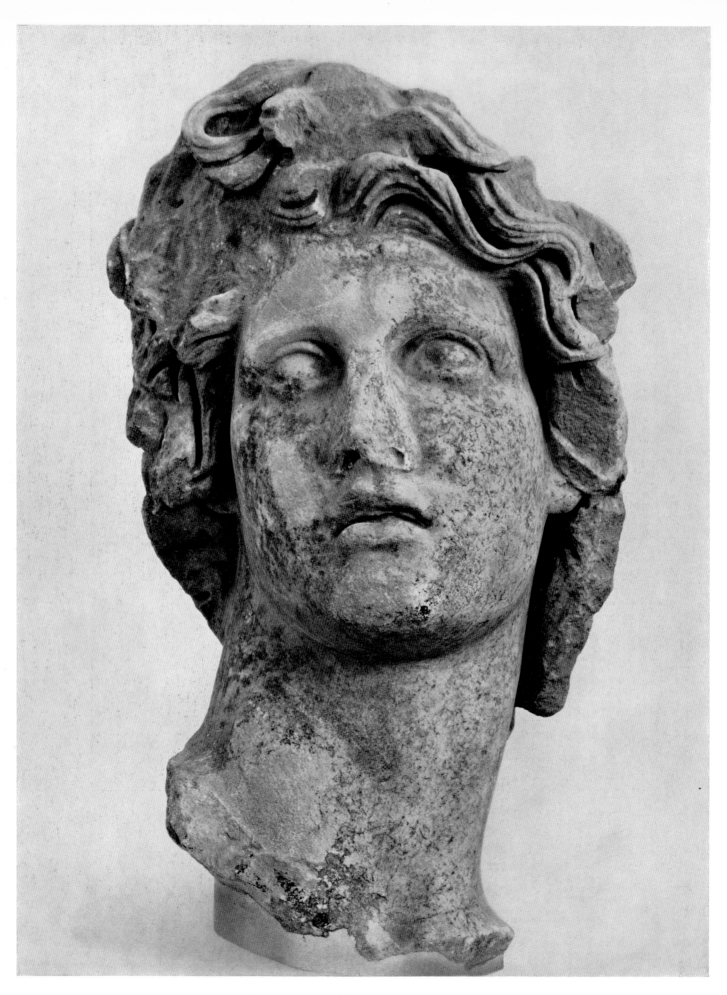

304 Head of Helios, from Rhodes. Parian (?) marble. Height 55 cm. Mid 2nd century B.C. Rhodes Museum

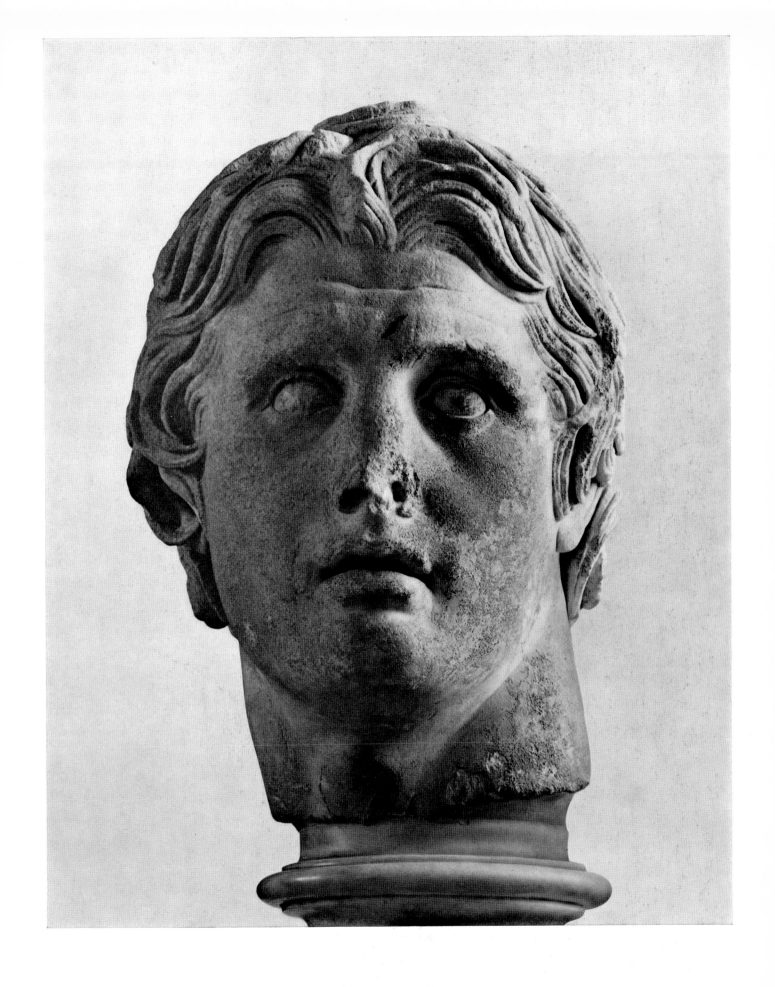

305 Head of Alexander the Great, from Pergamon.
Marble. Height 41 cm. Mid 2nd century B.C. Istanbul, Archaeological Museum 538

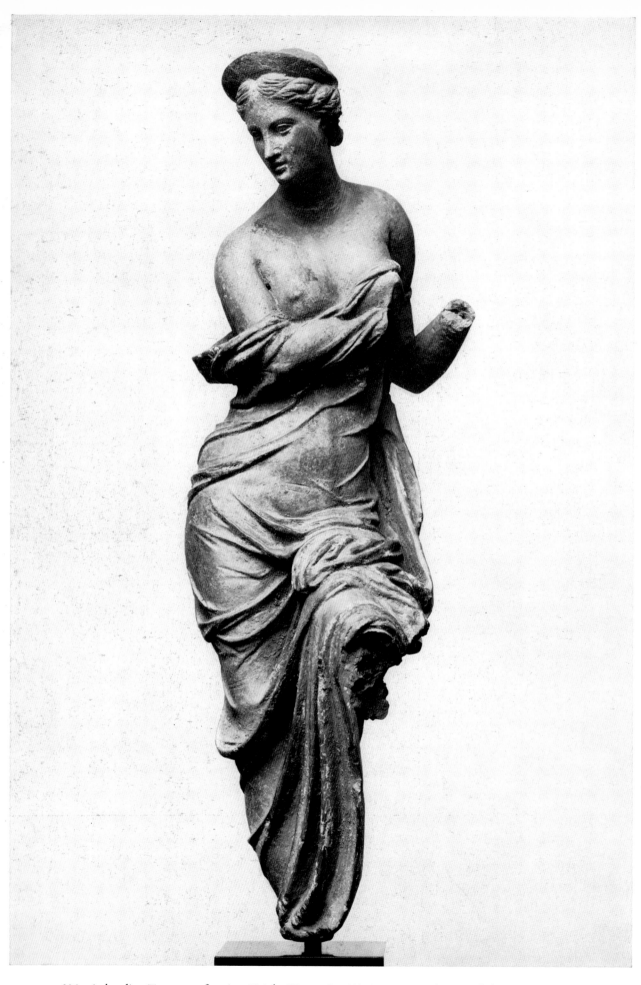

306　Aphrodite. Terracotta figurine. Height 37 cm. Ca. 160–150 B.C. Berlin, Staatliche Museen 31272

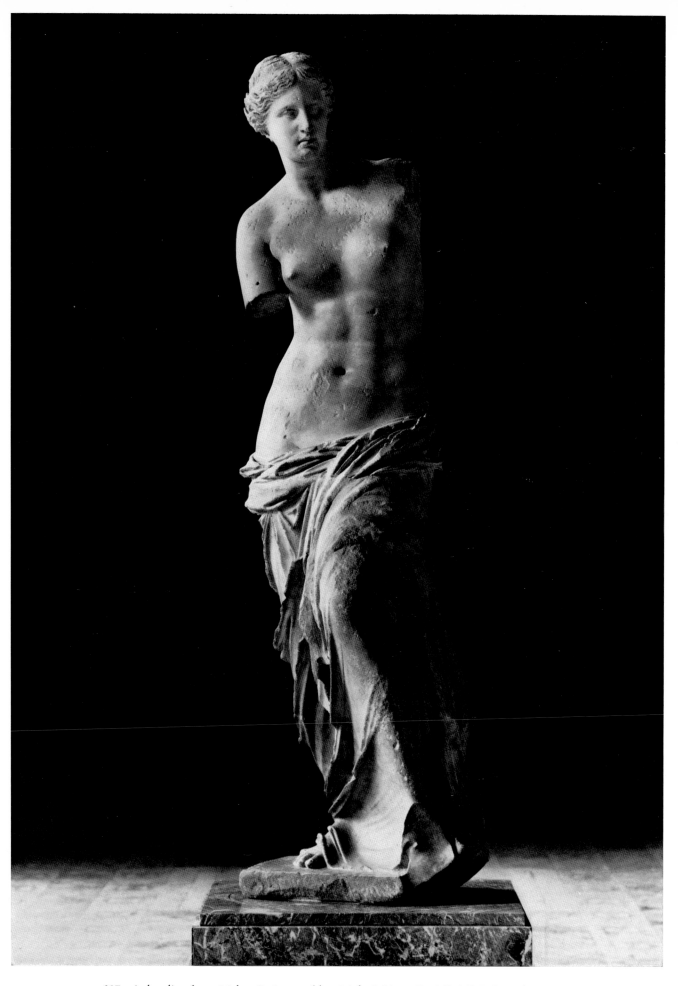

307 Aphrodite, from Melos. Parian marble. Height 2.04 m. Ca. 160–150 B.C. Paris, Louvre

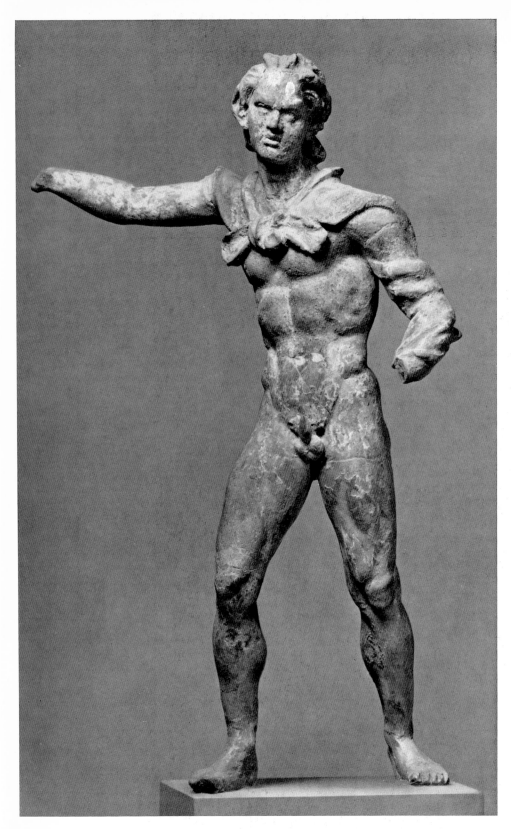
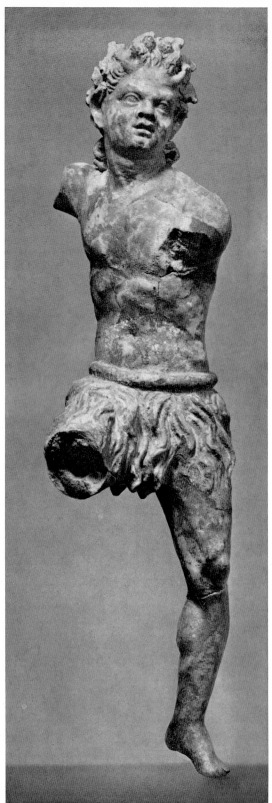

308 Two satyrs. Terracotta figurines. a, from a tomb in Tarentum.
Height 32.1 cm. Middle of 2nd century B.C. Tarentum, Museo Nazionale.
b, from Centuripe. Height 34 cm. End of 2nd century B.C. Syracuse, Museo Nazionale Archaeologico

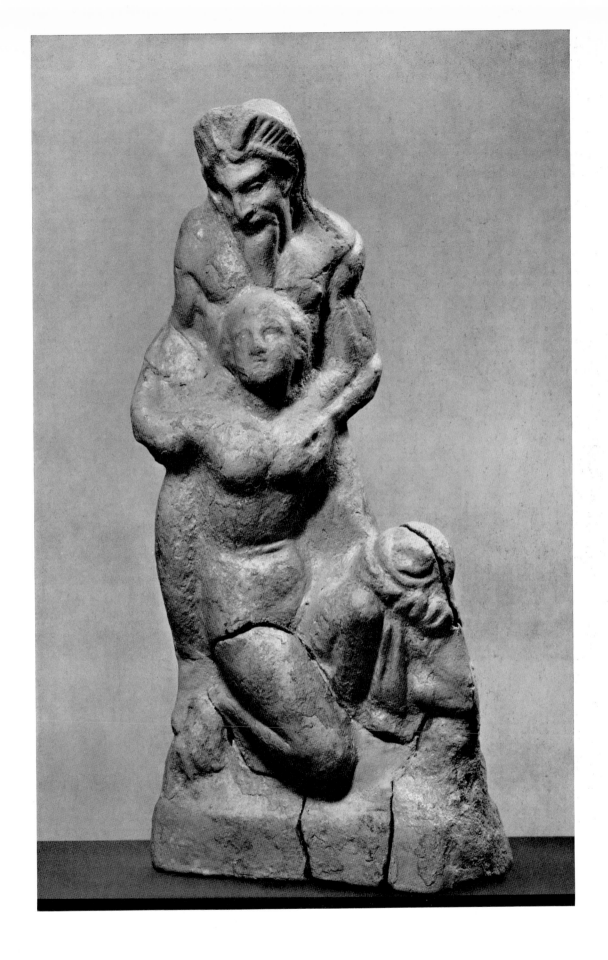

309　Pan and a nymph, from Centuripe. Terracotta group. Height 19.6 cm.
End of 2nd century B.C. Syracuse, Museo Nazionale Archaeologico

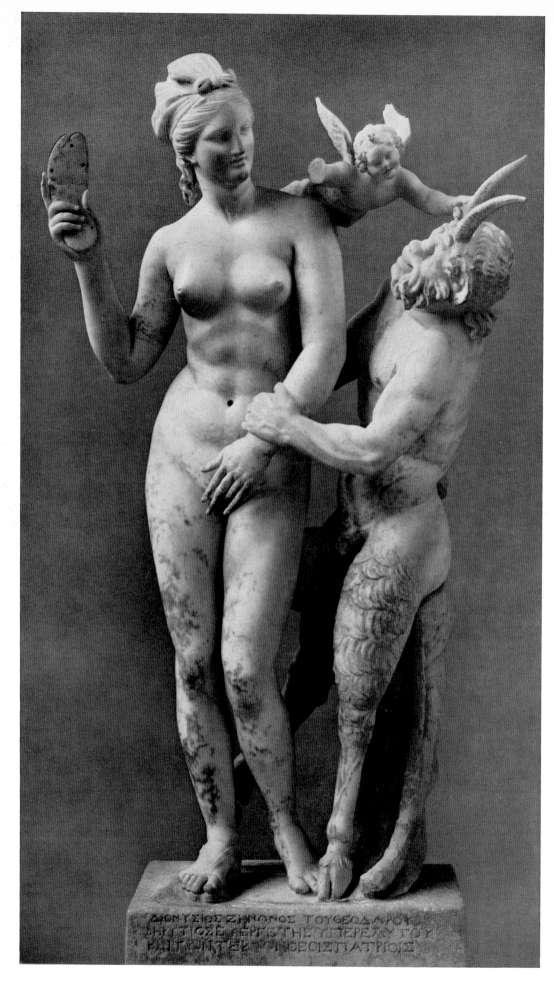

310 Aphrodite and Pan, from Delos. Height 1.32 m. Ca. 100 B.C. Athens, National Museum 3335

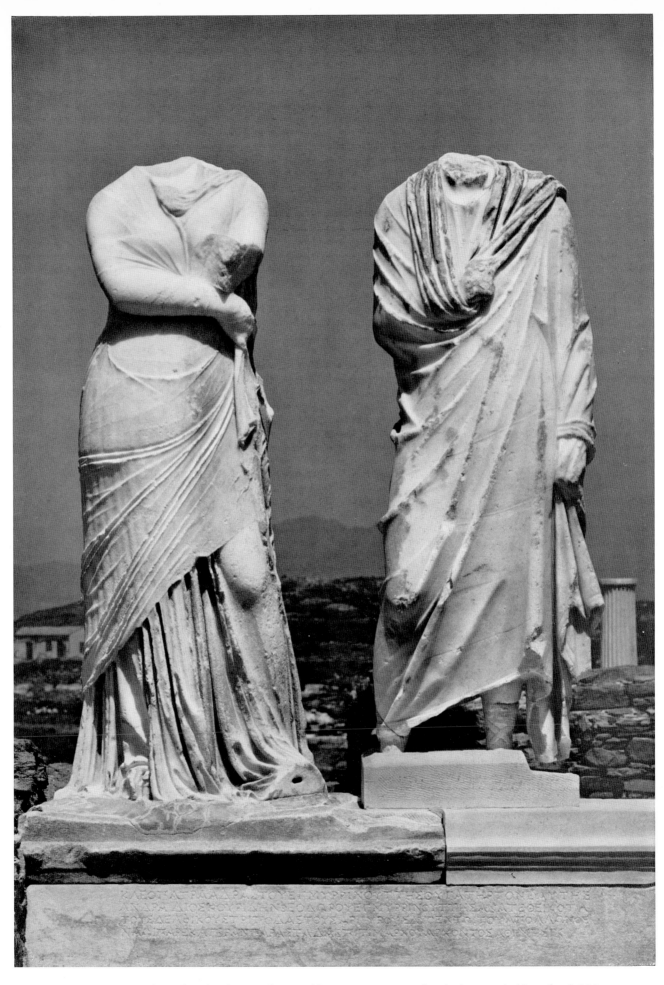

311 Cleopatra and Dioskurides, from Delos. Marble statue group. Height of Cleopatra (without base) 1.52 m.
Ca. 130 B.C. Delos

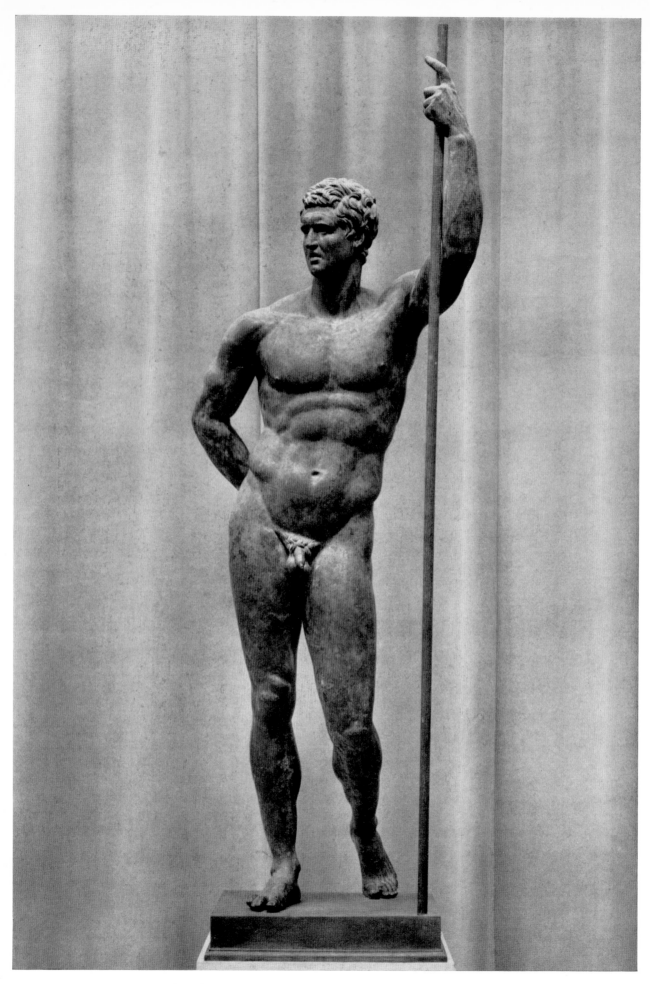

312 Bronze statue of a ruler. Height 2.37 m. End of 2nd century B.C. Rome, Museo delle Terme 544

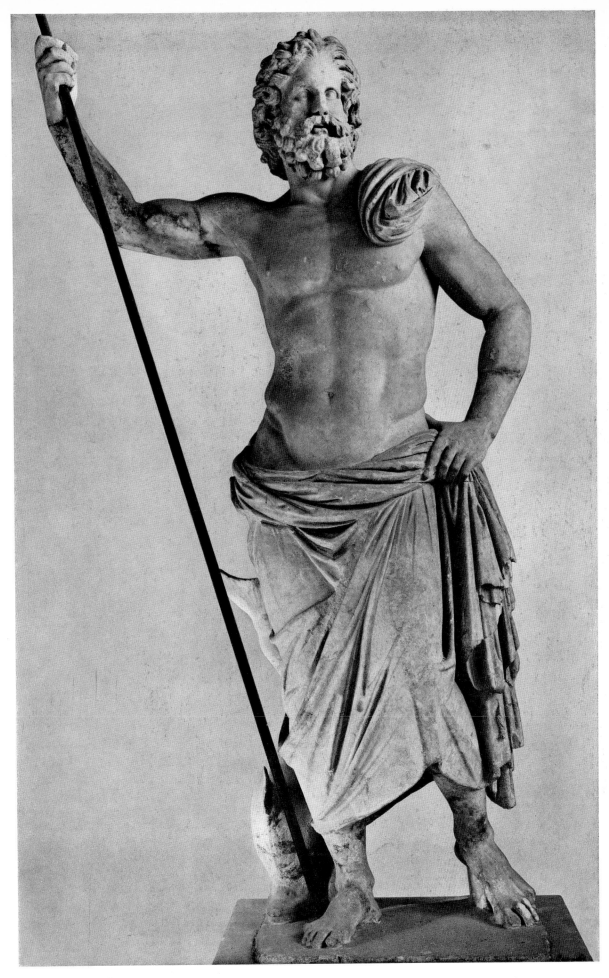

313 Poseidon, from Melos. Marble. Height 2.45 m. End of 2nd century B.C. Athens, National Museum 235

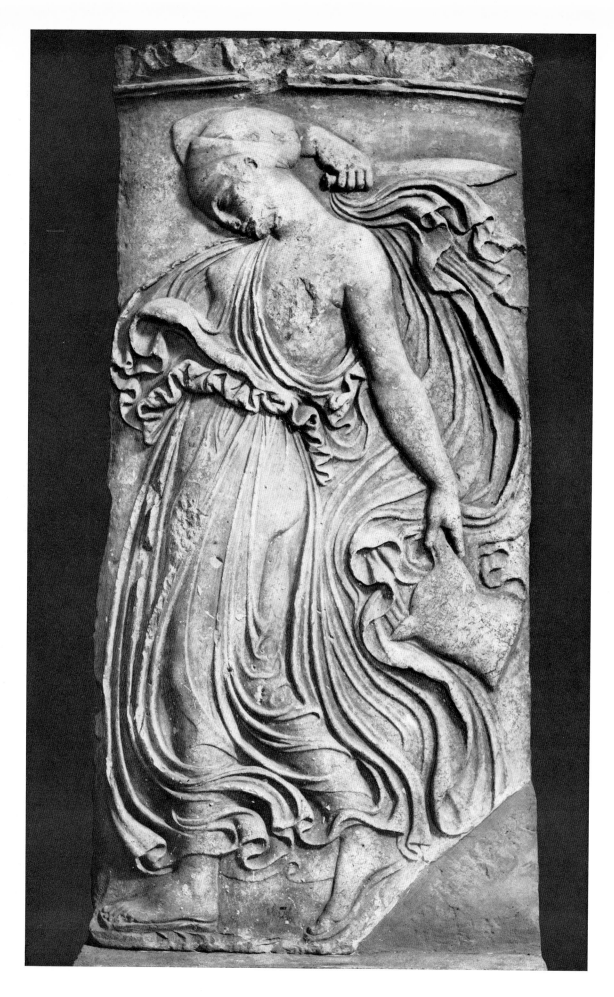

314 Maenad. Relief from a circular base. Pentelic marble. Height 1.29 m.
Neo-Attic copy (end of 2nd century B.C.) of a late-5th-century B.C. original by Kallimachos.
Rome, Palazzo dei Conservatori

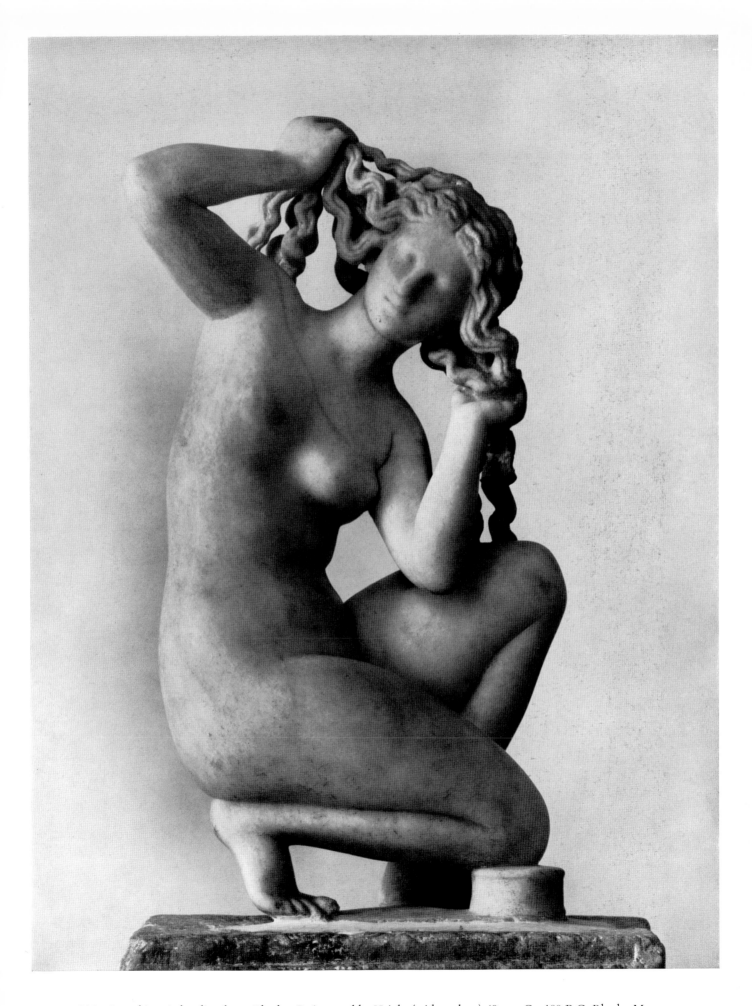

315 Crouching Aphrodite, from Rhodes. Parian marble. Height (without base) 49 cm. Ca. 100 B.C. Rhodes Museum

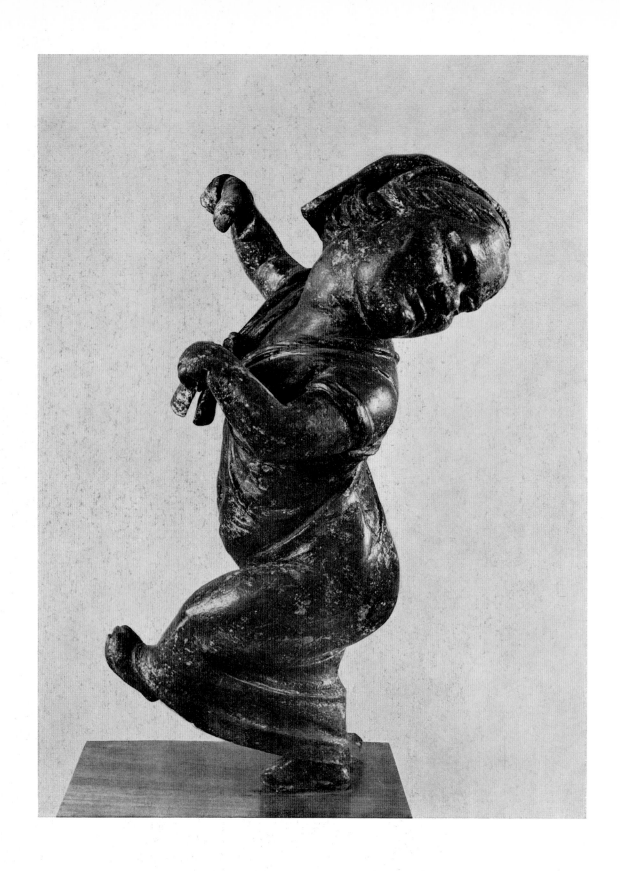

316 Grotesque woman dancer, from Mahdia. Bronze figurine. Height 30 cm.
Ca. 130 B.C. Tunis, Musée Alaoui

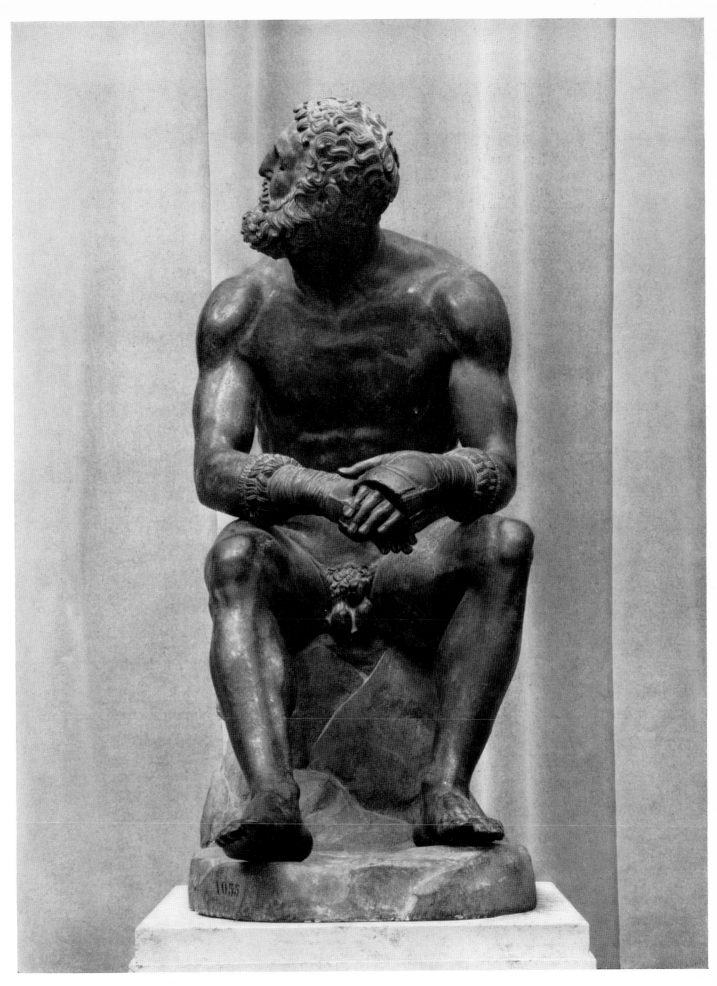

317 Seated boxer. Bronze. Height 1.28 m. Mid 1st century B.C. Rome, Museo delle Terme 545

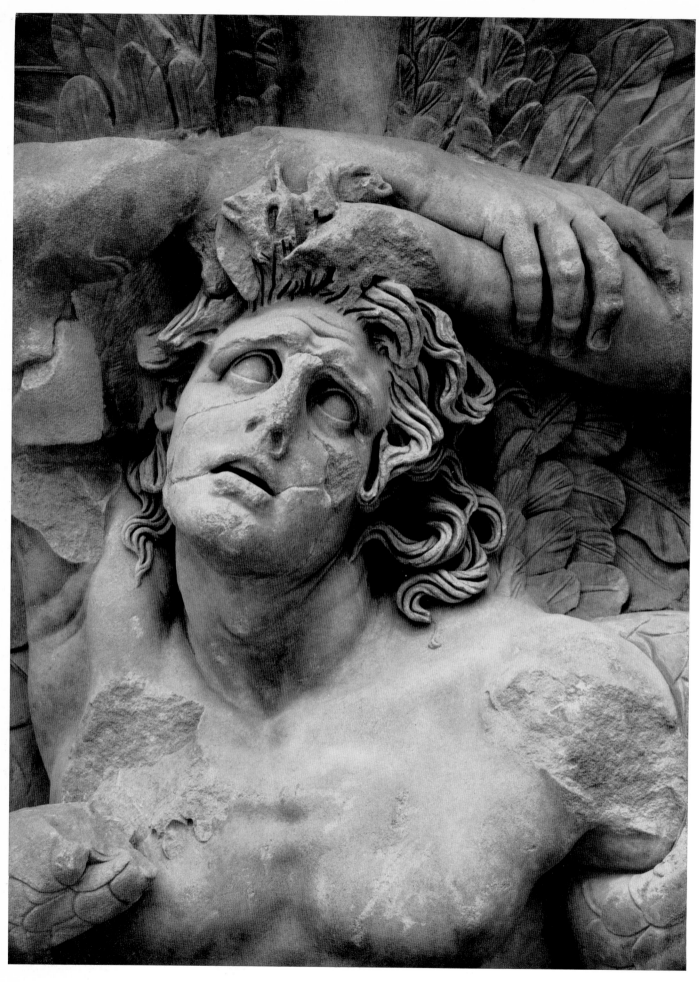

318 From the Great Frieze of the Pergamon Altar, east section. Head of Alkyoneus.
Marble. Ca. 180/160 B.C. Berlin, Pergamon Museum. Cf. plate 293

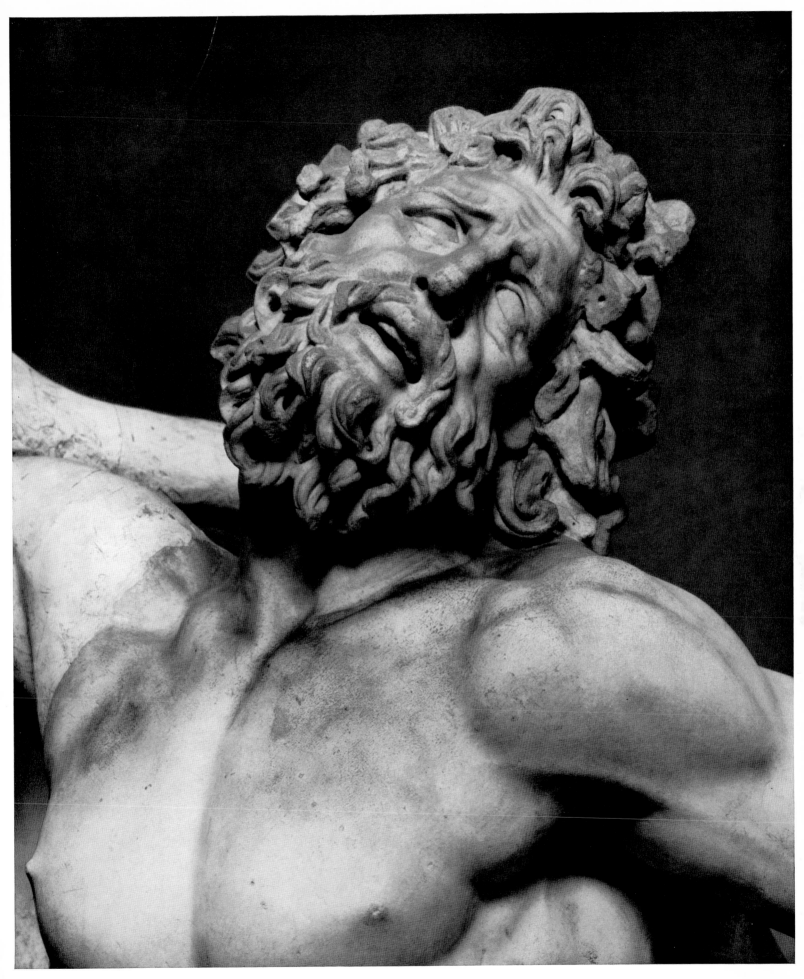

319 Head of Laokoön, from the Laokoön group. Mid 1st century B.C. Vatican Museum 74

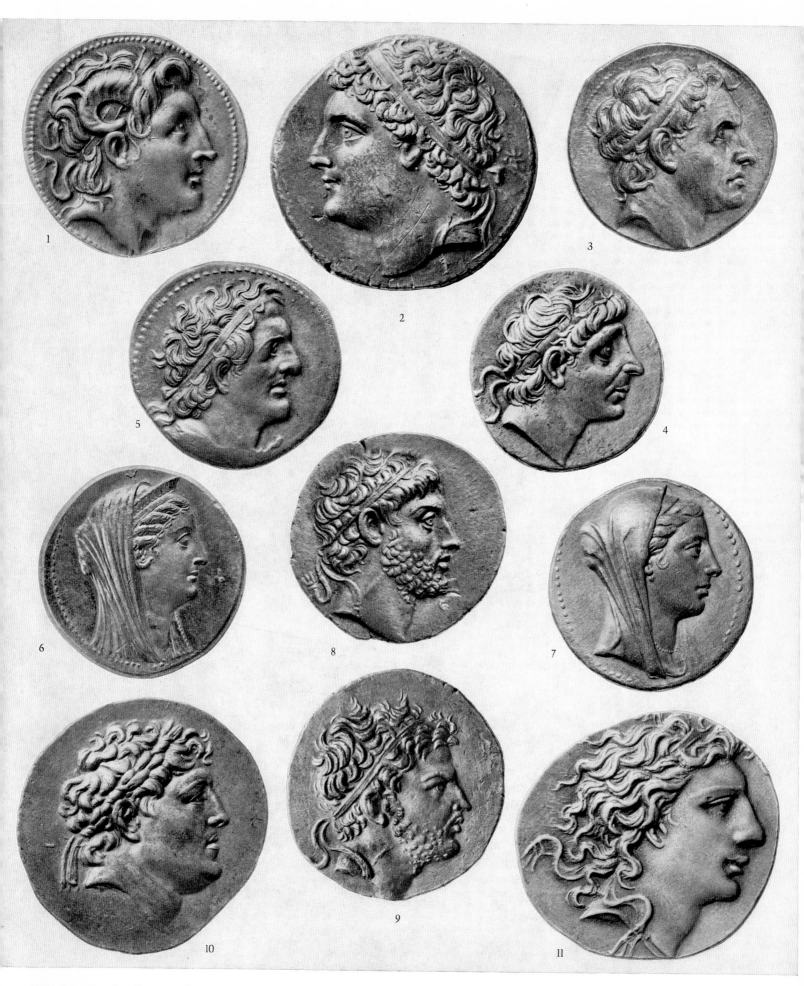

320 Portraits of Hellenistic rulers on Greek coins. 1 Alexander the Great, from a tetradrachm of Lysimachos of Thrace. 2 Hieron II. 3 Seleukos I.
4 Antiochus I. 5 Ptolemy I. 6 Arsinoe II, gold. 7 Berenice II, gold. 8 Philip V. 9 Perseus. 10 Philetairos. 11 Mithradates VI. All 2:1

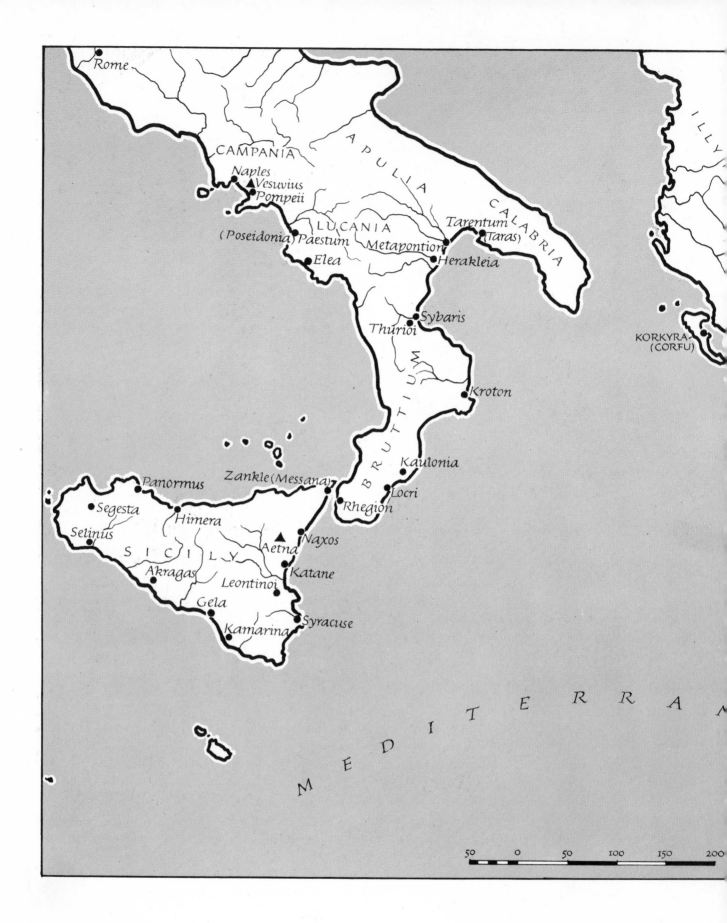

Rome

CAMPANIA

APULIA

CALABRIA

Naples
▲Vesuvius
Pompeii

LUCANIA

Tarentum
(Taras)

(Poseidonia) Paestum

Metapontion

Elea

Herakleia

Sybaris

Thürioi

KORKYRA
(CORFU)

Kroton

B
R
U
T
T
I
U
M

Kaulonia

Panormus

Zankle (Messana)

Locri

Segesta

Himera

Rhegion

Selinus

S I C I L Y

Aetna ▲

Naxos

Akragas

Katane

Leontinoi

Gela

Kamarina

Syracuse

M E D I T E R R A N

50 0 50 100 150 200

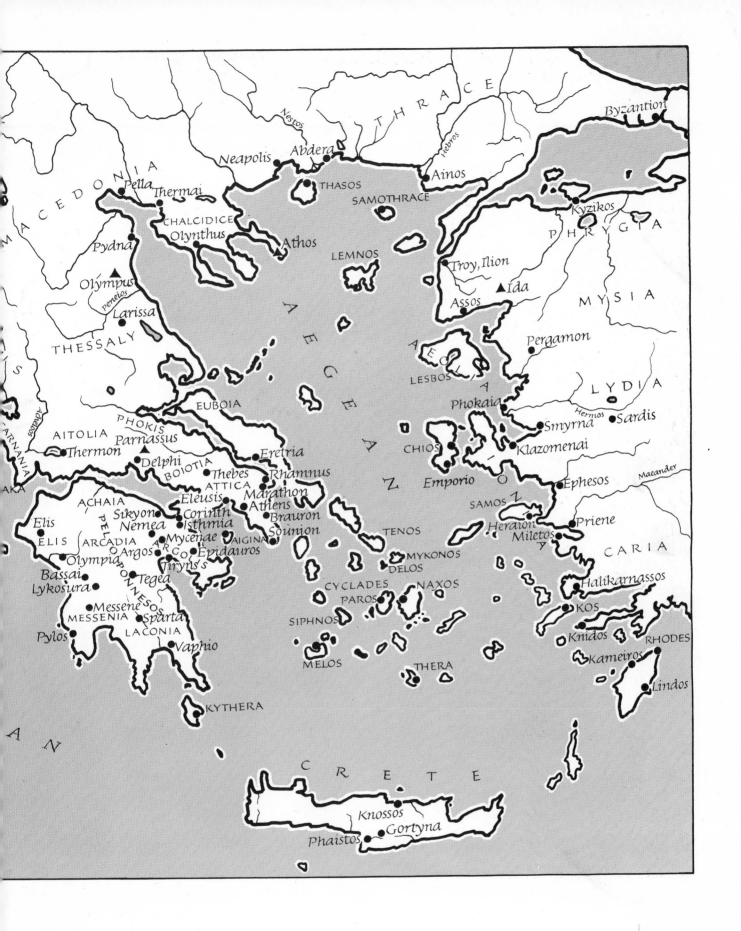

THRACE

Nestos

Byzantion

Neapolis Abdera

Ainos

MACEDONIA

Hebros

Pella THASOS

Thermai SAMOTHRACE

Kyzikos

PHRYGIA

CHALCIDICE

Olynthus

Athos LEMNOS

Troy, Ilion

Pydna

Ida MYSIA

Olympus Assos

Peneios

Larissa AEGEAN Pergamon

THESSALY AEOLIA

LESBOS LYDIA

Hermos Sardis

EUBOIA Phokaia

Smyrna

PHOKIS Klazomenai

AITOLIA Parnassus CHIOS

ARNANIA Thermon Eretria Emporio Ephesos

Delphi Maeander

BOIOTIA Rhamnus

AKA Thebes SAMOS

ATTICA Marathon Priene

ACHAIA Eleusis Athens Heraion

Sikyon Corinth Brauron Miletos

Elis Nemea Isthmia Sounion CARIA

ELIS Mycenae AIGINA TENOS

ARCADIA Argos ARGOLIS Epidauros

Olympia Tiryns MYKONOS Halikarnassos

Bassai Tegea DELOS KOS

Lykosura CYCLADES NAXOS

Messene PAROS Knidos RHODES

MESSENIA Sparta SIPHNOS Kameiros

Pylos LACONIA MELOS THERA Lindos

Vaphio

KYTHERA

AN

CRETE

Knossos

Gortyna

Phaistos

NOTES

The key to the abbreviations used is to be found at the beginning of the Bibliography on page 587.

GEOMETRIC ART · 1100–700 B.C.

1 E. Kunze, *VII. Olympia-Bericht* 1961, 146 on pl. 60/61.
2 B. Snell, *The Discovery of the Mind*, 3 ed. 1955, xi ff.
3 *AJA* 38, 1934, 10 ff.
4 *Schefold*, 26, pl. 6a.

ARCHAIC ART · 700–500 B.C.

1 Thus on the fragment of a Protocorinthian skyphos with Bellerophon and Chimaira, in the Aegina Museum. *Ca.* 670 B.C. Cf. *Schefold*, 38 pl. 22.
2 P. Perdrizet, *Fouilles de Delphes V*, 1 1906, 30, No. 17, pl. I, 7; F. Matz, *Geschichte der Griechischen Kunst* 1950, 159, pl. 64.
3 E. Kunze, *IV Olympia-Bericht* 1944, 128 ff., fig. 97/98.
4 *Schefold*, 42, pl. 27a.
5 There is a similar treatment in the courtship scene on the neck of a Cretan jug, from Arkades. Cf. *Schefold*, 42, pl. 27b.
6 In the museum at Tenos, found in the Sanctuary of Demeter. Cf. *Schefold*, 32, pl. 13.
7 Tarentine clay tablet, in Naples, Museo Nazionale Archeologico. Cf. *Schefold*, 46, pl. 32b.
8 E. Buschor, *Frühgriechische Jünglinge* 1956, 13, fig. 10.
9 H. G. G. Payne, *Protokorinthische Vasenmalerei* 1933, pl. 23, 1–3.
10 In the pediment of a small building on the Acropolis. Cf. *Schefold*, 68, pl. 54a.
11 R. Heberdey, *Altattische Porosskulptur* 1919, 29 ff., pl. 1.
12 R. Heberdey, *Altattische Porosskulptur* 1919, 16 ff., pl. 2. E. Kalinka, Der Olbaumgiebel, in: *ÖJh* 31 1939, 19 ff. Schefold, *Griechische Plastik I* 1949, pl. 22.
13 *Schefold*, 56, ill. 40b.
14 J. D. Beazley, *The Development of Attic Black-Figure* 1951, 88 ff.; *ABV*, 89 f.: The Burgon Group.
15 A. Rumpf, *Sakonides*, 1937, pl. 18–20; *ABV*, 107, No. 1.
16 There are still differences of opinion as to the precise nature of the scene depicted on the Arkesilas cup. Cf. bibliography in *Arias/Hirmer/Shefton*, 309 f. Despite Rumpf's weighty objections (*Rumpf*, 54) it is more often than not interpreted as representing King Arkesilas II (569/568 B.C.) of Kyrene, supervising the loading onto a sailing-ship of a consignment of silphion, a plant much sought-after in the Mediterranean region but now extinct. Although its basic supports have been demolished, the very attractiveness of this explanation still wins it adherents. But: for one thing, the cup is not by a Kyrenian, but a Laconian, painter; for another, the inscription ΣΛΙΦΟΜΑΧΟΣ does not necessarily imply a combination of ΣΛΙΦΟ (=Silphion) and the Egyptian 'mache' (=scales), nor relate to the weigher of the silphion. S. Benton (*Archaeology* 12 1959, 178 ff.) takes this inscription to be the cry of the man standing on the right. His index-finger points to the bird on the arm of the scales, which Benton claims is an 'insect-hunter' (σίλφη+μάχος), i.e. a woodpecker. Oddly enough, Benton nevertheless maintains that the scene on the cup represents trading in silphion.
17 W. Technau, *Exekias* 1936, 7; J. D. Beazley in: *BSA* 32 1932, 20.
18 The korai 619 and 677. Cf. *Payne/Young*, pl. 18–20.
19 Nike 693 on the Acropolis. Cf. *Payne/Young*, pl. 50/120.
20 Lower portion of the Acropolis Kore 582. Cf. *Payne/Young*, pl. 14.
21 Pair of feet 81. Cf. F. Eichler in: *ÖJh* 16 1913, 86 ff., fig. 46/47, 49, 55.
22 Funerary stele of spearman by Phaidimos, *ca.* 560 B.C. Cf. G. M. A. Richter, *Archaic Gravestones of Attica*, 2 ed. 1961, No. 27, pl. 83/85.
23 Sphinx, from the Kerameikos. Cf. G. M. A. Richter, *Archaic Gravestones of Attica*, 2 ed. 1961, No. 11, pl. 34–39.
24 Phaidimos, Funerary stele of a youth. Cf. G. M. A. Richter, *Archaic Gravestones of Attica*, 2 ed. 1961, No. 30, pl. 90.
25 Diskophoros funerary stele, from Phoenicia. Cf. G. M. A. Richter, *Archaic Gravestones of Attica*, 2 ed. 1961, No. 26, pl. 88.
26 Torso of a youth from the Acropolis, 665. Cf. *Payne/Young*, pl. 97, 98.
27 Dog from the Acropolis, 143. Cf. *Payne/Young*, pl. 131.
28 Lion's-head waterspout from the temple of the Peisistratids on the Acropolis, 69. Cf. *Payne/Young*, pl. 132.
29 Ram's-head waterspout, from Eleusis. Cf. *Antike* 18 1942, 125, fig. 35.
30 Sphinx, in the Kerameikos. Cf. G. M. A. Richter, *Archaic Gravestones of Attica*, 2 ed. 1961, No. 11, pl. 38 f.
31 Head of a youth MNC 748, in Paris, Louvre. Cf. G. M. A. Richter, *Kouroi* 1960, No. 66, fig. 221/222.
32 Boxer stele, in the Kerameikos. Cf. G. M. A. Richter, *Archaic Gravestones of Attica*, 2 ed. 1961, No. 31, pl. 92.
33 Endoios, seated Athena 625, from the Acropolis. Cf. *Payne/Young*, pl. 116.
34 Philermos, Kore. Cf. *Payne/Young*, pl. 60.
35 Damaged base. Cf. *JHS* 45 1925, 167, fig. 2; A. Raubitschek, *Dedications* 1949, 491 ff.
36 Webb head in the British Museum, 2728. Cf. *BCH* 17 1893, pl. 12 f.

37 Youth, from east pediment of the temple of the Alkmaionidai (Temple of Apollo V) in Delphi. Cf. P. de la Coste-Messelière-de Miré, *Delphes* 1957, pl. 142.

THE SEVERE STYLE · 500–450 B.C.

1 J. D. Beazley, *Der Kleophrades-Maler* 1933, 13.
2 For example, the beautiful lutrophoros in the Louvre, CA 453. Cf. *Arias/Hirmer/Shefton*, 331, pl. 126–128.
3 Iliupersis by Makron, on the cup in the Louvre, G153. J. D. Beazley in: *Bulletin van de Vereeniging tot Bevordering der Kennis van de Antieke Beschaving* 29 1954, 12–15.
4 Cup F2290. Cf. A. Neugebauer, *Führer durch das Antiquarium, Vasen* 1932, 99, pl. 51; *Pfuhl*, fig. 438; *ARV*, 462, No. 48.
5 Herakles and Busiris by the Pan Painter, on the pelike in the National Museum, Athens, 9863. J. D. Beazley, *Der Pan-Maler* 1931, No. 32, pl. 7–10.
6 J. D. Beazley, *Der Pan-Maler* 1931, 11.
7 The head of the satyr Oreimachos, which was damaged during the post-war period, is reproduced in its undamaged state in a photograph in A. Greifenhagen, *Antike Kunstwerke der Stiftung Preussicher Kulturbesitz*, Staatliche Museen Berlin, 2 ed. 1966, fig. 42/43. Rear view, cf. *Arias/Hirmer/Shefton*, pl. 150, 152.
8 The former Hearst amphora, in the Metropolitan Museum of Art 56.171.38, New York. J. D. Beazley, *Der Berliner Maler* 1930, pl. 21; *ARV*, 197, No. 3.
9 Regarding the Amazonomachy on the volute-krater 279, in Bologna, cf. *Pfuhl*, fig. 508; D. von Bothmer, *Amazons in Greek Art* 1957, 169.
10 Calyx-krater 415 by the Syriskos Painter, in the Cabinet des Médailles, Paris. Cf. *JdI* 56 1942, 11, fig. 7.
11 Regarding the three works by Kalon of Aegina among other Aeginetan works on the Acropolis, cf. A. Raubitschek, *Dedications* 1949, No. 85–87.
12 The cloaked figure Corinth-Capitol is best preserved in the replica in the Museo Nuovo, cf. *Lippold*, 174, with note 8, pl. 63, 3. Its hitherto customary interpretation as Demeter or Kore is unconvincing. It rests on a stylistic affinity with the chthonic goddess Corinth-Mocenigo (here pl. 169 left; cf. also index of plates). The unquestionable association with a single votive offering was thought to be sufficient to identify the figure as Demeter or Kore. Yet, despite all the correspondences, I can see stylistic differences between the two figures which preclude one from attributing both works to the same master, or indeed to Onatas of Aegina. A third figure seems to me to hold the key to the correct interpretation, namely the cloaked figure Torlonia 495–Hierapytna. E. Schmidt has discussed this type in the publication in honour of W. Amelung, *Antike Plastik* 1928, 223 ff. In the light of his findings the copy of Hierapytna appears to me to reproduce the bronze original most faithfully. To judge by the quiver attribute—Schmidt regards this as a copyist's addition— Artemis was here originally portrayed. *Lippold*, 174 f., noticed the interrelationship—correctly, in my opinion—but did not draw the necessary conclusions. All these explanations, put forward in lectures and papers, deserve fuller discussion.

13 Photographs in the DAI, Athens, Neg. No. Akr. 2226–2228.
14 Little marble head 00.307, from Tarentum, in the Museum of Fine Arts, Boston. Cf. L. D. Caskey, *Catalogue Boston Sculpture* 1925, 9 f., No. 6 with ill.
15 Little marble head in the Barracco Collection. Cf. A. Barraco/W. Helbig, *La Collection Barracco* 1893, pl. 30. W. Helbig, *Führer durch die öffentlichen Sammlungen*, vol. I, 3 ed. 1912, 612, No. 1087.
16 Little terracotta head in the Loeb Collection. Cf. *J. Loeb Collection, Terrakotten I* 1916, pl. 10.
17 The name Omphalos Apollo has established itself for the entire group of copies of this type. This is owing to an omphalos having been found and hence associated with the Athens replica. The Apollo Choiseul Gouffier in the British Museum, shown in pl. 176 left, derives from the same original and, after the Athens statue, represents the best replica of Onatas's famous original.
18 Regarding the marble sphinx of Aegina, cf. A. Furtwängler in: *MJB* I 1906, pl. I; *Lippold*, 101, footnote 12.
19 A. Michaelis, *Strassburger Antiken*.
20 Orpheus (?). Fragment (Little marble head with fur cap) in the Barracco Collection. Cf. W. Fuchs in: *RM* 65 1958, 1 ff.
21 H. Möbius interprets them as grooms.
22 It is surprising that P. Naster, *La Collection Lucien Hirsch* 1959, No. 269, treats the self-evident fir-tree as an araucaria. True, in Sicily and along other Mediterranean coasts, the araucaria is grown as an ornamental tree in gardens and parks. This is the *Auracaria excelsa R. Br.*, which is named 'Norfolk fir' after its place of origin, the Norfolk Islands. But it must be remembered that these little South Sea islands, lying to the north of New Zealand, were first discovered in 1774 by Captain James Cook, no less than 2250 years after the founding of Aetna!

HIGH CLASSICISM · 450–400 B.C.

1 K. A. Pfeiff, *Apollon* 1943, 83.
2 F. Eichler in: *ÖJh* 30 1937, 75 ff. and 45 1960, 5 ff.
3 Regarding the Tiber Apollo, cf. *JdI* 80 1965, 230 ff.
4 Regarding the Barracco double herm, cf. *JdI* 80 1965, 116 ff., ill. 73.
5 E. Berger in: *RM* 65 1958, note 70; *ibid.*, *Staatliche Kunstsammlungen Kassel, Antike Kunstwerke. Neuerwerbungen*, 9 ff., No. 3, cf. also 41; lastly, *JdI* 80 1956, 200 ff. Attempted reconstruction (photomontage), 209 fig. 61.
6 P. Wolters, *Münchner Jahrbuch für Kunstwissenschaft* 11, 1934, 3 ff.
7 F. Studniczka in: *ÖJh* 2 1899, 192 ff.; G. Lippold in: *JdI* 23 1908, 203 ff.; *Lippold*, 166 with note 1.
8 J. Sieveking in: *JdI* 24 1909, 1 ff. There are better renderings of the head than of the body. Cf. C. Caskey in: *AJA* 15 1911, 215 f.; *Lippold*, 165 with note 2.
9 Regarding the Syracusan Artemis and Arethusa, cf. E. Boehringer, *Die Münzen von Syrakus* 1929, 99 ff.
10 Regarding the stylistic renderings of Naxos, cf. H. A. Cahn, *Die Münzen der sizilischen Stadt Naxos* 1944.

THE LATE CLASSICAL PERIOD · 400–323 B.C.

1 E. Q. Visconti, *Il Museo Pio Clementino* 3 1819, 119 ff., pl. 26.

2 B. Schlörb, Timotheos, in *JdI* 22 (supplement) 1965, 1–35 with appendix.

3 The themes on the Epidauros pediments could be ascertained from the fragments that were discovered. The reconstruction of the east pediment shown here in fig. 168 has been superseded by the work done by N. Yalouris in collaboration with a sculptor in the National Museum, Athens, in which they fitted together anew countless fragments.

4 Puntello is the name given to a protruding piece of marble, which indicates the original contact with a part of the body or attribute. Regarding the Hygieia of Timotheos, cf. B. Schlörb, Timotheos, in: *JdI* 22 (supplement) 1965, 37 ff., fig. 37–40.

5 G. Rodenwaldt, ΘΕΟΙ ΡΕΙΑ ΖΩΟΝΤΕΣ. *Abhandlungen der Preussischen Akademie der Wissenschaften* 1943. Philosoph.-Histor. Klasse, No. 13, 6 f.

6 Regarding the 'Kaufmann' head, cf. the bibliographical references in *Lippold*, 239, note 3.

7 Cf. H. Bulle, *Der schöne Mensch im Altertum*, 2 ed. 1912, 333 ff., pl. 155.

8 Cf. the discussion in G. Rodenwaldt, *op. cit.*, note 6.

9 K. A. Pfeiff, *Apollon* 1943, 137.

10 H. Brunn, *Geschichte der griechischen Künstler*, 2 ed. 1889, 229 f.

11 E. Buschor, *Von griechischer Kunst*, 2 ed. 1956, 213.

12 Regarding the bronze head of an African in the British Museum, No. 268, cf. *Lullies/Hirmer*, 90, note on pl. 210.

13 Cf. E. Schmidt in: *JdI* 49 1934, 193 ff., with fig. 4/5.

14 Regarding the corded-handle neck-amphora by the Suessula Painter, in the Louvre, Paris, S1677, cf. *Arias/Hirmer/Shefton*, 380, note on pl. 221.

15 The silphion plant, which used to grow wild, and was doubtless also cultivated, in Cyrenaica, and whose importance as an article of export was very considerable to that country, has since died out and is no longer precisely identifiable botanically, though it was certainly a member of the family of the umbellifers. It is to be assumed that the silphion plant belonged to the genus *asa* and so was related to the still surviving *asa foetida*, the medicinal silphion. The non-Greek word structure suggests a Libyan origin.

HELLENISTIC ART · 323–31 B.C.

1 For a somewhat more detailed analysis, the reader is referred to the original text in the German edition.

2 G. Kaschnitz von Weinberg, *Mittelmeerische Kunst* 1965, pp. 325 f.

3 Article by G. Despini in *Archäologischer Anzeiger* 1966.

4 Regarding the Sperlonga complex of finds bearing the signature of the Laokoön sculptor, of such importance to the study of late Hellenistic art, cf. G. Jacopi, *L'Antro di Tiberio a Sperlonga* 1963, and H. Sichtermann in: *Gymnasium* 73, 1966, 220–239, pl. 9–21. It is only necessary to mention that the setting-up of sculptures in grottoes so that they blend with the landscape to create a telling unity was not a specifically Roman idea, but was anticipated in early Hellenistic times. One has only to recall the suggestion of Deinokrates to transform Mount Athos into a gigantic likeness of Alexander, in one of whose hands an entire city was to have been carried, while the other held a bowl out of which the mountain's waters were to pour into the sea (Vitruvius, *De Architectura* II, pr. 3).

SELECT BIBLIOGRAPHY
ABBREVIATIONS

JOURNALS

AA	*Archäologischer Anzeiger*
AM	*Mitteilungen des Deutschen Archäologischen Instituts, Athenische Abteilung*
BCH	*Bulletin de Correspondance Hellénique*
Deltion	*Archaiologikon Deltion*
JdI	*Jahrbuch des Deutschen Archäologischen Instituts*
ÖJh	*Jahreshefte des Osterreichischen Archaeologischen Instituts*

BOOKS

ABV	J. D. Beazley, *Attic Black-Figure Vase-Painters* 1956
ARV	J. D. Beazley, *Attic Red-Figure Vase-Painters* 1963
Arias/Hirmer/ Shefton	P. E. Arias/M. Hirmer/B. B. Shefton, *A History of Greek Vase Painting* 1962
Berve/Gruben/ Hirmer	H. Berve/G. Gruben/M. Hirmer, *Greek Temples, Theatres and Shrines* 1963
CVA	*Corpus Vasorum Antiquorum*
Furtwängler/ Reichhold	A. Furtwängler/K. Reichhold, *Griechische Vasenmalerei* 1900–1932
Himmelmann	N. Himmelmann-Wildschütz, *Bemerkungen zur geometrischen Plastik* 1964
Kerameikos	Kerameikos, *Ergebnisse der Ausgrabungen* I–VI 1939–1959
Kraay/Hirmer (KH)	C. M. Kraay/M. Hirmer, *Greek Coins* 1966
Langlotz/Hirmer	E. Langlotz/M. Hirmer, *The Art of Magna Graecia* 1966
Lippold	G. Lippold, *Die Griechische Plastik. Handbuch der Archäologie.* Vol. 3, 1, 1950
Lullies/Hirmer	R. Lullies/M. Hirmer, *Greek Sculpture*, 2 ed. 196
Payne/Young	H. Payne/G. M. Young, *Archaic Marble Sculpture from the Athenian Acropolis* 1950
Pfuhl	E. Pfuhl, *Malerei und Zeichnung der Griechen*. 3 vols. 1923
Rumpf	A. Rumpf, *Malerei und Zeichnung. Handbuch der Archäologie.* Vol. 4, 1, 1953
Schefold	K. Schefold, *Myth and Legend in Early Greek Art* 1966

ARCHITECTURE

W. B. Dinsmoor, *The Architecture of Ancient Greece* 1950: the most comprehensive and reliable handbook, with full bibliography by subjects and sites · A. W. Lawrence, *Greek Architecture* 1957: less full than Dinsmoor but better on some subjects, like fortifications, and better illustrated · D. S. Robertson, *A Handbook of Greek and Roman Architecture* 1945: the most humane and succinct account, but dated · *Berve/Gruben/Hirmer*: Gruben's detailed descriptions of buildings are valuable · W. H. Plommer, *Ancient and Classical Architecture* 1956: chapter 5 is useful on orders and construction R. Martin, *Manuel d'Architecture grecque* I, *Materiaux et Techniques* 1965: the fullest recent account of this aspect, but uneven · R. E. Wycherley, *How the Greeks built Cities* 1962: a useful account of civic planning and architecture · I. T. Hill, *The Ancient City of Athens* 1953

ART, GENERAL

J. D. Beazley/B. Ashmole, *Greek Sculpture and Painting* 1932: succinct and sympathetic · G. M. A. Richter, *Handbook of Greek Art* 1959: survey by subject · J. Boardman, *Greek Art* 1964: survey by periods · G. M. A. Richter, *Archaic Greek Art* 1949 · K. Clark, *The Nude* 1957

SCULPTURE

Lippold: concise and comprehensive survey with references · C. Picard, *La Sculpture* 1935–63: diffuse but comprehensive · *Lullies/Hirmer*: good pictures and commentary · G. M. A. Richter, *Sculpture and Sculptors of the Greeks* 1950 and A. W. Lawrence, *Classical Sculpture* 1928: both general studies,

rather dated · C. Blümel, *Greek Sculptors at Work* 1955 and S. Adam, *The Technique of Greek Sculpture* 1967: for techniques · *Payne/Young*: the best work on Archaic sculpture · P. Corbett, *The Sculpture of the Parthenon* 1959 · F. Johansen, *Attic Grave Reliefs* 1951 · M. Bieber, *The Sculpture of the Hellenistic Age* 1960: comprehensive and fully illustrated · A. W. Lawrence, *Later Greek Sculpture*, 1927 · Illustrated compendia of great value by G. M. A. Richter: *Kouroi: Archaic Greek Youths* 1960, *Archaic Gravestones of Attica* 1961 and *Greek Portraits* 1966

VASE PAINTING

Arias/Hirmer/Shefton: full study and descriptions with good pictures · R. M. Cook, *Greek Painted Pottery* 1960: thorough archaeological survey with good bibliography · C. M. Robertson, *Greek Painting* 1959: colour pictures and excellent commentary · J. D. Beazley, *The Development of Attic Black-Figure* 1951

COINS

Kraay/Hirmer: excellent pictures and commentary · C. Seltman, *Greek Coins* 1955: dated, but a useful survey · British Museum, *Guide to the Principal Coins of the Greeks* 1959

OTHER ARTS

R. A. Higgins, *Greek and Roman Jewellery* 1961 · H. Hoffmann/P. F. Davidson, *Greek Gold* 1966 · W. Lamb, *Greek and Roman Bronzes* 1929 · D. Strong, *Greek and Roman Gold and Silver Plate* 1966 · G. Kleiner, *Tanagrafiguren* 1942 · A. Furtwängler, *Die antike Gemmen* 1900

REFERENCES AND SOURCES FOR ILLUSTRATIONS

COLOUR PLATES

I, II *Berve/Gruben*, pl. XXII, XXIX · III *Arias/Hirmer/Shefton*, p. 267, pl. I · IV *ibid.*, p. 272, pl. II · V *Schefold*, p. 190, pl. I; *Arias/Hirmer/Shefton*, p. 274, 13 · VI *ibid.*, pp. 275 f., pl. IV · VII *Schefold*, p. 191, 20 · VIII *Lullies/Hirmer*, p. 58, pl. I/II; *Schefold*, p. 193, 56b · IX *Arias/Hirmer/Shefton*, p. 282, pl. IX; *Schefold*, p. 194, 60a, pl. III · X *Arias/Hirmer/Shefton*, p. 283, pl. XII; *Schefold*, p. 190, pl. V · XI *ibid.*, p. 190, pl. VI · XII *Arias/Hirmer/Shefton*, pp. 309 f., pl. XXIV · XIII *ibid.*, pp. 310 f., pl. XXV; *Schefold*, p. 194, 66 · XIV *Arias/Hirmer/Shefton*, pp. 299 f., pl. XXV · XV *ibid.*, p. 303, pl. XVIII · XVI *ibid.*, pp. 301 f., pl. XVI · XVII *ibid.*, pp. 302 f., pl. XVII · XVIII *Lullies/Hirmer*, pp. 66 f., pl. III · XIX *Arias/Hirmer/Shefton*, pp. 312 f., pl. XXVII · XX *ibid.*, p. 317, pl. XXIX · XXI/XXII *ARV* 182/6 · XXIII *ARV* 206/126 · XXIV *ARV* 372/32 · XXV *ARV* 371/15 · XXVI *ARV* 860/3 · XXVII *Lullies/Hirmer*, pp. 71 f., pl. IV · XXVIII *ibid.*, p. 75, pl. VI ·

XXIX *Arias/Hirmer/Shefton*, p. 315, pl. XXVIII · XXX *Langlotz/Hirmer*, p. 246, pl. X · XXXI *ARV* 987/1 · XXXII/XXXIII *ARV* 997/155 · XXXIV/XXXV *ARV* 1022/138 · XXXVI *ARV* 1017/54 · XXXVII *ARV* 1312/2 · XXXVIII *ARV* 1384/12 · XXXIX *Lullies/Hirmer*, p. 93, pl. VII · XL *ibid.*, pp. 96 f., 239 · XLI *Arias/Hirmer/Shefton*, pp. 385 f., pl. XLVIII · XLII *ibid.*, p. 391, pl. XLIX · XLIII *ARV* 1475/4 · XLIV A. Rumpf, Zum Alexander-mosaik in: *AM* 77 1962, pp. 229 ff. · XLV X.I. Makaronas in: *Deltion* 173 1961/62, pp. 209 ff. · XLVI *Lullies/Hirmer*, pp. 95 f., pl. VIII · XLVII A. Köster, *Die griechischen Terrakotten* 1926, pl. 48; G. Kleiner, *Tanagrafiguren* 1942, 142 · XLVIII *Lullies/Hirmer*, pp. 100 f., pl. X · XLIX *Langlotz/Hirmer*, p. 248, pl. XV · L *ibid.*, p. 249, pl. XX · LI *Lullies/Hirmer*, p. 106, pl. XI · LII *Arias/Hirmer/Shefton*, p. 392, pl. LII.

1 S. Marinatos, *Crete and Mycenae*, pl. 139 · 2 *Berve/Gruben/Hirmer*, pl. 48 · 3 *ibid.*, pl. 49, 54 · 4 *ibid.*, pl. 90 · 5 *ibid.*, pl. 95 · 6 *ibid.*, pl. 42 · 7 *ibid.*, pl. 8 · 8 *ibid.*, pl. 11 · 9 *ibid.*, pl. 13 · 10 *ibid.*, pl. 14 · 11 *ibid.*, pl. 32 · 12 *ibid.*, pl. 40 · 13 *ibid.*, pl. 127 · 14 *ibid.*, pl. 108 · 15 *ibid.*, pl. 111 · 16 *ibid.*, pl. 121 · 17 *ibid.*, pl. 118 · 18 *ibid.*, pl. 122 · 19 *ibid.*, pl. 131 · 20 *ibid.*, pl. 154 · 21 German Institute, Athens · 22 *Berve/Gruben/Hirmer*, pl. 32 · 23 *ibid.*, pl. 23–24 above, Agora Excavations · 24 below *Berve/Gruben/Hirmer*, p. 27 · 25 *ibid.*, pl. 25 · 26 *ibid.*, pl. 163 above · 27 *ibid.*, pl. 166–7 · 28 Hirmer · 29 *Berve/Gruben/Hirmer*, pl. 38 above, 78 · 30 *ibid.*, pl. 72 · 31 *ibid.*, pl. 158 · 32 *ibid.*, pl. 100 · 33 *ibid.*, pl. 101 · 34 *ibid.*, pl. 171 · 35 *ibid.*, pl. 59 · 36 Agora Excavations; H. A. Thompson, *The Athenian Agora*, Guide · 37 Berlin Pergamon Museum · E. Rohde, *Pergamon Burgberg und Altar*, 18 · 38 *Berve/Gruben/Hirmer*, pl. 80 · 39 *ibid.*, pl. 1 · 40 *ibid.*, pl. 7, 5 · 41 *ibid.*, pl. 106 · 42 above Lippold, 176 · 42 centre J. M. Cook, *The Greeks in Ionia and the East* 1962, pl. 13 · 42 below *Berve/Gruben/Hirmer*, fig. 110 · 43 above W. Hahland, *JdI* 79 1964, 189, fig. 47 · 43 centre A. W. Lawrence, *Classical Sculpture* 1928, pl. 33 · 43 below *Berve/Gruben/Hirmer*, pl. 6 · 44 above W. Hahland, *JdI* 79 1964, p. 189, fig. 47 · 44 below *Berve/Gruben/Hirmer*, pl. 87 below · 45 above *Berve/Gruben/Hirmer*, pl. 86 below · 45 centre J. Boardman, *Antiquaries Journal* 1959, pl. 30c · 45 below *Berve/Gruben/Hirmer*, pl. 97 below · 46 above *Langlotz/Hirmer*, pl. 33 · 46 below left J. Caskey, *Catalogue of Sculpture*, Boston, No. 13 · 46 below right *AM* 1933, Suppl. 12.2 · 47 *Langlotz/Hirmer*, pl. 78, 80 · 48 above *Berve/Gruben/Hirmer*, pl. 114 · 48 below *Langlotz/Hirmer*, pl. 24 above · 49 *Etudes Thasiennes* 1, pl. 12 · 50 *Berve/Gruben/Hirmer*, pl. 169 · 51 above *Lullies/Hirmer*, pl. 207–9 · 51 below *Festschrift F. Matz*, pl. 12–13 · 52 *Berve/Gruben/Hirmer*, pl. 152 · 53 *ibid.*, pl. 4 · 54 above E. Rohde, *Pergamon, Burgberg und Altar* · 54 below *Berve/Gruben/Hirmer*, Fig. 7 · 55 J. W. Graham in *Parthenos and Parthenon* 77 ff. (Greece and Rome Suppl.) · 56 *Expl. de Délos* viii, pl. 17–18 ·

57 *Kerameikos* I 1939, pl. 56, No. 556 · 58 *ibid.*, pl. 55, 58, No. 544; *Arias/Hirmer/Shefton*, p. 266, pl. 1 · 59 above *Kerameikos* I 1939, pl. 34, No. 567 · 59 below *Kerameikos* IV 1943, pl. 26, No. 641 · 60 *Kerameikos* I 1939, pl. 56, No. 560 · 61 *Arias/Hirmer/Shefton*, p. 266, pl. 2 · 62 *ibid.*, p. 266, pl. 3 · 63 above *Kerameikos* I 1939, pl. 56, No. 560 · 63 below *Kerameikos* V, I 1954, pl. 54, No. 257 · 64 *Arias/Hirmer/Shefton*, p. 267, pl. 4 · 65 *ibid.*, pp. 267 f., pl. 5 · 66 *ibid.*, pp. 268 f., pl. 7 · 67 *ibid.*, p. 268, pl. 6 · 68 above left Himmelmann, fig. 42 · 68 above right *ibid.*, fig. 44 · 68 below *Arias/Hirmer/Shefton*, p. 269, pl. 8 · 69 left Schefold, p. 191, pl. 8 · 69 right *ibid.*, p. 190, pl. 4b · 70 left Himmelmann, fig. 24–27 · 70 right E. Kunze, VII *Olympia-Bericht* 1961, pp. 145 ff., pl. 60/61 · 71 left Himmelmann, fig. 37/38; Schefold, p. 190, pl. 4a · 71 right *Lullies/Hirmer*, p. 53, pl. 2 · 72 K. Vierneisel in: *AM* 74 1959, Beil. 58

73 above F. Matz, *Geschichte der Griechischen Kunst* I 1950, pl. 18 · 73 R. Tölle in: *AA* 78 1963, 654 · 73 centre F. Matz,

loc. cit., pl. 143a–d · 73 below Schefold, p. 192, pl. 24a · 74 *ibid.*, p. 191, pl. 23 · 75 *Arias/Hirmer/Shefton*, p. 274, pl. 12/13; Schefold, p. 193, pl. 46 · 76 *Arias/Hirmer/Shefton*, p. 279, pl. 35 · 77 *ibid.*, p. 279, pl. 26 · 78 *ibid.*, pp. 277 f., pl. 22; Schefold, p. 42, 188, pl. 10 · 79 *Lullies/Hirmer*, p. 54, pl. 4 · 80 left Lippold, pl. 9, 1 · 80 right G. M. A. Richter, *Kouroi* 1960, fig. 12/13 · 81 J. Dörig in: *AM* 77 1962, pp. 72 ff., Beil. 16 f.; Schefold, p. 46, 188, pl. 14 · 82 *ibid.*, p. 43, 188, pl. 12 · 83 *ibid.*, p. 46, 189, pl. 34/35 · 84 left Lippold, pl. 11, 2 · 84 right *Lullies/Hirmer*, p. 54, pl. 6 · 85 left H. Walter, *Das griechische Heiligtum* 1965, pp. 17 f., fig. 10/11 · 85 right Himmelmann, fig. 4–6 · 86 *Lullies/Hirmer*, p. 55, pl. 7 · 87 Schefold, p. 191, pl. 17 · 88 H. Walter in: *AM* 74 1959, pp. 43 ff., Beil. 87 ff. · 89 above J. Dörig in: *AM* 76 1961, pp. 67 ff., Beil. 40 ff. · 89 below *Lullies/Hirmer*, p. 55, pl. 8 · 90 *Arias/Hirmer/Shefton*, p. 280, pl. 28 · 91 *ibid.*, pp. 275 f., pl. 16 · 93 above Schefold, p. 191, pl. 18 · 93 below *ibid.*, p. 191, pl. 21 · 94 G. M. A. Richter, *Kouroi* 1960, p. 51, pl. 15 · 95 *Lullies/Hirmer*, p. 55 f., pl. 11 · 96 left G. M. A. Richter, *Kouroi* 1960, p. 46, 6, fig. 50 ff., No. 6 · 96 right *ibid.*, p. 42, 2, fig. 33 ff., No. 2 · 97 *Lullies/Hirmer*, p. 58, pl. 20/21 · 98 *ibid.*, p. 55, pl. 10 · 99 *ibid.*, p. 56, pl. 14 · Schefold, p. 192, pl. 38 · 100 *ibid.*, p. 193, pl. 42/43 · 101 *Lullies/Hirmer*, p. 56 ff., pl. 17; E. Kunze in: *AM* 78 1963, pp. 74 ff. · 102 Schefold, p. 193, pl. 56 · 103 *Lullies/Hirmer*, p. 58, pl. 24 · 104 *Arias/Hirmer/Shefton*, pp. 276 f., pl. 19 · 105/106 *ibid.*, p. 284, pl. 35 f. · 107–111 *ibid.*, pp. 287 ff., pl. 40 ff.; Schefold, p. 193, pl. 46–52 · 112 *Arias/Hirmer/Shefton*, pp. 295 f., pl. 51 · 113 *ibid.*, p. 299, pl. 55 · 114 *ibid.*, p. 297, pl. 53 · 115 *ibid.*, pp. 299 f., pl. 56 · 116 *ibid.*, p. 302, pl. 61 · 117 above *ibid.*, p. 302, pl. 60 below · 117 below *ibid.*, p. 303, pl. 64 · 118 *ibid.*, pp. 302 f., pl. 63 · 119 Lippold, pl. 7, 2 · 120 left *Lullies/Hirmer*, pp. 60 f., pl. 33 · 120 right, 121 H. Walter, *Das griechische Heiligtum* 1965, pp. 69 ff., fig. 70/71; N. Himmelmann-Wildschütz, *Marburger Winckelmanns-Programm* 1963, pp. 13 ff., pl. 3 · 122 *Lullies/Hirmer*, pp. 59 f., pl. 27 · 123 O. Rubensohn, *Mitteilungen des Instituts* I 1948, pp. 21 ff. · 124 *Lullies/Hirmer*. p. 61, pl. 37 · 125 *ibid.*, p. 61, pl. 34 · 126 *ibid.*, p. 60, pl. 31 · 127 *ibid.*, pp. 62 f., pl. 43 · 128/129 R. Lullies, *Vasen der reifarchaischen Zeit* 1953, pl. 2, 3; *ARV* 4/9 · 130 *ARV* 23/2 · 131 *ARV* 20/1 · 132 *ARV* 27/4 · 133 *Lullies/Hirmer*, pp. 64 f., pl. 57 · 134/135 *ibid.*, pp. 63 f., pl. 48 ff. · 136 Lippold, pl. 24, 1 · 137: 1 Kraay/Hirmer (hereafter *KH*) 335; 2 *KH* 478; 3 *KH* 345; 4 *KH* 349; 5 *KH* 351; 6 *KH* 355; 7 *KH* 489; 8 *KH* 374; 9 *KH* 446; 10 *KH* 611; 11 *KH* 585; 12 *KH* 589; 13 *KH* 584; 14 *KH* 591; 15 *KH* 625; 16 *KH* 626; 17 *KH* 628; 18 *KH* 595; 19 *KH* 698; 20 *KH* 708; 21 *KH* 709; 22 *KH* 704; 23 *KH* 705 · 138 1 *KH* 223; 2 *KH* 264; 3 *KH* 212; 4 *KH* 217; 5 *KH* 295; 6 *KH* 259; 7 *KH* 224; 8 *KH* 2; 9 *KH* 72; 10 *KH* 73; 11 *KH* 74

139 *ARV* 21/1 · 140 *ARV* 26/1 · 141 *ARV* 185/35 · 142/143 *ARV* 182/6 · 144 *ARV* 189/74 · 145 *ARV* 369/1 · 146 *ARV* 465/82 · 147 *ARV* 318/1 · 148 *ARV* 238/1 · 149 *ARV* 556/101 · 150 *ARV* 437/16 · 151 *ARV* 434/74 · 152/153 *ARV* 204/124 · 154 *ARV* 196/1 · 155 *ARV* 380/172 · 156 *ARV* 879/880/2 · 157 *ARV* 879/1 · 158/159 *ARV* 660/22 · 160/161 *ARV*

612/1 · 162–167 *Lullies/Hirmer*, pp. 67 f., pl. 72 ff., 82 ff. ·
168 W. H. Schuchardt, *Die Epochen der griechischen Plastik*
1959, p. 34, fig. 27 and dust-wrapper · 169 left *Lippold*, p.
175 with note 2 · 169 right A. Blanco, *Cat. Madrid*, No. 24E ·
170 *Lippold*, pl. 32, 2 · 171 *Lullies/Hirmer*, p. 71, pl. 99 ·
172 *ibid.*, p. 71 f., pl. 103 · 173 right E. Babelon/J. Blanchet,
Catalogue des Bronzes Antiques de la Bibliothèque Nationale
1895, No. 313 · 173 left G. Dontas, *Annuario della Scuola
Archeologica di Atene e delle Missioni Italiane in Oriente* 37/38
1959/1960, pp. 329 ff., ill. 1–3 · 174/175 *Lullies/Hirmer*, p. 75,
pl. 131/132 · 176 *Lippold*, pl. 32, 1 · 177 *ibid.*, pl. 34, 3, 4 ·
178 *Lullies/Hirmer*, p. 70, pl. 89 · 179 *ibid.*, pp. 70 f., pl. 96 ·
180 *Lippold*, pl. 45, 1 · 181 *ibid.*, pl. 24, 3 · 182 W. H.
Schuchardt, *Die Epochen der griechischen Plastik* 1959, p. 38,
fig. 31 and p. 70 · 183 left *Lippold*, pl. 39, 2 · 183 right A.
Furtwängler, *Kleine Schriften* 2 1913, pl. 47; V. Poulsen, *Acta
Archeologica* 8 1937, p. 90, fig. 53 · 184 above *Lullies/Hirmer*,
pp. 76 f., pl. 138 · 184 below *ibid.*, p. 76, pl. 134 · 185 left
ibid., pp. 75 f., pl. 133 · 185 right *ibid.*, p. 77, pl. 140 · 186
ibid., p. 77, pl. 139 · 187 *ibid.*, pp. 80 f., pl. 174 · 188–196 *ibid.*,
pp. 73 ff., pl. 107 ff. · 197: 1a KH 78; 1b KH 80; 2 KH 18;
3 KH 156; 4 KH 33; 5 KH 186; 6 KH 6; 7 KH 88; 8 KH
28 (O), 31 (R); 9 KH 24; 10 KH 35; 11 KH 67; 12 KH 93 ·
198: 1 KH 261; 2 KH 298; 3 Hess/Leu 1964, No. 17; 4 KH
357; 5 KH 360; 6 KH 433; 7 KH 380; 8 KH 436; 9 KH 419;
10 KH 427; 11 KH 394; 12 KH 461; 13 KH 630; 14 KH 651;
15 KH 728

199 *Lippold*, pl. 51, 1; C. Karusos, *Neue Beiträge zur Alter-
tumswissenschaft. Festschrift B. Schweitzer*, pp. 161 ff., pl. 31, 2 ·
200 *Lippold*, pl. 51, 3 · 201 W. H. Schuchardt, *Antike Plastik*,
2 ed. 1965, pp. 31 ff., pl. 20–37 · 202 K. Schefold, *Dichter-
bildnisse* 1965, pl. 7 · 203–215 *Lullies/Hirmer*, pp. 78 ff., pl.
142 ff. · 216 J. Dörig in: *JdI* 80 1965, pp. 241 ff., fig. 83–91 ·
217 J. Dörig *loc. cit.*, pp. 143 ff., fig. 1–12 · 218 W. H.
Schuchardt, *Die Epochen der griechischen Plastik* 1959, p. 41,
fig. 34 and p. 72 · 219 *Lippold*, pl. 49, 3, 4 · 220 J. Dörig, *Antike
Plastik* 6 ed., in the press. Cf. meanwhile: *Neue Zürcher
Zeitung* of 28.2.1965, Sunday edition No. 824 (22) · 221 S.
Aurigemma, *Bolletino d'Arte* 40 1955, pp. 67 ff., fig. 6–12;
B. Schweitzer in: *JdI* 72 1957, pp. 1 ff., ill. 1 · 222 *Lippold*,
pl. 61, 1 · 223 *ibid.*, pl. 61, 3 · 224 *ibid.*, pl. 62, 2 · 225 *Lullies/
Hirmer*, pp. 82 f., pl. 183 · 226 *Lippold*, pl. 59, 1 · 227 *ibid.*,
pl. 59, 2 · 228 *Lullies/Hirmer*, p. 83, pl. 184 · 229 left B. Freyer
in: *JdI* 77 1962, p. 223, fig. 8 · 229 right B. Freyer *loc. cit.*,
pp. 211 ff., fig. 1–4 · 230 *ARV* 1228/12 · 231 *ARV* 1143/2 ·
232 *ARV* 1250/34 · 233 *ARV* 1312/2 · 234 *ARV* 1152/2 ·
235 *Lippold*, pl. 70, 2 · 236 *Lullies/Hirmer*, p. 81, pl. 178 ·
237 *ibid.*, p. 85, pl. 191 · 238 *ibid.*, p. 84, pl. 187 · 239: 1 KH 8;
2 KH 98; 3 KH 101; 4 KH 148; 5 KH 129; 6 KH 111; 7 KH
44; 8 KH 46; 9 KH 104; 10 KH 122; 11 KH 118; 12 KH 179;
13 KH 190 · 240: 1 KH 287; 2 KH 273; 3 KH 276; 4 KH 251;
5 KH 303; 6 KH 494; 7 KH 498; 8 KH 499; 9 KH 500;
10 KH 507; 11 KH 452; 12 KH 453; 13 KH 457; 14 KH 422;
15 KH 406; 16 KH 437; 17 KH 407; 18 KH 483; 19 KH 531;
20 KH 537

241 *Lullies/Hirmer*, pp. 85 f., 192 · 242 *Lippold*, pl. 68, 2 ·
243 J. Dörig, *Antike Plastik*, 4 ed. 1965, pl. 6 · 244 above

B. Schlörb, *Timotheos* 1965, 22 Suppl. to *JdI*, pp. 24 ff., fig.
25/26 · 244 below W. Züchner, *Griechische Klappspiegel*, 14
Suppl. to *JdI* 57 1942, p. 62, No. 86 · 245 B. Schlörb,
Timotheos 1965, pp. 36 ff., fig. 37–40 · 246 *Lippold*, pl. 79, 3 ·
247 *ibid.*, pl. 83, 1 · 248 W. H. Schuchardt, *Die Epochen der
griechischen Plastik* 1959, p. 97, fig. 77 · 249 *Lullies/Hirmer*, p.
95, pl. 228 · 250 *ibid.*, pp. 92 f., pl. 219 · 251 *ibid.*, p. 93, pl.
222 · 252 *ibid.*, p. 94, pl. 224 · 253 *Lippold*, pl. 98, 3 · 254
Lullies/Hirmer, pp. 90 ff., pl. 214 ff. · 255 *Lippold*, p. 251 with
note 5 · 256 *Lullies/Hirmer*, p. 90, pl. 211 · 257 above K.
Schefold, *Meisterwerke griechischer Kunst* 1960, 258, No.
VII, 332, fig. p. 257 · 257 below E. Schmidt in: *JdI* 47 1932,
pp. 292 ff., fig. 40–43 · 258 J. Dörig in: *JdI* 79 1964, 266, fig.
12 · 259 right V. Poulsen, *Acta Archaeologica* 15 1944, pp.
63 ff., fig. 1–4; W. H. Schuchardt, *Festschrift B. Schweitzer*,
pp. 223 ff. · 259 left K. Schefold, *Basler Antiken im Bild* 1958,
pl. 31 · 260 A. Rumpf, *Analecta Archaeologica. Festschrift F.
Fremersdorf*, pp. 93 ff., pl. 22c · 261 above *Lippold*, p. 281 with
note 4 · 261 below cf. provisionally P. Arndt/G. Lippold,
text accompanying photographs 3493–3494; *Freiburger Uni-
versitatsblätter*, vol. 8, May 1965, pp. 22 f. · 262 right J. Dörig
in: *JdI* 79 1964, pp. 264 ff., fig. 7–11 · 262 left above *JdI* 79
1964, p. 268, fig. 14–17 · 262 left below E. Babelon/J. Blanchet,
Catalogue des Bronzes Antiques de la Bibliothèque Nationale
1895, No. 15 · 263 left E. Babelon/J. Blanchet, *loc. cit.*, No.
1 · 263 right *JdI* 79 1964, p. 267, fig. 13 · 264 *Lullies/Hirmer*,
p. 94, pl. 226 · 265 *ibid.*, pp. 94 f., pl. 227 · 266 *ARV* 1414/89 ·
267 *Arias/Hirmer/Shefton*, p. 383, pl. 224 · 268 *ARV* 1475/1 ·
269: 1 KH 439; 2 KH 513; 3 KH 503; 4 KH 409; 5 KH 410;
6 KH 414; 7 KH 463 (O), 462 (R); 8 KH 515; 9 KH 514;
10 KH 539; 11 KH 553; 12 KH 552; 13 KH 425; 14 KH 442;
15 KH 567; 16 KH 563; 17 KH 569 · 270: 1 KH 124; 2 KH
133; 3 KH 206; 4 KH 208; 5 KH 209; 6 KH 270; 7 KH 306;
8 KH 308; 9 KH 315; 10 KH 318; 11 KH 237; 12 KH 241;
13 KH 226; 14 KH 290; 15 KH 608; 16 KH 644; 17 KH
729; 18 KH 726; 19 KH 788

271 *Lullies/Hirmer*, pp. 95 f., pl. 233 · 272 *Berve/Gruben/Hirmer*,
pl. 160 · 273 *Lullies/Hirmer*, p. 97, pl. 243 · 274/275 A. Blanco,
Catalogo de la Escultura 1957, No. 99; Arndt-Bruckmann, pl.
491 ff.; E. Buschor, *Das hellenistische Bildnis*, 1949, 9 · 276
Lippold, p. 303, note 1; Arndt-Bruckmann, pl. 1111–14 · 277
Lullies/Hirmer, pp. 98 f., pl. 245 · 278 *Lippold*, p. 302, note 6,
pl. 108, 1 · 279 *Lullies/Hirmer*, p. 99, pl. 246 · 280 left *Langlotz/
Hirmer*, p. 294, pl. 140 · 280 right KH 137, 474 (R) · 281
H. B. Walters, *Catalogue of the Terracottas* 1903, 324, D161 ·
J. Boardman, *Greek Art* 1964, ill. 212; re motif, J. Dörig in:
Museum Helveticum 16 1959, 29–58 · 282 H. Sichtermann in:
Antike Plastik IV 1965, pp. 71 ff., pl. 39–52; *Lullies/Hirmer*,
pp. 107 ff., pl. 280 · 283 Brunn-Bruckmann, pl. 540; *Lippold*,
p. 348, note 4 · 284 *Lullies/Hirmer*, p. 99, pl. 247 · 285 R.
Lullies, *Die kauernde Aphrodite* 1954, p. 12, No. 6, fig. 7, 21/22 ·
286 *Lullies/Hirmer*, p. 98, pl. 244 · 287 R. Horn, *Stehende
weibliche Gewandstatuen in der hellenistischen Plastik* 1931, 46,
13, 2 · 288 *Lippold*, p. 342, note 5, pl. 122, 3 · 289 *ibid.*, p. 342,
note 3, pl. 122, 1 · 290–296 *Lullies/Hirmer*, pp. 101 f., pl.
251–259 · 297 *ibid.*, pp. 102 f., pl. 262 · 298 *Lippold*, p. 322,
note 4, pl. 112, 2 · 299 *ibid.*, p. 321, note 15, pl. 112, 3–4 ·

300–301 *Lullies/Hirmer*, pp. 99 f., pl. 248/249 · 302 *Lippold*, p. 327, note 6, pl. 116, 4 · 303 A. K. Orlandos in: *Praktika* 1962 (1966), pl. 103, 2–4; G. Despinis in: *AA* 1966 · 304 *Lullies/Hirmer*, p. 103, pl. 263 · 305 *ibid.*, p. 102, pl. 260 · 306 *ibid.*, pp. 105 f., pl. 272 · 307 *ibid.*, p. 105, pl. 270 · 308 *Langlotz/Hirmer*, p. 298, pl. 148 · 309 *ibid.*, p. 299, pl. 150 · 310 *Lippold*, p. 368, pl. 135, 3 · 311 *ibid.*, p. 369, note 4 · 312 *Lullies/Hirmer*, p. 103, pl. 264 · 313 *Lippold*, p. 370, note 7, pl. 130, 4; J. Schäfer in: *Antike Plastik* V or VI (in prepara-tion) · 314 W. Fuchs, Die Vorbilder der neuattischen Reliefs, in: *JdI* 1959, 20 suppl. vol., pp. 73 ff., no. 1; Helbig,[4] No. 1590 (W. Fuchs) · 315 *Lullies/Hirmer*, p. 106, pl. 273 · 316 W. Fuchs, *Der Schiffsfund von Mahdia* 1963, 18, no. 8, pl. 17; A. Adriani in: *Römische Mitteilungen* 70 1963, pp. 80 ff., pl. 32, 2 · 317 *Lullies/Hirmer*, pp. 106 f., pl. 277 · 318 see 290–296 · 319 *Lullies/Hirmer*, p. 107, pl. 279 · 320: 1 *KH* 581; 2 *KH* 142; 3 *KH* 736; 4 *KH* 743; 5 *KH* 799; 6 *KH* 802; 7 *KH* 804; 8 *KH* 577; 9 *KH* 578; 10 *KH* 739; 11 *KH* 775

TEXT FIGURES

1 London, Science Museum · 2 Dinsmoor, fig. 16 · 3 Lawrence, fig. 50 (after Stephani) · 4 *Berve/Gruben/Hirmer*, fig. 4 (after Krauss) · 5 *ibid.*, fig. 21 · 6 *ibid.*, fig. 113 (after Wiegand and Schrader) · 7 Dinsmoor, fig. 48 · 8 G. Gruben, *Die Tempel der Griechen* 315, 1966, fig. 249 · 9 H. C. Butler, *Sardis* ii 1925, pl. B, C · 10 *ibid.*, fig. 28 (after Dinsmoor) · 11 J. Boardman, *Antiquaries Journal* 1959, pp. 174 f., fig. 1–2 · 12 *Berve/Gruben/Hirmer*, fig. 112 · 13 R. Ghirshman, *Persia*, fig. 186 · 14 E. F. Schmidt, Persepolis 1, 95 · 15 G. Roux in *Bull. Corr. Hell.* 1953, pl. 31 (after Martin) · 16 *Berve/Gruben/ Hirmer*, fig. 49 (after Dugas and Clemmensen) · 17 *ibid.*, fig. 54 (after Defrasse and Lechat) · 18 *ibid.*, fig. 134 (after Dinsmoor) · 19 *ibid.*, fig. 14 (after Borrmann) · 20 *ibid.*, fig. 88 (after Gabrici) · 21 Lawrence, pl. 29 (after Borrmann) · 22 N. Thomas in: *Arch. Reports* for 1964–1965, 66, fig. 5 · 23 J. Boardman, *Antiquaries Journal* 1959, pl. 31–32 · 24 Lawrence, fig. 97 (after Middleton) · 25 *ibid.*, pl. 62 (after Penrose) · 26 *ibid.*, pl. 54a (after Penrose) · 27 *Berve/Gruben/ Hirmer*, fig. 25 (after Dinsmoor) · 28 *ibid.*, pl. 140 below · 29 J. Boardman, *Greek Emporio* 79, fig. 42 · 30 *id.*, *Antiquaries Journal* 1959, pl. 33b · 31 C. Blümel, *Die archaische griechischen Skulpturen*, Berlin, fig. 192 (after Krischen) · 32 *Berve/Gruben/ Hirmer*, fig. 114, 115 (after Schleif) · 33 *ibid.*, fig. 107, 108 (after von Gerkan) · 34 Lawrence, fig. 117 · 35 *Berve/Gruben/ Hirmer*, fig. 1 · 36 *ibid.*, fig. 3 (after Kawerau) · 37 *ibid.*, fig. 8 · 38 *ibid.*, fig. 38 · 39 *ibid.*, fig. 21 (after Courby) · 40 *ibid.*, fig. 42 · 41 *ibid.*, fig. 41 (after Furtwängler and Fiechter) · 42 *ibid.*, fig. 13 · 43 *ibid.*, fig. 9, 10, 12 (after Doerpfeld) · 44 *ibid.*, fig. 44 · 45 *ibid.*, fig. 43 (after Krischen) · 46 G. P. Stevens in: *Hesperia* 1955, 250 · 47 *Berve/Gruben/Hirmer*, fig. 61 · 48 *ibid.*, fig. 69 · 49 *ibid.*, fig. 79 · 50 *ibid.*, fig. 86 (after Koldewey) · 51 *ibid.*, fig. 89 (after Hulot and Fougères) · 52 *ibid.*, fig. 92 (after Hulot and Fougères) · 53 *ibid.*, fig. 100 (after Dinsmoor) · 54 *ibid.*, fig. 101 (after Lawrence) · 55 *ibid.*, fig. 72 (after Krauss) · 56 *ibid.*, fig. 75 (after Krauss) · 57, 58 *ibid.*, fig. 76, 77 (after Krauss) · 59 *ibid.*, fig. 96 (after Koldewey) · 60 *ibid.*, fig. 78 (after Krauss) · 61 *ibid.*, fig. 121 (after Buschor and Schleif) · 62 *ibid.*, fig. 123 (after Dinsmoor) · 63 fig. 126 (after Krischen) · 64 *AM* 1915, pl. 5 · 65, 66 *Berve/Gruben/Hirmer*, fig. 64, 65 · 67, 68 G. P. Stevens in: *Hesperia* 1946, 93 ff. · 69 *Berve/Gruben/Hirmer*, fig. 139 (after Schede) · 70 *ibid.*, fig. 140 (after Wiegand and Schrader) · 71 *ibid.*, fig. 128 (after Krischen) · 72 *ibid.*, fig. 129 (after Knackfuss) · 73 *ibid.*, fig. 135 (after Knackfuss) · 74 *ibid.*, fig. 36, 37 (after Pomtow and Lawrence) · 75 *ibid.*, fig. 70 (after Travlos) · 76 Dinsmoor, fig. 77 (after Doerpfeld) · 77 *Berve/Gruben/Hirmer*, fig. 55 (after Doerpfeld) · 78 *ibid.*, fig. 138 (after von Gerkan) · 79 Dinsmoor, fig. 91 · 80 *Berve/Gruben/Hirmer*, fig. 30 (after Fomine) · 81 H. A. Thompson, *Athenian Agora*, Guide, fig. 5 (after Travlos) · 82 *ibid.*, pl. III · 83 Lawrence, fig. 161 (after Krischen) · 84 J. Bühlmann, *Architektur* 1904 · 85 *Lullies/ Hirmer*, fig. 11 (after Krischen) · 86 T. Fyfe, *Hellenistic Archi-tecture*, fig. 10 (after Keil) · 87 J. Boardman, *Greek Emporio* 39, fig. 18 · 88, 89 M. Schede, *Ruinen von Priene*, fig. 118–119 (after Wiegand and Schrader) · 90 Bruneau/Ducat, *Guide de Délos* 154, fig. 35 · 91 *ibid.*, 118, fig. 21 (after Fister) · 92 *British School Annual* 1958–1959 15, fig. 3 (after Nicholls) · 93 *Berve/Gruben/Hirmer*, fig. 137 (after Wiegand and Schrader) · 94 G. P. Stevens in: *Hesperia* 1946

96 G. Dontas in: *Deltion* 17 1961/1962, Chronika p. 9, pl. 5 below · 96 F. Willemsen, Dreifusskessel von Olympia, *Olympische Forschungen*, Bd. 3 1957, pp. 1 ff., pl. 1 · 97 *ibid.*, pp. 100 ff., pl. 63 left · 98 *Arias/Hirmer/Shefton*, p. 267, pl. 4 · 99/100 D. Ohly, *Griechische Goldbleche des 8. Jahrhunderts v. Chr.* 1953, pl. 15/16 · 101 *Schefold*, p. 29, pl. 4 · 102 *ibid.*, p. 26, pl. 5c · 103 *ibid.*, p. 23, pl. 6b · 104 *ibid.*, p. 23, pl. 7a · 105 *ibid.*, 24, pl. 7b · 106/107 P. Courbin in: *BCH* 81 1957, pp. 322 ff., pl. 2/3; E. Buschor, *Die Plastik der Griechen* 1958, fig. p. 9

108 *Schefold*, p. 42, pl. 9 · 109/110 *CVA* Berlin 1, pl. 20/21; *Schefold*, p. 47, pl. 36a · 111 *ibid.*, p. 44, pl. 13 · 112 R. H. Higgins, *Greek and Roman Jewellery* 1961, p. 112, pl. 20 · 113 D. Ohly in: *AM* 74 1959, p. 54, fig. 7 · 114 J. Dörig in: *AM* 76 1961, p. 79, fig. 1 · 115 *Schefold*, p. 30, pl. 5 · 116 J. Dörig in: *AM* 77 1962, pp. 88 ff., Beil. 23, 2 · 117 W. H. Schuchhardt in: *AM* 60/61 1935/1936, p. 84, fig. 12 · 118 G. Rodenwaldt, *Korkyra* 2 1939, pl. 1; J. Dörig/O. Gigon, *Der Kampf der Gotter und Titanen* 1961, in particular pp. 13 ff.; E. Kunze in: *AM* 78 1963, pp. 74 ff. · 119 W. H. Schuchhardt, *Archaische Giebelkompositionen* 1940, pp. 17 ff., fig. 2 · 120/121 *ibid.*, pp. 20 ff., fig. 3/4 · 122 *Schefold*, p. 80, pl. 67a · 123/124 A. Rumpf, *Sakonides* 1937, pl. 21–23; *ABV*, p. 108, No. 5 · 125 E. Langlotz, *Griechische Vasen in Würzburg* 1932, pp. 23 f., No. 164, pl. 26 f. · 126 S. Karusu, *The Amasis Painter* 1956, pl. 44; *ABV*, 154, No. 157 · 127 J. D. Beazley, *The Develop-ment of Attic Black-Figure* 1951, pl. 32, 1: *ABV*, 145, No. 18 · 128 J. D. Beazley, *The Development of Attic Black-Figure* 1951, p. 74, pl. 33; *ABV* 140, No. 1 · 129 N. Himmelmann-Wildschütz, *Marburger Winckelmanns-Programm* 1963, pp.

13 ff. · 130 *Arias/Hirmer/Shefton*, pp. 318 f., pl. 92 ff. · 131/132 J. Dörig, Lesefrüchte, in: *Festschrift K. Schefold* · 133 *Kraay/Hirmer*, No. 397, 401, 426 · 134, *ibid.*, No. 48, 62, 168, 184 · 135 *ibid.*, No. 784

136 *Furtwängler/Reichhold*, pl. 161; *ARV*, p. 459, No. 3 · 137 *Encyclopédie Photographique* 3 1938, p. 13, D; *ARV*, pp. 472 f., No. 211 · 138/139 *Pfuhl*, pp. 475 f.; *ARV*, p. 550, No. 1 · 140 *Furtwängler/Reichhold*, pl. 116/117; *ARV*, p. 613, No. 1 · 141 *Furtwängler/Reichhold*, pl. 118/119; *Pfuhl*, fig. 507; *ARV*, p. 616, No. 3 · 142 *DU* 215, Jan. 1959, p. 23, 4; *Lullies/Hirmer*, p. 50, fig. 3 · 143 A. Furtwängler, *Aigina* 1906, pl. 23; *Lullies/Hirmer*, p. 51, fig. 4 · 144/145 *Olympia* III 1894, pl. 45; W. H. Schuchhardt, Inhalt und Form bei Olympia-Metopen, in: *Festschrift H. Friedrich* 1965, pp. 239 ff. · 146 *Lullies/Hirmer*, p. 73, fig. 5 · 147 *ibid.*, p. 73, fig. 6 · 148 C. Haspels, *Attic Black-Figured Lekythoi* 1936, p. 256, No. 50 · 149 *Kraay/Hirmer*, No. 13, 15, 20

150 *Arias/Hirmer/Shefton*, p. 380, pl. 220 · 151/152 J. Liegle, *Der Zeus des Phidias* 1952, pl. 1 ff.; cf. A. Mallwitz/W. Schiering, *Die Werkstatt des Phidias in Olympia. Olympische Forschungen*, Bd. 5 1964, pp. 1 ff. · 153/154 *Lullies/Hirmer*, p. 145, fig. 9/10 · 155/156 *Lullies/Hirmer*, p. 144, fig. 7/8 · 157/158 H. Cahn, *Robinson Studies* 1, pp. 559 ff., pl. 42/43b; most recently, *JdI* 80 1965, p. 224, fig. 67a/b · 159 *JdI* 80

1965, p. 163, 12, note 113 · 160/161 *JdI* 80 1965, pp. 174 ff., fig. 18 ff. · 162 E. Buschor, *Lekythen der Parthenonzeit. Münchner Jahrbuch* 1925, pl. 5 · 163 *Rumpf*, p. 116, fig. 8 · 164 *ibid.*, 41, fig. 2 · 165 *Kraay/Hirmer*, No. 107, 109, 42 · 166 *ibid.*, No. 158, 161, 164 · 167 *ibid.*, No. 170, 173, 175

168 B. Schlörb, Timotheos. 22 Suppl. to *JdI* 80 1965, Beil. 169 Arguments for this attempted reconstruction will be given elsewhere · 170 *Lippold*, pp. 249 ff. · 171 J. D. Beazley/B. Ashmole, *Greek Sculpture and Painting* 1966 · 172 *Universitas* 14 1959, p. 1280 · 173 *Olympia* IV 1897, p. 236 · 174 *JdI* 72 1957, p. 33, fig. 12 · 175 After *JdI* 3 1888, p. 190 with fig.; based on this, G. Kleiner in: *JdI* 65/66 1950/1951, p. 229, fig. 15 · 176 N. Himmelmann-Wildschütz, *Zur Eigenart des klassischen Götterbildes* 1959, pp. 17 ff., note 27, fig. 5a/b · 177 *Pfuhl*, fiig. 604 · 178 W. Züchner, Griechische Klappspiegel, 14 Suppl. to *JdI* 57 1942, p. 24, No. 26, pl. 15 · 179 *ibid.*, p. 46, No. 59, pl. 21 · 180 *ibid.*, pp. 14 ff., No. 17, pl. 17 · 181 *Pfuhl*, 646; *Rumpf*, pp. 143 ff., pl. 47, 2 · 182 *Pfuhl*, 647; *Rumpf*, pl. 47, 1 · 183 *Kraay/Hirmer*, No. 235, 228, 241

184 *Lullies/Hirmer*, p. 104, pl. 268 · 185 W. Fuchs, *Der Schiffsfund von Mahdia* 1963 · 186 F. Magi, *Atti della Pontificia Accademia*, Memorie 9 1960 · 187 *Pfuhl*, fig. 684 · 188 *Kraay/Hirmer*, No. 621, 658, 660, 718 · 189 J. N. Svoronos 1904–1908, No. 1871

Professor Max Hirmer's photographs are supplemented by pictures from the undermentioned sources:

Alinari, Florence: pl. 222, 246, 278, 299 right · Anderson, Rome: pl. 226, 242, 258 right, 284, 285 · E. M. Androulaki: pl. 80 right · Archäologisches Seminar, Munich: pl. 120 right, 121; fig. 129 · Athens, Agora Excavations: pl. 24 above, 36; fig. 82 · Athens, French School: pl. 44, 49 above · Athens, German Institute: pl. 21, 46 below right, 51 below, 57, 61, 63 below, 68 above, 69 right, 70 right, 71 right, 75 left, 79, 80 left, 83, 84 left, 85, 88, 89 below, 96 right, 100, 101, 168, 173 left, 182, 183 left, 229 left, 244 above, 313; fig. 159, 169 · Basle, Öffentliche Kunstsammlungen: pl. 259 left · Berlin, Staatliche Museen: pl. 37, 43, 54 above, 97, 171, 185 right, 244 below, 290–296, 306, 318 · Prof. Dr. H. Bloesch, Winterthur: pl. 257 above · J. Boardman, Oxford: pl. 45 centre; fig. 5 · Boris, Paris: pl. 216 left · Boston, Museum of Fine Art: pl. 46 below left, 67, 273 · Brogi, Rome: pl. 314 · Prof. J. M. Cook, Bristol: pl. 42 centre ·

Copenhagen, Nationalmuseum: pl. 89 above · Copenhagen, Ny Carlsberg Glyptotek: pl. 68 below, 202, 223, 259 right, 276 · G. Despinis, Athens: pl. 303 · J. Dörig, Freiburg: pl. 220 · Dresden, Staatliche Kunstsammlungen: pl. 200, 240 left, 255 · P. R. Franke, Munich: fig. 152 · Frankfurt, Städtische Galerie: pl. 262 right · Giraudon, Paris: pl. 229 right, 302 · G. Hafner: pl. 224 · C. Hansmann, Munich: pl. XLVII · Kassel, Staatliche Kunstsammlungen: pl. 199 · F. Kaufmann, Munich, pl. 218, 247, 298 · Leningrad, Hermitage: pl. 268; fig. 160, 161, 176, 177 · London, British Museum: pl. 43 centre, 176 left, 260 · London, Science Museum: fig. 1 · Munich, Staatliche Antikensammlungen: pl. 69 left · New York, Metropolitan Museum of Art: pl. 66, 71 left, 74, 81, 95, 267 · Oxford, Ashmolean Museum: pl. 42 above, 183 right · Paris, Bibliothèque Nationale: pl. 173 right · F. Roiter, Venice: pl. XLV · Rome, German Institute: pl. 258 left, 261 above; fig. 171 · Scala, Florence: pl. XLIV · Stockholm, Nationalmuseum: pl. 76 · N. Tombazis, Athens: fig. 172 · Toronto, Royal Ontario Museum, pl. 55

CORRIGENDA

Captions to the plates:

69 For 'of Odysseus' read '(of Odysseus?)'.
120 For 'Philippe' read 'Ornithe'.
134 For 'b' read 'd'; for 'c,d' read 'b,c'.

141 For 'Javelin-thrower and trainer' read 'Cassandra threatened by Aias'
220 Add '(from a plaster cast in Freiburg/Br.)'.

The Publishers regret that there are also some minor inconsistencies in the spelling of Greek names; this applies in particular to the sections on coins.

Errata
In the captions to colour plates VI, VII, VIII, XIV, XV, XVII, XXI, XXII, XXVII, XXVIII, and XXXIX, the cross references should be to plates 92, 93, 102, 115, 117, 118, 142, 143, 172, 175, 233 and 251, respectively.

INDEX OF WORKS ILLUSTRATED

Arranged by locations. Text figures in italic

MONUMENTS

WORKS OF ART IN MUSEUMS

Athlete with strigil 444 f., 446, 447; pl. 258
Laokoön group 74 319 f.; *186*; pl. 319

VENICE, Biblioteca Marciana
Head of Dionysos 447; pl. 261 below

VENICE, Museo Archeologico
Votive relief 17, for Kybele and Attis 508; pl. 286

VIENNA, Kunsthistorisches Museum
Athlete with strigil 3168 434; pl. 243

VLASTOS COLLECTION (Athens, National Museum)
Small Zeus head from Tarentum, cast from clay mould 448;
 pl. 262 above left

WÜRZBURG, Martin-von-Wagner Museum (the University
 Museum)
Chiot chalice 311 158; pl. 90
Amasis Painter. Amphora 265 170; pl. 113
'Eye-cup' 164, 'Phineus Cup' 172; *125*
Brygos Painter. Cup 479 268; pl. XXIV

COINS IN STATE COLLECTIONS

ATHENS, National Museum, Coins Section Pl. 240 (16), 269 (7,
 r.), 320 (6)

BERLIN, Staatliches Münzkabinett Pl. 137 (2, 15, 17, 19), 138 (4,
 5, 6), 198 (1, 4, 11), 239 (5, 8), 240 (9, 10, 12, 18, 20), 269 (1, 6, 14,
 17), 270 (9, 14, 15), 320 (7); *133 (2, 3), 151, 165 (1, 2, 3), 183 (1),
 188 (4)*

BRUSSELS, Bibliothèque Royale de Belgique, Cabinet des Méd-
 ailles Pl. 137 (7), 197 (4, 5); *134 (4), 166 (1, 3)*

FLORENCE, Museo Nazionale Archeologico *152*

LONDON, British Museum, Department of Coins and Medals
 Pl. 137 (5, 6, 8, 9, 10, 11, 14, 16, 18, 20), 197 (1b, 2, 6, 7, 11),
 198 (13, 14, 15), 239 (3, 6, 7, 11), 240 (3, 6, 7, 8, 11, 13, 15, 19),

269 (2, 3, 10, 15, 16), 270 (10, 16), 320 (2, 11); *134 (1), 149 (2),
 188(1)*

MUNICH, Staatliche Münzsammlung Pl. 137 (12), 138 (11),
 239 (12), 269(8), 270 (17)

NAPLES, Museo Nazionale Archeologico, Cabinetto Numis-
 matico Pl. 198 (2); *183 (2)*

PARIS, Cabinet des Médailles Pl. 137 (4, 13, 21, 23), 138 (1, 7),
 197 (1a), 198 (12), 239 (9), 240 (4), 269 (9, 12), 270 (6, 19); *133 (1),
 135*

SYRACUSE, Museo Nazionale Archeologico Pl. 138 (9), 197 (8,
 r.), 270 (2, 4)

The remaining coins belong to various private collections.